Saint Peter and the Vatican

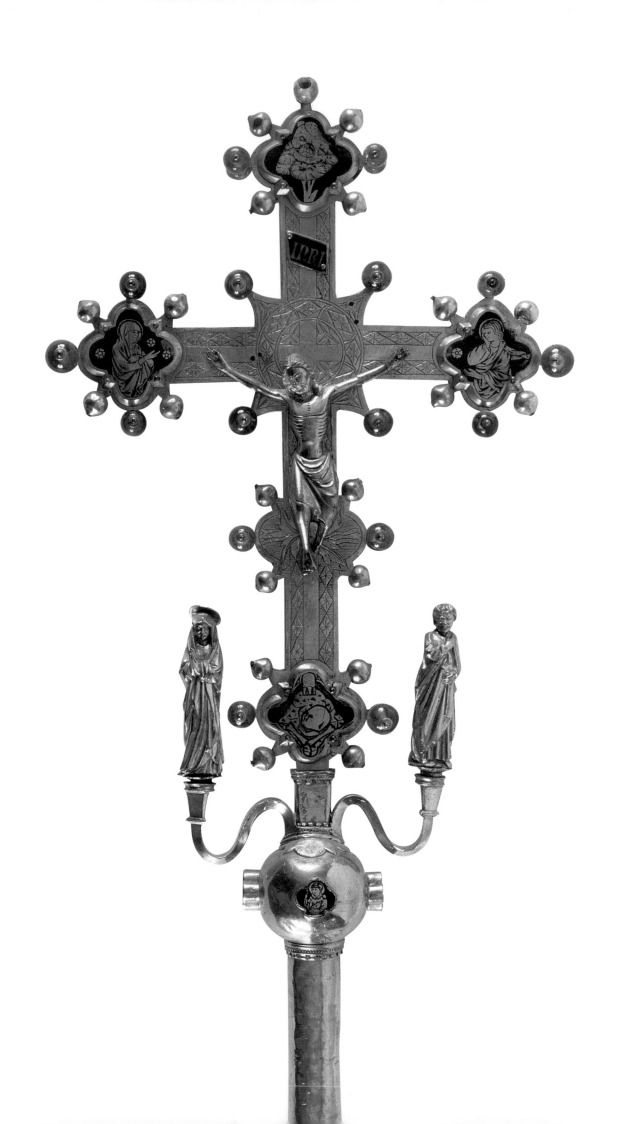

Saint Peter and the Vatican

The Legacy of the Popes

Allen Duston, O.P., and Roberto Zagnoli

Art Services International
Alexandria, Virginia
2003

Frontispiece:

Processional Cross

Early 15th century, Tuscany
Gilt metal, rock crystal, enamel 70 × 34 × 4 cm
Vatican Museums, Vatican City State
Inv. 62058

This splendid processional cross is a masterpiece of the
Tuscan Renaissance, and the precious materials and the
complex composition make it a work of rare beauty.
At the joint of the cross is a globe and the wooden staff is
decorated with four enamel plaques. These portray Christ
emerging from the sepulcher, the Virgin Mary, Saint John,
and another saint with a book and palm branch. Extending
from the globe is a large Latin cross, the ends of which
are decorated with small enamel plaques edged with
alternating metal and crystal balls. Similar crystal balls are
attached to the joint at the arms of the cross, and other
crystal and metal balls appear on the lower vertical arm on
the same plane as the suppedaneum, the shelf supporting
Christ's feet.

Christ is portrayed in full relief, attached to the arms of
the cross, decorated with delicate geometric engravings.
Over Christ's head is the inscription "INRI" ("Jesus the
Nazarene King of the Jews"), also rendered in enamel.
Statues of the Virgin Mary and Saint John the Evangelist are
mounted on top of two volutes that extend from the top
of the globe. The enamel at the top of the cross shows a
pelican; according to an ancient belief, this bird nourished
its young with its own blood by pecking at its chest. At the
ends of the horizontal arms are enamel busts of Mary and
Saint John. At the bottom an enamel represents the skull
of Adam: according to Jewish tradition, it was buried in
"a place called Golgotha, that is, the place of the skull"
(Mt 27:33), where Jesus was crucified.

On the back of the cross is a relief of the Easter Lamb
and enamel plaques representing the four symbols of the
evangelists: John (eagle), Luke (ox), Mark (lion), and
Matthew (angel). An inscription reads "QUESTA CROCE
A FATA FARE LA CO[M]PAG/NIA DI SA(N)TA MARIA DI
GHALCIANO" ("This cross was commissioned by the
company of Saint Mary of Ghalciano"), likely a church in
Val d'Arno, near Florence.

This cross contains elements symbolic of Christ's
Sacrifice, achieved by his death on the Cross and his
Resurrection. The pelican, for example, recalls how Christ
offered his blood for the salvation of his people. Also, the
blood of the Redeemer drips onto Adam's skull, which
represents Christ, the new Adam, restorer of the original
purity of humanity. The Lamb, known universally as
Christ, is "the lamb of God that takes away the sin of the
world" (Jn 1:29). U.U

Cover:
Pietro Perugino,
Consignment of the Keys to Saint Peter 1480,
fresco, Sistine Chapel

Saint Peter and the Vatican: The Legacy of the Popes
This volume accompanies an exhibition organized and circulated by
Arts Services International, Alexandria, Virginia, in conjunction with
the Governatorato of the Vatican City State and the Office of the Patrons
of the Arts in the Vatican Museums. The exhibition has been produced by
Clear Channel Exhibitions in association with Trident Media Group.

Library of Congress Cataloging-in-Publication Data available upon request.

ISBN 0-88397-140-2 (paperback catalogue)
ISBN 0-88397-141-0 (hardcover catalogue)

Edited by Susan Higman
Designed by Derek Birdsall, Omnific Studios, London
Index by Maureen MacGlashan
Map of the Vatican City State by Michael Robinson
Printed in China by Sun Fung Offset Binding Co. Ltd.

Contents

John Paul II

Bishop of Rome
Vicar of Christ
Successor of the Prince of the Apostles
Supreme Pontiff of the Universal Church
Patriarch of the West
Primate of Italy
Archbishop and Metropolitan of the Roman Province
Sovereign of the State of the Vatican City
Servant of the Servant's God

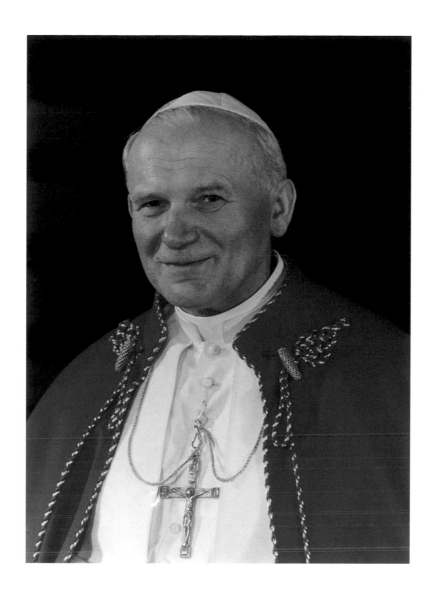

May all who visit the exhibition

"Saint Peter and The Vatican,"

in admiring the beauty of the works of art contained therein,
draw near with confidence to Jesus Christ the Redeemer,
who made the *Apostle Peter* his vicar on earth.

From the Vatican, 3 September 2002

Joannes Paulus II

Honorary Committee

UT UNUM SINT

My Name is Peter.

On 10 June 1969, at the headquarters of the World Council of Churches in Geneva, the late Pope Paul VI, in a clear and impassioned voice, introduced himself in these words: "We are here among you. Our name is Peter. Scripture tells us the meaning Christ willed to give to this name, and what duties he lays upon Us: the responsibilities of the Apostle and his successors." The assembly was deeply moved by this statement, which, by returning to the distant past, transcended divisions created over the course of centuries. It was a moment of deep emotion which created a heartfelt desire for fraternal communion.

My name is Peter.

"You are Peter and on this rock I will build my community" (Mt 16:18). Peter is the rock on which Christ established his Church. The First Letter of Peter takes up the image of a rock, applying it to Christ, the "cornerstone," and applying it to all Christians: "Come to him, to that living stone, rejected by men but in God's sight chosen and precious; and like living stones be yourselves built into a spiritual house, to be a holy priesthood, to offer spiritual sacrifices acceptable to God through Jesus Christ" (1 Pet 2:4-5). In the Vatican Grottoes, on a perfect axis with the papal altar of the basilica above, lies the tomb of Peter. The tomb is itself a symbol of the Rock on which the Church is built, a Church symbolized by the basilica that rises above the Tomb of the Apostle and encloses it like a precious casket. When the pope celebrates the Eucharist on the high altar of Saint Peter's Basilica, he makes present once again, in the continuity of history, not only the saving Death and Resurrection of Jesus Christ, but also the visible continuity between Peter and his successors, and between Christ, Peter, and the Church.

My name is Peter.

As the successor of Peter, the pope is also called the vicar of Christ. This traditional title can only be understood properly in the context of the whole Gospel. Before ascending to heaven, Jesus said to his apostles: "Lo, I am with you always, to the close of the age" (Mt 28:20). Unseen, Christ remains personally present in the life of his Church and in her sacraments, particularly the Holy Eucharist. He is likewise present in every Christian through the grace of baptism. Against this broader horizon, the expression "vicar of Christ" takes on its full meaning. It refers not so much to a dignity as to a service; it is meant to emphasize the pope's responsibilities in the Church, his Petrine ministry, intended for the good of the Church and of the Christian faithful. Pope Saint Gregory the Great understood this perfectly well when, of all the titles associated with the office of the bishop of Rome, he preferred that of *Servus servorum Dei* (Servant of the Servants of God).

My name is Peter.

For every pope, the Sistine Chapel is a place associated with memories of a particular day in his life. There, in that hallowed space, the cardinals gather to discern Christ's will concerning the next successor of Peter. There, on that now distant day of 16 October 1978, in a spirit of obedience to Christ and with confidence in the intercession of the Blessed Virgin Mary, Cardinal Karol Wojtyla accepted the outcome of the conclave's election and declared to the cardinal camerlengo his readiness to serve the Church in this new and lofty role. For the Catholic world, the Sistine Chapel had once more witnessed the working of the Holy Spirit, who raises up bishops in the Church, and in particular the one who is to be the bishop of Rome and the successor of Peter.

My Name is Peter.

The Tomb of the Apostle not only lies on a perpendicular axis with the altar of Saint Peter's Basilica, but also with the summit of Michelangelo's Dome, which towers above the city of Rome and which, from its summit, offers a view toward the distant horizon. That view embraces as it were the entire pilgrim journey of the Church, which following the great jubilee of the year 2000 has been called to press forward with renewed enthusiasm. The successor of Peter has expressed this summons in the words of Jesus himself, who, after teaching the crowds from Simon's boat, commanded the apostle to "put out into the deep" for a catch: *Duc in altum!* (Lk 5:4). Peter and his companions put their faith in Christ's words and lowered their nets. "And when they had done this, they enclosed a great shoal of fish" (Lk 5:6).

Duc in altum! Put out into the deep! These words continue to resound in our hearts today. They invite us to remember the past with gratitude, to live the present with enthusiasm, and to embrace the future with hope: "Jesus Christ is the same yesterday and today and for ever!" (Heb 13:8).

From the Vatican,
September 3, 2002, Feast of Pope Saint Gregory the Great

+ Angelo Card. Sodano

Secretary of State

It gives me great pleasure to send this exhibition to the United States from the various Vatican institutions whose cooperation have made it possible. Since the closing of the very successful exhibition *The Invisible Made Visible: Angels from the Vatican*, in 1999, many individuals and groups, including the Patrons of the Vatican Museums, have requested another exhibition of that same high caliber.

As with the Angel exhibition, this one too has an important focus and a central theme: the papacy beginning with its origins in Christ, and Saint Peter, the first pope, to the present pontiff, Pope John Paul II. Because the papacy is one of the world's most vibrant ancient institutions, it continues to fascinate and interest Christians and non-Christians alike. It is an institution and an office, but above all, a pastoral ministry which the present pope, John Paul II, has exercised with great energy by his many pastoral journeys throughout the world, as well as the activities and liturgies he celebrates in Rome. One need only think of the recent jubilee year celebrations to understand the warmth, devotion, and attraction that millions of people feel toward the successor of Peter.

The opening section of this exhibition focuses on Saint Peter, the first pope, his life and work in the city of Rome, and his martyr's death on the Vatican Hill. Indeed, since that time, Saint Peter's Basilica has always been sacred to his name and the papacy. Here, as well, his successors have often been elected. Many of them reigned, lived, and died within the complex which today we call the Vatican City.

This exhibition and the accompanying catalogue, in both English and Spanish, as well as the works of art, artifacts, documents, and liturgical objects are the result of close cooperation between the Vatican and various groups in the United States. I would like to thank the many individuals here in the Vatican who have so freely given of their time and talents; also Art Services International for its organizational expertise and with whom we cooperated very well on the Angel exhibition; Clear Channel communication for its generous sponsorship; and the Office of the Patrons of the Arts in the Vatican Museums, whose ceaseless interaction and coordination with the Vatican and American entities have made this exhibition so successful. Finally, I thank the Patrons whose generosity has funded the conservation and restoration of these works.

I pray that this exhibition will be a great inspiration for the thousands of Americans who view *Saint Peter and the Vatican: The Legacy of the Popes*.

+ Edmund Card. Szoka

Edmund Cardinal Szoka
President of the Governatorato
Vatican City State

Patrons of the Arts
in the Vatican Museums

James Augur
Alice O'Neill Avery
Michael and Stella Banich
Alice Benvenuti
Dr. and Mrs. David Benvenuti
Helen & Harold P. Bernstein
Elizabeth and Charles Bowden, Jr.
John J. Brogan
William and Laurie Brosnahan
Helen Anne Bunn
Jo Campbell
Florence D'Urso
Lisa D'Urso
Helen Duston
Mario Di Paolo
Mr. and Mrs. John R. Ford
Gareth, Barbara & Charles Genner
Ellen and John Grimes
Frank, Sally & Elizabeth Hanna
Mark & Ann Hardaway
Timothy Heney
The Kane Family
Mr. & Mrs. James Kelly
Maureen A. Kucera
Mr. & Mrs. William Martin
Dona & Reuben D. Martinez
Mr. and Mrs. Brent McAdam
Angela & James J. McNamara Jr.
Siobhan Nicole McNamara
Thomas W. McNamara & James J. McNamara III
Marie-Louise Brulatour Mills
Juan Mireles and Amalia Rivera
Mr. & Mrs. Stanley Mortimer
Lucia Nielsen Musso
Mr. David S. Negri
Michael Novarese and Robert Nelson
Thomas C. Quick
Lorna Richardson
Ruby Rinker & Andrew Bytnar
Mr. and Mrs. Timothy James Rooney
Rodrigo Saval Bravo
Anne & Bob Scott
Msgr. Michael A. Souckar
Susan Sullivan
Bruce Allen Sutka
Kathleen Dolio Thornson
Sylvia and John R. Tillotson
Johan M. J. van Parys
Elizabeth L. Westerby

Patron Chapters

California Chapter
Canada Chapter
Florida Chapter
Georgia Chapter
Illinois Chapter
International Chapter
Louisiana Chapter
Massachusetts Chapter
Michigan Chapter
Minnesota Chapter
New York Chapter
Oregon Chapter
Pennsylvania Chapter
Philadelphia Chapter
Texas Chapter
Washington, D. C. / Baltimore Chapter

Preface

The Vatican Museums contain thousands of masterpieces, both secular and religious, which are unsurpassed in beauty and spirituality. Through the generosity of the Patrons of the Arts in the Vatican Museums, many precious objects in these collections are now available for us, and future generations, to study and enjoy. In 1982–83, the Patrons were organized in the United States to support the restoration and conservation of works of art for the exhibition *The Vatican Collections: The Papacy and Art*. In 1996, the Patrons also provided funds for the conservation of the objects in *The Invisible Made Visible: Angels from the Vatican*. Many Patrons have once again contributed generously in support of this exhibition, *Saint Peter and the Vatican: The Legacy of the Popes*. We are most grateful to them for their unstinting generosity and their continual support in helping to preserve the cultural and artistic heritage of the Vatican.

The idea for *Saint Peter and the Vatican* originated in a conversation some five years ago between His Excellency Msgr. Piero Marini, the papal master of ceremonies; Msgr. Roberto Zagnoli, consultant to the Papal Sacristy; Mr. Jerzy Kluger, a childhood friend of Pope John Paul II; and potential corporate sponsors. The hope was to mount a show of works from the Papal Sacristy, very few of which had ever been exhibited and are not on view in the Vatican. With the support of His Eminence Cardinal Edmund Szoka, president of the Governatorato of the Vatican City State, I became involved with the project and we then decided to expand the scope of the exhibition. Art Services International, with whom we had previously enjoyed a successful collaboration, was our obvious partner to realize and oversee this tour in America. As nearly half the objects are from the Papal Sacristy, it seemed appropriate to place them in the broader context of the papacy: its origins, its mission to the church and the world, and its history, liturgy, and ceremonies. In so doing we were able to draw from the collections and archives of other Vatican institutions. Their generous contributions have enriched the Exhibition and demonstrate the concern of the popes for people everywhere.

I would like to express my deep gratitude to those in the Vatican whose support and generosity have made this exhibition possible: His Eminence Angelo Cardinal Sodano, secretary of state; His Eminence Edmund Cardinal Szoka, president of the Governatorato; His Eminence Crescenzio Cardinal Sepe, prefect of the Congregation for the Evangelization of Peoples; His Excellency Msgr. Stanislaw Dziwisz, personal secretary of His Holiness Pope John Paul II; His Excellency Msgr. Francesco Marchisano, president of the Fabbrica of Saint Peter's Basilica; and above all His Excellency Msgr. Piero Marini, master of the liturgical celebrations of the Supreme Pontiff.

Many others, both in the Vatican and the United States, have been instrumental in the conservation and loan of works for the exhibition, as well as in writing, translating, and editing the catalogue. Special thanks are due to Clear Channel Communications, whose generosity has made it possible to bring these works to the United States of America. A particular expression of appreciation is also due to the organizers of the exhibition, Art Services International, whose expertise and judgment we greatly trust and respect. Finally, gratitude is due to Msgr. Roberto Zagnoli, my close collaborator and curator of this exhibition, and to all those who have worked so assiduously in my office to turn the ideas for this exhibition into a reality.

Allen Duston, O.P.
Patrons of the Arts in the Vatican Museums
Director of the Exhibition

Acknowledgements

Dating back over two thousand years, the papacy is one of the world's oldest continuous institutions. The legacy of the popes is an enduring one, beginning with Saint Peter's founding of the Church, and touching every major event in world history up to the present day. Art Services International is pleased to bring two thousand years of cultural and religious world history to the American public in *Saint Peter and the Vatican: The Legacy of the Popes*.

The U.S. audience for this tour and, indeed, this international publication, are honored by the personal blessing bestowed on this project by His Holiness John Paul II. His generous endorsement of this immense undertaking is fundamental to its existence and highlights the significance of its message.

With pleasure we commend Father Allen Duston, O.P., director of the exhibition, who, more than any other, shepherded the project through the labyrinthine course of its development within the Vatican's walls. His buoyant spirit and dedication to the ultimate goals of the project have been a constant source of inspiration. It has been a joy to work with him again, following our previous collaboration on Art Services International's 1998 exhibition titled *Invisible Made Visible: Angels from the Vatican*.

We gratefully recognize the lenders to the exhibition, without whose contributions the impact of this project would have been greatly diminished: Office of the Liturgical Celebrations of the Supreme Pontiff, Vatican City State; Congregation for the Evangelization of Peoples, Vatican City State; The Reverenda Fabbrica of Saint Peter, Vatican City State; Vatican Museums, Vatican City State; Patriarchal Basilica of Saint Paul's Outside-the-Walls, Vatican City State; Apostolic Floreria, Vatican City State; and Casa Buonarroti, Florence, Italy.

This project is led by a distinguished Honorary Committee whose members have been fundamentally responsible for determining the stupendous outcome of this timeless project. Ably leading the committee as president is His Eminence Edmund Cardinal C. Szoka, president of the Governatorato of the Vatican City State. We are grateful to him for his vision and for his personal dedication to the success of this project. The other members of the committee include Cardinal Angelo Sodano, Secretary of State; The Most Reverend Gabriel Montalvo, apostolic nuncio to the United States of America; The Most Reverend Wilton Daniel Gregory, president of the United States Conference of Catholic Bishops; The Most Reverend Joseph Anthony Fiorenza, bishop of Galveston-Houston; The Most Reverend John Clement Favalora, archbishop of

Miami; The Most Reverend Daniel Edward Pilarczyk, archbishop of Cincinnati; The Most Reverend Robert Henry Brom, bishop of San Diego; and The Most Reverend Gianni Danzi, secretary general of the Governatorato of the Vatican City State.

A myriad of the details encompassing this project have been overseen with vigor by Msgr. Roberto Zagnoli, curator of the exhibition, who, throughout, maintained an admirable level of energy and optimism. Key advisors to the exhibition who generously shared their time and expertise include Francesco Buranelli, director of the Vatican Museums; Antonio Baldoni, O.S.A., and Msgr. Roberto Zagnoli, Office of the Liturgical Celebrations of the Supreme Pontiff; Luis Manuel Cuña Ramos, Historical Archives of the Congregation for the Evangelization of Peoples; Sandro Benedetti, Alfio Maria Daniele Pergolizzi, and Pietro Zander, The Reverenda Fabbrica of Saint Peter; D. Paolo Lunardon, O.S.B., Patriarchal Basilica of Saint Paul's Outside- the-Walls; and Dott. Pina Ragionieri, Casa Buonarroti, Florence.

We are delighted to acknowledge our museum colleagues who are participating in this mammoth project for the benefit of their communities: Rebecca McDonald, president, Hayden Valdes, director of exhibits and Lisa Rebori, director of collections, Houston Museum of Natural Science; R. Andrew Maass, interim director, Robert Granson, director of finance and administration, and Jorge H. Santis, curator of collections, Museum of Art, Fort Lauderdale: Douglass McDonald, president and CEO, John E. Fleming, Ph.D., vice president of museums, Sandra L. Shipley, vice president of exhibits and planning, and David J. Duszynski, vice president of theaters, Cincinnati Museum Center; and Don Bacigalupi, Ph.D., executive director, Heath Fox, director of administration, and D. Scott Atkinson, chief curator, San Diego Museum of Art. It is an honor to work with such dedicated professionals.

Charting the course of more than two hundred centuries of papal art and history is an immense undertaking, which has been splendidly accomplished by the numerous scholars who collaborated on this publication. Leading this auspicious field are Cardinal Jorge Mejía, Cardinal Crescenzio Sepe, Cardinal Virgilio Noé, Archbishop Francesco Marchisano, Bishop Piero Marini, Bernard Berthod, Sheila Campbell, Eamon Duffy, Allen Duston, O.P., Charles Hilken, F.S.C., Terence Hogan, Joan Lewis, Maureen McGlashan, Christiane Denker Nesselrath, and Msgr. Roberto Zagnoli. The objects on display in this exhibition are discussed in depth in the catalogue entries, and we recognize Alfredo Maria Pergolizzi (AMP), Arnold Nesselrath (AN), Cristina Guarnieri (CG), Claudia Lega (CL), Carlo Pellegrini (CP), Daniela Zanin (DZ), D. Dodge

Thompson (DDT), Guido Cornini (GC), Giorgio Filippi (GF), Giampaolo Pes (GP), Giandomenico Spinola (GS), Ilaria Sgarbozza (IS), John Lindsay Opie (JLO), Leonardo Marra (LM), Luis Manuel Cuña Ramos (LMCR), Luis Martinez Ferrer (LMF), Luciano Orsini (LO), Maria Antonietta De Angelis (MADA), Maria Carlotta Romano (MCR), Marco Nocca (MN), Maria Serlupi Crescenzi (MSC), Micol Forti (MF), Pietro Amato (PA), Pietro Zander (PZ), Paolo Lunardon (PL), Roberta Vicchi (RV), Roberto Zagnoli (RZ), Stefano Zanella (SZ), Tatiana Bartsch (TB), Umberto Utro (UU), Valentina Conte (VC), and Valentina Muraglie (VM). The multi-lingual text was capably translated by Piers Amodia, Sabrina Arena Ferrisi, Lisa Dasteel, Andrew Ellis, Reginald Foster, O.C.D., Yorik Gomez Gane, Judy Goodman, Luis Manuel Cuña Ramos, Eugenio Rizzo, Peter Spring, and Dario Cavalieros.

Many others have been instrumental in the preparations for this international presentation, and special thanks are due to Msgr. Giorgio Corbellini, Pierpaolo Bessio, Lino Fantinel, Fr. Todd Lajiness, Elena Montesi, Orietta Robino, and Alberto Tricarico, Governatorato of the Vatican City State; Bishop Vittorio Lanzani, Temistocle Capone, Agostino Cicciotti, Nazzareno Gabrielli, Teresa Todaro, and Simona Turriziani, The Reverenda Fabbrica of Saint Peter; Edith Cicerchia and Francesco Riccardi, administration of the Vatican Museums; Diego Artuso, Nicoletta Camilloni, Andrea Carignani, Isabella Cordero di Montezemolo, Guido Cornini, Jeanette DeMelo, Rosanna DiPinto, Luciano Gagliano, Elizabeth Heil, Marta Monopoli, Filippo Petrignani, Sara Savoldello, Amalia Scassellati, Daniela Valci, and Mario Vitaletti, Vatican Museums; Paolo Sagretti, Apostolic Floreria; Stefano Gnazi, Leonardo Marra, Carlo Pellegrini, and Massimiliano Zonetti, Office of the Liturgical Celebrations of the Supreme Pontiff; D. Raffaele Farina, Luigia Orlandi, and Sever Voicu, Vatican Apostolic Library; Giovanni Fosci, Historical Archives of the Congregation for the Evangelization of Peoples; Elisabetta Archi and Luciano Berti, of the Casa Buonarroti (Florence); Prof. Corrado Bozzoni, Università degli Studi di Roma; and Sergio Baldini, Anne Scott, Iva Lisikewycz, Gerard McKay, Kenneth Whittaker, Carlos Evaristo, Sergio Gobbi, William Duston, and Guibert Mariani.

We extend heartfelt thanks to the individuals and chapters of the Patrons of the Arts in the Vatican Museums, specifically identified throughout this publication, for sponsoring the restoration of the works in the exhibition. Their support has enabled these treasures of art and history to be secured for safe travel, and preserved for the appreciation of future generations. These meticulous restorations were carried out by numerous professionals: Stefano Antonelli (of Gypsum S.N.C.), Alessandra Bertoldi, Massimo Buonamici, Flavia Callori, Elisabetta

Caracciolo (of Consorzio Capitolino), Tiziana dall'Oglio, Michele di Stasio, Tonino di Stasio, Luciano Ermo, Barbara Gallas, Antonio Giglio, Gabriella Grandinetti, Corinna Lamberti, Arnaldo Mampieri, Angelica Mazzuccato, Dario Narduzzi, Geremia Russo, Alessandro Tilia, Stefano Tombesi, Alfredo Valente (of Gypsum S.N.C.), Elisabetta Zatti, (of Consorzio Capitolino), and Bruna Zizola. The photography of Felice Bono, Alessandro Bracchetti, Mallio Falcioni, Luigi Giordano, Diego Motto, Danilo Pivano, Federico Sardella, and Pietro Digrossi has captured the works of art in all of their renewed glory. Assisting us with archival photographic needs were Gianfranco and Diego Motto/ Archivio Federico Motta Editore, Milan; Servizio Fotografico; L'Osservatore Romano; Archivio Fotografico of Museo di Capodimonte, Naples; Archivio Fotografico of Musei Capitolini, Rome; Archivio Fotografico of Musei Vaticani, Vatican City State; and Archivio Fotografico of The Reverenda Fabbrica of Saint Peter, Vatican City State.

We compliment the professionals involved in the production of this complex exhibition catalogue: Susan Higman, editor; Derek Birdsall, designer, and Sun Fung Offset Binding, printer. Each was chosen for their special talents, and the inspiration with which they undertook their mission has, happily, created a showcase for their expertise.

Clear Channel Exhibitions is to be recognized for its overall support, particularly Mark P. Mays, Brian Becker, Stacy F. King, Jeffrey S. Wyatt, Peter Radetsky, Dennis Bartz, and Mike Kemp, along with Robert Gottlieb and Sheldon R. Shultz of Trident Media Group.

We are pleased to commend the Trustees of ASI for their ongoing support and, for her personal devotion to this project, send a special note of thanks to Roma S. Crocker.

The organization of an exhibition of such complexity and detail could only happen with the enthusiasm and perseverance of a dedicated staff. We thank the team at ASI – Douglas Shawn, Melissa Liles-Parris, Lynda Tews, Emily Pegues, Heather Schweizer, Sara Rycroft, Kathy Turner, Sally Thomas, with assistance from William McDonald and John F. Poliszuk, Jr. – for their steadfast commitment.

Lynn K. Rogerson Joseph W. Saunders
Director Chief Executive Officer

Art Services International

Clear Channel Worldwide Acknowledgments

In producing the exhibition *Saint Peter and the Vatican: The Legacy of the Popes*, our design and development team needed to look no further than the objects themselves for inspiration. The experience of creating a presentation for these amazing works has been an extraordinary journey undertaken with the Governatorato of the Vatican City State, the Patrons of the Arts in the Vatican Museums, Art Services International, the curator, and the scholars.

Our goal in designing the exhibit was to create contextual environments that would allow the objects to tell the story of the history and influence of the papacy from Saint Peter to the present day. The presentation was designed to make the subject, and the objects, approachable, personal, and understandable in a context that helps define them.

Beginning with a recreation of Saint Peter's tomb, the exhibition's treasures are presented in settings that evoke the context of this rich tapestry. As the church grows in reach and power through the centuries, the presentation becomes more varied and extensive, mirroring the complexity of the papacy's authority and responsibility, until finally focusing on the promise of the new millennium, as exemplified by the long-serving pope, His Holiness, John Paul II.

In all this, the objects themselves are central. They embody the timelessness of art, the richness of history, and the spirit of faith. In each of these objects a greater purpose and larger significance is revealed. They are at once touchstones of a grand historical pageant and awe-inspiring gifts offered by the artists to the glory of God.

Through *Saint Peter and the Vatican: The Legacy of the Popes*, visitors can experience these wonderful works for their intrinsic artistic and symbolic value, their meaning within the papacy and the church, and as introductions to a rich historical spectacle, one that has played a compelling role in shaping our world.

Mark P. Mays
President and Chief Operating Officer
Clear Channel Worldwide, Inc.

Lenders

Office of the Liturgical Celebrations of the Supreme Pontiff, Vatican City State

Congregation for the Evangelization of Peoples, Vatican City State

The Reverenda Fabbrica of Saint Peter, Vatican City State

Vatican Museums, Vatican City State

Patriarchal Basilica of Saint Paul's Outside-the-Walls, Vatican City State

Apostolic Floreria, Vatican City State

Casa Buonarroti, Florence, Italy

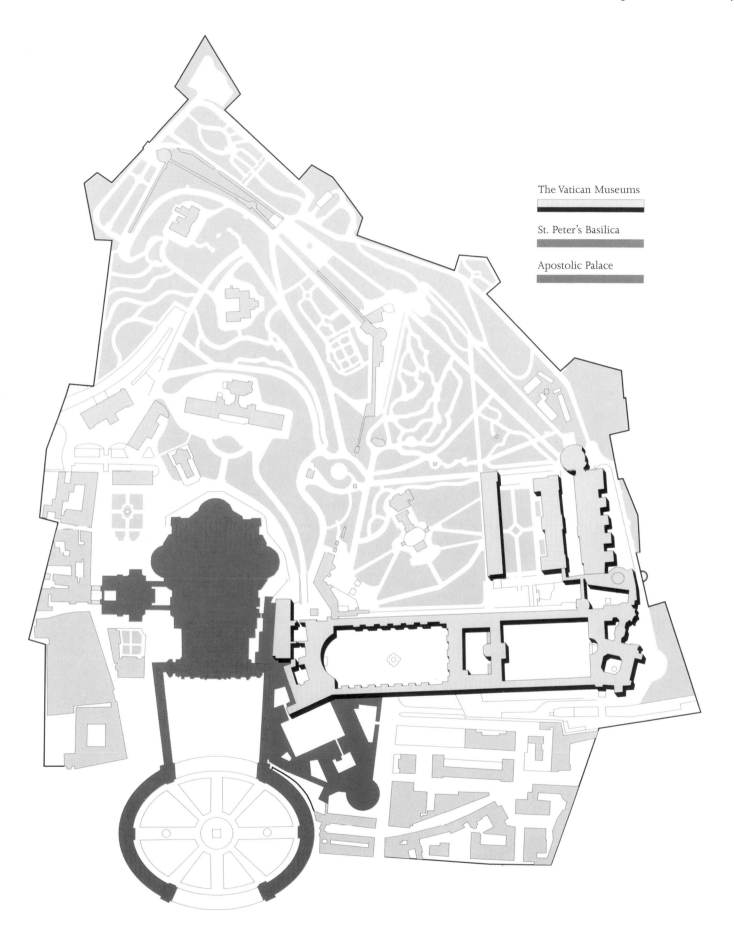

The Vatican Museums

St. Peter's Basilica

Apostolic Palace

Saint Peter and the Tropaion of Gaius

64	Beginning of persecution of Christians by Emperor Nero
64/5, or 67	Execution of Saints Peter and Paul
ca. 136	Execution of Pope Saint Telesphorus
ca. 160	The first tomb-shrine of Saint Peter, the so-called Trophy of Gaius, at the Vatican
235–238	Persecution by Emperor Maximinus Thrax
235	Imprisonment and death of Pope Saint Pontian
250	Persecution by Emperor Decius
250	Execution of Pope Saint Fabian
257–258	Persecution by Emperor Valerianus
258	Execution of Pope Saint Sixtus II
281–305	Reign of Emperor Diocletian
303–311	The Great Persecution
306–337	Reign of Emperor Constantine the Great
311	Edict of Toleration for Christians
312	Battle of the Milvian Bridge
312–326	Eusebius of Caeserea, *The Ten Books of Church History*
313	Edict of Milan, legalizing Christianity
314–335	Pontificate of Pope Saint Silvester I

The Constantinian Basilica of Saint Peter

312–318	Construction of Constantinian basilica of Our Savior at the Lateran
319 to mid-fourth century	Construction of Constantinian basilica of Saint Peter
325	First Ecumenical Council, at Nicea
326	Consecration of Basilica of Saint Peter
331	Constantinople made capital of empire
380	Christianity made the religion of the empire
432–461	Saint Patrick's mission in Ireland
440–461	Pope Saint Leo the Great
ca. 520	Foundation of the monastic order of Saint Benedict
590–604	Pope Saint Gregory I the Great. Consecration of a new altar over the tomb of Saint Peter
596	Augustine of Canterbury sent as missionary to Britain
768–814	The reign of Charlemagne
800	Crowning of Charlemagne as emperor of the Romans
862–885	The missions of Saints Cyril and Methodius to the Slavs
989	Baptism of Prince Vladimir of Kiev
1049–54	Pope Saint Leo IX
1059	Reform of papal election procedures
1096	The First Crusade to reconquer Jerusalem
1123	Consecration of a new altar over the tomb of Saint Peter
1181–1226	Saint Francis of Assisi, the "little poor man"
1215	The Fourth Lateran Council
ca. 1230	First Franciscan missionaries to Asia
1276	First papal conclave
1300	Pope Boniface VIII called the first jubilee
1305–74	The papacy in Avignon
1348	The outbreak of the plague, or Black Death, in Europe
1378–1417	The Great Schism in the papacy, between Rome and Avignon
1420	Permanent return of the papal court to Rome

The Renaissance Basilica

1447–55	Pope Nicholas V, the first humanist pope of the Renaissance
1448	Irreparable state of the old Saint Peter's basilica recognized
1450	Leon Battista Alberti began work on the sanctuary of the old basilica
1453	Capture of Constantinople by the Turks
1463	Calling of last crusade to reconquer Jerusalem
ca. 1474	Erection of a new ciborium over the papal altar of Saint Peter
1483	Dedication of the Sistine Chapel
1475	Opening of the Vatican Library
1492–1504	Christopher Columbus's four voyages of discovery
1503	Bramante hired to build a new Saint Peter's basilica
1506	Ground-breaking for the new basilica
1506	Swiss guards made official protector of pope
1508–12	Michelangelo Buonarroti painted the ceiling of the Sistine Chapel
1508–14	Raphael painted the frescoes of the apartments of Popes Julius II and Leo X
1517	Beginning of the Protestant Reformation by Martin Luther
1519–22	First circumnavigation of the world by Magellan
1522	The last pope elected from outside Italy until 1978
1527	Sack of Rome
1531	Henry VIII as supreme head of the church in England
1534	Foundation of Jesuit Order
1534–41	Michelangelo painted The Last Judgment in the Sistine Chapel
1537	Papal condemnation of Indian slavery
1545–63	Council of Trent
1547	Michelangelo appointed chief architect of Saint Peter's Basilica
1562	Beginning of slave trade between Africa and America
1564	Death of Michelangelo
1566–72	Pope Saint Pius V, canonized in 1712
1582	Reform of the calendar by Pope Gregory XIII
1590	Completion of the dome of the new Saint Peter's Basilica
1592	Discovery of remains of Pompeii
1607–14	Facade of Saint Peter's by Carlo Maderno
1622	Foundation of Congregation for the Propagation of the Faith
1626	Consecration of the new basilica of Saint Peter
1626	Inauguration of the Vatican Polyglot Press
1624–33	Bernini erected the bronze baldachino over the papal altar of Saint Peter's Basilica
1627	Foundation of the Collegium Urbanianum for the training of missionaries
1633	Galileo's trial and condemnation
1654	Queen Christina of Sweden moved to Rome
1656–67	Bernini designed Saint Peter's Square and the basilica apse
1661	Translation of New Testament into Algonquin
1672	Russian Tsar became Protector of all Greek Orthodox Christians
1706	Excavations at Pompeii and Herculaneum
1759	British Museum opened
1769–70	Cook's discovery of Australia
1771–92	Construction of the Pio-Clementine Museum at the Vatican
1773	Suppression of the Jesuit Order
1775–83	American Revolution
1789–92	French Revolution

The Modern Papacy

1794	Abolition of slavery in French colonies
1796	Rise of Napoleon
1798–99	Imprisonment and death Pope Pius VI
1798	Looting of Vatican by French army
1804	Imperial coronation of Napoleon
1805–22	Construction of the Chiaramonti Museum at the Vatican
1808	United States prohibited importation of slaves
1809–14	Imprisonment of Pope Pius VII
1814	Restoration of the Jesuit Order
1815	Napoleon banished
1820	Papal permission to teach Copernican astronomy
1823	Saint Paul's Outside-the-Walls destroyed by fire and rebuilt
1831–46	Pope Gregory XVI created more than seventy new missionary dioceses
1835	Removal of Galileo's Dialogue from the Index of Prohibited Books
1837	Opening of the Gregorian Etruscan Museum at the Vatican
1839	Papal condemnation of African slave trade
1839	Opening of the Gregorian Egyptian Museum at the Vatican
1844	Inauguration of the Lateran Profane Museum by Pope Gregory XVI
1845	Potato famine in Ireland
1848	Political revolutions in Europe and California Gold Rush
1846–78	Blessed Pope Pius IX, who enjoyed the longest pontificate thus far in history
1854	Declaration of the Doctrine of the Immaculate Conception
1854	Opening of the Pius Christian Museum at the Lateran palace
1869–70	The First Vatican Council and the declaration of Papal Infallibility
1870	The unification of Italy and end of the Papal States
1878–1903	Leo XIII, who enjoyed the second longest pontificate in history
1903–14	Pope Saint Pius X, canonized in 1954
1908	United States no longer considered missionary territory
1927	Inauguration of the Pontifical Museum of Missionary Ethnology at the Lateran palace
1929	Creation of the Vatican City State
1932	Opening of the Vatican Picture Gallery
1935	Inauguration of Papal Observatory at Castel Gandolfo
1939–45	World War II
1940–50	Excavation of the tomb of Saint Peter
1950	Declaration of the doctrine of the Bodily Assumption of Mary into Heaven
1958–63	Blessed Pope John XXIII
1962–65	The Second Vatican Council II
1963–70	Transfer of the Lateran Profane and Christian Museums to the Vatican
1963–78	Pope Paul VI
1969/70	Transfer of the Missionary Ethnological Museum to the Vatican
1973	Opening of the Vatican Collection of Modern Religious Art
1973	Founding of the Vatican Historical Museum
1978–present	Pope John Paul II, who has published eighty-eight major documents and has made more than ninety-six pastoral journeys, and has beatified or canonized more than 1,143 people
2000	Beatification of Pope Pius IX and Pope John XXIII

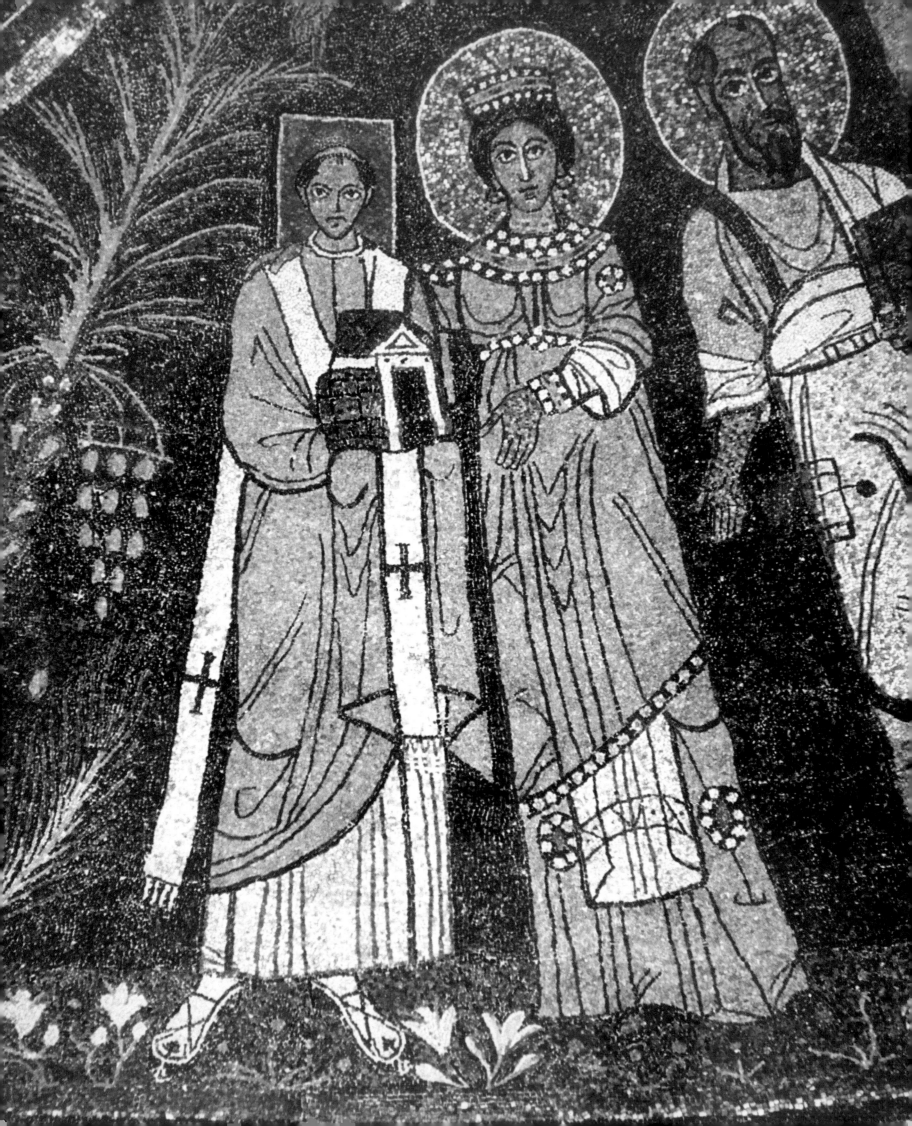

FromVisible
to Invisible Beauty

Bishop Piero Marini

Saint Peter and the Vatican: The Legacy of the Popes presents works of art, furnishings, and sacred vesture from the Vatican collections, dating from the seventeenth century to today. Some of the works clearly reflect particular tastes, at times quite different from our own, and others express the spirit of noble simplicity characteristic of the period following the Second Vatican Council.

These objects, whether highly ornate or simple and austere, are of significant artistic beauty. Though usually out of public view, they were created to be seen and appreciated by all. By being shown in this exhibition, they in some way recover their original purpose, which is to awaken the wonder born of beauty. In his *Letter to Artists*, Pope John Paul II wrote that

> *faced with the sacredness of life and of the human person, and before the marvels of the universe, the only appropriate response is wonder....Thanks to this wonder, humanity, whenever it loses its way, will be able to lift itself up and set out again on the right path. It has been said with profound insight that "beauty will save the world." Beauty is a key to the mystery and a call to transcendence. It is an invitation to savor life and to dream of the future (p. 16).*

The sense of wonder and transcendence evoked by these works is directed, above all, to the beauty and grandeur of God. This is particularly evident in the case of objects created for divine worship and, thus, as an expression of the primacy of God (fig. 2). Precious materials and distinguished artists help "to make the things set apart for use in divine worship worthy, becoming, and beautiful, signs and symbols of supernatural realities" (Vatican Council II, *Constitution on the Sacred Liturgy*, 122). This, then, is what the visitor is first invited to reflect upon throughout this exhibition.

The Life and Ministry of the Bishop of Rome
The objects on view are not simply elegant artifacts or works of art to be admired. Each is linked to the bishop of Rome and each has a distinct purpose: to testify to important historical events or the events of everyday life, and to illustrate the ministry that the successor of Peter has exercised — and continues to exercise — in the church's pilgrimage through history.

Some objects recall places linked to the Roman pontiffs, such as the Basilica of Saint Peter and the Tomb of the Apostle. Others reveal aspects of the pope's private life or illustrate his public activity in Rome and the world. Still others evoke the most significant moments in the life of the pope: his election, the solemn inauguration of his pastoral ministry in the church, his death and funeral, the vacancy of the apostolic see, and the conclave that elects his successor.

Of particular interest are those works connected with the liturgical celebrations at which the bishop of Rome presides. Some papal vestments and items have fallen into disuse or were purposely abandoned — the tiara, the buskins, the ceremonial gloves or the "fistula" for receiving communion from the chalice — because they no longer speak to contemporary sensibilities or express the authentic Petrine ministry. Many of the objects shown here, however, continue to be used at papal liturgical celebrations and testify to the variety and the distinctiveness of that liturgy over the centuries. When the pope presides at the celebration of the sacred mysteries and proclaims the word of God, he most clearly manifests his specific Petrine ministry. In the words of Scripture, this ministry can be described as the work of confirming his brethren in the faith (cf. Lk 22:31-32).

Figure 1
Pope Paschal I with the Pallium, ninth century,
Basilica of Saint Cecilia in Trastevere

In admiring the beauty of these objects, the visitor will, then, intuit something of the invisible beauty of God but also ponder the profound, authentic meaning of the faith and the liturgical theology embodied in them. In some way this means recognizing the vital link between liturgical celebration, ecclesial life, and episcopal ministry. While all liturgical celebrations, and the Eucharist in particular, are manifestations of the church in different offices and ministries (cf. *Constitution on the Sacred Liturgy*, 41), it is also true that the ministry of presiding at the liturgy manifests the ministry of presiding over the church. When it is the successor of Peter who presides at the liturgy, it is all the more evident that one pastor has been set over the church.

Consequently, the art and sacred vestments aimed at evoking the liturgical ministry of the bishop of Rome are significant not simply because of their precious material, beauty, or history, but, above all, because, through the language of sign and symbol, they continue to speak of faith – a faith lived out in different ways over time, but ever alive in the community of believers and constantly confirmed by the successor of Peter.

Some Vestments and Liturgical Insignia Proper to the Bishop of Rome
The Second Vatican Council, returning to the biblical and patristic tradition, addressed a fundamental pastoral concern, namely, that of helping the faithful better understand the meaning of the celebration and participate in it fully, actively, and as a community (*Constitution on the Sacred Liturgy*, 21). To that end, the council emphasized the liturgy as the celebration of the mystery of Christ and the church, "through sensible signs" and "through rites and prayers." This has led to a rediscovery, especially in recent years, of the importance of signs and gestures as a form of nonformal communication in the liturgy.

Among the sensible signs are sacred vestments and insignia, which are an outward manifestation of the diversity of ministries that constitute the church, the mystical body of Christ. This exhibition includes vestments and insignia worn by the Roman pontiffs at liturgical celebrations. It might be helpful to explain a few of these, which are outstanding for their antiquity and their ecclesial significance.

The Miter and the Tiara
For centuries the miter (fig. 3) and the tiara have been the headdress worn by the pope in liturgical celebrations. The first known use of the miter dates from the eleventh century, during the pontificate of Pope Leo IX. Previously, bishops had not worn any liturgical headdress, but by the second half of the twelfth century, the miter was widely used by all bishops. It is likely that, as in the case of other types of dress, the miter was based on an nonliturgical item, perhaps the headdress called the *camelaucum* or *phrygium*, worn by emperors and high officials, especially in the East, and which the pope had worn since the eighth century in solemn ceremonies outside of church and during processions. This exhibition includes six miters belonging to five popes. Of particular historical interest is the miter of Pius IX, which was worn in 1854 during the solemn proclamation of the Dogma of the Immaculate Conception of the Blessed Virgin Mary.

The tiara, in the form represented in the exhibition, came into liturgical use at the beginning of the seventeenth century, under Pope Urban VIII. This headdress was associated with the coronation of the newly elected pope (fig. 4). With its three symbolic crowns, the tiara expressed the pope's power as described in the formula used for its imposition: *Patrem Principum et Regum, Rectorem orbis, in terra Vicarium Salvatoris nostri Iesu Christi* ("Father of Princes and Kings, Ruler of the World, Vicar on Earth of our

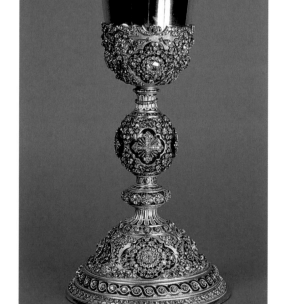

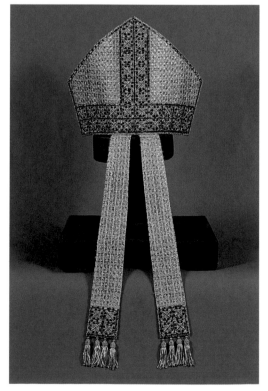

Figure 2
Pietro Paolo Spagna, chalice with diamonds, gift to Pope Pius IX

Figure 3
Decimo Regio, Miter of Pope John Paul II, used during the opening ceremony of the jubilee year 2000

Figure 4
Pope Paul VI on the day of his solemn coronation as pope wearing the papal tiara

Savior Jesus Christ"). For some, the three crowns symbolized the power of the Father, the wisdom of the Son, and the love of the Holy Spirit; for others, the three theological virtues.

Pope Paul VI was the last to be crowned with the tiara. He renounced this symbol of power to better emphasize the "service" that the successor of Peter is called to render in following the example of Jesus, who "came not to be served but to serve, and to give his life as a ransom for many" (Mt 20:28). In 1964, at the pope's request, the tiara was sold and the proceeds given to the poor. Today, Pope Paul's tiara is housed in the Basilica of the Immaculate Conception in Washington, D.C. Under Pope John Paul I the rite of papal coronation was modified to the "Inauguration of the Ministry of Supreme Pastor." From then on, the bishop of Rome has worn only the miter, the traditional headdress of all bishops, to underscore the relationship of communion and unity linking the successor of Peter to the Episcopal College.

Tiaras belonging to three nineteenth-century popes are on view here, the most important being that of Pius VII. Not only is it the oldest of the three, but it is linked to the troubled history of the papacy during the Napoleonic period. The most precious tiara is that of Leo XIII, which is richly decorated with diamonds.

The Pallium

The pallium, the history and meaning of which are not widely known, is the most ancient and characteristic emblem of the bishop of Rome. It consists of a simple band of white wool, several centimeters wide, which is placed over the chasuble. The band is adorned with black crosses and three pins. This exhibition includes the pallium used by Pope John Paul II.

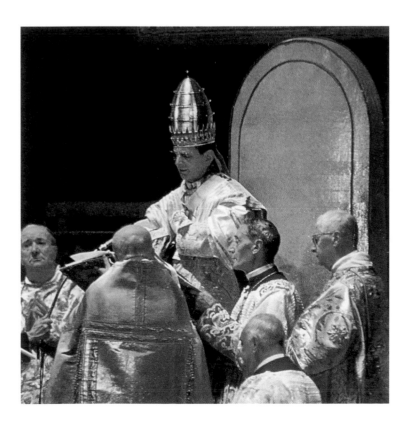

Use of the pallium in the West, first mentioned in 336 in connection with Saint Mark, was reserved for the Roman pontiff, upon whom it was imposed, at least from the sixth century onward, during the rite of episcopal ordination. For several centuries it remained the distinctive sign of the office and authority of the pope. This office or "munus" was presented in relation to the apostle Peter, and the grant of the pallium was always accompanied by the words "de corpore beati Petri sumptum." Eventually the pope granted the pallium to other bishops. Numerous grants were made during the pontificate of Gregory the Great, in the sixth century, and during the Carolingian period several synods decreed that all metropolitans were to seek the pallium from the Roman pontiff. Despite these grants, it was always clear that the bishop of Rome alone had the original right to wear it, whereas other bishops merely received it as a privilege.

Over the centuries the pallium took on a rich liturgical and theological symbolism. At first it had a fundamentally ecclesiological meaning. This was reflected in the most ancient form of the insignia, which can also be seen in the sixth-century mosaics of Sant'Apollinare in Classe in Ravenna or in those of such Roman basilicas as Santa Cecilia, the apse of which contains a portrait of Pope Paschal I (fig. 1). The two bands of the pallium, woven of wool, were draped around the neck to fall from the left shoulder to signify the sheep carried by the Good Shepherd. In ancient iconography, carrying the sheep on the left was typical of the Christian pastor. In addition, the pallium was always decorated by several black crosses, symbolic of the flock; the most ancient mosaics always represent the sheep surrounding Christ with black stripes (Gn 30:40).

From the eleventh century onward, the pallium changed shape and took on a christological meaning. The insignia took the form of a Tau, and thus a cross, and the two bands now fell from the center in front of and behind the celebrant. The four crosses were frequently red and always accompanied by three large pins. From its earlier ecclesiological meaning (the flock and its shepherd), the cross-shaped pallium thus came to refer specifically to Christ: the red crosses represent his wounds, and the three pins symbolize the nails of the Crucifixion, in accordance with Western tradition.

Several centuries later, when the size of the chasuble was reduced and its form curtailed, the pallium also became smaller, taking the shape still seen today. In the wake of the liturgical reform promoted by the Second Vatican Council, the chasuble, the vestment of the celebrant, returned to its original size and shape, whereas the pallium kept its Renaissance form. From a desire to restore visibility to the insignia and better to illustrate its meaning, the Office of Liturgical Celebrations of the Supreme Pontiff proposed a modification of the pallium. At the celebration of Christmas Midnight Mass for the opening of the Great Jubilee of the Year 2000, the pope wore a larger and more visible pallium decorated with red crosses. The form restored the Tau shape and thus expressed, above all, its christological meaning. A further modification seems in order, one which would bring the pallium closer to its ancient form and symbolism (the sheep carried on the left shoulder), while keeping the red crosses and the pins (the shepherd who gives his life for his sheep). The pallium, given a new form and solemnly consigned to the new pope at the inauguration of his papal ministry, could once more become a powerful sign of the distinctive office of the Roman pontiff.

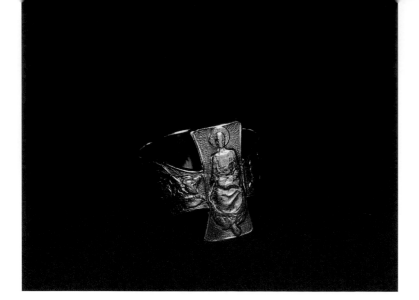

Figure 5
Ring of Pope John Paul II

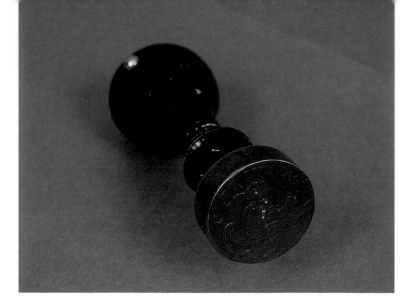

Figure 6
Fisherman's ring (seal) of Pope Paul VI

The Ring

Among other pontifical insignia, the ring is an important symbol of the episcopal ministry. It is given during the rite of ordination and must always be worn: "anulus… ab Episcopo semper deferatur" (*Caeremoniale Episcoporum*, 58). The ring has a particular history and meaning, both anthropologically and biblically (cf. Est 8:8; Gn 41:40-42; Lk 15:22). Judging from the testimony of Bishop Optatus of Milevis, by the end of the fourth century bishops likely wore an "anulus episcopalis" that they had received in the rite of ordination. The first certain testimonies to a liturgical rite of consigning such a ring come from the first half of the seventh century in Spain (cf. IV Council of Toledo: 633; Saint Isidore: 560-636). Two centuries later, at the time of Emperor Charles II "the Bald" and Pope Nicholas I, this practice is also attested in the Frankish ritual.

In its earliest use, the ring served as a seal and its introduction was probably motivated less by symbolic than by practical reasons. The ring enabled bishops to authenticate their own acts, a frequent custom in ancient times.

By the time of episcopal feudalism, the ring had lost its original meaning and increasingly came to be associated with temporal power. With the church's victory in the Investiture Controversy, the ring took on a new, nuptial meaning, based on its use in the rite of matrimony. The episcopal ring symbolized the union of Christ and the church: the bishop, following the example of Christ, was considered wedded to the church entrusted to him. The new symbolism led also to a change in style, and in place of the seal it now featured a precious stone: "In episcopi digito geminatus fulget anulus" (G. Durand, *Rationale divinorum officiorum*, book 3, ch. 14); "Anulus pontificalis… ornatur unica gemma pretiosa vel quasi pretiosa" (*Introductio in Caerimoniale Episcoporum*, 1956 ed.).

The postconciliar liturgical reforms after 1965 preserved the nuptial association of the ring: "Anulus, insigne fidei et coniunctionis nuptialis cum Ecclesia, sponsa sua, ab Episcopo semper deferatur" (*Caerimoniale Episcoporum*, 1984 ed., no. 58). It no longer retained its function as a seal, much less that of a sign of authority or honor, and the precious stone generally has been abandoned. The rings of recent popes – Paul VI, John Paul I, and John Paul II (fig. 5) – are examples of the simpler form deemed more expressive of the episcopal office.

The "Fisherman's Ring"

The exhibition also includes the fisherman's rings of four popes. In its present form (e.g., that of Pope Paul VI; fig. 6), this ring is a kind of stamp bearing the name of the pope and the figure of Peter casting nets. This was originally a ring with which the popes set their seal upon documents. Some, such as that of Pope Clement IV, date from the Middle Ages. Only in the middle of the nineteenth century did the fisherman's ring lose its shape and take its present form. Today the ring has fallen into disuse.

The pope's ring is no different from that of other bishops. John Paul II, for example, wears the ring he received from Pope Paul VI, on June 26, 1967, in the consistory in which he was made a cardinal. It seems appropriate, therefore, that the pope's ring, while maintaining the form and simplicity of other episcopal rings, should have a distinctive character to indicate that its wearer is the successor of Peter. The fisherman's ring could be reinstated as a powerful sign of his office. Like the pallium, it could be given to the new pope at the celebration marking the beginning of his pontificate.

The Pastoral Staff

Pastoral staffs are common to all bishops. Those of the popes in this exhibition are not in the form of a bishop's crosier, characterized by the traditional crook, but in the form of a cross. Like the ring, the staff has its own meaning both anthropologically and biblically (cf. Ex 4:17; Ps 23:4. Church Fathers such as Origen and Augustine also link the staff of Moses to the Cross of Christ).

The origin of the staff in the liturgical context is unclear, but it is probably of Eastern derivation. The staff was likely introduced in Constantinople by the emperor, who presented it to the patriarch. Later, it became one of the insignia used in episcopal ordinations. In the West, the staff was first used in monastic settings. Originally, the staff was part of the monk's equipment: it was considered his traveling companion and a sign of Christ's cross. In the seventh and eighth centuries, the staff was used by abbots in both Gaul and the British Isles. The earliest evidence of a liturgical rite for the consignment of the staff to the bishop is from the seventh century and, as in the case of the ring, comes from Spain (cf. IV Council of Toledo: 633, can. 28). Two centuries later, the staff was commonly used

by bishops of Gaul. Only in the thirteenth century, in the *Pontificale* of Guillaume Durand, bishop of Mende, did the staff become commonly used in the more important liturgical celebrations at which the bishop presided. Over the centuries, the staff has always retained its ancient meaning as a sign of authority, governance, and leadership.

Although the popes adopted the ring from the Hispanic and Gallican liturgies, they never adopted the staff. They had their own traditional mark of office, namely, the *ferula*, a rod mounted by a cross. The pastoral staff did not, therefore, become part of the papal liturgy, because at the time its use had become more widespread the popes already had a similar distinguishing mark of their own. Moreover, the staff had become the sign of a subordinate authority received from another, indicated according to some by its curved crook; therefore it could not be accepted by the pope: "Romanus vero Pontifex, quia potestatem a solo Deo accipit, baculum non habet" (G. Durand, *Rationale divinorum officiorum*, book 3, ch. 15). The *ferula*, like the staff, was a sign of authority, jurisdiction, and governance, yet it was never consigned during the rite of ordination or the coronation of the pope. Normally the *ferula* was bestowed when the new pope took possession of the Basilica of Saint John Lateran, and, with rare exceptions, it was used outside of liturgical settings. Beginning with Pope Paul VI, the *ferula* has been revived for liturgical use. Since then, during their liturgical celebrations the popes have used a pastoral staff in the form of a cross, which recalls the ancient *ferula*.

Three pastoral staffs – two from the nineteenth century and one used by John Paul II – are in the exhibition. The one of John Paul II is a reproduction of that used by Pope Paul VI (fig. 7). It is now recognized throughout the world, thanks in part to the media, as one of the distinctive signs of the Roman pontiff.

The vestments and episcopal insignia in this exhibition should not be admired merely for their splendor and artistic beauty. These liturgical objects are designed to manifest the sacred character of the celebration. They are part of the "signa sensibilia" of the liturgy and are intended to awaken an awareness of the invisible presence of the mystery being celebrated. The sacred vestments and insignia are also a manifestation of the church in the variety of her offices and ministries (fig. 8). In particular, the vestments and episcopal insignia used by the bishop of Rome bring out the distinctive "munus" or office of the successor of Peter, who is called to preside over the universal assembly in charity.

This introduction is meant to help visitors to the exhibition view the objects with greater interest and respect, and to see them as signs rich in history, signs pointing to the reality of faith and to the things of the spirit. It is my hope that the experience of visitors will not end once the exhibition closes. Thanks to the communications media, whenever they see the bishop of Rome vested in pallium and miter, wearing the ring and holding the pastoral cross, they will be able to see in these signs an invitation to grow in knowledge both of the papacy and of the mystery of the church in the world. May these signs be for everyone, believer and nonbeliever alike, an invitation to set out into the deep: *Duc in altum!*

Figure 7
Pope John Paul II with the pallium and his pastoral staff

Figure 8
Depiction of the church as the vessel of salvation.
Detail of chasuble of Pope Pius XI

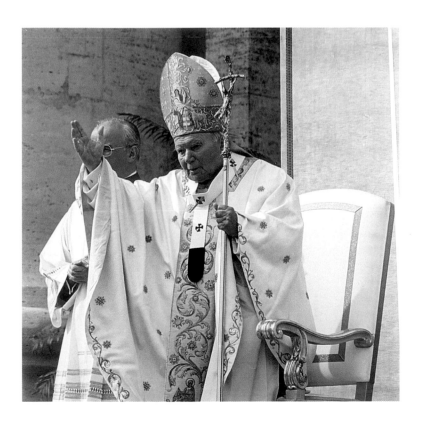

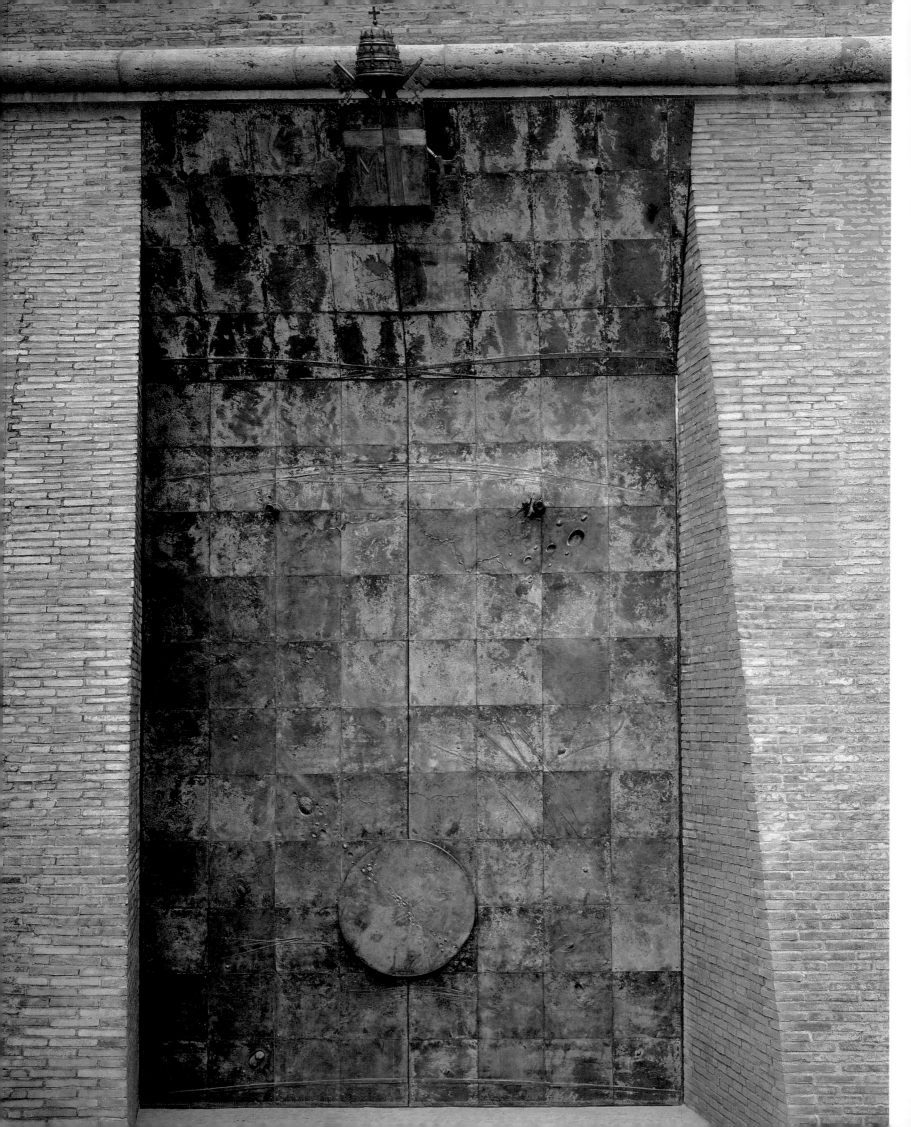

Through Stately Gates and Sacred Portals: The Vatican Collections

Allen Duston, O.P.

In 1946, Monsignor Giovanni Battista Montini, later Pope Paul VI, wrote:

The Vatican is not only a complex of monumental buildings of interest to artists, nor only a magnificent emblem of past centuries of interest to historians, nor a treasure trove of bibliographical and archeological treasures of interest to scholars, nor is it only a famous museum containing sublime works of art of interest to tourists, nor only a temple sacred to the martyrdom of the Apostle Peter of interest to the faithful. The Vatican is not only the past: it is the dwelling place of the Pope, of an authority still living and working. The Vatican is not only what one sees: it is the expression of a thought, of a design, of a program that aims to touch mankind as a whole and still has in itself the secret of immanent youth, of perennial actuality.

In short, the Vatican is a place both mysterious and beautiful, difficult even for the believer to completely comprehend (figs. 1,2). The Vatican continues to fascinate the world even as it confounds those who seek to conquer it, whether physically or morally.

This essay will introduce both the visitor to the exhibition and the reader of the catalogue to some of the institutions of the Vatican City that have contributed works of art, documents, and artifacts to this exhibition. Some, such as Saint Peter's Basilica and the Vatican Museums, are known to the millions of pilgrims and tourists who visit Rome each year. Others are nearly invisible to them and yet are vitally important to the preservation of the cultural patrimony of the Vatican or to the vitality and mission of the Holy See and the Catholic Church.

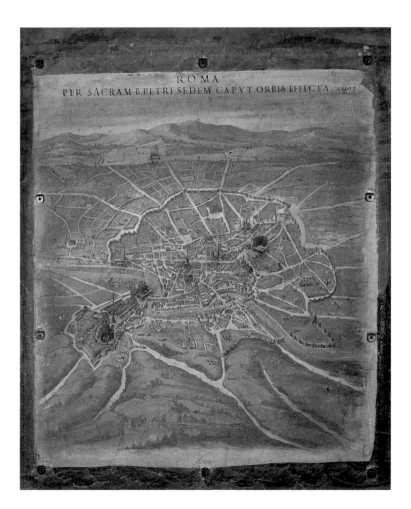

Figure 1
Cecco Bonanotte, Bronze Doors for the new entrance of the Vatican Museums, 2000

Figure 2
Cesare Nebbia, Girolomo Muziano, and assistants,
View of Rome, 1565, fresco,
Gallery of the Maps, Vatican Museums

The Governatorato

From the moment the pope accepts his election by the cardinals, he also becomes the sovereign of the Vatican City State. The Vatican City State has an absolute monarch in the pope, who has full legislative, executive, and judicial powers. When the Holy See is vacant these powers are exercised by the *camerlengo* (cardinal chamberlain) of the College of Cardinals.

The legislative provisions of the state are issued by the pope, and in his name by the Pontifical Commission for the Vatican City State, which is composed of seven cardinals, one of whom is its president. This commission also promulgates these regulations. The president of the Pontifical Commission has ordinary executive authority for the Governatorato, the structure through which the Vatican City State is administered and managed (fig. 3). He is assisted by the general secretary and a vice secretary general, director generals, and directors that manage a wide variety of services including the Vatican Civil Security Corps, the fire department, medical service for the employees, the post office, and maintenance of all the buildings of the Holy See and the Vatican City State. Also part of the administrative structure are the Vatican Museums, the office of the Patrons of the Arts, the Vatican Gardens, the Papal Villa at Castel'Gondolfo, and the Floreria Apostolica. This last-named office is responsible for the decorations and furnishings for liturgical celebrations, ceremonies, and audi-ences presided over by the Holy Father and cares for the furnishings of the papal apartment as well as those of the cardinals and other prelates assigned to the Holy See and the offices of the Vatican City State.

Entrance into the Vatican for most visitors is through Saint Peter's Square and the doors of the basilica. For others who live or work within the city state or wish to visit the Vatican Museums there are five other entrances. All are guarded by the Pontifical Swiss Guards and the Corpo di Vigilanza, the civil security corps of the Vatican City. The majority of Vatican institutions and congregations that have loaned works or art, artifacts, and documents making this exhibition possible are located within the territory of Vatican City behind these gates and portals.

The Vatican Museums

If the works of the greatest artists of yesterday are a reason for visiting the Vatican Museums, so too are the efforts of the artists of today, whose works in the collections are in dialogue with past masters and with us, with our world and our faith. So it is fitting that the new entrance to the Vatican Museums – long considered one of the world's greatest repositories of art – is through two new monumental bronze doors designed and sculpted by the Cecco Bonanotte for the jubilee year of 2000 (fig. 1).

After ascending the four floors from the new entrance hall the visitor is near the old heart of what was once the core of the papal sculpture collection in the Octagonal Courtyard of the summer palace of Pope Innocent VIII (fig. 4). It was here in 1506 that Pope Julius II first installed his personal collection of antique sculptures. Among these are the *Apollo Belvedere* and the *Laöcoon*, which can still be seen there today. Throughout most of the sixteenth century, Julius II's successors continued to transform and adorn the private papal gardens and the summer palace with important sculpture of ancient Rome, including the Belvedere Torso. This collection became known as the Antiquario delle Statue (Antiquarium of the Statues), but its accessibility was limited to members of the papal court, artists, and scholars. Many great artists came here to study and copy these masterpieces of antiquity, including Raphael, Bramante, and Michelangelo. Their works in painting, architecture, and sculpture transformed and embellished the Vatican for future generations. From this original nucleus has grown in the course of five centuries one of the most important art collections of the world. From its conception it was never envisioned to be this, but at times slowly, at times more rapidly, the popes and members of the papal court collected and commissioned artists and architects to decorate, enrich, and adorn the buildings, chapels, hallways, stairways, apartments, offices, and reception rooms of the Vatican complex. On the walls and ceilings and even the floors are illustrated the mysteries of faith, the history of the Church, and the significant events of the Western world.

The Vatican Museums today comprise thirteen different institutions representing diverse periods in papal and church history as well as the Western world, ranging from Etruscan and Egyptian art, to Classical Greek and Roman sculpture; Renaissance and baroque masterpieces; modern and contemporary art; and an important ethnological collection representing most of the world's cultures and religions. Many visitors and pil-

Figure 3
Palace of the Governatorato

Figure 4
Octagonal Courtyard of the Belvedere Palace

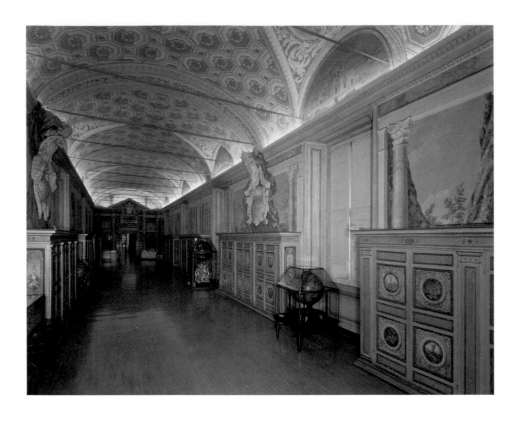

Figure 5
Hallway of the Museum of Sacred Christian
Artifacts, Vatican Apostolic Library

Figure 6
Salone Sistino, established as the Vatican Library
Reading Room under Pope Sixtus V

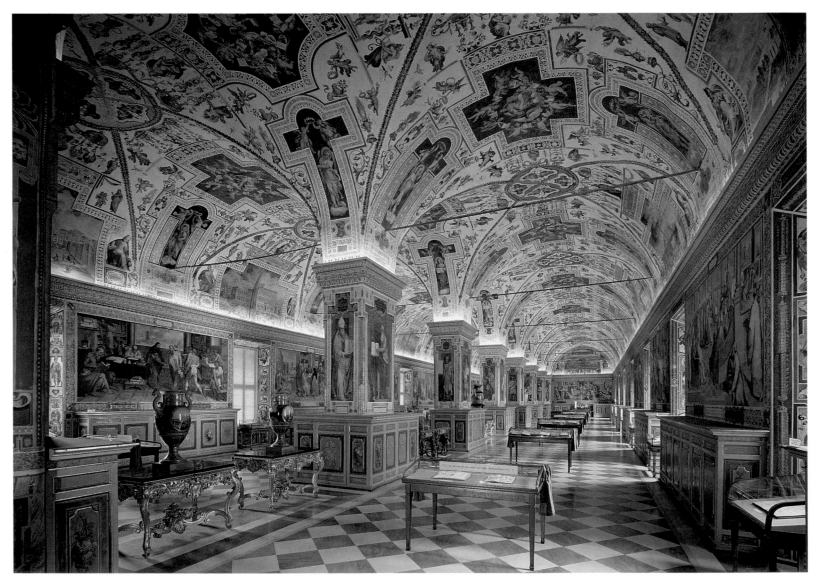

grims are first attracted to the works of Michelangelo in the Sistine Chapel, but with a little extra time and stamina they can see the vastness of the Western world unfolding in the several miles of galleries and rooms that make up the itineraries to be discovered and appreciated in the complex of the Vatican Museums.

The works for this exhibition have been drawn principally from four of the Vatican museums – the Painting Gallery, the Missionary Ethnological Collection, the Collection of Modern Religious Art, and The Vatican Historical Museum – as well as two museums that until 1999 were under the care and jurisdiction of the Vatican Apostolic Library – the Museum of Secular Antiquities and the Museum of Sacred Christian Artifacts. The contents of the last-named museums are exhibited in beautifully designed cases along a long hallway dating from the eighteenth and nineteenth century known as the Library Corridor, which links the Sistine Chapel to the summer palace of Innocent VIII some eleven hundred feet away.

Museo Sacro (Museum of Sacred Christian Artifacts)

The Museo Sacro, or Museum of Sacred Christian Artifacts, began in 1756 under Pope Benedict XIV and was established specifically for collecting and displaying antiquities dating from the earliest centuries of Christian history, East and West (fig. 5). Today the collection includes early Roman crosses, lamps, rings and seals; small Byzantine icons; paleo-Christian and Coptic fabrics; ancient and medieval reliquaries and ivories; glass objects and ceramics from the catacombs; and liturgical vessels and crosses from many European countries.

Halfway down the corridor is the Salone Sistino, named in honor of its patron, Pope Sixtus V (fig. 6). Built by Domenico Fontana between 1587 and 1589, it served as the primary exhibition room for the Vatican Library and divides the Cortile del Belvedere, designed by Bramante earlier in the sixteenth century. This courtyard was, in its essence, a vast tiered garden that connected the Apostolic Palace to the south with the summer palace to the north.

Museo Profano (Museum of Secular Antiquities)

Continuing along the Library Corridor is the Museo Profano, or Museum of Secular Antiquities, which was established under Pope Clement XIII in 1767 (fig. 7). Beautiful cases, designed by Luigi Valadier, contain a large collection of coins and medallions; Etruscan, Greek, and Roman bronzes; antique ivory carvings; glass vessels; and antique jewelry.

Pinacoteca (Picture Gallery)

A number of the papal portraits and other paintings in this exhibition come from the Pinacoteca, or Picture Galley. As it stands today, the Picture Gallery is composed mainly of the paintings taken to Paris by Napoleon from Rome and the Papal States. In 1815, the Congress of Vienna ruled that these works must be returned to Rome and the Vatican after the defeat of Napoleon. Works by Perugino, Raphael, Fra Angelico, Barocci, Domenichino, and Caravaggio now also augment the collection. Pope Pius VII installed them in the Borgia Apartments. The paintings were often moved within the Apostolic Palace due to limited space, and in 1932 a proper picture gallery was built and dedicated by Pope Pius XI (fig. 8).

Figure 7
Hallway of the Vatican Apostolic Library containing the Museum of Secular Antiquities

Figure 8
Room IV of the Pinacoteca (Painting Gallery)

The Pontifical Missionary Ethnological Museum

During the pontificate of Pope John XXIII, a decision was made to consolidate within Vatican City all the museums previously established in the Lateran Palace: the Gregorian Profane, the Pious Christian, and the Missionary Ethnological. The Lateran Museums were closed to the public in 1963, their works of art carefully stored, and construction began on a new building within the precincts of the Vatican City adjacent to the Picture Gallery. The building was completed, the collections installed, and opened to the public in 1970 under John XXIII's successor, Pope Paul VI. The Pious Christian Museum, with its extensive collection of Early Christian sarcophagi, sculpture, mosaics, and inscriptions from the Christian and Jewish catacombs of Rome, occupies the mezzanine. It overlooks the Gregorian Profane Museum, with its rich collection of Classical Roman sculpture, mosaics, and inscriptions. The Pontifical Missionary Ethnological Museum is housed in the subterranean space of the same building and demonstrates the religious expressions of non-European countries and cultures (fig. 9).

The origins of the Missionary Ethnological Collections date to 1925, when Pope Pius XI organized an exhibition at the Lateran Palace chronicling mission work throughout the non-European world. Since the seventeenth century, missionaries had sent to the Vatican a variety of art, artifacts, and other objects associated with the many cultures and religions they encountered on their journeys. Until the 1925 exhibition, these objects had been kept, and occasionally displayed, in a variety of offices and buildings of the Roman curia and the Vatican City. A large number of other works and gifts arrived from missionaries and civil governments from around the world on this occasion. At its conclusion, Pope Pius

Figure 9
Works from the Indian subcontinent in the Missionary Ethnological Museum

Figure 10
"Room of the Mysteries" by Pinturicchio in the Borgia Apartment of the Apostolic Palace, now home to the Collection of Modern Religious Art. Shown here are works by Marino Marini of the early to mid-twentieth century

thought it an excellent idea to use this material as the nucleus of a museum to be dedicated to the anthropology and ethnology of non-European cultures and their religions. Given the collection's origins in the missionary activity of the church, Pius XI called it the Pontificio Museo Missionario–Etnologico (Pontifical Museum of Missionary Ethnology). Its primary purpose was not to be an art collection, but rather a didactic and scientific museum at the service of the missions.

The Collection of Modern Religious Art

Pope Paul VI was also keenly interested in the relationship between contemporary art and religion. Meeting with artists in the Sistine Chapel to initiate a rapprochement between the church and the contemporary art world, he stated, "We must again become allies. We must ask of you the possibilities which the Lord has given you, and therefore, within the limits of the functionality and finality which form a fraternal link between art and the worship of God, we must leave to your voice the free and powerful chant of which you are capable." An important response to this open invitation to form a new and vital relationship resulted in generous gifts from artists, collectors, foundations, and national committees. In 1973, Pope Paul VI inaugurated a new collection within the Vatican, the Collection of Modern Religious Art (Collezione D'Arte Religiosa Moderna), dedicated to the renewed relationship between contemporary artists and the church. The collection is installed in the Borgia Apartment, which had been frescoed at the end of the fifteenth century by Pinturicchio, and in a number of rooms below the Sistine Chapel (fig. 10). It is from this collection that most of the modern and contemporary works in this exhibition have been drawn.

The Vatican Historical Museum

The most recent of the museums in the Vatican was founded in 1973, also at the request of Pope Paul VI, and is known as the Vatican Historical Museum (Museo Storico Vaticano). Part of this museum is housed within the complex of the Vatican Museums, and the other collections are in the Lateran Palace. The Carriage Pavilion contains carriages, sedan chairs, and automobiles used by the popes and important members of the papal court from the eighteenth through the twentieth centuries (fig. 11).

The museum in the Lateran Palace, inaugurated in 1990, is composed of two distinct yet complementary sections: the papal apartments and the collections proper. The papal apartments consist of large halls, galleries, offices, and a chapel that were frescoed in the sixteenth century under Pope Sixtus V. The walls in several of the rooms are hung with seventeenth- and eighteenth-centuries tapestries woven by Gobelins, Barberini, and San Michele. These rooms, furnished with antique furniture, though never actually lived in by the popes, nevertheless reflect the historical splendor of the papal court. The other collections housed here include portraits of the popes from 1500 to the present, objects used during papal ceremonies, the arms and equipment of the Pontifical Army Corps, and a variety of court uniforms worn by the now-dissolved Corps of the Noble Guard, as well as the *sedia gestatoria* (portable thrones), *flabellae* (ceremonial fans), and other objects used in solemn papal processions. The chapel contains a splendid set of seventeenth-century papal vestments relating to the pontificate of Pope Urban VIII Barberini, a recent gift from the descendents of his family.

Figure 11
The Gran Gala Berlina Papal Carriage, built in the late eighteenth century by Gaetano Peroni, in the Carriage Pavilion of the Vatican Historical Museum

The Patriarchal Basilica of Saint Paul's Outside-the-Walls

The Vatican extraterritorial property in Rome situated farthest from Vatican City is the patriarchal basilica of Saint Paul's Outside-the-Walls and the adjacent Benedictine monastery. This, the largest church in Rome after Saint Peter's, is built on the site where Saint Paul, apostle to the Gentiles, is said to be buried. Saint Paul is the apostle most responsible for the spread of the Gospel throughout the Roman and Greek world as recorded in the New Testament in his writings and preaching during his many journeys throughout the Mediterranean. Even today the basilica serves as a meeting place for the pope and representatives of other Christian denominations. Such was the case on January 25, 2000, the feast of the Conversion of Saint Paul, when Pope John Paul II met world religious leaders here and together they opened the holy door ushering in the third millennium of Christianity.

The name of the basilica originates both from the connection to the tomb of Saint Paul and the fact that it is about a mile and a half outside the Roman city walls constructed under the emperor Aurelia, 270–275 AD. Saint Paul's is the place where today one can best see the plan of the original Early Christian basilica churches. In this, it is also very evocative of the original Constantinian basilica of Saint Peter in the Vatican (fig. 12). Both once had large forecourts, or atria, and a porch just before the entrance into the church structure. The interior has a vast central nave with four lower aisles, two on each side, which direct the eye toward the altar con-

Figure 12
Interior of the Patriarchal Basilica of Saint Paul's
Outside-the-Walls, Rome

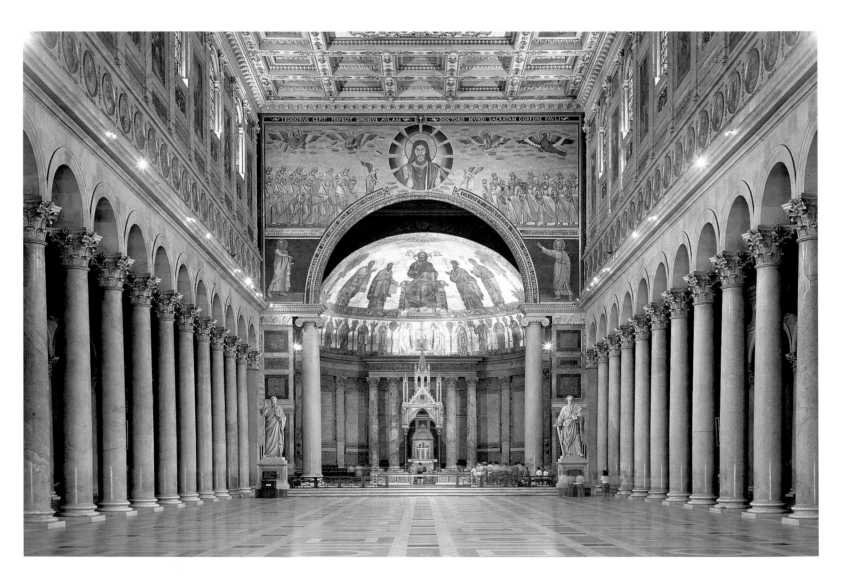

structed over the Tomb of the Apostle, which is surmounted by a beautiful-
ly carved ciborium or baldachin. Saint Paul's appears today much as it did
when built by the emperor Constantine and consecrated on November 18,
324, by Pope Sylvester I. Over the centuries this church, like that of Saint
Peter's, was enriched with stunning works of art to signify its importance
as the burial place of Saint Paul and hence a destination for many pilgrims
to the Eternal City.

Of great importance is the inner side of the holy door of Saint Paul's,
called the Byzantine Door (fig. 13). The name of the artist, Theodore of
Constantinople, is known from an inscription on the panels; it is also
recorded that the door was cast in bronze in 1070 by a man known as Stau-
rachio. It was a gift to the basilica by Pantaleone of Amalfi. The church's
liturgy reflecting Sacred Scripture also gives a symbolic value to the doors.
Christ calls himself the door that leads to the fertile pastures of heaven.
Hence, the doors of many churches were adorned with carvings and
reliefs to underscore this theological meaning as well as the aesthetic.
What remains of the Byzantine Door today consists of fifty-four panels
narrating scenes from the life of Christ and the apostles, as well as Old
Testament prophets, all interspersed with a variety of animal motifs. In
1967 it was moved from its previous location as the central door of the
basilica to its present position as the holy door that is opened only during
jubilee years.

Also significant are the portraits of the popes located below the win-
dows of the nave. As each pope was elected, his portrait was placed among
those of his predecessors. Pope Saint Leo the Great initiated this tradition
with portraits that were originally in fresco. Today, forty-three of these
original portraits remain and are kept in the Benedictine monastery adja-
cent to the basilica. Six of them are in this exhibition.

In 1847, Pope Pius IX had a new series of papal portraits created in
mosaic by the Vatican Mosaic Studios, beginning with Saint Peter. This
gallery gives visual evidence to the apostolic succession from Saint Peter
through all his successors to the current pope, revealing them as the legiti-
mate successor of the first apostle and hence the most authoritative repre-
sentative of Christ in his church.

Over the papal altar and the *confessio* is the ciborium, or shrine, marking
the place where Saint Paul is buried. This elegant structure is the work of
Arnolfo di Cambio and dates to 1285, when it was commissioned by
Abbot Bartolomeo of Saint Paul's (fig. 14). It is an eloquent witness of the
introduction of the new sculptural language of the Gothic into Rome in
the late thirteenth century. The ciborium, which rests on four porphyry
columns, is rich in bas-reliefs and mosaic decoration. The bas-reliefs rep-
resent figures related to the basilica, including the abbot Bartholomew
offering the ciborium to Saint Paul; Saint Timothy, Paul's disciple; Saint
Peter; and Saint Benedict, founder of the religious order that bears his
name.

At least since the pontificate of Pope Saint Gregory the Great there is
mention of Benedictine monks presiding over the celebrations in the
basilica and living in the adjoining monastery. Today, with the exception of
the cloister, little remains of the ancient monastic buildings that were also
used as a place of refuge and defense against raids coming up the Tiber
from the sea. The cloister that adjoins the south transept of the basilica rep-
resents what remains of a once beautiful early thirteenth-century monas-
tic space. The works in the present exhibition are ordinarily kept in the

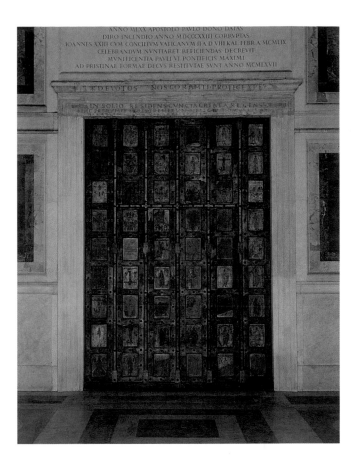

Figure 13
Theodore of Constantinople, Bronze door of the Basilica of Saint
Paul's Outside-the-Walls, Rome, 1070

Figure 14
Arnolfo di Cambio, Ciborium over the tomb and altar of Saint Paul
the Apostle, marble, porphyry, mosaic, 1285, Patriarchal Basilica of
Saint Paul's Outside-the-Walls, Rome

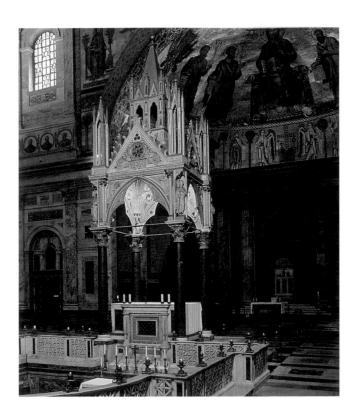

reliquary room and the small Painting Museum found just off the cloister, as well as in the library and galleries of the monastic enclosure.

This great basilica remained as it had been conceived and built until the night between July 15 and 16, 1823. The workers repairing the roof left a fire burning that engulfed the building in a great conflagration causing the entire structure to collapse and destroying most of the works of art and historical treasures that had been collected there for more than fifteen hundred years.

News of the disaster was kept from Pope Pius VII, who lay dying. His successor, Pope Leo XII, was left with the burden of rebuilding one of Christianity's holiest sites and largest churches. Pope Leo's strong decisive character and conservative tendencies determined that the form of the building would be a replica of the Early Christian basilica that had just burned. While others suggested an altogether new design for the building, the pope's opinion was dominant and determinative in this matter. In the holy year of 1825 the pope took the opportunity to make Christians aware of the importance of rebuilding the basilica dedicated to Saint Paul. Late in 1825 the rebuilding began, incorporating some of the remains of the ancient mosaics in the apse and proscenium arch, and the ciborium above the altar. On December 10, 1854, Pope Pius IX dedicated the new basilica of Saint Paul's Outside-the-Walls, but many more years were needed to complete the church.

The Congregation for the Evangelization of Peoples (Propaganda Fide)

Situated at the end of the Piazza di Spagna is the palace that presently houses the Congregation for the Evangelization of Peoples, formerly known as the Congregation of Propaganda Fide (fig. 15). This was originally the property of the Serattini family, whose most illustrious member was a cardinal. When he died in 1620, it was acquired by a Spanish priest, Giovan Battista Vives. His intention was to use the palace as a center for priests who would be sent out to engage in the missionary activities of the church. In 1627, Pope Urban VIII, following this same idea, founded a college for missionaries in the palace. It was named in his honor and even today is known as the Urbanianum. The college remained there until 1925, when Pope Pius XI moved it to a new building above the Vatican City on the Janiculum Hill, where it continues to serve the educational needs of missionaries from around the world.

To the original palace other wings and rooms were added. The architects were Gian Lorenzo Bernini, who designed the facade still seen today, and Francesco Borromini, who was responsible for the internal renovation and the design of the Chapel of the Magi. Over the centuries, the cardinal prefects of the Congregation of Propaganda Fide decorated the rooms, library, and archives with paintings, frescoes, sculpture, and furniture.

Of special importance was the collection of Cardinal Stefano Borgia, prefect of the Congregation from 1789 until 1804. The scope of the collection was to bring together works from all the missionary countries of the world to document the traditions and cultures beyond Europe. Upon the death of the cardinal the collection was disbursed: part was sold by his heirs, another part given to the Vatican Apostolic Library, and in 1927, when the Missionary Ethnological Museum was founded, other works were displayed there. The present prefect, Cardinal Crescenzio Sepe, has begun an initiative to form a new museum to conserve and exhibit the important works still in the Congregation's possession (fig. 16).

Figure 15
Palace of Propaganda Fide in the Piazza di Spagna, Rome

Figure 16
New archival facility of the Congregation for the Evangelization of Peoples (Propaganda Fide)

Office of the Liturgical Celebrations of the Supreme Pontiff

On the north side of Saint Peter's Square, where Bernini's majestic colonnade joins the wing connecting the basilica and the Apostolic Palace, is the bronze door. The Swiss Guards oversee this entrance to the Apostolic Palace, and the area is strictly reserved for the pope and members of his household (fig. 17). Located here is the pope's private apartment, reception rooms, and library, as well as other offices directly concerned with the administration of the Holy See: the Secretariat of State and the Prefecture of the Pontifical Household, and the Office of the Master of Pontifical Liturgical Celebrations, a position of ancient institution in the church. His chief responsibility is the preparation of all that is necessary for the liturgical celebrations and other sacred rites at which the pontiff presides. This includes the liturgies celebrated by the pope during his pastoral visits to the parishes and institutions of the diocese of Rome, as well as his apostolic visits in Italy and abroad. The celebration of consistories and the liturgical celebrations of the College of Cardinals when the Roman see is vacant are also part of his competency. The office is also responsible for the papal sacristy and chapels of the Apostolic Palace, including the Sistine Chapel, as well as the Lipsanoteca.

This is the institution that has lent the greatest number of works to the present exhibition.

The Sistine Chapel

Of all the chapels within the Vatican Apostolic Palace, surely the most famous is the Sistine Chapel. It is justly known for its magnificent frescoes by Michelangelo and earlier artists (fig. 18) and as the site of papal elections.

The first pope to live in the Vatican was Pope Nicholas III. To him is due the construction of the original nucleus of the palace. He is also generally considered to have been responsible for building the first palatine or palace chapel. This was demolished in the fifteenth century by Pope Sixtus IV for the Sistine Chapel. The chapel itself has a very simple design: it consists of a rectangular hall (40.23 × 13.41 m), the same proportions as those attributed to the Temple of Solomon (2 Chr 3:3), with a polycentric vault and lunettes corresponding to the twelve windows. Construction commenced in 1477 and was finished in 1483, when the frescoes on the lower areas of the walls were also completed. The fresco decoration was entrusted to the greatest artists from Tuscany and Umbia of the quattrocento (Pinturicchio, Perugino, Ghirlandaio, Botticelli, Cosimo Roselli, and their assistants). The frescoes were articulated on three registers, with the lowest representing faux tapestries. The central register illustrates scenes from the lives of Moses and Christ; while the upper register between the windows depicts the first popes, painted full length, standing in painted niches. At the time of the completion of the chapel in 1483 the ceiling depicted a star-studded sky.

In 1508 the decoration of the ceiling was entrusted to Michelangelo by Pope Julius II. The original idea of representing the Twelve Apostles was much simpler than the finished product. His ambitious monumental work includes the history of the Creation, along with the Fall and reconciliation with God after the Flood. All this was inspired by the early chapters of the Book of Genesis (fig. 19). These nine scenes are inserted into cornices flanked by *Ignudi*, monumental nudes who support garlands of oak branches and acorns (the emblem of the Della Rovere Family of which

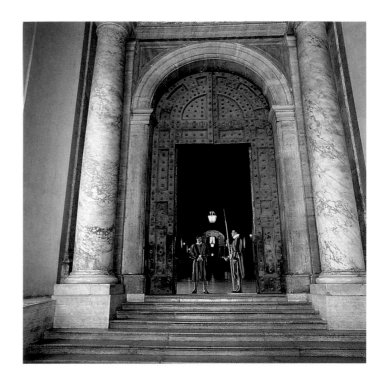

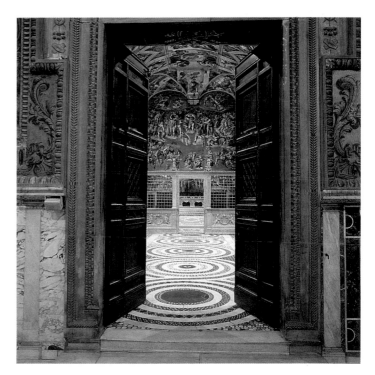

Figure 17
Bronze door at the entrance to the Vatican Apostolic Palace with the Pontifical Swiss Guards standing watch

Figure 18
View into the Sistine Chapel, showing the altar wall with Michelangelo Buonarotti's *Last Judgment*, 1536–41, fresco

Figure 19 (overleaf)
Ceiling of the Sistine Chapel, Vatican Apostolic Palace, with frescoes by Michelangelo Buonarotti, 1508–12

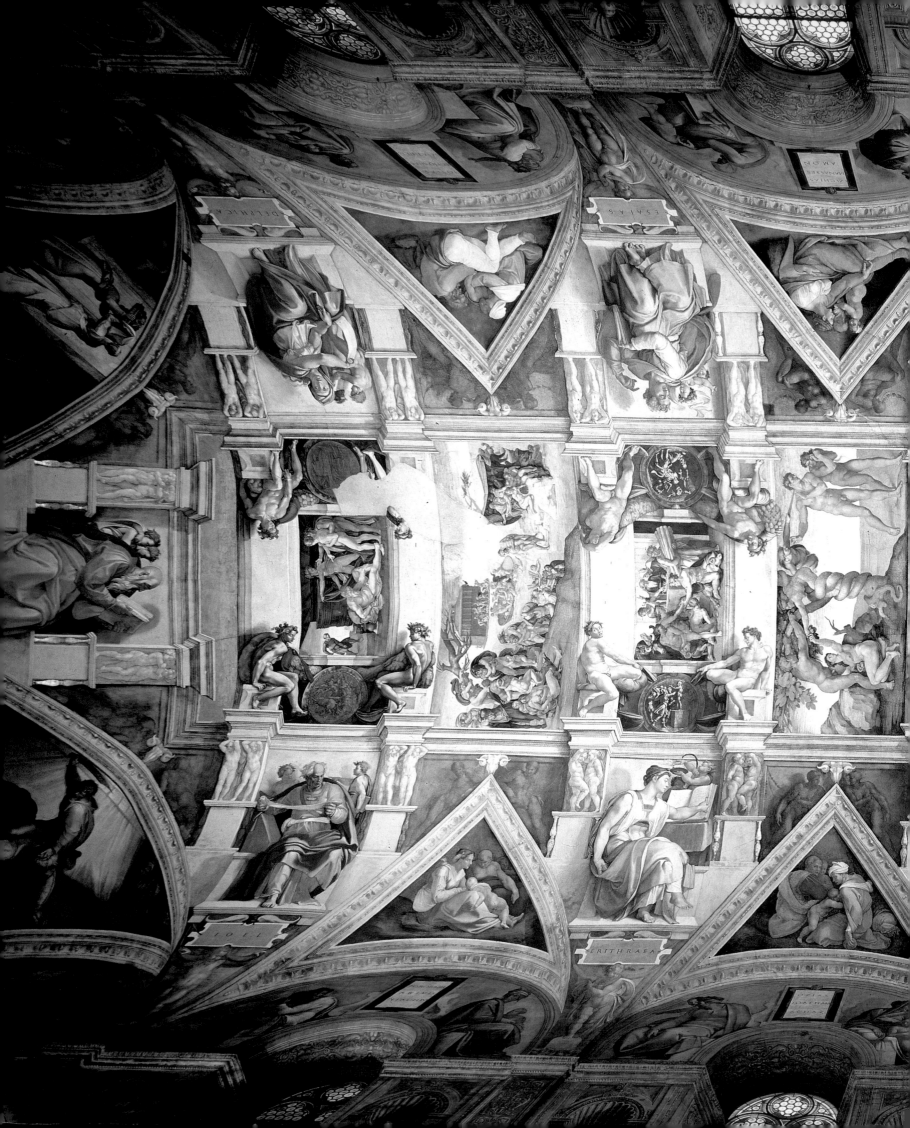

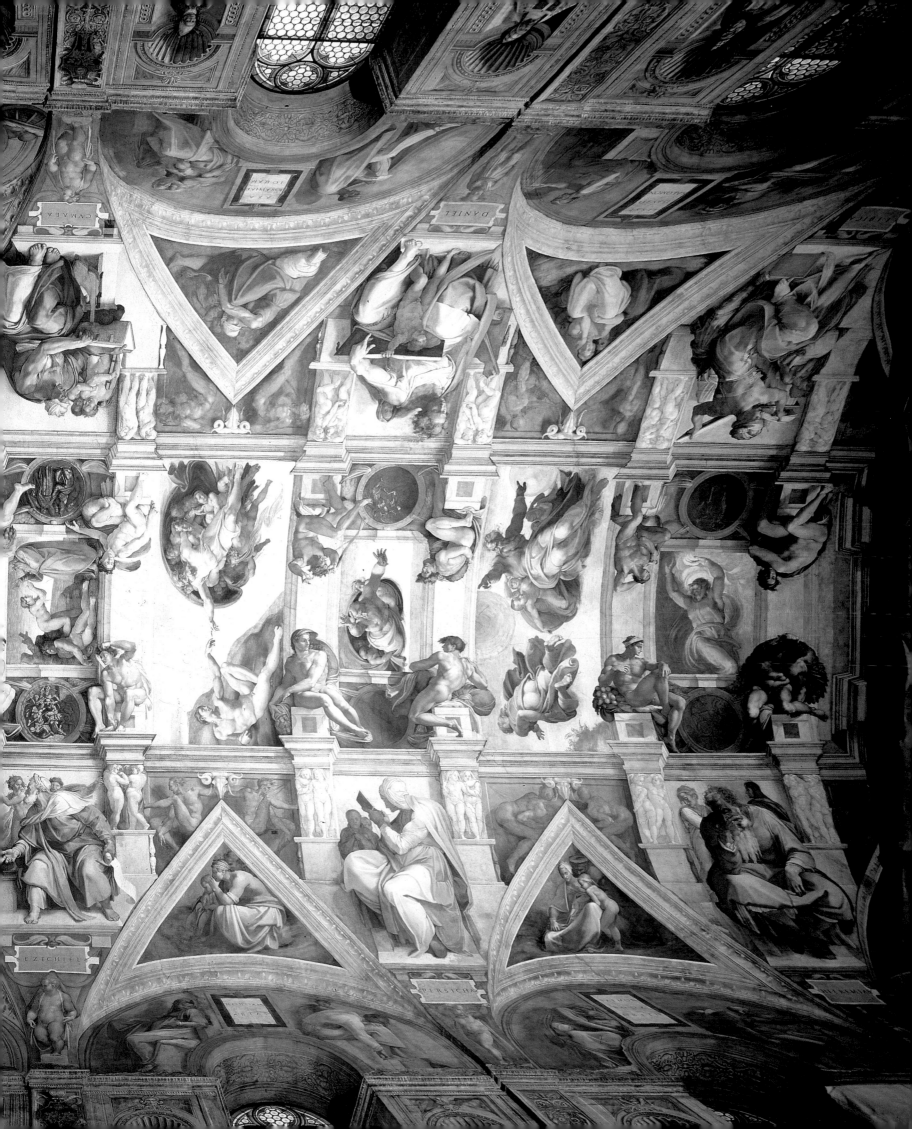

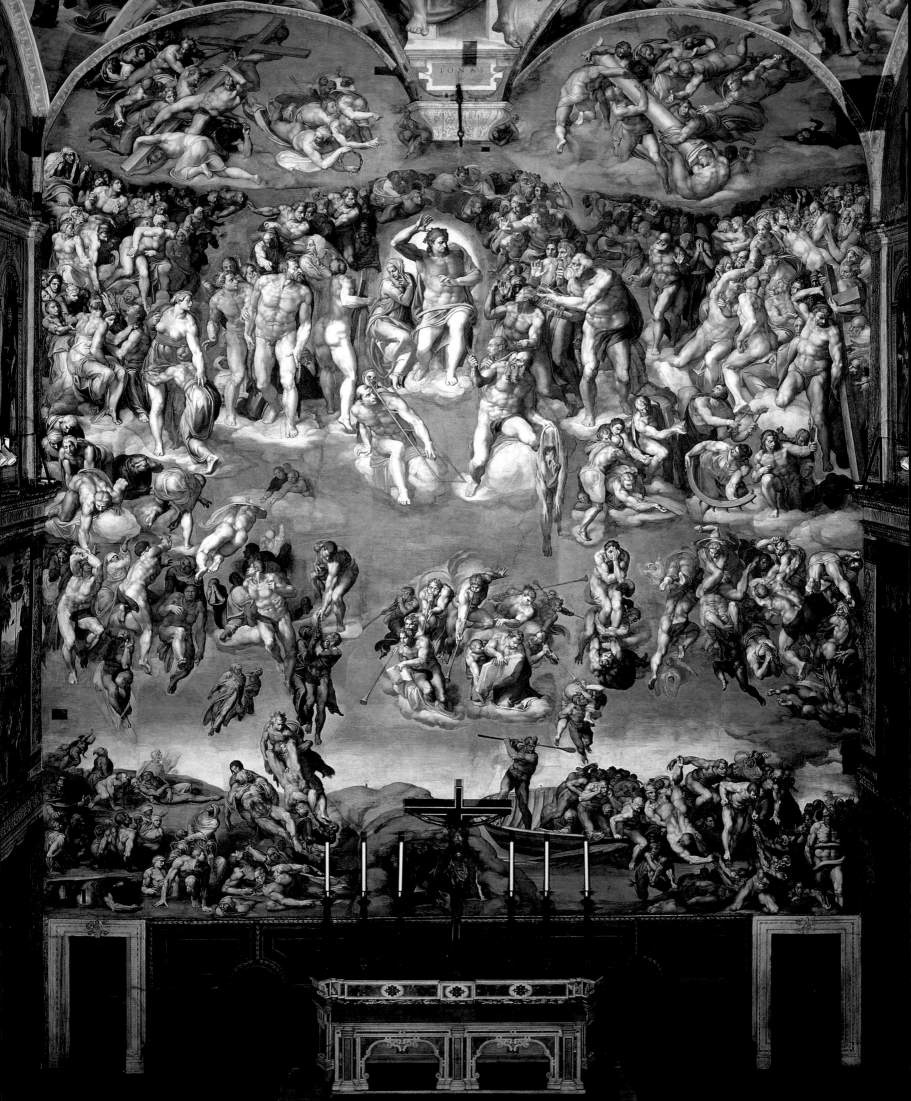

Sixtus IV and Julius II were the most illustrious members), and medallions of bronze with other biblical scenes. On the sides of the central scenes, between the spandrels, seated on monumental thrones, are five Sibyls and seven Prophets, who foretold the coming of the Redeemer, the former in the pagan world, the latter in the Judaic. In the lunettes above the windows, depicted in small family groups, are the ancestors of Christ mentioned in the first chapter of the Gospel of Matthew. Finally, in the large corner spandrels, Michelangelo represents the stories of four Old Testament heroes—David, Judith, Esther, and Moses—whose deeds reflect God's intervention for the salvation of his chosen people. The ceiling frescoes were intentionally related to the fourteenth-century frescoes below as prefigurations of what was to be accomplished through the lives of Moses and Christ.

The chapel was solemnly inaugurated on November 1, 1512, the feast of All Saints. Thereafter it was opened to the public for the first time. Vasari wrote, "the wonder and astonishment of the whole of Rome, or rather the whole world and I along with the whole world was stupefied by what I saw."

Until 1535 the Sistine Chapel remained much as Michelangelo had left it in 1512. Then, at the urging of Pope Paul III, he undertook the last and perhaps most important of his frescoes in the papal chapel, *The Last Judgment*. Working mostly alone, he first had to destroy what was already on the altar wall of the chapel, including Perugino's frescoes of the 1480s and his own work of the ancestors of Christ in the lunettes.

The composition of the *Last Judgment* is articulated by the groupings of the figures without architectural components on three levels (fig. 20). In the lowest band, Michelangelo has represented the damned surrounding the boat of Charon as it moves across the mythical River Styx to deposit these souls in Hades. Behind and above him, summoned by trumpet blowing angels, the dead rise from their graves. Around the group of angels sounding their horns, hordes of devils drag the damned into hell and angels assist the just into Paradise. The upper scene is dominated by the figure of Christ the Judge who, with the Blessed Virgin at his side, constitutes the focal point of this massive fresco. The Son of Man, Christ, with his right hand raised, is in the act of separating the damned from the saved as recorded in the Gospel of Matthew: ". . . and they will see the Son of Man coming on the clouds of heaven with power and great glory. . . . All nations will be assembled before him and he will separate people one from another as the shepherd separates sheep from goats (Mt 24:30, 25:32).

Around Christ and Mary is the glorious circle of the saints and martyrs, including Saint Peter who gives back to Christ the keys of the kingdom entrusted to him until the end of the world. In the lunettes above, angels bear the symbols of the Passion through which Christ has redeemed the world. The fresco was unveiled on November 1, 1541, the feast of All Saints, arousing admiration but also unleashing some harsh criticism of Michelangelo for depicting so many nude figures in the papal chapel.

The Papal Sacristy

To the left of the altar below the *Last Judgment*, a small door leads to the Little Room of Tears, where the newly elected pope vests for the first time in the papal cassock. From there one enters directly into the papal sacristy, which is sometimes called the treasury of the papal sacristy (fig. 21).

Figure 20 (opposite)
The Last Judgment, 1536–41, fresco, Sistine Chapel

Figure 21
The door leading to "The Little Room of Tears," the antechamber of the Papal Sacristy located behind the altar wall of the Sistine Chapel

Figure 22
Room of the *Copricapi* (headcoverings), housing papal
tiaras and copes in the Papal Sacristy of the Sistine Chapel

Figure 23
A cupboard in the Papal Sacristy with papal cassocks,
shoes, gloves and hat

Figure 24
The Lipsanoteca (Relic Room), Apostolic Palace

A sacristan in charge of organizing and preparing for the papal liturgies, as well as conserving the objects and vestments used, can be traced back to the fourth century. This position first existed in the Lateran Basilica, where the sacristan served not only in the private apartments but also in the cathedral and traveled with the pope when he presided at churches within and outside of Rome.

Each new pope also had vestments and other articles made specifically to his measurements. As a result, the sacristan was also responsible for preserving what accumulated in the sacristy from previous pontificates. From the time of Pope Alexander VI, the apostolic or papal sacristan was to be chosen by papal decree (*Ad sacram*, issued on October 15, 1497) from among the ranks of the Order of Augustinian Hermits, and was often ordained a bishop after his appointment. Among his most important responsibilities was the care of the sacred vessels and vestments. Over the centuries certain other duties were assigned to the sacristan and his assistants, including care of the bodies of the martyrs from the catacombs and, later, authenticating the relics of saints.

Today the sacristy is divided into two sections. The pope's ordinary vestments and other liturgical materials are kept in two rooms accessible from the Sala Regia outside the Sistine Chapel (figs. 23, 24). The more precious and historical vestments, miters, chalices, and other objects are kept in the area behind the Sistine Chapel. In 1991, all the offices and matters related to the papal liturgical celebrations became the ultimate responsibility of the Master of Pontifical Liturgical Celebrations and his Office of the Liturgical Celebrations of the Supreme Pontiff.

The Lipsanoteca (Relic Room)

The Vatican Lipsanoteca, or Relic Room, is located in a long narrow room that opens off the Chapel Redemptoris Mater, also called the Matilde Chapel, established in 1907 by Pope Saint Pius X in the Vatican Apostolic

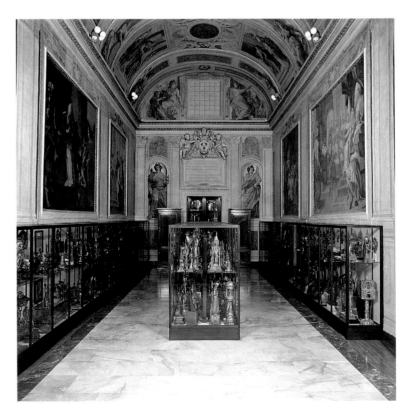

Palace. The room has a frescoed ceiling painted by Gianfrancesco Romanelli, dating to the pontificate of Pope Urban VIII (fig. 24). The receipt for payment to him of 150 scudi, dated September 6, 1637, is extant. From the artist's name this room is called the Romanelli Gallery, or Galleria Romanelli. The frescoes illustrate scenes from the life of the Countess Matilde of Canossa and Pope Gregory VII.

Preserved in cases along the walls and down the center of the Lipsanoteca are some six hundred reliquaries of various epochs and styles. Among the oldest are those from the pontificate of Pope Alexander VII. Most of the more ancient ones disappeared at the time of the invasion and Sack of Rome in 1527 by the troops of Emperor Charles V. Many were also taken in 1808 when the Napoleonic forces invaded Rome and the Vatican.

The Lipsanoteca Vaticana and the Apostolic Sacristy are not open to the public.

The Reverenda Fabbrica and Saint Peter's Basilica

On the left of Saint Peter's Basilica is another entrance to the Vatican City called the Arch of the Bells (l'Arco delle Campane), because the bells of the church are placed above it in the facade. Passing under the arch, just ahead is the sacristy of Saint Peter's built in the eighteenth century. In front of it on the ground is a marker designating the place where the obelisk once stood in the circus of Nero. Today this same obelisk is in the middle of Saint Peter's Square.

The Scavi or Excavations of the Ancient Cemetery

Here, in fact, *iuxta obeliscum*, Saint Peter was crucified upside down, as ancient tradition testifies, and buried in a simple rock tomb in the necropolis that extended a little north along the via Cornelia. Just to the right of the sacristy under another archway is the entrance to the *scavi*, or excavations, of the basilica leading to the remains of the via Cornelia; from there one can approach the place where Saint Peter was buried.

With the construction of the Constantinian basilica the tomb and the surrounding necropolis disappeared from sight and eventually from consciousness. However, both the Constantinian and the present basilica were built in such a way that the papal altar is situated directly over the original tomb, making it the axis for the two massive basilicas that eventually arose over the modest original tomb of Peter.

It is due in great part to Pope Pius XII that the original tomb was discovered and the necropolis excavated during 1940–57 (fig. 25). The most important part of the necropolis is the area that contained the body of Peter, called Field P (the archaeologist identified the areas of excavation with letters). It lies in the western section containing many other burial sites from the first and second centuries alongside that of the apostle.

By the second century, Saint Peter's tomb was distinguished from the others by a trophy, or *aedicule*, by which it was surmounted. This was a niche flanked by two small columns set very near to the so-called red wall, erected to fix the boundaries of Field P on the west. In the third century, perpendicular to the red wall the so-called Wall G, or graffiti wall, was built. This is of great archaeological interest because within in it was identified a small cavity to which the remains of Saint Peter were moved from the original tomb under the red wall, to save them from possible profanation. In the fourth century Emperor Constantine built his church on the Vatican Hill, and above the tomb of Peter placed a small tabernacle-like monument

with an elegant bronze baldachino supported by four bronze columns. This was the origin and the model for much of the construction that was to follow over and around the Tomb of the Apostle for the next thirteen hundred years.

Figure 25
View of the excavations (*scavi*) under Saint Peter's Basilica

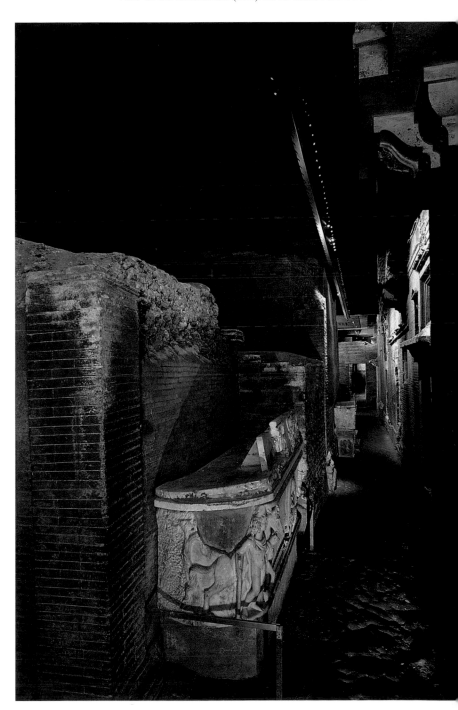

The Reverenda Fabbrica

To the left of the sacristy and attached to it is the building in which the clergy of the basilica reside, and where the offices of the Reverenda Fabbrica of Saint Peter's Basilica is located (fig. 26). The Fabbrica di San Pietro had its origins in the reign of Pope Julius II and the beginning of the reconstruction of Saint Peter's in 1506. In 1523 Pope Clement VII named a permanent commission of sixty experts directly dependent on the Holy See to supervise the construction and administration of the basilica. It was Pope Sixtus V in 1589 who subjected them to the authority of the cardinal archpriest of Saint Peter's Basilica; shortly thereafter they were given the status of a dicastery, or administrative department of the Holy See, with all the responsibilities that had accumulated to that point. This dicastery was know as the Sacred Congregation of the Reverenda Fabbrica of Saint Peter's. In addition to the cardinal archpriest of Saint Peter's, who also became the prefect of the congregation, its membership was composed of other cardinals and prelates.

Figure 26
The Sacristy of Saint Peter's Basilica with the residence of the canons and the offices of the Reverenda Fabbrica

Figure 27
View from Saint Peter's Square toward the basilica

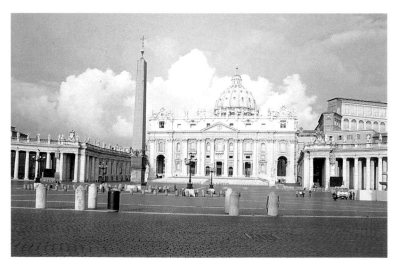

With the reform of the Roman curia under Pope Paul VI in 1967, it ceased to exist as a congregation of the curia and its work was taken over by the palatine administrations. Finally, Pope John Paul II, with his curial reforms of 1988, required in *Pastor Bonus* that "the Fabbrica of Saint Peter's according to its proper laws would continue to dedicate itself to all matters pertaining to the Basilica of the Prince of the Apostles; its conservation and decoration as well as the administration and discipline of its workers and the pilgrims that visit the church." Today its responsibilities include the basilica and its interior and exterior maintenance, including Saint Peter's Square; the sacristy; the building of the Fabbrica; its vast archives and collections of art and artifacts; the Vatican Mosaic Studio; as well as the papal grottoes and the *scavi* in and around the tomb of Saint Peter.

The Patriarchal Basilica of Saint Peter

One approaches the largest church in Christendom from Saint Peter's Square, which was enhanced in 1586, the year in which Carlo Maderno moved the obelisk from its centuries-old location on the south side of the basilica from what was once the circus of Nero. He re-erected it in the center of Saint Peter's Square and rebuilt the two fountains that still flank it (fig. 27). In 1667, Bernini's genius conceived the dramatic massive colonnade that defines the piazza to this day.

Moving from the piazza toward the basilica the visitor is immediately aware of moving up the slope of the Vatican Hill. The marble *sagrato*, or platform, with its many steps leads into the great portico of the church designed by Carlo Maderno and built between 1608 and 1612. The purpose of the atrium, here, as in the earliest Christian churches, was to prepare the faithful for the spiritual experience awaiting them within the church. It is the area that fosters the passage from the cares of daily life into that of prayer and contemplation by providing a space for recollection and silence. In the atrium of Saint Peter's, the principal decorative themes in marble, stucco, bronze, and mosaic underscore the presence of Saint Peter and Saint Paul in Rome and, in particular, Peter's preeminent relationship to the life and mission of Christ.

Today there are five imposing sets of bronze doors that lead into the basilica. All but the central doors were created in the twentieth century. The central doors were originally in the atrium of the Constantinian basilica and are know as the Doors of Filarete, after the artist who designed them in 1433 under Pope Eugene IV. Their reliefs tell the stories of the martyrdoms of Saint Peter and Saint Paul, as well as the hoped for reconciliation of the Western and Eastern churches promoted by Pope Eugene at the Council of Florence in 1438. These doors are an imposing link between the two massive church buildings that have stood on this site honoring the simple fisherman who became the prince of the apostles.

To the extreme right of the atrium is the holy door, which is closed except during the holy year or jubilee celebrations. The present holy door dates from 1950 and replaced one that had been there since 1749. It was a gift to Pope Pius XII from the Diocese of Basel, Switzerland, in thanksgiving for their country having been spared the destruction of World War II. It is composed of sixteen panels illustrating the biblical and theological theme of the holy years: great conversions and great pardons (fig. 28). The inscription at the bottom reads, in part, "Let the waters of divine grace flow copiously, purifying all those who pass through here. May they be filled with peace sublime and instilled with Christian virtue, Holy Year 1950."

The planning and building of the present church until its completion spans a period of some 167 years. Pope Nicholas V made the decisions to rebuild in it 1450 and Pope Urban VIII consecrated it in 1626. It was Pope Julius II, however, who approved Bramante's pure and grandiose design: a Greek-cross plan with a majestic dome resting on four gigantic piers. Variations on this plan had been offered by Raphael and Antonio Sangallo the Younger, but it was to Bramante's original concept that Michelangelo returned in 1546 when Pope Paul III made him architect of Saint Peter's. To this great project he was to dedicate his enormous energy for the rest of his life. Michelangelo oversaw the completion of the apse and the southwest transept, the four piers, and the drum of the dome. He died, however, before his dome was finished by Giacomo della Porta and Domenico Fontana in 1590.

Entering the nave of the church through Carlo Maderno's portico can be an overwhelming experience. There is uncertainty as to where to focus the eyes amid all the decoration and the sheer mass of the building with its interplay of light and shadows created from the natural and artificial sources of light. From the door to the apse the basilica measures 186.86 meters long and 140 meters wide, covering a surface of 25,616 square meters with 44 altars, 11 domes, 778 columns, 395 statues, and 135 images in mosaic. This basilica is the fruit of the creative work of many artists and craftsmen attesting to the faith and devotion of the church founded on Christ and to the beauty and the glory of God, the source of all faith and all beauty.

Two images inevitably draw the attention of the pilgrims and visitors: the statue of Saint Peter and the *confessio*. The bronze statue of Peter has a right foot abraded by the kisses and the touch of the faithful who still today repeat these ancient gestures of devotion (fig. 29). Attributed to Arnolfio di Cambio and once believed to be of much more ancient origins, this image shows Saint Peter seated in an act of blessing, while he holds in his left hand the keys symbolizing the power given to him by Christ to govern the Church and to open the kingdom to those who believe.

Figure 28
Vico Consorti, Holy Door of Saint Peter's Basilica (detail), 1949, bronze

Figure 29
Pope John Paul II praying before the statue of Saint Peter on the feast of Saints Peter and Paul, June 29, 1979

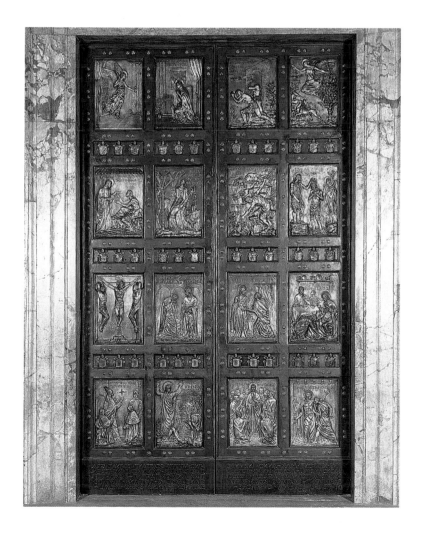

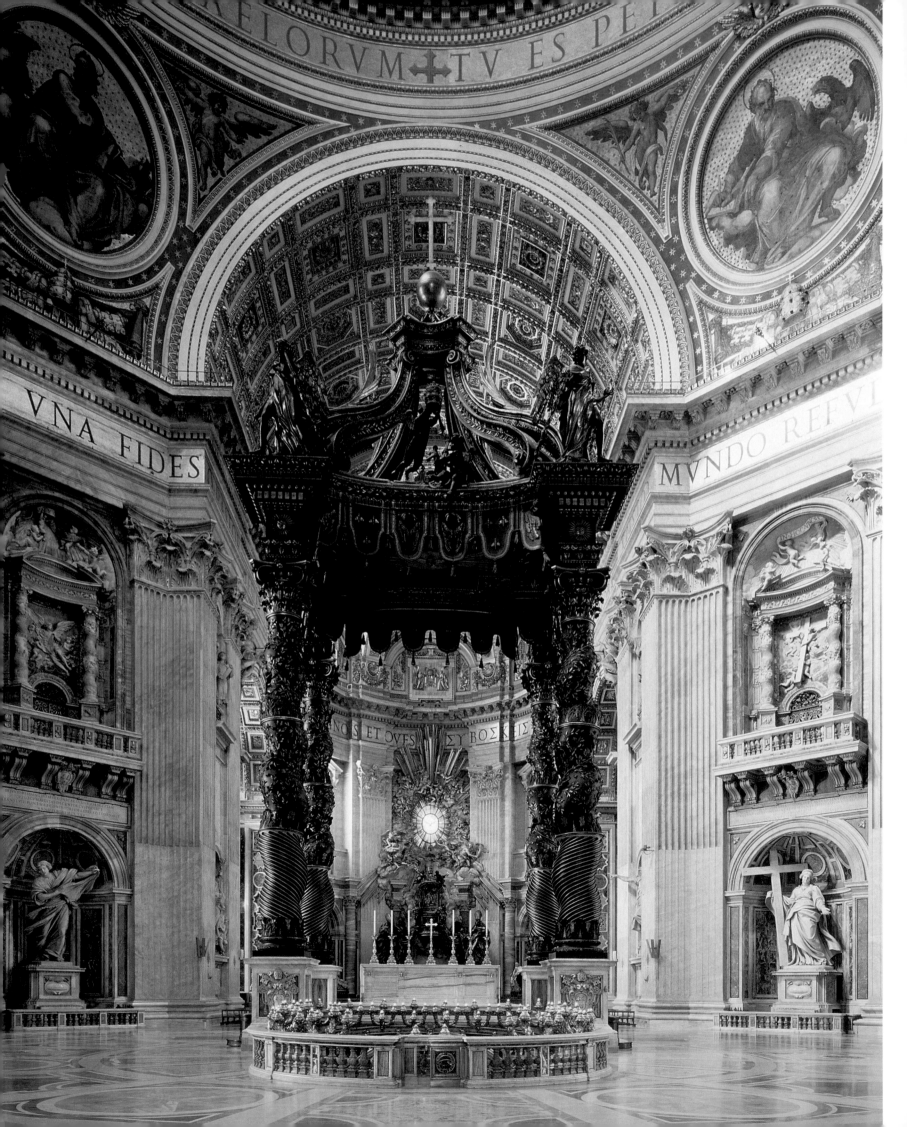

Nearby is the visual focus of the basilica, the *confessio* of Saint Peter. Here the faithful kneel and confess their faith as well as to pray that the apostle will protect the church, the pope who is his successor, and our world. The *confessio*, ringed by nearly one hundred oil lamps burning day and night, consists of the first-century tomb of Peter, invisible from this point and actually some four floors beneath the altar, the papal crypt or grottoes where many popes are interred, the imposing papal altar, and, soaring above, Bernini's masterful bronze baldachino (fig. 30). This all rests under Michelangelo's dome 193 meters above, crowning it like the dome of heaven.

On this spot one feels the humble beginning and the enormity of the two thousand years of the history of the Church. It began by the Sea of Galilee, in a distant land, when Peter professed his faith in Christ as the Son of God. In turn, Christ says to Peter, "'Come after me and I will make you fishers of people.'" And on another occasion, "'You are Peter and on this rock I will build my church. And the gates of hell shall not prevail against it. I will give you the keys of the kingdom of Heaven: whatever you bind on earth will be bound in heaven; whatever you loose on earth will be loosed in heaven'" (Mt 4:19; 16:18-19; fig. 31).

In a sense, then, this end brings us back to the beginning – from Saint Peter's tomb, to this exhibition – from the first pope to his successors, to explore the mystique and beauty of the Vatican.

Figure 30
Gian Lorenzo Bernini and assistants, *confessio* with bronze baldachino 1624–33

Figure 31
Pietro Perugino, *Consignment of the Keys to Saint Peter*, 1480, fresco, Sistine Chapel

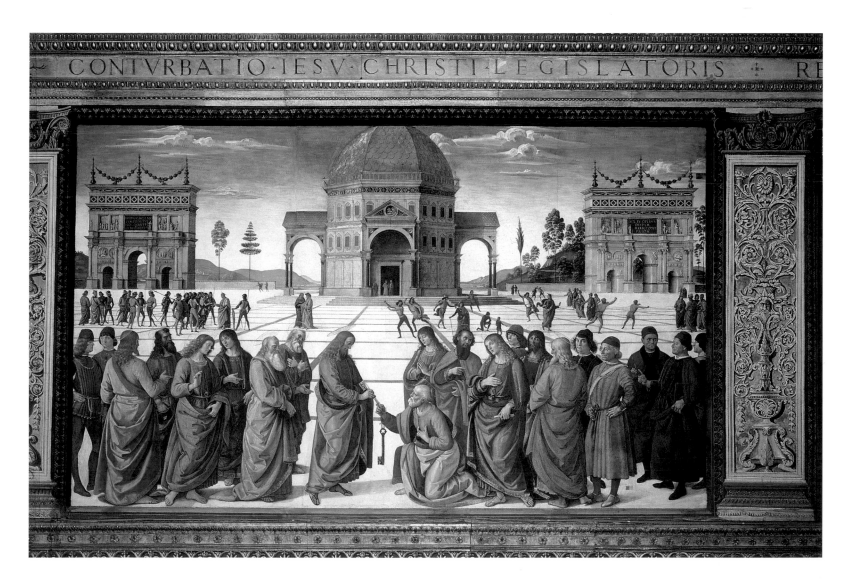

The Petrine Office in the Biblical Texts and the Ecclesiastical Tradition

Cardinal Jorge Maria Mejía

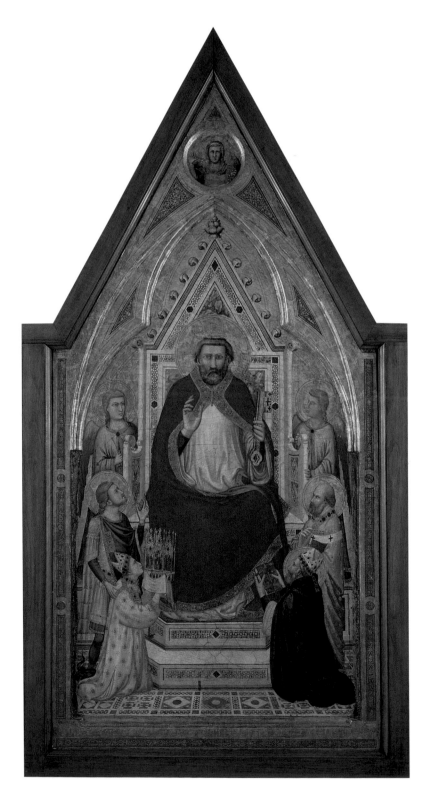

To write something both new and of interest about the office of Peter is always a challenge. The following is intended more, therefore, as a reflection or, rather, meditation, on the image of the apostle Peter in the Scriptures and tradition (figs. 1, 2).

Throughout the New Testament, there are few texts in which Peter appears as a central figure. Fewer still are those in which his "office" is mentioned. In some of the texts, Peter is not even presented in a favorable light. This is a significant fact to bear in mind. When those texts were recorded, Peter already held a prominent position in the early Church, as can be seen in the Acts of the Apostles, particularly the first fifteen chapters. One would think, then, that the oral and, later, the written traditions would have presented a more positive image of him in light of his station in the early Church and the veneration surrounding him (e.g., Acts 5:15, in which even his shadow could heal the sick). That did not happen, however. Peter is not idealized in the texts. None of his past history, from the time before the Resurrection, was omitted, not even by Mark, who was thought, as early as the second century, to have transcribed what he heard directly from Peter. At the same time, the exclusive rights that accrue to Peter are carefully described and transmitted. There was, apparently, no fear that those prerogatives would be diminished by particular details about his character.

What does this mean for our understanding of the Petrine office? What has this meant, in fact, for the tradition?

Those writers inspired by the Holy Spirit were, I suggest, conscious of two things. First, that Jesus did not choose the most perfect person, as Paul makes clear: "…not many of you are wise by human standards, not many influential, not many from noble families. No, God chose those who by human standards are fools to shame the wise; he chose those who by human standards are weak to shame the strong…" (1 Cor 1:26-27). Peter is, in fact, shown to be quite "weak," but he has been chosen. Second, this undercores that the one who is to be the "rock" of the Church and the "shepherd" of the flock, according to both Matthew (16:18) and John (21:13-17), will not need to be perfect, as is true for Peter and his successors.

Peter is also shown to be a sinner, and it is insightful to critically compare him with Judas. Judas betrays Jesus and, worse yet, sells him for thirty pieces of silver. He was clearly aware that he was placing Jesus, his master and friend, in the hands of his executioners. It is his "friend and master" whom he kisses in the very moment of betrayal: "My friend, do what you are here for" (Mt 26:48-50); "are you betraying the Son of Man with a kiss?" (Lk 22:48). The "Son of Man" is indeed the Son of God, as the centurion will confess soon afterward (Mk 15:39).

Figure 1
Giotto di Bondone, *The Stefaneschi Triptych* (detail), ca. 1320, Vatican Museums

Figure 2
Arnolfo di Cambio, Statue of Saint Peter, ca. 1278, bronze, Basilica of Saint Peter

On the other hand, Peter denies the Lord, his friend and master, whom he had declared to be the Son of God (Mt 16:16, "You are the Christ, the Son of the living God"). The denials are presented in great detail, if differently, by the Four Evangelists, but all describe a man who is both fearful and weak. Peter does not want to be involved in his master's destiny, which, at that moment, looks extremely dangerous. So he dissociates himself, denying all knowledge of Jesus: "I do not know the man you speak of" (Mk 14:71). But then the cock crows a second time "and Peter recalled what Jesus had said to him, 'Before the cock crows twice, you will have disowned me three times.' And he burst into tears" (Mk 15:72; fig. 3). Meanwhile, Judas' response to his actions is to hang himself (Mt 27:5). Here, the parallel between Peter and Judas ends. It had begun with the list of those called to be apostles, with Peter at the beginning and Judas, significantly enough, at the end (Mk 3:16-19).

In the oral and written traditions, then, Peter is objectively presented as weak, a sinner, and somewhat oblivious to the mysteries he had witnessed or which had been made manifest to him and the others. A case in point is an episode in Matthew, just after his confession of faith referred to above:

"From then onwards Jesus began to make it clear to his disciples that he was destined to go to Jerusalem and suffer grievously at the hands of the elders and chief priests and scribes and to be put to death....Then, taking him aside, Peter started to rebuke him...But he [Jesus] turned and said to Peter, 'Get behind me Satan!... you are thinking not as God thinks but as human beings do'" (Mt 16:21-23). This is said to the disciple who had just professed his faith in the Son of the living God. It may be – although I am not at all convinced – that this sequence of events is not original; that is, perhaps the two scenes were not linear but rather separated in time. Even so, this would not alter the situation. It is always the same Peter, at one time confessing his faith, at another time failing to understand the full meaning of that confession.

This is the picture of Peter presented in the Gospels during Jesus' earthly ministry and at the time of his calling. There is another similar event showing Peter's fear, hesitation, and, therefore, imperfection, after the Resurrection, in the full exercise of his prerogatives. There it is not Jesus but another apostle, namely, Paul, who rebukes Peter: "I did oppose him to his face since he was manifestly in the wrong...When I saw, though, that

their behavior was not true to the gospel…" (Gal 2:11-14). This was not tradition, but a direct witness to the wrong – or at least debatable – exercise of Peter's ministry. It is written to a Christian community that knew Peter well and was quite aware of his place in the Church, a fact which Paul does not ignore or question. Paul is not afraid to point out the limitations of the man Peter, the same limitations that are found in the Gospels.

The Gospels, then, present Peter, the choice of the Lord Jesus, as a weak, not especially enlightened, disciple, who will deny the Lord in the face of danger. But one should also note Peter's courage and generosity to maintain perspective. He comes to the Lord across the raging waves (Mt 14:27-30), and, at the Last Supper, says, "Lord…I would be ready to go to prison with you, and to death" (Lk 22:33). Peter is also the only one who tries to prevent Jesus' arrest by attacking Malchus, a minor figure, and cutting off his ear (Mt 26:51). But soon thereafter, when Jesus is arrested, Peter flees with all the others (Mk 14:50: "they all deserted him and ran away"). If there was generosity (or, perhaps, impetuosity), it was not a consistent hallmark of his character. Nor was Peter present at the Crucifixion.

Yet in spite of all this, or most likely *because* of all this, Peter was chosen by Jesus. As were, one may add, all the apostles. The choice of Peter, therefore, combined with all that is known about him from the Gospels, and transmitted faithfully by the tradition, means only one thing: whatever he was called to be and became in the Church, and whatever he left to his successors, is only and exclusively a pure gift from, and by the grace of, God. In him and in his successors in the "Petrine" ministry both aspects of his personality can be found, albeit in different proportions: alternately the saint or the sinner, or, perhaps better stated, a saint *and* a sinner (fig. 4). At the same time, however, he is (and they are) the "rock" upon which the Church rests, the supreme pastor of the flock, and the first witness and teacher of the faith and, for this reason, the vicar of Christ.

Peter is called the "rock" (Mt 16:18), a name given to him by the Lord on their first meeting, according to John (1:42). The implication is clear: the man who bears this name is to be the foundation of something, which we later learn is the Church: "on this rock I will build my community" (Mt 16:18). There is no question, then, that the Church rests upon Peter, indeed, upon his person. No exegetical finesse can deny this fact.

Two questions can, and should, be posed. The first is, what is the Lord's design in making Peter "the rock"? We have already dealt at length with his weakness. Nothing weak can be a rock of any structure, much less a building with the transcendental mission of the Church. In the case of Peter, however, I believe his weakness is essential to his being the rock, and this is what tradition intended by carefully transmitting and then recording the stories referenced above. Clearly this man is not "the rock," nor was he chosen to be one, because of any special personal trait. He was made the rock purely and exclusively by God. And so he remains, and the same is true of his legitimate successors. In the episode at Caesarea Philippi, two things point decisively in that direction. The first is revelation: Peter's profession of faith is a result of God's revelation. The second is the human condition: indeed, everything properly human is explicitly excluded. Let us read the text again: "Simon, son of Jonah, you are a blessed man! Because it was no human agency that revealed this to you but my Father in heaven" (Mt 16:17). And then the Lord continues: "So I now say to you: You are Peter and on this rock…" (v. 18).

Figure 3
Michelangelo da Caravaggio, *The Denial of Saint Peter*, ca. 1594, Vatican Museums

Figure 4
F. Pedrini, *Saint Peter Penitent*, eighteenth century, Seminary of Bedonia, Parma

The second question is, what are the consequences of such an extraordinary gift, that is, to be made the rock of the Church? Two are found in the text, in Jesus' words: "…the gates of the underworld can never overpower it [my Church]" (v. 18), and "I will give you the keys of the kingdom of Heaven: whatever you bind on earth will be bound in Heaven; whatever you loose on earth will be loosed in heaven" (v. 19; fig. 5). Both consequences extend beyond any human realm, without losing touch with human history and daily reality. On the one hand, the "gates of the underworld" are mentioned: the powers of death and, therefore, sin and evil, and also, at least indirectly, the cause of every evil, the "Evil one." All these operate in this world but have their source and their end well beyond it. On the other hand, the consequences of earthly decisions ("to bind or to loose") are said to be found in "heaven," that is to say, in God's presence. According to this text, the man who is the rock, having received strength and solidity from God's intervention, stands somehow more on God's side than on merely human terrain: the Church, whose weight he is supposed to bear, is assured of victory against any attacks, even supernatural ones, and the acts of his governance will be not only known, but also ratified, in heaven. This does not mean, however – nor is it said or implied here – that he will be sinless or impeccable. The Church will not be overpowered by evil, even, one is tempted to add, from the sinful personal failures of the one chosen as its "rock." His governing acts, not his private conduct, will be sanctioned before God. Thus, Peter and his successors are in a unique position.

Although the words about the binding and loosing on earth, and therefore in heaven, were addressed to all the apostles (Mt 18:18), only one is named the "rock" unto whom revelation is granted and to whom the promise is given that the Church will persevere in spite of evil. If all the apostles are seen as the foundations of the heavenly city (Rv 21:14), this does not in any way impinge upon Peter's privilege. One might say that he is the foundation of the foundations. Beyond him and beside him, there is only one other foundation, Christ Jesus (1 Cor 3:11), and the link between this suprahistorical foundation and the historical one is Peter's faith. Postbiblical tradition has always repeated this *theologumenon*, taking its cue from Luke (22:31-33): "Simon, Simon! Look, Satan has got his wish to sift you all like wheat; but I have prayed for you, Simon, that your faith may not fail, and once you have recovered, you in your turn must strengthen your brothers." Again, Satan is rendered impotent, and Peter's faith is guaranteed by Jesus' prayer, which will always accomplish its end.

If, in Matthew and Luke, Peter is granted the flock on account of his faith, it is in John that love is the reason he is called as the chief shepherd. The scene is well known. The Resurrected Lord meets his disciples at the

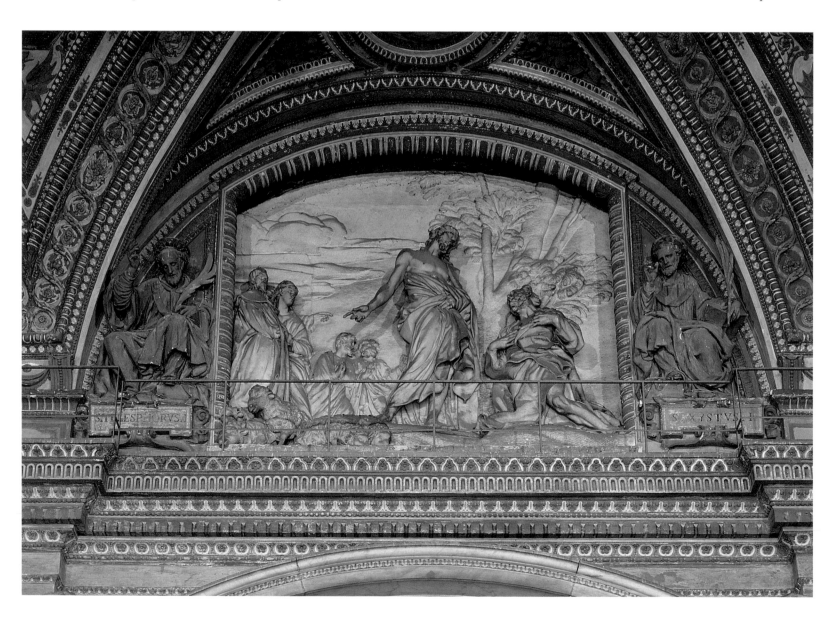

Sea of Galilee, tells them where to find fish, prepares their breakfast, and then proceeds to speak to Peter, who has arrived first (Jn 21:1-14). John is also there, with Thomas, Nathanael, James, and two others. The presence of the apostles, particularly John and James, is important here, as they are to witness what the Lord Jesus says to Peter, whom they knew had denied him earlier.

Jesus speaks as the Good Shepherd, a title given to him only in John (10:11). He mentions neither Peter's denial nor his contrition afterward. In a way, he continues as if nothing had ever happened. There is, however, a question, as there was previously a question, or rather two, in Matthew (16:13, 15). But here the question is addressed only to Peter. A very direct question, indeed an almost embarrassing question, and one only the Lord can ask of him: "Simon son of John, do you love me more than these others do?" (Jn 21:15). The others present hear the question. What is Peter to answer? Again, one has to remember that tradition has faithfully transmitted this dialogue and that one of the disciples present was the one "whom Jesus loved" and was the first to have recognized him standing on the shore. Now, however, the question is put to Peter about his love of Jesus in relation to the others. What is he to say when the question is repeated three times, a subtle reminder in the transmitted narration of the three denials? Peter answers that Jesus knows who loves him and how. "He could tell what someone had within," as the same Gospel had written before at the beginning of Jesus' ministry (Jn 2:25).

Then the charge is given: "Feed my lambs...Look after my sheep" (Jn 21:15-16). The flock is his and he entrusts it to Peter. The reason, if any, is love, and love stronger than those present, including the one "whom Jesus loved," may have. The text goes on to foreshadow nothing less than Peter's martyrdom: "...when you grow old you will stretch out your hands, and somebody else will put a belt round you and take you where you rather would not go. In these words he indicated the kind of death by which Peter would give glory to God" (Jn 21:18-19). Death, this kind of death, will be the main proof of Peter's love.

The scene is more concrete than the one at Caesarea Philippi described in Matthew. Here there is a fishing expedition, a catch, a breakfast on the shore. Nothing solemn or "formal," although each detail is mysterious: from the presence of the Resurrected Lord to the draught of the fish (fig. 6), to the content of the breakfast, to the dialogue with Peter, to the last exchange about the destinies of the "disciple whom Jesus loved" and the one who loves him "more."

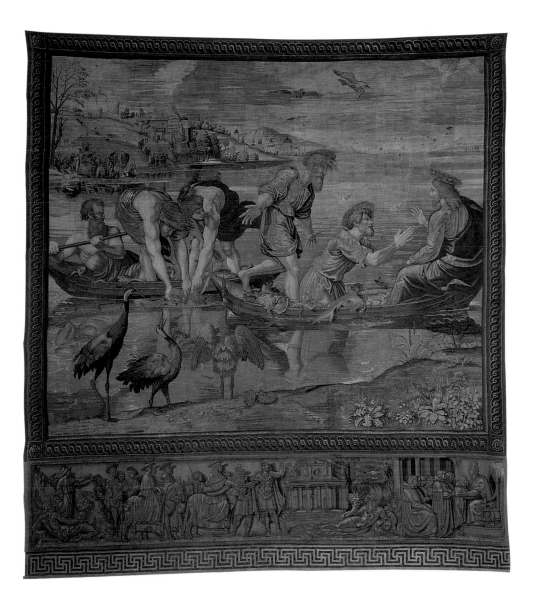

Figure 5
Gian Lorenzo Bernini, *Pasce oves meas*, 1633—46,
Basilica of Saint Peter

Figure 6
Raphael Sanzio, *The Miraculous Draught of Fishes*,
ca. 1532, Vatican Museums

Here, Peter's denial or apostasy is in the background, and here as well divine mercy is granted to the sinner. Peter, therefore, a sinner, is made to experience the mercy he is invited to give to others. But mercy, as experienced here, takes on an extraordinary dimension. It is concentrated in a question about love. Not faith, not revelation, but love – the love the Lord has never ceased to have for Peter. If he is not, at least until then, "the disciple whom Jesus loved," he becomes it from that moment on, and if he loves "more" it is certainly because he is loved more.

As a result of his profession of love, Peter is given charge of the fold. The Good Shepherd gives to the apostle the care of the flock, for which he has given his life (cf. Jn 10:11). There are no supernatural references here, but instead the decisive relationship between the care and tending of the flock and the call to give one's own life for it. If Matthew 16 does not refer, at least directly, to the personal holiness of the "rock," here, with the background of sin and mercy, the call for holiness, even to the sacrifice of the shepherd's life, is first and foremost. This is the true meaning of the love revealed in Christ.

There are other peculiarities to be noted in John (21). We have Peter, of course, but we also have the sons of Zebedee, Thomas the Twin, Nathanael, and two others (v. 2). Now, Thomas is the one who had doubted (Jn 20:26-29), and the sons of Zebedee are those who had demanded the primary places either through their mother (Mt 20:20) or directly (Mk 10:35-37). Here they learn who will be granted the primary place, if they had not learned beforehand. Moreover, if John is to be identified with "the disciple whom Jesus loved" (21:7), he also learns now that Peter loves Jesus more than he does, which means that he is more loved than the others. This, perhaps, explains why Peter is more concerned about that disciple's future than he is about his own. The three main figures here (or four, if we include Thomas), were guilty of some degree of unfaithfulness, if not sin.

This is all the more remarkable in that those three apostles are the ones chosen to be with the Lord on very special occasions: the healing of Jairus' daughter (Mk 5:37), the Transfiguration (Mt 17:1-8 and parallels), and the Agony in the Garden (ibid. 26:36-46 and parallels). The written tradition, surely following the oral one, always puts Peter in the primary place. Again, this is perhaps another manifestation of the Lord's preference for sinners when it comes to the assignment of first places. Peter, who, besides Judas, was the most noted sinner of all, is given the primary position.

Thus we are once more drawn to the beginning. The man chosen to be the rock, the keeper of the keys of heaven, the shepherd, or, in other words, the paramount believer and the one with the greatest love, arises from the depths of human frailness and inconstancy. And with this, or, perhaps even *because* of this, he bears the titles the Church applies to him, and which he has, in the tradition and, therefore, in the faith of the Catholic Church, transmitted to his successors.

It is also in this very special context that the notion of apostolic service finds one of its sources. Whoever has been chosen from such depths could never pretend to lord it over others. This is part and parcel of his unique call. There is also, and in the first place, the example of the Lord Jesus, explicitly taught to all the apostles: "the Son of man himself came not to be served, but to serve, and to give his life as a ransom for many" (Mk 10:45). This is, thus, a description of Peter's vocation. Peter himself kept this well in mind when he outlined to the elders the sense of their mission (cf. 1 Pt 5:1-3), notwithstanding the supreme shepherd who will come to judge him and all the others (ibid., v. 4).

The picture emerging from this analysis, or, rather, meditation, presents, I hope, a profile of what Peter was meant to be in the New Testament tradition. The postbiblical tradition chose to emphasize some aspects instead of others, which was not only inevitable but perhaps desirable. More to the point, however, the historical exercise of the papacy by such different individuals in every sense, including personal holiness or lack thereof, provides us with varying embodiments of this image, some nearer to it, some rather distant from it. One could be tempted to say that, in some cases, at least, the picture is only recognizable with the exercise of faith. But it is there. And it stands as the prototype to return to and to follow, even if this demands revision and reform.

The pope is the vicar of Christ. This title is used now and has been very much in use for many centuries. It is not stated as such in biblical tradition, although it is faithful to it. The Second Vatican Council, however (in *Lumen Gentium*, chap. 3, n. 27), applied the same title to bishops around the world, so the title tends to fade before others. I once heard Pope John Paul II say to his guests that he is quite aware of three designations given to his office, and he listed them: vicar of Christ, primate of the Church, and bishop of Rome. He told us he preferred the third. Because he is the bishop of Rome he is the primate of the Church and the vicar of Christ and not the other way round. Rome, however, is not mentioned in the New Testament in relation to Peter's office. Remarkably enough, it is now quite clearly a primary part of his ministry. The reason for this reveals how deeply and definitively Peter's exercise of his ministry, guided by the Holy Spirit, helped shape the profile of this ministry.

Whether Peter came to Rome before or after Paul is immaterial. What is important is that he ended his unique call in the city, when he was put to death, as he had been told would happen when he was made the shepherd of the entire flock. It is not, then, because the city was capital of the empire or for any other reason that Rome became linked with Peter's ministry. It was that in dying there he manifested the final sense of what had been entrusted to him by his Lord. He died in Rome. This is why, since ancient times, Rome has been the first apostolic see, consecrated by Peter's martyrdom (fig. 7).

We are still left with Paul's rebuke in the Letter to the Galatians (2:11-14), which, though negative, I am convinced has its own providential meaning. Peter was already the head of the Church, or, to use Paul's language, one of those "recognized as pillars" (v. 9). No one would oppose his position, much less Paul, but perhaps Peter had failed, or had been mistaken, and needed to be corrected. In the complex and confused situation of those early years of the Church, this is only too understandable. What is this rebuke, then, but another indication, on a different level, of Peter's frailty and human limitations, with which and for which he was chosen?

Thus, this reference is left to the Church, particularly to Peter's successors, for them and for us to be even more conscious of the absolute gratuitousness of Peter's privilege and of the need for the Church to pray unceasingly "to God for him": for Peter and for each of his successors, as the Acts of the Apostles (12:5) has taught us to do since the church's beginnings.

Figure 7
Guido Reni, *The Crucifixion of Saint Peter*,
1604–05, Vatican Museums
"'…when you grow old you will stretch out
your hands, and somebody else will put a belt
round you and take you where you rather
would not go.' In these words he indicated
the kind of death by which Peter would give
glory to God." (Jn 18-19).

From Revolution to the Wailing Wall: The Evolution of the Modern Papacy

Eamon Duffy

Figure 1
Eugène Delacroix, *Liberty Leading the People* (detail), 1830, Musée du Louvre, Paris

Figure 2
Pompeo Batoni, *Pope Pius VI*, 1679, Vatican Museums

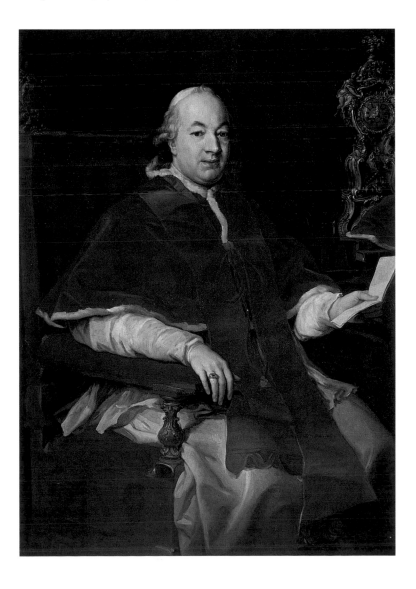

The outbreak of the French Revolution in 1789 is one of the "real" dates in history, an event so decisive that after it the world is unmistakably and profoundly different (fig. 1). The consequences of the revolution for the church, in particular, were immediate and devastating, and determined the policies and attitudes of the popes for more than a hundred years. The story of the modern papacy begins, therefore, in 1789.

The papacy on the eve of the revolution was embedded in Europe's authoritarian *ancien regime*. The pope was not merely a priest but also a king, ruling much of central and northern Italy, as his predecessors had done for a thousand years. Catholicism was the state religion of most of Europe and of Latin America. Catholic doctrine was enforced by the law, Catholic morality was the measure of public behavior, Catholic institutions were protected and patronized. Religious dissidents – Protestant, Muslim, Jewish – were passively discriminated against or actively persecuted. In theory, at least, the pope was the unchallenged spiritual leader of most of the Western world.

The reality, however, was rather different. The universal spiritual claims of the popes, rooted in Christ's commission to Saint Peter and elaborated over almost two millennia of Christian history, militated against the absolute autonomy of the nation-state. Though the eighteenth-century popes maintained the high claims of their medieval predecessors, in practice, even the Catholic states of Europe minimized and resisted papal authority. In the early 1770s the Catholic powers had ruthlessly forced Pope Clement XIV to dissolve the single greatest international support of the papacy, the Jesuit order. In France and Germany, anti-papal theologies lessened papal claims, and the powerful prince-bishops of the Rhine snubbed and declaimed against papal nuncios and ignored papal directives. In Austria, Emperor Joseph II exercised an iron grip on the church and implemented a program of rationalization, policing the doctrinal teaching in the seminaries, closing more than four hundred monasteries and convents, and diverting their funds into more "useful" channels such as education, tailoring Catholic teaching to the cool rationalism of the Enlightenment.

Pope Pius VI, who presided over the Catholic Church in 1789, was himself a man of the *ancien regime* (fig. 2). Tall, stately, handsome, and more than a little vain, he was a pope in the grand manner, spending lavishly – on abortive civic projects like the draining of the Pontine marshes, and on the adornment of Rome and Saint Peter's. He was also a collector and took a special interest in the Vatican library and museums. Though his personal moral life was blameless, his pontificate was overshadowed by scandal. He adopted his sister's sons, made one a duke and the other a cardinal, built them a lavish palace, and became personally involved on their behalf in a sordid legal dispute over a contested will.

His authority as well as his reputation was challenged. In the Kingdom of the Two Sicilies, the royal government at Naples had abandoned its centuries-old feudal loyalty to the popes and contested the pope's right to appoint bishops. Pope Pius retaliated by rejecting royal episcopal nominations, so by the early 1790s half the bishoprics of southern Italy were vacant. In the mid 1780s the bishops of Tuscany, ruled by the emperor's brother Leopold II and led by the brash and doctrinaire bishop of Pistoia, Scipio Ricci, promoted a drastic reform that included the suppression of pilgrimages and the cult of images and relics, abolished permanent vows for monks and nuns, advocated Bible reading and even the celebration of

the mass in Italian, and attacked papal authority. The movement was deeply unpopular with the common people and was solemnly condemned by the pope, but it influenced Catholic opinion throughout Europe and increased the sense of crisis in the papacy.

Crisis became nightmare with the outbreak of the French Revolution in May 1789. Desperate for money, the leaders of the Revolution turned on the church, and the entire wealth of the French church was put "at the disposal of the nation." Radical versions of the reforming ideas rampant in Austria and Italy became part of the revolutionary program. Permanent religious vows were abolished: hordes of monks (but few nuns) abandoned their monasteries and walked away, and the ancient abbey of Cluny, once the greatest church in Christendom, was demolished and sold as builder's rubble. The Catholic Church's religious monopoly was abolished as Jews and Protestants were given full civil rights. In August 1790, the French Assembly enacted the civil constitution of the clergy. From then on, bishops and priests would be chosen by the civil electorate and become civil servants. Parishes and dioceses were reduced and made to coincide with the secular electoral departments. Bishops were to rule in collaboration with a council of twelve priests selected by the clergy. The pope would no longer appoint or even institute bishops, who would be chosen and consecrated locally. A government-backed schismatic "constitutional church" was formed, and the rest of the clergy and the bulk of the hierarchy were labeled "refractories" and persecuted. But as the revolution soon became increasingly anti-Christian, clergy and religious were arrested and butchered in the hundreds. Thirty thousand clergy fled France as refugees to Italy, Austria, Germany, and England. In 1794, the constitutional church itself was abolished, and the revolution became officially pagan.

In 1796 revolution came to Italy. The young general Napoleon Bonaparte invaded Lombardy and established a republic at Milan, demanding that the pope withdraw his opposition to the civil constitution and announcing his intention to "free the Roman people from their ancient slavery." When Pope Pius refused, Napoleon invaded the Papal States, and

Figure 3
A.J. Etienna Valois, *Triumphal Arrival in Paris of Art from the Vatican in 1798* (detail), Manufacture Nationale de Sévres

in 1797 forced the humiliating Treaty of Tolentino on the powerless pope, who was obliged to recognize the French Republic and order Catholics to obey it. In addition, he had to buy Napoleon off with the cream of the Vatican art collections (fig. 3). Even so, this bought only a temporary respite. In February 1798 the French invaded Rome, proclaimed a republic, and deposed the pope as head of state. Pius was arrested and taken first to Tuscany, then across the frozen Alps to France. He died a prisoner in the citadel at Valence in August 1799, and was buried in the local graveyard. Many were convinced that he would prove to be the last of the popes.

Pope Pius, however, had made emergency plans for the next conclave to meet in Venice, which was free of French control. Conservative monarchs all over Europe looked to the cardinals to elect a pope who would throw his weight behind the forces of European counter-revolution. Aware of the need for flexible and resourceful leadership, the conclave, however, eventually chose a mild-mannered monk, Barnabà Chiaramonte, whose conservative credentials were far from sound (fig. 4). As cardinal bishop of Imola under the French occupation he had won Napoleon's ironic admiration by preaching sensible, pragmatic sermons, declaring that the church could live with any form of government, including, in particular, democracy. He had even used notepaper headed with the revolutionary-sounding slogan "Liberty, equality and peace in our Lord Jesus Christ." Chiaramonte took the name Pius VII, in solidarity with the sufferings of his predecessor, but he was a very different man: modest, unassuming, and above all a realist who recognized that the world had now changed decisively. He was willing to bend to those changes where necessary while remaining quietly resolute where he thought Catholic principle was at stake. He was blessed, too, with one of the ablest advisers any pope has ever had, his secretary of state, Cardinal Ercole Consalvi, whose shrewd intelligence made him more than a match for any statesman in Europe.

Napoleon, by now first consul of France, could also be a realist, and he recognized that the conflict between Catholicism and France was as damaging for the revolution as it was for the church. The people of Europe were Christian, and so stable government demanded a religious settlement. But France itself was deeply divided over religion: the Catholic Church and its smaller constitutional rival each had many martyrs to the revolution. Their competing bishops each claimed the soul of France, and the bitter memories of the revolutionary era made agreement between them seem an impossibility. Only a pope could untangle this knot.

In July 1801, after eight exhausting months of negotiation, France and the Holy See agreed to a treaty or "concordat" that placed the alliance between church and state in France on an entirely new footing, and which was to provide the model for the Catholic Church's relationship with the modern world for the next century. Catholicism would no longer be the sole legal religion of France, but was acknowledged as the religion of the vast majority of citizens, and as such received special favor. Catholicism was to be freely practiced, though public worship was to be subject to "police regulations." This apparent restriction gave the church far more than it took, for it meant that while public cult (like processions through the streets) needed police approval, everything else, like contact between the pope and the French bishops, would, in theory, at least, be free from government interference. The consuls would nominate to bishoprics (as

the kings of France had done for centuries), but bishops needed institution from the pope to function. The bishops would appoint the parish clergy, but could appoint only priests acceptable to government. Confiscated church buildings and cathedrals would remain the property of the state, but would be "put at the disposal" of the bishops. Bishops and clergy would receive state salaries.

Though the church lost much from this concordat (including most of its land and property), it also gained a great deal. After the murderous anti-Christianity of the Revolution, and despite the loss of its monopoly status, Catholicism was once again the favored religion of France. The papacy, in particular, gained in ways inconceivable under the *ancien regime*. The pre-revolutionary church of France had kept the pope at arm's length and resisted papal control of the bishops. Now, however, at Napoleon's request, the pope called on all the bishops of France to resign their dioceses into his hands. The number of dioceses was reduced from 135 to sixty, and the pope appointed a new hierarchy drawn from the ranks of both the refractory and the constitutional bishops. Forty-eight bishops resigned willingly, and thirty-seven refused on the grounds that to do so would be to recognize the legitimacy of the Revolution. When Pius VII declared their sees vacant, however, most accepted his judgment. For the first time, therefore, a pope had dissolved and re-created the entire hierarchy of an ancient and established church. At a stroke, all the venerable theoretical arguments

Figure 4
Domenico DeAngelis, *Proclamation of Pope Pius VII*, ca. 1818, fresco, Vatican Museums

against the fullness of papal authority over the local churches were blown away, like thistledown before a gale. The revolution had destroyed forever the ancient Constantinian identification of church and state, but it had also planted the seed for the emergence of an enormously enhanced exercise of papal authority (fig. 5).

Pope Pius VII and his secretary of state understood the value of the concordat, and for the rest of the century other papal treaties would be modeled on it. Despite French attempts to whittle away the freedoms it granted the church, the pope was willing to do much to conciliate Napoleon. In 1804 he even traveled to Paris to anoint him emperor, a gesture that horrified conservatives who believed that Bonaparte was a tyrant and a usurper (fig. 6).

Confrontation between pope and emperor became inevitable, however, once Napoleon had himself declared king of Italy in 1805. Napoleon's vision of the papacy was as a glorified imperial chaplain, preferably resident in France, whose main religious function would be the sprinkling of papal holy water over the expansion of French rule. When the pope refused, maintaining his independence as father of all the faithful, the French occupied Rome in 1808, and in solitary confinement Pius became

a prisoner at Savona. In June 1812 Napoleon had the pope, by now a sick man, deported across the Alps to France and imprisoned at Fontainebleau. The tragic fate of Pius VI seemed about to befall his successor.

In the isolation of Fontainebleau Napoleon was able to bully Pius into total surrender. In return for financial compensation, the pope agreed to give up the Papal States, the sovereignty of Rome, and much of his authority over the French church. A draft of this disastrous agreement was roughed out and initialed in January 1813, almost literally on the back of an envelope. The pope almost at once repudiated the agreement, however, deploring his own frailty in conceding it and raging against the stooge French cardinals (including Napoleon's uncle) for their part in persuading him. But the exultant Napoleon had it proclaimed as an achieved concordat throughout France.

In fact, Napoleon's power was now tottering after his defeat in Russia, and the agreement was never implemented. Within a year, the emperor offered the pope full restoration to Rome, but Pius no longer needed anything Napoleon had to offer. His return journey to Italy increasingly took on the character of a triumph, his carriage drawn to Saint Peter's from the gates of Rome by teams of aristocratic young Romans, led by the king of

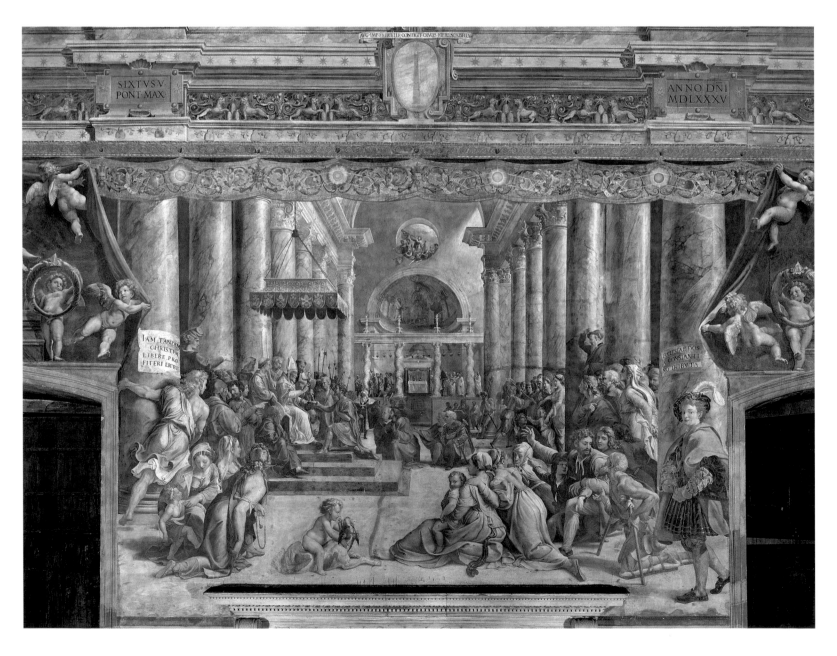

Spain, Carlos IV. It was a foretaste of things to come. In the political reconstruction of Europe after the Congress of Vienna, in 1815, the conservative powers, led by Britain and Austria, saw the full restoration of the Papal States as a symbol of the return of ancient legitimacy and the old political order. Papal neutrality during the Napoleonic Wars, and sufferings at the hands of the French, was now amply rewarded.

This restoration of the Papal States was the single most important fact about the nineteenth-century papacy, the key to understanding its history for the next hundred years (fig. 7). The popes had learned to detest not merely revolution, but the godless democracy they associated with it. They had also come to identify the temporal power of the papacy as crucial for the defense and maintenance of the papacy's spiritual authority and independence.

To begin with, at least, both these perceptions were widely shared. Everywhere in Europe a profound reaction against the glib certainties of the Enlightenment and the libertarian ideals of the revolution had set in. The solvent power of pure reason was now distrusted, for it had plunged Europe into bloody conflict. Instead, tradition, authority, and ancient stabilities were valued. Joseph de Maistre, Sardinian ambassador to the court of the tsar, wrote a best-selling book, *Du Pape*, arguing that the infallible papacy, exalted above anarchic democratic questioning and criticism, was

the great paradigm for all legitimate power. The alliance of throne and altar, priest and king, was proclaimed as the cornerstone of society. That alliance took very concrete form, as governments everywhere took steps to ensure that "sound," loyal, and politically conservative bishops were appointed. Under the many agreements signed between the papacy and the restored governments of Europe, the state came to appoint the overwhelming majority of bishops. By 1829, secular governments had the right to nominate 555 (80%) of the bishops of the Catholic Church, as opposed to the 95 or so appointed directly by the pope.

Figure 5
Raphael Sanzio and assistants, *The Donation of Rome*, 1514, Vatican Museums

Figure 6
Jacques Louis David, *Napoleon Crowning Josephine in the Presence of Pope Pius VII, Notre Dame Cathedral, Paris, December 2nd, 1804* (detail), Musée du Louvre, Paris

Figure 7
Map of the Papal States, 1824

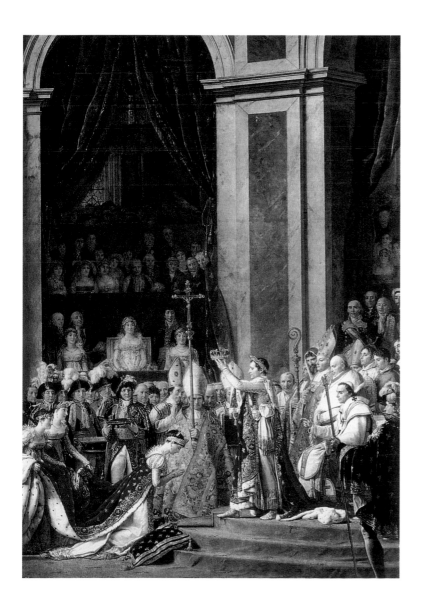

Even Catholics who rejected authoritarian political views and valued the new freedoms and equalities that the revolution had brought nevertheless looked with longing for a more powerful papacy. In France in the 1830s, a new movement emerged under the leadership of the priest Felicite de Lamennais (fig. 8). He was convinced that the church could gain nothing from any alliance with cynical kings and tyrants who valued religion only when it supported their power. Concordats, he thought, were recipes for enslavement, producing poodle bishops obedient to the whims of reactionary governments, and the papacy should repudiate all such worldly treaties. Instead, he urged the popes to assert their absolute freedom from state interference, and to place themselves at the head of a great new movement of the common people against their princely oppressors. The liberties the revolution had proclaimed in the name of humanity should now be demanded in the name of God. An infallible papacy would thus be a witness for the freedom of the human spirit, and against the tyrannical exercise of state power.

The popes who succeeded Pius VII were delighted by protestations of loyalty and deference from whatever source, but they had little understanding of or sympathy for De Lamennais' attempts to unite papal authority and the revolutionary values of liberty, fraternity, and equality. Pope Pius VII and Consalvi had recognized the impossibility of turning the clock back, and had allowed many of the reforms introduced by Napoleon into the government of the Papal States to stand. Pius' immediate successor, Leo XII, however, was chosen by the zealot party among the cardinals because of his unbendingly backward-looking pious puritanism (fig. 9). Uninterested in political accommodation or adaptation to the postrevolutionary world, he dismissed Cardinal Consalvi, the architect of the concordats, and under Leo the Papal States returned to rigidly authoritarian clerical government, where harsh repression and an elaborate system of spies and informers stifled any dissidence. These trends were continued under Gregory XVI, pope from 1831 to 1846 (fig. 10). Gregory had been an exemplary monk of the austere Camaldolese Order. At the height of the persecution of the church in 1799 he had published a defiant treatise called *The Triumph of the Holy See*, and he was a profoundly conservative man who would not allow "infernal" steam engines into the Papal States, and who frowned on any challenge to "legitimate" authority. The repressive government of the Papal States had triggered widespread discontent and a

Figure 8
The Abbé Félicité of Lamennais, ca. 1835, lithograph by Delpech based on a drawing by Belliard

Figure 9
Pope Leo XII, late nineteenth century, Vatican Museums

growing anti-clericalism. Gregory was determined to stamp this out and distrusted movements for political freedom everywhere. At a time when many Catholic populations were seeking independence from oppressive non-Catholic rule – in Ireland, in Belgium, in Poland – these were unhelpful convictions in a pope. In 1832 he condemned the Polish rising against Russian rule, leaving Polish Catholics with a deep sense of betrayal. In the same year, his encyclical *Mirari Vos* condemned the ideas of Lamennais and his followers in France, denouncing the "liberties" proclaimed by the revolution as "poisonous," and repudiating the idea of freedom of conscience as a "delirium." Looking back to the prerevolutionary era, he insisted that it was the duty of the state to protect and enforce Catholic teaching: there could be no question of a "free church in a free state."

Pope Gregory XVI's stark rejection of Lamennais was formulated against a rising tide of change in Italy, long divided and ruled by foreign powers. The 1830s and 1840s saw an increasingly urgent movement for Italian unity and for the ejection of the forces of occupation like the Austrians. Some leaders of this movement were anti-clericals, informed by the ideals of 1789 or merely alienated by the church's privileges, its authoritarian connivance with the state, and its excessive wealth. Acutely conscious that the very existence of the Papal States might be threatened by any moves toward unification, Gregory was even more unsympathetic to these

national stirrings than he had been to those of Poland or Belgium. For European liberals he became in his last years the living symbol of a church in denial: reactionary, truculent, at odds with the world around it.

It was, therefore, with huge expectation that the world greeted the election of Pius IX, an apparently "liberal" pope, in 1846 (fig. 11). As bishop of Imola, Giovanni Mastai-Ferretti had been an outspoken critic of repressive government in the Papal States. He was a patriot who shared Italian aspirations toward national unity, and he was a warm-hearted, impulsive man prone to demonstrative gestures into which others read more than he himself intended. He delighted Italy and Europe with a series of such gestures – an amnesty for Italian political prisoners, the easing of ancient restrictions on the Jews of Rome, the introduction of a consultative assembly with lay representatives into the government of the Papal States. For a brief period he was an international hero: there was even talk of a federal Italy with the pope as president.

Figure 10
Francesco Podesti, *Pope Gregory XVI*, ca. 1850, Vatican Museums

Figure 11
Francesco Podesti, *Pope Pius IX*, 2nd half of the nineteenth century, Vatican Museums

When revolution erupted in Europe in 1848, this bubble burst. The pope refused to put himself at the head of a national alliance against the Austrians and reaffirmed the obligation of obedience to "lawful" government: there was a backlash (fig. 12). Pellegrino Rossi, the pope's prime minister, was assassinated on the steps of the *cancelleria*, and the pope fled to Neapolitan territory on November 24, 1848. Deeply disillusioned, he returned to Rome, backed by French troops, in 1850, and from then on was resolutely opposed to the "Risorgimento," the unification movement. The flirtation with liberalism was at an end. The pope's disillusion was matched by that of secular Italy. For patriots, pope and church increasingly seemed a shadow blocking out the light of the new age, and the principal obstacle to nationhood.

The theorists of the new Italy were inspired by secular liberal ideals, and sought to bring under state control aspects of public life that had traditionally been the concern of the church: marriage and divorce, religious liberty, education, family welfare. To the pope, state interference in such matters was anathema, an invasion of the sanctuary derived from the anti-Christian principles of the revolution. That opposition of ideas was sharpened by the progressive annexation of the Papal States by Italy. The patrimony of Peter shrank to the region immediately around Rome, and revived memories of the kidnapping of Pius VI and Pius VII. The maintenance of the temporal power of the pope seemed now literally a matter of life and death, on which the very survival and freedom of the papacy depended. Liberal Catholics, in Britain and America, in Belgium and Germany, and in France and Italy, watched in dismay as under these pressures Pope Pius IX's pontificate froze into defiant rejection of the modern world. The church polarized, as papalist or "ultramontane" Catholics came to identify undeviating loyalty to the pope as the fundamental litmus test of true Christianity, and denounced reserve about or criticism of papal policy as treachery in the face of the enemy.

In 1864 this papal intransigence was given symbolic expression in the publication of the so-called *Syllabus of Errors*. This was a collection of eighty condemned propositions, mostly culled from documents concerned with the immediate situation in Italy, but which, taken out of context, seemed to identify the church with reaction, as in proposition 80, which con-

Figure 12
Battle near the Walls of the Vatican, 1849

demned the idea that "the Roman Pontiff can and should reconcile himself with progress, liberalism, and modern civilization." Liberal Catholics did what they could to soften or explain the tone of the *Syllabus*, but to the world at large it seemed to encapsulate all that was obscurantist. The *Syllabus* was banned in France and burned in Naples, and the French bishop Dupanloup wrote that "if we do not succeed in checking this senseless Romanism, the church will be outlawed in Europe for half a century."

But ultramontane Catholicism thrived on confrontation. Papalist Catholics loved to contrast the spiritual greatness of the pope with his precarious temporal circumstances. The sufferings and setbacks of Pope Pius IX were the re-crucifixion of Jesus; hostility to him was the rejection of God himself. The high tide of this emphasis on the unique authority of the pope was reached in 1870, when the First Vatican Council (fig. 13), summoned by Pope Pius IX to confront the errors of the age, solemnly defined that the pope, when he spoke *ex cathedra* as pastor and teacher of all the faithful, on matters of faith or morals to be held by all the faithful, "possessed that Infallibility with which the Divine Redeemer wished the church to be endowed." This definition, ardently worked for by ultramontane enthusiasts within the council, including the pope himself, was, in fact, a carefully nuanced statement that set very clear limits and conditions on the exercise of papal infallibility. In the event, the flood of papal utterances demanding unquestioning obedience, an infallible definition "every morning at breakfast with *The Times*," for which ultramontanes like Wilfred Ward had hoped, did not materialize. But its timing made it a shout of defiance in the face of secular Europe. Exactly two months after the definition Italian troops entered Rome, and a thousand years of papal rule over the city came to an end. Pope Pius IX became "the prisoner of the Vatican," refusing to venture beyond Saint Peter's square or to have anything to do with what he considered the bandit government of the new Italy. He refused all offers of financial compensation for the loss of the Papal States, forbade Catholics to participate in Italian elections, and refused to see visiting heads of state if they also called on the king of Italy at the Quirinal Palace.

The confrontation with Italy was replicated elsewhere. The government of protestant Prussia, the most powerful state in Europe, was alarmed by the vigor and expansion of the Catholic Church in its territories, and saw in the definition of papal infallibility a dangerous challenge to the allegiance of Catholic Germans. It began to harass and restrict Catholicism: schools and seminaries were policed, religious orders expelled. The pope retaliated by refusing to appoint bishops; the Prussian government responded by exiling or imprisoning more than one thousand priests. It seemed that the papacy was doomed to lead Catholics into an inevitable *Kulturkampf* against the modern world.

But the conflicts of the papacy with secular and non-Catholic governments were only one part of its transformation in the nineteenth century. The church was experiencing an astonishing expansion and explosion of new energies, in every one of which the papacy played a crucial role. After centuries of decline, vocations to the religious life were multiplying, and new religious orders sprang up to meet the needs of industrial Europe – and of the world beyond Europe – in teaching, hospital work, and overseas missions. Between 1862 and 1865, Pope Pius IX approved no fewer than seventy-four new congregations for women religious. In 1878, the year of his death, there were more than 30,000 monks and male religious, and nearly 128,000 women religious, in France alone. By the end of the century there would be more than 44,000 women religious working in mission territory. The papacy was crucial in supporting and directing these burgeoning energies, not least in developing and encouraging the growth of Christianity in the empires and colonies of this age of expansion. Even at their most intransigent, the nineteenth-century popes put the spiritual duties of the papacy ahead of political entanglements. Though Pope Gregory XVI detested and denounced rebellion, he had accepted reality and had appointed bishops for the Latin American rebel regimes that had seized independence from Spanish rule in the 1820s and 1830s. He defied Portuguese colonial racism by appointing native clergy, and abolished colonial bishoprics that he judged to be too subservient to their governments, replacing them with vicars apostolic answerable to Rome. Under Pope Pius IX these papal responsibilities expanded: he created more than

Figure 13
Vatican Council I, fresco, Vatican Museums

two hundred new bishoprics or apostolic vicariates, establishing Catholic hierarchies not only in mission territory but in protestant Europe, including England in 1850 and Denmark in 1853. In the 1850s and 1860s he would conclude a series of important concordats with the new nations of Latin America, securing for the church there a key role and special privileges.

This growing institutional centrality of the pope in a growing church was promoted by the emergence of cheap print, easier contact between Rome and local hierarchies, and steam-powered travel, which enabled bishops to visit Rome more frequently. It was also matched by a new spiritual centrality, as the pope came to loom larger in Catholic religious sentiment. Pope Pius IX shared the ardent Marian piety that was a growing feature of popular Catholicism. In 1854 he solemnly defined the long-contested doctrine of the Immaculate Conception of the Virgin, the first such independent exercise of papal teaching authority and a dramatic illustration *avant la lettre* of the infallibility that would be defined in 1870 (fig. 14). That infallibility was apparently endorsed from heaven itself in 1858, when the Virgin appeared to Bernadette Soubirous in the Pyrenean

Figure 14
Francesco Podesti, *Pope Pius IX, Proclamation of the Dogma of the Immaculate Conception*, 1870, Vatican Museums

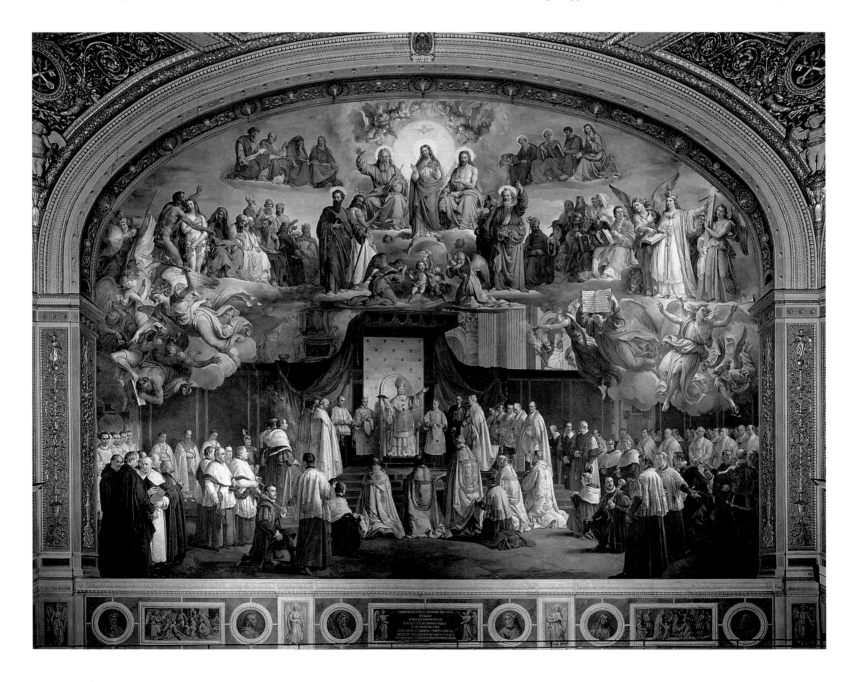

village of Lourdes and identified herself as the Immaculate Conception. In ultramontane Catholicism, papal authority and popular piety, hierarchy and holiness, joined hands as never before.

The new centrality of the papacy was partly the work of the pope himself. Pope Pius IX's engaging personality and cheerful informality won hearts even where heads disapproved of his policies, and his sufferings at the hands of Italy aroused ardent loyalties. "Peter in Chains" became in himself an object of devotion and pilgrimage: pictures of the pope became almost as familiar as the crucifix or the Madonna in Catholic households from Manchester to Mexico.

By the time of his death in 1878, after the longest pontificate in history, the papacy dominated Catholicism as it had not done since the High Middle Ages. His successor, Pope Leo XIII, would increase that prominence while easing the tensions between the pope and the secular world (fig. 15). Every bit as conservative as his predecessor, Pope Leo was a good deal more intelligent, and infinitely more diplomatic. Through his long pontificate he worked consistently to come to terms with the hostile states of Europe, Italy excepted, for like Pope Pius IX he cherished vain hopes of the restoration of papal rule in Rome. The Vatican and the Quirinal therefore remained at odds. But in France, where Catholics had locked themselves into a virulent and intransigent royalism against the republic, he worked to encourage their leaders to come to terms with the government, in the interests of the church's educational and religious mission. In Germany, he negotiated through the papal nuncios a reconciliation with Prussia, where Catholicism had, in fact, flourished under persecution and a powerful Catholic "Center Party" had emerged, so that Bismarck had come to realize, like Napoleon before him, that conflict with the church was damaging to the unity and stability of the state.

Under Leo XIII many of the most familiar features of the modern papacy took their distinctive shape. He expanded the role of papal nuncios as key figures in the management of international Catholicism and insisted on their precedence over local bishops as representatives of the Holy See. He exercised a tight control over local episcopal conferences, and the first conference of the Latin American bishops was held in Rome and chaired by the pope himself. Above all, Leo established the perception of the pope as the chief teacher of Catholicism. He published no fewer than eighty-six encyclicals, on subjects ranging from the recitation of the rosary to the need for social justice in society. The most famous of these encyclicals, *Rerum Novarum* (1891), attacked the evils of uncontrolled capitalism and insisted on the rights of labor to a just wage, a dignified family life, and the right to organize. Socially conservative, paternalist, and romantic in tone, it now seems a tame enough response to the chronic social inequalities that had elicited the *Communist Manifesto*. Nevertheless, it was based on the latest and best Catholic social thinking and experimentation of France and Belgium, and was utterly different in tone from the angry jeremiads of Pope Pius IX's utterances on social questions. A serious effort to articulate a Christian ethic for the industrial era, it became and has remained the starting point for all subsequent Catholic social teaching.

Leo also took the lead in a renewal of Catholic theology and theological education, opening the Vatican archives to historical research, establishing the Pontifical Biblical Commission, and endorsing the legitimacy of the scientific study of the Bible. He encouraged a renaissance in Catholic philosophical and doctrinal studies, though in characteristically conserva-

tive fashion, by canonizing the works of Saint Thomas Aquinas as the official standard of truth in the encyclical *Aeterni Patris* of 1871. This was an improvement on the ossified teaching of the Roman theological schools, but had its limitations as a formula for resolving all the intellectual difficulties of nineteenth-century Christians. The limits of Leo's sympathy with nineteenth-century modernity were also on display in his condemnation in 1899 of Americanism, in which he called a halt to the attempts of liberal Catholics in the United States to accommodate their faith and its cultural and doctrinal expression to the attitudes and norms of democratic society. Nevertheless, by the time of his death in 1903, Pope Leo had done much to reestablish the morale and prestige of world Catholicism, and to reestablish the unquestioned centrality of the papacy within the church.

Yet the balance he bequeathed to the church was a fine one. At the beginning of the twentieth century, the church looked to the pope as never before for intellectual leadership, spiritual guidance, organizational direction, diplomatic support in dealing with secular governments, and, increasingly, for the appointment of bishops. But the papacy as an institution was also deeply scarred by the experience of revolution and dispossession, fearful of democracy, suspicious of many of the tendencies of modern thought, hostile to some of the most vital energies within the church, and in particular to those which sought to reconcile Catholicism with modernity.

Figure 15
Chartan, *Pope Leo XIII*, late nineteenth century, Vatican Museums

These paradoxes became evident in the pontificate of Pope Leo XIII's successor, Pius X (fig. 16). Chosen as a deliberate contrast to his aristocratic and remote predecessor, Giuseppe Sarto was a warm-hearted peasant with a lifetime of effective pastoral ministry behind him. His priorities were first and last practical: he had no understanding of politics, and rapidly and ineptly undid much of the work of reconciliation between the church and the modern states that Pope Leo had achieved. By the end of Pope Pius's pontificate, relations between France and the church would be worse than at any time since the 1790s. In pastoral terms, however, his touch was very sure, and he set about renewing the spiritual effectiveness of the church in a series of practical reforms – improving seminary education and lay catechesis, reforming church music to rid it of decadent operatic excess and restoring the use of Gregorian chant, simplifying the breviary to make it more prayerful and less burdensome to hard-worked parish priests, encouraging lay people to receive communion more often, and lowering the age at which children made their first communion to seven. He also instigated a reorganization of the papal curia to cope with its many new or

increased responsibilities, and he ordered a complete overhaul of the code of canon law. The new code was not promulgated until three years after his death, but it formalized the enhanced centrality of the pope in the church that had developed over the preceding century. The code, for example, laid down for the first time that all bishops were to be nominated directly by the pope, one of the most striking recent extensions of papal authority, achieved largely in the preceding fifty years.

But alongside Pius X's sensitive pastoral practicality went a deep-seated suspicion of intellectuals and a profoundly authoritarian distrust of modernity. Leo XIII's reign had encouraged many philosophers, theologians, and historians to speculations that sometimes took them beyond the limits of strict orthodoxy. In 1907 Pius X called a halt to all such exploration in the encyclical *Pascendi Dominici Gregis*, a blistering attack on the "Modernism" or "synthesis of all the heresies" that he believed was rotting Catholic belief from within. In the wake of the encyclical there was a worldwide purge of Catholic intellectuals from church institutions, and suspicion, paranoia, and unjust accusation ruined many promising careers

Figure 16
B. Lippay, *Pope Pius X*, early twentieth century,
Vatican Museums

Figure 17
Giacomo Grosso da Cambiano, *Pope Benedict XV*,
1919, Vatican Museums

and embittered many lives. The Anti-Modernist Oath that followed in 1910, and which was required of every priest until the 1960s, did much to sterilize and suffocate intellectual originality in the church for three generations. His successor, Pope Benedict XV, would call a halt to the witch hunt, but he could not eradicate the climate of distrust and intellectual mediocrity to which it had given rise (fig. 17).

Pope Pius X's death coincided almost exactly with the outbreak of the First World War. The next three pontificates would be dominated by issues of peace and war, by the collapse of the political order established in the wake of the defeat of Napoleon a century before, and by the rise of the dictatorships of the right and the left, which between them were to make the twentieth century the bloodiest and most terrible in human history. The pope of the First World War, Benedict XV was a skilled diplomat, who saw the church's (and especially his own) role as that of peacemaker and reconciler. To that end, he maintained a scrupulous and sometimes painful neutrality between the warring nations. He also began the process of reconciliation with the state of Italy by lifting the ban on Catholic heads of states visiting the Quirinal. By the time of his death in 1922 he had vastly expanded the diplomatic activity – and international standing – of the papacy, and twenty-seven countries had ambassadors accredited to the Vatican.

This increased diplomatic activity was to continue under the next two popes, Pius XI and Pius XII. The reordering of Europe and Europe's former colonies in the wake of the war meant that freedom of action for the church's work had to be secured by a series of new concordats – with Latvia in 1922, Bavaria in 1924, Poland in 1925, Lithuania in 1927, and, above all, with Italy in 1929. This Lateran Treaty, concluded by Pope Pius XI after three years of fraught bargaining with Mussolini's Fascist government, at last ended the state of warfare that had existed between the church and Italy since 1870, and removed the papal preoccupation with territory that had been a crippling limitation on the church's work (fig. 18). The concordat established the tiny, independent Vatican state, thereby guaranteeing the pope's liberty. Italy recognized canon law and permitted the teaching of Catholic doctrine in state schools, and the pope was at last compensated for the loss of the Papal States, receiving 1,750,000,000 lire, an endowment that put the work of the papacy on a secure financial footing.

Figure 18
Cardinal P. Gasparri and Benito Mussolini sign the Lateran Pacts, 1929, Archives of *L'Osservatore Romano*

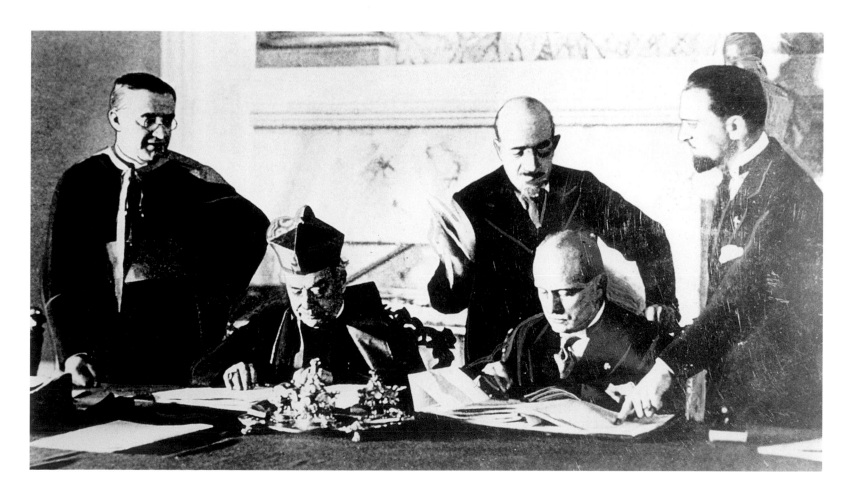

The concordat with Fascist Italy highlights the ambivalences of papal diplomatic activity in the twentieth century. In doing business with Italy, as in all the other concordats, Pius XI's primary concern was to ensure the church's freedom of action: behind such treaties was a model of the church as a "perfect" (i.e., self-contained and complete) society, like a nation, which could make treaties with other powers on matters of mutual concern without necessarily endorsing or adapting the values of those with whom it did business. But to many outside the church, and some within, such treaties raised painful moral questions. Pope Pius XI was a remarkable and effective pope (fig. 19), and his most enduring achievements were spiritual, above all a huge expansion of the church's missionary work, with a special emphasis on the establishment of native, noncolonial hierarchies, symbolized by his personal ordination, in the face of entrenched opposition, of six indigenous bishops for China in 1926, followed soon after by ordinations of Japanese, Indian, and Malaysian bishops. But he was also a man of the right, with a low opinion of democracy and democratic freedoms, and a horror for Socialism in all its manifestations. Detesting the rise of Nazism, he would denounce its racist ideology as well as its attacks on the church in one of his most outspoken encyclicals, *Mit brennender Sorge*, smuggled into Hitler's Germany and read from the pulpits in 1937. But he reserved his harshest condemnations for the overtly atheistic materialism of Communism, especially in Mexico and Russia. Both he and his successor, Pope Pius XII, would consistently view Communism as a more demonic force and a worse threat to humanity than Nazism.

As a result of this judgment, perceptions of his successor's pontificate have recently been dominated and distorted by retrospective condemnation. Eugenio Pacelli, who was elected as Pope Pius XII in March 1939, had spent a lifetime in the papal diplomatic service (fig. 20). He had a hand in several of the concordats of the inter-war years, and the concordat of 1933

with Nazi Germany, the first international treaty signed by the Nazis, was his work. Pius XII despised Nazism, but thought it right for the papacy to secure freedom for the German Church by signing a treaty with Hitler, as it had once secured freedom for the French Church by signing a treaty with Napoleon. Cautious by nature, legalistic by training, like Benedict XV in the First World War he saw the pope's role in international affairs as peacemaker and mediator, and dreaded any appearance of partisanship that might compromise that role. During the war, therefore, though evidence of Nazi genocide against the Jews mounted, he shrank from open condemnation. Diplomatic protest and negotiation, not denunciation, seemed to him the only hopeful strategy: he feared that denunciation would merely antagonize Hitler and thereby worsen the plight of the Jews, and draw in Catholic victims as well. Condemnation would be cheap for the pope, costly for those in the power of the Nazis (fig. 21).

The situation, however, is complicated by other factors. After the war, for all his caution, Pius XII would roundly and repeatedly denounce Communist regimes, even though Catholics under Communist rule might suffer. The pope, moreover, undoubtedly shared the cultural distaste for Jews and Judaism that was deplorably pervasive in European society before the Holocaust, and to which Catholicism had contributed the notion that the Jewish people collectively bore the guilt of deicide, because of the Crucifixion. Many people now believe that a decisive papal intervention might have prevented the deportation of the Roman Jews: Jews were hidden in the Vatican and the Roman monasteries, but the pope did not openly intervene. Debate rages as to whether his action was the wise avoidance of a Nazi invasion of church premises and consequent discovery of the concealed Jews, or a reprehensible indifference.

These are, in part, questions about an intensely private individual conscience: as such they may never be resolved. But Pope Pius XII's relationship with Nazi Germany highlights two developments that are

Figure 19
Pope Pius XI and the inauguration of Vatican Radio, 1931,
Archives of *L'Osservatore Romano*

fundamental to any understanding of the development of papal policy over the preceding century. First, the papacy's chosen mode of relation to secular society was diplomatic rather than prophetic. Second, in securing freedom for the work of the church, the papacy conceived that work in global rather than local terms. In negotiating the concordat, Rome acted independently of the local hierarchy and was prepared to sacrifice local institutions as bargaining counters. Thus, part of the deal that secured the concordat was the dissolution of the Center Party, which had been so vigorous and effective an expression of German political Catholicism. The elimination of such local institutions, however, undoubtedly eroded the possibility of democratic resistance to Nazism. It seems that here the authoritarian character of ultramontane Catholicism decisively weakened the local church in confronting and contesting tyranny.

Once again, however, the matter is by no means simple. Rome and Rome's diplomatic networks were to prove an inestimable asset to persecuted churches under postwar Communist regimes, a precious lifeline to the outside world and a point of international leverage. In particular, the part played by Pope John Paul II in securing and extending the liberties of the people of Poland between 1979 and 1981, and indeed in the eventual downfall of Soviet Communism, was a triumphant demonstration of the service which this aspect of the papacy could offer to the local churches and to human freedom.

The long pontificate of Pius XII saw many positive developments – the beginning of a pastoral recovery of the beauties of the ancient Roman liturgy, in particular the restoration of the eloquent ceremonies of Holy Week; the promotion of biblical studies; and the encouragement of a richer and less legalistic understanding of the corporate nature of the church. But the more negative legacy of the age of Pius IX and Pius X was also powerful, and Pius XII's last years were overshadowed by a stultifying authoritarianism and fear of modernity, in which many of the greatest and most creative theologians of the century, like Father (later Cardinal) Yves Congar and Father Karl Rahner, fell under suspicion and were silenced.

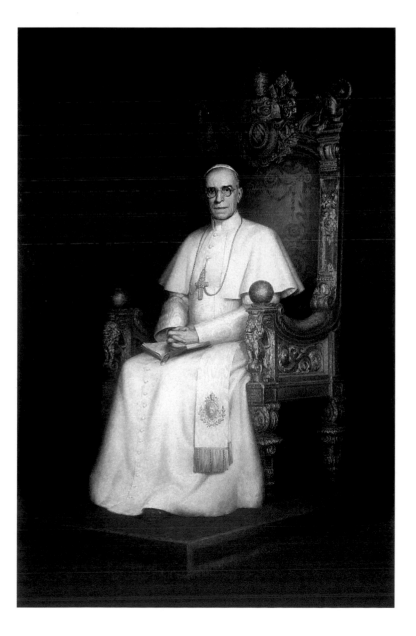

Figure 20
L. Boden, *Pope Pius XII*, mid-twentieth century, Vatican Museums

Figure 21
Pope Pius XII prays with the Romans after the bombardment of Rome, 1943, Archives of *L'Osservatore Romano*

The pontificate of Pope John XXIII was to mark an immense watershed in the history of the church, though perhaps less so in the history of the papacy (fig. 22). John was seventy-seven when elected in 1958, chosen as a genial and holy compromise candidate who would not reign long. He was, indeed, to be pope for less than five years, but in that short time he revolutionized Catholicism in two quite distinct ways. Breaking decisively with the remote and hieratic style of every pope since Pius IX, he exercised an old man's freedom and enchanted the world by the warmth of his manifest and ebullient humanity, sallying out of the Vatican as no pope for a hundred years had done to the Roman hospitals and prisons, embracing visitors to the Vatican, who included not only the leaders of other churches, but even the children of the soviet leader Nikita Khrushchev.

Even more momentously, in a desire to "throw open the windows," he summoned the bishops of the world to a general council. The First Vatican Council had met in a spirit of siege, to confute and confound the modern world. John explicitly designed the Second Vatican Council to bring the church up to date ("Aggiornamento"), and to seek a creative harmony between the perennial truths of the Gospel and the best insights and values of the cultures within which the Gospel had to be proclaimed.

The Second Vatican Council opened in October 1962 and closed in December 1965 (fig. 23). For most Catholics, above all the participating bishops and theologians, it was a revelation of the vitality and universality of the church. Twenty-eight hundred bishops attended, fewer than half of them from Europe. Also present and influential were representatives of the Orthodox, Anglican, and Protestant Churches. After long years of suppression, the council released titanic energies for change, and the contact

between bishops and theologians from all over the world in an atmosphere of high spiritual and intellectual excitement, and under the increasingly minute scrutiny of the world's press, produced a truly revolutionary ferment. In a series of momentous documents, above all the constitution on the church, *Lumen Gentium*, and that on the modern world, which had the significantly upbeat title *Gaudium et Spes*, every aspect of the church's life was reexamined and re-expressed (fig. 23). From the council emerged a renewed understanding of the spiritual and communal nature of Catholicism, contrasting strongly with the legalistic and exaggeratedly hierarchical conceptions that had prevailed. The hostile superiority that had characterized Catholic attitudes to other Christians was now abandoned in favor of a fraternal openness expressed in shared prayer and action, aspiring to fuller unity. The council called for a new attentiveness to other faiths, and for cooperation with all men and women of good will in the service of humanity, a stark contrast to the fortress mentality and suspicion of secular modernity that had obtained since the French Revolution. Not least, the council deplored the age-old Christian enmity with the Jews, and solemnly disowned the charge of deicide against the Jewish people. And in a momentous departure from centuries of insistence that error had no rights, the council embraced the notion of religious liberty, and proclaimed freedom of conscience as a fundamental aspect of human dignity.

John died before most of these new perceptions had been formulated, and it fell to his successor, Paul VI (fig. 24), elected in 1963, to try to guide and contain the volcanic expectations, and the often bitter disappointments and divisions, which the aftermath of the council inevitably brought. The council was the most profound upheaval in the church since

Figure 22
Pope John XXIII visiting with prisoners of Regina Coeli
in Rome, 1963, Archives of *L'Osservatore Romano*

Figure 23
Opening of the Second Vatican Council, October 11, 1962,
Vatican City, Archives of *L'Osservatore Romano*

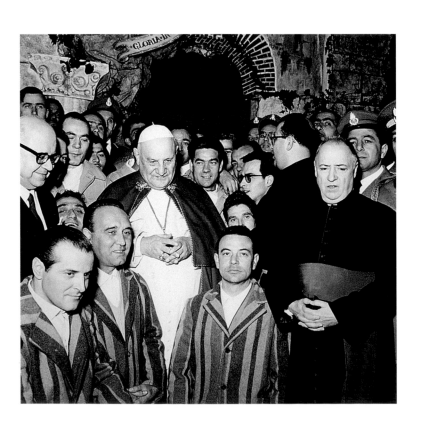

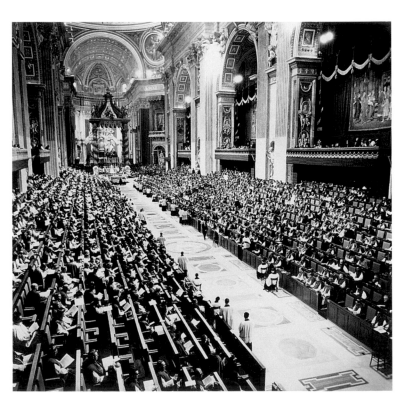

the Reformation of the sixteenth century. For most Catholics, it brought an immense sense of liberation, not least in the field of worship, for the mass was now translated into the vernacular for the first time, and the world's Catholics could worship in their own tongues. But the council coincided with a period of profound dislocation in Western culture, and the universal shaking of old certainties and venerable institutions in the 1960s was reflected also in the church. In the wake of the council, religious life, which had boomed till the 1950s, collapsed everywhere in the West. Thousands of priests and nuns abandoned their vows and left to marry. Where enthusiasm ran ahead of judgment, liturgical experimentation could be crass and graceless, theological expression shallow or extreme. There were many who were troubled by what seemed the repudiation of traditional certainties, and many more who deplored what they saw as the vulgarization or betrayal of the church's liturgical and doctrinal heritage.

Many had expected, and some had hoped, that the council would mean a reduction of the role of the papacy in the church. *Lumen Gentium* had reaffirmed the importance of the local churches and the local episcopate, and had stressed the shared or collegial responsibility of all the bishops. This would be expressed after the council in the establishment of regular international episcopal synods. But in the event the synods worked to tightly controlled papal agendas and proved less independent than many had hoped. In any case, given the scale and diversity of the worldwide church, the papacy under Pope Paul VI was inevitably confronted with the urgent and formidable task of implementing the conciliar reforms, while preserving the unity of a church undergoing seismic change. New Vatican institutions and instruments were established, like the Secretariats for Christian Unity and for Non-Christian Religions, and Rome pumped out a stream of directives, admonition, and guidance designed to urge on the reluctant and contain the impetuous. Papal authority remained central to Catholic identity, and even expanded its scope, though it soon became clear that the monolithic obedience of the preconciliar age was a thing of the past. This was made evident in 1968, when Paul VI issued his encyclical *Humanae Vitae*, reaffirming the church's traditional opposition to artificial birth control in the face of widespread calls for change. The encyclical, designed to end uncertainty, provoked a storm of protest and open rejection, which bewildered and wounded the pope, who never wrote another encyclical. Dissent and criticism of papal teaching, though rarely as vehement as in the aftermath of *Humanae Vitae*, has remained an aspect of Catholic life, and it seemed to many observers that the relationship of Catholics to papal teaching, at any rate in the West, had been permanently modified.

Pope Paul VI was responsible for another profound shift in the role of the papacy. He began to travel, a pilgrim for peace and reconciliation, to the United Nations in New York in 1963 to call for an end to war, to Jerusalem in 1964 to seek reconciliation between the Orthodox and Catholic Churches, to Geneva to address the World Council of churches in 1969 (fig. 25). In the same year he became the first pope to set foot in Africa, where he ordained local bishops and encouraged the development of an indigenous church, and in the following year he made a similar trip to the Philippines and Australia.

Pope Paul's journeyings were a new development for a papacy that had been static in Rome for more than a century, but they were to pale into insignificance compared to the apostolic journeyings of Pope John Paul II

Figure 24
Dina Bellotti, *Pope Paul VI*, Vatican Museums

Figure 25
Pope Paul VI adressing the General Assembly of the United Nations, New York, October 4, 1975, Archives of *L'Osservatore Romano*

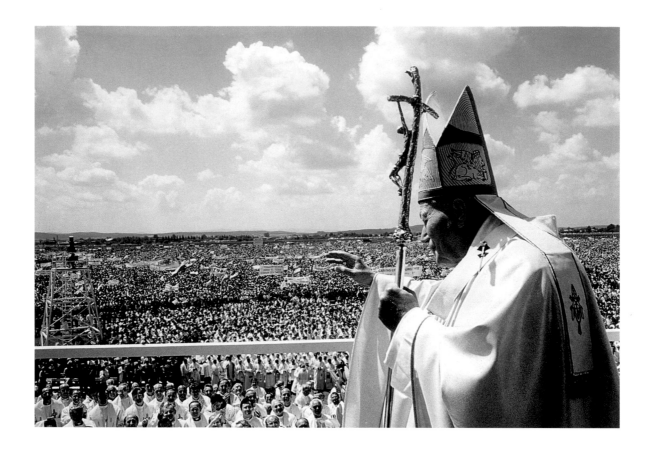

Figure 26
Apostolic trip of Pope John Paul II to Poland,
Archives of *L'Osservatore Romano*

Figure 27
Apostolic trip of Pope John Paul II to Africa, 1985,
Archives of *L'Osservatore Romano*

who was to make this the distinctive mark of his own papacy, reaching out directly not merely to all the Catholics of the world, but to all people of good will (figs. 26, 27). In a hundred separate journeys to more than 130 countries he has traversed more than a million miles, exhorting, encouraging, inspiring, rebuking, canonizing local saints, meeting heads of states, negotiating liberties for the local churches or the release of political prisoners, and everywhere attracting immense crowds. He has thereby embodied in his physical presence the spiritual bond that links all the local churches in one communion. This is a dramatic extension of the Petrine office, unimaginable before the age of jet travel and mass media.

And the election in 1978 of a Polish pope, who had lived first under Nazi and then under Stalinist tyranny, was in itself a mark of the profound transformation of Catholicism in the twenty years since the death of Pius XII. The church no longer saw itself as primarily a Western European institution, and no longer looked automatically to Italy for leadership. The ministry of John Paul II has continued and developed many of the established modes of papal service. Like Leo XIII and Pius XII he is the author of a stream of weighty and challenging encyclicals. Unlike them, his encyclicals are written in the first person, and *Veritatis Splendor* and *Fides et Ratio* represent the personal engagement of an academically trained philosopher with fundamental questions of human meaning and value. He has also followed in the footsteps of Paul VI in addressing directly the injustice of the world's economic ordering: John Paul's critique of both capitalism and Communism in his encyclical *Sollicitudo rei Socialis* represents an extension of the task begun by Paul in *Populorum Progressio*.

In Pope John Paul, therefore, the teaching office of the papacy is alive and vigorous as seldom before. But it is likely that his papacy will be considered distinctive for two other emphases. The first of these is his strong reaffirmation of central authority and the need for Catholic unity around the person of the pope. In the wake of the council it appeared to many that such an emphasis belonged to the age of Pope Pius IX rather than to the eve of the third millennium. Under John Paul, however, it has proved unexpectedly resilient, and despite the upheavals of the conciliar period, there are now more continuities with the pontificate of Pius XII in evidence than anyone could have predicted in the troubled later years of Paul VI. Unsurprisingly, these continuities have provoked very mixed responses among Catholics and the wider world. There has been a more wholehearted welcome for the prophetic leadership Pope John Paul has given to the church above all in his many apostolic journeys. The pope has used these visits as opportunities to challenge oppressive regimes, to encourage local Christian communities, to break down old hostilities. His visits in 2001 to Greece and the Ukraine, for example, were designed to help heal the age-old breach between the Roman and Orthodox Churches. But his concerns have never been merely with internal Christian divisions. No pope has reached out as he has done to the other world faiths, and among his most memorable journeys was that to the Holy Land in the bimillennial year 2000, when he prayed at the Wailing Wall and inserted between its stones a confession of Christian sins against the Jews, and a plea for forgiveness (fig. 28). In such a gesture, without precedent in two thousand years of Christian history, the continuing ability of the ancient institution of the papacy to surprise, challenge, and inspire are made manifest.

Figure 28
Pope John Paul II at the Wailing Wall in Jerusalem, 2000, Archives of *L'Osservatore Romano*

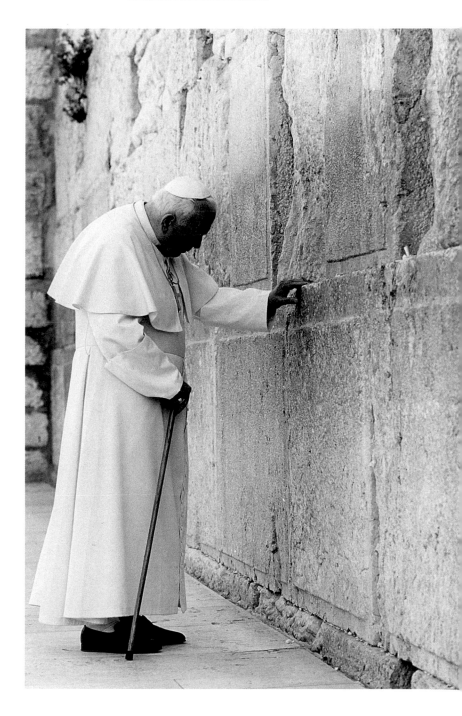

From Saint Peter's Tomb to Michelangelo's Dome

Archbishop Francesco Marchisano

Figure 1
Nicholas Cordier, Orazio Censore, Onorio Fanelli,
Cancello della nicchia dei palli, detail showing the *Crucifixion of Peter*, 1617, gilded bronze, Saint Peter's Basilica

Figure 2
Ambrogio Buonvicino, *The Consignment of the Keys*, 1613,
marble, Saint Peter's Basilica

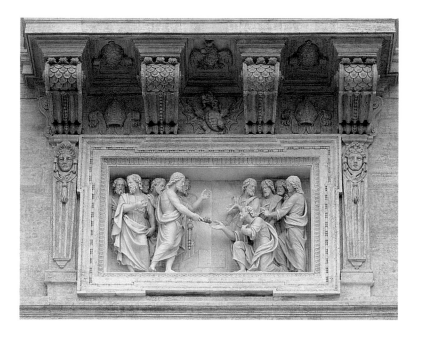

It was July of the year 64 AD when a terrible fire devastated the city of Rome. A rumor arose, soon giving rise to popular fury, that the emperor Nero was behind the tragic event and, to escape the anger of the mob, he blamed the Christian community. In Nero's garden was a circus – the only public arena left standing – and there he first gave shelter to the Roman citizens who had escaped the fire and later ordered a massacre of those whom he had identified as responsible for the conflagration. Thousands of Christians were crucified, with only their faith to support them; others, according to Tacitus,[1] were burned alive. Among them, on an unspecified day between 64 and 67 AD, the apostle Peter was also put to death (fig. 1). Much later, at the site of his martyrdom, the first basilica was built to protect his tomb, and from the very first it became the greatest shrine in Christendom.

The Vatican

Nero's circus, where the first basilica was later built, was at a place known as *Vaticanum* or *ager Vaticanus*. The origin of the name is still debated. One theory is that it derives from a temple there dedicated to a god who predicted the future, whose priest-augurs were known as *vates*. According to Pliny, however, the site bore that name because the Romans had been encouraged by the voice of a *vates* (augur) to conquer the west bank of the Tiber, which was occupied by the Etruscans.

The area known as the Vatican was on the west bank of the Tiber, between the river and the Janiculum Hill, and was crossed by three consular roads: the Aurelian Way, the Triumphal Way, and the Cornelian Way. The land near the river was marshy, insalubrious, and abandoned. In this area, far from the urban throng but well connected to the city by a bridge[2] and the three main roads, Agrippina, the wife of Germanicus and mother of Caligula, constructed her villa. It was in his mother's gardens that the emperor Caligula (37–41) built a private circus where he could exercise his passion for horses by practicing chariot races. Six hundred meters long and nearly a hundred wide, the circus lay to the left of and parallel to the modern basilica and was marked by the obelisk that today stands in Saint Peter's Square. It soon became the most important building in the area. Following Caligula's death, the circus and its surrounding gardens passed to the emperor Claudius and, after him, to Nero, who probably completed the building and decorations.

Peter

Matthew's Gospel says: "So I now say to you: You are Peter and on this rock I will build my community. And the gates of the underworld can never overpower it. I will give you the keys of the kingdom of Heaven: whatever you bind on earth will be bound in heaven; whatever you loose on earth will be loosed in heaven" (Mt 16:18–19; fig. 2). With these words, Christ entrusts Peter with his privileged role among the apostles and elects him to guide the people.

But who was Peter, the man who became the prince of the apostles, the first vicar of Christ, and the first bishop of Rome? His real name was Simon and he lived in Capernaum with his brother Andrew, both of them fisherman. As he was at work on Lake Galilee, Jesus invited him to follow him and from then on called him *kephas*, Aramaic for "rock," whence the Latin *Petrus*. His coming to Rome is testified by authors who lived a short time after him who confirm that he suffered martyrdom during the persecutions of Nero. According to Tertullian (ca. 160–225), it was Peter himself who asked to be

crucified head down; he resolutely urged his executioners to upend the cross because he did not feel worthy to die in the same position as Christ. As a simple fisherman, Peter can never have imagined that his humble tomb would come to be celebrated and conserved by the greatest church of Christendom.

The Tomb

Archaeological discoveries and later studies[3] have confirmed that Peter's tomb was not far from Nero's circus in an open-air pagan necropolis in which the mausolea, large rooms with vaulted roofs and entrances facing east toward the rising sun, belonged to the families of rich freedmen. Inside, they were decorated with elegant paintings, plaster decorations, and, in some cases, mosaics. Here, in a place not far from the site of his martyrdom, Peter's mortal remains were laid to rest (figs. 3, 4). Unlike the rich mausolea close by, the grave of the apostle was very simple, marked with a small and modest funerary monument supported by a red-plaster wall. The monument, a niche separated into two parts by a slab of travertine, laid horizontally and supported at the front by two slender white-marble columns, is today known as the "Tropaion of Gaius" (fig. 5). This name became common after the mid-fourth-century historian Eusebius of Caesarea, in his *Historia ecclesiastica*, reported the words of a priest called Gaius who lived in Rome about 200 AD.[4] Gaius was in a dispute with the heretic Proclus, who boasted of important apostolic tombs at Ierapolis in Asia Minor. Gaius countered this claim with the "trophies"[5] of the apostles Peter and Paul, located, respectively, at the Vatican and on the road to Ostia. Eusebius' account has always been considered important, so much so that when, during the course of systematic excavations under the main altar of the Vatican, the small commemorative monument to Peter was found, it was called the Tropaion of Gaius. Over this monument, which from the very first had become a venerated holy site, the emperor Constantine built a marble edifice. In exactly the same place, Pope Calixtus II built his altar in 1123 and later, in 1594, Pope Clement VIII built another, which can still be seen today under the baldachino of Gian Lorenzo Bernini. Despite the changes that have taken place over the centuries, the cross atop Michelangelo's dome stands directly over Peter's grave and indicates to people arriving in Rome that there, in that precise spot, lies the tomb of the prince of the apostles (fig. 6).

Figure 3
Area around the Vatican according to a seventeenth-century plan.
In Carlo Fontana, *Il Tempio Vaticano e la sua origine*, Rome, 1694

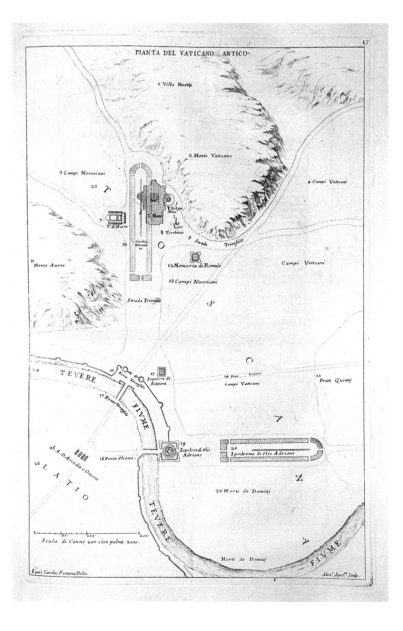

Figure 4
View of the Vatican necropolis

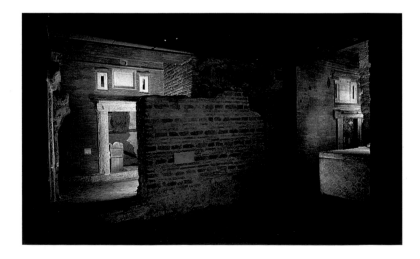

Figure 5
Tropaion of Gaius, Vatican necropolis

Figure 6
View from the lantern on the great dome to the floor of the basilica

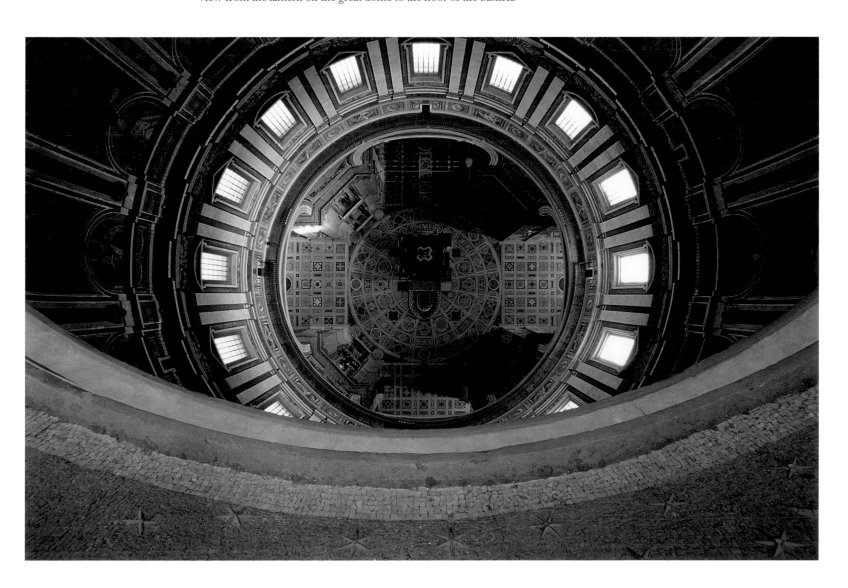

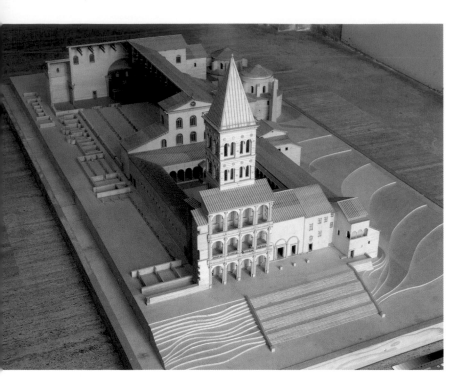

Figure 7
Wooden model of the Constantinian basilica

Figure 8
Giovan Battista Ricci of Novara, *Interior of the Constantinian Basilica,*
seventeenth century, fresco, Reverenda Fabbrica of Saint Peter

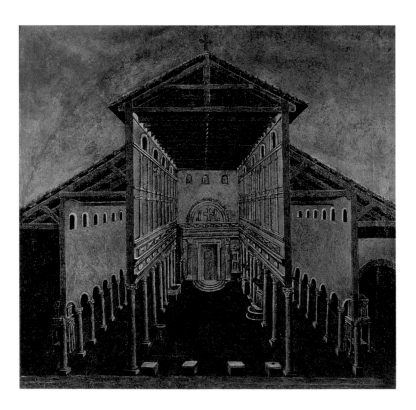

The Basilica of the Emperor Constantine

To build the medieval basilica, Constantine and his architects had to face and solve enormous legal, economic, and technical difficulties. The necropolis, or cemetery, constituted the first real problem as it was still in use at the time. Roman law, ever respectful of the cult of the dead, was strict on this question and guaranteed the inviolability of graves, any transferal or destruction of which could only be authorized by the emperor. So as not enter into conflict with the important families who owned the mausolea, the necropolis was not destroyed but filled in with earth; a solution which, though permanently preventing access to the tombs, left the bodies and the buildings around them substantially intact. The second problem was the nature of the terrain, as it was difficult to build the large and imposing edifice on the slopes of a hill. Such obstacles, however, did not discourage the emperor and work began on leveling the upper part of the hill and filling in the lower slopes with enormous supporting walls more than seven meters high. No difficulty could hamper the construction work, so great was the conviction that the shrine had to be built on the exact site where Peter's body had been laid after martyrdom. Work was still under way when Pope Sylvester I consecrated the building, but neither the pope nor the emperor lived to see it finished. It was completed just before 350 during the reign of Constans I, the second son of Constantine the Great.

The Exterior

Contemporary writers considered the finished basilica built at the behest of the emperor Constantine as a marvelous and beautiful work (fig. 7). The faithful arriving in Rome during the Middle Ages found a church that was continually being embellished and adorned, to which they gained access by a great stairway of thirty-five steps flanked at the base by statues of Saints Peter and Paul. At the top of the stairway they entered the atrium, or quadriporticus, with the bell tower to the right, the tallest in Rome, over which was a gilded bronze sphere surmounted by a cockerel also made of bronze.[6] Having passed through the doors they were faced with an open space, fifty-six meters long by sixty-two meters wide, with a portico around all four sides supported by forty-six columns. Here, originally, was a garden with flowers and hedges. Later, the area was paved and a *cantharus* was placed in the center, a fountain reserved for ablutions covered with a bronze baldachino supported on eight porphyry columns and decorated with two bronze peacocks and four gilded dolphins. A great bronze pinecone stood behind a fence; this work of art was made in Rome and may be seen today in the Cortile della Pigna in the Vatican Museums. The facade of the basilica was entirely decorated with mosaics, with a design divided into three orders. A total of five gates gave access to the interior of the sacred complex: the *Guidonea* (reserved for pilgrims accompanied by their guides); the *Romana* (so-called because the victory emblems were hung here and it could only be used by Romans); the *Argentea* (plated by Pope Honorius I with a sheet of silvered metal, stolen by the Saracens in 864); the *Ravenniana* (where entrance was reserved only for those who lived beyond the Tiber, an area known as *civitas ravennatium*), and the *Iudici* (reserved for funeral processions).

The Interior

The interior of the basilica, in the form of a Latin cross, was ninety meters long by eighty-four meters wide with an apse at the end (fig. 8). The space was divided into five: a nave with two aisles on either side, separated by four rows of twenty-two columns each. The nave was more than twenty-three meters wide. During the day, the space was illuminated by sunlight that entered through seventy-two windows, protected first with metal plates and later with sheets of perforated marble. Pope Saint Leo IV had them covered with mica, alabaster, and glass, and in the fifteenth century, the brick frames having been changed for marble ones, stained glass was fitted. Apart from the natural light, seven hundred lamps were kept burning night and day, 122 of them around Peter's tomb; oriental perfumes and balsams were used to fill the basilica with a pleasant aroma and combat the smell of burning oil.

The walls of the nave were decorated with a fresco cycle at two levels representing stories from the Old and New Testaments. The Old Testament scenes showed episodes from Genesis and Exodus and were painted on the right-hand wall; facing them was the Life and Passion of Christ. The scene showing the Crucifixion had a preeminent position at the center of the nave, being the only fresco to cover both levels. At the upper level, between the windows, were figures of patriarchs, prophets, and apostles. The areas without frescos were entirely covered with precious marble, mosaics, metal, and statues. Apart from the altar of the *confessio*, built over the tomb of Saint Peter and where only the pope could celebrate, were seventy other altars, of which at least sixteen were dedicated to the Virgin.

A triumphal arch separated the central body of the church from the transept, which was ninety meters long. It projected beyond the outside walls and was much lower than the nave. At the end near the apse was the tomb of Saint Peter, then as today the heart and center of the basilica.

The Confession

The tomb of Peter immediately became a shrine and was referred to with the term "Confession." Under Constantine, the simple monument that protected the apostle's grave was encased in marble and open at the front to allow the faithful to see the tomb. Three centuries later, Pope Gregory the Great, wishing to celebrate mass directly over the apostle's resting place, modified what Constantine had built. The floor of the presbytery, an area exclusively reserved for priests, was raised and an underground tunnel was constructed around the grave to keep it accessible. This new arrangement was separated from the rest of the basilica by a double row of six spiral columns. In 1123, Pope Calixtus II enclosed Pope Gregory the Great's altar within another, and nearly five hundred years later Pope Clement VIII repeated the same operation, building a new altar, still in use today, over that of Calixtus (fig. 9).

For almost twelve centuries, the Constantinian basilica welcomed pilgrims from near and far who had come to Rome to pay homage at the simple tomb of the first vicar of Christ. In 1506, this celebrated and well-loved building, together with the immense historical patrimony it had accumulated over the centuries, began to be demolished to make way for the present basilica. The history of the Constantinian basilica finally came to an end on November 15, 1609. On that day, the last mass was held prior to the destruction of what remained of the old building with which Constantine had sought to honor Peter the apostle.[7]

The dismantling and destruction of the Constantinian basilica was a progressive operation. After 1451, Pope Nicholas V (fig. 10) gave Bernardo Gamberelli, known as Rossellino, the task of enlarging and restoring the old basilica. Rossellino drew up plans for a church in the form of a Latin cross with a portico, a semicircular apse, and a large central dome; however, work ceased with the death of the pope.

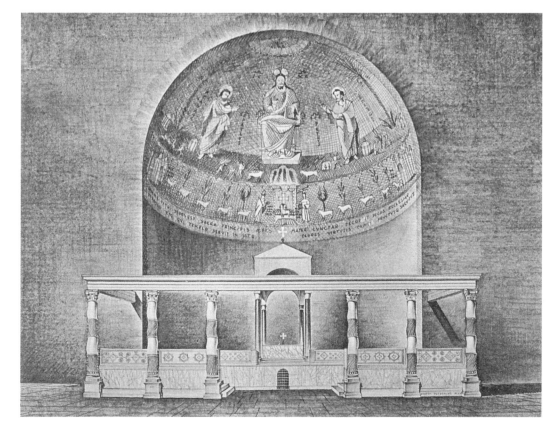

Figure 9
Front elevation of the semicircular corridor and the raised presbytery

Figure 10
Roberto Bompiani, *Pope Nicholas V*, nineteenth century, oil on canvas, Reverenda Fabbrica of Saint Peter

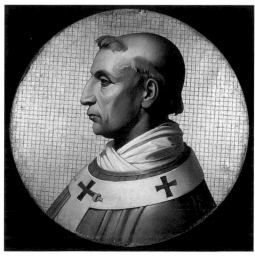

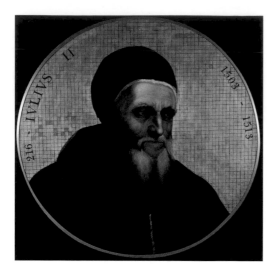

Figure 11
Vincenzo Canterani, *Pope Julius II*, nineteenth century, oil on canvas, Reverenda Fabbrica of Saint Peter

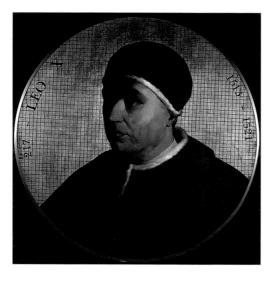

Figure 12
Vincenzo Podesti, *Pope Leo X*, nineteenth century, oil on canvas, Reverenda Fabbrica of Saint Peter

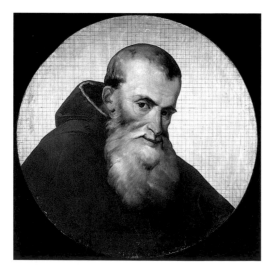

Figure 13
Vincenzo Podesti, *Pope Paul III*, nineteenth century, oil on canvas, Reverenda Fabbrica of Saint Peter

After a period of normal maintenance work, it was with Pope Julius II that the immense task began once again (fig. 11). The pope commissioned Donato Bramante to plan the new basilica and the architect accepted the challenge, proposing a square building surmounted by a dome, which, supported by massive piers, was to rise upward as if suspended in the sky. Extending out from the central dome were the four arms of a Greek cross, terminating flat on the outside and with a curved apse on the inside. Planning difficulties, as well as Bramante's death on April 11, 1514, meant the work had to be abandoned.

Prior to his death, Bramante had reconsidered his plans and was working on a second idea in the form of a Latin cross. This would be taken up by Raphael Sanzio when Pope Leo X (fig. 12) gave him the job of continuing the work along with Fra Giovanni Giocondo and the almost seventy-year-old Giuliano da Sangallo. However, all three died within the short space of six years and the project did not get beyond the planning stages. Pope Leo X then appointed as director of works Antonio da Sangallo the Younger, who had been Bramante's assistant from 1505. Later, in 1520, he was joined by Baldassare Peruzzi, the architect and painter from Siena.

Despite these new faces, work continued at a painfully slow pace for almost fifteen years until a new pope came along to change the situation with energy and determination. In 1536, just two years after his election, Pope Paul III (fig. 13) confirmed Antonio da Sangallo the Younger in his position as architect and asked him to draw up new plans and restore and consolidate what had already been built. Three years later, to explain more clearly the results of his studies to the pope, Sangallo had a great wooden model built using silver fir, maple, linden, poplar, walnut, and chestnut. The model – 7.36 meters long, 6.02 meters wide, 4.68 meters high to the top of the dome, and weighing six tons – is now housed in the Fabbrica of Saint Peter. It is an imposing structure and was paid with a sum that would have been more than adequate to build a real church. This ambitious and impracticable project was only realized in a very small part: the consolidation of Bramante's piers and the raising of the floor of the new basilica by more than three meters so as to give better illumination and more harmonious balance to a building that would otherwise have been tall and narrow. Sangallo died in 1546 and on January 25 of the following year, forty years after work had first begun, Pope Paul III appointed a new architect, the celebrated Michelangelo Buonarroti. Michelangelo rejected the ideas of his predecessor and went back to the first inspiration of Bramante, though in a more energetic and simplified form. He thought the three external arms should be shaped almost as a sculpture and, on the foundation of the lofty external structures, he imagined the greatest dome of modern times (fig. 14). When he died in 1564, only the drum had been built and it remained incomplete until January 19, 1587, when Pope Sixtus V commissioned Giacomo Della Porta, with Domenico Fontana as his assistant, to finish the task. Della Porta was guided by the wooden model built while Michelangelo was still alive, although he was not entirely faithful to the fully rounded dome of the original, which he modified with a more slender curve accentuating its verticality. Between July and August 1588, once the attic story was finished, work on the dome began. From December 22, 1589, to May 14, 1590, work was completed on the upper ring to support the lantern. On May 19, thanks to the efforts of eight hundred laborers, who had also worked at night by the light of burning torches, Pope Sixtus V was able to celebrate mass to inaugurate the closing of the

lantern, an event attended with fireworks and great joy (fig. 15). Contrary to predictions of ten years, just twenty-two months had passed. The scaffolding alone had required one hundred thousand beams, held together with more than fifteen thousand hundredweight of hemp and ten thousand hundredweight of iron.

Pope Paul V (fig. 16), elected in 1605, made the decision to hasten the demolition of what remained of the old basilica and to accelerate the completion of the new one: chapels, altars, oratories, the portico, the atrium with its papal and imperial tombs, the Loggia of the Blessings, and the bell tower all disappeared. At the pope's express wish, what remained of the funerary monuments was placed in the grottoes, which was still low-roofed and cramped until 1939, when they were restored and the ceiling was raised, rendering them a place of prayer and pilgrimage to the tombs of past popes.

The most pressing problem was to complete the construction work and raise the facade. The idea of a finished building in the form of a Greek cross was rejected, both because contemporary taste had a different view of space and because Michelangelo's plans did not fully satisfy liturgical requirements. Furthermore, if the fourth arm – the front arm facing east – were equal to the others, forming the Greek cross, this would not give enough space within the new side chapels to include the entire surface area of the basilica built by Constantine and consecrated by Pope Sylvester I. In 1607, the work was put out to bid and the most illustrious names of

Figure 14
Michelangelo Buonarroti, *Wooden Model of the Great Dome*, 1558–61, Reverenda Fabbrica of Saint Peter

Figure 15
Lantern of the great dome

Figure 16
Pope Paul V, nineteenth century, oil on canvas, Reverenda Fabbrica of Saint Peter

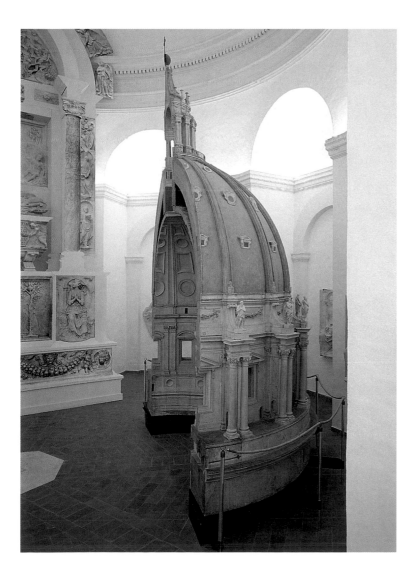

the age submitted proposals. The eventual winner was Carlo Maderno of Bissone, Domenico Fontana's nephew. Maderno was constrained in that he had to use the side walls already built by Michelangelo. He therefore limited himself to creating the attic over the lower order; this story goes right round the building as, indeed, had already been established in Michelangelo's plans. On Palm Sunday 1615, the basilica appeared for the first time in its completely new form; other adornments, mostly by Bernini, were still to come. When he died on June 28, 1621, Pope Paul V proudly left his fellow citizens the greatest church in Christendom, with the outside complete and the interior decorations well under way.

Among the people who came to the square, the greatest impression was provoked by the imbalance between the facade and the powerful and dynamic exterior wall. In order to remedy this defect Maderno began work on two bell towers, one at either end, which would render the facade lighter and more slender and, at the same time, frame and highlight the dome. At the death of Pope Paul V, however, the construction of the bell towers, which had yet not reached the top of the facade, had to be interrupted because the ground underneath was giving way. Their absence, rather than attenuating the horizontal expanse of the facade, tends to accentuate it. Bernini had no better luck twenty years later in 1641, when he suffered the only great professional failure of his career. He was forced to demolish – at his own expense – the bell tower he had built on the left side of the facade because it was threatened by cracks that had appeared in the underlying structure. Today, all that remains of the bell towers are their bases – the two great arches at the sides – and thus they have come to form part of the facade when they should have risen above it. Even the two clocks, designed by Giuseppe Valadier and put in place in 1786 and 1790, did not fully remedy the situation, even though their mosaic faces are more than four meters in diameter.

The facade does not so much lean against the basilica as stand in front of it independently on its own foundations. Work on those foundations began on November 5, 1607, the first stone was laid on February 10, 1608, and by July 21, 1612, most of the immense task was already complete. It is 118.6 meters wide and 48 meters high, not counting the statues. Characterized by immense columns and pilasters with Corinthian capitals, it is divided into two orders: the five entrances to the atrium may be seen in the lower order while, above, are nine windows, three of them with balconies. The central balcony, known as the Loggia of the Blessings, is where the pope appears to impart his solemn *Urbi et Orbi* and where the cardinal pro-dean announces the election of the new pontiff.

Although the inscription bears the date 1612, the facade was actually only completed two years later when work was finished on the cornice, the attic story and the balustrade surmounted by the statues of Christ the Redeemer, Saint John the Baptist, and eleven Apostles (fig. 17). Only Saints Peter and Paul are missing from this series of apostles: their statues are in the square below, at either side of the stairway leading up to the basilica.

The Colonnade

Before Gian Lorenzo Bernini, the square in front of the basilica was entirely without form and full of buildings in differing architectural styles. There was no protection against wind or rain, and during ceremonies the route from the apostolic palaces to the basilica had to be prepared each time with a series of passageways covered in awnings. Between 1656 and 1667, at the orders of Pope Alexander VII (fig. 18), Bernini completely remodeled the area in front of the new facade.

The square was divided into two parts: the oval space within the two great semicircles of quadruple rows of columns with Tuscan capitals linked by a flat entablature, and the central trapezoidal area, bounded by the two

Figure 17
Facade of Saint Peter's Basilica

Figure 18
Domenico Toietti, *Pope Alexander VII*, nineteenth century, oil on canvas, Reverenda Fabbrica of Saint Peter

straight arms that emerge from the colonnade and, diverging slightly, reach the extreme ends of the facade. Thus, the overall effect is of great openness while the facade, distanced from the great oval by the two straight arms that seem to be shorter than they really are, appears, thanks to this illusion, to be more balanced and almost reduced in size. The colonnades have a total of 284 Doric columns and eight pilasters, all made of travertine, and are linked by a simple entablature decorated with a series of 140 3.1 meter-high statues of saints and six coats of arms of Pope Alexander VII, who promoted the construction. To avoid any imbalance that could arise from the curve of the colonnade and, at the same time, to heighten the visual impact of the square, Bernini positioned the quadruple row of 284 columns in a radial pattern, gradually increasing the columns' diameter toward the outside. Thus, he managed to maintain an unchanging proportion between columns and spaces, even in the outside rows. If one stands on a porphyry disk set into the ground at the sides of the obelisk and looks at the closest semicircle, only the first internal row of columns will be visible, while the others line up and disappear behind them, almost as if they were moving into place. At its widest point the diameter of the ellipse measures 240 meters, fifty-two meters more than that of the Colosseum.

Saint Peter's Square, which was completed in ten years (1657–67), although it contributed to weakening pontifical finances, remains the greatest architectural project of the seventeenth century and among the most spectacular works of the Roman baroque (fig. 19). Bernini, balancing his lively imagination with a classical vein that he never denied and expressed here in the most simple of ancient styles, managed to give Christianity its epicenter.

The Obelisk

The center of the square is marked by the obelisk that once stood on the *spina* of Nero's circus (fig. 20). Rising upon a base of 8.25 meters, it is a single block of red granite 25.31 meters high and weighs about 330 tons. After the Lateran obelisk, this is the second highest in Rome and the only one to be inscribed with Latin letters, not hieroglyphics. There is mention of it as long ago as the first century AD, in Pliny the Elder's *Naturalis Historia*. It came to Rome in AD 40, brought from Egypt by the emperor Caligula. He had it transported in a ship filled with lentils to spread the weight and placed it on the *spina* of his circus, which later became that of Nero. After it had been used, the ship was filled with pozzolana and sunk to form the foundation for the left-hand breakwater of Claudius' port at the mouth of the Tiber.

For centuries the obelisk remained half-buried at the left side of the basilica until Pope Sixtus V, putting into effect a desire already expressed by a number of his predecessors, ordered it be moved to the center of the square. He examined a number of projects and eventually entrusted the task to Domenico Fontana. Solid foundations were prepared and, on April 30, 1586, the first part of the enterprise – which involved 907 men, 75 horses, and 40 winches – began. On September 10 the obelisk was raised and placed upright; six days later it was positioned on its pedestal and, on September 26, it was blessed and consecrated. In place of the bronze sphere that had once adorned the top of the obelisk, the pope's coat of arms was fixed, surmounted by a cross containing relics from the True Cross.

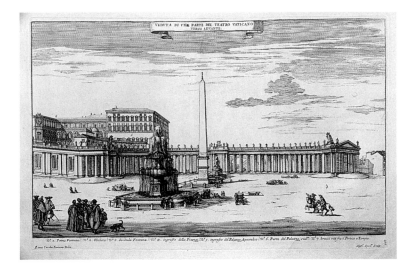

Figure 19
View from the south side of Saint Peter's Square.
In Carlo Fontana, *Il Tempio Vaticano e la sua origine*, Rome, 1694

Figure 20
Obelisk in Saint Peter's Square

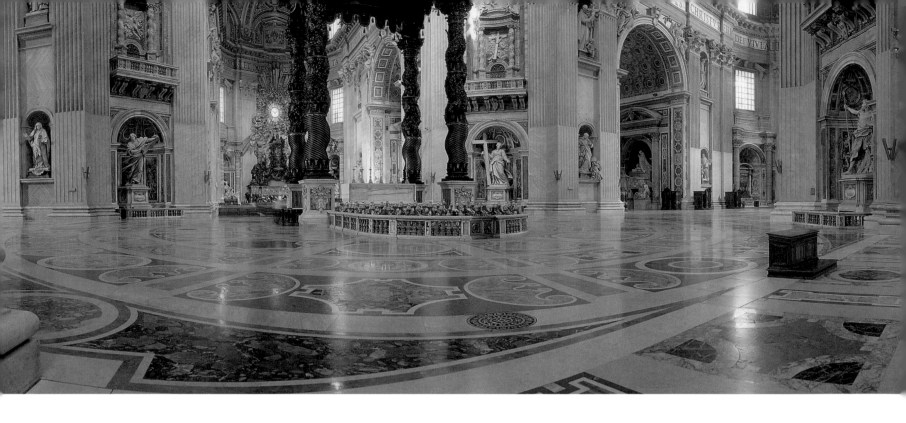

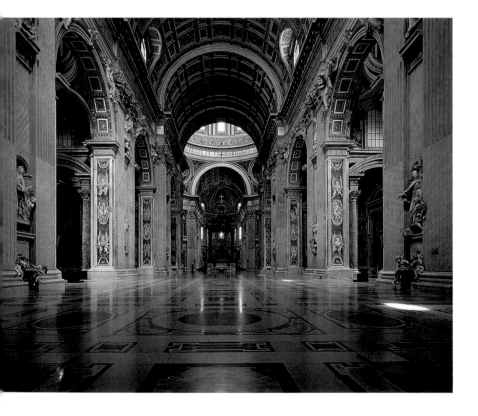

Figure 21
View of Saint Peter's Basilica (photo: Nando Mutarelli)

Figure 22
Nave of Saint Peter's Basilica

The Basilica of Saint Peter Today

Before entering the Vatican Basilica, one must cross the atrium. Completed between 1608 and 1612, it is 71 meters long, 12.8 meters wide, about 19 meters high, and one of Carlo Maderno's most important works. On the vault, thirty-two stucco scenes, based on cartoons by Giovan Battista Ricci of Novara, relate the story of the apostles Peter and Paul, highlighting Peter's preeminence and his strong association with the life and mission of Christ. As if to underline this message, under the vault at the sides of the lunettes are thirty-one statues representing the first popes, all martyrs for the faith. The atrium, today as in the past, prepares visitors to absorb the spiritual richness of the interior (fig. 21). Like the quadriporticus of paleo-Christian basilicas, it is a place to pause respectfully and reflect before proceeding down the great nave toward the tomb of Peter, the heart and center of the basilica.

As in the Constantinian basilica, the five gateways in the atrium correspond to the five doors giving access to the interior of the basilica. Of these, only the one in the center does not date from last century; it is known as the Door of Filarete (7.14 x 3.6 meters) from the name of the artist who made it. It was cast in 1455 for the old basilica of Constantine and was adjusted for its new position with the addition of two bands in 1619.

Passing through the door of the Sacraments (the second from the right) one enters the nave, Carlo Maderno's extension to the original design, work on which began in 1609 (fig. 22). Maderno's contribution included building three spans of the nave and entirely constructing the two smaller side aisles that open, on the right, into the chapels of the *Pietà*, Saint Sebastian, the Holy Sacrament, and, on the left, into the chapels of the Baptistery, the Presentation, and the Choir. The bronze statue of Saint Peter (fig. 23) marks the point where the earlier structure built by Michelangelo joins the part designed by Maderno, who thus creates a whole with Buonarroti's great central octagon with its four piers supporting the dome, and the three equal arms of the cross forming the transept and tribune.

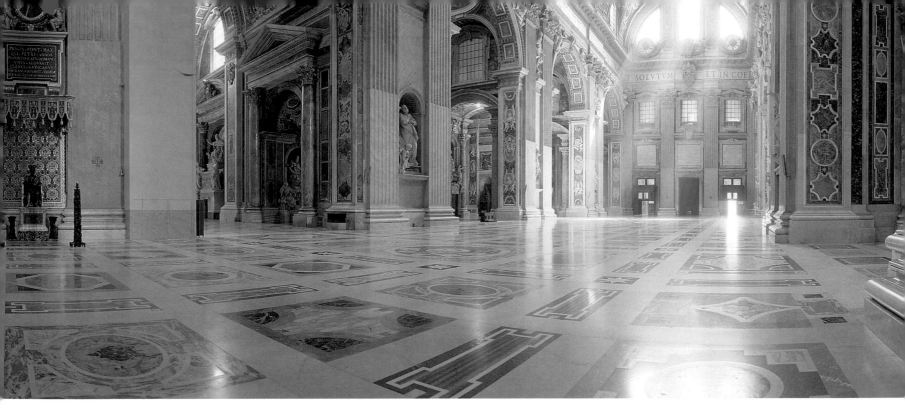

Saint Peter's Basilica is the biggest church in the world today. This primacy is indicated along its longitudinal axis where inscriptions in letters of gilded bronze give the internal lengths of other great basilicas of Christendom.

The vast nave, the axis of which is slightly displaced toward the apostolic palaces, is flanked by massive columns characterized by fluted lesenes set in pairs and finished with Corinthian capitals. Great arches 13 meters wide and 23.5 meters high give access to the side aisles. The truly vast scale of the architecture and its particular features is not immediately perceptible, because of the great attention to proportion and because the rich marble decorations covering the walls have been progressively altered with great sensitivity to the unity of the whole. Approaching the two holy-water fonts – constructed in 1722 and 1725 and positioned at the base of the first arch – gives us a point of comparison with which to appreciate the true dimensions: the putti are more than two meters high.

The covered surface area of the basilica is 20,139 square meters; its overall internal length is 186.3 meters. The transept measures 137.85 meters and the width of the nave and the side aisles is 58 meters. The dome has an internal diameter of 41.5 meters and an external diameter of 58.9 meters, being supported by arches 44.8 meters high and 23 meters wide. The height from the floor to the vault of the lantern is 117.57 meters and to the cross 133.3 meters.

Figure 23
Arnolfo di Cambio, *Saint Peter*,
thirteenth century, bronze, Saint Peter's Basilica

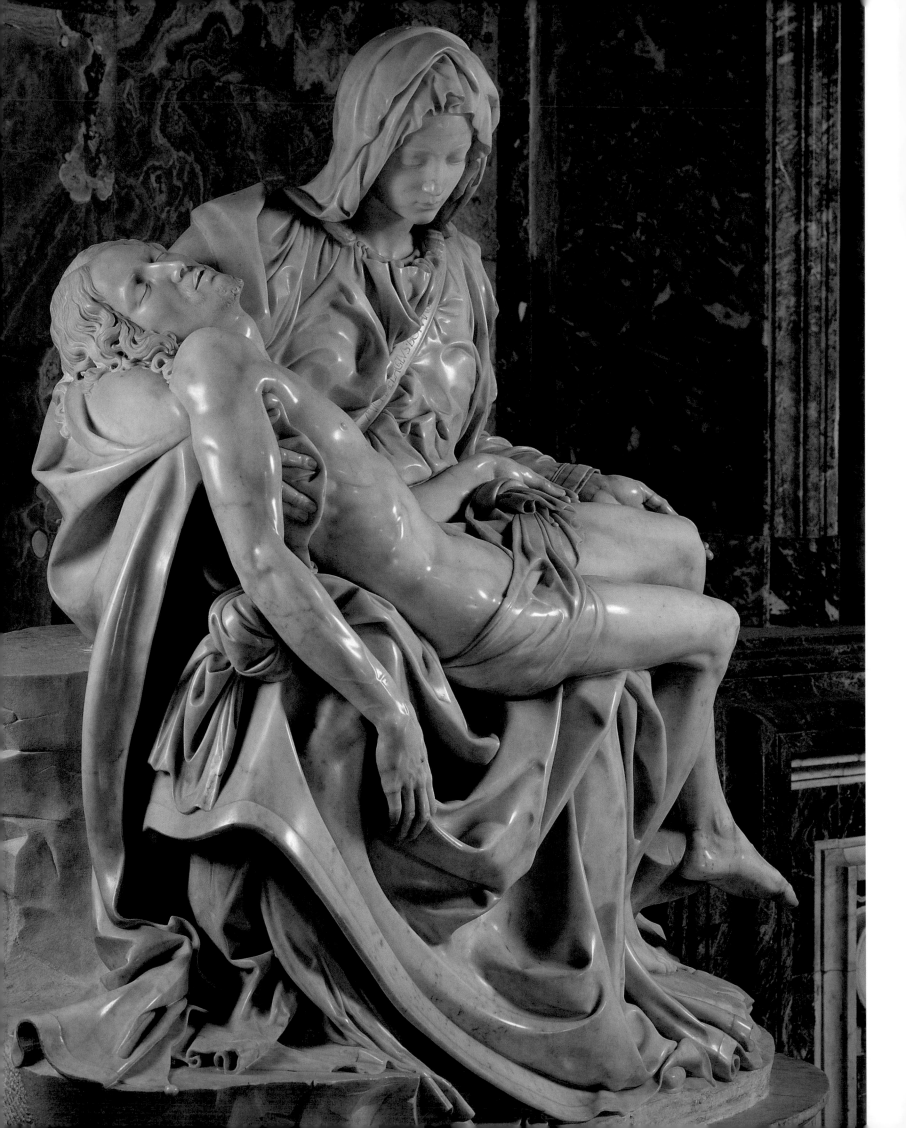

The Decoration, from Michelangelo to Gian Lorenzo Bernini

Michelangelo had imagined the interior of his Greek-cross construction without much decoration, the walls bare and distinguished only by their architectural features; however, this forceful and unitary concept, following Maderno's extension, rendered the vastness of the basilica too cold and austere. The decisive contribution – particularly the marble cladding of the columns and the sculptures in the nave – was that of Gian Lorenzo Bernini and his helpers. In decorating the inside surfaces of the columns along the nave, Bernini engaged, for the first time, the considerable number of forty-one collaborators, recruiting every sculptor then available in Rome. In cladding the columns he planned two pairs of white-marble putti, or cherubim, supporting oval medallions with portraits of the first fifty-six martyr-popes, from Saint Peter to Pope Benedict I. In the center, another pair of putti show the emblems of papal authority: keys, tiara, and books. It took a little more than one year to prepare 56 medallions, 192 cherubim, and 104 doves.

To the right upon entering the basilica, the first chapel that one encounters is that of the Pietà, so-called because it houses the famous sculpture by Michelangelo (figs. 24,25). Once, this chapel was dedicated to the Crucifix because it contained a wood sculpture of the dying Christ fixed to a marble cross, which may still be seen at the back of the chapel. It changed its name in 1749 when Pope Benedict XIV ordered that Michelangelo's Pietà be moved there from the chapel of the Choir. The decoration of the interior, the work of Giovanni Lanfranco, is in keeping with ancient tradition, which held that at the entrance of a church there had to be, if not actually a chapel with the crucified Redeemer, then at least a crucifix. This is the only chapel in the entire basilica to be decorated with frescos, which here have not been substituted by mosaics.

The Pietà sculpture was created by Michelangelo when he was still only twenty-three, for Cardinal Jean Bilheres de Lagraulas, abbot of Saint-Denis and Charles VIII's ambassador to Pope Alexander VI. The cardinal, who had commissioned the sculpture to decorate his own tomb in the old chapel of Saints Michael the Archangel and Petronilla, died a few weeks after the work was finished. Completed in 1499, the Pietà was immediately acclaimed as a masterwork, all the more extraordinary because the sculptor was so young. Michelangelo signed his full name on the ribbon falling from the left shoulder of the Virgin: MICHAEL ANGELVS BONAROTVS FLORENT(inus) FACIEBAT. As Benedetto Varchi recalled in his funeral oration for the artist, he was never to do so again on any of his other works.

Although it was one of his first works, the Pietà testifies to the full artistic maturity of Michelangelo, who purposely accentuated the youth of the Virgin in a clear break with the normal figurative tradition where Mary appeared well advanced in years. The Madonna, Virgin and Mother at one and the same time, conserves the immaculate youth of her face almost as an incarnation of the symbol of eternal life. Yet, in her absorbed silence she nonetheless expresses all her pain at the death of the son who is shown recumbent, almost weightless, upon her lap. The figure of Christ does not have the rigidity of a corpse, nor does it show the signs of the wounds with which realists portrayed him: his is the perfect humanity of God-Man, neither deformed by death nor disfigured by pain. The Pietà is the most complete and virtuous of Michelangelo's works, yet at the same time it is the most moving, borne up by heartfelt but serenely contained suffering.

At the end of the nave, upon a pedestal of precious marble and gilded metals placed against the pier of Saint Longinus, is the venerated bronze statue of Saint Peter. He is sitting on a marble *cathedra* and is wearing the philosophers' pallium. His left hand is clasped against his chest and holds the keys, while the right is raised in blessing. His right foot extends slightly beyond the base and has been worn smooth by the kisses of the faithful. The statue was once believed to be a fifth- or sixth-century work, but modern critical opinion holds almost unanimously that it dates from the thirteenth century and is to be ascribed to the school of Arnolfo di Cambio. Above the statue is a medallion with a mosaic portrait of Pope Pius IX. On June 16, 1871, he celebrated twenty-five years as pontiff, the first pope in history to reach that legendary anniversary. Only the apostle Peter had guided the church for such a long time, and a long-standing tradition had held that no one else would be conceded a reign lasting more than a quarter of a century.

Figure 24 (opposite)
Michelangelo Buonarroti, Pietà, 1499, marble, Saint Peter's Basilica

Figure 25
Pietà (detail)

Standing in the center of the building, under the dome, it is possible to admire the inside surface of the four great piers that support the dome: they are each forty-five meters high and have a perimeter of seventy-one meters. This was some of the first work done by Bernini in Saint Peter's, as he adorned each of the four great niches with a huge statue in Carrara marble. The statues, notable for their theatrical poses, are between 4.5 and 5 meters high and represent a visual celebration of the relics housed in the basilica (figs. 26-29). Above each niche is a loggia or balcony, with rich decorations that follow the same pattern on each pier. Lower down, two fluted lesenes frame two spiral columns taken from the Constantinian basilica. In the center, a marble bas-relief shows an angel holding the particular relic associated with each pier: The Holy Lance of the Roman centurion Longinus; The Head of Saint Andrew; Fragments of the True Cross found by the Empress Helena, mother of Constantine; and The Veil of Veronica.

At the center of the basilica, as if indicated and protected by the great dome, is the *confessio*, the site marking the tomb of Saint Peter. Covered in multicolored marble on the floor and walls, architecturally speaking it is the most important example of a hardstone mosaic to be executed in Rome during the seventeenth century, and the last work of such grandness and richness to be done using that technique. In 1615, Pope Paul V commissioned Carlo Maderno, the architect of Saint Peter's, to undertake the work, which was completed in 1618. The semicircular space is illuminated by eighty-nine perpetually burning lamps set in elegant glided-bronze cornucopias designed by Mattia de' Rossi. A small apse at the back of the frontal niche is covered with a mosaic dating from the ninth century (fig. 30). It shows Christ with his right hand raised in blessing, while in his left is an open book with the inscription: EGO SVM VIA, VERITAS ET VITA: QVI CREDIT IN MEVIVET (I am the way, the truth and the life, who believes in me will live). This image, precious for its symbolic value, probably dates from the time of Pope Saint Leo IV and was the only element from the Constantinian basilica to be replaced on Peter's tomb. The niche is known as the "nicchia dei Palli" because a bronze urn – donated by Pope Benedict XIV – contains the "palli" (*pallia*). These are strips of white wool 4–6 centimeters wide and decorated with six black crosses. They are made with the wool of two white lambs that are blessed on January 21 at the church of Saint Agnes on Rome's via Nomentana. The *pallia* are then blessed by the Pope on June 29, feast of Saints Peter and Paul, and given to new metropolitan archbishops as a distinctive liturgical vestment.

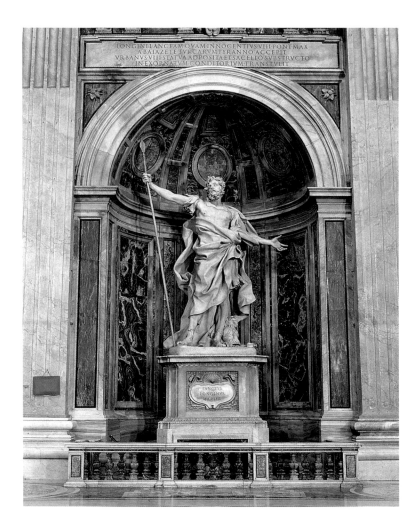

Figure 26
Gian Lorenzo Bernini, *Saint Longinus*, 1638, marble, Saint Peter's Basilica

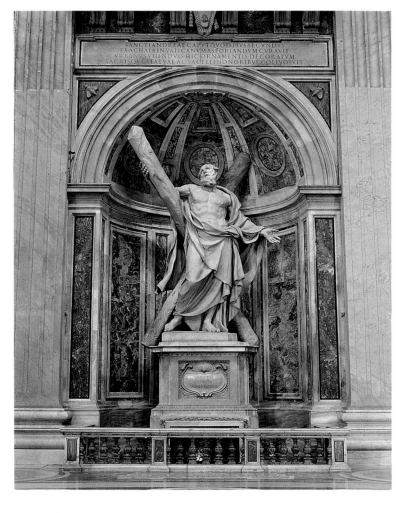

Figure 27
François Duquesnoy, *Saint Andrew*, 1640, marble, Saint Peter's Basilica

Figure 30
Nicchia dei palli, Saint Peter's Basilica

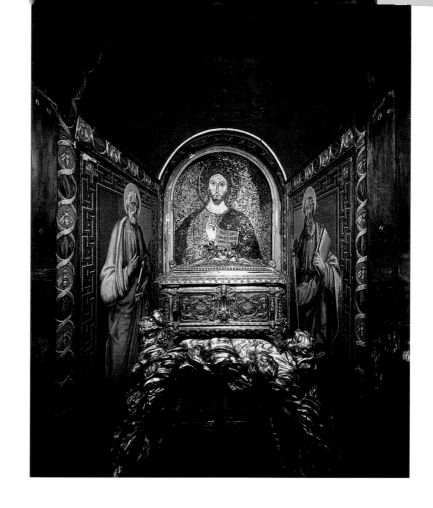

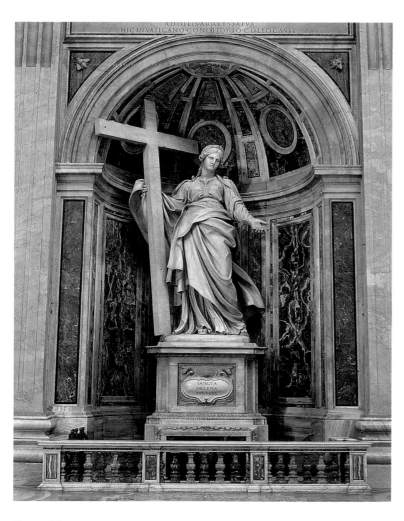

Figure 28
Andrea Bolgi, *Saint Helena*, 1640, marble, Saint Peter's Basilica

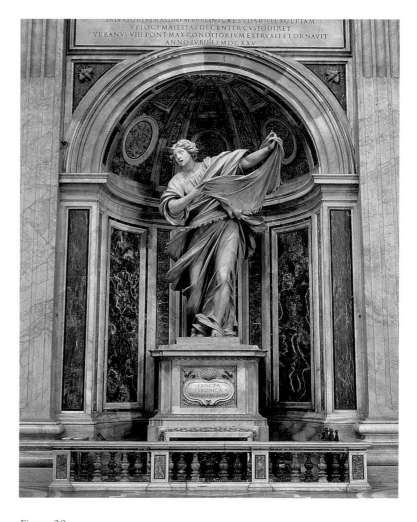

Figure 29
Francesco Mochi, *Saint Veronica*, 1640, marble, Saint Peter's Basilica

Above the *confessio*, at the top of a flight of seven steps in Greek marble, is the papal altar (fig. 31), built in vertical succession over the earlier altars of Pope Gregory the Great and Pope Calixtus II. It sits not directly below the center of the dome but slightly nearer the apse and faces east toward the rising sun as was common in paleo-Christian basilicas. This altar is reserved for the pope or someone delegated by him. It was commissioned in 1594 by Pope Clement VIII that there might be a fixed altar table in the part of the basilica that had already been completed. The surface of the altar rests on an architrave of Parian marble, 4.35 meters long and 2.1 meters wide. The four austerely decorated sides of the altar, as well as the moldings, are of *pavonazzetto* marble. Panels divided by tapering pilaster strips decorate the sides, three on each long side and one on each short side; above are eight-pointed stars in gilded metal, the heraldic emblem of Pope Clement VIII. At the center of the long sides is an inlaid trefoil cross of *giallo antico* marble, as in the altar of Pope Calixtus II. Pope Clement VIII consecrated the altar on Sunday, June 26, 1594, and celebrated the first mass three days later, on the feast of Saints Peter and Paul.

Prior to the construction of the present baldachino by Bernini, Pope Paul V had ordered that a wooden canopy, of the type used in processions, be placed over the altar. This canopy, the work of Ambrogio Buonvicino and Camillo Mariani, was nine meters high and supported by four angels made of painted plaster and papier-mâché. However, it was only a transitory solution, certainly not in harmony with the grandness of the basilica. Pope Urban VIII had been aware of this problem ever since his election in 1623 and, on July 12 of the following year, he commissioned Bernini to design a different and more imposing canopy, sparing no expense that the end result be worthy of its position and function. The artist recompensed the pontiff's faith by creating the greatest bronze structure in the history of Roman baroque sculpture, which, notwithstanding its unusualness and proportions (it is more than twenty-eight meters high), fits harmoniously into the vastness of the basilica. Indeed, the baldachino does not diminish but rather increases the sensation of depth of the interior; making the apse, framed between its columns, appear even further away as one enters the building. Bernini sought to create a pictorial rather than an architectural effect. Drawing inspiration from processional canopies, he imagined his work animated by folds of cloth giving the sensation of a light, almost provisional and mobile structure, an effect enhanced by the four slender spiral columns of gilded bronze supporting the canopy. Thus he managed to avoid the monotony that would inevitably have been produced by four smooth pillars of such a height. The columns are divided into three sections: the lower part has helical fluting, the next has laurel branches and bees, and then olive branches, putti, and lizards. This invites the gaze to move from one curve to another of the spiral and favors a dynamic and uplifting vision. At the same time the baldachino recalls ancient tradition as, following Pope Gregory the Great, spiral columns were used to divide the tomb and the presbytery from the rest of the basilica, the same columns that were later used by Bernini to decorate the Loggia of the Relics.[8] The bronze columns of the baldachino, resting upon marble pedestals decorated with the coat of arms of Pope Urban VIII, are topped with elaborate composite capitals. Above this are four dados with radiant faces in relief (another emblem of the Barberini family) and then an elaborate entablature. Ornamental scrolls ascend from the four corners, meeting at the top of the baldachino where they support a globe surmounted by a cross. Earlier plans had envisaged a statue of the Savior triumphant in this position, but the idea was abandoned because it was felt to be too heavy for the wooden framework of the canopy. Four angels bearing floral

Figure 31
Papal altar, Saint Peter's Basilica

Figure 32
Giuliano Finelli, *Angel bearing a Garland*,
bronze baldachino, Saint Peter's Basilica

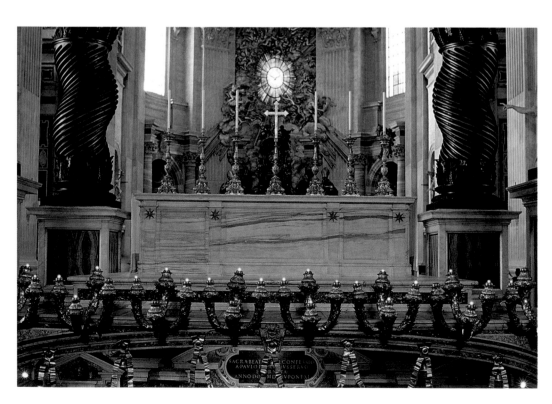

garlands may be seen at the corners, the work of Andrea Bolgi, Giuliano Finelli (fig. 32), and François Duquesnoy. Eight putti bear the keys and tiara of Saint Peter, and the sword and book of Saint Paul.

On June 29, 1627, feast of Saints Peter and Paul, exactly three years after the plans were approved, the bronze columns were unveiled to the public. Six years later, on June 29, 1633, the completed baldachino was inaugurated, although finishing-off work lasted until 1635.

Before looking up to the dome, one's attention is naturally drawn to the decorations against the back wall of the nave, in the apse where, flanked by two great pillars of African marble taken from the Constantinian basilica, and as if framed by the bronze columns of the baldachino, is the monument to the *cathedra Petri*, the chair of Saint Peter. This monument is an immense bronze structure enclosing a wooden *cathedra*, or chair, decorated with plaques of engraved ivory representing the labors of Hercules. An ancient tradition holds that Saint Peter himself sat on the chair to preach. However, the archaeologist Giovan Battista De Rossi – who examined the chair in 1867, the second centenary of the construction of the monument and the last time the relic was displayed on the altar of the Gregorian chapel – concluded that only the framework of acacia wood dated from paleo-Christian times, while the ivory plaques and the parts made of oak, fixed to the frame with metal strips, belonged to the Carolingian period.

On February 6, 1656, the Congregation of the Reverenda Fabbrica, at the express wish of Pope Alexander VII, ordered the chair be transferred from the Baptistery to the apse and, on March 3, 1657, Gian Lorenzo Bernini's project for the new altar was authorized. The execution of the project involved thirty-five collaborators and, after various changes, was concluded on January 16, 1666. Bernini, inspired by other baroque constructions, created a mobile and fluid composition that decorates rather than overwhelms the structure of the building. The ancient wooden *cathedra* is enclosed within another gilded-bronze chair seven meters high, the lower part of which is decorated with a floral design by Giovanni Paolo Schor. The back and the two sides have bas-reliefs by Bernini: the *Pasce oves meas* (feed my sheep) on the back, the washing of the feet on the right, and the consignment of the keys to Saint Peter on the left, all important episodes that affirm Peter's primacy. The throne is supported by four bronze statues representing Fathers of the Latin and Greek Church. The huge figures, 5.35 meters high, are wearing gilded vestments while their faces and hands are bronze colored. The pedestal on which they stand is made of black and white French marble and Sicilian jasper, and is decorated with two bronze coats of arms of Pope Alexander VII who commissioned the work. At the front and representing the Latin Church are Saint Ambrose, on the left, and Saint Augustine, on the right. Behind, Saint Athanasius to the left and Saint John Chrysostom to the right represent the Greek Church. The enormous bronze *cathedra*, covered in arabesques and gold embossing, is flanked by two standing angels and surmounted by two putti holding the emblems of papal authority: the tiara and keys. Above, Bernini exploited the light from the central window of the apse, making it the epicenter of a glorious and turbulent mass of angels and putti who fly amidst clouds and thunderbolts around the stained glass image of the Dove of the Holy Spirit (fig. 33). A typical example of baroque decoration, the monument also expresses a sublime theological concept: the churches of East and West, united in the faith of the Catholic Church, pay homage to the Roman *cathedra*.

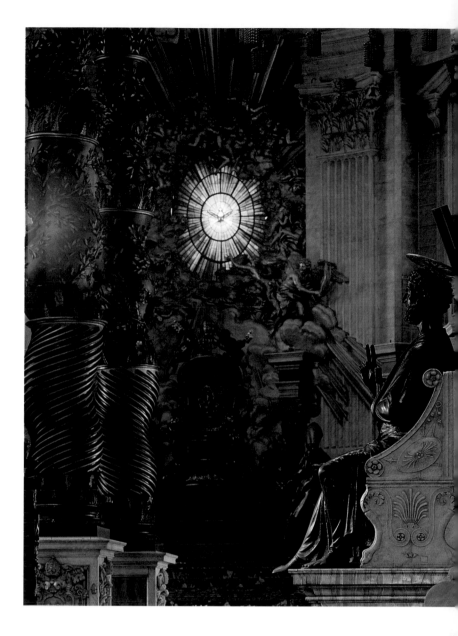

Figure 33
Bronze statue of Saint Peter with the *cathedra Petri* in the background

Figure 34 (overleaf)
The great dome seen from within the *confessio*

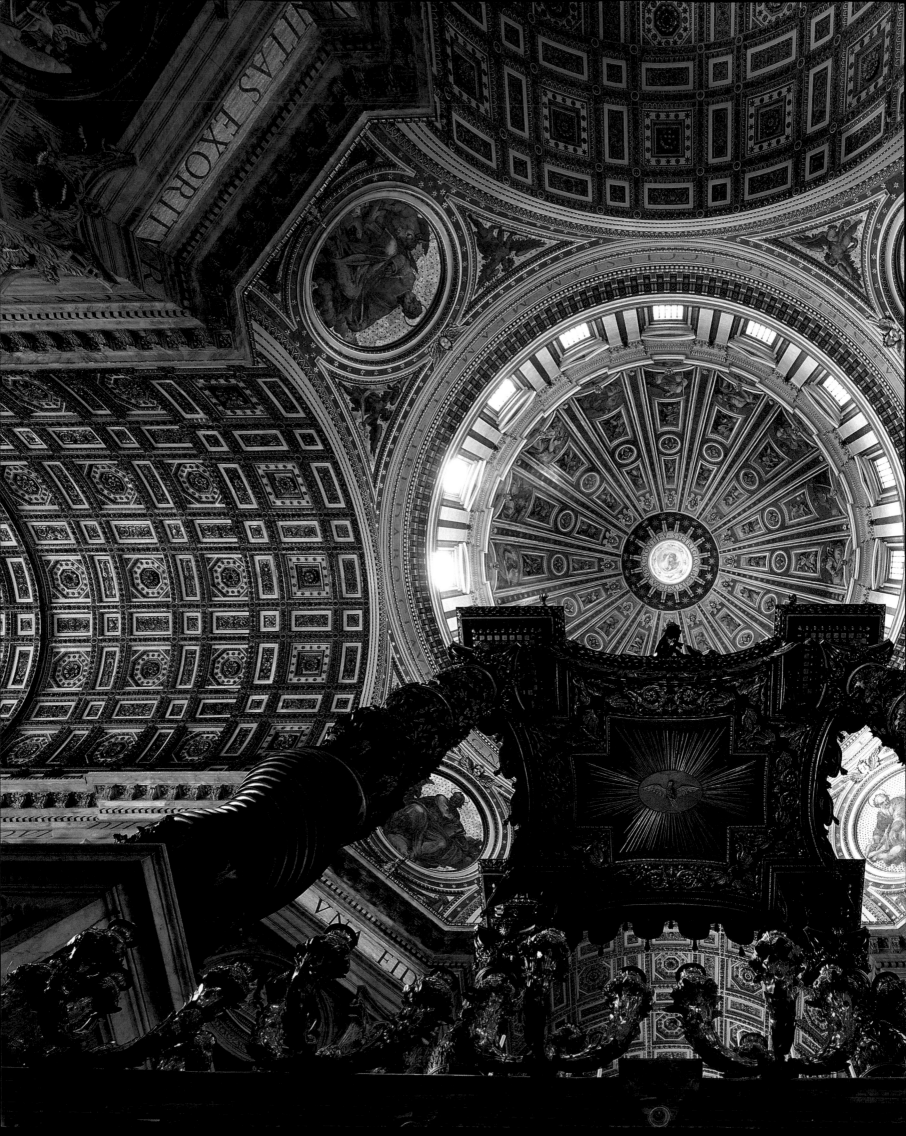

Above everything else is the great dome, reaching up to the sky as an architectural and symbolic seal to the entire basilica. The internal surface is formed by sixteen segments, each divided into six sections, giving a total of ninety-six figures in trapezoidal and round backgrounds. In the luminous eye of the lantern, surrounded by eight angel heads, is God the Father. Next, in three concentric rings, is a choir of angels, the depiction of which was inspired by the *De coelesti Hierarchia* of Dionysius the Pseudo Areopagite. The seraphim, in the ring nearest the throne of God, are made of stucco with gilded heads and white wings. A ring of adoring angels separates them from the cherubim, who have gilded heads surrounded by six blue wings in a gilded background covered with stars. Additional angels may be seen, in prayer and supported by clouds; three display the symbols of the passion. By the glory of God the Father, this church of pure spirits is associated with the Church of the World, at the head of which is Christ, Man-God, king, and judge, assisted by the Virgin Mother and Saint John the Baptist. Next to them are Saint Paul and the Twelve Apostles. Between the lunettes are half-length portraits of patriarchs and bishops. On the upper ring, the following inscription appears, surrounded by thirty-two gilded stars on a blue background: S. PETRI GLORIAE SIXTVS PP. V A. MDXC PONTIF.V (To the glory of Saint Peter. Pope Sixtus V in the year 1590, fifth of his pontificate). The inscription was ordered by Pope Clement VIII in memory of Pope Sixtus V, his predecessor and the patron of the building of the dome. On the inside ring at the base of the dome is a mosaic inscription that recalls and perpetuates Jesus's words to Peter: TV ES PETRVS ET SVPER HANC PETRAM AEDIFICABO ECCLESIAM MEAM (You are Peter and on this rock I will build my community).

Notes

1. A famous Roman historian of the second half of the first century AD, author of the *Annals* (the passage concerned appears in XV, 44). Prior to Tacitus, Pope Clement I also mentions the ferocious persecutions, highlighting the leading role of the apostles Peter and Paul, and their importance in the Christian community at that time (*Epistulae ad Corinthos* 1, 5–6).
2. Even today, when the Tiber is low, the remains of a bridge, known by its late medieval name of *pons Neronianus*, appear above the water.
3. The results of the archaeological and scientific studies ordered by Pope Pius XII in 1940 and completed ten years later are to be found in A. Ghetti et al., *Esplorazioni sotto la Confessione di San Pietro in Vaticano*, Vatican City State, 1951.
4. "I can show you the trophies of the Apostles. If, indeed, you wish to go to the Vatican or along the road to Ostia, you will find the trophies of those who founded this Church" (*Historia ecclesiastica* 2, 25, 6-77).
5. In Greek, *tropaion* means victory monument, victory over death through the martyr's faith. Within the basilica, Peter's grave is indicated by the term *Confessione* (from the Latin *confiteri*, to profess, bear witness). The apostle professed and witnessed his faith in God, even unto martyrdom.
6. In a tradition going back to early Christianity, the iconographic significance of this animal is meant to recall the words of the evangelist Mark: "So stay awake, because you do not know when the master of the house is coming, evening, midnight, cockcrow or dawn; if he comes unexpectedly, he must not find you asleep" (Mk 13:35–36). At the same time, it is difficult not to associate it with Peter's betrayal and his repentance.
7. A detailed study of the basilica of Constantine may be found in S. De Blaauw, *"Cultus et Décor." Liturgia e architettura nella Roma tardoantica e medievale*, Vatican City State, 1994.
8. The bibliography on Saint Peter's Basilica is immense and is given almost in its entirety in the most complete study to date, A. Pinelli, ed., *La Basilica di San Pietro in Vaticano*, Mirabiliae Italiae, Modena, 2000.

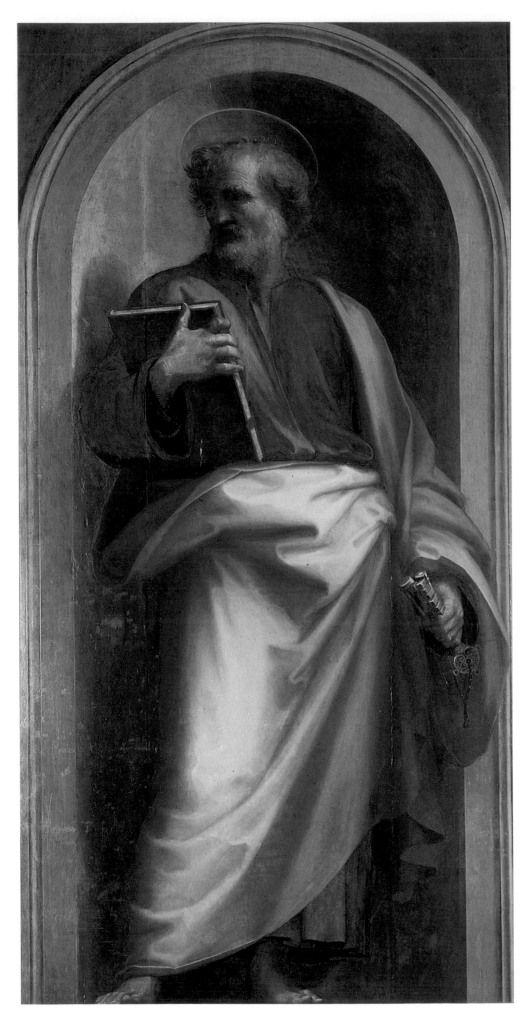

Death, Burial, and Election of the Popes

Charles Hilken, F.S.C.

Cum autem senueris, extendes manus tuas, et alius te cinget, et ducet quo tu non vis. ("*when you grow old you will stretch out your hands, and somebody else will put a belt round you, and take you where you would rather not go,*" Jn 21:18).

Saint John preserved for us an intimate and very human moment in the friendship between our Lord and Saint Peter. Jesus warned Peter that he would grow old and one day be led where he would not want to go. This, of course, was of small import in the face of the great commissioning in love (Jn 21:15-17), confirmed around the glowing embers of the campfire at the Sea of Galilee. Jesus made Peter's profession of love for him a gentle but insistent call to serve the church. What did it matter how he would end his days? Yet almost forty years later, on the eve of his martyrdom, did Peter recall the dialogue by the lake? It is edifying to think that he did and that Jesus' words are an echo from Peter at Rome. The apocryphal Acts of Peter preserve the story of Peter meeting Christ on the road as the one was fleeing Rome and the other entering the city to die once more for the church. Peter's decision at that moment to remain in Rome and risk his life to serve the Christian community is another evocation of the great charge that Jesus had given him by the lake.

The Petrine ministry is the source of legitimacy and the model for the papal ministry. The popes walk in the shoes of Peter, who followed Jesus in everything, and each remembers his own response to Jesus' call to serve his flock. It must be an added source of comfort and strength that the popes, most of them old men at their death, could think of Peter as old, like themselves, when he faced the moment of death. Whether it is the warmth of a grandfatherly smile or the stern visage of the wise old judge, it is the face of an elderly man that we see most often when we call to mind his holiness, the pope (fig. 1). The image is very much true to the historical record. The church usually elects a man who has demonstrated leadership over many years. Pope Gregory the Great considered fifty to be a good age to take up leadership in the church. He borrowed an image from the Book of Numbers (8:24-26), where, at the age of fifty the Levites begin to care for the vessels in the tent of meeting. Gregory saw that custom as prefiguring the ordination of priests, who are "the custodians of the vessels, since they become doctors of souls" (*Dialogues* 2, 2). And, so, the pontifical ministry is perforce relatively brief. The average span of service in the history of the papacy is little more than seven years. Of the twentieth-century popes, the youngest was fifty-eight; the average age at election, sixty-six; and the average reign, twelve years.

Popes die alone, without the comfort of family and loved ones around them in their last moments. Their passing, like their years of service, is a kind of martyrdom, or persistent confession of faith in the promises of Christ. Modern popes live according to the rigorous demands of their public ministry, keep to a regular regime of prayer and liturgy, and die in remarkably simple surroundings within the sixteenth-century papal palace. Even in death, popes lead the faithful by example in their following of Jesus along the road to Calvary. One contemporary scholar has argued recently that the medieval papacy deliberately cultivated symbols and rituals that reminded both pope and church of the transience and fragility of papal lives to underscore God's hand in the maintenance of the papal office. Many such symbols and rituals have lapsed. For example, the body of the deceased pope is no longer set out for display, unclothed and unattended, a practice noted by the Franciscan friar Salimbene in the thirteenth century (*The Chronicle*, 425-26). Nor does a minor cleric go before the new pope on the day of his elevation, holding burning rags and saying "sic transit gloria mundi" ("so passes worldly glory"), as a reminder of mortality.

Figure 1
Fra Bartolomeo and Raphael, *Saint Peter*,
Papal Apartments, Vatican City State

Today papal funerals have a simple yet solemn dignity. They communicate the surpassing worth of the human person, the great dignity to be found in death, and, of course, the promises of the faith. The papal funeral rite is found in the *Ordo exsequiarum summi pontificis vita functi* (1978). The prayers and rubrics are consistent with the general rite of Christian burial, with the added call to Christians everywhere to prayerful recollection of the universal church.

Upon word of the pope's death, the cardinal camerlengo certifies death through a medical examiner. (As recently as 1903, at the passing of Pope Leo XIII, the camerlengo himself verified death by striking the head of the corpse with a hammer. With this same hammer, the camerlengo would smash the pope's ring, thereby signaling the end of that pope's authority.) The body is then dressed in red liturgical garments and miter, and moved to the audience hall for viewing by the papal household. The cardinals present offer a prayer, which states, in part, "Lord, we humbly commend to you your servant our pope, whom you accompanied always with immense love. May you now command that he enter into eternal peace,

Figure 2
Tomb of Pope Nicholas V,
Vatican Grottoes, Saint Peter's Basilica

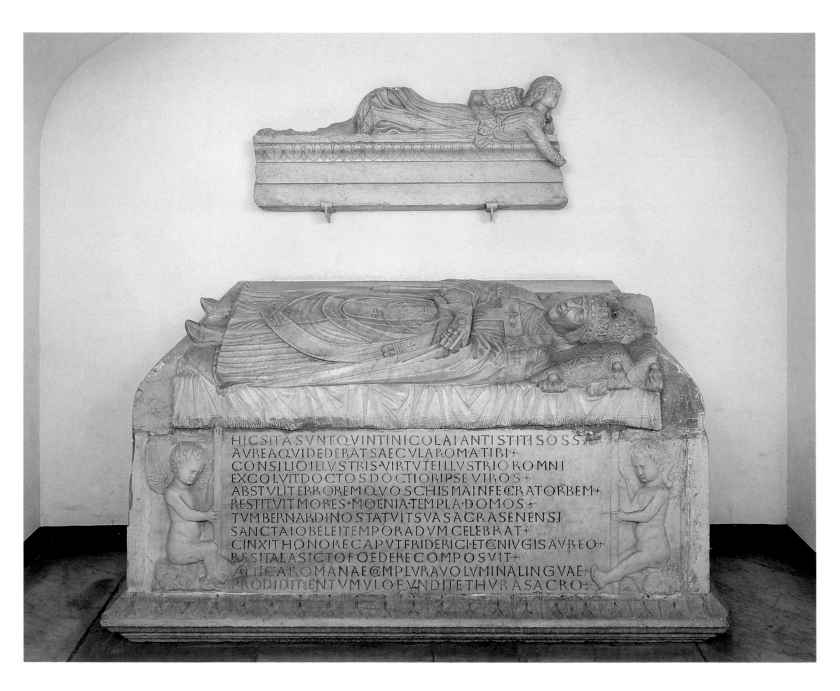

freed from every evil" (*Ordo exsequiarum*, 11). A series of readings follows, among them a passage from the dogmatic constitution on the church in the modern world, *Gaudium et Spes* (18, 22), which extends the hope of salvation to all, Christians and non-Christians alike: "[Eternal life] is valid not only for the faithful of Christ, but also for all men and women of good will in whose heart grace is working in an invisible manner" (*Ordo exsequiarum*, 11).

The body is then carried in a formal procession to the Basilica of Saint Peter. At the entrance, cantors sing a litany of the saints, including Mary, the apostles, popes, fathers and doctors of the church, missionaries, pastors, and men and women dear to the church at Rome, and prayers are recited to ask God to relieve the world of its many ills, plagues, hunger, and war, and to bestow upon all people peace and true concord. Given the international ministry of the papal office, the very public-minded intentions of the funeral rite are not surprising. The theme of world unity has been greatly promoted by Pope John Paul II, just as it was at the beginning of the last century by Pope Leo XIII, whose epitaph at the Lateran basilica attests to the international respect he had been given: *Ad patriam fili ex omni regione veneraturi conveniunt. Ecclesia ingemuit complorante orbe universo* (Sons come home from every region to give reverence. The church moaned when all the world mourned).

Throughout the prayers and readings are moments of recollection for the church and the world, and all are invited to remember our common humanity and our common ideals of renewal, justice, peace, fraternity, and liberty. The universal mission of the church and the divine commissioning of the Petrine office are the themes of the biblical readings at the funeral mass. The readings from the Apocalypse, Acts of the Apostles, and Gospel of John tell of the vision of a new heaven and earth, the preaching of Peter, and the risen Christ's three-fold question to Peter about love. The message of church unity is struck at the final blessing and commendation of the body, when a patriarch of the Eastern church offers a supplication for the pope, who then is remembered as vicar of Peter and pastor of the church.

The body is buried in the crypt (fig. 2), near the Tomb of the Apostle, in a private ceremony attended by a few select cardinals, canons of the basilica, and family relations of the pope. The burial and decoration of the tomb follow any instructions made by the late pontiff in his last will and testament. This is an ancient, but not universal, custom. Popes have been buried also in the catacombs, at the cathedral church of Saint John Lateran, at Saint Mary Major, and other churches inside as well as outside the city of Rome. The last two popes buried away from Saint Peter's were Pope Pius IX, whose remains are at San Lorenzo fuori le mura, and Pope Leo XIII at the Lateran. There are forty-nine extant papal tombs or epitaphs at Saint Peter's, and historical records of another ninety-nine papal burials of which all physical remains have disappeared.

The funeral rites last nine days, and daily mass is celebrated for the repose of the soul. At the same time, preparations begin for the conclave to select the next pope. The papal election is carefully governed by the apostolic constitution, *Universi dominici gregis: On the Vacancy of the Apostolic See and the Election of the Roman Pontiff* (1996), and the rubrics of the *Ordo sacrorum rituum conclavis*, which are the product of almost two thousand years of practice with much trial and error. Indeed, the process is surely the oldest continuous electoral tradition in the world. The new pope steps into a position that he has not sought and which, one can only imagine, he approaches with some apprehension. (The vesting room for the newly elected pontiff is known as the "little room of tears"; fig. 3) The next pope will be the 264th successor to Peter as bishop of Rome, vicar of Christ, and pastor of the universal church. The election gives an added dimension to the significance for any pope of Jesus' final admonition to Peter that he will be taken where he would rather not go.

Popes are elected. The transition of institutional authority in the absence of a supreme authority or a natural right of succession can be determined either by election or by lot. The church of the Apostles in Jerusalem used the casting of lots to decide between Matthias and Barsabbas. Though historians argue cautiously that episcopal authority developed gradually over the first century and a half after Saint Peter, the Roman church, it seems, always elected its leaders. The earliest historical records take for granted that the church, whether in its assembled priests, elders, or brethren, would meet to deliberate over and choose the next pope. Candidates emerge by virtue of their personal merits; they neither promote themselves nor are promoted, and are not taken from a preselected pool. Pope John Paul II, in his apostolic constitution on the election of a pope, gave a sense of the immediacy and openness of the election in his exhortation to the electors who, "having before their eyes solely the glory of God and the good of the church, and having prayed for the divine assistance, … shall give their vote to the person, even outside the College of Cardinals, who in their judgment is most suited to govern the universal church in a fruitful and beneficial way" (*On the Vacancy of the Apostolic See*, 83).

Figure 3
"The Little Room of Tears," Antechamber to the Sacristy of the Sistine Chapel

The current process emerged during the first centuries of the second century. The eleventh-century popes, to safeguard against venality, identified the cardinal bishops and cardinal clerics of Rome as the leading voices in electoral deliberations. These men were the chief liturgical and pastoral assistants in Rome. They became, in the eleventh-century papal reforms, the representative body of the Roman church in the election of the popes. A century later, the Third Lateran Council (1179) established that a two-thirds vote of the cardinals was necessary for election, thereby creating an exclusive electoral body. The secret ballot also entered into common use at this same time. The Second Council of Lyons (1274) mandated that the cardinals deliberate behind locked doors. This type of electoral meeting, known as a conclave, was modeled after practices in the new municipal governments of the Italian city-states. In subsequent centuries the papacy would refine the election process to protect against abuse, outside interference, or prolonged delay.

One of the last major modifications to the electoral process was the abolition, a century ago, of the right of veto granted to the Catholic rulers of Europe. It had been an accepted practice for cardinals to represent their national churches and, therefore, to announce in conclave that a particular

Figure 4
Girolamo Muziano, *The Descent of the Holy Spirit*,
ceiling of the Second Hall of Vestments, Apostolic Palace

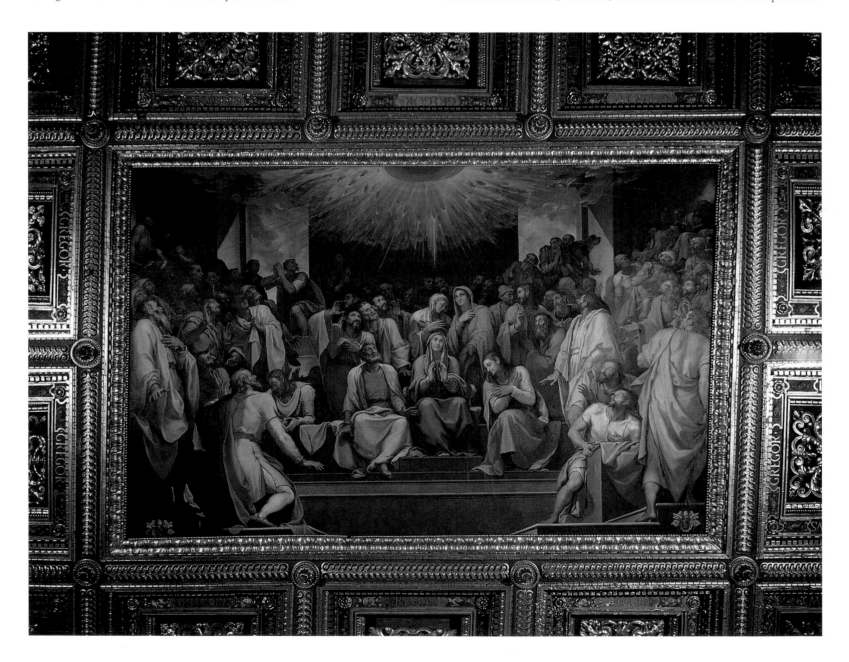

candidate would be an unwelcome choice back home. The principle was an ancient one that saw the state as a divinely ordained institution at work for the edification of the church. Emperors and kings, much like King David of old, were anointed ministers working in tandem with the bishops in the preservation and promotion of Christianity. The last known exercise of the right of veto was in 1903, during the conclave after the death of Leo XIII. A cardinal speaking for Emperor Franz Joseph let it be known that the late Pope Leo's secretary of state, Cardinal Rampolla, would be unacceptable in the empire because of his perceived bias against the Central European powers. Pope Pius X, during his first year in office, abolished the veto in the apostolic constitution, *De civili "veto" seu "exclusiva" uti vocant in electione summi pontificis* (1904). He argued that the veto impeded rather than corresponded to the votes of the electors, and that changing times had made the influence of civil power in church affairs devoid of reason and equity. The force and eloquence of the pope's arguments were all the greater given that he had been a participant and was elected in the conclave of 1903.

Pope John Paul II is the fifth pontiff of the last century to reissue the rules for the conclave, and the next one will follow rubrics that conform to his apostolic constitution. Some major changes include the abolition of election by unanimous acclamation *quasi ex inspiratione* ("as if by inspiration") and the abolition, also, of election *per compromissum*, or arbitration by a small committee of electors in conclaves where there has been almost two weeks of deadlock. Pope John Paul II has reasoned that election *per compromissum* lessens the responsibility of the individual electors. Another change will be the use of the *Domus Sanctae Marthae* to house the cardinal electors, who will commute daily to the Sistine Chapel, no longer under lock and key, but sworn to secrecy and out of communication with the world all the same. The daily commute will end the long practice of sealing the doors of the Apostolic Palace throughout the conclave. It will be the end of an era that stretches back to the winter of 1272, when the laity locked the electors within the conclave hall, then removed the roof, and restricted the meals to bread and water, exposing the cardinals to cold and hunger until they could end a three-year electoral impasse following the death of Clement IV.

There is a simple elegance about the election rules. No more than twenty days may pass after the death of the pope before the beginning of the election conclave. Every cardinal younger than eighty at the time of the pope's passing is entitled to vote and must proceed, by virtue of obedience, to Vatican City. Pope Paul VI established that there can be no more than one hundred and twenty cardinal electors, though the present pontiff has superseded that number. On the morning of the start of the conclave, the cardinals celebrate a solemn mass for the election of the Saint Peter's. In the afternoon they gather in the Pauline Chapel of the Apostolic Palace (fig. 4) and then process into the Sistine Chapel, site of all but five conclaves since the end of the fifteenth century (fig. 5). Pope John Paul II's stated reason for continuing to use the Sistine Chapel is that there "everything is conducive to an awareness of the presence of God, in whose sight each person will one day be judged" (*On the Vacancy of the Apostolic See,* introduction), which is a lovely tribute to the artistic and religious genius of Michelangelo and his predecessors who designed and decorated the chapel.

The first afternoon is occupied with the swearing of oaths of perpetual secrecy and the reading of rules. The election begins the next morning and continues until the electors have chosen a candidate by a two-thirds majority. The voting is done without speech or debate. Each cardinal receives a ballot and inscribes a name. Each approaches the altar, one by one, and drops his ballot into a urn, saying aloud the following oath: "I call as my witness Christ the Lord who will be my judge, that my vote is given to the one who before God I think should be elected" (*On the Vacancy of the Apostolic See,* 66). The vote is counted, and if a two-third's majority has not been attained, balloting continues, twice in the morning and twice in the afternoon, day after day, until a candidate has been elected. The electors are

Figure 5
The Sistine Chapel prepared for the election of Pope Benedict XV, 1914

authorized to act as a committee of the whole after thirty-three ballots and no election. The camerlengo must invite the electors to express their opinion about how to proceed, and after the discussion, by a majority vote, the cardinals can opt either to reduce the number of votes needed to an absolute majority or restrict the vote to the two names which in the ballot immediately preceding have received the greatest number of votes. Ballots are burned twice a day, at the end of the morning and again in the afternoon. Following the successful election, a chemical is added to the burning ballots that turns the smoke pure white, which signals to the assembled faithful in Saint Peter's Square that the announcement of the new pope is imminent.

The man elected, assuming that he is present, is approached immediately after the balloting and asked to accept. As soon as he accepts he is asked by what name he wishes to be called. In a little antechamber of the sacristy of the Sistine Chapel the newly elected vests in a white papal soutane, which has been especially prepared in three sizes. He reenters the Sistine Chapel and sits in a chair before the altar and receives a formal act of homage and obedience from each of the electors in order of their status in the College of Cardinals. Afterwards the new pope blesses the people from the Loggia of Benediction in the facade of the basilica (fig. 6). The senior cardinal deacon introduces the pontiff to the city and the world with the words: "Annuntio vobis gaudium magnum; habemus Papam" (I announce to you a great joy; we have a pope).

The rubrics governing the conclave teach the faithful three things about the election of the pope, namely, that the electors stand in judgment before God in the work that they do; that the Holy Spirit operates through them to ensure the continuation of the redemptive ministry of the church in the world; and that, in a certain manner, the universal church is gathered together in the conclave, much like the first church at Pentecost, gathered with Mary, the Mother of God. This last lesson was the special emphasis of Pope Paul VI, which Pope John Paul II has preserved in his own apostolic constitution. The beauty and import of Pope Paul's exhortation is clearly seen in comparison to the text upon which it expanded.

Figure 6
Pope John XXIII blessing the crowds from the Loggia of Saint Peter's Basilica on the day of his coronation, 28 October, 1958

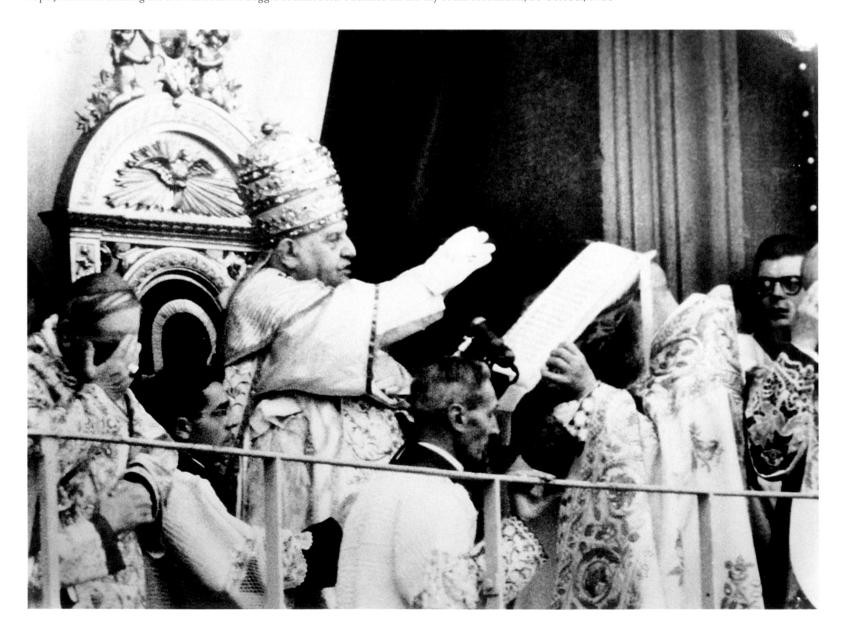

Exhortation to universal prayer by Saint Pius X, Pius XII, and Blessed John XXIII:

Since, moreover, the faithful ought not to be driven so much by the aid of human industry or even worry, but rather ought to hope in humble and devout prayer, to this end we lay down that in all cities and other places, at least the more important ones, as soon as news is received of the death of the pontiff and solemn funeral rites are celebrated for him by the clergy and the people every day (meanwhile there will have been provision for the Roman church concerning its pastor), there be humble and persevering prayers offered to the Lord, so that he may so effect the hearts of the cardinals in electoral concord, so that a swift, unanimous and useful course be followed, insofar as the salvation of souls and the utility of the whole world require. (Constitutio de sede apostolica vacante, 104)

Exhortation to universal prayer by Paul VI and John Paul II:

During the vacancy of the Apostolic See, and above all during the time of the election of the Successor of Peter, the Church is united in a very special way with her Pastors and particularly with the Cardinal electors of the Supreme Pontiff, and she asks God to grant her a new Pope as a gift of his goodness and providence. Indeed, following the example of the first Christian community spoken of in the Acts of the Apostles (cf. 1:14), the universal Church, spiritually united with Mary, the Mother of Jesus, should persevere with one heart in prayer; thus the election of the new Pope will not be something unconnected with the People of God and concerning the College of electors alone, but will be in a certain sense an act of the whole Church. I therefore lay down that in all cities and other places.... (On the Vacancy of the Apostolic See, 84)

Figure 7
Lello Scorzelli, *Pentecost: The Descent of the Holy Spirit in the Supper Hall of Jerusalem*, 1967, bronze, Collection of Modern Religious Art, Vatican Museums

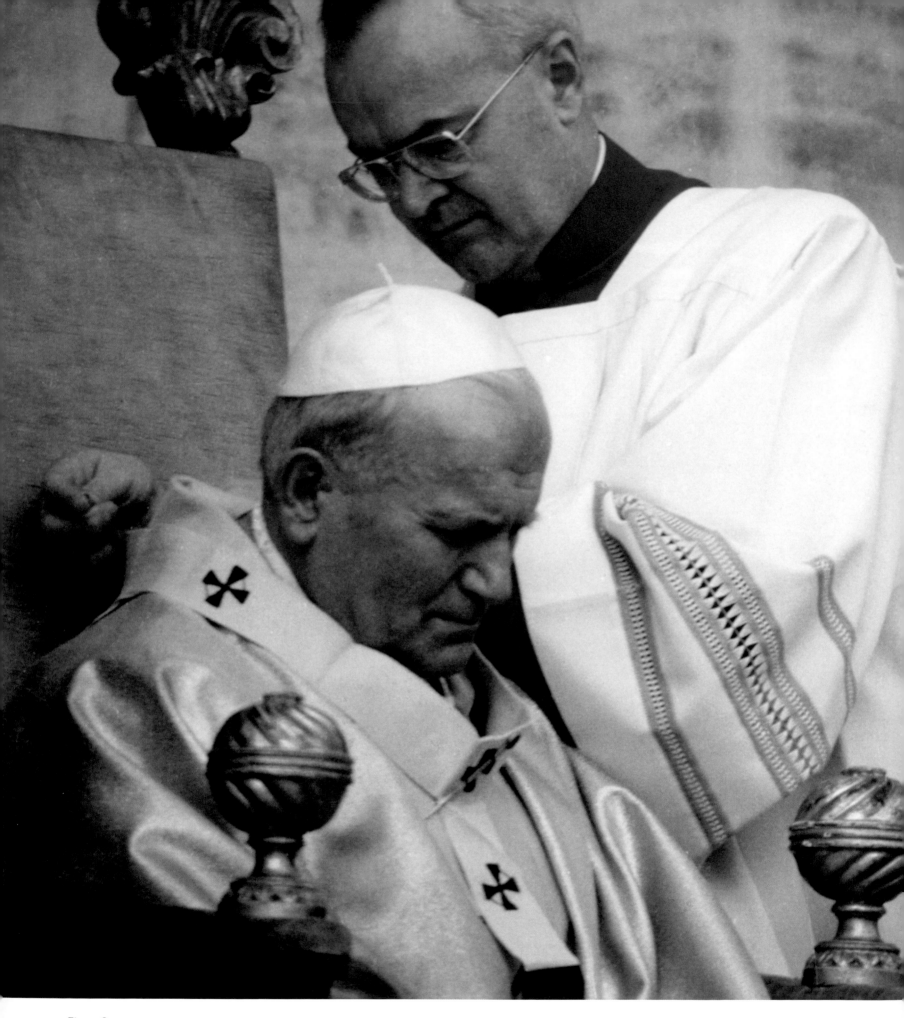

Figure 8
Pope John Paul II receiving the pallium at the ceremony marking the beginning of his pontificate

Pope Paul's evocation of Pentecost as a proper image for the church at work in the election of the pope was a continuation of the Pentecost theme so prevalent in the wake of the Second Vatican Council and captured so beautifully by the artist Lello Scorzelli in his bronze bas-relief *Pentecost*, completed in 1967, in memory of the council (fig. 7). The work of conclave, council, and church is all one, the continuation of the Gospel message of redemption and peace to a waiting world.

The newly elected's ministry as pope begins immediately upon his consent to the election. The solemn inauguration and the ritual possession-taking of the Lateran basilica that follow are symbolic of the pope's consecration to the Petrine ministry. The pope is bishop of the church in Rome and pontiff of the universal church, who visibly represents Jesus, the unseen pastor, who leads the church and world to salvation. In both these offices, the pope continues the pastoral leadership of the earliest apostles, especially Peter and Paul in Rome, and ultimately Peter as the one to whom Christ entrusted the duty of acting as visible head of the church on earth.

The inauguration ceremonies are occasions for blessing the new pope and bestowing upon him the insignia of office. Formerly known as the papal coronation, since the time of Pope Paul VI the ceremonies have been called the "Celebrations for the Start of the Ministry of the Universal Pastor of the Church." In Saint Peter's Basilica, the new pontiff presides at a mass in which he receives a pallium (fig. 8), a miter, and a pastoral staff. Popes no longer receive the tiara, or conical headdress with three crowns, which can still be seen as part of the papal coat of arms. In a more ancient ceremony, after the mass the pope would proceed outside the basilica where the archdeacon would place a tiara on his head as a sign of the universal authority of the papacy. The borrowing of the word tiara from the Vulgate (Ex 29:5-6), where it was used to describe the headpiece worn by the high priest in ancient Israel, betokens its liturgical origin. By the second millennium, however, the tiara had lost its liturgical function and become the distinctive sign of the pope as universal pastor. The gradual addition of one, then two, and finally three crowns reflected the development of the doctrine of the relationship between the church, with the pope as its visible head, and civil society. The triple crown signified that the pope represents Christ, whose message of redemption is good for all forms of earthly authority — spiritual, royal, and imperial — and that Christ is ultimately lord of all. The tiara, therefore, is a symbol of Christ's victory on the cross. Popes in our own time have retired it, perhaps because of the confusion of symbols of worldly glory and Christian salvation. Crowns no longer speak to contemporary society of God's ordering all things, nor are kingship and empire understood as ministries ordained to serve society. Instead of the tiara, Paul VI chose a cloth miter decorated with the symbols of the four Gospels as a sign of the papal office. John Paul II will most often be remembered standing erect, bearing the silver shepherd's staff made into the cross of Christ, and, in his later years, leaning upon the same for support. Symbols will change, but the reality remains the same. The popes stand in the place of Peter and must give the same proof of love, "Feed my sheep."

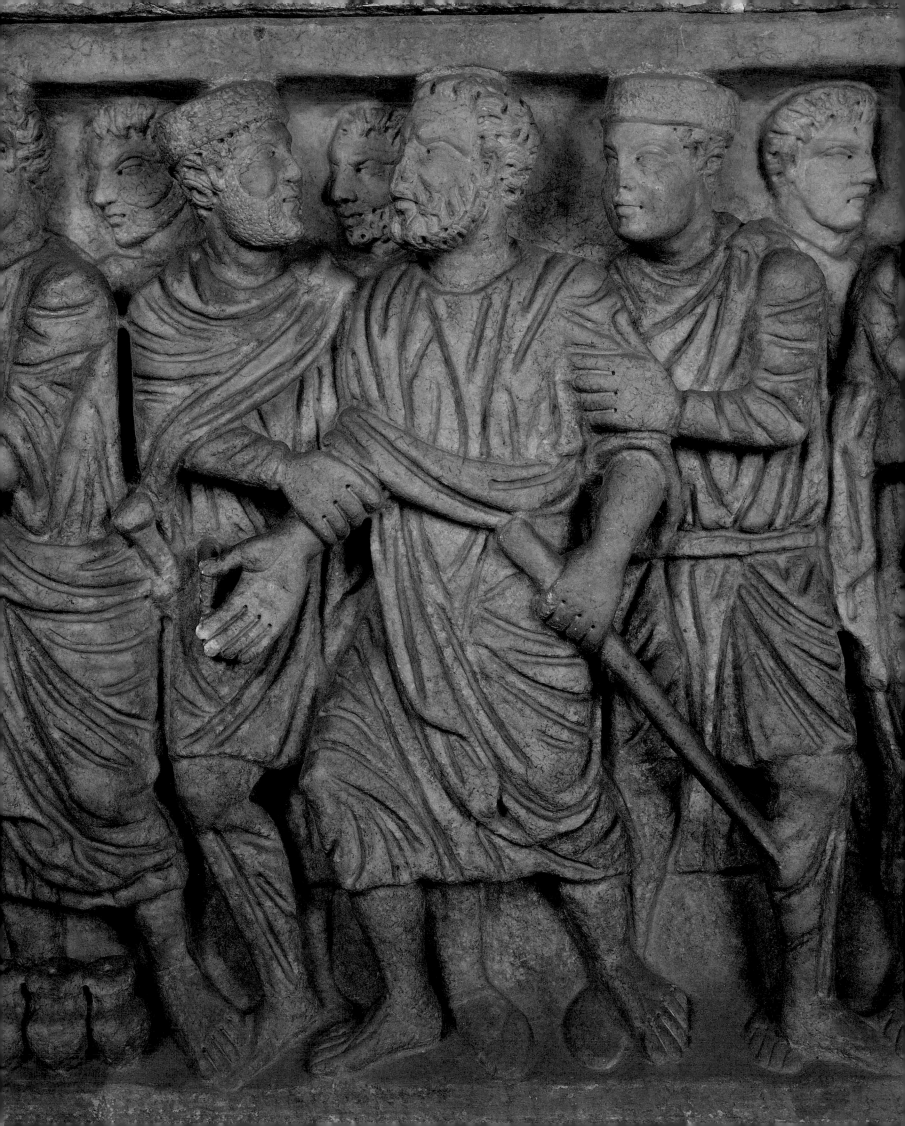

The Likeness of Peter's Successors: 2000 Years of Papal Portraits

Christiane Denker Nesselrath

Figure 1
The Arrest of Saint Peter, detail from an Early Christian sarcophagus, Museo Pio Cristiano, Vatican Museums

Figure 2
Portrait of Pope Liberius (detail), *arkosolium* of Celerina, Praetextatus Catacomb, Rome

The face of Pope John Paul II is not only familiar to Christians throughout the world. Ever since his election in 1978, his image has been daily transmitted by the media, whether in religious ceremonies or on apostolic journeys or during meetings with statesmen, religious leaders, and prominent public figures. In Rome, especially, pilgrims and tourists have the chance to acquire portraits, and even statuettes, of the pope in all shapes and sizes. Even in the Middle Ages, long before the advent of the printing press, the faithful wanted portraits of the head of the church, as illustrated by a passage in the medieval lives of the popes, the *Liber Pontificalis*: Pope John VII "commissioned portraits to be made in various churches, so that anyone, who wished to do so, could find a likeness of him."[1]

But what do the portraits, which through the centuries have transmitted the features of the successors of Peter, look like? In the following, some examples of the huge repertoire of papal portraits that have survived from the two thousand years' history of the papacy will be presented in roughly chronological order.

Today we take it as axiomatic that it's the primary, if not exclusive, task of a portrait to capture a resemblance to the person portrayed, but those of the early and high Middle Ages do not, nor were they intended to, fulfill this modern definition. The papal portraits of the early Middle Ages are, for the most part, comparable to the idealized images of saints. Nonetheless, features such as hairstyle, type of beard, color of hair and eyes, etc., can still be observed; the individuals, moreover, are usually identifiable by the accompanying inscriptions specifying the pope's name. In the thirteenth century portraits were imbued with greater vitality and received a new and more naturalistic humanity, while at the same time expressing a spiritual beauty. Only toward the end of the fourteenth century did a new realism appear through the naturalistic reproduction of features, which led to the emergence of the "portrait" in the modern sense.

The Earliest Papal Portraits of the Fourth Century

At the beginning of papal history stands Peter himself. A group of sarcophagi on which he is represented as a particular type dates not to his lifetime, nor to the period soon after his death, but to the early fourth century (fig. 1). His virile, powerful appearance with rumpled hair and short, thick beard and his resolute expression provided a prototype for representations of Peter in the following centuries.[2] This ideal type was seen as the embodiment of the apostle to whom Jesus had entrusted his church.

The earliest surviving papal portrait arose in the period after Christianity had been recognized and promoted in the Roman Empire by the emperor Constantine (306–337). It is a representation of Pope Liberius, found in a wall painting in one of the catacombs,[3] and it must have been painted during or shortly after the lifetime of the pope (fig. 2). Presumably Liberius was portrayed as protector or intercessor in front of the tomb of the deceased, a woman named Celerina, who must have been somehow connected with or related to him. The almost life-size frontally posed portrait of the pope in a white tunic and white pallium, with an elongated face and large prominent eyes, is accompanied by an inscription identifying the figure as Liberius. The pope is raising his right hand to impart his blessing. He is accorded equal rank within the cycle of saintly figures in which he stands and to which he is related in his ideal type and form.[4]

Figure 3
Gold Glass with portraits of Pastor,
Pope Damasus I, Saint Peter, Saint Paul,
Museo Cristiano, Vatican Museums

Figure 4
Clipeus with portrait of Pope Urban I,
Saint Paul's Outside-the-Walls, Rome

The Roman catacombs have also yielded a series of unusual papal portraits, dating to the later fourth century, on so-called gold glasses, originally drinking vessels, of which only the circular bases have been preserved. Sheet gold was laid on these bases, and then drawings were engraved on it. One of these depicts four half-figures, all of the same undifferentiated saint type (fig. 3). They are arranged in pairs, and between each pair is a christogram. Inscriptions identify them as PASTOR, DAMAS, PETRVS, and PAVLVS. In all probability Damas is Pope Damasus I, so it may be assumed that the pope was represented during his lifetime – together with Pastor, another contemporary – with the apostles Peter and Paul. The gold glasses depict not only saints, but also profane iconography or toasts. They were probably used as drinking vessels, because Christians in Rome in the Early Christian period retained the ancient pagan custom of celebrating so-called *refrigeria* for the commemoration of their dead. These glasses were often given as gifts on the corresponding feast days of the saints represented.[5]

Series of Papal Portraits

Rows of papal busts were painted on the walls of Old Saint Peter's and Saint Paul's Outside-the-Walls, presumably commissioned by Pope Leo the Great. They make visible, in iconographic form, the unbroken succession of the popes from Peter onward, and thus give powerful expression to the idea that each pope was the heir and vicar of Peter, just as Peter was the vicar of Christ, by apostolic succession. As early as the late second century written lists were compiled of the immediate successors of Peter as bishops of Rome. The first names in these lists – Linus, Anacletus, and Clement – are otherwise unrecorded. These lists also provided the basis for the reconstruction of the papal succession found in the *Liber Pontificalis*, which was first compiled at the end of the fifth century and which contains short accounts of the lives of all the Roman bishops since Peter. It was later continued down to the ninth century. Far more immediate in effect, and far more prominent in situation, however, were the rows of papal portraits in the basilicas. Their conspicuous public location would have made them accessible to the whole community of the faithful. In these cycles, the portrait busts are represented in circular medallions, called *imagines clipeatae*. The portraits in Old Saint Peter's were destroyed to make way for the new basilica and have survived only in drawings copied after them in the seventeenth century.[6] Of the sequence in Saint Paul's Outside-the-Walls, forty-one frescoes survived the fire that ravaged the basilica in 1823 and are now displayed in the cloister and museum.[7] The first eighteen medallions, from Saint Peter to Pope Urban I, were originally on the upper wall of the nave above the arcades (fig. 4). Over each arch were two paired medallions, with the name of the pope and the dates of his pontificate inscribed between them. Each pope, dressed in tunic and pallium, is represented *en face*, and the hairstyle varies. These were not created as individual portraits, but rather had the character of icons. The largely unvarying sequence would have provided visual confirmation to the visitor or pilgrim that the ruling pope was the legitimate heir and successor of Peter and that through him the Roman Church took precedence over all others.

Papal representation was frequently repeated in later centuries.[8] Under Pope Nicholas III new medallions were commissioned both in Saint Paul's Outside-the-Walls and in Saint Peter's; like the earlier cycles they are limited to the available space on the walls of the nave. They do not continue the

sequence to the pontificate of the pope under which they were painted, but recycle the previous series by representing the succession of the early popes from Peter onward. This did not change until the eighteenth century, when the rows were completed to include the reigning pope. Pope Benedict XIV, then, likely commissioned the medallions in Saint Paul's Outside-the-Walls with the sequence that continued to his own pontificate.

Two monumental papal sequences were painted during the Renaissance. During the decoration of the Sistine Chapel under Pope Sixtus IV, Perugino, Botticelli, Ghirlandaio, and Cosimo Rosselli were commissioned to paint a series of full-length standing figures of the popes, in niches between the windows in the upper register of the walls, above the oblong scenes of biblical episodes (fig. 5).[9] The life-sized popes are haloed with idealized features and wear the papal tiara. Some are dressed in a pluvial (cope); others, in a chasuble with fanon (short cape) and pallium. The series originally began on the altar wall, where Michelangelo later painted the *Last Judgment*, and presumably began with the representation of Christ, followed by Saint Peter and the first popes Linus and Cletus, ending with Marcellus I. The idea of beginning the sequence with Christ was developed in the later Middle Ages as a way of visually enforcing the transfer of the title "vicarius Christi" to the pope.[10]

Another Renaissance series, in the Cathedral in Siena, consists of terracotta papal busts placed high above the arcades. Like that in the Sistine Chapel, the series begins on the altar wall with a representation of Christ. The fact that ten different, continually repeated types were used for the busts of the 170 popes – with the exception of Christ and Saint Peter – is further proof that the focus was not so much on the individuals as on the representation of their succession. The Sienese series, too, does not end with the reigning pope, but with Lucius III.

In the following centuries papal series were used not only as a motif for picture galleries, but also for the decoration of manuscripts, prints, and medallions. One such painted series is in the Palazzo Altieri in Oriolo Romano. Commissioned by the nephew of Pope Clement X, Cardinal Paluzzo Altieri, it has been continued to John Paul II. The aim was not so much to legitimize apostolic succession as to emulate, and indeed surpass, the galleries of ancestors of noble families. The popes are painted as busts

Figure 5
Workshop of Botticelli, Ghirlandaio, Perugino, and Cosimo Rosselli, Papal Gallery, Sistine Chapel

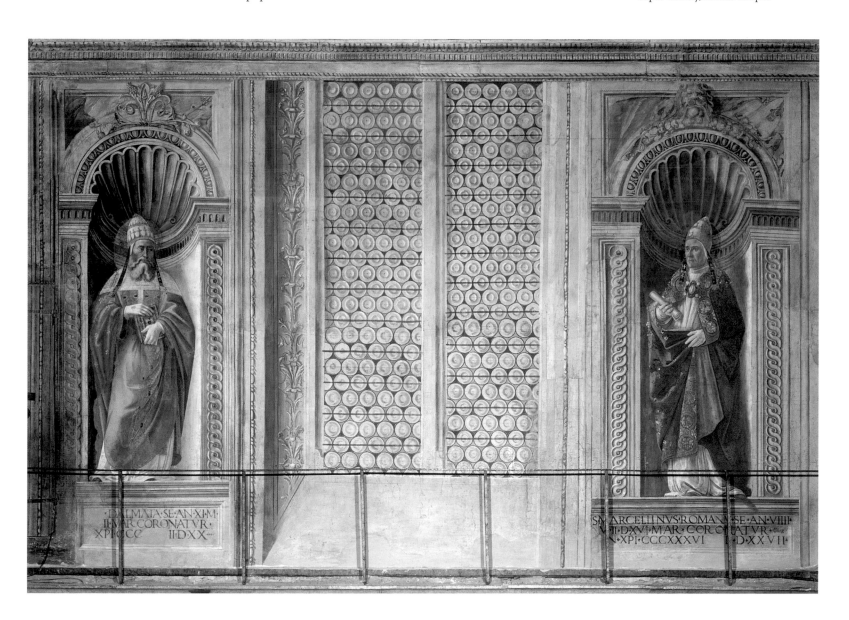

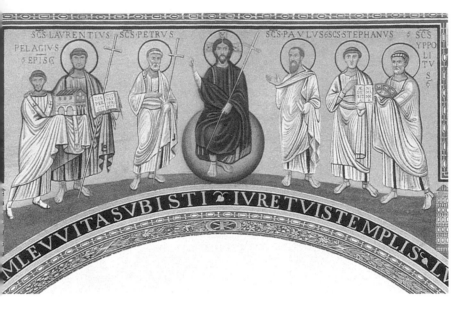

Figure 6
Back of the triumphal arch, mosaic,
S. Lorenzo fuori le mura, Rome

on oblong panels, in profile, *en face*, or in three-quarter view. To the right of each is a cartouche crowned with a coat of arms and a brief biography. The representations are based on various sources; genuine models exist for the popes since the twelfth century, so that it was possible to give a more individual character to portraits of the later popes.

Papal Portraits in Mosaics of the Sixth to Ninth Centuries
Following the series of papal portraits in the fifth century, a new way of representing the popes appeared. Individual popes were included in the monumental mosaics of the Roman basilicas. The popes were represented as founders who had commissioned the building or patrons who had presided over its decoration. In this role they appear in the circle of saints around Christ. The first surviving example of this genre is the figure of Felix IV in the apse mosaic of the basilica of SS. Cosma e Damiano that he had commissioned.[11] Slightly later is the mosaic portrait of Pelagius II, originally on the rear of the triumphal arch of S. Lorenzo fuori le mura (fig. 6).[12] He steps into the scene from the left, holding the model of the church, and is inducted by Saint Lawrence into heaven. He is dressed in a white dalmatic and chasuble, over which is hung the white pallium adorned with black crosses. Pelagius, identified by an inscription, is distinguished from the saints by his lack of a halo. Although it depicts individual features, his portrait approximates more closely the ideal images of the saints.

In the Marian oratory of Old Saint Peter's, built by Pope John VII, a new iconographic scheme was introduced.[13] Only a fragment of the mosaic with his portrait has been preserved (Museo Petriano), but its composition is known from drawings of the early sixteenth century (fig. 7).[14] The figure of the Virgin Mary, who appears both as Queen of Heaven and Madonna Orans, dominates. She is crowned like a Byzantine empress. Standing beside her at a lower level is the pope holding the model of the oratory. John VII is the first pope to have himself portrayed as the servant of Our Lady. She embodies the kingdom of heaven, to whom the insignia of

Figure 7
Madonna Regina with Pope John VII, Grimaldi Album,
A64 ter. fol. 49

Figure 8
Saint Peter handing over Power to Pope Leo III and the Emperor Charlemagne, Barb. Lat. 2738, fol. 104 r,
Vatican Apostolic Library

the Byzantine Empire have been iconographically transmitted. Thus, the pope is subordinated not to worldly but to supernatural power. One further innovative feature is found here, namely, the rectangular halo, which signifies that a living figure is being portrayed. The round form of the *clipeus* was unsuitable, as it could be easily confused with the round nimbus. The living popes were differentiated from the representation of saints by the square halo from the eighth century onward.[15]

Pope Leo III commissioned a mosaic for a large audience hall that he had newly erected in the old Lateran Palace. It survives only in an eighteenth-century reconstruction on the exterior of the Chapel of the Scala Santa, on what is now the Piazza of Saint John Lateran,[16] but it needs to be discussed here because of its historical importance and its innovative form of papal portraiture. The mosaic, originally in one of the three apses of the triclinium, has been transmitted in various copies that provide information on the central scene in the apse and the spandrel to the right. (The scene in the left spandrel was destroyed at the beginning of the seventeenth century, when the mosaic was restored for the first time.)[17] In the central lunette the standing Christ is shown sending the eleven apostles out into the world. The mosaic to the right of the apse shows the enthroned Saint Peter. To Pope Leo III, who is kneeling to the left in front of him, he hands the pallium, and to Charlemagne, who is enthroned to his right, a banner affixed to a lance (fig. 8, top). Thus, Saint Peter transmits the symbols of spiritual rule to the living pope and of temporal rule to the king of the Franks. The iconography expresses both the dependence of the Carolingian kingdom on Rome and the balance between statehood and priesthood. The triclinium mosaic is the first example of a kneeling papal portrait.[18]

Pope Paschal I commissioned the three great mosaic cycles in the basilicas of Santa Prassede, Santa Maria in Domnica, and Santa Cecilia in Trastevere.[19] In the apses of Santa Prassede and Santa Cecilia the pope is identified as still living by his square halo and is shown in the role of founder in the community of the saints. The scheme corresponds to that of the Early Christian mosaics in Rome. In the apse mosaic of Santa Maria in Domnica, in contrast, Pope Paschal I is shown kneeling before the enthroned Madonna and Child (fig. 9). He embraces her right foot and she points to him as her servant.

The Frescoes of the Lateran Palace

In the twelfth century, a new form of papal portraiture appeared in the figure of the enthroned pope, which acquired great significance in the following centuries. Calixtus II commissioned a large-scale fresco cycle to decorate the "Camera pro secretis consiliis" in the Lateran Palace. The room was next to the large aula or audience hall used for consistories and assemblies of the pope with the cardinals. The fresco cycle relates to the historical events of the so-called Investiture Controversy,[20] a conflict between church and state begun under Pope Gregory VII and Emperor Henry IV (1056–1106). The pope had repudiated the temporal ruler's right to perform the investiture of bishops and abbots, because only he (the pope) had received the power to do so from Peter. It was not until 1122, under Callixtus II, that the conflict was finally settled in the Concordat of Worms. Peace with the empire was celebrated by the pope at the First Lateran Council the following year. The frescoes from the medieval Lateran Palace have not survived and have only been transmitted through drawings

dating to the second half of the sixteenth century (fig. 8, bottom).[21] In a series of similar compositions, the popes of the Investiture Controversy are enthroned and frontally posed, surrounded by standing members of their ecclesiastical suites. In the last scene of the cycle the reigning Pope Callixtus II is also shown enthroned in the center, while the right half of the composition depicts the standing figure of Emperor Henry V (1106 – 1125) and the large written document of the Concordat of Worms, which both the pope and the emperor are holding. In contrast to the preceding scenes in the cycle, the composition is strikingly asymmetrical. Pope and emperor are in no way accorded equal importance in the composition. The standing figure of Henry V assumes the role of a founder, asking the pope as the vicar of Christ for his blessing.[22] In the very schematic copies of the frescoes that have come down to us, a smaller crouching figure is shown below the feet of the enthroned pope in each of the scenes; they represent

Figure 9
Madonna venerated by Pope Paschal I (detail),
apse mosaic, Santa Maria in Domnica, Rome

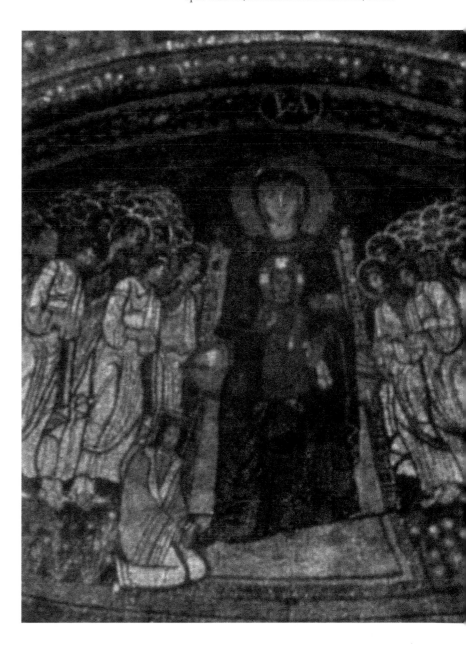

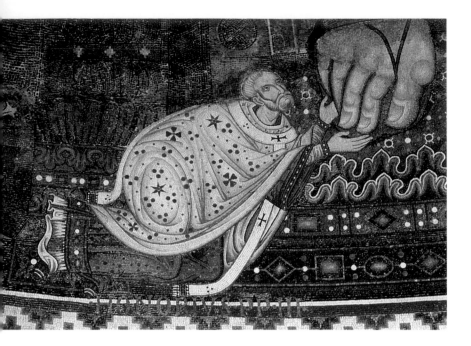

Figure 10
Christ with Pope Honorius III (detail), apse mosaic,
Saint Paul's Outside-the-Walls, Rome

Figure 11
Pietro di Odirisio, *Portrait of Pope Clement IV,*
San Francesco, Viterbo

the anti-popes who had enjoyed imperial support during the conflict. The legitimate popes, by contrast, are dressed in their full papal regalia of tiara and pallium, and they raise their right hands in the gesture of blessing, while in their left hand they hold a book. The motif of enthronement had previously been reserved for the supernatural rule of Christ and the Virgin Mary or for the temporal rule of the emperor. In the Lateran Palace frescoes it was assumed by the papacy and became appropriate iconography for the representation of the pope. It expresses the triumph over the anti-popes and the pope's role as the vicar of Christ, who is authorized to judge and to pardon, to bind and to loose.

Papal Portraits of the Twelfth and Thirteenth Century
A stronger humanization of papal portraits began around the middle of the twelfth century. Representations of the popes came more markedly to personify earthly history. As in the frescoes of the medieval Lateran Palace, they are represented enthroned, as rulers of Christendom, but they are also represented as miniature figures kneeling at the feet of Christ, the Virgin Mary, or a particular saint. They also began to be represented in an entirely new form: as funerary effigies, recumbent on their sarcophagi.[23] Additional historical episodes, which underline the papal victory in the conflict with the empire, are portrayed in murals executed under Popes Innocent II and Alexander III. By contrast, Pope Honorius III had himself represented as a tiny figure in *proskynese*, abasing himself before Christ's right foot, in the apse mosaic of Saint Paul's Outside-the-Walls (fig. 10). This has been iconographically preserved in its original state in spite of the disastrous fire of 1823.[24]

The First Papal Statues

The earliest papal funerary monument with the recumbent statue of the deceased is the tomb of Pope Clement IV, sculpted by Pietro di Odirisio,[25] in the church of San Franceso in Viterbo (fig. 11).[26] Clement IV had begun building the papal residence in Viterbo, because the pope and the curia could no longer remain in Rome, where Charles of Anjou, crowned king of Sicily in 1266, had taken up residence in the Lateran Palace. The pope was prevented from returning to the city throughout his pontificate and was also denied a burial in Rome at his death in 1268. Like most of the thirteenth-century popes, he was buried in the Papal States, but not in Rome.[27] The statue of his funerary monument was seriously damaged in the Second World War, but is in essence authentic: he lies supine on his sarcophagus, his eyes shut and his gloved hands crossed over his torso. The pose provided the prototype and model for subsequent papal funerary monuments. The features of the dead man are strikingly portrayed and express his final agony. By representing its natural appearance, the sculptor has imbued the face, despite its idealism, with a new individuality.

From the thirteenth century onward the funerary monuments of the popes have been an important iconographic means of commemoration, commissioned from the most important artists of the day. That the popes were concerned even during their lifetime by how they would be commemorated in their own tombs can be shown ever since the pontificate of Boniface VIII.[28]

In addition to the funerary monument, another new form of papal portrait appeared toward the end of the thirteenth century: the honorary statue.[29] The first statue to be raised in honor of a pope was that of Nicholas III from the noble Roman Orsini family. It was erected in Ancona, but it has not survived.[30] The custom of raising honorary statues, typical of the ancient world, had already been revived by secular rulers: the emperor Frederick II (1194–1250) had commissioned an enthroned statue of himself to be set up on the triumphal gate of Capua, and soon afterward a statue was erected on the Capitol in Rome in honor of Charles of Anjou. From the time of Nicholas III the popes attempted to emulate this tradition: statues were intended not just to commemorate the individual pope but to celebrate papal rule. To understand how spectacular this was, it should be recalled that the genre of monumental sculpture had been repudiated by Christians for centuries, ever since the decline and fall of the ancient world, because it had been equated with the pagan cult of statues.[31] Further, sculpture was not introduced for papal representation before the second half of the thirteenth century, and then only in funerary monuments.

A portrait of Pope Nicholas III has been preserved in the wall paintings of the Chapel of the Sancta Sanctorum in the Lateran (fig. 12).[32] On the left side of the window above the altar the pope is represented kneeling as a founder with the model of the chapel in his hands. It is received by Saint Peter, who leads him toward the enthroned Christ to the right of the window. The pope's face is distinguished by a natural liveliness. Though sublimated into the ideal dimension, it does preserve individual features, such as the light-colored eyes.

Figure 12
Pope Nicholas III Kneeling (detail), fresco, Sancta Sanctorum, Basilica of Saint John Lateran, Rome

The Last Roman Apse Mosaics

The last two magnificent apse mosaics in Rome were created by Jacopo Torriti for Pope Nicholas IV.[33] In the mosaic in Saint John Lateran the pope appears with the saints in a lower register, while the upper zone is reserved for Christ and the angels. The pope, who is kneeling with his hands raised in prayer, is far smaller than that of the saints. In this humble posture he seeks intercession for admittance to the kingdom of heaven. Mary has placed her hand on his tiara in a gesture of acceptance. This form of papal representation had already been expressed in the lost facade mosaic of Old Saint Peter's, in which Pope Gregory IX had been shown in a similar pose of humility. This form of representation may be based on Franciscan devotion, as both popes had been closely associated with that Order: Gregory IX as cardinal protector, and Nicholas IV as former General of the Franciscan Order.[34] Saint Francis appears directly behind the pope in the apse mosaic in Saint John Lateran, his hands similarly raised in prayer. Nicholas IV is represented in a comparable way in the apse mosaic of Santa Maria Maggiore, where his figure is tiny in comparison with those of the saints among whom he stands (fig. 13).

Figure 13
Pope Nicholas IV Kneeling (detail), apse mosaic,
Santa Maria Maggiore, Rome

Figure 14
Pope Boniface VIII, Museo Civico, Bologna

Boniface VIII

Pope Boniface VIII, of the noble Caetani family from Anagni, is key to any discussion of the history of the papal portrait.[35] He proclaimed the first jubilee in the history of the Church in 1300. A series of statues was erected in his honor in Bologna, Florence, Orvieto, and Anagni, and another was planned for Padua.[36] The one in Bologna (Museo Civico) shows the standing pope with his right hand raised in blessing and his left hand over his breast (fig. 14). The city had ordered the erection of the statue in 1300 in thanksgiving for the pope's arbitration in its favor over a dispute with the rival communes of Ferrara, Modena, und Reggio. According to a document dated July 15, 1300, no marble sculptor could be found in Bologna so the work was entrusted to a goldsmith.[37] The statue is, in fact, of beaten copper plates, laid over a wooden core and originally gilded. It was apparently installed on the *renghiera* (balcony) of the Palazzo della Biada (corn exchange). In its schematized geometrical form the statue has no character as an individual portrait, but like the enthroned statues of Boniface VIII it was a powerful expression of the pope's temporal power. Here, the worldly aspect of the papal portrait is pushed even more forcibly into the foreground. After the pope's death this element even provoked sharp criticism, as statues installed outside churches were rightly associated with the memory of ancient, that is, pagan imperial statues.[38] But the form of the enthroned statue is also reminiscent of the famous bronze statue of the enthroned Saint Peter, his hand raised in blessing, for the Vatican Basilica, where it remains. Dating roughly to the pontificate of Boniface VIII,[39] it

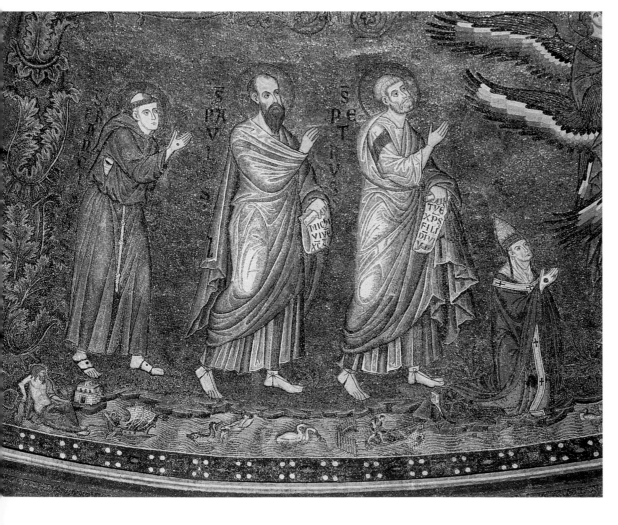

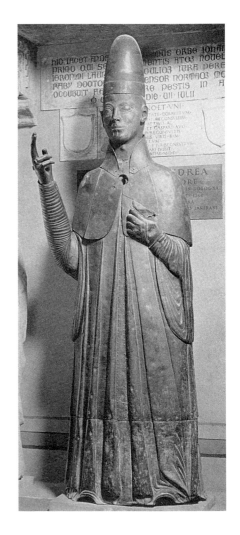

established a new Christian tradition – and hence legitimacy – for this type of papal representation.[40]

The tomb of Boniface VIII,[41] sculpted by Arnolfo di Cambio, not only occupies an exceptional place in the history of papal portraiture, but exhibits outstanding artistic qualities (fig. 15). The tomb, of which only parts have been preserved in the Vatican Grottoes, was originally a large funerary monument at the inner entrance of the Old Saint Peter's; its original appearance is preserved in drawings of the early seventeenth century.[42] In 1301, two years before the death of Boniface VIII, the sarcophagus was incorporated in an already completed tabernacle erected over the relics of Pope Saint Boniface IV. Above the sarcophagus the rear wall of the tabernacle was decorated with a mosaic by Jacopo Torriti, of which two fragments have been preserved.[43] It represents, in a *clipeus*, the Madonna and Child, before whom Boniface VIII kneels in prayer, with Saint Peter interceding at his side. A half-figure of the pope, with his right hand raised in blessing and his left hand holding the keys, also sculpted by Arnolfo di Cambio, was to one side of the funerary monument (fig. 16).[44] (Under Pope Paul VI the statue was removed to the papal apartments.) The keys, hitherto an exclusive attribute of Saint Peter, were introduced into papal iconography by Arnolfo di Cambio as an attribute of Boniface VIII: they made manifest that the pope claimed for himself the power of the keys of heaven and earth transmitted by Saint Peter, not only in the religious sense as the sacramental authority to bind and loose, but also in the secular sense as the supreme judicial authority.[45] The recumbent funerary statue, which seems transfigured by death, and the half-figure, in which the dignity of the papal ministry is reflected, combine to give an ideal impression of the person of the pope, though this did not conflict with his natural appearance. Common to all the portraits of Boniface VIII is his full, oval, beardless face.[46]

A striking feature of all the portraits of Boniface VIII is the high papal tiara. Under Boniface VIII the triple-crowned tiara, the *triregnum*, appeared for the first time. Formed by the addition of two superimposed crowns to the diadem, it provided the model for the still existing form of the papal tiara.[47]

The most important forms of papal representation, which would continue to provide the obligatory models for artists, had thus appeared by the end of the thirteenth century: the recumbent funerary statue, the standing or enthroned honorary statue, the pope kneeling in prayer, and the half-figure of the pope as the precursor of the later bust.

Figure 15
Arnolfo di Cambio, *Tomb of Pope Boniface VIII* (detail), Vatican Grottoes

Figure 16
Arnolfo di Cambio, *Bust of Boniface VIII*, Papal Apartments

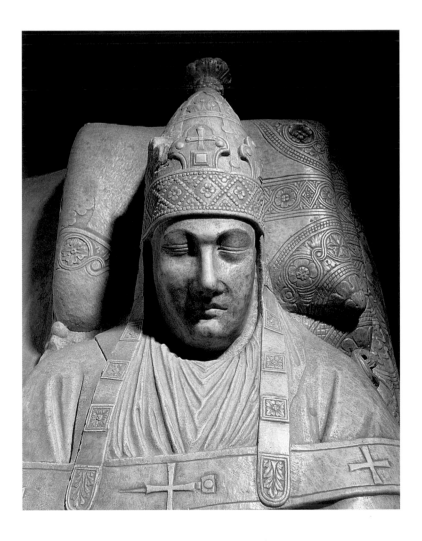

Figure 17
Pope Boniface IX, Saint Paul's Outside-the-Walls, Rome

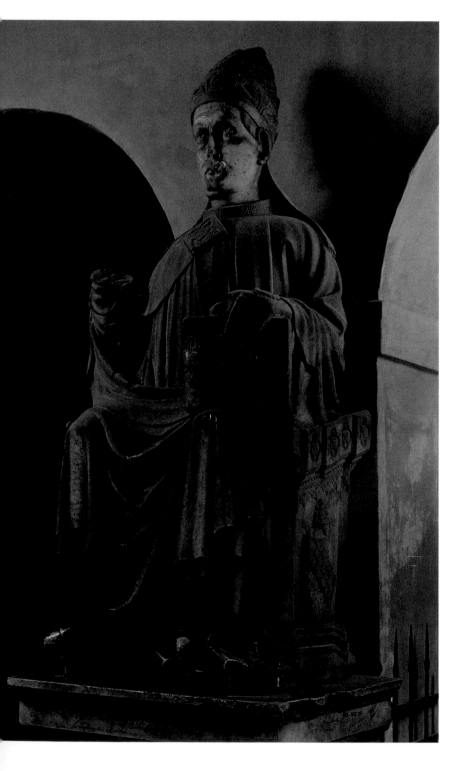

Avignon and Boniface IX

Even during the exile of the papacy in Avignon, initiated by Pope Clement V, a new realism in papal portraiture made itself felt at the end of the fourteenth century. An example of this is the head of the cenotaph of Pope Urban V from Saint-Martial in Avignon, now displayed in the Musée Calvet. Here ideal beauty is replaced by a far more naturalistic rendering of the features, as in the wrinkles and folds of the face, the loosely drooping cheeks, and the bags below the eyes.[48] In view of the generally stronger wish for a more naturalistic and lifelike rendering of the human face, it is no surprise that Cennino Cennini in his treatise on art, written in the last years of the fourteenth century, should have exactly described the process of how to take masks from living human beings.[49] That a true likeness could, on the other hand, be completely avoided is shown by a half-figure installed in Saint Peter's in honor of Pope Benedict XII, now in the Vatican Grottoes. It was produced in Rome in the absence of the pope, who was in exile in Avignon but who concerned himself with the maintenance of the Vatican Palace and Saint Peter's Basilica.[50] Its sculptor clearly derived inspiration from the model of the half-figure of Boniface VIII, whose type and artistic qualities were decisive. Only the inscription reveals that the pope represented is Benedict XII.[51]

The first enthroned papal statue in Rome was installed in honor of Pope Boniface IX, a member of a leading Neapolitan family, the Tomacelli (fig. 17). It was originally located in the left aisle of the basilica of Saint Paul's Outside-the-Walls, the restoration of which Boniface IX had promoted on the occasion of the holy year in 1400; it is now in the cloister adjacent to the basilica. The right hand, originally raised in blessing, is missing and the face damaged. Boniface IX, the second Italian pope to be elected in Rome after the exile in Avignon, found himself in the catastrophic situation of a renewed schism, with an anti-pope resident in Avignon. Against this background the statue, though in artistic terms of little moment, acquires a particular significance: the enthroned pope, in a frontal pose, holds an open book in his left hand, supported on his left knee. The inscription identifies him as a member of the house of Tomacelli and descendant of the Cibo; the family coat of arms adorns the side of the throne.[52] A direct parallel between the papal statue and the enthroned Christ in the apse mosaic in Saint Paul's, created under Honorius III, is suggested: there Christ is represented as Pantokrator, as the omnipotent, and as the God of the Last Judgment, enthroned, with his hand raised in blessing and with the book of the Gospel open before him. If Pope Honorius III was represented in that mosaic as a tiny figure and servant at Christ's feet, Boniface IX claims for himself, through the type of representation alone, the title of vicar of Christ, who has the power to judge and to pardon. Thus, the theme of the Lateran fresco from the period of the Investiture Controversy is revived. That such a direct analogy between Christ and the pope may have been intended is corroborated by a miniature dating to the last quarter of the fourteenth century, in which Christ and the pope are paralleled: Christ presides over the Last Judgment above, the pope as worldly judge in the lower register. Both are enthroned and make similar gestures.[53]

The prominent inscription on the book of the statue of Boniface IX emphasizes his aristocratic Italian origins, underlines his worldly aspirations to power, and unambiguously refers to the private person and not to the spiritual ministry of the pope. It seems to be aimed at underscoring the

legitimacy of his Roman pontificate and, by implication, repudiating the claims of the anti-pope. The emphasis placed on the pope's noble descent and, more particularly, on his family name, has a further implication. It seems to be indicative of the nepotism practiced by Boniface IX and criticized by his contemporaries:[54] the statue was erected in honor of the pope by the Congregation of Montecassino, to which Boniface IX had appointed his kinsman Enrico Tomacelli as abbot in 1396. In the next two centuries, the popes' concern to promote the well-being of their own families was to be expressed in a far more explicit way.

A new form of papal representation has been preserved from the time of Pope Boniface IX. A miniature in a chronicle dating to the beginning of the fifteenth century represents the pope on horseback under the title "How Pope Boniface IX made himself Lord of Rome" (fig. 18).[55] Boniface is shown riding on a white horse, dressed in a purple mantle and crowned with the tiara. He grasps a sword in his right hand. A standard-bearer rides through the city gate in front of him. He is followed by a train of cardinals and soldiers on horseback. White steed, purple mantle, and tiara can be traced back to the Donation of Constantine:[56] they were the pontifical insignia, with which the pope was distinguished as bishop of Rome during his coronation and the ensuing "Possesso," the ceremonial procession by which he officially took possession of the Lateran Basilica. In the miniature, this kind of representation of the pope, who is dressed as in the ceremonial of the "Possesso," is transferred to a historic event. The miniature presumably celebrates the final subjugation of the free Roman Commune (the short-lived republican regime at the close of the fourteenth century), which Boniface IX defeated with the help of the Florentine *condottiere* Paolo Orsini in 1398.[57] That the miniature is intended to represent not a reli-

Figure 18
Pope Boniface IX entering Rome on Horseback,
Archivio di Stato, Lucca, Biblioteca Manoscritti 107, c. 260 verso

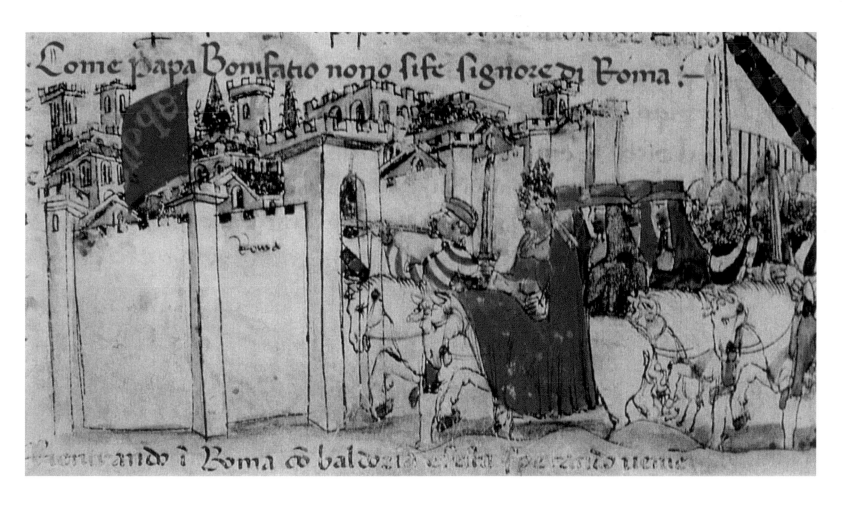

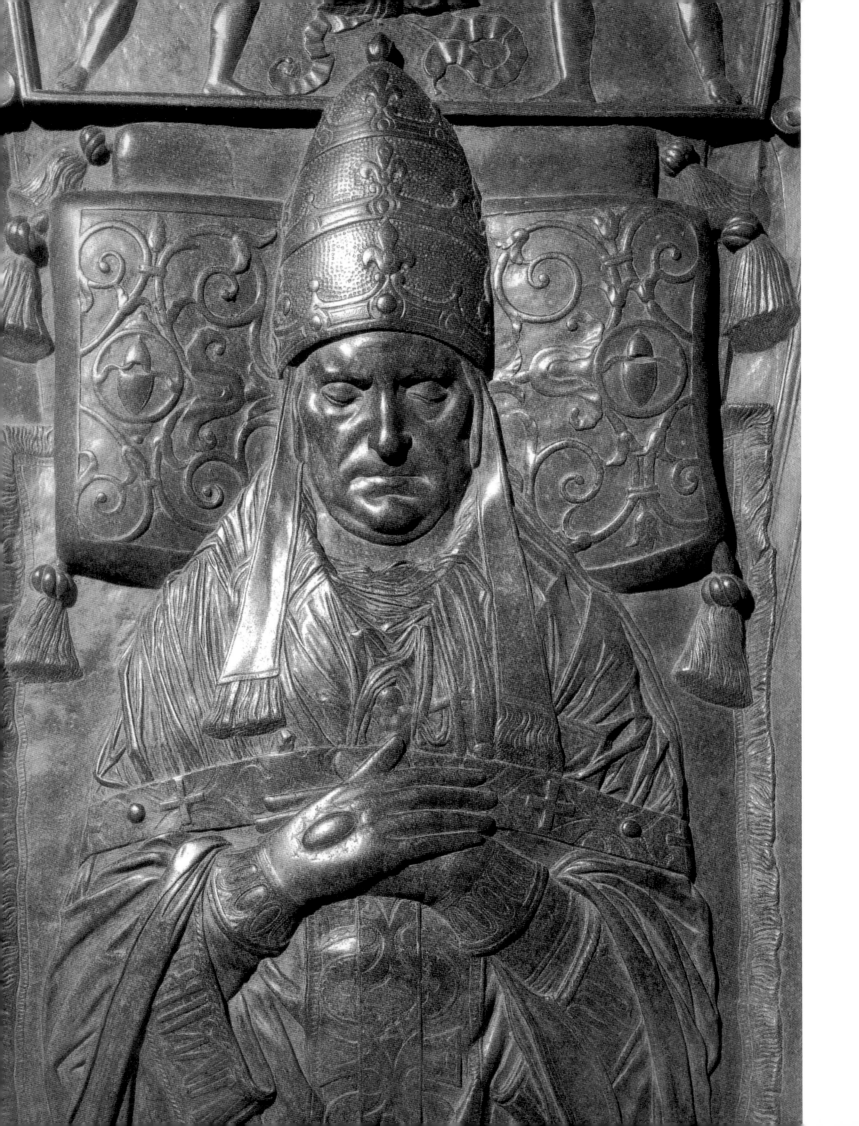

gious but a military theme is clearly expressed by the unsheathed sword in the pope's hand and the soldiers in his suite.

An exceptional position in the history of the papal portrait is occupied by the bronze grave slab of the Colonna Pope Martin V in Saint John Lateran (fig. 19).[58] It was Martin V's wish that he be buried in a simple earth grave there and his tomb was originally placed in a slightly raised position in the nave in front of the high altar. It was transferred to its present site in the *confessio* in 1853. The grave slab is cast from bronze. Within a broad ornamental frame the recumbent figure of the pope is slightly recessed; he lies on a carpet or ornamental cloth with his hands crossed over his breast and his tiara-crowned head resting on a cushion. Very impressive is the accomplished three-dimensional modeling of the head, which contrasts with the flat relief of the body. An entry in the Roman customs registers of the period shows that this large bronze plate was, in fact, cast in Florence and sent to Rome by ship in 1445. Donatello's authorship of the great recumbent figure of the pope can thus be substantiated. Newly published documents have also established that the work was commissioned by Prospero Colonna, the pope's nephew.[59] Donatello had previously collaborated with Michelozzo in sculpting a magnificent funerary monument for Pope John XXIII, who had been elected in 1410, but had been deposed by the Council of Constance in 1415; he died in Florence in 1419, and was buried in the Florentine Baptistery.[60] For our purposes, however, the more modest tomb slab of Martin V lies not so much in its by now traditional form of representation as in its peculiarity as a distinctive papal portrait. The features of the pope, which radiate a blessed sense of serenity and peace, show that the person represented is a quite individual person, whose age can be determined and is wholly compatible with the age of sixty-two at which Martin V died. The archival document also states that the funerary figure was not sculpted in Rome in the presence of the pope, but only commissioned in Florence after his death. The question, therefore, arises whether the sculpture truly presents a likeness of the man – "similitude," as was demanded in the treatises and documents of the quattrocento[61] – and, if so, how could the artist have achieved it. Colonna would unlikely have agreed to a figure for which someone else had substituted the pope as a model, even if the portrait did not arrive in Saint John Lateran until fourteen years after the pope's death.[62] If the authentic features of Martin V are indeed conveyed in the grave slab (as seems likely), it is clear that models must have been placed at Donatello's disposal. He, admittedly, may have had an occasion to see the pope during his residence in Florence in 1419 and may even have drawn his likeness. But that is hypothetical: in any case, it would leave one to expect a younger portrait than that actually produced, which corresponds to the real age of Martin V at the time of his death. It may be presumed, therefore, that drawings, pictures, coins/medals, descriptions, or perhaps even a death mask of Martin V were sent to the artist in Florence and would have served as the model for the portrait. That death masks were being used in Italy by the mid-fifteenth century is shown by the example of Filippo Brunelleschi, from whose head a mask was taken on his death in Florence in 1446; a plaster cast of it is in the Museo dell'opera del Duomo in Florence.[63]

Papal Portraits in the Renaissance

An especially widespread phenomenon in the Renaissance is that of the so-called crypto-portraits, by which the features of contemporaries were lent to figures from the past. Thus, in the fresco cycle of Fra Angelico in the Cappella Niccolina in the Vatican, in which scenes from the lives of Saints Stephen and Lawrence are recounted, Pope Nicholas V, who commissioned the decoration, is represented in two scenes as the third-century pope Saint Sixtus II (fig. 20).[64] In the early Middle Ages, the portraits of the popes coincided with those of the saints. But now the roles are reversed: the portraits of the saints coincide with those of the living and are actualized through them.[65]

In general, the individual person of the pope was pushed into the foreground in the Renaissance. Like the princes of the Renaissance courts, the humanistic popes were leading patrons of the arts and sciences. They devoted themselves to the welfare, the revival, and the patronage both of the city of Rome and Saint Peter's and the Vatican. It is in just this role that the Della Rovere Pope Sixtus IV appears in the fresco of Melozzo da Forlì (fig. 21). It was painted for the public library of the Vatican Palace, founded by Sixtus IV in 1475 – but already planned by Nicholas V – and is now in the Pinacoteca of the Vatican Museums.[66] The fresco is the first surviving example of what was to become a typical papal genre: an official group portrait of the pope with his nephews. Sixtus IV is seated in profile on the right margin of the scene. Behind him, aligned in a row parallel with the picture plane, stand his Della Rovere and Riario kinsmen, whose advance-

Figure 20
Fra Angelico and collaborators, *Pope Nicholas V portrayed as Pope Sixtus II ordaining Saint Lawrence as a deacon* (detail), Cappella Niccolina

Figure 21
Melozzo da Forlì, *The Foundation of the Apostolic Library with Portrait of Pope Sixtus IV*, Pinacoteca, Vatican Museums

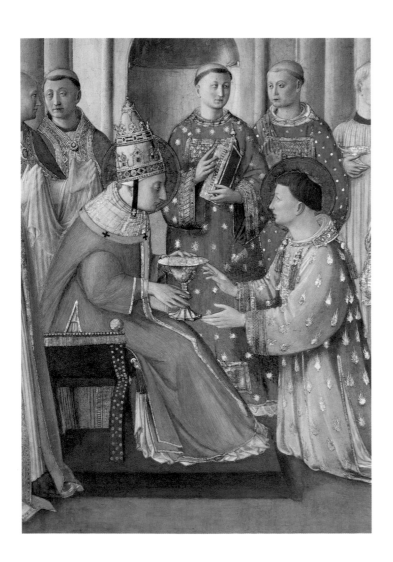

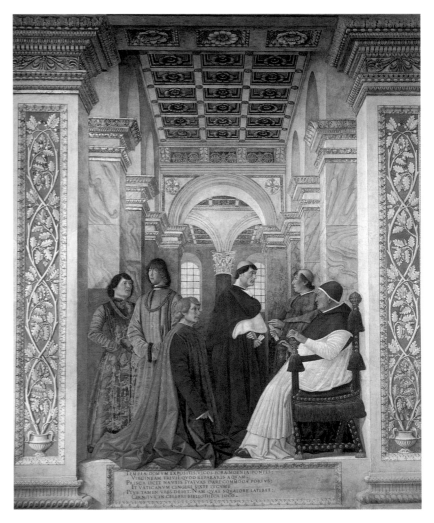

ment in the church he had promoted, dominated by the future Pope Julius II at the center. Kneeling in the foreground is the humanist and librarian Bartolomeo Platina, who points to the prominent painted inscription below the scene. Written by Platina himself, the epigram glorifies the numerous building enterprises of Sixtus IV, concluding with the new library that Rome owed to him. The individual and personal character of the representation is also reflected in the pope's dress. He does not wear the usual ceremonial pontifical garments, but only a mozzetta, a short hooded cope, over the white undergarments; on his head he wears a fur-trimmed cap, the *camaura*. This informal papal dress would henceforth become the norm in portraits. The tiara and pluvial would be reserved especially for honorary statues, funerary sculptures, and scenes in which the pope is shown presiding over a liturgical celebration.

Sixtus IV also commissioned a fresco cycle in the Ospedale di Santo Spirito, the hospital he rebuilt in Rome between 1476 and 1484. It recounts the life of the pope in forty-six scenes: his childhood and youth, his university and ecclesiastical career, scenes from political life, and especially the various buildings he erected, including the Vatican Library.[67] The cycle was continued after the pope's death in 1484 in three scenes, beginning with his burial. This is followed by the scene in which the kneeling Sixtus IV, accompanied by models of his various buildings borne up by angels, is being recommended by the Virgin Mary and Saint Francis (the pope was a Franciscan), not to Christ, as in earlier founder representations, but to God the Father. The cycle ends with a fresco in which Sixtus IV is being led by Saint Peter into Paradise, which is represented as a Renaissance palace, its loggia thronged with angels. In spite of the poor artistic quality of the frescoes, which have been repeatedly restored and overpainted, these scenes show how strongly papal portraiture was personalized during the Renaissance: here the person of the pope himself became the central protagonist of art.

Many of the funerary statues of the following popes were sculpted by leading artists of the time. The main challenge lay in varying the form and iconography of the magnificent funerary complexes, whereas the recumbent figure of the pope remained more or less true to the tradition that had developed in the thirteenth century. At the same time, a very decisive innovation, which was to have important consequences for later papal funerary monuments, was made by Antonio del Pollaiuolo in the bronze tomb he sculpted for Pope Innocent VIII,[68] now in the left aisle of Saint Peter's (fig. 22). Here the pope is represented not only as the deceased recumbent on his sarcophagus, but also as a living man. In the tomb's original position[69] the pope was enthroned at the center of the wall monument below the sarcophagus with the recumbent figure. His right hand is raised in the gesture of blessing, while in his left hand he holds the point of the Holy Lance that had been presented to him by the Turkish Sultan Bajazet II. The pope's nephew, Lorenzo Cibo, ordered a ciborium to contain the precious relic of Christ, and it was he, too, who commissioned the pope's funerary monument after Innocent VIII's death.

Figure 22
Antonio del Pollaiuolo, *Tomb of Innocent VIII*, Saint Peter's Basilica

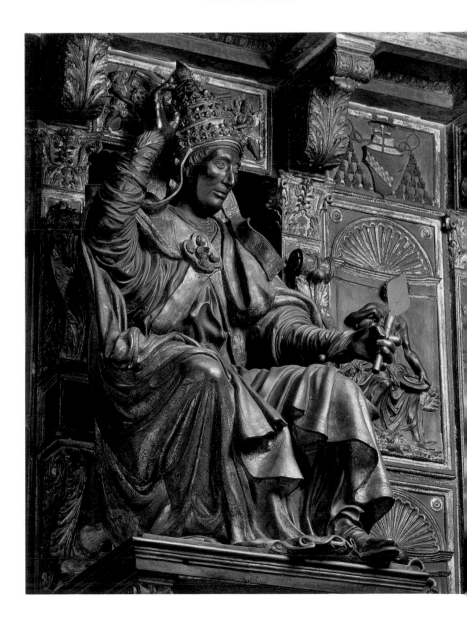

With his portrait of the Della Rovere Pope Julius II, painted, together with an altarpiece of the *Holy Family*, for the Della Rovere-privileged church of Santa Maria del Popolo in Rome (fig. 23),[70] Raphael introduced a new kind of papal portrait, which was to become an inseparable part of papal representation right down to the present day, now also transposed to the medium of photography. The painting in the National Gallery in London[71] represents Julius II seated in three-quarter profile in a diagonally placed armchair. The sixty-nine-year-old pope is dressed in the mozzetta and *camauro*, as in the earlier fresco of his uncle, Sixtus IV, by Melozzo da Forlì. The expression on his face is serious and introverted, but at the same time determined. His sensitive hands are adorned with rings. His left hand grasps the armrest and he holds a handkerchief in his right hand over his lap. The powerful effect that the portrait had on contemporaries is described by Giorgio Vasari in his *Life* of Raphael, where he says that the painting is "so true and life-like that the portrait struck fear just to see it, as if he were truly alive."[72] What is revolutionary in this new form of portraiture is captured in Vasari's description: the pope is pushed into an unprecedented closeness to a living relationship with the observer. He is portrayed in a moment of reflection, from which he will, at any moment, it seems, emerge and be ready for action. Julius II needed no inscription or coat of arms to identify him, because the contemporary viewer would have immediately recognized the features of the reigning pope and would also have noticed the unmistakable symbol of his family: the prominent knobs of the backrest of his chair are modeled in the shape of acorns, the heraldic device of the pope's family, the Della Rovere ("of the oak tree"). Raphael has caught the complex, character of his patron: the cultured patron of the arts, who ordered the building of the new Saint Peter's and showered commissions on Bramante, Michelangelo, and Raphael, but also the wise head of the Catholic Church and the resolute defender of the Papal States.

Raphael's famous portrait of the Medici Pope Leo X with his two cousins (fig. 24), in the Uffizi in Florence,[73] also had a major influence on later papal portraiture. Here the pope is sitting in the center of the picture in a diagonally skewed, leather-backed armchair. He sits at a table, on which rests a handbell and an open illuminated manuscript. He is flanked to the left by Cardinal Giulio de Medici, future Pope Clement VII, and to the right, leaning on the backrest of his chair, Cardinal Luigi de' Rossi. In contrast to Julius II, Leo X is shown in a private atmosphere. His sensitive hand holding the magnifying glass, which he has just been using to study the precious illuminated Bible before him, rests idly on the tablecloth; it contrasts with his rather thick and ungainly body. He looks diagonally out of the picture, into the distance. The two cardinals are placed in no active relation to him: Cardinal Giulio looks out of the picture in the opposite direction, Cardinal Luigi alone directs his gaze toward the observer. In his unusual composition Raphael combines the private person of the pope and the office holder. The painting was presumably commissioned by Leo X for the celebrations in Florence on 8 September 1518, held in honor of Lorenzo de' Medici, the duke of Urbino (Leo's nephew), following his marriage with a kinswoman of the French king François I.[74] So a quite particular function can be attributed to the painting: on the one hand, it represented "in effigy" the three highest dignitaries of the Medici family who could not be present in person at the celebrations in Florence; on the other, it openly expressed the dynastic policy conducted by Leo X.[75] Leo X here parades his two cousins as possible successors on the throne of Saint Peter;

Figure 23
Raphael Sanzio, *Portrait of Pope Julius II*, National Gallery, London

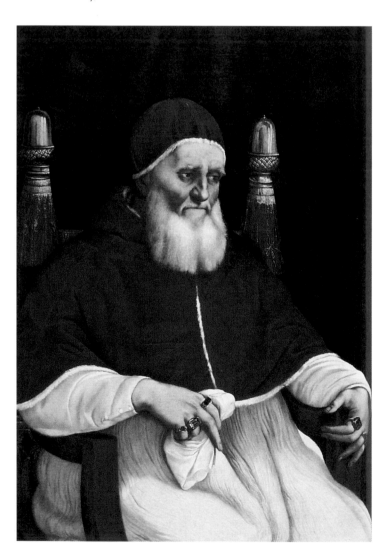

their election would ensure the continuity of papal power for the Medici family. The pope had already taken steps to promote the worldly interests of the Medici dynasty by advancing his nephew to the duchy of Urbino and now by marrying him into the French royal family. Raphael, who was constantly in contact with the pope to discuss the fresco decorations of the rooms in the Vatican Palace and the building of the new basilica of Saint Peter, allows us to see his patron with great sympathy, just as he had done before with Julius II. Without attempting to gloss his unprepossessing features, Raphael allows us to glimpse the virtues of the pope: in his pose alone is expressed his love for art, and in his features his benevolent nature.

Raphael appears to have drawn on, or alluded to, an earlier painting in his portrait: namely, the lost portrait of Pope Eugenius IV, painted by the French master Jean Fouquet for the Dominican monastery of Santa Maria sopra Minerva in Rome. In it, too, the pope was apparently represented sitting between two standing figures, perhaps his nephews.[76]

In the tradition of Raphael's portrait of Julius II stands Sebastiano del Piombo's portrait of another Medici Pope, Clement VII, who as Cardinal Giulio de' Medici had already been represented with Leo X in Raphael's painting. Sebastiano del Piombo's portrait, in the Museo di Capodimonte in Naples (fig. 25),[77] was painted in 1526, a year before the Sack of Rome, when the troops of the emperor Charles V plundered Rome and held the pope and his suite prisoners in the Castel Sant'Angelo until the end of the year. In all later portraits the pope is portrayed with a beard, which he grew after this shattering event. The magnificent portrait of Sebastiano del Piombo shows Clement VII sitting in a diagonally placed chair. In contrast to Julius II, the youthful pope is erect in pose and energetic in expression. He swivels his head and looks proudly over his right shoulder. Contemporaries describe Clement VII as a handsome man, with a well-built figure and noble features, though he squinted a bit with his right eye.[78] The painted portrait corroborates the written descriptions of the pope's appearance, but the small defect of the right eye is elegantly glossed over by the three-quarter profile that conceals it in shadow. The pope in this portrait is oblivious of the impending catastrophe of the church, threatened both by political dissension and by the growing movement of the Reformation north of the Alps.

Figure 24
Raphael Sanzio, *Portrait of Pope Leo X with Two Cardinals*, Museo di Capodimonte, Naples

Figure 25
Sebastiano del Piombo, *Portrait of Pope Clement VII*, Museo di Capodimonte, Naples

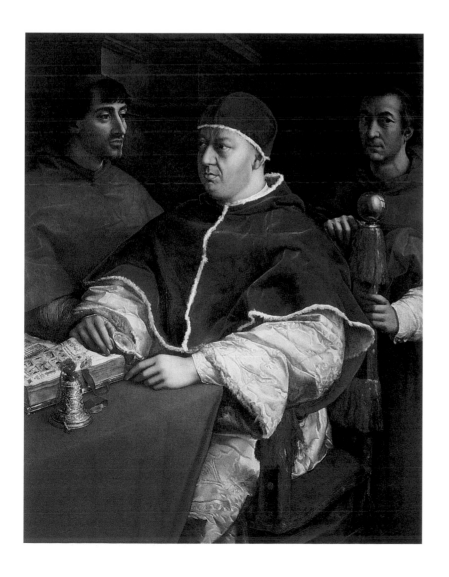

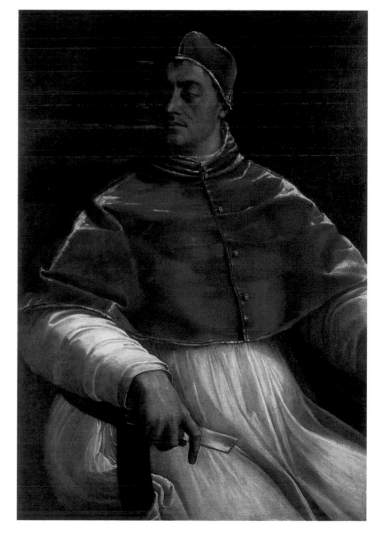

One of the most interesting of all papal portraits was painted by Titian for the Farnese Pope Paul III, now in the Museo di Capodimonte in Naples (fig. 26).[79] The Venetian master began work on this large-scale canvas at the end of 1545. It shows the frail seventy-eight-year-old pope sitting between his two grandsons: to the left behind his chair is Cardinal Alessandro, while approaching from the right, bowing and genuflecting obsequiously, is Duke Ottavio. The painting was presumably intended as a dynastic portrait to celebrate the prestige of the family and to adorn the huge family residence built by the pope at the heart of Rome, the Palazzo Farnese. The composition clearly derives from Raphael's portrait of Leo X, though the three figures are shown in an active relationship to each other and, like the group portrait of Melozzo da Forlì, are shown full length. The portrait is especially memorable because of Titian's penetrating characterization of Paul III, not as the head of the church who promoted far-reaching reforms and convened the Council of Trent, but as a pope who was preeminently concerned with advancing his family to power and prestige. His political program is unmistakably expressed: Duke Ottavio, whom he had married to a natural daughter of Charles V (Margaret of Austria), was chosen to found the dynasty, and Cardinal Alessandro, to succeed him in the leadership of the church. But his ambitious family policy foundered on the strong rivalry between his four grandsons and the ambitions of his son Pier Luigi. Titian, the favorite painter of Charles V, had already painted various portraits for the Farnese, but was disappointed and hurt by his treatment at the hands of Paul III, who had evidently wooed him with

Figure 26
Titian, *Paul III with His Nephews*,
Museo di Capodimonte, Naples

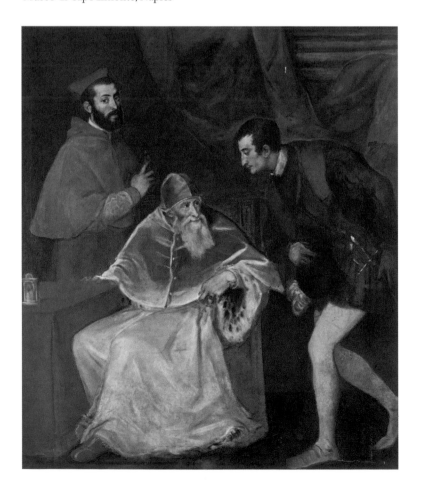

promises, never kept, of a benefice for the painter's own son.[80] In this painting he represents the pope as a stooped old man, clutching the armrest of his chair with one hand as he swivels his head to look up at his approaching grandson Ottavio. His aged features, with small deep-sunken eyes and long pointed nose, allow us to glimpse the cunning and guile of this Renaissance pope.

We may briefly mention here another portrait of Paul III – though one painted after his death – in the Palazzo Farnese in Caprarola. Commissioned from Taddeo Zuccari by Cardinal Alessandro Farnese, it forms part of the fresco decoration of the rooms of the palace and represents the meeting between Paul III and Charles V after the latter's return from his expedition against the Saracens in Tunis in 1535. Enthroned and dressed in the pluvial and tiara, the pope holds his hand in a sign of benediction over the emperor, who has sunk to the ground to kiss his foot. Since the emperor would only have lent himself to such a ceremonial in a modified form, it seems that Cardinal Alessandro consciously wished to present this humbling of the erstwhile opponent of his grandfather.[81] One may recall in this connection the early thirteenth-century apse mosaic in Saint Paul's Outside-the-Walls, where Pope Honorius III himself adopts the same pose of abasement at Christ's feet.

Papal Portraits from the Seventeenth Century to Modern Times

To the great painter, sculptor, and architect Gian Lorenzo Bernini, posterity owes a large number of papal portraits, from the pontificate of Paul V to that of Clement X, and embracing the genres of painting, drawing, and sculpture.[82] Apart from funerary and honorary statues, the bust was the favorite form of creating portraits for ceremonial or private purposes during this period. Papal busts already had a long tradition and can be traced back at least to Pope Paul II. Bernini's marble bust of the Barberini Pope Urban VIII, dating to 1632, in the Galleria Nazionale d'arte Antica, in the Palazzo Barberini, is just one of the many portraits that Bernini sculpted in the course of the twenty-one-year-long pontificate of his patron (fig. 27).[83] It shows the pope wearing a conical mozzetta and *camauro*. His head is slightly turned to the right, and the expression on his face is serious, meditative, and introspective. The bust's likeness to the pope was praised by contemporaries. What impresses the contemporary observer are the extraordinary liveliness and nuances of the features and the suggestion of natural movement subtly achieved by the drapery of the bust. The various portraits that Bernini created over the years of his trusted patron, with whom he forged a close bond of friendship, enable us not only to follow the physiognomic alterations of Urban VIII, but also to gain an insight into the pope's personality. In comparison with the earlier portraits of Urban VIII, this bust seems more troubled in mood. Its creation coincided with the trial of Galileo Galilei by the Inquisition, which reached its climax in the summer of 1632. The pope had been an erstwhile promoter and admirer of the scientist.

Bernini, who saw the pope at close range throughout his life, captured the changes in Urban VIII's appearance. That of his successor, the Pamphilij Pope Innocent X, can be examined, in turn, by comparing the portraits by three leading artists of the time, Alessandro Algardi, Gian Lorenzo Bernini,[84] and Diego Velázquez.

In 1645, the Roman Senate commissioned a statue of Innocent X, which was intended to be installed on the Capitol, in gratitude for the

resources that the pope had made available for the completion of the Palazzo Nuovo, now the Capitoline Museum. The commission was originally given to the sculptor Francesco Mochi, but Alessandro Algardi, the favorite artist of the pope's nephew Camillo Pamphilij, was able to win the commission for himself and so enter into direct rivalry with Bernini, whose statue of Urban VIII was displayed in the Sala dei Conservatori in the Palazzo dei Conservatori, on the opposite side of the same room.[85] Honorary statues of the popes already had a long tradition on the Capitol: the first papal statue to be erected there was in honor of Pope Leo X; it was transferred to Santa Maria in Aracoeli in 1876, after the papacy's temporal rule was abolished in 1870.[86] The genre of the enthroned papal statue, with the pope dressed in pluvial and tiara and the right hand raised in blessing, has a long tradition and can be traced back to the pontificate of Boniface VIII.

The size of the statue, its material, and the high pedestal on which it is placed give the statue of Innocent X an imposing monumentality, while his elaborate dress, gesture, and determined expression characterize the pope as a spiritual and temporal ruler (fig. 28). The nuanced modeling of the face gives the statue the character of a subtle portrait, although Algardi, in comparison with other portraits of the pope, clearly strives at an idealization for his monument. Algardi also produced a terracotta bust of Innocent X, more intimate in character: it represents the not particularly handsome features of the pope with consummate naturalism. By suggesting just the hint of a melancholy smile it gives the portrait an almost private character.[87]

Figure 26
Titian, *Paul III with His Nephews*,
Museo di Capodimonte, Naples

Figure 27
Gian Lorenzo Bernini, *Bust of Pope Urban VIII*,
Palazzo Barberini, Rome

Figure 28
Alessandro Algardi, *Innocent X*,
Musei Capitolini, Rome

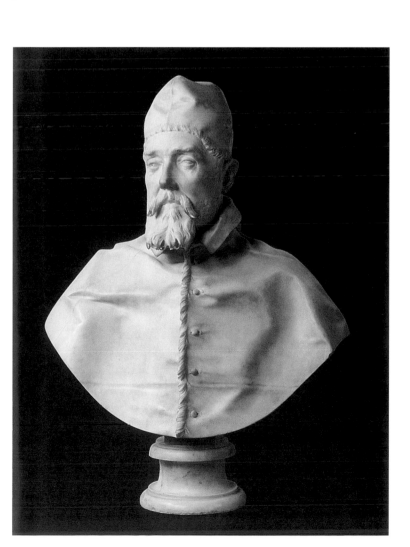

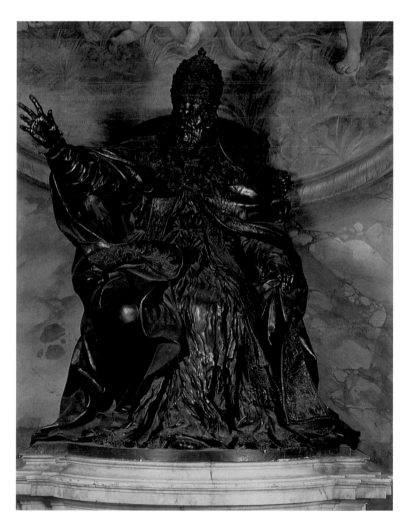

A comparison with the magnificent portrait of Innocent X by Diego Velázquez, painted during his Roman visit in 1649–50, is instructive (Galleria Doria Pamphilij; fig. 29). Velázquez had traveled to Italy on an official commission from Philip IV; he was the court painter of the Spanish king and famed as a portrait painter. He has represented the pope with mozzetta and *camauro*, sitting in a diagonally placed armchair; the pose is an evident reprise of Raphael's portrait of Julius II. How far this genre of portrait had since come to be understood as typically papal is suggested by the portraits that Velázquez painted of members of the Spanish court: the king and his family were represented standing, on horseback or as half-figures, never seated. The pose of the sitter in the armchair, or on the throne, always conceals an allusion to the "cathedra Petri" that was the prerogative of the pope. In Velázquez's portrait, Innocent X sits in a tense and vigilant pose. In his left hand he holds a letter and through steely blue-gray eyes he directs a searching glance at the observer. His expression and pose betray intense concentration. The realistic portrayal of the large fleshy nose, the narrow compressed lips, and the sparse beard do not make the face particularly appealing. Yet Velázquez, in his extremely vivid portrait, endows the pope with a detached aristocratic dignity. Velázquez remained in Rome only for a short time, and his connection with the pope consisted only of this single commission. In contrast to Raphael with Julius II and Leo X, Bernini with Urban VIII, and Algardi with Innocent X, he could not explore the pope's personality in the course of a long confidential relationship. Yet in this portrait he gave proof of a genius for observation and penetration: he seems to have grasped the essence of the pope's character in a quite objective way. The distance that separates him from the head of the church is preserved, even emphasized – a characteristic consistent with the function of an official portrait intended to embellish the family palace.

The prestige associated with a papal portrait commission is suggested in a drawing by Agostino Masucci, representing Pier Francesco Mola as he was painting Pope Alexander VII (fig. 30).[88] Mola is sitting at his easel. The pope in his armchair turns not to the painter but to the observer and points benevolently with his left hand to the painter. The drawing was made for a biography of Mola, written in 1724, long after the painter's death in 1666. The situation represented is, of course, imaginary: the dome of Saint Peter's glimpsed through the window alludes to the Vatican, the table and the curtain in the foreground allude to the finished painting. The amiable Pope Alexander VII seems a model of patience: ready to pose for the painter for so long as was needed for him to complete his portrait. But was this necessarily the case? How can the artist's work on a papal portrait be really imagined?

Figure 29
Diego Velázquez, *Innocent X*,
Galleria Doria Pamphilij, Rome

Figure 30
Agostino Masucci, *Pier Francesco Mola Portraying Pope Alexander VII*, National Museum, Stockholm

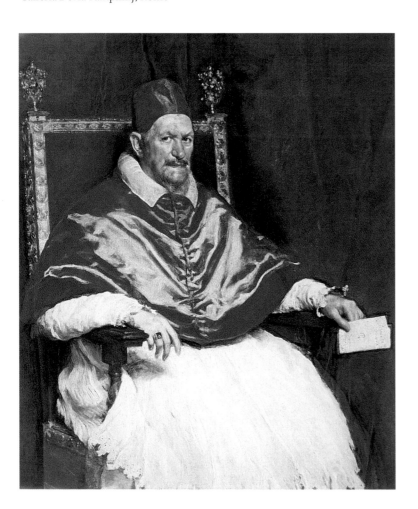

In his *Life* of the painter Carlo Maratta, Bellori, the seventeenth-century librarian, antiquarian, and biographer of the artists, describes the genesis of the portrait that Maratta painted of Pope Clement IX.[89] The painting, now in the Vatican Pinacoteca (fig. 31),[90] follows the traditional form of representation introduced by Raphael. It shows the very refined, somewhat fatigued sixty-nine-year-old pope sitting in his armchair with a book in his hand and regarding the observer with a gentle expression. According to Bellori, Maratta proposed to the pope that he should begin painting the portrait during Carnival, because Clement IX planned to retire to Santa Sabina on the Aventine during this period and would, as a result, be relatively free of engagements. Maratta also showed concern for the pope's well-being by posing him in as untiring a way as possible. Clement IX, in Bellori's version, praised this and remarked that, in contrast to his experiences with other artists, he had found his sessions with Maratta not tiresome but entertaining. Bellori points out that in the completed portrait the pope is shown in a moment of rest; the dignity of his face is preserved, despite the fact that his age and his weakness are not hidden. The pope's state of health must, however, already have been giving rise to anxiety, as Bellori later describes a fainting spell during one of the sessions. Bellori also recounts how the artist, before he began painting, subjected his sitter to careful scrutiny and imprinted an image on his mind's eye, on which he could draw, in the event of the pope being prevented, by a sudden feeling of weakness, from maintaining his features in the pose in which Maratta wanted to portray him. Only the face was completed in the pope's presence. The rest of the portrait was painted by the artist at home. Bellori stresses that Maratta was given permission to sit at his easel while painting the pope's portrait, an exceptional privilege, as an artist was normally obliged to stand in the pope's presence. Clement IX in his benevolence decided that the painter should be comfortably seated while working. This, notes Bellori, was an honor for painting, which was thus recognized as an intellectual activity.

The long series of official papal portraits, in which the pope is shown seated, was interrupted for the first time by Pope Benedict XIV, who was portrayed standing. His portrait by Giuseppe Maria Crespi, in the Vatican Pinacoteca,[91] was, however, painted before his election and originally showed him as a cardinal (fig. 32). To adjust the portrait to Cardinal Lambertini's newly acquired dignity Crespi made only a few slight alterations, such as the addition of a tiara on the tablecloth and the overpainting of the cardinal's robes. If he were to have painted the pope in the traditional seated pose, Crespi would have had to have painted an entirely new portrait.

Figure 31
Carlo Maratti, *Portrait of Pope Clement IX*, Pinacoteca, Vatican Museums

Figure 32
Giuseppe Maria Crespi, *Portrait of Pope Benedict XIV*, Pinacoteca, Vatican Museums

In describing how the painter set about painting a portrait Bellori wrote of the idea that Maratta had formed, and impressed on his mind, the pope's features by close observation. An important practical preparation for a portrait, however – apart from the purely visual and cerebral process – was the drawing that could be rapidly sketched in the presence of the model and then worked up later in studio. Portrait drawings of the popes have been preserved since the time of Julius II. Some are rapid thumbnail sketches, others drawn with the greatest care; they served as models for the official portraits and spared the popes from lengthy or too many sessions. The pope's dress and the room in which he is posed, however, were painted in the atelier. It is also debatable how far the impressive hands of the papal portraits really belong to the popes in question. Photographs later took over the function of the preparatory drawings.

The portraits of the popes of the last few centuries have, with only a few exceptions, been in the form of their funerary monuments. Ever since Bernini erected his huge and imposing memorial for Pope Urban VIII in the sanctuary of the new Saint Peter's, and placed it opposite Guglielmo della Porta's similar monument for Paul III,[92] papal monuments have been incorporated in the architecture of Saint Peter's. The monumental sculptures of the popes, either in bronze or marble, follow the four traditional types of representation that had been developed for papal portraits since Boniface VIII. The most widespread type is the representation of the enthroned pope, his hand raised in blessing, that can be traced back to Pollaiuolo's funerary monument for Pope Innocent VIII. It was later adopted by Della Porta for his monument of Paul III, by Bernini for that of Urban VIII, and continued in the seventeenth, eighteenth, and nineteenth centuries. The latest example is Francesco Nagni's monument of Pius XI, which was not sculpted until 1965. It again shows the pope enthroned, wearing the tiara, although papal portraits since Benedict XV had eschewed this form of papal insignia.

Far rarer is the representation of the kneeling and praying pope. The motif was first introduced into funerary sculpture by Domenico Fontana's tomb of Sixtus V in Santa Maria Maggiore. Sixtus V was a strict Franciscan, and no doubt took as his model the humble pose of Pope Nicholas IV in the apse mosaic of Santa Maria Maggiore. Here, as also in later representations of the kneeling pope, he is represented bare headed; the tiara is supported on the cushion beside him. This compositional scheme was introduced into Saint Peter's by Bernini in his funerary monument of Alexander VII. Bernini's original design for his tomb of Alexander VII also influenced Antonio Canova in the kneeling pose adopted for his imposing monument of Pope Clement XIII in Saint Peter's. The same pose was adopted by Canova for his statue of Pius VI, erected in 1822. The pope, taken prisoner by Napoleon, had been forced to abandon Rome, and had died in exile in Valence in 1799; only in 1802 were his mortal remains finally restored to the eternal city. The statue, situated opposite the *confessio* in the Vatican Grottoes, and its inscription "Orate pro eo," are a reminder of the pope's personal sufferings; for the first time the observer does not look up to the pope, but looks down on him from above: the pope appears, as it were, from the depths of the grave. This impression is unfortunately lost, because the statue has since been moved back into the Grottoes and is no longer visible from above. Another pope to be portrayed kneeling was Benedict XV. The unusually moving funerary monument by Pietro Canonica (fig. 33) shows the figure of the pope, carved from white marble, kneeling in a

sideways position in front of a bronze relief, on which is represented the Madonna and Child, who holds up an olive branch in his hand over a world that has gone up in flames. Benedict XV's dress is also unusual for a papal funerary monument: he is not wearing the pluvial, but the short cape, the mozzetta; nor is it a tiara, but a book, that is lying before him.[93] Represented with great realism, the features of the pope, who has sunk to his knees in prayer for suffering humanity, are careworn but benevolent. Canonica tried in this monument to express the pope's indefatigable efforts to restore peace and provide humanitarian relief during the First World War.

The standing and blessing pope, known from statues from the time of Pope Boniface VIII, was only much later introduced into the repertoire of funerary sculpture. In his first designs for the funerary monument of Benedict XIV, Pietro Bracci had conceived of a traditional format, with the pope enthroned. Only later did he adopt the form of the standing pope; he wanted to give the impression that Benedict XIV had just stood up from his throne to impart his blessing. The last pope to be shown as a standing figure in Saint Peter's was Pius XII. He is portrayed, in his funerary monument, as extraordinarily impressive. The tall narrow figure, enveloped in the all-encompassing pluvial, from which only a withered hand emerges in a gesture of blessing, the head crowned with the miter, and the eyes hidden behind thick glasses, lend Pius XII a very forbidding appearance. Argument raged between the artist Francesco Messina and the Commission of Cardinals, which had commissioned the statue, about various details of the monument. Messina's proposal to represent Pius XII wearing the miter, in deference to his role as bishop of Rome during the Second World War, encountered initial resistance within the Commission, which would have preferred the tiara. So, too, did the spectacles: the cardinals, and the pope's nephew Carlo Pacelli, would have preferred a more idealized portrait.

The recumbent sarcophagus figure, which had adorned papal tombs since the thirteenth century, was not revived for any of the funerary monuments in the new Saint Peter's. Only on the tomb of Innocent VIII, which had been salvaged from the old basilica and reinstalled in its present position in 1621, does the recumbent figure of the deceased appear. Death is only shown symbolically in the more recent monuments in Saint Peter's. The pope is perpetuated as a living man.[94] Only in the twentieth century has there been a revival of the medieval form of sarcophagus tomb; this was because Pius X – and all popes since – was not buried in the basilica, but in the Vatican Grottoes below. When Benedict XV died in 1922, the city of Bologna, where the pope had been archbishop, commissioned a bronze recumbent figure for his sarcophagus, which was placed in the Grottoes. Giulio Barberi represented Benedict XV with sunken features, closed eyes, a serene expression, and hands crossed over his breast. He thus returns to the tradition embodied by the older papal tombs in the Vatican Grottoes.

The papal portraits of the last two centuries are in the main artistically conventional works. They reflect the far-reaching change in the relation between church and art that has taken place since the nineteenth century. In earlier centuries the church was the source of artistic impulses and the main source of patronage. Leading commissions closely linked artists with the church. Since the nineteenth century, the various artistic avant-gardes dissolved their links with the church in the quest for new contents and new forms of expression. In the later papal monuments, essentially con-

servative in style, this led to an obstinate attachment to the traditional forms of representation. The question of how far these forms of representation can still continue to lend meaningful expression to our altered understanding of the papacy today is thus posed. Following the loss of the Papal States, the papacy has ever more powerfully been transformed from its former worldly power into a moral authority; its former links with the world of art have thus been sundered. Attempts to reestablish a dialogue between the popes and contemporary art have not been entirely lacking. John XXIII's favorite sculptor was Giacomo Manzù, whom he patronized and who also enjoyed an international reputation. Paul VI opened up the Vatican Museums to the huge field of contemporary art. Yet it was also Paul VI who expressed the wish that no monument be erected to him after his death. Perhaps one way out of the resulting dilemma for believers, and their continuing need for the person of the pope to be commemorated in iconographic form, is the fact that ever since the 1950s the embalmed bodies of Saint Pius X, the Blessed Innocent XI, and now the Blessed John XXIII have been transferred to three altars in Saint Peter's and venerated as relics in glass sarcophagi. In the basilica of San Lorenzo fuori le mura, the embalmed remains of Pope Pius XII have also been similarly exposed to the veneration of the faithful in his own funerary chapel. In all these cases the visual transmission of the pope's appearance is no longer entrusted to art.

Figure 33
Pietro Canonica, *Monument of Benedict XV*, Saint Peter's Basilica

Notes

1. *Liber pontificalis*, ed. L. Duchesne, Paris, 1955, 1: 385; Gerhart B. Ladner, *Die Papstbildnisse des Altertums und des Mittelalters*, 3 vols., Vatican City, 1941–84, 1: 94-95.

2. Ladner 1941–84, 1: 9-11; on the iconography of Saint Peter and his earliest portraits, cf. Fabrizio Bisconti, "Pietro e Paolo: L'invenzione delle immagini, la rievocazione delle storie, la genesi delle teofanie," in *Pietro e Paolo. La storia, il culto, la memoria nei primi secoli*, ed. Angela Donati, Milan, 2000, 43-49.

3. Rome, Catacomb of Praetextatus, in the *arkosolium* of the tomb of Celerina; cf. Ladner 1941–84, 1: 12-16.

4. One of the main concerns of Ladner was to pose the question of how far the Early Christian and medieval papal portraits may represent, if not a physiognomically distinctive individual, at least a particular person. He assumed that our contemporary concept of the portrait, and its degree of realism or verisimilitude, cannot serve as a criterion for such an investigation. Instead, we must adopt a medieval concept, according to which the terms of the equation are reversed: it is precisely the ideal that is real. Cf. Ladner 1941–84, 1: 1-7, 46; and more generally, for a discussion of the classification of medieval papal portraits in the context of the history of the portrait, 3: 320-69.

5. On gold glasses, cf. Ladner 1941–84, 1: 18-37; on the *refrigeria* celebrated by Christians, cf. Bernhard Schimmelpfennig, *Das Papsttum*, Darmstadt, 1996, 22.

6. Biblioteca Apostolica Vaticana, Cod. Barb. lat. 2733, fols. 109r ff.; cf. Ladner 1941–84, 1: 52-59.

7. On the rows of papal portraits in the basilicas of Rome, cf. Ladner 1941–84, 1: 38-59.

8. On the later rows of papal portraits, cf. Ladner 1941–84, 3: 159-241.

9. Starleen K. Meyer, "The Papal Series in the Sistine Chapel: The Embodiment, Vesting and Framing of Papal Power," *Bollettino (Monumenti Musei e Gallerie Pontificie)* 20 (2000): 131-61.

10. The title "vicarius Christi" was used for the first time by Peter Damian in a letter of 1057 and has been reserved for the pope since Innocent III; cf. Agostino Paravicini Bagliani, *Il corpo del Papa*, Turin, 1994, 82-83.

11. Ladner 1941–84, 1: 62-64; Guglielmo Matthiae, *Mosaici medioevali delle chiese di Roma*, Rome, 1987, 135-42; Vitaliano Tiberi, *Il restauro del mosaico della Basilica dei Cosma e Damiano a Roma*, Todi, 1991.

12. Ladner 1941–84, 1: 65-69; Matthiae 1987, 149-68.

13. Ladner 1941–84, 1: 88 – 98; Matthiae 1987, 215-24.

14. Saint Peter's, Chapter Archive, Grimaldi Album, A 64 ter, fol. 49. On the documentation of the mosaic, cf. Maria Andaloro, "I mosaici dell'Oratorio di Giovanni VII," in *Fragmenta picta. Affreschi e mosaici staccati del Medioevo romano*, Rome, 1989, 169-77.

15. On the square halo, cf. Ladner 1941–84, 3: 310-18.

16. Ladner 1941–84, 1: 113 – 28; Christopher Walter, *Prayer and Power in Byzantine and Papal Imagery*, Aldershot, 1993, VII a, 157-60, 170-76; Ingo Herklotz, "Francesco Barberini, Nicolò Alemanni, and the Lateran Triclinium of Leo III: An Episode in Restoration and Seicento Medieval Studies," *Memoirs of the American Academy in Rome* 40 (1995): 175 – 96; Bauer in *Carlo Magno a Roma*, Rome, 2001, 89-90.

17. Walter 1993, VIIa, 159-60; Rusich in *Carlo Magno a Paolo*, 2001, 176-79.

18. In later representations, the kneeling pope no longer receives the pallium from Saint Peter but the keys of the kingdom of heaven, the symbol of the power of binding and loosing, that was transmitted by Christ to Peter (cf. Mt 16: 19).

19. Ladner 1941–84, 1: 130 – 41; Matthiae 1987, 233-35.

20. Ladner 1941–84, 1: 190 – 218; Walter 1993, VIIa, 162-66, VIIb, 109-23; Ingo Herklotz, *Gli eredi di Costantino*, Rome, 2000, 95-158.

21. Biblioteca Apostolica Vaticana, Barb. Lat. 2738, fols. 104r, 105v.

22. For a detailed analysis of this composition and its historical circumstances, cf. Herklotz 2000, 131-51.

23. Ladner 1941–84, 2: 11-12.

24. Ladner 1941–84, 2: 80-96.

25. Ladner 1941–84, 2: 143-65; Herklotz *"Sepulcra"* e *"Monumenta" del Medioevo*, Rome, 1985, 164-70; Michael Borgolte, *Petrusnachfolge und Kaiserimitation*, Göttingen, 1995, 206-9.

26. But it should be noted that the heavily damaged tomb slab of Lucius III, according to Ladner (1941–84, 2: 38) the first surviving sculpted papal portrait, is still *in situ* in the Cathedral of Verona. On this see Ingo Herklotz, 1985, 114-16.

27. Borgolte 1995, 179-232.

28. Borgolte 1995, 228.

29. For a discussion of the terminology of papal statues in the Middle Ages, and the distinction between the concepts of *Ehrenstatue* and *Repräsentationsstatue*, cf. Monika Butzek, *Die kommunalen Repräsentationsstatuen der Päpste des 16. Jahrhunderts in Bologna, Perugia und Rom*, Bad Honnef, 1978, 72-73.

30. Ladner 1941–84, 2: 226; Herklotz 1985, 214-15.

31. On the polemic against heathen images in the fourth century, cf. Thomas Sternberg, "Vertrauter und leichter ist der Blick auf das Bild," in *..kein Bildnis machen*, eds. C. Domen and T. Sternberg, Würzburg, 1987, 32-35.

32. Ladner 1941–84, 2: 219 – 23; Serena Romano, "Il Sancta Sanctorum: gli affreschi," in *Sancta Sanctorum*, Milan, n.d, 38-125.

33. Ladner 1941–84, 2: 234-47; Matthiae 1987, 347-66; Alessandro Tomei, *IACOBUS TORRITI PICTOR*, Rome, 1990, 77-125.

34. Ladner 1941–84, 3: 362.

35. Ladner 1941–84, 2: 285-340.

36. On the statue in Bologna, cf. Ladner 1941–84, 2: 296-301; Butzek 1978, 66-67; on that in Florence, cf. Ladner 1941–84, 2: 322-31, Butzek 1978, 70-71; on that in Orvieto, cf. Ladner 1941–84, 2: 332-36; Butzek 1978, 63-65; *Bonifacio VIII e il suo tempo*, 133, cat. 70; on that in Anagni , cf. Ladner 1941–84, 2: 337-38; *Bonifacio VIII e il suo tempo*, 136, cat. 73b; on the statue planned for Padua, cf. Ladner 1941–84, 2: 339-40; Butzek 1978, 67-69.

37. Ladner 1941–84, 2: 296-301; Butzek 1978, 66-67.

38. Herklotz 1985, 215; on the indictment made against Boniface VIII by Philip the Fair in 1310, cf. Ladner 1941–84, 2: 299-301; Butzek 1978, 59-63.

39. On the much-discussed bronze statue of Saint Peter, cf. Francesco Caglioti in *La basilica di S. Pietro in Vaticano*, Modena, 2000, 4: 761-68.

40. Butzek 1978, 58-59.

41. Ladner 1941–84, 2: 302 – 17; Paravicini Bagliani 1994, 319 – 23; Borgolte 1995, 227-31.

42. Giacomo Grimaldi, Bibl. Apost. Vat., Barb. lat. 2733 fol. 7 v, 8 r.

43. The two fragments in question are the head of Mary (Brooklyn Museum of Art) and the Christ Child (Moscow, Pushkin Museum), cf. *Bonifacio VIII e il suo tempo*, Milan, 2000, 140, cat. nos. 80, 81.

44. A contemporary in ca. 1304 described a portrait of Boniface VIII placed against the wall to one side of his funerary monument; cf. Paravicini Bagliani 1994, 325 – 26; on the half-figure, cf. Ladner 1941–84, 2: 313-17; Butzek 1978, 69-70.

45. Butzek 1978, 52-54.

46. Ladner 1941–84, 3: 362.

47. On the tiara, cf. Ladner 1941–84, 3: 270-307; Butzek 1978 , 49-52.

48. Ladner 1941–84, 3: 367; Borgolte 1995, 247-48.

49. Cennino Cennini, *Il libro dell'arte o trattato della pittura*, cap. CLXXXI – CLXXXIV, ed. Fernando Tempesti, Milan 1975, 146-49.

50. Borgolte 1995, 241f.

51. Butzek 1978, 70.

52. Family coats of arms appear on papal tombs since the second half of the thirteenth century; Grimaldi's seventeenth-century drawings thus show the coat of arms of the Caetani in the tomb of Boniface VIII; cf. Herklotz 1985, 199.

53. On the miniature in Berlin, Kupferstichkabinett No. 4215, cf. Harald Keller, "Die Entstehung des Bildnisses am Ende des Hochmittelalters," *Römisches Jahrbuch für Kunstgeschichte* 3 (1939): 311, Abb. 277; I wish to thank Peter Seiler for kindly bringing this miniature to my attention.

54. Arnold Esch in *Dizionario biografico degli Italiani* 12 (1970), 14-15.

55. Giovanni Sercambi, *Croniche*, Archivio di Stato, Lucca, Biblioteca Manoscritti 107, fol. 260 v.; cf. Arnold Esch, "I giubilei del 1390 e del 1400," in *La storia dei Giubilei*, 1997, 1: 281, fig. 5.

56. Jörg Träger, "Die Begegnung Leos des Grossen mit Attila," in *Raffaello a Roma*, Rome, 1986, 99-100.

57. Arnold Esch, "La fine del libero comune di Roma nel giudizio dei mercanti fiorentini. Lettere romane degli anni 1395 –1398 nell'Archivio Datini," in *Bollettino dell'Istituto Storico Italiano per il Medio Evo e Archivio Muratoriano*, 1976 –77, 235-77.

58. Arnold und Doris Esch, "Die Grabplatte Martins V. und andere Importstücke in den römischen

Zollregistern der Frührenaissance," *Römisches Jahrbuch für Kunstgeschichte* 17 (1978): 209–17; Joachim Poeschke, *Die Skulptur der Renaissance in Italien*, vol. 1, Munich, 1990, 109f.; Arnold Esch, "La lastra tombale di Martino V ed i registri doganali di Roma," in *Atti del Convegno. Alle origini della nuova Roma: Martino V (1417–1431)*, Rome, 1992, 625-41; Borgolte 1995, 265-67.

59. Esch 1992, 632-38.

60. Poeschke 1990, 97-99.

61. On the concept of *similitudo*, cf. Poeschke 1990, 28-29, 34.

62. Quite different, for instance, was the portrait of Pope Julius II that Albrecht Dürer painted in 1506 for the altarpiece of the Rosenkranzfest (Nationalgalerie, Prague). In contrast to the emperor Maximilian I kneeling opposite him, the portrait of the pope bears no resemblance to Julius II. The altarpiece was painted for the German community in Venice, which clearly attached no value to how far the portrait resembled the reigning pope. See Fedja Anzelewsky, *Albrecht Dürer. Das malerische Werk*, Berlin, 1971, 192-95.

63. Eugenio Battisti, *Filippo Brunelleschi*, Milan, 1976, figs. pp. 16, 340.

64. Gerhart B. Ladner, "Die Anfänge des Kryptoporträts," in *Von Angesicht zu Angesicht. Porträtstudien – Michael Stettler zum 70. Geburtstag*, eds. Florenz Deuchler, M. Flury-Lemberg, and K. Otavsky, Bern, 1983, 78-97; Renate Colella, *Päpstliche Suprematie und kirchliche Reform. Die Fresken Fra Angelicos in der Kapelle Nikolaus V. Ein päpstliches Programm in spätkonziliarer Zeit*, Munich, 1993, 112-13; on the frescoes of Fra Angelico, see also Innocenzo Venchi et al., *Fra Angelico and the Chapel of Nicholas V*, ed. Allen Duston O.P. (Recent Restorations of the Vatican Museums, 3), Vatican City State, 1999.

65. Ladner 1941–84, 3: 368-69.

66. José Ruysschaert, "Sixte IV fondateur de la Bibliothèque Vaticane et la fresque de Melozzo da Forlì (1471–1481)," in *Sisto IV e Giulio II, mecenati e promotori di cultura*, Savona, 1985, 27-44; Matthias Winner, "Papa Sisto IV quale exemplum virtutis magnificentiae nell'affresco di Melozzo da Forlì," in *Arte, committenza ed economia a Roma e nelle corti del Rinascimento*, ed. A. Esch, C. L. Frommel, Turin, 1995, 171-95.

67. Pietro de Angelis, *L'architetto e gli affreschi di Santo Spirito in Saxia*, Rome, 1961; Maria Alessandra Cassiani, "L'ospedale di Santo Spirito in Sassia: cultura francescana e devozione nel ciclo pittorico della corsia sisitina," in *Sisto IV. Le arti a Roma nel Primo Rinascimento*, Rome, 2000, 167-73.

68. Poeschke 1990, 183; Borgolte, 1995, 287–88; Aldo Galli in *La Basilica di San Pietro in Vaticano*, Modena, 2000, 4: 541-47.

69. It is transmitted by a drawing of Marten van Heemskercks, Berlin, Kupferstichkabinett, *Römische Skizzenbücher*, 2: fol. 22, and by another anonymous seventeenth-century drawing also in Berlin, Kupferstichkabinett, KdZ 5200; cf. Galli 2000, figs. 364-65.

70. Giorgio Vasari, *Le vite de' più eccellenti pittori scultori ed architettori*, ed. G. Milanesi, Florence, 1906, 4: 338-39.

71. Cecil Gould, *Raphael's Portrait of Pope Julius II. The Re-emergence of the Original*, London, 1970; Bram Kempers in *Hochrenaissance im Vatikan. Kunst und Kultur im Rom der Päpste. 1503-1534*, Bonn, 1998, cat. no. 4, p. 434.

72. Vasari 1906, 4: 338.

73. Alfio del Serra et al., *Raffaello e il ritratto di Papa Leone*, Cinisello Balsamo-Milan, 1996; Arnold Nesselrath in *Hochrenaissance im Vatikan, Kunst und Kultur im Rom der Päpste. 1503–1534*, Bonn, 1998, cat. no. 22, 441-43.

74. Max-Eugen Kemper, "Leo X. – Giovanni de'Medici," in *Hochrenaissance im Vatikan*, 1998, 39.

75. Roberto Zapperi, *Tizian. Paul III. und seine Enkel. Nepotismus und Staatsporträt*, Frankfurt, 1990, 23-28.

76. Klaus Schwager, "Über Jean Fouquet in Italien und sein verlorenes Porträt Papst Eugens IV.," in *Argo. Festschrift für Kurt Badt*, eds. M. Gosebruch and L. Dittmann, Cologne, 1970, 206-34.

77. Michael Hirst in *Hochrenaissance im Vatikan* 1998, cat. no. 54, 448-49.

78. Cf. Ludwig von Pastor, *Storia die Papi dalla fine del Medio Evo*, Rome, 1956, 4: 161-62.

79. Roberto Zapperi, *Tizian. Paul III. und seine Enkel. Nepotismus und Staatsporträt*, Frankfurt, 1990.

80. On Titian's relations with the Farnese, cf. Zapperi 1990, 28-43.

81. On this gesture of abasement alluded to in Titian's painting of Duke Ottavio, cf. Zapperi 1990, 10-12, 69-70.

82. Valentino Martinelli, *I ritratti di pontefici di G.L. Bernini*, Rome, 1956.

83. Sebastian Schütze, "Urbano VIII," in *Bernini Scultore. La nascita del Barocco in Casa Borghese*, eds. A. Colliva, S. Schütze, 240-51.

84. The bust that Bernini sculpted of Innocent X stands opposite the famous portrait of the pope by Velázquez in the Palazzo Doria Pamphilij, providing an unique opportunity to compare the features of the pope in both portraits.

85. Jennifer Montagu, "La vita di Alessandro Algardi," in *Algardi. L'altra faccia del barocco*, ed. J. Montagu, Rome, 1999, 14.

86. Ludwig von Pastor 4: 509; on the papal statues on the capitol, cf. Butzek 1978, 202-322.

87. The bust is now in the Museo Nazionale del Palazzo Venezia in Rome; cf. Francesca Cappelletti, in *Algardi. L'altra faccia del barocco*, cat. no. 29, 158; *Earth and Fire. Italian Terracotta Sculpture from Donatello to Canova*, ed. Bruce Boucher, New Haven, 2002, cat. no. 41, 190-91.

88. The drawing is in the Nationalmuseum in Stockholm, Inv. No. 554/1863; cf. Nicholas Turner, "Pier Francesco Mola: i disegni," in *Pier Francesco Mola. 1612–1666*, Milan, 1989, 110. I would like to thank Jennifer Montagu for bringing this drawing to my attention.

89. Giovan Pietro Bellori, *Le Vite de' Pittori, Scultori e Architetti moderni*, ed. E. Borea, Turin, 1976, 591-93.

90. Fabrizio Mancinelli in *The Vatican Collections. The Papacy and Art*, New York, 1982, cat. no. 89, 167.

91. Fabrizio Mancinelli, "Mostra dei Restauri in Vaticano," in *Bollettino. Monumenti, Musei e Gallerie Pontificie*, 1982, 4: 286-95.

92. Werner Gramberg, "Das Grabmal für Paul III. Farnese," in *Römisches Jahrbuch für Kunstgeschichte* 21 (1984), 254-364.

93. The same clothing, and the same praying pose, is also adopted for the statue of Pius IX by Ignazio Iacometti, installed in the *confessio* in Santa Maria Maggiore in commemoration of the extensive work carried out in the basilica during his pontificate. Here a parallel not only with the form, but also with the site, of Canova's statue of Pius VII is sought. The parallel is prompted, not least, by analogies in the fate of the two popes: under Pius IX, as under Pius VII, the Catholic Church had once again suffered the loss of her worldly claims and the imprisonment of her head. On the statue, cf. Roberto Luciani, "La Basilica dal Settecento al Novecento," in *Santa Maria Maggiore e Roma*, ed. R. Luciani, Rome, 1996, 201.

94. Already in the Renaissance, as in the funerary monument of the Dutch Pope Adrian VI in Santa Maria dell'Anima, the deceased is represented not as a corpse, but as someone sleeping, supporting his head on his arm that rests on a cushion.

The Congregation for the Evangelization of Peoples (De Propaganda Fide) and Its Historical Archives

Cardinal Crescenzio Sepe

Figure 1
Entrance to the Palazzo di Propaganda Fide

Figure 2
Fra Bartolomeo della Porta,
Saint Paul, the first great missionary of the Church,
Papal Apartments, Vatican City State

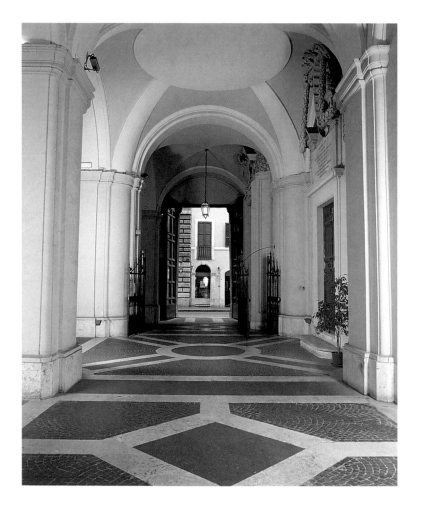

The Congregation for the Evangelization of Peoples, known historically as De Propaganda Fide (fig. 1), is one of the dicasteries that form the Roman curia: "that group of Dicasteries and organizations that assist the Roman pontiff in the exercise of his supreme pastoral office for the good and service of the universal Church and of particular Churches; a service that reinforces the unity of faith and the communion of the People of God and that promotes the mission of the Church in the world."[1]

The pilgrim church is, according to the *Ad gentes* decree of Vatican Council II, missionary by nature (fig. 2).[2] Her awareness, however, of her self and of her mission has grown and developed under the guidance of the Holy Spirit, and the foundation of the Congregation "De Propaganda Fide" marks an important moment in this growth. The church, starting from the very top – in other words, from the pope – recognizes her inalienable call to announce Christ, the one Savior of the world, and, thus, her duty to guide, stimulate, and organize all forces at her disposal so that this announcement of salvation reaches everyone.

The report of the first meeting of cardinal members of the new Congregation "De Propaganda Fide," on January 6, 1622, conveys precisely this message: "[…] Sanctissimo in Christo Pater, et Dominus Gregorius Divina Providentia PP. XV., animadvertens, praecipuum Pastoralis Oficij caput esse propagationem Fidei christianae, per quam homines ad agnitionem, et Cultum Veri Dei perducuntur, et sobri, ac pie, et juste vivunt in hoc saeculo; erexit Congregationem …" (The most Holy Father and Lord in Christ Gregory XV by Divine Providence, noting that the most important task of pastoral care is the spread of the Christian faith, through which people are brought to the recognition and honor of the true God and live soberly, piously and justly in this world, instituted the Congregation …).[3]

The idea of creating a dicastery within the Holy See that would, in the name of the pope, oversee the mission – that is, the propagation of the faith – came from the Spaniard Ramón Lull who, around the year 1400, suggested the idea of a missionary center in Rome. During the period of the great conquests in America, the mission received strong support with the creation of the Royal Spanish vicariate and the Portuguese Padroado. The pope conceded special privileges to the monarchs of these two kingdoms, who, in turn, committed themselves to financing and supporting the mission.

Pope Pius V, encouraged by Francis Borgia, the superior general of the Jesuits, created a cardinalatial Congregation to oversee the spiritual matters of the mission and another to supervise church affairs in Germany and other Protestant countries.

Pope Clement VIII managed to establish a Congregation De Propaganda Fide, but because of the death of its chief supporter, Cardinal Giulio Antonio Santori, and resistance from within the Padroado, it lasted for only a short period (1599–1604).

Finally, on January 6, 1622, Pope Gregory XV established the Congregation De Propaganda Fide as the central and supreme body for the propagation of the faith, entrusting it with a twofold mission: to seek union with Orthodox and Protestant churches, and to promote and organize the mission among non-Christians. The particularity of the new Congregation lay in its being the Holy See's ordinary and exclusive instrument in the exercise of its jurisdiction over all missions.

According to the act by which it was created, the Congregation was to be composed of thirteen cardinals, of whom one was prefect; two prelates;

Figure 3
Sienese school, *Adoration of the Magi*,
Collection of the Congregation for the
Evangelization of Peoples

and a secretary. Soon afterward, a Carmelite religious was added to this number as was, in 1626, a pronotary and, in 1630, the assessor of the Sant'Uffizio, who from that moment on was a member by right.

The members would meet in an assembly called the general congregation, usually once a month. From 1953 to 1967, this monthly meeting was known as the plenary congregation. Since 1968 this term has been reserved for the annual meetings of the new body that constitutes the dicastery as introduced by Vatican Council II, comprising cardinals, twelve missionary bishops, four other bishops, four religious superiors general, four national directors of the Pontifical Missionary Works, and the secretary. The monthly meeting is now known as the ordinary congregation.

Matters that called for more in-depth study were consigned to a special commission of cardinals and others who met in so-called particular congregations that were strictly ad hoc. Only for the Far East was a permanent particular congregation formed, which convened until 1856.

The cardinal prefect, together with his secretary and assistants, expedites everyday missionary matters in a weekly meeting known as the congress. Problems that call for pontifical intervention are brought to the pope's attention by the cardinal prefect in a special audience. In that instance, the Congregation informs the interested parties of the decisions made by means of letter, decree, instruction, or circular.

The Work of the First Secretary

From the very beginning, Msgr. Franceso Ingoli, the first secretary of the dicastery (1622–1649; fig. 4) sought to gather information from nuncios, superiors general of the various religious orders, and individual missionaries on the ecclesiastical and missionary situation in their territories. Such documentation, Ingoli believed, would be important not just for developing a careful program of activities but also from a historical perspective. He meticulously collected all documents regarding the work of the Congregation (reports, letters, appeals from missionaries, minutes of meetings of dicastery members and personnel, registers and copies of his own letters, instructions, circulars, decrees, etc.) and so laid the foundations for the missionary archive of the Congregation, of which he himself was the first archivist.

Thus, a unique collection of documents came into being, one that concerned all the countries and peoples dependent on the Congregation and which remains unmatched in the church and perhaps in the world. The information it contains is not only missionary and ecclesiastical but also cultural, ethnographic, and geographic, and is of inestimable value for the peoples of Africa, Asia, Oceania, and elsewhere. The collection houses approximately twelve million documents in fifteen thousand files, and covers all the mission lands – Africa, Asia, Oceania, and North America, as well as Northern and Eastern Europe – from 1622 until today.[4]

Figure 4
Signature of the first secretary of Propaganda Fide,
Francesco Ingoli

Propaganda Fide during the French Revolution and the Napoleonic Age

During the eighteenth century, a particularly noteworthy aspect of the Congregation's commitment was its insistence on establishing schools in the missions, because it considered them an important aid toward the development of the local population and the propagation of the faith. Furthermore, during the same century, the dicastery prohibited the slave trade, which it saw as a dangerous obstacle to the mission and, in this way, made an energetic and repeated contribution to the abolition of slavery. In the same manner, it reiterated the ban on its missionaries from participating in politics.

The end of the eighteenth century and the period of the French Revolution was a particularly dark and painful moment in the history of the Church, for missions, in general, and for the Congregation De Propaganda Fide, in particular. Pope Pius VI was deposed and arrested by French revolutionaries on February 15, 1798, and died in prison on August 29, 1799. On March 15, 1798, the Congregation De Propaganda Fide was suppressed by "citizen" Haller as being an "établissement fort inutile," and the prefect of the Congregation, Cardinal Gerdil, was exiled from Rome.

Cardinal Stefano Borgia

At that difficult time, on January 15, 1799, Pope Pius VI appointed as proprefect of the dicastery a man who would turn out to be providential to the very survival of Propaganda Fide, Cardinal Stefano Borgia (fig. 5). The pope entrusted him with the administration of all missions and chose the city of Padua in Italy as a provisional headquarters for the Congregation.

The greatest merit of Cardinal Stefano Borgia, first as proprefect then as prefect (1798–1804), was that of salvaging the Congregation in such a difficult period. He was one of the most cultured cardinals of all time, with a vast proficiency in many fields. He created a museum in his family home at Velletri, near Rome, in which he gathered antiquities, works of art, and manuscripts, which he ordered be used in studying the culture, religion, history, and customs of other peoples. He promoted the creation of local bishops in the missions, the erection of indigenous hierarchies, and the celebration of the liturgy in local languages. He also concerned himself with forging harmonious relations with the powers of the Padroado (Portugal and Spain), in order to be able to work with them in the propagation of the Christian faith.

When the new pontiff, Pope Pius VII, entered Rome in July 1800, he was accompanied by Cardinal Borgia who, as soon as the French troops withdrew from the city, began to buy back Propaganda Fide's various properties that the French had put up for auction. He was particularly concerned to reacquire the precious codices, manuscripts, books, and furniture, and also began to rebuild the dicastery and deal with the most pressing missionary problems.

Napoleon's attitude to Propaganda Fide was quite different from that of the Revolution. He admired the Congregation and thought to turn it and its international relations to his own profit. Consequently, he did not suppress Propaganda Fide but allowed it to continue its activities, declaring that its expenses and those of the Urban College were imperial expenses and appointing a special commission to administer its patrimony. Nonetheless, Propaganda again suffered considerable material damages in this period: its entire archive was transported to Paris, and when it was returned, in 1815, many of the documents were missing.

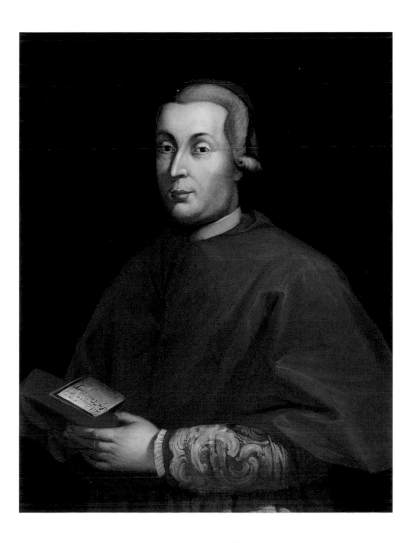

Figure 5
Ferdinando Barsanti, *Cardinal Stefano Borgia*,
after 1789, prefect of Propaganda Fide

The Congregation for the Evangelization of Peoples Today

At present, the territories dependent upon the Congregation, which, following the reform of the curia by Pope Paul VI became known as the Congregation for the Evangelization of Peoples or "De Propaganda Fide," and, after Pope John Paul II's apostolic constitution *Pastor Bonus*, simply as the Congregation for the Evangelization of Peoples, include some regions in southeastern Europe and in America, almost all the continent of Africa, the Far East and Oceania (with the exception of Australia), and almost the entire Philippine Islands.

The Congregation's task is to direct and coordinate the evangelization of peoples and missionary cooperation throughout the world, save in those areas under the authority of the Congregation for the Oriental Churches. Furthermore, the dicastery enjoys a direct and exclusive role in its territories except in matters that concern other dicasteries of the Roman curia.

Figure 6
Francesco Borromini, interior of the chapel of
Propaganda Fide

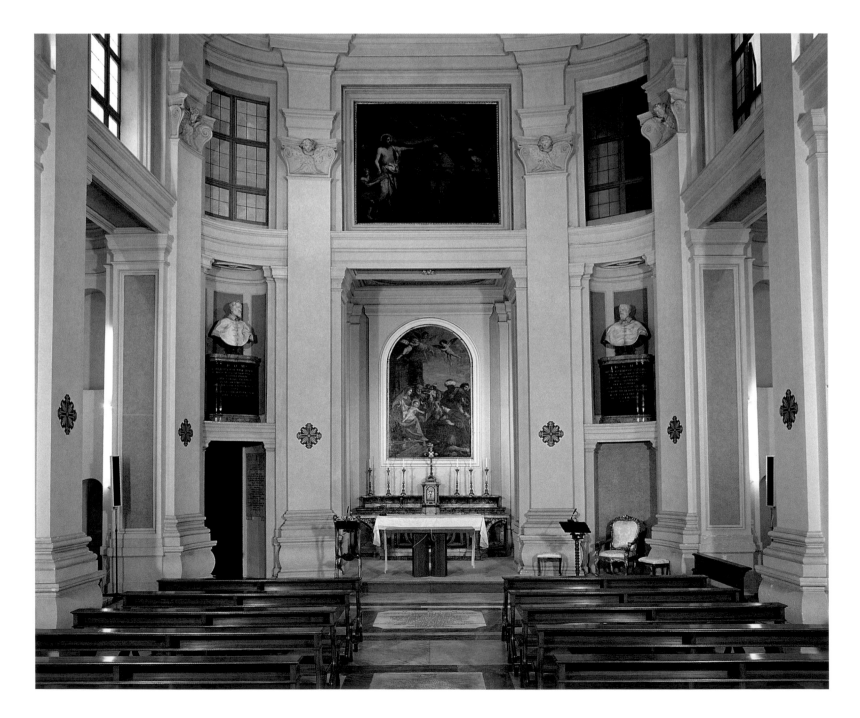

The Congregation creates and divides the missionary circumscriptions in its territory in accordance with particular requirements; presides over the running of the missions; examines problems and studies reports sent in by resident bishops, nuncios, and episcopal conferences; oversees the Christian life of the faithful, the discipline of the clergy, charitable associations, and Catholic Action; and supervises the progress of Catholic schools and seminaries.

The Archive

The Congregation has never deposited documents or archival material of any kind with any other institution (not even the Vatican Secret Archives), thus it has managed to conserve all its own historical material practically intact. Some limited losses were caused by the transfer of the archive during the French occupation, when various valuable works were lost and others taken to the State Archives in Vienna, and only restored to the Congregation much later.

As early as 1627, Pope Urban VIII made space available in the Vatican palace in which to safeguard this documentation. Later, for a brief period, the archive was housed in the Apostolic Chancellery where Msgr. Ingoli had his office. Finally, following the death of Ingoli, the archive was moved to the Palazzo di Propaganda Fide, which had in the meantime been built in Rome's Piazza di Spagna. In January 2002, 380 years after the foundation of the dicastery, the archive was transferred from this historical site to a new location on the Janiculum Hill near the Pontifical Urban University and the Pontifical Urban College, thus upholding a long tradition of care and protection for this authentic "shrine of memory," one of the most important sources – if not the most important – for the history of the mission (fig. 7).

As regards the documentation, the collections of the historical archive can be divided into two periods: 1622–1892, in which the cataloguing system remained substantially unchanged; and 1893 to the present, when a system of indexes and reference numbers was introduced.

In accordance with this division, the collections of the historical archive up to 1892 are as follows:

Acta Sacrae Congregationis (*Acta*) (1622–2000), minutes from the monthly meetings of cardinals and other members of the Congregation and reports of the cardinal prefect or of the secretary and the resolutions of the members (293 vols., each with a more or less detailed index).

Original Documentation presented in General Congregations (S.O.C.G.), documents upon which the general congregations based their deliberations, such as letters from bishops, missionaries, and princes; dispatches from nuncios; acts of synods and apostolic visits, etc. (vols. 1-417 [1622–68], divided geographically; vols. 418-1044 [1669–1892], divided chronologically).

Particular Congregations (C.P.) (1622–1864), relating to the cardinalatial commissions appointed, usually by the Holy Father, to deal with particular difficulties and problems (161 vols., plus two misc. vols.).

Documentation presented in Congresses (S.C.), documents discussed during the weekly congress, which have great historical value because they reflect the daily life of the mission (1553 vols., in two series).

Audiences of Our Lord (*Udienze*) (1666–1895), requests addressed to the Holy Father, the nature of which exceeded the powers of the cardinal prefect or of the Congregation (252 vols.).

Briefs and Bulls (1775–1952), the most solemn pontifical decisions concerning the territories under the care of Propaganda Fide (11 vols.).

Instructions (1623–1808), instructions sent by Propaganda Fide to nuncios, bishops, and apostolic vicars concerning disciplinary matters (7 vols.).

Decrees (1622–75, 1719–1819), a series of internal documents that was used by the Secretariat of Propaganda Fide. The earlier volumes date to the time of the first secretary, Msgr. Ingoli, and bear his marginal notes.

Letters (1622–1892), copies of letters sent by the Congregation concerning the implementation of the decisions of the prefect, the general congregations, the particular congregations, or the congresses (338 vols.).

Minor Collections: Acts of the Commission for the revision of Rules (1887–1908; 26 vols); Diocesan Synods (19 plus 2 misc. vols.); Information (1696–1730; 17 vols.); Vienna Collection (74 vols.); Miscellaneous (various misc., 57 vols.; general misc., 35 vols.; diverse misc., 45 vols.); The Spiga Collection (1686–1728; 86 vols.); The Consalvi Collection (37 vols.); Regestum Facultatum (1670–1895; 19 vols.); Collection of Printed Instructions, Circulars, and Decrees (3 vols.); Archive of the Procurator of the Congregation in the Far East (47 boxes).

Figure 7
New headquarters of the archive of Propaganda Fide, June 5, 2002

Soon, other collections, which are coming into being as the current reorganization of the unindexed part of the archive proceeds, will have to be added. A considerable part of these new collections will contain documents from suppressed monasteries, former religious, and the archives of various aristocratic families.

The archive system underwent a radical change at the beginning of 1893 with the introduction of indexes and reference numbers. This was a response to a broadening in the activities of the dicastery and to the modern requirements of missionary organization and administration. Under the new system, each document (reports, letters, minutes, decrees, instructions, memoranda, etc.) was given a consecutive reference number, under which it was registered, and an index number which

Figure 8
Detail of the altar in the chapel of Propaganda Fide

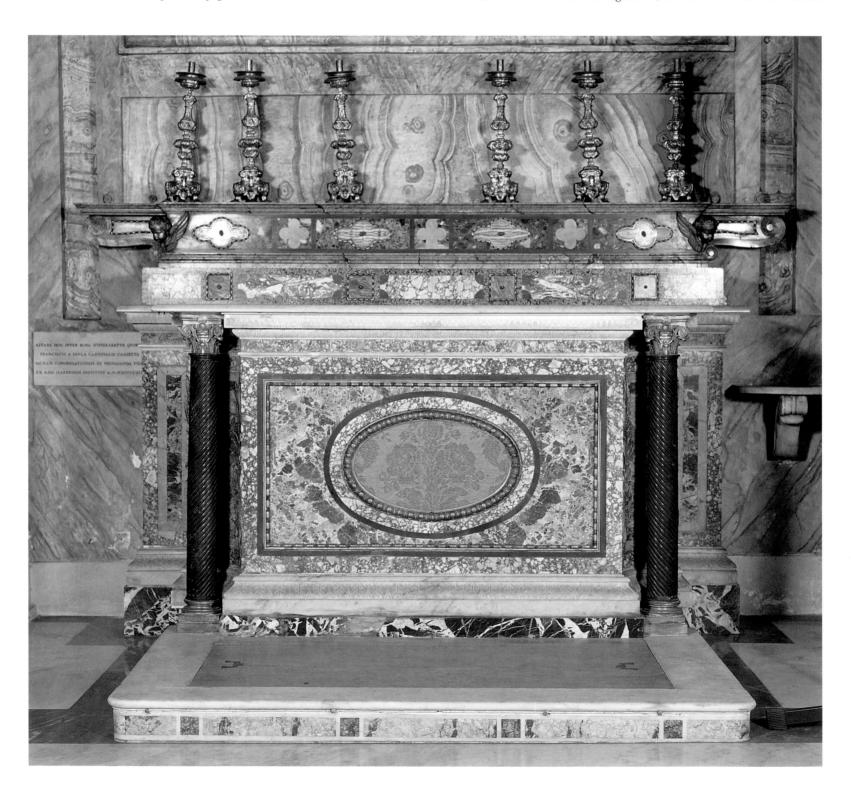

corresponded to its content. The index system is particularly important because it is the key element of the archive system, enabling the documents to be rapidly and accurately consulted. For example, Index 1, "Supreme Pontiff, Bulls, Briefs, Consistorial Acts, Formal Pontifical Speeches, General Provisions"; Index 35, "Eucharist as Sacrament – Communion, Form and Manner of Exposition, Pastoral Precept, Viaticum. Eucharist as Sacrifice – Mass, application and bination etc., Private Oratory, Portable Altar, etc."; and Index 126, "Turkish Empire in Asia, Asia Minor, Smyrna, Mesopotamia, Palestine, Holy Land, Syria." In 1923, subindexes were also introduced, thus providing a further aid to identifying material in the archive.

The historical archives of the Congregation for the Evangelization of Peoples constitute an authentic shrine of memory. A special place whence a history of the church may be traced, not one based solely upon her errors and sins or that shows only the human – at times too human – aspect of her members, but also a history of sanctity and saints. During the recent holy year, Pope John Paul II asked forgiveness for the sins of the children of the church, but also gave thanks to God for the most mature fruits that following Christ have brought her.[5] From 1622 onward, the archive of this dicastery bears witness to that sanctity. It is a record of daily life, of the joys and sorrows of men and women who through the centuries have shared a single passion: that of bringing to those who live in the shadow of death, the person and message of Christ the Savior, Son of God, who was born, died and rose again. They traversed seas and oceans, crossed whole continents on foot, risked and frequently lost their lives, translated into other languages, invented alphabets, thought out new strategies, and all so that Christ might reach hearts in anguish. Here are the names of just a few of them.

Saint Oliver Plunket (1629–81) of Ireland: He was professor of theology at the Urban College of Propaganda Fide. Elected archbishop of Armagh and Primate of Ireland, he was arrested in Dublin in 1679 and taken to London where he was condemned to death for "high treason." He was hanged, drawn, and quartered on July 11, 1681, during the anti-Catholic persecutions.

Blessed Daniel Comboni (1831–81): In 1864, as he knelt in prayer before the altar of the *confessio* in Saint Peter's Basilica, he conceived his "plan for the regeneration of Africa," a grandiose project for educating and supporting native Africans as teachers, catechists, and priests. In 1867 in Verona, Italy, he founded the Institute of African Missions. Appointed as apostolic vicar for Central Africa and, in 1877, as bishop, he moved to Khartoum, Sudan. His ministry stands out, above all, for his struggle against slavery.

Saint Frances Cabrini (1850–1917): She was a young orphan who became a nursery school teacher and came to act as mother to many children, founding the Missionary Sisters of the Sacred Heart. When she learned of the dramatic and desperate plight of thousands of Italian emigrants disembarking in New York without the slightest material and spiritual assistance, she decided to care for them, establishing meeting and help centers. Her main concern was for orphans and the sick in New York, Chicago, and other cities in the United States.

Saint Justin de Jacobis (1800–1860): A priest of the Congregation of the Mission, his superiors sent him to Ethiopia where, in 1839, he became the first apostolic prefect of the prefecture of Abyssinia, Ethiopia, and adjoining regions. He established his center of operations at Adua, where he founded a seminary for locals that became a true center for Christian life. He was condemned to exile because of his apostolic zeal and died of fever on the plains of Eidelé.

There are so many other witnesses to faith in Christ to be presented, so many documents. There are the martyrs of Korea, Japan, and China, such as Saint Gabriel Perboyre (1802–40). There are the documents of such men as Cardinal John Henry Newman (1801–90), convert to Catholicism, apostle of truth in the world of English intellectuals, and student of the Urban College of Propaganda Fide, whose cause of beatification is under way. There are hundreds of original documents of Mother Teresa of Calcutta (1910–97); hers was no abstract and theoretical faith but the concrete exercise of Christian love, and the cause for her beatification is also in process.

The Congregation for the Evangelization of Peoples is not just a memory, but a living reality made up of 1,071 ecclesiastical circumscriptions (missionary dioceses, apostolic vicariates, apostolic prefectures, etc.), of which 153 are in places where the church still suffers persecution. It is in daily contact with the problems, needs, and difficulties of missions, in other words, of announcing Christ to all the people of our world at this moment in the course of human history. Its activity today is a constant proclamation that God tirelessly continues to act in history, which, thus, continues to be the history of Salvation.

1. Pope John Paul II, Apostolic Constitution *Pastor Bonus* on the Roman curia, Vatican City, 1988.
2. *AG*, 2.
3. Establishment of the Holy Congregation "De Propaganda Fide." APF, Acta 3, f. 1r.
4. *Sacrae Congregationis de Propaganda Fide Memoria Rerum, 350 anni a servizio delle missioni (1622–1972)* (Rome-Freiburg-Vienna, 1971–76). Though it was published between 1971 and 1976, this three-volume work edited by Fr. Josef Metzler OMI is vital to understanding the history of the Congregation.
5. "This lively sense of repentance, however, has not prevented us from giving glory to the Lord for what he has done in every century, and in particular during the century which we have just left behind, by granting his Church a great host of saints and martyrs. … Holiness, … from one continent to another of the globe, has emerged more clearly as the dimension which expresses best the mystery of the Church. Holiness, a message that convinces without the need for words, is the living reflection of the face of Christ" (*Novo millennio ineunte*, 7).

The Pontifical Sacristy

Bernard Berthod

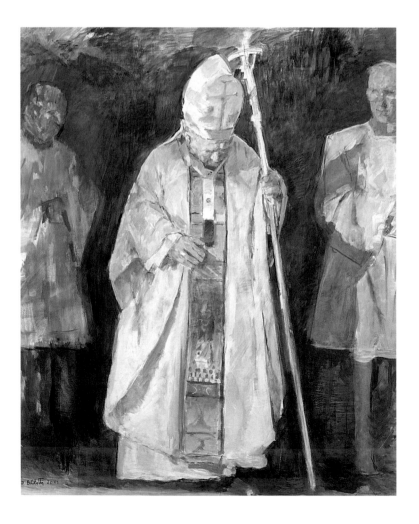

Dina Bellotti, *Pope John Paul II with the Master of Pontifical Celebrations, Monsignor Piero Marini*, 2001, Office of the Liturgical Celebrations of the Supreme Pontiff, Vatican City State

The papacy, the most ancient of Western institutions, rests on a double charism, that of priesthood and that of sovereignty. This dual nature, encompassing both spiritual and temporal dimensions, extending over almost two thousand years, made the successor of Peter not only a bishop but also a head of state. His pastoral mission, his primacy, and his sovereignty traditionally involved the use of many liturgical objects, either of gold or other precious materials, the number of which increased as the Roman liturgy developed and the papal institution expanded. Some of these objects, such as the tiara, were for the sole use of the pope. Others, such as reliquaries, were for the benefit and veneration of the faithful. Together these works of art constitute the pontifical sacristy, the liturgical treasury of the popes.

Medieval Rome was rich in liturgical treasures. All the basilicas – not only the four patriarchal ones – were enriched with objects necessary for the cult of relics. In the Renaissance, the popes devoted much attention to this treasury, which enhanced the grandeur of the papacy. In Saint Peter's there are two: the treasury of the chapter, housing the gifts of pilgrims to the Tomb of the Apostle; and the liturgical treasury proper, for those objects used in the celebrations and rites officiated by the Roman pontiff. In the course of time, some objects have passed from one sacristy to the other.

The liturgical treasury is constantly changing. Valued for their quality and richness, the objects within also constitute a substantial financial reserve. If needed, the pope could draw on it to cover costs in emergencies, as in 1488, when Pope Innocent VIII was obliged to pawn his tiara for twenty thousand gold ducats. Over the centuries, some objects deemed obsolete have been transformed, remodeled, or recycled; thus, Pope Pius VI dismantled the tiara of Julius II. On two occasions the treasury was entirely dispersed: at the Sack of Rome in 1527, and during the invasion of the Papal States by French troops in 1797–98.

For more than a millennium, the papal residence was in the Lateran palace, a complex of buildings adjacent to the basilica of Saint John Lateran. Little is known about the liturgical treasury preserved in the *Sancta sanctorum*, the palatine chapel there, during this long period. Some descriptions refer to reliquaries containing the relics of the head of the apostles Peter and Paul, the reliquary of Saint Agnes, and that of Saint Lawrence. The treasury was entrusted to a member of the pope's entourage; up to the eleventh century it was the person responsible for the papal wardrobe, the *vestiarius*, and later the confessor, who was delegated to keep guard over it, with the exception of the tiaras entrusted to the *camerarii*.

In the inventory drawn up under Pope Boniface VIII, this treasury comprised eighty-four categories and more than sixteen hundred objects. The trials and tribulations of the medieval popes, and their frequent displacement from one place to the next, were not conducive to the conservation of precious objects. Some were damaged, others lost; some were left where they were, others dispersed. In the fourteenth century, during the pope's exile in Avignon, a part of the treasury was reassembled on the banks of the Rhône.

With the return of the papacy to Rome and the artistic revival in the fifteenth century, the humanist popes reconstructed the liturgical treasury in magnificent fashion. They drew on the services of such goldsmiths of the period as Simon de Florentia or Raimond Johannis, who also crafted ceremonial swords (*stocco*) and golden roses. Contemporary testimonies of

this period of splendor, however, were lost in the Sack, which dispersed the liturgical treasury and the Roman heritage as a whole. What was not pillaged was melted down for the extraordinary ransom demanded by the troops of Charles V. Priceless pieces such as Pope Paul II's reliquary of the True Cross, the tiara of Nicholas V and that of Eugenius IV, a masterpiece of Ghiberti, disappeared forever. Reliquaries of the head of Saint Lawrence, the sponge of the Crucifixion, a garment of Saint Prisca, and the chalice of Saint Sylvester were among the items spared. No sooner did Pope Clement VII return to Rome, after the Sack, than he devoted himself to reassembling what had been looted and commissioning new reliquaries and sacred vessels from Benvenuto Cellini. The inventory drawn up under Pope Paul III in 1547 numbers more than five hundred objects, testifying to the patronage of the Farnese pope and his desire to make good the spoliations of the imperial armies. He also commissioned a magnificent tiara studded with precious stones rediscovered in the tomb of the empress Maria, wife of the fifth-century emperor Honorius.

In the following centuries, the popes and their families, as well as the sovereigns of Europe, enriched this collection. In the eighteenth century, Ridolfino Venuti described some exceptional pieces, such as a golden chasuble embroidered with scenes illustrating the Seven Sacraments; several precious miters; a papal ring with a large sapphire, surrounded by diamonds; the golden chalice used during conclaves; and numerous reliquaries. Pope Pius VI, famous for his munificence, commissioned several liturgical objects from Luigi Valadier; he ordered the tiaras of Julius II and Paul III to be dismantled and had those of Clement VIII and Urban VIII remodeled for his own use. Meanwhile, the arrival of the French revolutionary troops in Rome, in February 1798, sounded the death knell of the ancient sacristy treasury already decimated by the punitive clauses of the Treaty of Tolentino imposed by the French *Directoire* in 1797. Sacred vessels were melted down; gemstones were stripped and sold; illuminated missals and liturgical books were crated and shipped to Paris, along with the emerald of Gregory XIII that Pope Pius VI had mounted on his tiara. Liturgical vestments were burnt at the Quirinal and in the Cortile del Belvedere at the Vatican; from the huge brazier that burned for three days, the revolutionary troops derived a meager booty of gold and destroyed centuries worth of precious embroideries. The inventory books, so valuable for historical studies, were also consumed by the flames.

The treasury, necessary, as it is, to the pope's liturgical activity, has always been kept in his immediate vicinity. In the middle ages, the liturgical vestments and the reliquaries were preserved in or close to the palatine chapel at the Lateran, the *Sancta sanctorum*. A part of the treasury followed the popes during their peregrinations in the twelfth and thirteenth century. After the Avignonese period, Pope Martin V installed himself in the Apostolic Palace of the Vatican in 1420 and the liturgical objects were then placed close to the palatine chapel. When Pope Paul V turned the Quirinal into the official residence of the popes in 1605 and fitted it out with a large palatine chapel, a part of the liturgical treasury was transferred there, and the rest remained in the Vatican where it was used when the pope came to officiate liturgical celebrations in the Sistine Chapel. The part transferred to the Quirinal eventually returned to the Vatican with Pope Pius IX, in September 1870, after the breach of the Porta Pia and the entry of Piedmontese troops into Rome.

Today the treasury occupies seven rooms on three floors in the build-

ing adjacent to the Sistine Chapel (fig. 1). One room is reserved for the *mantum*, long pluvials exclusive to the popes, and two rooms are reserved for gold and silver work. Two other rooms, fitted out as a sacristy, are equipped with a central case and wall cabinets. One large room on the upper floor is used to store bulky objects, such as banners, faldstools, and candelabra. The treasury is under the authority of the Master of the Liturgical Celebrations of the Supreme Pontiff, who succeeded the Sacristan of the Sacred Palaces in this role in 1991. The present master of ceremonies, the Most Reverend Msgr. Piero Marini, has organized this space in a functional manner and according to museum storeroom criteria. The reliquaries are preserved in a room (the so-called lipsanoteca) to the side of the Redemptoris Mater Chapel, formerly known as the Mathilde Chapel, on the third floor of the Apostolic Palace.

The treasury now houses more than twenty-five hundred objects: twelve hundred pieces of gold and silver work and over thirteen hundred liturgical vestments and various precious fabrics. This collection includes material necessary for the celebration of the Eucharist and other religious functions: chalices, ciboria, monstrances, cruets, chasubles, dalmatics, tunics, copes, and humeral veils. It also contains objects reserved for the

1
Jean-Dominique Ingres, *Pope Pius VII on the Throne during Mass in the Sistine Chapel*, 1820, Musée du Louvre, Paris

episcopate, such as crosiers, portable candlesticks, pectoral crosses, rings, ampules of holy oil, trowels, and hammers (for the opening of holy doors), miters, pastoral stoles, gloves and sandals, archiepiscopal pallium and morse, as well as objects that only the pope himself may use.

Little remains to testify to the pre-Napoleonic period. The medieval and Renaissance chalices now preserved in the treasury were donated in the nineteenth or twentieth centuries. Among the liturgical vestments, only those with the coats of arms of the Barberini or the chasuble of Pope Paul V testify to the baroque period. On the other hand, the collection of reliquaries has suffered less from the political upheavals of the late eighteenth century, and numerous pieces predate the pontificate of Pope Pius VI.

In large part, the existing treasury is due to the generosity of the Catholic world. Pope Pius VII, at the time of his arrival in Rome in 1800, was devoid of everything and forced to commission the basic liturgical needs from Roman goldsmiths, and thus was the treasury reborn. The emperor Napoleon I played his small part, wishing to make good the spoliations that he, as General Bonaparte, had ordered during his invasion of Italy, in particular by returning the emerald of Gregory XIII; it was mounted on the tiara that he donated to the pope in 1804. The silk merchants of Lyons donated a lightweight tiara in silver stuff in 1821. The treasury retains no objects that belonged to Pope Pius VI's immediate successors, Leo XII and Pius VIII. In 1834, Pope Gregory XVI ordered a new tiara and

2
Chalice of Pope Pius IX, 1846, given by Sultan Absul Medji, Office of the Liturgical Celebrations of the Supreme Pontiff, Vatican City State

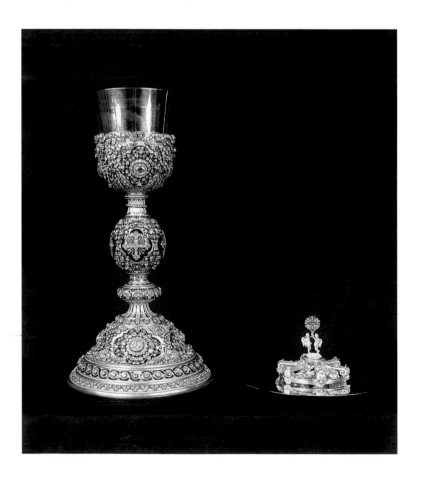

received some gifts such as a pastoral stole and a papal cross, donated on the occasion of the consecration of the new basilica of Saint Paul's Outside-the-Walls (destroyed by fire in 1823). Above all, it was the gifts of leading Roman families and cardinals that permitted the treasury's reconstitution in the first half of the century.

The ultramontane movement was a great source of gifts. From the pontificate of Pius IX on, Rome became the arbiter of liturgical practice, as well as a factor of unity. After the fall of the papacy's temporal power in 1870, Pius IX, the last pope to act as a temporal ruler, was extolled in Catholic circles as a martyr and a prophet. The celebrations marking the twenty-fifth anniversary of his pontificate in 1871 and of his episcopal jubilee in 1877, a few months before his death, gave rise to a great movement of popular affection manifested in numerous gifts from all over the world. His successor, Pope Leo XIII, enjoyed the same veneration, and his long pontificate was marked by the celebration of two jubilee anniversaries and the holy year of 1900. The jubilee of his ordination as priest, celebrated with considerable magnificence in 1888, gave rise to many gifts, which were exhibited in the Vatican. The most striking and sumptuous of these were deposited in the sacristy of the Sistine Chapel, and many others were sent as gifts all over the world. The celebration of his episcopal jubilee in 1893 was less spectacular, but did attract some fine gifts. Lastly, the holy year in 1900, solemnly celebrated after an interruption of seventy-five years, was an occasion for the faithful to honor the nonagenarian pope with gifts connected with the holy year, jubilee hammers and trowels, liturgical vestments, and sacred vessels.

At the jubilee celebration of Pope Pius X, in 1909, fewer exceptional gifts were registered, though some were of great value, such as a solid gold cross from Peru, a diadem of diamonds from Brazil, and the emerald-encrusted pectoral cross that the pope placed in the Treasury of Saint Peter's. Pope Pius XI received a tiara from his former Milanese diocese, and the Lateran Treaty was an occasion for the House of Savoy to make some conspicuous gifts with a view to effacing the long dispute with the papacy following the unification of the kingdom of Italy. Pope Pius XII, whose pontificate coincided with the Second World War, received only a few objects, among which was the gold rational offered during the Marian year in 1954.

The gifts to the papacy revived under the pontificate of Pope Paul VI, encouraged by his apostolic journeys and artistic tastes. This revival is all the more interesting as it unreservedly bears the hallmark of contemporary art, exemplified by Tot's jubilee trowel and hammer, and Senesi's rational and golden rose of Our Lady of Guadeloupe. This trend of commissioning liturgical art from leading contemporary artists has continued throughout the pontificate of Pope John Paul II, with Scorzelli's sacred vessels, pectoral cross, and rational; Beaugrand's Canadian chalice; and Goudji's processional cross and candelabra.

The list of donors is impressive, comprising several sovereigns, some of them non-Catholic (fig. 2). In addition to Napoleon I, emperor of the French (fig. 3), were other kings and queens. Isabella, queen of Spain, presented a diadem to Pius IX; the sultan of Constantinople presented to the same pope the diamonds that adorn the chalice of the Immaculate Conception (1854). Emperor Franz Josef of Austria gave a small crucifix to Leo XIII, who was also presented with a diamond-studded rational by Queen Maria Christina of Spain, and a chalice and a ciborium by Alfonso XII of

Spain. After the Lateran Treaty (1929) and the restoration of the image of the Roman pontiff as sovereign, Pope Pius XI received numerous heads of state on their official visit to Rome and the Vatican. King Alfonso XIII of Spain brought with him as a gift a golden chalice; Victor Emmanuel III, a pectoral cross studded with pearls; his daughters, a precious basin and vessels.

It became the custom for cardinals of the curia to bequeath at their death some pieces from their private chapel or their ecclesiastical vestments, in the image of the *spolium* of the bishops. That is why we find in the pontifical treasury the crucifix of Cardinal von Reisach, chalices, candlesticks, pectoral crosses, and miters belonging to cardinals Mattei, Polidori, Medici, de Gregorio, Maglione, and Micara. The faithful who came to Rome on pilgrimage were often prompted to offer to the pope a precious object created by a famous artist in their hometown. Some artists made spontaneous gifts themselves, as in the case of the Parisian goldsmith Poussièlgue-Rusand, who gave a papal cross on the occasion of the jubilee of Pope Leo XIII's ordination as priest, and Goudji, who offered a precious hammer and a gem-studded rational for the opening of the holy door in 1999.

The collection of reliquaries was built up in the course of the high Middle Ages, as is testified by the inventories of the *Sancta sanctorum*. It was developed thanks to successive beatifications and canonizations. It was the custom for the religious family or the next of kin of the future saint or blessed to offer a reliquary at the time of the ceremony, usually commissioned from a famous artist.

Ever since the Early Christian period, it was the tradition for the pope to celebrate liturgies in the various sanctuaries and basilicas of the Eternal City, depending on the feast day. This way of celebrating the principal events in the church calendar lasted until the exile in Avignon in the early fourteenth century. Pope Clement V, unable to celebrate in the basilicas of which the city on the Rhône was destitute, celebrated in the papal chapel. The papal liturgy thus became palatine (the word derives from the Latin *palatinus*, belonging to the palace). This palatine usage was preserved after the papacy was restored to Rome in the early fifteenth century. It was thus that Pope Nicholas V had a small chapel decorated by Fra Angelico installed in the Apostolic Palace at the Vatican. A few years later, the Cappella Niccolina had become too small for the solemn liturgical celebrations of Pope Innocent VIII, so a more spacious chapel was created before Pope Sixtus IV remodeled it into the chapel that now bears his name, the Sistine Chapel. Henceforth, right down to the twentieth century, it was there that most of the papal liturgical ceremonies were held. Liturgical objects were conceived and designed in relation to the chapel's relative intimacy.

A large number of objects and articles of clothing used by the pope belong more properly in the category of episcopal vestments and insignia: miters, rings, pectoral crosses, pontifical sandals, and gloves. Some are exclusive to the papal mass and are explained by its liturgy and the role the pope played in it. In fact, since the Avignon period, the pope, often elderly, did not himself officiate the daily liturgy but remained enthroned during the rite and watched the function being celebrated by a cardinal: this was the mass *ad coram papa*, which entailed a good deal of toing and froing between the throne and the altar, in particular to take the sacred species to the seated pontiff. Moreover, the papal mass, relatively simple up until the pontificate of Innocent VIII, gained added complexity under the influence

3
Tiara of Pius VII, 1804, given by Napoleon I, Office of the Liturgical Celebrations of the Supreme Pontiff, Vatican City State

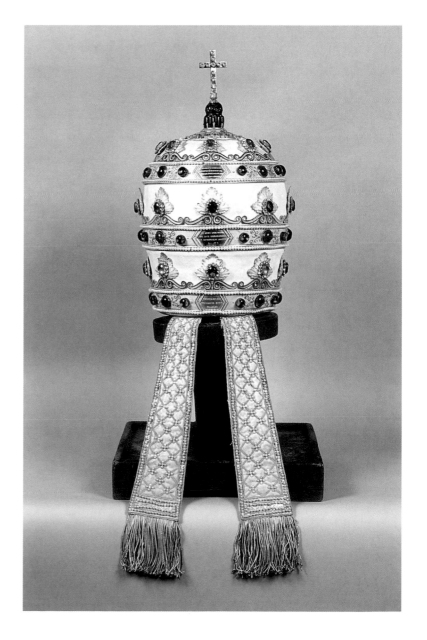

of two masters of ceremonies, Agostino Patrizi and Johann Burchard. A series of liturgical objects were specifically reserved for the pope: the spoon, which permitted the gifts to be tasted; the *asteriskos*, a little golden star that protected the host when it was taken to the pope; the embroidered linen cover for the chalice, different from that used at the altar, and placed over the chalice as it was taken by the cardinal-deacon to the pope to enable him to take communion without rising from his throne; and the golden drinking straw with which he took it. This elaborate and rather theatrical liturgy was maintained until the twentieth century. Pope Paul VI, however, preferred to return to the poetic grandeur of the mass of Innocent III and the august simplicity of the liturgy of Nicholas V by celebrating at the altar himself and by restoring the liturgical colors.

The rod (*ferula*) is also an object specific to the papal ministry. It is a pastoral staff consisting of a Greek cross in precious metal mounted on top of a short rod. It symbolizes the double spiritual and temporal power. The pope used it during certain liturgical celebrations: for his entry, blessing, and leave-taking from the solemn mass and for the consecration of bishops. It was abandoned during the seventeenth century. Pope Paul VI, however, revived it and used it as a crosier during liturgical functions.

Another strange object made its appearance in the nineteenth century. It was a cross – the so-called papal cross – with a triple cross-bar that the artists of previous centuries had claimed for the pope. None was realized, however, before that of De Angelis and Jacobini for Pope Gregory XVI. Two others were later offered to Pope Leo XIII for the jubilee of his ordination as priest: one by the papal knights and the other by the French goldsmith Poussièlgue-Rusand.

The papal tiara is not a liturgical headdress but a sign of sovereignty. Ever since the Middle Ages it has been regularly worn by the sovereign pope when he is not exercising his liturgical function, in particular during processions and during the blessing "Urbi et Orbi." On 13 November 1964, Pope Paul VI made a gift of his own to the poor: since then it has no longer been worn but remains present in the wardrobes of the Roman pontiff. Ten tiaras are preserved today: two belonged to Pope Pius VII, four to Pope Pius IX, three to Pope Leo XIII, one to Pope Pius XI, while the last is a copy of the one that Pope Paul VI gave away.

The analysis of liturgical art in the pontifical treasury is of particular interest because Rome is situated at the crossroads of two clearly distinguished zones of influence: the Franco-Germanic zone and the Mediterranean zone. In the Franco-Germanic zone an important shift may be noted at the beginning of the nineteenth century with the abandonment of the aesthetic principles of the baroque and a return to medieval art: this was the period of the Gothic Revival, which exerted so deep a fascination on artists. By contrast, in the Latin countries bordering on the Mediterranean, liturgical art still remained attached to the baroque and the canons of Roman art.

Baroque art appeared in Rome with Bernini and his pupils about 1630. This triumphal style influenced religious goldsmith's work, and its influence may still be found at the beginning of the nineteenth century with the dynamic *rocaille* style, rich in volutes and with cherubs and eucharistic symbols appearing in the clouds. Exemplifying this style is the elaborately decorated reliquary of the Mandylion of Edessa, made in 1623, and the pax of the Cardinal of York, cut from a solid block of polychrome agate a century later.

4
Pietro Paolo Spagna, golden rose given to Austrian Empress Carolina Augusta, 1819, Kunsthistorisches Museum, Vienna

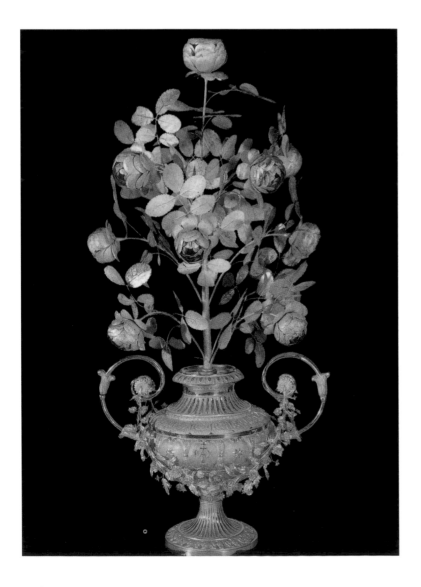

The Enlightenment had little interest in liturgical art. The sacred vessels, commissioned from skillful goldsmiths, were treated as secular art. Liturgical vestments were often made from ordinary cloth without even simple embroideries to lend a Christian connotation. Luigi Valadier and the Spagna dynasty of goldsmiths (fig. 4), however, were able to restore a Christian sense to liturgical objects by interpreting them according to the reigning neoclassical style. It is this purity of line and gracefulness that are encountered in the relief of the chalice of cardinals de Gregorio and Polidori, as well as in Pietro Paulo Spagna's reliquary of the Holy Lance.

The Empire period, under Napoleon, inherited this situation, which rapidly developed under the influence of various socio-religious parameters. About 1810, a great pro-Christian movement rose to prominence from the intellectual circles of Europe, drawing inspiration from the values Chateaubriand had extolled in the *Génie du Christianisme* (1802). After the fall of Napoleon I, the reorganization of the church in France and the restoration of peace in Europe permitted the countries of Christendom to enjoy a revival. This gave rise to the development of an iconography with the representation of the acts of the Passion of Christ and its prefiguration by the sacrifices of the Old Testament, the death of Abel, and the sacrifices of Abraham and Melchisedech.

The enthusiasm for neo-Gothic art developed in tandem with the desire for unity around the Roman rite. Under the pontificate of Gregory XVI, the pastors of the church realized the urgent need for a liturgical reform.

From 1835, liturgical expression was considered by the ultramontane elite as a major vehicle of apostolate: it was by beauty that the pastors could best combat dechristianization. To this end, the liturgy had to be purified and rediscover the grand hieratic simplicity of the Gregorian Reform and of Saint Louis. Inspired by a return to a medieval aesthetic, artists designed liturgical objects and vestments based on the works of art of the thirteenth and fourteenth centuries (fig. 5). This neo-Gothic style essentially found adepts in the Franco-Germanic area: Augustus Pugin in London, Canon Franz Bock in Cologne, Dom Guéranger and the Jesuit Arthur Martin in France, Jean-Baptiste Bethune and Pierre Grossé in Belgium. Pugin, an Anglican converted to Roman Catholicism, designed liturgical vestments and established a goldsmith's firm in Birmingham. As for Canon Bock, he collected medieval fabrics and was inspired by them to design patterns for the weavers of Krefeld and the church furnishers of Munich.

At this time, enamelwork and *niello* reappeared in goldsmith's work. Liturgical vestments underwent a real transformation; fabrics were woven by hand and decorated with medieval patterns and motifs. Vestments rediscovered the ample forms they once had; orphreys were richly embroidered with narrative scenes and decorative motifs. The chasuble and the pluvial lost their rigidity due to the buckram lining; the chasuble once again became a circle or an oval in form. The dalmatic was once again given sleeves and the miter was shortened. If the medieval ornamentation of fabrics and orphreys spread everywhere, the ample forms encountered more resistance and remained the privilege of an elite, especially as Rome remained attached to the Roman form. The First Vatican Council was the occasion for an exhibition of liturgical art to which all the great European church furnishers of the period contributed; it permitted not only comparison but also standardization.

5
Lamy and Giraud, chasuble, 1856, wool, silk, gold thread, and cut glass, Moulins Cathedral

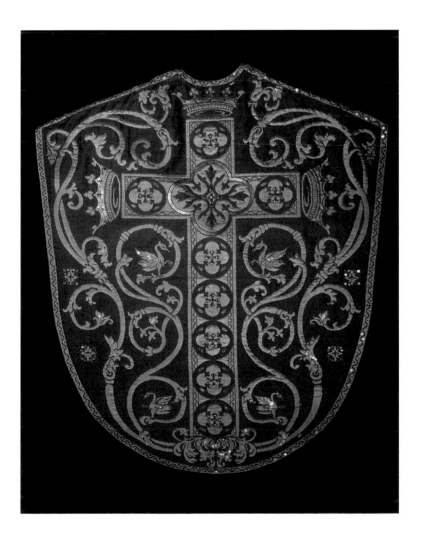

After forty years of unrivaled supremacy, the neo-Gothic movement declined. It was then that artists discovered the immense resource of Christian iconography and religious symbolism. Two emblematic figures, in particular, were developed: that of the Sacred Heart of Jesus and that of the Blessed Virgin Mary in her Immaculate Conception. The development of the Marian cult in the nineteenth century was both a spiritual and iconographic event on a hitherto unprecedented scale. The major innovative feature of the cult in the iconographic field was the ever more frequent representation of the Virgin without the Christ Child, inspired by the proclamation of the Dogma of the Immaculate Conception in 1854 (fig. 6). This definition of the Immaculate Conception of Mary by the bull *Ineffabilis* removed Mary from the common destiny of man, sin. It inspired artists to create cosmic images, situated in an expanded space as if seen by God himself. The representation was also inspired by the vision of the Apocalypse, of a woman appearing in heaven, clothed with the sun, with the moon under her feet, and on her head a crown of twelve stars (Rv 12:1). The proclamation of the dogma, celebrated with exceptional magnificence in Saint Peter's, in the presence of the whole papal court and a hundred or so European bishops, facilitated the diffusion of the new Marian image throughout the world.

The rediscovery of iconography also permitted the history of the saints to be revived, and the rich hagiographic traditions of the local churches to be rediscovered and celebrated on sacred vessels and liturgical vestments. Thanks to the erudite studies of Benedictine men of learning, wonderful stories of the evangelizers of the provinces and the founders of dioceses and monasteries were exhumed. While the Roman missal gradually gained ground from 1840 on and suppressed numerous local saints, these continued to make their appearance on the walls and stained glass of churches, on sacred vessels and reliquaries, created in the hundreds to replace those destroyed during the French Revolution and the Napoleonic wars. The saints associated with the religious orders were those that reappeared most rapidly, having never disappeared from the enclosed world of monasteries and convents.

After 1870, when anticlerical governments were installed almost everywhere in Europe, hagiography went beyond mere catechetical concern. It permitted the glorification of the saints who had christianized Europe: the first Frankish, Irish, or German bishops, Rémi of Rheims, Patrick, Boniface of Mainz, Rupert of Salzburg; the protagonists of the first crusades, Bernard of Clairvaux, and Urban II, whose exploits are illustrated on the chalice of the *Catholic Alliance* by Théophile Laurent. These saints

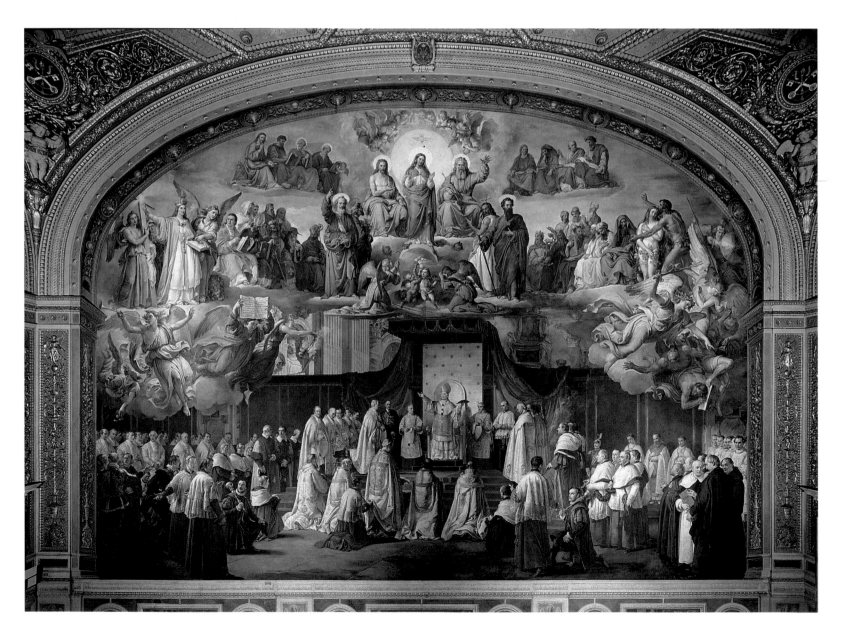

were often presented in long processions, as in the basilica of Our Lady at Loreto and the church of San Gioacchino in Rome. Saint Michael the Archangel became the archetype of the struggle between Good and Evil, a struggle that now took the form of the defense of Christian values against the "godless" values of the secular state.

The interest in the Early Christian martyrs developed especially after 1850, with the rediscovery of the catacombs by the archaeologist Giovanni Battista de Rossi and the growth of pilgrimages to Rome. It led to a new iconography: orants dressed in tunics in the antique fashion became a favorite motif. The whole symbolic grammar found in the catacombs was now used to decorate sacred vessels: the anchor, the fish (symbol of the Christian), the dove drinking at the fountain of life, the loaves of bread marked with the chrism. The renewal of the cult of Early Christian martyrs permitted a shift toward the new martyrs, as essential role models for missionaries, such as the Lazarist Jean-Gabriel Perboyre, beatified in 1899, Auguste Chapdelaine, François de Capillas, and the martyrs of Tonkin, beatified in 1900. The prototype of the contemporary martyr, however, was Blessed Pius IX, the last pope as temporal ruler, the self-proclaimed prisoner in the Vatican. A kind of osmosis was established between the pope and Saint Peter: both the one and the other are shown receiving the keys of Christ, Peter is dressed as the pope and the view of Saint Peter's Basilica appears everywhere. The exemplary figure of Pope Pius IX was celebrated by artists and by their patrons; the royal scepter of Armand-Calliat offered by the diocese of Besançon is the most striking example of this.

The beginning of the twentieth century was marked by art nouveau. Various schools of art in Europe rejected the aesthetic canons of neo-Gothic and symbolist art, which had become too industrialized. These artists, for the most part committed Christians, conceived their art as a sacred task, almost an apostolate. They created and fashioned their works by hand and scrupulously avoided production in series. These schools gained ground after the First World War. The Benedictines played an important role in this regard: in France, there was the Benedictine atelier of Dom de la Borde at Solesmes (fig. 7); in Germany, the abbey of Saint Martin de Beuron, from which Pius XI received a chalice; in Belgium, the abbey of Mont César. The French painter and decorator Maurice Denis grouped round him several disciples, while the Scuola Beato Angelico, inspired by Dominican spirituality, developed in Lombardy. In gold and silver work, enamels were gradually abandoned in favor of ivory and exotic woods, under the influence of the colonial arts. The working of metal became more visible; craftsmen did not fight shy of showing the effects of hammering, and stones were mounted uncut and unpolished, in their natural state. Some metalworkers tried to encrust copper with silver. In the field of liturgical vestments, hand-weaving replaced the industrial production of ready-to-wear chasubles, and fabric appliqués were preferred to embroidery. African art and such schools of painting as the Nabis or the Ecole de Pont Aven influenced the colors and what little iconography still survived. The artists of the non-European schools were emancipated and expressed themselves according to the criteria and aesthetic values of their own culture.

Iconography gradually disappeared from liturgical art in the course of the twentieth century. After the Second World War, even more so than at the beginning of the century, artists preferred to privilege metalwork or fabrics to the detriment of iconography. If all neo-Gothic influence was now eliminated from the decoration and conception of gold and silver ware,

the same did not hold for liturgical vestments. In fact, the ample form dear to Bock and the French and Belgian Benedictines dethroned the Roman form under the pontificate of Pope Paul VI, who, after he had restored the usage of the colors of the liturgical year, celebrated mass with wide chasubles. At the close of the twentieth century, Scorzelli used stylized floral and plant motifs on chalices and pectoral crosses, while Goudji, the creator of the reliquary and processional cross of the Blessed Padre Pio, remains more attached to the form and chasing of precious stones than to any specific iconography.

6
Francesco Podesti, *Pope Pius IX proclaiming the Dogma of the Immaculate Conception*, 1870, Room of the Immaculate Conception, Apostolic Palace, Vatican City State

7
Dom de la Borde, cope, ca. 1920, Saint Pierre Abbey, Solesmes

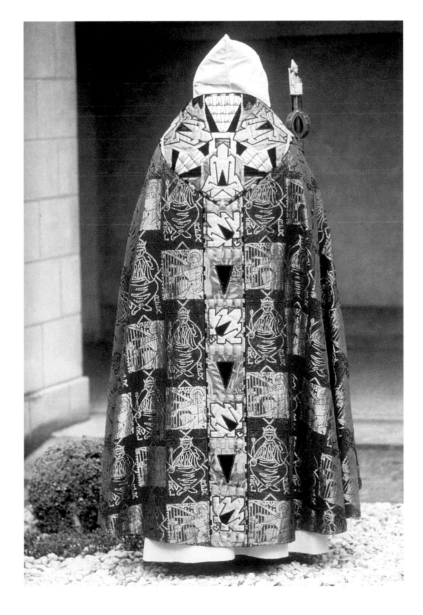

The collection of liturgical art in the pontifical sacristy illustrates, in its composition, the major role played by Roman and French goldsmiths in European production. The work of some Viennese goldsmiths may also be noticed. As for Spanish artists, the lack of any obligation to mark their wares with hallmarks often makes it difficult to identify their hands.

Nothing unfortunately remains of the production of the Valadier family for the papal liturgical treasury. Some of the numerous pieces they produced were not kept in the Vatican; others are happily preserved in the collections of museums elsewhere in Europe. On the other hand, several chalices and reliquaries testify to the mastery of another famous dynasty of artists, the Spagna, and exemplify the quality of religious art that characterized the pontificate of Pope Pius VI. The Spagna formed a dynasty fairly restricted in date. The first goldsmith Paolo worked from 1772 to 1788, his son Giuseppe, born in 1765, was active from 1791 to 1817; he was responsible for a large number of liturgical vessels which he produced in

close association with Giuseppe Valadier, especially for the cathedral of Arezzo. Giuseppe's son, Pietro Paolo, also worked with Valadier, before becoming titular goldsmith of the papal court under the pontificate of Gregory XVI. The end of the nineteenth century in Italy was worthily represented by the Milanese goldsmith Bellosio, who realized a ciborium and rational for Leo XIII.

French gold and silver work is well represented in the pontifical sacristy, which contains works by Poussièlgue-Rusand (fig. 8) and Paul Brunet, as well as Armand-Calliat (fig. 9), Froment-Meurice, and Théophile Laurent.

Palcide Poussièlgue-Rusand, born in Paris in 1829, had the great merit of obtaining the collaboration of the architect Eugène Violet-le-Duc and the Jesuit Arthur Martin. He began to practice his art in 1849, on succeeding his father as head of the atelier. Thanks to his commercial acumen, he rapidly developed his business and proposed numerous models in the

8
Poussièlgue-Rusand, *Reliquary of the Holy Cross*, 1872, silver gilt and enamels, Saint Maurice Cathedral, Angers

9
Armand-Calliat, monstrance, 1876, silver gilt, diamonds, stones, enamels, Musée de Fourvière, Lyon

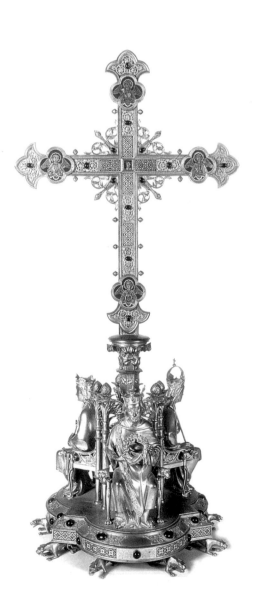

neo-Gothic style to an enthusiastic clientele. The pontifical treasury contains several prestigious pieces made by him, such as the church plate donated by the princesse de Saxe and the cross with the triple cross-bar given to Leo XIII for his jubilee. Paul Brunet belonged to the same generation. His whole oeuvre testifies, sometimes excessively so, to his passion for the Middle Ages; it is characterized by filigree work in silver and gold, cabochons mounted in the Carolingian manner, and copies of medieval vessels. He worked for Lourdes, Fourvière, and the Dominican Order.

Emile Froment-Meurice, born in 1837, succeeded his grandfather Pierre Meurice and his father François-Désiré. He was a skilled craftsman, much influenced by symbolist art. He expressed his mastery in works of prestige. The Pontifical Sacristy preserves in particular two of his works: the golden chalice of Bayonne, and the tiara offered by the Parisians to Leo XIII in 1888.

Thomas-Joseph Armand was born in the Dauphiné on 24 October 1822. He became a goldsmith by his marriage, in 1853, to Jeanne Calliat, the heir to a goldsmith's workshop founded by her father in 1820. A self-taught artist deeply influenced by the archaeological movement of the time, Armand devoted himself exclusively to sacred art. In a little over a decade he had emerged as one of France's leading goldsmiths, rivaling Poussièlgue-Rusand as the recognized furnisher of liturgical art to the episcopate. The cross of the Council offered by the Marquis O'Bute, the scepter of Besançon, and the mass set of Moulins offered to Pius IX perfectly illustrate his artistic and spiritual development.

The creations of the Parisian goldsmith Goudji, of Georgian origin, entered the pontifical treasury during the pontificate of John Paul II. He has worked for the church of France since 1985. After the realization of baptismal fonts and an Easter candlestick for the cathedral of Notre-Dame in Paris, he renewed the liturgical furniture of the cathedral of Chartres. Between 1992 and 1996, he designed twenty-five pieces, including the high altar and its furnishings, cross, chalice, paten, cruets; the binding of the evangelary; the thrones of the bishop and his assistants. In 1995, the bishop of Luçon commissioned him to make the high altar for his cathedral and the liturgical furniture and vessels to go with it. He also created, in 1994 and 1996, two crosiers for the Benedictine abbeys of Saint-Maurice de Claurvaux and Notre-Dame de Truirs. In 1998, he realized the reliquaries of two Cistercian blesseds for the abbey of Sept-Fons and that of Padre Pio (fig. 10). What is so striking in the art of Goudji is its mystic dimension. The use of gems goes well beyond simple decor: it invests the work with a symbolic and sacred character. The dozen precious stones cited by the Apocalypse as the foundation of the heavenly Jerusalem (Rv 21:19-21) are constants of his art. The bestiary he frequently uses is also symbolic, recalling his native Georgia.

The liturgical objects preserved in the Pontifical Sacristy represent a richness for the church. But it is not richness in the sense of a treasure hoard aimed at vying with the treasuries of the principalities of this world. Rather, it is a cultural and liturgical richness that testifies to the pastoral activity of the bishop of Rome, successor of Peter, and to the sense of unity of the Catholic community, attested by the many gifts gathered together here. The numerous reliquaries are memories enshrined, indispensable for the congregation of the faithful. They bear witness to the confessors and martyrs whose faith did not waver and on whose witness the church of the centuries is built.

10
Gougdji, *Reliquary of Saint Padre Pio de Petrelcina*, 1999, silver, rock crystal, oeuil-de-fer and mother-of-pearl

Seasons of Pardon and Grace: The Popes and the Holy Years

Joan Lewis

Throughout history the popes have always been patrons of the arts, sponsoring the building of churches, great and small, and commissioning artists, architects, sculptors, and gold- and silver-smiths to produce the statues, altars, tombs, stained-glass windows, chalices, and other artifacts that filled those churches. For the last seven hundred years, however, one event has always been an impetus for the Roman pontiff to embellish the Vatican and the city of Rome: a jubilee or holy year.

Jubilees in the Bible

Jubilee is a biblical term, from the Hebrew *jobhel*, or ram's horn. It was a period to be observed every fifty years, during which time Jewish slaves were freed, lands were restored to original owners, fields left untilled, and agricultural work undone. The *jobhel* was blown to announce the start of this jubilee year. As described in Leviticus (25:8-55), the jubilee fell after every seventh sabbatical year, that is, at the end of seven times seven, or forty-nine years. Verses 10-13 tell us:

> You will declare this fiftieth year sacred and proclaim the liberation of all the country's inhabitants. You will keep this as a jubilee: each of you will return to his ancestral property, each to his own clan. This fiftieth year will be a jubilee year for you; in it you not sow, you will not harvest the grain that has come up on its own or in it gather grapes from your untrimmed vine. The jubilee will be a holy thing for you; during it you will eat whatever the fields produce. In this year of the jubilee, each of you will return to his ancestral property.

The word "liberation" in verse 10 meant a general release and discharge from all debts and bondages, and a reinstating of every man to his former possessions. This jubilee year began on the Day of Atonement, the tenth day of the seventh month of Tishri.

Jubilare is also a Latin term that means "to shout for joy." In the Catholic Church, jubilee years, also called holy years, trace their origins to the first holy year established by Pope Boniface VIII in 1300.

Jubilees are preeminent religious occasions and periods of great grace: times for the forgiveness of sins and punishment due to sin, for reconciliation between man and God and man and man. As Pope John Paul II reminded us in his 1994 Apostolic Letter *Tertio Millennio Adveniente*, jubilees are not only celebrated in Rome: "On these occasions the Church proclaims 'a year of the Lord's favor,' and she tries to ensure that all the faithful can benefit from this grace. That is why jubilees are celebrated not only 'in Urbe' but also 'extra Urbem.'"

When they fall within the preset pattern of years jubilees are "ordinary" and "extraordinary" when proclaimed for an outstanding event, such as the one called by Pope John Paul II in 1983 to celebrate the 1950th anniversary of the Redemption. There have been 120 jubilees celebrated to date: 26 have been ordinary and 95 extraordinary. The great jubilee of the year 2000 was the twenty-sixth ordinary jubilee.

The First Jubilee: 1300

The very first holy year was the jubilee of 1300, called for by Pope Boniface VIII (fig. 1). Cardinal Jacopo Stefaneschi, an influential member of the Roman curia, wrote in his chronicle of events of late December 1299 and early January 1300 that huge crowds of Romans were flocking to Saint Peter's Basilica, having heard rumors that extraordinary indulgences would be obtained by those who prayed at the tomb of Peter, the first pope,

or who venerated Veronica's veil. This relic, a recent arrival to the basilica and called quite simply "the Veronica," was allegedly the veil with which Jesus' face was wiped, leaving a perfect image, as he carried the cross through Jerusalem to Calvary.

Pilgrimages continued throughout the month of January, with ever growing numbers of faithful visiting the basilica. Pope Boniface, reading "the signs of the times," consulted the cardinals of the curia and, on February 22, 1300, promulgated the *Antiquorum habet digna fide relatio*, with which he instituted the jubilee celebration (fig. 2).

According to that decree, those who wished to obtain a plenary indulgence "must visit the basilicas of Saint Peter and Saint Paul for 30 days continuously, or interpolatedly and at least once a day if they were Romans, or fifteen days in the same manner if they were foreigners." Previously, indulgences had been granted only on exceptional occasions. Thus, with this papal bull, the plenary indulgence became part and parcel of jubilee celebrations.

History records that the city of Rome made preparations to worthily accept foreign pilgrims, including increasing the number of places one could obtain food and lodging. Another gate was opened in the city walls to receive the influx of visitors and the now famous Sant'Angelo Bridge, which crossed the Tiber River to the Vatican, was divided into two "lanes" by a low wall, with arriving pilgrims on one side and departing pilgrims on the other. As "all roads lead to Rome," roads from major cities in Europe were often improved and bridges either restored or repaired.

In medieval times, the three most prominent destinations for pilgrims were Rome (to the tombs of Saints Peter and Paul), Santiago de Compostela in Spain (the tomb of Saint James), and Jerusalem (the Holy Sepulchcr). A pilgrim to Rome was called a *romeo*, those to Spain *jacquaires* (from Jacques, the French for James), and those to Jerusalem, *palmieri*, or palm bearers, because, as a symbol of their pilgrimage, they brought home a palm branch from the Holy Land.

Often the pilgrims bore a distinctive mark on their hats or clothing. Visitors returning from Rome had either the image of Saints Peter and Paul or that of the Holy Face from Veronica's veil (fig. 3); for Jerusalem pilgrims, the palm was again their symbol; and for those coming from Compostela, it was a scallop shell. A pilgrim's outfit usually consisted of a walking staff, a shoulder bag to carry some of life's necessities, a broad hat to protect against sun and rain, and a cape, known as a pelerine (from *peregrinus*, meaning one who comes from afar). These capes were frequently coated with wax to shield travelers from the rain and cold.

Pope Boniface VIII had decreed that future jubilee celebrations would take place at one hundred-year intervals. In 1343, however, a delegation of Romans, including members of noble families, went to see Pope Clement VI in Avignon, where the seat of the papacy had been moved in 1309. They petitioned the pope to change the frequency of holy years, reasoning that most people would never live long enough to celebrate a jubilee. Pope Clement responded by calling for a holy year in 1350 and decreed that they be celebrated every fifty years.

In his bull *Unigenitus Dei Filius* proclaiming this jubilee, Pope Clement VI made two noteworthy — and interrelated — statements: he officially described the church doctrine on indulgences, saying that jubilees were periods when great graces could be obtained, but under certain conditions, and he also brought to three the number of patriarchal basilicas that pilgrims must visit to obtain the jubilee indulgence, adding Saint John Lateran to the basilicas of Saint Peter and Saint Paul.

The jubilee of 1350 was celebrated in Rome, but without the pope. It was a difficult jubilee as Rome had allowed many buildings and monuments to deteriorate during the Avignon period. Also, the plague had swept Europe in 1348 and, while it spared Rome to a great extent, some pilgrims were still afraid to make a trip to the Eternal City. Romans, however, in thanksgiving to the Virgin for having generally spared them, erected the marble staircase of *Ara coeli*, the altar of heaven, leading to the church of the same name.

Figure 2
Pope Boniface VIII, *Papal Bull of the Proclamation of the First Christian Jubilee* (1300), Portico of the Basilica of Saint Peter, Vatican City State

Figure 3
Albrecht Dürer, *Saint Veronica along with Saint Peter and Saint Paul shows the Holy Face of Christ*, ca. 1510, Vatican Apostolic Library

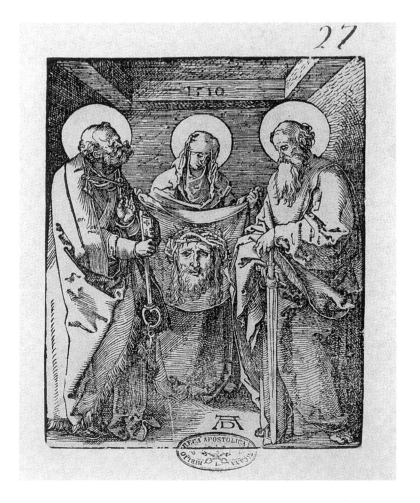

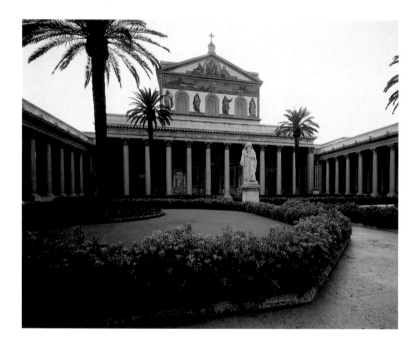

Figure 4
The Four Major Basilicas of Rome: (clockwise)
Saint Peter's, Saint John Lateran, Saint Mary Major,
Saint Paul's Outside-the-Walls

The Jubilee of Four Basilicas: 1390

Pope Urban VI, successor to Pope Gregory XI, who returned the papacy to Rome from Avignon, decided in 1389 to celebrate that return with a jubilee. He also decided that henceforth jubilees would occur every thirty-three years, the age of Jesus at his death. However, this meant that the one after 1350 should have taken place in 1383. As it was now 1389 – thus too late – he called for a jubilee to be held the following year, 1390. Pope Urban VI, in his bull for the jubilee, reaffirmed Pope Gregory XI's rules about visiting the basilicas and added yet another – Saint Mary Major – to the list. Pilgrims would have to visit Rome's four patriarchal basilicas – Saint Peter, Saint Paul, Saint John Lateran, and Saint Mary Major – to gain the jubilee indulgence (fig. 4). That holds true today.

The term "basilica" comes from the Greek *basilike oikia*, meaning "royal house," kingly and beautiful structures where the ruler lived. In Roman times this term applied to all official buildings built in a particular style, that is, in the shape of a parallelogram, the opposite sides of which are parallel and equal in length. The middle space was usually separated by columns from the side spaces or aisles. This term was used for early or medieval Christian churches built with a central nave, two or four aisles, one or more semicircular vaulted apses, and open timber roofs. Now this is an honorific title given to the most eminent churches around the world.

There are two kinds of basilicas: major and minor. Rome has seven major basilicas: Saint Peter's, Saint John Lateran, Saint Mary Major, Saint Paul's Outside-the-Walls, Saint Lawrence Outside-the-Walls, Holy Cross in Jerusalem, and Saint Sebastian. Basilicas usually have special privileges reserved to them, such as the granting of certain indulgences.

The first five of these major basilicas are also called patriarchal basilicas. The word "patriarch" comes from the Greek for "ruler of a family." A patriarch is also a bishop who holds the highest rank, after that of pope, in the hierarchy of jurisdiction. Major patriarchs hold the title or see of one of the five great ancient patriarchates: Rome, Constantinople, Alexandria, Antioch, and Jerusalem. Patriarchates are independent of each other and equal in authority.

The patriarchal basilicas were originally linked with the five ancient patriarchates, and the patriarchs, when they visited Rome, stayed at their respective churches. The five basilicas are: Saint John Lateran (the archbasilica for the patriarch of Rome); Saint Peter's (for the patriarch of Constantinople); Saint Paul's Outside-the-Walls (patriarch of Alexandria); Saint Mary Major (patriarch of Antioch); and Saint Lawrence Outside-the-Walls (patriarch of Jerusalem).

Pope Boniface IX, the Pope of Two Jubilees

Pope Urban VI died before officially opening the 1390 holy year; this task fell to his successor, Pope Boniface IX. The 1390 jubilee was not one of the more auspicious celebrations. Few pilgrims came, there was an anti-pope in Avignon, and the Great Schism of 1043 continued to divide Christianity.

Pope Boniface celebrated a second jubilee in 1400, in accordance with the directives of his namesake predecessor who in 1300 had directed that holy years be held at every turn of a century. Historians are not always in agreement on whether or not to include 1400 as an official jubilee, given that there was no bull of convocation. Vatican archive documents, however, do speak of a jubilee. In fact, it seems that the term "holy year" (*anno santo*) appeared for the first time in 1400, though the term jubilee continued to be used.

Pope Martin V opens the First Holy Door: 1423

Pope Martin V, following Pope Urban VI's decree of jubilees at thirty-three-year intervals, proclaimed one for 1423, thus dating it from 1390 and skipping the year 1400. Again, there seems to be no bull for this holy year. A tradition began that has continued to this day: Pope Martin opened the first holy door at the Basilica of Saint John Lateran.

A holy door is a walled-up door, usually a double one, found in each of the four major Roman pilgrimage basilicas. The cemented or walled-up portion is on the inside of the church, and this part is dismantled to allow the outer door to be opened for a holy year.

The holy door of Saint Peter's is the last to the right of the five doors found in the basilica's atrium and is always opened by the pope. The current holy door – two bronze panels – was donated by Swiss Catholics for the 1950 jubilee and was inaugurated on December 24, 1949, by Pope Pius XII. It was sculpted by the Sienese artist Vico Consorti and replaced the wood panels of the inner door that had been inaugurated Christmas Eve, 1749, by Pope Benedict XIV. It contains sixteen panels, fifteen of which are scenes from the Old and New Testaments: the expulsion from the Garden of Eden, the Annunciation, the Baptism of Christ, the Good Shepherd, The Prodigal Son, the resurrection of Lazarus, the healing of the paralytic, the adulteress, Peter's denial of the Lord, the repentant thief, the good thief, the doubting Thomas, the sacrament of Penance, the conversion of Saint Paul, and the Resurrection. The last panel is the opening of the holy door by Pope Pius XII.

They are called "holy doors" because of the symbolism attached to them – doors opening to allow the faithful to enter a church, as well as to "enter" a year dedicated to sanctifying their soul – and because all the materials used to build them and the hammers used to open them are blessed. In the Gospels, Jesus tells us that he is the door to heaven: "I am the gate: Anyone who enters through me will be safe: such a one will go in and out and will find pasture" (Jn 10:9).

In *Tertio Millennio Adveniente*, Pope John Paul II wrote: "The holy door of the jubilee of the Year 2000 should be symbolically wider than those of previous jubilees, because humanity, upon reaching this goal, will leave behind not just a century but a millennium."

The Jubilee of Beatifications and Canonizations: 1450

Pope Nicholas V, considered the first humanist pope, included the jubilee year 1400 as a legitimate historical jubilee. Preferring to adhere to the fifty-year intervals, he called another one for 1450, the first in the early Renaissance period. Pope Nicholas introduced the custom of a pontiff greeting and blessing the faithful in Saint Peter's Square on Sundays and holidays, and made canonizations and beatifications a regular part of jubilee-year celebrations.

Pope Paul II Sets Jubilees at Twenty-Five-Year Intervals

Twenty years later, Pope Paul II issued a bull, *Ineffabilis Providentia*, declaring that holy years would, starting in 1475, be celebrated at twenty-five-year intervals, and that they would begin on Christmas Eve and end a year later on Christmas. Except for extraordinary holy years, that time frame is still respected today.

Pope Sixtus IV, Restorer of Rome, Promoter of the Arts

Pope Paul II did not live to see the 1475 jubilee: it was inaugurated by his successor, Pope Sixtus IV, a Franciscan and a culture-loving pope who commissioned countless works of art and architecture, enlarged the Vatican Library, and gave his name to the Sistine Chapel, which he had ordered built in 1473. Called "the city's restorer," Pope Sixtus issued orders that Rome be improved and beautified; one of the city's better-known bridges, Ponte Sisto, is named for him. He also built Santo Spirito Hospital and dedicated two Renaissance churches, Santa Maria del Popolo and Santa Maria della Pace.

One novelty of the 1475 holy year was the use of the newly invented press to print the bull of indiction, as well as posters for pilgrims, announcing the times and places of ceremonies. For the holy year, Pope Sixtus IV nullified all other indulgences to give greater importance to the jubilee-year plenary indulgence. The term "holy year" came into regular use at this time.

The Jubilee of Four Holy Doors: 1500

The holy year 1500 definitively ushered in the custom of opening a holy door on Christmas Eve and closing it the following year on Christmas Day. Pope Alexander VI opened the first holy door in Saint Peter's Basilica on Christmas Eve, 1499, and papal legates opened the doors in the other three patriarchal basilicas (figs. 5, 6).

Figure 5
The holy door of the Basilica of Saint Peter,
Reverenda Fabbrica of Saint Peter, Vatican City State

Figure 6
The holy door of the Basilica of Saint John Lateran, Rome

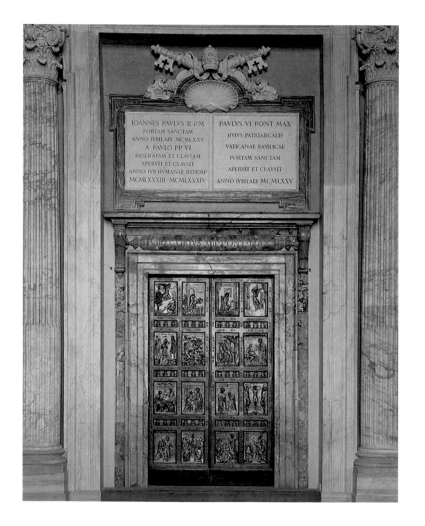

For this occasion, Pope Alexander had a new opening created in the portico of Saint Peter's and commissioned a door, made of marble, 3.5 meters high and 2.2 wide (11 feet by 7 feet). It lasted until 1618, when another door was installed in the new basilica. That door, in turn, was replaced in 1950 by the bronze door, which is still in use.

In a ceremony strikingly similar in many ways to today's ritual opening of a holy door, Pope Alexander VI was carried in the gestatorial chair to the portico of Saint Peter's. He and the members of his retinue, bearing long candles, processed to the holy door, as the choir intoned Psalm 118:19-20: "Open for me the gates of saving justice, I shall go in and thank Yahweh. This is the gate of Yahweh, where the upright go in." The pope knocked three times on the door, it gave way (assisted from within by workers), and everyone then crossed the threshold to enter into a period of penance and reconciliation. Thus, Pope Alexander, a lover of pomp and ceremony, formalized the rite of opening a holy door and began a tradition that continues, with few variations, to this day. Similar rites were held at the other patriarchal basilicas.

Pope Alexander VI was also the first to institute a special rite for the closing of a holy door. On the feast of the Epiphany, January 6, 1501, two cardinals – one with a silver brick and the other with a gold one – symbolically began to seal the holy door. Basilica workers known as *sampietrini* completed the task, which included placing small coins and medals, minted during the holy year, inside the wall.

For four hundred years it has been the *sampietrini* – whose name comes from the Italian for Saint Peter, San Pietro – who care for, clean, maintain, and preserve the altars, confessionals, mosaics, chapels, chandeliers, and thousands of square meters of marble flooring in Saint Peter's Basilica. The basilica has been called "the jewel in the Vatican Crown" and the *sampietrini* have been called the jewelers. *Sampietrini* also means "cobblestones" in Italian, derived, it is believed, from the Latin word for rock or stone.

Over the centuries, the popes performed a similar ritual of symbolically sealing the holy door, often with a silver or golden trowel (figs. 7,8). This ceremony lasted until 1975 when Pope Paul VI simply closed the door, and the task of sealing it fell to the *sampietrini*. Today, the rite is the same. Before sealing the door, the basilica workers place special metal receptacles, called caskets, containing metals, coins, and other jubilee memorabilia, inside the wall. These caskets remain sealed until several days before the holy door is opened for yet another jubilee: they are removed in a ceremony called a *recognitio* and their contents are examined.

The holy door at Saint John Lateran is the last door on the right, and that of Saint Mary Major is the last on the left. The most noteworthy holy door, from an artistic and historical perspective, is that of Saint Paul's Outside-the-Walls. Located on the far right of the atrium, the loveliest part of this door is inside the basilica. Known as the Byzantine Door, it was the main entrance of Saint Paul's until the church was destroyed by fire in 1823. After a restoration, the Byzantine Door was placed inside the church, on the back of the holy door, in 1967. From Latin and Greek inscriptions, we know that it was made in 1070 by an artist named Teodoro. The double door consists of fifty-four panels carried out in silver damascening and depicting twelve scenes from the life of Christ, the twelve apostles, twelve prophets, scenes of various martyrs, two eagles, two crosses, and several panels with Latin inscriptions. Though the door was restored in 1965–66, four of the panels were lost.

Pope Clement VII, a member of the Medici family, opened the holy year 1525, which was overshadowed by the Protestant Reformation. The atmosphere was quite tense and the jubilee took place in a very understated fashion, with far fewer pilgrims than normal coming from abroad.

The tenth ordinary holy year in 1550 was marked by the tensions of both the Counter-Reformation and the Sack of Rome in 1527. The jubilee took place during the Council of Trent (1545–63), convened by Pope Paul III to help ease those tensions. Pope Paul died in 1549 and his successor, Pope Julius III, immediately proclaimed the holy year after his election on February 22, 1550. Two future saints – Ignatius of Loyola and Philip Neri – participated in this jubilee. That same year the pope gave his approval to the order founded by Ignatius, the Society of Jesus, or Jesuits.

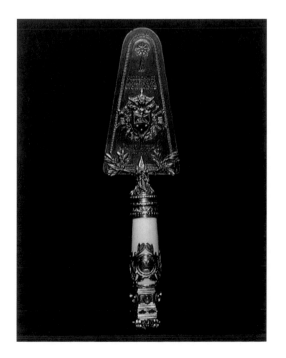
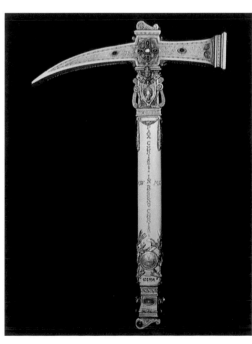

Figures 7, 8
Trowel and hammer for the opening of the
holy door, 1925, Archives of the Papal Sacristy

The Jubilee of Seven Pilgrimage Churches: 1575

Pope Gregory XIII proclaimed the holy year 1575 with a bull issued on the feast of the Ascension and read again on the last Sunday of Advent, a practice that continues today. This was indeed a year for jubilation as the Council of Trent had been brought to a successful conclusion twelve years earlier and Rome had been restored and embellished following the Sack of Rome. Pilgrims flocked to the Eternal City in 1575: some accounts put the number at three hundred thousand – an astonishing figure when one considers that Rome's population at the time numbered forty thousand.

Jubilee year 1575 saw the number of pilgrimage churches increased to seven, a number considered to be holy. In addition to the four patriarchal basilicas, pilgrims had to visit Saint Lawrence Outside-the-Walls (the fifth "patriarchal" basilica), Holy Cross in Jerusalem, and Saint Sebastian, adjacent to the catacombs of the same name (fig. 9).

A visit to Saint Peter's gave the faithful a glimpse into both past and present. The Constantinian basilica of 326 A.D. had not yet been totally demolished and the new Saint Peter's, whose cornerstone had been laid by Pope Julius II in 1506, was still under construction.

Figure 9
A. Lafréry, map of the seven Roman churches visited by pilgrims during jubilee years, ca. 1575, Vatican Apostolic Library

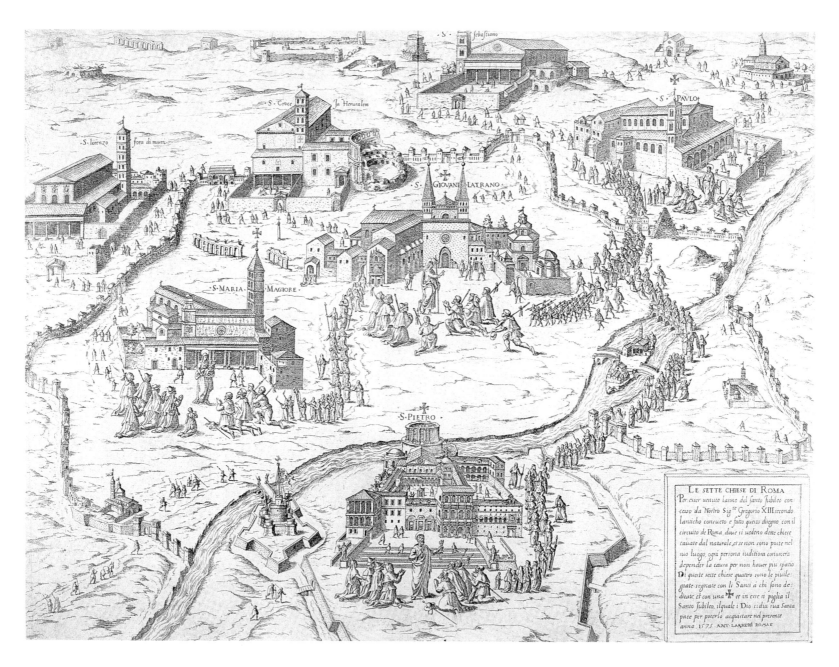

Pope Clement VIII was pontiff during the holy year 1600, which, chronicles tell us, had "the most massive ever participation by pilgrims." The pope instituted two commissions of cardinals to whom he entrusted the ceremonial and logistical aspects of the jubilee. Pope Clement VIII was the pilgrim par excellence: not only did he visit Rome's basilicas – history tells us he made sixty visits – he personally assisted pilgrims and donated large sums of his own money to this end. During Lent he invited twelve poor people to eat meals with him.

The holy year 1625 was celebrated in the new Saint Peter's Basilica, even though its official dedication would not occur until November 18, 1626, the same day on which the first basilica had been dedicated in 326. This jubilee took place during the Thirty Years War (1618–48). A flood had made Saint Paul's unusable for the jubilee, so Pope Urban VIII substituted it with Santa Maria in Trastevere and personally opened the holy door. He also issued an order extending the spiritual effects of a holy year to all who would be unable to participate in person but who wished to do so: old people, the ill, cloistered religious, and prisoners. Roman pontiffs since then have respected this instruction.

Pope Innocent X proclaimed the holy year 1650, the first of the high baroque era and a period of relative peace. The pope had the Lateran basilica rebuilt in the new baroque style, and it lost much of what had marked it as an Early Christian basilica.

Queen Christina of Sweden and the Jubilee of 1675

The jubilee year 1675, proclaimed by Pope Clement X, is often linked to Queen Christina of Sweden. In 1654 the queen had converted to Catholicism, renounced the throne, and moved to Rome. Considered a symbol of the faith, she was active in ecclesial events, constantly attending papal and other ceremonies, but became better known for her charitable work, most especially during the holy year. Her personal library became celebrated worldwide and, after her death in 1689, it was given to the Vatican Library. She is buried in Saint Peter's Basilica.

This jubilee year was also noted as being the year in which Theatine Father Carlo Tommasi obtained permission from the pope to dedicate the Colosseum to the memory of martyrs. Among the canonizations that took place in 1675 were those of Gaetano da Thiene, founder of the Theatines; the Dominican Rose of Lima, the first saint of Latin America; and Francesco Borgia, a superior general of the Jesuits.

As happened in prior jubilees, the preparatory period saw Rome enriched by artistic works. Gian Lorenzo Bernini, seventy-seven at the time of the jubilee, designed Saint Peter's Square, the portico of Saint Peter's Basilica, the Scala Regia (royal staircase) of the Apostolic Palace, the church of Sant' Andrea al Quirinale, and the Fabbrica di San Pietro (Fabric of Saint Peter), the office that is responsible for the administration, care, and preservation of the Vatican basilica. He also completed the little elephant that still supports the obelisk in Piazza della Minerva, in front of the church of Santa Maria sopra Minerva, where Saint Catherine of Siena, Fra Angelico, and Pope Benedict XIII are buried. For this holy year Bernini also designed the gilt bronze tabernacle for the Blessed Sacrament Chapel in Saint Peter's Basilica.

The holy year 1700 was also a jubilee of two popes. The much-loved pope of the Enlightenment, Innocent XII, called the jubilee in 1699 but was too ill on Christmas Eve to open the holy door. His delegate, Cardinal Emanuele Bouillon, opened it in his stead. Though Pope Innocent was eighty-six years old, he fulfilled many works of piety throughout the year. He died in September 1700. On November 23, Pope Clement XI was elected and it was he who – just thirty-three days later – would close the holy door.

Only a month after his election on May 29, 1724, Pope Benedict XIII, a Dominican, proclaimed the holy year 1725. A simple, humble, austere man, and a pastor first and foremost, Pope Benedict, as bishop of Benevento, Italy, had had direct experience in preparing the faithful of his diocese as pilgrims in the jubilee year 1700. Thus, he was no stranger to the preparations for his first jubilee as pope.

Pope Benedict asked that holy year 1725 be celebrated in a very rigorous and spiritual way, characterized by self-denial, penance, prayer, and simple, not ostentatious, liturgical ceremonies. The sacred aspects should prevail over the profane – something that had not always happened in the past. The Holy Father himself became the model pilgrim and man of prayer and penance.

As were most jubilees, the holy year of 1725 was marked by canonization and beatification ceremonies, and by an increase in Rome's artistic patrimony. One of the city's foremost landmarks was inaugurated that year, the Spanish Steps, a masterful staircase that leads to the church of the Most Holy Trinity in the heart of Rome.

On May 5, 1749, Pope Benedict XIV issued the papal bull *Peregrinantes a Domino* that called for the eighteenth jubilee year. This was the first such bull ever to be addressed not only to Catholics, but to heretics and schismatics as well, inviting everyone to a year of penance.

To predispose and prepare pilgrims for the 1750 jubilee, the pope also issued a series of encyclicals, explaining the meaning of a holy year, outlining how to obtain indulgences and making confession a prerequisite for receiving the jubilee indulgence. Greatly concerned with the spiritual preparation necessary for a jubilee, he also laid out precise rules of conduct for the clergy. In his writings he exhorted pastors to "keep churches clean and decent," and to be dignified and diligent at all times.

Before the holy year began, the pope wrote to all the world's bishops and examined the biblical, canonical, and liturgical origins of a holy year. Going to confession and receiving the Eucharist became a mandatory part of a pilgrim's jubilee celebrations and, to this end, the pope addressed a letter to confessors, reminding them of the importance of this sacrament and how to properly celebrate it.

A Franciscan friar, Fra Leonardo da Porto Maurizio, brought a special Franciscan devotion, the Way of the Cross, to Rome and convinced Pope Benedict to allow him to set up a *Via Crucis* in the Colosseum. The pope personally blessed it and dedicated the Colosseum to the passion of the martyrs.

Saint Mary Major received a new facade for this holy year and the basilica of the Holy Cross in Jerusalem was remodeled and its facade redone in the rococo style.

Before closing the holy door on Christmas Day, 1750, Pope Benedict published the bull *Benedictus Deus*, in which he extended this holy year throughout 1751 for those who had been in some way impeded from coming to Rome in 1750. Almost simultaneously his encyclical *Celebrationem magni* was published, extending holy year indulgences to the entire

Christian world, on the condition that certain works of charity were performed. Such extensions had been granted in the past, but only after bishops had requested a pontiff to do so. This time, it was Pope Benedict who took the initiative.

First Jubilee Bull to be Written in Italian: 1775

Jubilee year 1775 was the third time that one pope announced a holy year and another brought it to completion. Pope Clement XIV, who had proclaimed the holy year with the bull *Salutis nostrae auctor* in 1774, died that same year on September 22. His successor, Pope Pius VI, was not elected, however, until February 15, 1775. Immediately after his election, the new pope published a bull of indiction proclaimed by his predecessor. This was the first such bull to be written in Italian and not Latin: *L'Autore della nostra vita* ("The Author of Our Life"). Several days after his coronation on February 26, Pope Pius VI opened the holy door of Saint Peter's.

Only One Holy Year Celebrated in the Nineteenth Century: 1825

Pope Pius VII was prevented from calling a holy year in 1800 because of the political climate in Europe and the difficult situation for the Catholic Church under Napoleonic rule.

Pope Leo XII proclaimed the 1825 jubilee year. As Saint Paul's had been destroyed by fire in 1823, the church of Santa Maria in Trastevere was sub-stituted as one of the obligatory destinations for pilgrims. That was the only jubilee of the century, the only time that holy doors were opened and public celebrations were held (fig. 10).

No jubilee was held in 1850 because of the troubled political situation on the Italian peninsula, including the Papal States, and because of the temporary exile of Pope Pius IX. He did proclaim a jubilee year but there were no ceremonies to open or close the holy door due to the occupation of Rome by King Victor Emmanuel.

Although political circumstances in the now-unified Kingdom of Italy made it impossible to hold a holy year in 1875, Pope Pius IX proclaimed one in an encyclical dated December 24, 1874, and he extended it to the whole world. No holy doors were opened or closed and no pilgrims came, but this year has nonetheless come to be celebrated in the annals of jubilees as the twenty-first ordinary holy year.

Pope Leo XIII Proclaims First Holy Year of the Twentieth Century

Holy year 1900 was declared by Pope Leo XIII (fig. 11). In his bull promulgating the jubilee, *Properante ad exitum saeculo*, Pope Leo, then ninety years old, reminisced about his participation in a jubilee seventy-five years earlier and about the many negative changes that had taken place since, including the loss of the Papal States and the fact that the popes were restricted to living in the Vatican.

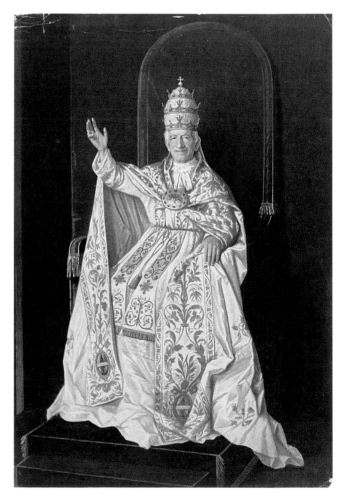

Figure 10
Brick to close the holy door, 1825,
Archives of the Papal Sacristy

Figure 11
Pope Leo XIII, ca. 1900,
Archives of the Papal Sacristy

Though this was the first holy year celebrated following the integration of the Papal States into Italy, it was endorsed by the Italian government and by King Umberto I who, however, was assassinated in Monza in July 1900. It was a holy year of new technology and a newer, faster way to travel: the airplane. Great and enthusiastic crowds came to Rome and, to help accommodate them, Saint Martha's Hospice was built in the Vatican and took care of forty thousand pilgrims that year.

The jubilee was marked by the canonizations of John Baptiste de la Salle and Rita of Cascia; the first Assembly of the Episcopacy of South America, which took place in the Vatican; and by the building of Saint Anselm's church on the Aventine Hill. A particular novelty was linked to the ceremony of closing the holy door at Saint Peter's: twenty bricks from as many Italian mountains, each of which had a statue of the Redeemer built on it during the holy year, were walled up in the holy door.

The jubilee of 1925 was proclaimed by Pope Pius XI and, occurring such a short time after World War I, was an especially joyful occasion. It is said that the pope rejoiced because of the presence of people from so many countries throughout the world, with the notable exception of Russia. And, for the first time, statistics are available on the number of pilgrims: 582,234 faithful came to Rome.

Pope Pius XI also resolved any discussion about the exact number of ordinary holy years that had taken place, when he said in December 1925: "The twenty-third holy year is drawing to a close." He thus included the holy year of 1875. During this year, Theresa of the Child Jesus, Peter Canisius, the Cure d'Ars, John Vianney, and John Eudes were canonized. Bernadette of Lourdes was beatified. It was Pope Pius XI who introduced the now commonplace weekly general audience. He also revived a custom that had been banned since 1870: the papal "Urbi et Orbi" ("to the city and to the world") blessing from the central loggia of Saint Peter's Basilica. This is traditionally pronounced on New Year's Day and Easter.

The Extraordinary Jubilee of the Redemption: 1933

Pope Pius XI celebrated another jubilee in 1933, when he called a holy year to celebrate the Lateran Treaty, signed in 1929 between the Italian State and the Holy See. Seeking a religious justification to celebrate this church-state reconciliation, the pope consulted the rector of the Biblical Institute who told him that 1933 would mark the 1900th anniversary of the Redemption and would thus be an appropriate occasion for a jubilee.

A number of "firsts" marked this holy year. There had been extraordinary holy years in the past but Pope Pius called this one "an extraordinary among extraordinaries" as it was the first to celebrate the Redemption, and not Christ's birth. Of special note was the fact that the ceremony of opening the holy door was transmitted via radio: Vatican Radio had been established two years earlier by Guglielmo Marconi. The holy door was opened on Passion Sunday, 1933 (fig. 12), and closed Passion Monday a year later. And, for the first time since the end of papal temporal power, a pope could celebrate holy year liturgies outside of Saint Peter's Basilica. Pope Pius XI led processions to the three other major basilicas in Rome.

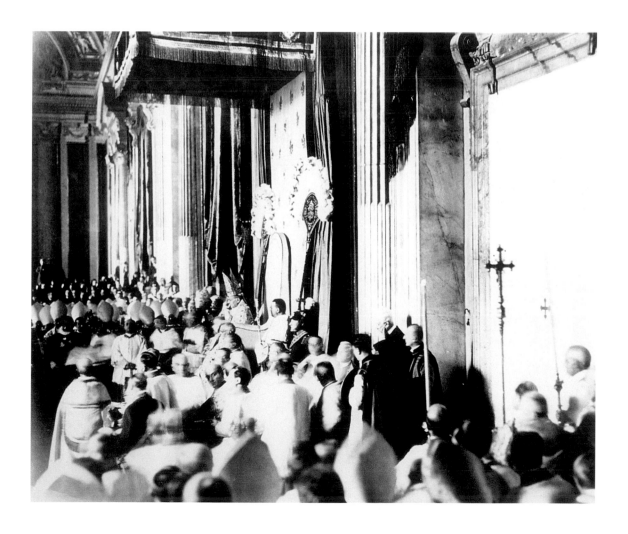

Figure 12
Pope Pius XI prepares to open the holy door, 1933,
Archives of *L'Osservatore Romano*

Figure 13
Pope Pius XII closes the holy door, 1950,
Archives of *L'Osservatore Romano*

Figure 14
Saint Peter's Square during the proclamation of the
Dogma of the Assumption of the Virgin, 1950,
Archives of *L'Osservatore Romano*

The Dogma of the Assumption: 1950

The twenty-fourth holy year, that of 1950, was proclaimed by Pope Pius XII in May of 1949 with the bull *Jubilaeum maximum*. This would truly be a year of jubilation, following as it did so shortly upon the ravages of World War II. Pope Pius XII was called "the pope of Peace," and it is said that his presence in the see of Peter, as much as the holy year itself, attracted nearly three million pilgrims to Rome.

That year a new holy door was installed in Saint Peter's Basilica (fig. 13). This door was funded by the diocese of Basel, Switzerland, in thanksgiving for having been spared devastation during the war, and to honor Pope Pius XII. In between the sixteen panels are the coats of arms of the popes who had opened or closed holy doors in previous years.

Vincent Pallotti was beatified this year and Maria Goretti was canonized, but the culminating point of the 1950 jubilee was the proclamation in Saint Peter's Square on November 1, feast of All Saints, of the Dogma of Mary's Assumption into Heaven (fig. 14). Just more than a month later, Pope Pius XII, in his Christmas message, announced the rediscovery of Saint Peter's tomb that recent excavations had brought to light. Today, the tomb of the first apostle and pope can been seen when one visits the *scavi*, or excavations, under the Grottoes of Saint Peter's Basilica.

Holy Year 1975

Holy year 1975 marked the tenth anniversary of the closing of the Second Vatican Council (1962–65). Pope Paul VI announced this celebration during his May 9, 1973, weekly general audience, answering those who in recent years had questioned whether or not a holy year was an anachronism. In his apostolic exhortation *Gaudete in Domino*, he asked that this jubilee year be a period of joy, conversion, reconciliation, and renewal. Television brought many holy year events into homes around the world, and the airplane, by now a common means of transportation, brought an estimated nine million faithful to Rome. Elizabeth Ann Seton, a convert to

Catholicism and the first American-born saint, was canonized in 1975, as was Irish martyr Oliver Plunkett. Great attention was given this year to ecumenism, to youth, and to women as the jubilee coincided with the International Year of the Woman that had been proclaimed by the United Nations (fig. 15).

The Holy Years of Pope John Paul II

Pope John Paul II (elected on October 16, 1978) has proclaimed one extraordinary jubilee, one Marian year, and one ordinary holy year, the great jubilee of 2000. He proclaimed 1983–84 "A Jubilee Year of Redemption" to mark 1950 years since the death of Christ, and extended it to the entire world. He declared a Marian year for 1987–88, and on March 25, 1987, issued an encyclical "On the Blessed Virgin Mary in the Life of the Pilgrim Church."

The 1983–84 jubilee year began on the March 25 feast of the Annunciation. The first preparatory celebration for the World Youth Day was held in Rome, on Palm Sunday 1984, during this holy year (fig. 16). The pope also baptized twenty-seven catechumens and held numerous beatification and canonization ceremonies, including the beatification of the Dominican friar-painter Fra Angelico, whom he named patron of artists.

The Marian year began on the feast of Pentecost 1987 and concluded on the feast of the Assumption, August 15, 1988. The pope wished this year to be a special prelude to the great jubilee of 2000.

Figure 15
Pope Paul VI celebrates the beginning of the jubilee year of 1975, Archives of *L'Osservatore Romano*

Figure 16
Pope John Paul II in Saint Peter's Square during the first World Youth Day, March 30, 1984, Archives of *L'Osservatore Romano*

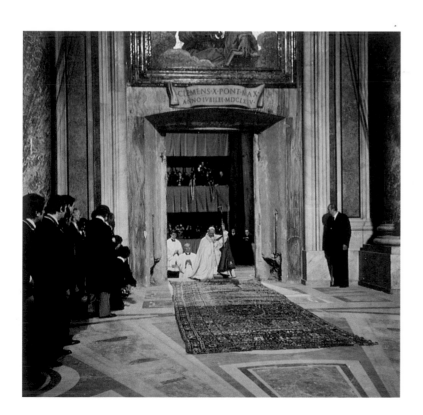

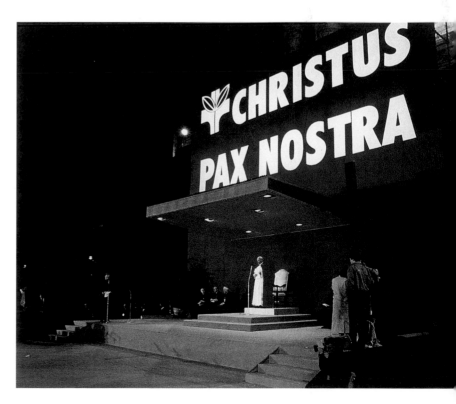

Into the Third Millennium

Pope John Paul's bull of indiction for the jubilee year 2000, *Incarnationis mysterium*, was made public on November 29, 1998, the first Sunday in Advent and the start of the third year of preparation for the great jubilee:

> Contemplating the mystery of the Incarnation of the Son of God, the Church prepares to cross the threshold of the Third Millennium. The birth of Jesus at Bethlehem is not an event which can be consigned to the past. . . . Jesus is the genuine newness which surpasses all human expectations and such He remains forever, from age to age. The Incarnation of the Son of God and the salvation which He has accomplished by His Death and Resurrection are therefore the true criterion for evaluating all that happens in time and every effort to make life more human.

Just over one year later, Pope John Paul II, in an unprecedented move, and breaking with centuries of tradition, officially started the great jubilee of 2000 by personally opening the holy doors of the four patriarchal basilicas (fig. 17).

Having constantly referred to it as "the great jubilee," Pope John Paul felt that the holy year 2000 should, therefore, be marked by events and liturgies that set it apart from other jubilees. Thus he decided to personally open all four holy doors: Saint Peter's on Christmas Eve 1999, Saint John Lateran on Christmas Day, Saint Mary Major on January 1, the Solemnity of Mary, and Saint Paul's Outside-the-Walls on January 18. This date marks the start of the annual Week of Prayer for Christian Unity, when ecumenical services are held at Saint Paul's. Given Pope John Paul's solicitude for ecumenism, he expressed the desire to personally open the holy door at this basilica on that date.

A number of changes in the ceremony of opening holy doors also marked the celebrations of 2000, in particular at Saint Peter's, the first door to be opened. Until the holy year 1975, when Paul VI opened the door at Saint Peter's, the door was cemented shut and opened only by breaking down the mason work. Theoretically the mason wall was to fall back in one piece but that year, several pieces of debris fell very close to the pope, causing some concern. For the jubilee year 2000, the sealed portion of the holy door that is inside Saint Peter's Basilica was removed prior to the official opening ceremony. During the Christmas Eve ritual, Pope John Paul, assisted by workers inside the basilica, simply pushed the doors open.

The Great Jubilee of the Year 2000

In mid-December 1999, about ten days before the official opening of the holy door at Saint Peter's, there was a *recognitio* or on-the-spot inspection in the presence of numerous officials of the Roman curia. Prayers were said and then workers removed the wall that sealed the inside of the holy door. Various receptacles within this wall were removed and the contents later examined in the sacristy and then given to the Holy Father. They contained such items as coins, stamps, and other memorabilia from the previous holy year. There were also bricks sealed inside the wall from that jubilee and these too were removed.

Yet another departure from custom in the opening ceremony for the jubilee 2000 was the absence of a hammer. In early years popes simply took hammers from workmen at the church and, in a symbolic gesture, knocked three times on the door before actually opening it. In later years, pontiffs performed the ritual three knocks with hammers that were made

Figure 17
Pope John Paul II opens the holy door at the Basilica of Saint Paul's Outside-the-Walls with representatives of other Christian churches, January 18, 2000, Archives of *L'Osservatore Romano*

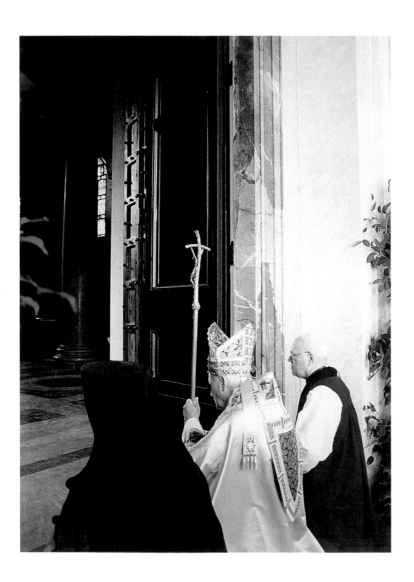

of gold, silver, or other precious materials, usually commissioned by high-ranking ecclesiastics and donated to the pope.

On December 24, 1999, Pope John Paul II simply opened the holy door at Saint Peter's, forgoing hammers and tradition. The ceremony began with a procession in the atrium of the basilica with members of the curia and other high-ranking church officials (fig. 18). The procession stopped at the holy door for a moment of prayer and a reading from the Gospel of Luke. The Holy Father read three verses from the Psalms, starting with "I will enter into your house, O Lord," and then he opened the holy door. Carrying the Book of Gospels, he processed to the main altar, where the Book of Gospels was enthroned. He then formally announced the start of the jubilee year, after which mass was celebrated.

The great jubilee of 2000 was remarkable in both preparations and scope. The Vatican and the city of Rome inaugurated plans to welcome the tens of millions of pilgrims who were expected in the Eternal City for this holy year marking the second millennium of Christianity.

Countless buildings, bridges, and monuments were renovated, and centuries of grime and dirt removed, city squares were enlarged and often made into pedestrian-only areas, gardens were planted, streets repaved, underpasses and underground garages built to accommodate traffic. A beautiful and functional new entrance to the Vatican Museums was created to ease the flow of the increasing numbers of visitors to the museums. The facades, as well as the interiors, of the four main patriarchal basilicas were cleaned, and they shone with a new and intense luminosity when they were unveiled just before the start of the holy year in December 1999.

The great jubilee of the year 2000 was marked by liturgies celebrated in diverse rites such as the Mozarabic, Coptic, and Syro-Antiochene. One of the more memorable events of this year was the March 8, Ash Wednesday liturgy, during which there was the church's request for pardon for the sins of her children in the past (fig. 19). Another event was the May 7th ecumenical service at the Colosseum for the "new martyrs" of our times.

Pope John Paul presided at each one of these events, which included countless specific jubilee celebrations such as those for children, young people, and the elderly; for priests, bishops, and those living the consecrated life; for artisans, journalists, and the world of entertainment. There were jubilee days for the ill, for health care workers, for members of the Roman curia, for workers and scientists, for families, missionaries, and farmers. World Youth Day drew an unprecedented two million young people to Rome in August of 2000. Scores of special events and liturgical ceremonies marked this holy year, drawing an estimated twenty-eight million faithful to Rome and the Vatican.

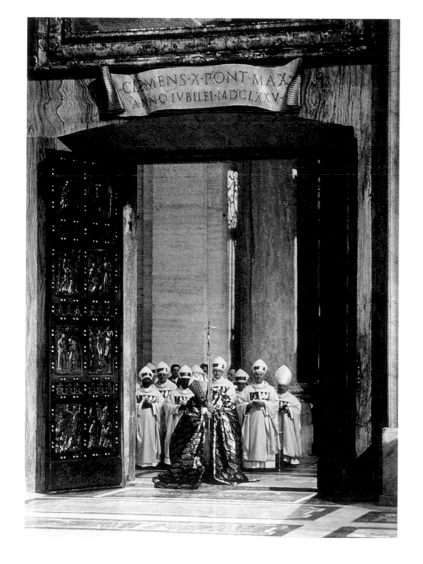

Figure 18
Pope John Paul II at the inauguration of the holy year 2000, Archives of *L'Osservatore Romano*

Figure 19
Pope John Paul II with Ali Agca, the man who had attempted to assassinate him in 1981, and whom the Pope later pardoned, Archives of *L'Osservatore Romano*

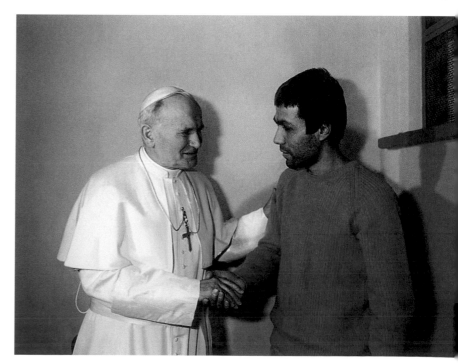

Saint Peter and His Successors

This list of popes and antipopes is derived from one compiled by A. Mercati in 1947 under the auspices of the Vatican; some changes have been made on the basis of recent scholarship, and the list has been brought up to date. The years of each pope's reign follow his name; for popes after the end of the Great Schism (1378–1417), family names are given as well. The names of antipopes are enclosed in brackets, while alternative numberings of papal names appear in parentheses.

Saint Peter (67)
Saint Linus (67–76)
Saint Anacletus (Cletus) (76–88)
Saint Clement I (88–97)
Saint Evaristus (97–105)
Saint Alexander I (105–15)
Saint Sixtus I (115–25)
Saint Telesphorus (125–36)
Saint Hyginus (136–40)
Saint Pius I (140–55)
Saint Anicetus (155–66)
Saint Soter (166–75)
Saint Eleutherius (175–89)
Saint Victor I (189–99)
Saint Zephyrinus (199–217)
Saint Callistus I (217–22)
[Saint Hippolytus (217–35)]
Saint Urban I (222–30)
Saint Pontianus (230–35)
Saint Anterus (235–36)
Saint Fabian (236–50)
Saint Cornelius (251–53)
[Novatian (251)]
Saint Lucius I (253–54)
Saint Stephen I (254–57)
Saint Sixtus II (257–58)
Saint Dionysius (259–68)
Saint Felix I (269–74)
Saint Eutychian (275–83)
Saint Gaius (Caius) (283–96)
Saint Marcellinus (296–304)
Saint Marcellus I (308–9)
Saint Eusebius (309)
Saint Miltiades (311–14)
Saint Silvester I (314–35)
Saint Mark (336)
Saint Julius I (337–52)
Liberius (352–66)
[Felix II (355–65)]
Saint Damasus I (366–84)
[Ursinus (366–67)]
Saint Siricius (384–99)
Saint Anastasius I (399–401)
Saint Innocent I (401–17)
Saint Zosimus (417–18)
Saint Noniface I (418–22)
[Eulalius (418–19)]
Saint Celestine I (422–32)
Saint Sixtus III (432–40)
Saint Leo I (440–61)
Saint Hilary (461–68)
Saint Simplicius (468–83)
Saint Felix III (II) (483–92)
Saint Gelasius I (492–96)
Anastasius II (496–98)
Saint Symmachus (498–514)
[Lawrence (498; 501–5)]
Saint Hormisdas (514–23)
Saint John I (523–26)
Saint Felix IV (III) (526–30)
Boniface II (530–32)

[Dioscorus (530)]
John II (533–35)
Saint Agapitus I (535–36)
Saint Silverius (536–37)
Vigilius (537–55)
Pelagius I (556–61)
John III (561–74)
Benedict I (575–79)
Pelagius II (579–90)
Saint Gregory I (590–640)
Sabinian (604–6)
Boniface III (607)
Saint Boniface IV (608–15)
Saint Deusdedit I (615–18)
Boniface V (619–25)
Honorius I (625–38)
Severinus (640)
John IV (640–42)
Theodore I (642–49)
Saint Martin I (649–55)
Saint Eugene I (654–57)
Saint Vitalian (657–72)
Deusdedit II (672–76)
Donus (676–78)
Saint Agatho (678–81)
Saint Leo II (682–83)
Saint Benedict II (684–85)
John V (685–86)
Conon (686–87)
[Theodore (687)]
[Paschal (687)]
Saint Sergius I (687–701)
John VI (701–5)
John VII (705–7)
Sisinnius (708)
Constantine (708–15)
Saint Gregory II (715–31)
Saint Gregory III (731–41)
Saint Zachary (741–52)
Stephen (752)
Stephen II (III) (752–57)
Saint Paul I (757–67)
[Constantine (767–69)]
[Philip (768)]
Stephen III (IV) (768–72)
Adrian I (772–95)
Saint Leo III (795–816)
Stephen IV (V) (816–17)
Saint Paschal I (817–24)
Eugene II (824–27)
Valentine (827)
Gregory IV (827–44)
[John (844)]
Sergius II (844–47)
Saint Leo IV (847–55)
Benedict III (855–58)
[Anastasius (855)]
Saint Nicholas I (858–67)
Adrian II (867–72)
John VIII (872–82)
Marinus I (882–84)

Saint Adrian III (884–85)
Stephen V (VI) (885–91)
Formosus (891–96)
Boniface VI (896)
Stephen VI (VII) (896–97)
Romanus (897)
Theodore II (897)
John IX (898–900)
Benedict IV (900–903)
Leo V (903)
[Christopher (903–41)]
Sergius III (904–11)
Anastasius III (911–13)
Lando (913–14)
John X (914–28)
Leo VI (928)
Stephen VII (VIII) (928–31)
John XI (931–35)
Leo VII (936–39)
Stephen VIII (IX) (939–42)
Marinus II (942–46)
Agapetus II (946–55)
John XII (955–64)
Leo VIII (963–65)
Benedict V (964–66)
John XIII (965–72)
Benedict VI (973–74)
[Boniface VII (974; 984–85)]
Benedict VII (974–83)
John XIV (983–84)
John XV (985–96)
Gregory V (996–99)
[John XVI (997–98)]
Silvester II (999–1003)
John XVII (1003)
John XVIII (1004–9)
Sergius IV (1009–12)
Benedict VIII (1012–24)
[Gregory (1012)]
John XIX (1024–32)
Benedict IX (1032–44)
Silvester III (1045)
Benedict IX (1045)
Gregory VI (1045–46)
Clement II (1046–47)
Benedict IX (1047–48)
Damasus II (1048)
Saint Leo IX (1049–54)
Victor II (1055–77)
Stephen IX (X) (1057–58)
[Benedict X (1058–59)]
Nicholas II (1059–61)
Alexander II (1061–73)
[Honorius II (1061–72)]
Saint Gregory VII (1073–85)
[Clement III (1080; 1084–1100)]
Blessed Victor III (1086–87)
Blessed Urban II (1088–99)
Paschal II (1099–1118)
[Theodoric (1100)]
[Albert (1102)]

[Silvester IV (1105–11)]
Gelasius II (1118–19)
[Gregory VIII (1118–21)]
Callistus II (1119–24)
Honorius II (1124–30)
[Celestine II (1124)]
Innocent II (1130–43)
[Anacletus II (1130–38)]
[Victor IV (1138)]
Celestine II (1143–44)
Lucius II (1144–45)
Blessed Eugene III (1145–53)
Anastasius IV (1153–54)
Adrian IV (1154–59)
Alexander III (1159–81)
[Victor IV (1159–64)]
[Paschal III (1164–68)]
[Callistus III (1168–78)]
[Innocent III (1179–80)]
Lucius III (1181–85)
Urban III (1185–87)
Gregory VIII (1187)
Clement III (1187–91)
Celestine III (1191–98)
Innocent III (1198–1216)
Honorius III (1216–27)
Gregory IX (1227–41)
Celestine IV (1241)
Innocent IV (1243–54)
Alexander IV (1254–61)
Urban IV (1261–64)
Clement IV (1265–68)
Blessed Gregory X (1271; 1272–76)
Blessed Innocent V (1276)
Adrian V (1276)
John XXI (1276–77)
Nicholas III (1277–80)
Martin IV (1281–85)
Honorius IV (1285–87)
Nicholas IV (1288–92)
Saint Celestine V (1294)
Boniface VIII (1294; 1295–1303)
Blessed Benedict XI (1303–4)
Clement V (1305–14)
John XXII (1316–34)
[Nicholas V (1328–30)]
Benedict XII (1335–42)
Clement VI (1342–52)
Innocent VI (1352–62)
Blessed Urban V (1362–70)
Gregory XI (1370; 1371–78)
Urban VI (1378–89)
Boniface IX (1389–1404)
Innocent VII (1404–06)
Gregory XII (1406–15)
[Clement VII (1378–94)]
[Benedict XIII (1394–1423)]
[Alexander V (1409–10)]
[John XXIII (1410–15)]
Martin V (Colonna, 1417–31)
Eugene IV (Condulmer, 1431–47)

[Felix V (1439; 1440–49)]
Nicholas V (Parentuccelli, 1447–55)
Callistus III (Borgia, 1455–58)
Pius II (Piccolomini, 1458–64)
Paul II (Barbo, 1464–71)
Sixtus IV (Della Rovere, 1471–84)
Innocent VIII (Cibo, 1484–92)
Alexander VI (Borgia, 1492–1503)
Pius III (Todeschini-Piccolomini, 1503)
Julius II (Della Rovere, 1503–13)
Leo X (Medici, 1513–21)
Adrian VI (Florensz, 1522–23)
Clement VII (Medici, 1523–34)
Paul III (Farnese, 1534–49)
Jiulius III (Ciocchi del Monte, 1550–55)
Marcellus II (Cervini, 1555)
Paul IV (Carafa, 1555–59)
Pius IV (Medici, 1559; 1560–65)
Saint Pius V (Ghislieri, 1566–72)
Gregory XIII (Boncompagni, 1572–85)
Sixtus X (Peretti, 1585–90)
Urban VII (Castagna, 1590)
Gregory XIV (Sfondrati, 1590–91)
Innocent IX (Facchinetti, 1591)
Clement VIII (Aldobrandini, 1592–1605)
Leo XI (Medici, 1605)
Paul V (Vorghese, 1605–21)
Gregory XV (Ludovisi, 1621–23)
Urban VIII (Barberini, 1623–44)
Innocent X (Pamphili, 1644–55)
Alexander VII (Chigi, 1655–67)
Clement IX (Rospigliosi, 1667–69)
Clement X (Altieri, 1670–76)
Blessed Innocent XI (Odescalchi, 1676–89)
Alexander VIII (Ottoboni, 1689–91)
Innocent XII (Pignatelli, 1691–1700)
Clement XI (Albani, 1700–1721)
Innocent XIII (Conti, 1721–24)
Benedict XIII (Orsini, 1724–30)
Clement XII (Corsini, 1730–1740)
Benedict XIV (Lambertini, 1740–58)
Clement XIII (Rezzonico, 1758–69)
Clement XIV (Ganganelli, 1769–74)
Pius VI (Braschi, 1775–99)
Pius VII (Chiaramonti, 1800–1823)
Leo XII (Della Genga, 1823–29)
Pius VIII (Castiglioni, 1829–30)
Gregory XVI (Cappellari, 1831–46)
Pius IX (Mastai-Ferretti, 1846–78)
Leo XIII (Pecci, 1878–1903)
Saint Pius X (Sarto, 1903–14)
Benedict XV (Della Chiesa, 1914–22)
Pius XI (Ratti, 1922–39)
Pius XII (Pacelli, 1939–58)
John XXIII (Roncalli, 1958–63)
Paul VI (Montini, 1963–78)
John Paul I (Luciani, 1978)
John Paul II (Wojtyla, 1978–)

Saint Peter, the Popes, and the Vatican

Near the right bank of the Tiber, on a small hill called the Vatican, some Roman nobles built their villas during the era before the birth of Jesus Christ. It was an area of art and gardens. The emperor Caligula (AD 34–41) had a private circus built here. If everything had ended there, today this area would be, at most, of archaeological interest and nothing more. But when, according to an ancient tradition, many Christians were martyred in that circus, an incredible story began in the area of the Vatican Hill. During the reign of the emperor Nero (54–68), the apostle Peter was also martyred here and buried in the nearby necropolis. In AD 313 the emperor Constantine issued the Edict of Milan, recognizing the right of the previously persecuted Christians to freedom of religion.

Between 320 and 350 Constantine ordered the construction of a church over the grave of the apostle Peter. Later, in the sixteenth and seventeenth centuries, it was substituted by the present basilica. It became the symbol of the Vatican territory which however received its present borders with the Lateran Treaty, signed between the Holy See and the Italian State on February 11, 1929.

Today this is known as the Vatican City State, a state small in area but great in significance. The pope, successor to Peter, is its sovereign. The Vatican City is its means and instrument of independence from any other constituted earthly power. The most symbolic place within the Vatican is the imposing Basilica of Saint Peter with its precious casket containing the remains of Saint Peter. To Peter and his successors, the popes, Christ entrusted the ministry of leading the Church. In the more than two thousand years of the life of the Church, the role and ministry of the pope, as the bishop of Rome and successor of the apostle Peter, is fundamental and central to the community of faith.

This exhibition provides an introduction to what the pope is and what the papacy means. Its subject is not necessarily a specific pope, but the sum of all the individual popes; from the apostle Peter to John Paul II. Anyone who visits the exhibition or reads the catalogue will, it is hoped, intuit that Christianity is open to dialogue with everyone, indeed, dialogue is a specific element of its essential character. The visitor or the reader will be confronted with works of art and objects that attest that each pope is more than the embodiment of personal psychological idiosyncrasies or peculiarities of his time. He is, above all, the instrument of dialogue, the representative of Him who came not to divide, but to break down the barriers of hostility and unite all men and women into a single people (cf. Saint Paul, *Letter to the Ephesians* 2:14)

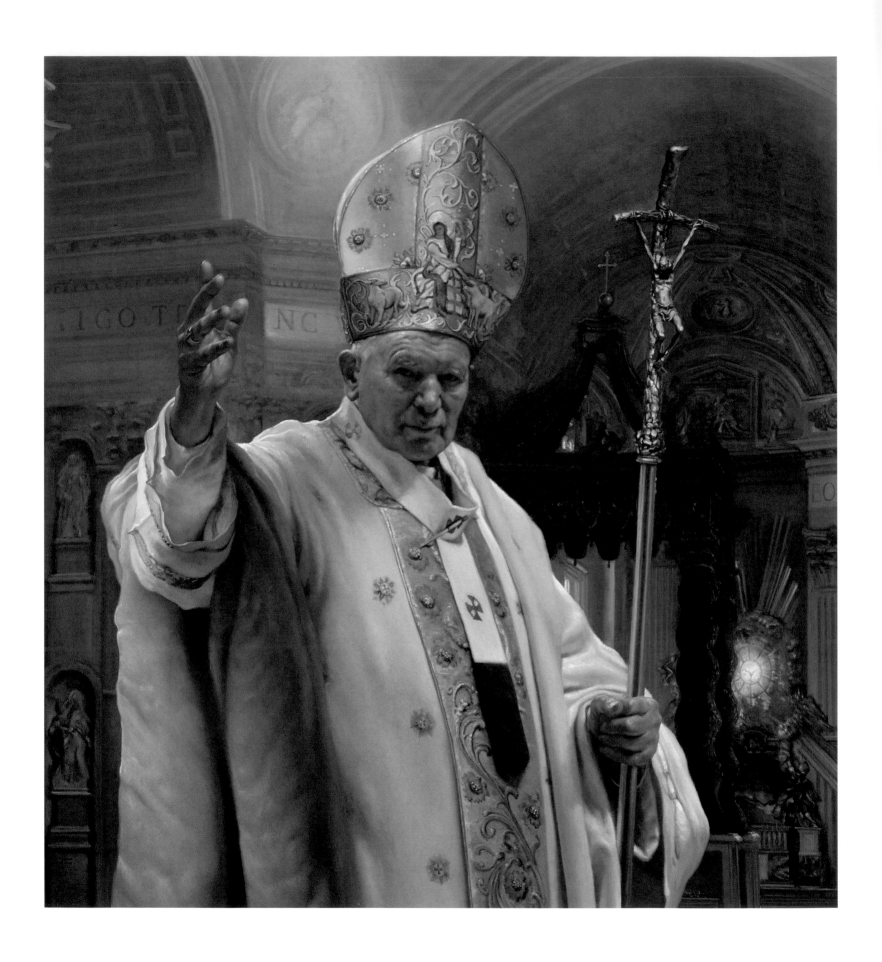

Portrait of Pope John Paul II

2002
Nelson Shanks (born 1937)
Oil on canvas
122 × 183 cm
Promised Gift to the Philadelphia Chapter of the
Patrons of the Arts in the Vatican Museums

Nelson Shanks, born in Rochester, New York, is
the foremost classically trained portrait painter
working in the United States today. His depiction
of Pope John Paul II is a magisterial example of
Shanks' ability to synthesize visual and psychologi-
cal information. It is at once universal and
commanding, and yet somehow personal and even
intimate. Shanks' likeness of the pope confidently
extends a five-hundred-year tradition of papal
portraits, informed by the artist's intense reading
of the Old Masters. The painter has rendered with
penetrating insight a towering historical personali-
ty near the end of his life, yet a figure who seems
altogether contemporary and familiar, a universal
father.

Shanks has long been engaged by the challenge
of rendering the physical attributes, gestures, and
psychology of political and cultural leaders. Among
his memorable, often definitive, portrait images are
those of heads of state (President Ronald Reagan,
President Bill Clinton, Lady Margaret Thatcher),
royalty (Her Royal Highness, Diana, Princess of
Wales, His Majesty King Gustav and Her Majesty
Queen Silvia of Sweden, Queen Juliana of the
Netherlands),
art world notables (National Gallery of Art director
J. Carter Brown, tenor Luciano Pavarotti, mezzo-
soprano Denyce Graves), and media magnates
(*Washington Post* owner Katharine Graham, *The New
York Times* publisher Arthur O. Sulzburger, Sr.).

Shanks is also exceptional among contemporary
artists for his discerning connoisseurship,
especially of the Italian Renaissance and baroque.
His remarkable personal collection is the envy of
museum curators. It is no surprise that Shanks, a
diligent student of art history, would develop a
first-hand acquaintance with the papal portraits
by Raphael, Titian, Guercino, Sacchi, Velázquez,
Maratta, Batoni, and Mengs.

Several of these interests are evident in Shanks'
portrait of Pope John Paul II. In April the artist
journeyed to the Vatican and observed the pope
celebrating mass and other ceremonies. Shanks
acquired a small collection of recent portrait and
journalistic photographs of the pontiff to supple-
ment his own firsthand observations, and worked

on the portrait from April to October 2002.

The artist chose to portray the pope standing,
offering benediction in the Great Crossing of
Saint Peter's Basilica, at the center of the church
reaching out to the faithful. The idea that the pope
follows Christ as the "light of the world" prompted
Shanks to reconcile multiple sources of light, from
Michelangelo's cupola to Bernini's Holy Spirit
window seen through the baldachino. The kindly
yet knowing gaze of the pope's pale blue eyes is
fixed on the viewer and yet somehow also on
something beyond. The raking light across his
forehead emphasizes his years and his mortal
world-weariness. Perhaps most conspicuously,
Shanks has captured the translucence of his rosy-
white flesh, which seems to be the result of yet
another source of light altogether.

In his left hand the pope holds the pastoral
staff created by Lello Scorzelli in 1978 for Pope
Paul VI, the first pontiff to use the staff as opposed
to a crosier. John Paul II is rarely seen without it.
He greatly admired Paul VI, who, as a cardinal,
worked closely and tirelessly with him on several
important initiatives.

The hand-carved and gilded frame for the
portrait was designed by the artist and constructed
and finished by Jim Brewster of Presentations in
Baltimore. It was conceived to evoke an Emilian
frame ca. 1600 and features around three sides a
relevant scriptoral passage (Matthew 16:18–19) in
Latin placed into relief by an intricate punchwork
background: TU ES PETRUS ET SUPER HANC
PETRAM AEDIFICABO ECCLESIAM MEAM ET TIBI
DABO CLAVES REGNI CAELORUM (Thou art Peter
and upon this rock I will build my church and
I give you the keys of the kingdom of heaven).
On the fourth side, the bottom section of the flat
panel of the frame, appears the identification of the
sitter: JOANNES PAULUS PP. II (Pope John Paul II).
The frame was made possible by the generosity of
Claire Boasi of the Philadelphia Chapter of the
Patrons of the Arts in the Vatican Museums.

Shanks' portrayal of Pope John Paul II is a work
of great sympathy and insight and will be our most
enduring painted image of one of the preeminent
religious and historical figures of the twentieth
century. D.D.T.

Twelve Apostles

17th century
Workshop of Gian Lorenzo Bernini
Gilded wood
60–63 × 27–30 × 18–22 cm
Office of the Liturgical Celebrations of the Supreme
Pontiff, Vatican City State
Inv. VR113a-n

Conservation courtesy of The Minnesota Chapter of
the Patrons of the Arts in the Vatican Museums

The apostles chosen by Jesus, as recorded in the
Synoptic Gospels, were Simon, whose name the
Lord changed to Peter (meaning "rock") and his
brother Andrew; James and John, the sons of
Zebedee; Philip; Bartholomew; Thomas; Matthew;
James the son of Alphaeus; Thaddaeus; Simon the
Zealot; and Judas Iscariot, who would later betray
Jesus and was replaced after his Resurrection by
Matthias. The apostles are frequently represented in
the art and history of the church, and they can each
be recognized by means of a relative attribute or
attributes indicating their specific mission or
martyrdom.

Peter, for instance, is shown with the keys as a
sign of the responsibility accorded him by Jesus for
the foundation of the Church; John is accompanied
by an eagle and James is clutching a pilgrim staff;
Andrew is often seen leaning on an X-shaped cross
in reference to his martyrdom; Bartholomew holds
a knife, because by tradition he was flayed alive.
Simon the Zealot is featured with a saw and Paul is
featured with a sword, the instruments of their
martyrdoms. (Here, Matthias is replaced by Paul.)

In the tradition of the Roman Catholic Church
the number twelve is symbolic of wholeness and
completion; thus, the Twelve Apostles represent the
idea of the salvation of all the world's peoples. R.V.

2 Jude Thaddeus

3 Philip

4 Paul

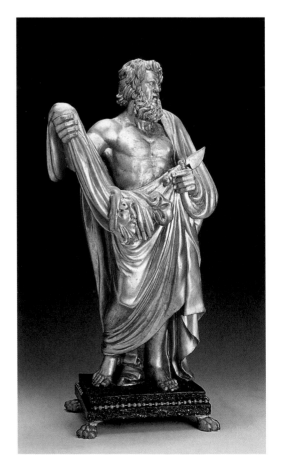

5 Bartholomew

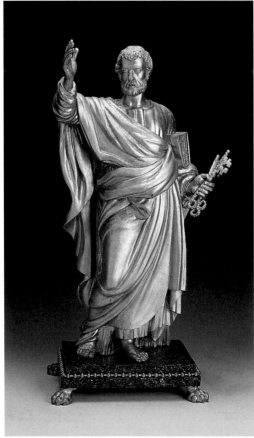

6 Peter

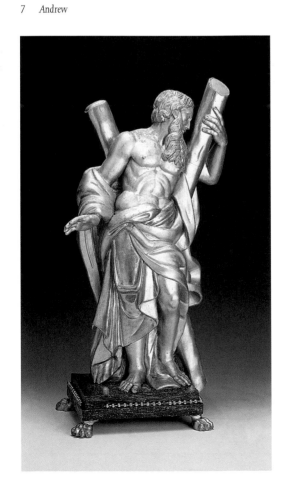

7 Andrew

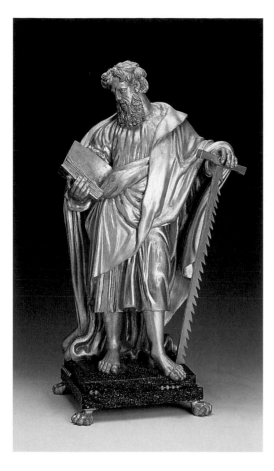

8 Simon

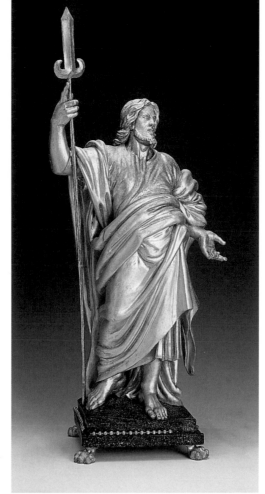

9 James the Lesser

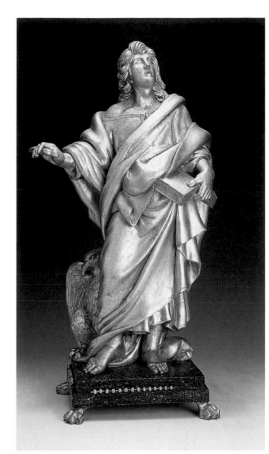

10 John

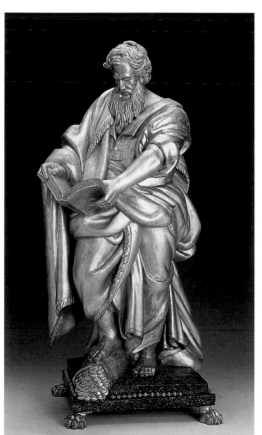

11 Matthew

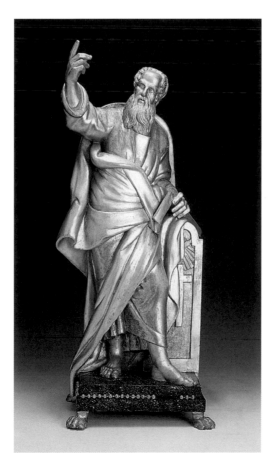

12 Thomas

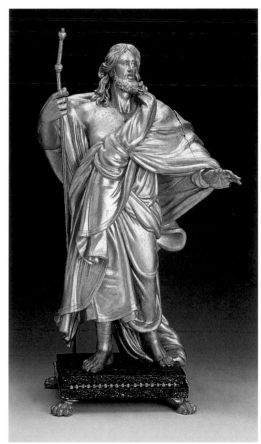

13 James the Greater

14

Christh Bearing the Cross

Christ Bearing the Cross

Ca. 1535
Marco Palmezzano (1459–1539)
Oil on wood
54 × 42.3 cm
Vatican Museums, Vatican City State
Inv. 40271

This painting was part of Cardinal Ferrieri's collection, which was bequeathed in 1888 to the Holy Congregation of Propaganda Fide by a testamentary provision. From there it was transferred to the Vatican, in 1912, and has been exhibited in the Pinacoteca since 1934.

In the half-length painting, Christ bears the cross on his shoulder. His hands are modeled by the light, and his head, in nearly perfect profile, is surrounded by a delicate halo and tilts downward. The texture of the wood is defined realistically in the pictorial description of the cross.

Christ is isolated against a neutral backdrop, painted a dark color. He wears a red tunic with delicate gold embroidery around the neckline and cuffs. On his left shoulder is a monogram. His hair and beard are rendered in detail and a crown of thorns pierces his forehead. Neither pain nor the drops of blood mar the perfection of Christ's features. He is resigned, yet regal, in his suffering.

The figure almost repeats the iconographic model of the Christ in the *Way to Calvary* in the Painting Gallery in Forlì. Inspired by the Gospel stories of Matthew, Mark, and Luke, the composition depicts Jesus kneeling at the center of a group of soldiers and Simon the Cyrenian after having fallen under the weight of the cross on the road to Golgotha. The Forlì painting is probably the best version of a theme that met with great success among the public of the time, and Palmezzano's workshop created various reproductions of the picture, three of them in 1535.

A *Christ Bearing the Cross*, in the collection of Marquis Vincenzo Giustiniani (Staatliche Museen zu Berlin, Preussicher Kulturbesitz, Gemäldegalerie) was exhibited recently in Berlin. It bears a label with Palmezzano's signature and the date MCCCCCIII, thus permitting us to recognize a prototype or the oldest extant version for many reproductions and variations. On the Vatican painting, the artist's name and date are partially legible on a piece of paper attached to the cross below Christ's left hand: MARCHUS PALMEZ[Z…US]/ PICTOR [M]CCCCC[X]XX[V].

Marco Palmezzano entered the workshop of Melozzo da Forlì at a young age. He assisted Melozzo in Rome and collaborated with him on the frescoes (destroyed in 1944) of the Feo Chapel in the church of S. Biagio in Forlì. He learned a great deal about perspective and volumetric values from Melozzo. He was also greatly influenced by Giovanni Bellini and, to a lesser degree, Bartolomeo Montagna and Giovanni Battista Cima da Conegliano as a result of time spent in Venice between 1495 and 1505. After this period he did not undergo noticeable changes in development, and he left an enormous output of paintings, both autograph and those produced by his workshop. His subjects were exclusively religious and manifest a controlled, precise, solemn monumentality inspired by Bellini. A certain sentimentality with Nordic overtones is also present in his work, for example in two versions of the *Madonna on the Throne among Saints* (inv. 40273 and 40619) and the *Holy Family with Saint Elizabeth and Saint John the Baptist as a Child* (inv. 40274), all in the Vatican Pinacoteca. M.S.C.

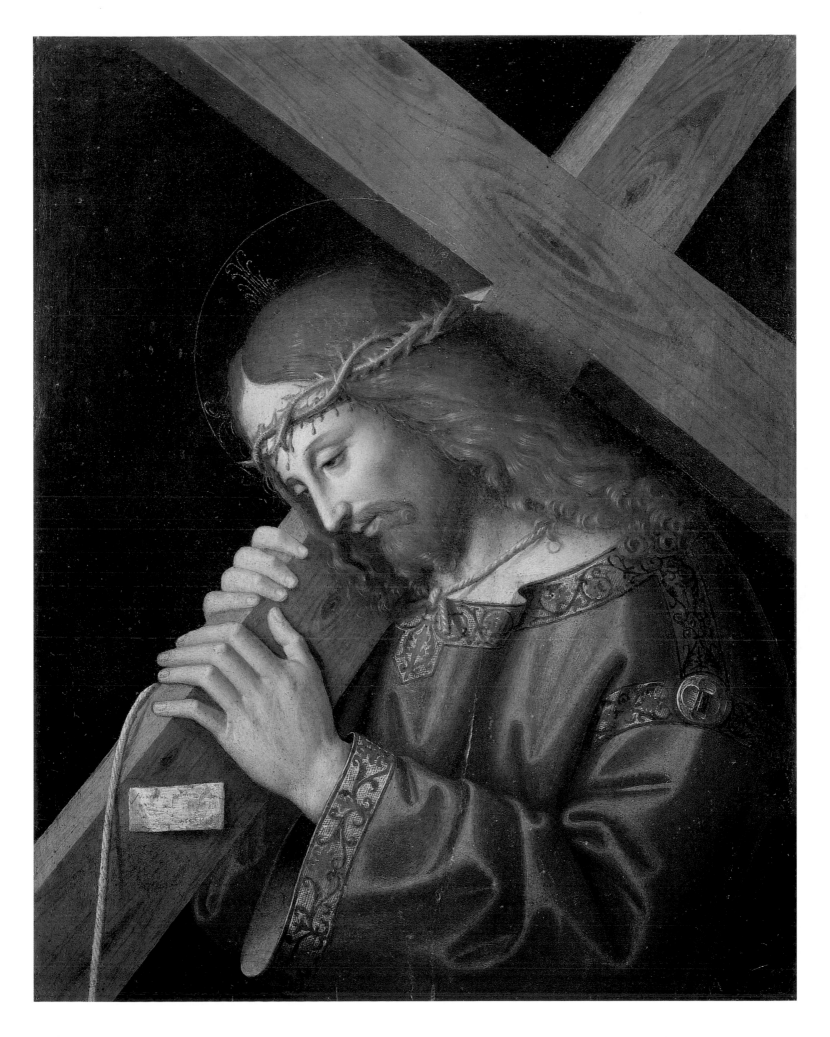

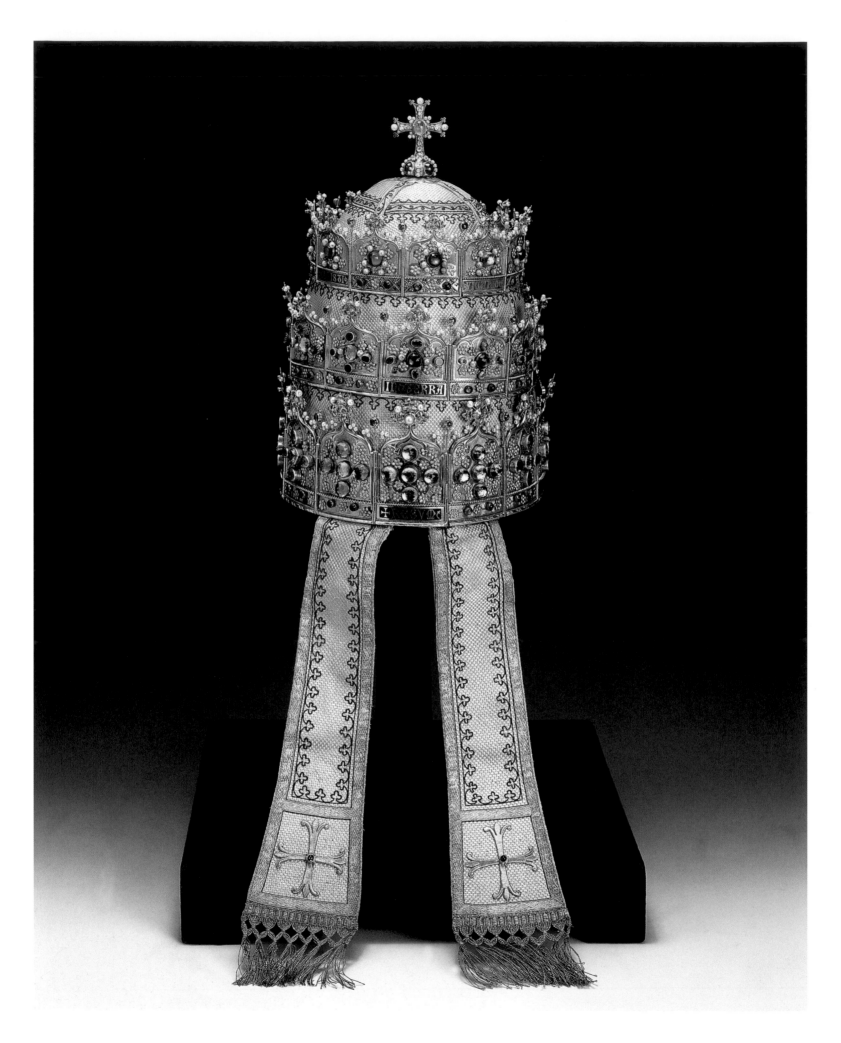

Papal Tiara of Pope Pius IX

1871, Bourdon, Ghent (Belgium)
After a design by Jean Baptiste Bethume, Ghent
Gold, pearls, gilt silver, emeralds, enamel,
precious stones
30 × 20 × 20 cm
Office of the Liturgical Celebrations of the Supreme
Pontiff, Vatican City State
Inv. TR11

Conservation courtesy of Florence D'Urso in honor
of His Excellency, Archbishop Renato R. Martino,
exemplary Papal Nuncio, and very dear friend

In 1871, Pope Pius IX celebrated the twenty-fifth
year of his pontificate and to mark the occasion the
ladies of the royal court of Belgium made him a
gift of this tiara. In the course of his long reign,
Pope Pius IX steered the church through years of
considerable strife and uncertainty. In 1848, just
two years into his papacy, Rome was proclaimed a
Democratic Republic, and soon after, when the
city was overrun in 1870, the Papal States were
abolished. During his pontificate the Dogma of the
Immaculate Conception was declared, in 1854, and
several years later during the First Vatican Council
(1868–70) the doctrine of papal infallibility was
defined. In the holy year of 2000, Pope John Paul II
proclaimed him blessed.

Though not an official headpiece, the tiara
remains a symbol of the papacy. Before Pope
Paul VI, who renounced wearing it out of respect
for the poor and to express his vision of the church
as a service more than the exercise of power, each
pope had worn the tiara during his coronation
ceremony.

Between the ninth and eleventh century the
first crown appeared, which symbolized the
spiritual. Pope Boniface VIII added a second crown,
symbolizing the worldly. The third crown was
added in the fourteenth century by Pope Boniface
XI or Pope Clement V.

In the thirteenth century the tiara was
embellished with two *infulae*, or lappets, originally
black, which hang down the back. The lappets here
are woven from silver thread and bordered with
spun gold, with a fringe along the bottom. Each
lappet carries a stylized red trefoil pattern, and
at the bottom a Greek cross with lily terminals and
a small gem at the center.

The crowning orb and cross appear for the
first time on the tiara of Pope Julius II. As a liturgical
ornament, the tiara has its origins in the Gothic
period, and the one on exhibit here is of Gothic
inspiration. R.Z.

Coat of Arms with Tiara and Keys

19th century
Gilt wood, gilt metal
38 × 50 × 18 cm
Apostolic Floreria, Vatican City State

The tiara, an oval headdress with two lappets
hanging down the back, originated in the East and
was used by Persians and Greeks as a symbol of
royal power. Later, in the eighth century, a crown
was added, and it was adopted for use by the popes.
At the beginning of the fourteenth century, when
Pope Boniface VIII added a second crown, it became
the papal coat of arms. The tiara became a triple
crown when a third was added by Pope Benedict
XII in 1334. The three crowns represent the pope's
authority as father of princes and kings, lord of the
world, and vicar of Christ.

The tiara does not have liturgical meaning but
rather represents the authority and jurisdiction of
the pope. It was used in official processions and
to label objects and places belonging to the pope.
In the coat of arms, it is associated with two
crossed keys, symbol of papal authority. According
to tradition, the left key is made of gold and
represents Heaven, and the right key is silver and
symbolizes Purgatory. This model is kept in the
papal sacristy, which conserves all the vestments,
sacred objects, and elements of wardrobe that must
be used for ceremonies when the pontiff travels
from one place to another. Thus, some of these
elements must be versatile and adaptable to use in
various circumstances with different functions. This
model could be hung and used above a doorway or
as a decoration of a baldachin. More likely, though,
it was hung over the back of a throne. The three
spheres that adorn the key ring are not symmetrical
with regard to its body. Instead, they are staggered
so as not to protrude and disturb the rungs
between the back of the throne. This piece, made
of polished wood and painted gold with bronze
straps, was probably made during the second half
of the nineteenth century. G.P.

Mosaic Fragment of Saint Peter from the Basilica of Saint Paul's Outside-the-Walls

5th century
Mosaic
74 × 54 × 5 cm
Reverenda Fabbrica of Saint Peter, Vatican City State

Conservation courtesy of Florence D'Urso, in honor of Reverend Monsignor Peter G. Finn, Rector, Saint Joseph's Seminary, and in honor too, of all the dedicated priests of the Archdiocese of New York

This mosaic fragment of Saint Peter comes from the right-hand pendentive of the triumphal arch of the Basilica of Saint Paul's Outside-the-Walls. Originally, it was part of the decorations commissioned by Galla Placidia (died 450) during the time of Pope Saint Leo the Great.

In the wake of the great fire that destroyed the basilica in 1823, the mosaic was removed from its original position and taken to the Vatican's mosaic studio for restoration. This precious relic remained at the Fabbrica of Saint Peter and, in 1840, was among the works to be conserved in the Vatican Grottoes. In 1924 the fragment was moved to the new Petrine Museum, but a few years later it was returned to the grottoes.

The central part of the figure, made of glass tesserae on painted mortar, remains unaltered. Discrepancies in colored and etched plaster around the cheeks probably date to the time of Pope Clement XII, and these were substituted with mosaic during the most recent restoration. Of the original blue background there remains only the double line of tesserae marking the upper part of the head; all the rest has been restored. The restoration of the background also extends under the chin of the apostle where the neck meets the chest; this isolates Peter's face in a medallion that makes it difficult to imagine that the head, 60 cm in length, was once part of a full-length figure more than 3.5 meters high.

The mosaic is striking for its expressive power; for the apostle's intense yet serene gaze as his eyes turn in one direction, his head in another; and for that intelligent and refined contrast of colors and shades that make this work one of the most important masterpieces of Roman art between late antiquity and the sixth century. P.Z.

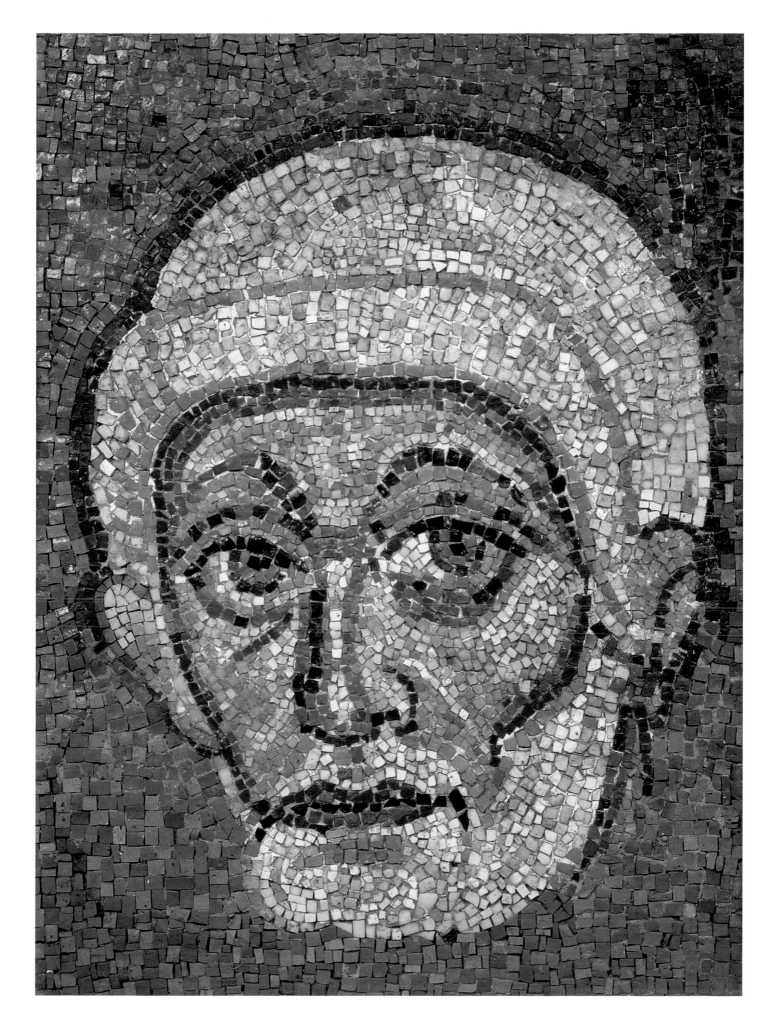

The Tomb of Peter

According to tradition, the two most important disciples of Jesus Christ were both executed in Rome in A.D. 64, during Emperor Nero's persecution of the Christians: Paul was beheaded, and Peter was crucified in the circus on the Vatican Hill.

The ancient writers Origen and Saint Jerome maintain that Peter humbly asked to be crucified upside down, because he did not consider himself worthy of dying like Jesus Christ. This episode is one of the many legends surrounding Peter during his time in Rome. Numerous churches were erected in his honor, evidence of the continuous and ever-increasing veneration of him by the Christians as vicar of Christ and the head of the Church, that is, the first pope.

For centuries Christians have believed that the tomb on the Vatican Hill was that of the apostle. Only recently, from 1939 to 1949, at the initiative of Pope Pius XII, was the ground level of the Vatican Grottoes lowered to make room for the tombs of the popes. So much archaeological data was found that it is difficult to doubt the authenticity of the tomb.

Most important was the discovery of relics and then numerous graffiti, some of which predate Constantine. These graffiti had been written by the faithful as a sign of their faith in Peter. In addition, an extraordinary number of coins (about 1,900), of every kind of metal, from different eras, and from mints of many regions throughout the western Roman Empire, were found. They are a testament to the presence of many devoted people, over centuries, at the tomb of the prince of the apostles.

Reliquary of Saint Conrad of Parzham

1934
Silver, ivory, wood
57 × 37 × 20 cm
Office of the Liturgical Celebrations of the Supreme
Pontiff, Vatican City State
Inv. RLQ257

This reliquary is dedicated to the German Saint Conrad of Parzham (1818–94), a religious of the Order of Friars Minor Capuchins, who for forty years exercised the function of door-keeper at the convent-shrine of Altötting in Bavaria. In this humble role, he gave a living example of great humility and charity toward all. In 1934, he was proclaimed a saint by Pope Pius XI. This reliquary was a gift to the pope on that occasion.

This most original reliquary, made of silver and ivory, has the form of a ship and rests upon an octagonal base. The base is decorated with chased work representing the waves of the sea. The hull of the ship is decorated with engraved scrolls and the words "Pentecost 1934." The stern of the vessel bears the coat of arms of Pope Pius XI, while over the prow is a churchlike building that is the reliquary of Saint Conrad of Parzham. Within the ship are six ivory cherubs holding symbols; there is also an angel bearing a chalice. The figure wearing a papal tiara and cope and blessing the kneeling saint represents Pope Pius XI. The mast rises from the center of the craft, complete with ladders and rigging and a large sail with a chased representation of Mary with the Infant Jesus. At the top of the mast is a dove within a sunburst pattern, a two-pointed standard with the Franciscan symbol, and a cross with three arms. In even the oldest Christian symbolism, the ship represents the Church guided by the pope of Rome. R.V.

Peter Saved from the Water

1715–25
Anonymous painter working in Rome
(circle of Giuseppe Ghezzi?)
Oil on canvas
165 × 133 cm
Congregation for the Evangelization of Peoples,
Vatican City State

Conservation courtesy of Mr. and Mrs. John R. Ford,
in memory of Louise E. Augur

This painting depicts an episode in Matthew, wherein Jesus walks on the lake: "When the disciples saw him… he came towards them, walking over the sea, and when the disciples saw him walking on the sea they were terrified. 'It is a ghost'… It was Peter who answered…. 'Lord,' he said, 'if it is you, tell me to come to you across the water.' Jesus said, 'Come.' Then Peter got out of the boat and started walking towards Jesus, across the water, but then noticing the wind, he took fright and began to sink. 'Lord,' he cried, 'Save me!' Jesus put out his hand at once and held him. 'You have so little faith,' he said, 'why did you doubt?'" (Mt 14:25-32).

Peter is represented according to traditional iconography, with large, almost crude bodily features, bald head, and with a thick beard, attired in the apostolic robe and cloak but without his attribute, the keys. By way of expansive gestures he bends toward Christ. The crowd of apostles in the background looms over the main figures. In this way, the excitement of the background contrasts with the calm of the central scene.

The figure of Christ, which is elongated and clad in a simple sober robe, seems to recall the style of Ludovico Carracci and Giovanni Lanfranco, but the apostles, who appear somewhat rough, bestow a naturalistic touch to the scene. A markedly folkloristic vein enlivens the story, which follows the example of Giuseppe Ghezzi.

Ghezzi was an important figure between the end of the seventeenth and the beginning of the eighteenth century in Rome. Secretary of the Accademia di San Luca from 1675 to 1721, untiring organizer of the exhibitions held in the church of the inhabitants of the Marches (San Salvatore in Lauro), as well as a painter, writer, orator, and restorer, he was a close friend of the patrons and consultant for the arts of Christina of Sweden and Clement XI. From his workshop in Rome emerged painters of great quality, such as his son Pierleone, a portrait painter, and Antonio Mercurio Amorosi, who produced genre paintings. Further studies of the paintings of the Congregation for the Evangelization of Peoples may help ascertain the place of origin of the painting and how it came to be part of the collections. I.S.

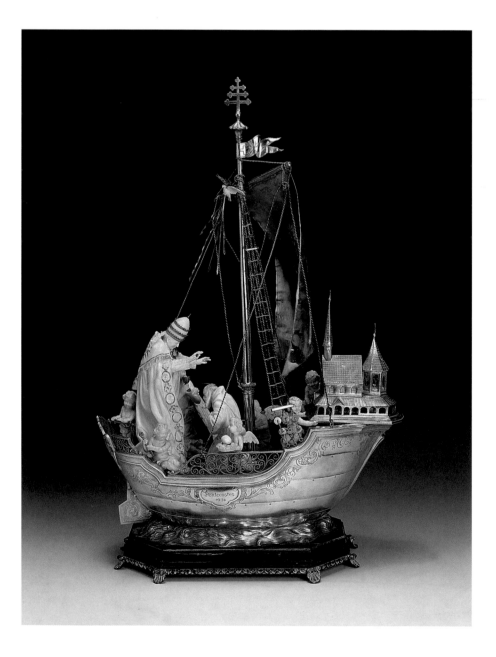

Euntes in Mundum Universum Praedicate Evangelium ("Go Forth into the World and Preach the Gospel")

Ca. 1770
Gaetano Lapis (1706–76)
Oil on canvas
75.5 × 93.5 cm
Inscriptions: (in the lower margin of the canvas, hidden from sight by a fold)
Euntes in Mundum Universum Praedicate Evangelium
Congregation for the Evangelization of Peoples, Vatican City State

The painting comes from the Borgia Apartment in the Altemps Palace. Since 1805 it has been part of the collection of the Sacred Congregation of Propaganda Fide, today known as Congregation for the Evangelization of Peoples. This theme emblematically represents Propaganda Fide's mission of evangelizing the world. By commissioning the painting the year he was nominated secretary of Propaganda Fide, 1770, Cardinal Borgia perhaps wanted to continue this missionary program of the Church of Rome.

An unpublished engraving, today in a private collection in Velletri, was specially made when Borgia became a cardinal in 1789. It identifies the painting with an inscription dedicated to the missionaries (*pientissimis preconibus evangeli*, "to the most pious proclaimers of the Gospel") and bears at the bottom these words indicating the author: "Cajetanus Lapis pinx. 24. Oct. 1770. Sculp. st Moretti 1789. Romae" (Painted by Cajetanus Lapis. Oct. 24, 1770. Sculpted by Moretti 1789, in Rome).

The engraving is contained in an oval and bears inscriptions in different Eastern languages in the four corners. It is accompanied below by the dedicatory inscription: *pientissimis praeconibus evangelii sacro romanae religionis magisterio per orientem fungentibus Stephanus Borgia Presb. Cardinalis curae veteris studiique sui ergo primum divinae missionis specimen ab urbe dedicat incitamentum laborum solatium aerumnarum* ("to the most pious proclaimers of the Gospel who in the East engage in the sacred teaching of the Roman religion, Card. Presb. Stefano Borgia dedicates as a sign of a long-lasting bond and personal affection the first representation of the divine mission, so that it may be of encouragement in the struggle and of solace in grief").

A stylistic analysis of the work reveals much in common with the usual pictorial methods of Gaetano Lapis. Born in Cagli in 1706, a disciple of Sebastiano Conca in Rome, Lapis distinguished himself early on by a marked classical tendency, supported by the indirect teachings of Baratti and by an admiration for Annibale Carracci (hence his nickname "Carraccetto"). A member of the San Luca Academy from 1741, from 1757 he directed the Accademia del Nudo in Rome. Author of various cycles of paintings in his hometown, in the second half of the eighteenth century Lapis embraced a pictorial language that clearly bears the mark of Maratta, but which goes beyond Roman classicism to a stylistic manner that recalls the seventeenth-century Bolognese style. He painted chiefly religious subjects, both for Roman churches (SS. Celso e Giuliano, S. Trinità degli Spagnoli, SS. Pietro e Marcellino) and those of his hometown (Cathedral of Cagli).

The painting on view was, at the cardinal's death, in the library of the Altemps apartment (1804), where it was inscribed in the catalogue in 1805 (Altemps, no. 179), and in the Room of the Congregations in 1854 (Minardi 1854, no. 45). It appears, then, to have been executed at the same time as Lapis' cycle in the Borghese Palace in Rome (*The Birth of Venus*, 1770–72) and as *Dawn* painted in the Villa Borghese Casino. M.N.

Reproduction of the Tomb of Saint Peter

20th century
Wood and gesso
69 × 93 × 48 cm (scale 1:5 of the original tomb)
Reverenda Fabbrica of Saint Peter, Vatican City State

This model represents the first monument to be erected over the tomb of Peter, about the middle of the second century AD. The reconstruction is based on archaeological findings made during the last century that enabled the remains of a funerary monument to be identified under the papal altar of the Vatican basilica. The monument was supported at the back by a wall covered in red plaster and contained a niche separated into two parts by a slab of travertine, laid horizontally and supported at the front by two slender columns of white marble. The southern column, still in its original position, is 1.18 meters in length. In the floor of the monument an opening gave access to the underlying tomb, which was simply a hole in the ground surrounded by other graves that were placed in such a way as to respect the central position of the Tomb of the Apostle.

Moderately proportioned and modestly decorated, this monument indicated to early Christians Peter's resting place. Mention of the tomb is found in Eusebius of Caeserea, who in his *Historia ecclesiastica* (2.25.7) quotes the response of the priest Gaius to the heretic Proclus, who boasted of the presence, in Asia Minor, of famous tombs from the age of the apostles. The learned Gaius, whom Eusebius indicates as having lived during the pontificate of Pope Zephyrinus, confronted his adversary with the existence, in Rome, of "trophies" (glorious tombs) of the apostles Peter and Paul, located, respectively, at the Vatican and on the road to Ostia. Hence the phrase, Tropaion of Gaius, is often used to indicate this second-century monument. Over the course of time, the monument underwent repairs and a number of transformations. One involved moving the most northerly of the two columns that supported the slab of travertine and constructing the "graffiti wall," which lies perpendicular to the "red wall" and derives its name from the surprisingly large amount of Latin graffiti scratched into the plaster by the faithful who visited the tomb between the end of the third and beginning of the fourth century. Within the graffiti wall was a cavity where, according to Margherita Guarducci, the relics of Peter were kept after they had been removed from the grave below.

In the fourth century, the emperor Constantine built a marble edifice that enclosed the Tomb of the Apostle, the second-century monument, the red wall, and the graffiti wall. The Constantinian memorial was hexagonal with, on its eastern face, an opening over the niche of the tomb.

Over the course of the centuries, other constructions were placed over the Constantinian monument in a highly significant continuous sequence: first, the altar of Pope Gregory the Great, then in 1123, the altar of Pope Calixtus II, and finally, in 1594, the altar of Pope Clement VIII, which was later covered by Bernini's baldachino under the great dome of Michelangelo. P.Z.

Votive Plaque from the Tomb of Saint Peter

6th–7th century
Gold
6.1 × 4 cm
Reverenda Fabbrica of Saint Peter, Vatican City State

Between 1939 and 1949, during the pontificate of
Pope Pius XII, archaeological explorations under
the altar of the *confessio* in Saint Peter's uncovered
the Tomb of the Apostle. He had been buried in the
bare earth during the reign of Emperor Nero, who
had ordered his death after the great fire of Rome
in AD 64. Very soon, that humble grave on the
southern slopes of the Vatican Hill became a place
of pilgrimage for an ever-growing number of
faithful. Around the middle of the second century,
a small funerary monument was built to indicate
to early Christians the exact location of the
venerable site.

Over that first monument, built on Peter's
grave and known as the Tropaion of Gaius, archaeo-
logical excavations have revealed monumental,
epigraphic, and material evidence of a devotion that
has been perpetuated for almost two thousand
years by the church and by multitudes of pilgrims.

Among the precious objects unearthed during
the excavations was this thin gold lamina, which
weighs some 6.5 grams and was wedged, perhaps
intentionally, into a crack that had formed between
the wall and the most northerly of the two slender
columns of the Tropaion of Gaius. This find is
decorated with a chased and embossed image
of two large eyes separated by a Latin cross with
punch marks for gems on the inside. The eyes are
almond-shaped with the pupils turned upward in
prayer; the eyelids are in relief and the lashes and
brows are rendered by fine inclined lines. The
background is made up of a series of dots that
become more dense toward the right of the plaque.
The function of the object is clear from the design
and the place it was found: it is an *ex voto* offered to
Saint Peter by a member of the faithful asking his
intercession to cure an eye problem. By comparing
it with similar objects, this votive plaque can be
dated to the sixth or seventh century. P.Z.

Pin with the Monogram of Christ

4th century
Gold
6.5 cm
Reverenda Fabbrica of Saint Peter, Vatican City State

This precious jewel is composed of a smooth
elongated pin that grows progressively wider
toward the top. At the head of the pin is a small
ring, to which is attached another ring of fine
filigree containing the Chi and Rho, the first two
letters of the Greek word *Christós*. The monogram is
flanked by the letters Alpha and Omega, indicating
that Christ is the beginning and the end of all
things (Rv 1:17–18).

The pin can be broadly dated to the second half
of the fourth century. It was probably used to fasten
clothing and in all likelihood belonged to someone
who was buried in the Constantinian basilica near
the tomb of Peter. It was found in 1942 in a
common grave that had been dug in 1545 and,
according to a Latin inscription of Pope Paul III,
housed "the bones of all the dead whom opinion
holds to be saints and who were taken from their
tombs to build the new temple, that they may rest
together in a common grave." P.Z.

24

Glass Medallion with Gold-Leaf Image of Saint Peter and Saint Paul

Second half of the 4th century, Rome (from an unidentified catacomb)
Glass; gold leaf
Diameter: 9 cm
Vatican Museums, Vatican City State
Inv. 60768

Originally the base of a goblet, this gold-glass piece is one of the best known in the Vatican Library's collection. Framed by a notched wheel and semicircles, it portrays the apostles Peter and Paul in an iconography derived from coins dating to Emperor Julian the Apostate (AD 361–363). The apostles, identified by Latin captions, face each other and partially overlap. Peter has a short beard and a full head of hair, and Paul is shown balding with a long beard. Each wears a tunic and pallium fastened with a gemmed fibula. The oak garland above them is also fastened with a fibula containing a gem. From the garland hang lemnisci, ribbons attached as a sign of honor.

The placement of the pair does not appear to be casual in the iconography of the concordia apostolorum, but refers to the actual relationship between them as reported in the Acts of the Apostles. Written by the evangelist Luke, Paul's traveling companion, the Acts bear witness to the tension that arose between Peter, head of the primitive Jewish-Christian community, and Paul, called the Apostle of the Gentiles, referring to the pagans. The height of that controversy was the meeting in Antioch (cf. Acts 15:1-4), before their reconciliation at the Council of Jerusalem (cf. Acts 15:7-11), when Peter continued to support circumcision even for pagans embracing the new faith. With reference to this conflict, Paul would say that "when Cephas came to Antioch, then did I oppose him to his face since he was manifestly in the wrong" (Gal 2:11).

Placing the two apostles one in front of the other probably recalls that confrontation of positions, viewed here not as opposition, but as the mirrorlike reflection of beneficial diversity. Such diversity translates into unity by representing a single garland as a symbol for the martyrdom of them both. In fact, it is on their concordant testimony (martyria) of Christ's Gospel that the church bases its foundation: Saint Peter and Saint Paul standing together as two solid columns. U.U.

189

Plan of the Vatican of Old, with Nero's Circus

From *Il Tempio Vaticano e la sua origine* (Rome, 1694), pl. 15
Carlo Fontana (1634–1714)
Drawing, Carlo Fontana
Engraving, Alessandro Specchi (1668–1729)
Print
47 × 34 cm
Reverenda Fabbrica of Saint Peter, Vatican City State

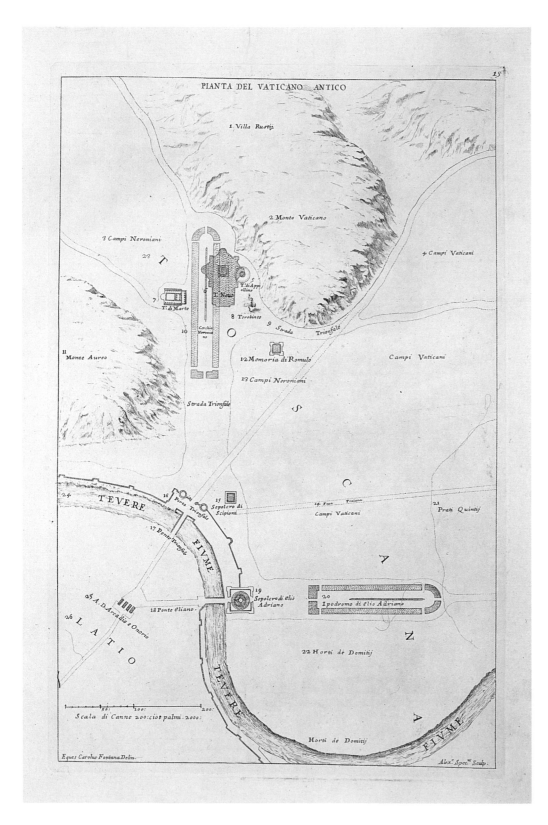

Carlo Fontana was a distinguished architect who had trained in the workshops of Giovanni Maria Bolino, Pietro da Cortona, Gian Lorenzo Bernini, and Carlo Rinaldi. From 1694 to 1699, he was "prince" of the Academy of San Luca and, from 1697, architect at the Fabric of Saint Peter's.

Fontana's drawing represents the principal monuments of the Old Vatican, on the basis of the topographical knowledge of the period. The area shown depicts the Augustan region, which stretched along the right bank of the Tiber across from the Campus Martius, at the periphery of the city to which it was linked by the so-called Triumphal (or Neronian) Bridge. This bridge is shown on Fontana's plan, and the remains of the original structure have been found below the modern Vittorio Emanuele II Bridge. Having crossed the river, one could follow the Triumphal Way north to Veio or the Cornelian Way, which led to the ancient Etruscan city of Caere (Cerveteri).

In the valley between the Vatican and Janiculum Hills were the imperial gardens of Agrippina the Elder, wife of Germanicus and mother of Caligula. It was here that the circus, which became the principal point of reference for Vatican topography, was built. In Fontana's drawing the circus is shown in its correct east-west orientation, more or less parallel to the present basilica, but its dimensions, almost six hundred meters long, are today considered excessive. Near the circus, the illustration shows the terebinth tree next to which Saint Peter was buried, and the Memoria Romuli, a large Roman pyramid tomb that was removed by Pope Alexander VI. The plan also shows the immense mausoleum of the emperor Hadrian, the modern-day Castel Sant'Angelo, linked to the city by a splendid bridge adorned with statues, the original appearance of which has come down to us on the bronze medallions issued by that emperor. Behind the mausoleum is a structure similar in shape to a circus. This is probably the Naumachia Vaticana, a theater for simulated naval battles, perhaps built by Trajan. P.Z.

Circus of Nero

From *Il Tempio Vaticano e la sua origine* (Rome, 1694),
pl. 29
Carlo Fontana (1634–1714)
Drawing, Carlo Fontana
Engraving, Alessandro Specchi (1668–1729)
Print
34 × 47 cm
Reverenda Fabbrica of Saint Peter, Vatican City State

The circus of Nero stretched along the eastern slopes of the Vatican Hill in an east-west direction, more or less parallel to the axis of the present-day basilica. It was built by the emperor Caligula on property belonging to his mother, Agrippina the Elder. Later it was used by Claudius and completed by Nero. The historian Tacitus (*Annals* 15, 39, 22) says that during the summer of AD 64, following the great fire that devastated a large part of the city, Nero placed his gardens in the Vatican at the disposal of multitudes of displaced people who were housed in huts and shelters built around the circus. It was there, as Nero proclaimed the games in the circus, that one of the cruelest persecutions against Christians took place; they were "accused of hatred towards the human race" and subjected to terrible torture, as Tacitus recounts in the fifteenth book of the *Annals*. At some time between AD 64 and 67, alongside the Christians "torn to pieces by dogs, crucified or burned alive like torches to lighten the darkness" (*Annals*, 15, 44, 4), Saint Peter underwent his martyrdom, crucified head downward according to the tradition that has come down to us through Saint Jerome (*De viris illustribus*, 1). The memory of those ferocious persecutions lives on in the name of the modern-day Piazza dei Protomartiri Romani (Square of the Roman Protomartyrs), which lies to the left of the basilica at a point corresponding to the center of the circus, where the obelisk stood some nine meters below the current ground level. Although the orientation of the circus is clear, its dimensions remain far from certain. The theory of an overall length of almost six hundred meters remains hypothetical and derives from the identification of structures found under the Palazzo delle Corporazioni, near the southern arm of Bernini's colonnade, as the stalls (*carceres*) from which the chariots departed. According to Filippo Magi, the curve of the circus lies behind the apse of the basilica near the modern-day site of the church of Saint Stephen of the Abyssinians. Nonetheless, there is other evidence to suggest that the Vatican circus, although still maintaining an east-west orientation, must have been smaller.

The circus in Fontana's drawing has proportions similar to those suggested by Magi, with the obelisk at the center of the *spina*, the low wall dividing the track. The external arches and steps are all shown as being made of masonry, although the lack of archaeological finds and the private nature of the building tend to suggest that such structures were largely made of wood and other perishable materials. On the northern side of the circus the letter M indicates the Temple of Apollo, a building mentioned in the *Liber Pontificalis* (1: 118, 176) on the subject of Peter's grave being near the site of his martyrdom. The letter N marks a hypothetical Temple of Mars, and the letter O supposedly indicates the terebinth tree next to which, according to a fourth-century tradition of the senator Marcellus, Saint Peter was buried. The Meta Romuli is marked with the letter P. This imposing pyramid, similar to the tomb of Gaius Cestius on the via Ostiense, was at what is now the start of via della Conciliazione. It was demolished in April 1499 on the orders of Pope Alexander VI for the via Alessandrina, Borgo Nuovo. P.Z.

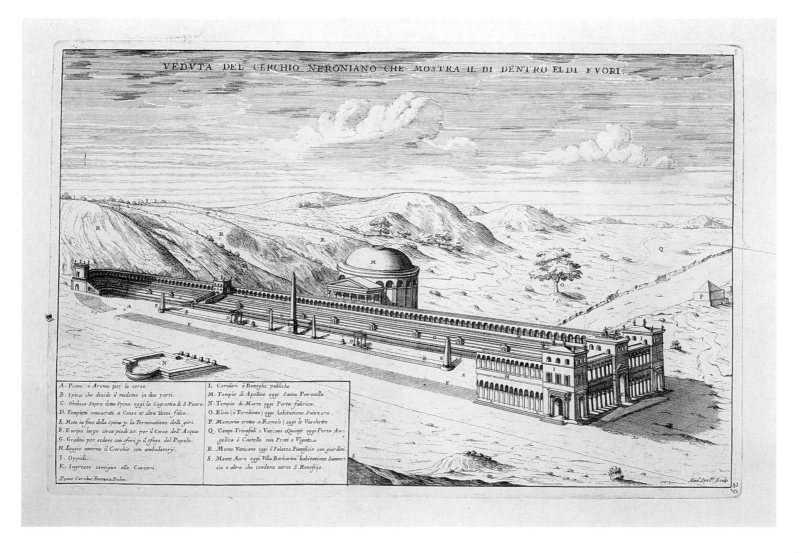

Lid of the Loculus of Asellus

End of the 4th century
Marble
18.5 × 86.5 × 3.2 cm
Vatican Museums, Vatican City State
Inv. 28596

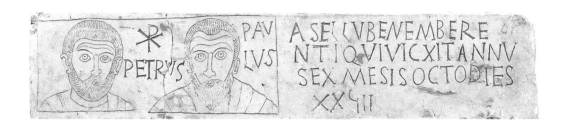

This slab of marble was originally used to close the entrance of a loculus. It is composed of two joined pieces, the borders of which have been trimmed, probably by the sculptor Bartolomeo Cavaceppi in the eighteenth century.

The figurative design is accompanied by an inscription with several irregularities in spelling and grammar, though this was fairly common at the time. At the center on the left is the christogram, the conventional allusion to Christ composed of the first two letters of the Greek word for Christ, **x** and **p** (chi and rho). Near the faces of Peter and Paul their names are inscribed. The text proceeds on the right with the dedication to Asellus, who lived a mere six years, eight months, and twenty days. The Latin cognomen "Asellus," a diminutive of *asinus*, meaning "ass," figured among the "names of humiliation" in use among early Christians as a sign of modesty, though here it adds a certain poignancy that is in keeping with the deceased's tender years.

The figurative detail is largely concentrated on the left half of the slab, where a border surrounds the relief figures of Peter and Paul. They are to be entrusted with the soul of the dead boy, and between them lies the *chrysmon*, alluding to the Concordia Apostolorum or pact reached between the two princes of the church after an early period of dissent (Acts 15:1–12; Gal 2:11). Peter's face is slightly more rounded than his companion's and his hair is thicker; Paul's features are elongated and his hair recedes at the temples. Both figures appear to be clothed in tunics, perhaps draped with mantles. Their expressions are intense and serious.

The Christian annunciation is being received by the young Asellus, and Peter and Paul are called to intercede for his soul and guide him toward Heaven. Their presence is fundamental not only for faith in Christ, but also for trust in the church. They usually assume different roles: Peter is heir to the keys of the kingdom of Heaven and the foundation of the Church (*ecclesia fundamentum*), and Paul is the sapient builder (*sapiens architectus*) and the apostle of the Gentiles (*doctorgentium*). Through them the church has its foundation, and the diffusion of the principles of the evangelical message is guaranteed to the world. G.S.

Frontal of a Sarcophagus, with Seasons

Early 4th century
Marble
70 × 168 cm
Vatican Museums, Vatican City State

The frontal of this sarcophagus is divided into five niches by six fluted columns that rest on tall, profiled bases and terminate in Corinthian-style capitals. Resting on these are four small arches for the lateral niches and a pediment for the central one. Set into the *extrados* of the lateral arches are two eagles, viewed frontally with their wings spread; the central ones bear two tritons with scaled tails and nude, erect busts. Below, pendant to all the niches, is a ring, to which a series of garlands are attached.

Above the slab, on the upper face, the remains of an unpublished inscription can be seen, mentioning the length of the deceased's life: "[- -] q[…] v(ixit a(nnis) XXV m(enses) II d(iebus) XXIIII [- -]." Set into the central niche is a bearded shepherd in a short tunic, bearing a lamb on his shoulder; in his right hand he carries a traditional

walking crook, while between his feet a dog cranes its head up toward him. The side niches contain representations of the Four Seasons, each featured as a shock-haired youth in a short tunic and mantel holding an attribute. The first figure from the left is Autumn, who holds a sprig of olive in his right hand and a basket of grapes in his left; a wine vat lies near his left foot, and a pannier of figs near the other. On the right stands Spring with two blossoming garlands in his right hand and a basket of flowers in the other; at his feet lies another basket of fruit. To the right of the aedicule with the shepherd is the niche containing Summer, brandishing a scythe in his right hand and two baskets of corn sprigs, one in his left hand and the other on the ground beside him; between his feet lies a second dog, its head turned toward the figure above. The right of the frontal terminates with the niche containing Winter, who holds a hare in his right hand and in his left a bulrush, complete with cane and leaves; at his feet lies a basket of apples. A hole near his left leg, later plugged, suggests that the sarcophagus, or at least the frontal, was reused as a basin for a fountain before it reached the Lateran basilica in 1854.

The sarcophagus's inclusion among the Early Christian treasures stems from the prominent presence of the herdsman shouldering a lamb, representing the Good Shepherd, but the pastoral theme appears frequently in pagan art, too. Both in the third and in the early fourth century certain so-called neutral subjects abounded, of Hellenistic derivation, which were assimilated into the Roman tradition and found their way into the Christian figurative vocabulary. Among these neutral themes, the pastoral scenes are linked both to the image of bucolic revelry, but also to Christ, the Good Shepherd. Of a more secular nature are the representations of the Seasons, posing as allegories of the natural mutation of life and, hence, in the funeral context, as the natural process of aging, through the death brought by winter, which was a necessary prelude to the rebirth of spring. G.S.

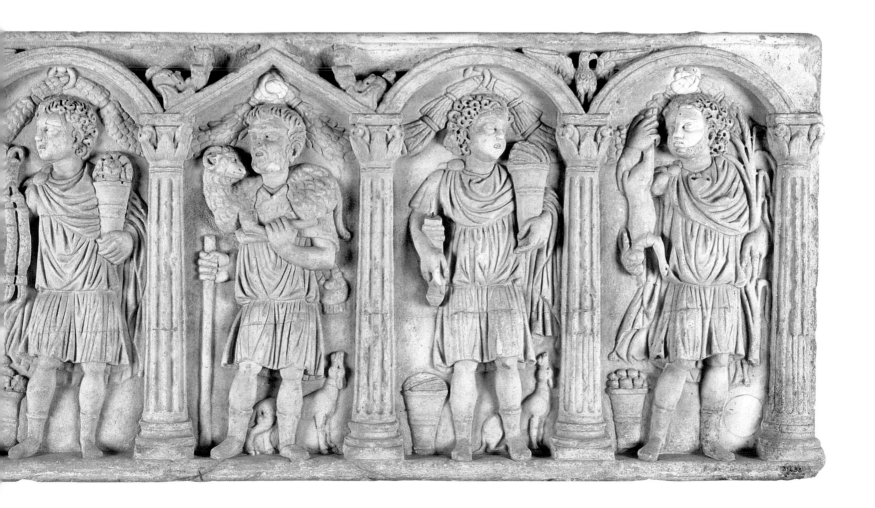

Oil Lamp with Bust of Saint Peter

Second half of 5th century
Red clay
13 × 8.1 × 4.8
Vatican Museums, Vatican City State
Inv. 62220

According to the archaeologist G.B. de Rossi, in 1868, this lamp was found in the port of Ostia in excavations carried out by Prince Alessandro Torlonia during the second half of the nineteenth century. De Rossi called the area of the housing development where it was found "xenodochium Pammachi," in reference to Senator Pammachius, who donated the structure for the care and shelter of foreigners in A.D. 398 Février, however, suggested that the construction be identified with the church dedicated to Saint Peter and Saint Paul, cited in Pope Benedict VIII's bull of 1018. New archaeological research, carried out at the beginning of the 1990s, established that the structure was probably a basilica, active from the middle of the fourth to the tenth through eleventh centuries. Whether or not this lamp came from the basilica is unknown, however.

This lamp is of a type made in Tunisia between the beginning of the fifth and seventh centuries. "North African classical" lamps were exported on a vast scale throughout the western Mediterranean basin, particularly after the middle of the fifth century. This type of lamp was also characterized by conspicuous decorative motifs inspired by Christianity, which made it an important means

for the transmission of the ideological-religious models regarding the profession of faith.

Like similar lamps found in the Mediterranean, this one has two symmetrical bands on the shoulders that enclose six embossed triangles on either side and an embossed drop at the end. A three-quarter bust is portrayed in the center, representing a bearded man in a tunic and pallium, like Saint Peter. The figure is truncated at shoulder level by two holes for filling the lamp with oil. There are distinct signs of combustion around the hole of the spout. The decorative motif of embossed triangles identifies central Tunisia as the place where the lamp was produced. Many of the patterns seen on North African classical lamps are identical to those appearing on African earthenware pottery, thus enabling us to trace the lamps back to the workshops where they were produced. This element also offers clues for dating the piece: the embossed triangles probably place it between the middle of the fifth century and the first half of the sixth. Two concentric circles engraved on the bottom of the lamp, inside the circular embossed foot, would also serve to locate its origin in central Tunisia and place it among the oldest production of the highest quality. C.L.

Lamp for Two Wicks with Double Volutes and Handle Decorated with the Monogram of Christ

4–5th century
Bronze
6 × 17 × 20 cm
Vatican Museums, Vatican City State
Inv. 60924

This lamp, perhaps made in Italy, has two characteristic ogival burners with five facets and two curvilinear, protuberant volutes. A shell with eleven lobes decorates the disk. In the middle of the shell is a hole for filling the lamp with oil, and four smaller holes for aeration are at the borders. The ascending, perforated handle is in the shape of a wheel. A band encircles the wheel, surrounded by a garland of eleven palmettes and outlined by an engraved border. The "wheel" is decorated with the monogram of Christ, composed of the Greek letters X (chi) and P (rho), the initials of the Greek name for Christ. Emphasis is given to the letters by an engraved line around the edges. Chains attached to rings, at the base of the shell, perpendicular to the two channels, indicate clearly that the lamp was intended to be hung.

Unlike terracotta lamps of Christian origin, few bronze ones are still in existence for two reasons: not many were originally produced and those that were have been melted down for the metal. Archaeological finds from the area around Vesuvius have shown that bronze lamps were uncommon even in ancient times, although they were not as rare as often thought. Bronze lamps were considered luxury items, and thus were only destined for use by the elite. Also, objects made of bronze lasted longer than earthenware ones so the production of them was limited, and the same styles were repeated for much longer periods of time.

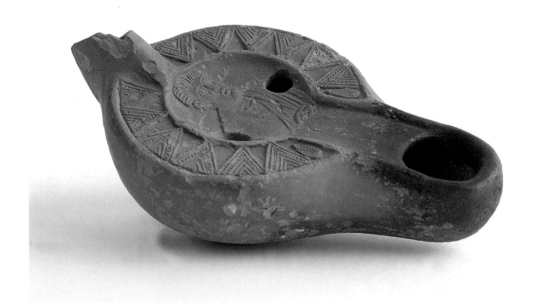

The advent of Christianity inspired decorations linked with the symbols and themes of the new religion. For technical reasons, the handles on bronze lamps were customarily decorated, in contrast with terracotta lamps, which were usually embellished on the disk and shoulders. These new symbols of Christianity were impressively, almost triumphantly, displayed on the handles of bronze lamps. Christians recognize a special symbolic link between Christ, light of the world, victorious over darkness, and the lamp. Therefore, it is not surprising that the handles of bronze lamps were often decorated, as here, with the *signa Christi*: the Chi-Rho or monogrammatic cross. At times this monogram was coupled with the apocalyptic letters Alpha and Omega, referring to Christ as the beginning and the end, or enclosed in a crown, the symbol of Christ triumphant over darkness and death.

Lamps with double volutes and Christian decorative motifs are generally dated between the fourth and sixth centuries. C.L.

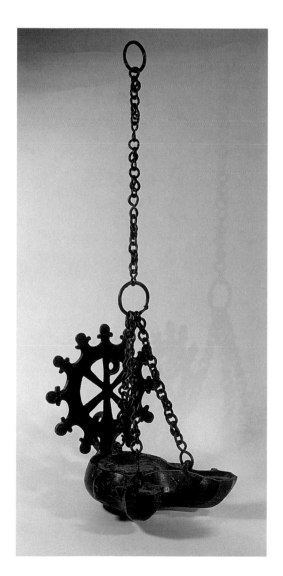

Oil Lamp with Monogrammatic Embossed Cross

Late 5th century – mid 6th century
Terracotta
3.4 × 13.2 × 8 cm
Vatican Museums, Vatican City State
Inv. 61297

The original purpose of the oil lamp was to provide illumination. Even in pagan Rome, however, other uses were found. Lamps had a role in feast days and religious processions, and were also used as votive offerings for divinities. Because they were considered to have magical, apotropaic properties, oil lamps were used to stave off harmful influences. In funeral rites, torches and lamps were lit next to where the body was laid out in the atrium of a house. Lamps were also placed inside tombs with personal objects or tools for everyday use in order to help the deceased feel at home in the afterlife, as well as light the way on his journey to the dark underworld. From several inscriptions, we also know that lamps were kept burning, perpetually or only during certain days, on top of tombs. This evidence would lead us to believe that lamps played a significant role in funeral rites and the cult of the dead, and did not merely exist as decorative elements or functional pieces of equipment. In the Jewish religion, a lamp was linked to the symbolism of "light." With the advent and spread of Christianity, the lamp assumed an eschatological meaning, becoming the symbol of Christ: "I am the light of the world; anyone who follows me will not be walking in the dark, but will have the light of life" (Jn 8:12). For the Fathers of the Church, Jesus and his Word represented the lamp that lights the way.

Fueled by the faithful, lamps were kept burning perpetually in the catacombs so that the dark hallways were always illuminated. They were the representation of the salvific light of Christ that defeats darkness and death. At times, the image of a burning lamp was used to decorate tombs. When represented with a candle and a dove carrying a branch in its beak, the image is an explicit reference to Paradise.

Charged with this new meaning, lamps were decorated with designs clearly inspired by Christianity: the Chi-Rho, fish, and dove as well as images drawn from biblical texts. After the first, rather sporadic appearances, the typology of lamps became uniform to the North African classical style, as well as imitations. This type of lamp was produced from the beginning of the fifth century in Tunisia. From North Africa, it was exported throughout the Mediterranean.

The center of this oil lamp is embellished with a monogrammatic cross (formed by an upside-down chi and rho, the initials of the Greek name for Christ), adorned with embossed "gems" in the shape of circles and diamonds. The cross is also decorated with four medallions representing the Agnus Dei: one at the center, one at the bottom of the vertical arm, and two at the ends of the loop in the rho. The embossed cross symbolizes triumph and victory over evil and death obtained by the sacrifice of the lamb, that is, Christ in his human form.

This ornamentation was repeated on pottery molds in African earthenware produced at the workshops of Oudna in northern Tunisia, and possibly also in Carthage. The same motif is found on lamps produced in the same workshops beginning at the end of the fifth century. Thus, the lamp can be dated between the end of the fifth and the first half of the sixth centuries.

A maker's mark is found on the base, consisting of a V engraved with a pointed tool before the clay was fired. C.L.

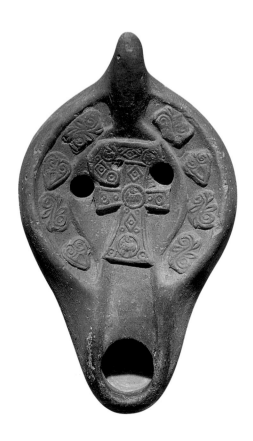

The Basilica of Constantine

When Constantine assumed power, in 306, the political climate was not favorable to Christians, who were in the minority. Yet aware of the disastrous consequences of the political persecutions of Diocletian and Galerius, Constantine put Christian doctrine, ethics, and discipline at the foundation of the reconstruction and the union of the Roman Empire. He personally worked to favor the Christians and reinforce their prestige, and to that end undertook construction of monumental buildings for followers of the new religion. The basilica over the tomb of Saint Peter is one of his great projects.

Although he ordered the construction, Constantine did not supervise the project. That task fell to Pope Sylvester I, who oversaw the bold and extraordinary undertaking with his own architects and construction managers. The emperor supplied the financing and the labor with all the necessary workmen and materials, a large part of which also came from the ruins of some of the great Roman buildings.

The tomb of Peter was decorated with lamps of gold and silver. A gold cross, a gift from the emperor and his mother Helena, was placed on the small altar of remembrance. Around the tomb and along the walls, in the atrium and also on the exterior walls, a series of sepulchral monuments arose, with altars, chapels, oratories, and mausoleums rich with works by such artists as Giotto and Pietro Cavallini. From Pope Sylvester I to Pope Sixtus IV, all the popes have contributed to the beautification and completion of the building.

Saint Peter

6th century
Fresco
131 × 131 × 6 cm
Patriarchal Basilica of Saint Paul's Outside-the-
Walls, Vatican City State
Inv. SP 1820

Conservation courtesy of John Brogan

The apostle Peter is indicated in the Holy Scriptures as the first of Jesus' successors, the foundation of his Church and the recipient of the keys to the kingdom of Heaven (Mt 16:17-19). Thus, it is not surprising that Saint Peter was the first in the series of portraits on the walls of the Basilica of Saint Paul's Outside-the-Walls until the fire of 1823. The series was painted with representations of the prophets and scenes from the Old Testament and the Acts of the Apostles. Each bust was painted inside a round medallion (called a *clipeus* or "shield") set on a large, red horizontal stripe. The portraits were positioned over the intercolumns in pairs and separated by inscriptions painted in white. The medallions were framed with three rings: the inner circle was painted green; the middle one, red; the outer one, yellow. The circles served as frames for the portraits of the popes, which were painted on a grayish background.

The portraits were painted in frontal view according to the tradition used in ancient times. The figures were depicted in gray white tunics and green yellow palliums. Their hair and beards varied according to the age of the figure, and almost all were tonsured.

Each pope was identified by his name and the length of his pontificate. The inscriptions, in columns with the text on short, unequal lines, alternated between pairs of medallions. The letters have been touched up more than once as evidenced by black shading. Seventeenth-century drawings demonstrate that they had been restored: the upper part of the shields is missing as are the first two lines of the inscriptions. There is no doubt, however, that the epigraphs and the portraits were painted at the same time. The inscriptions were regarded as essential for the identification of the subjects, painted as part of the official icono-graphical scheme.

Restorations and the artistic completion of the basilica date to the pontificate of Pope Saint Leo the Great by historical and archaeological evidence. The original mosaic on the triumphal arch was executed between 442 and 450, as is deduced from the inscription. The decoration of the nave with frescoes and stuccoes was probably continued until the death of Pope Leo I and was later resumed by his successors. Pope Saint Leo decided to have a

gallery of portraits painted that would include the images of all popes between Saint Peter and himself. He may have been influenced by a proto-type in the Vatican, where the paintings were accompanied by the name of each pope and the years of his reign. On the other hand, the similarity with that original series has led some to believe that they were painted contemporaneously. This issue remains unresolved. The *Liberian Catalog* listed the popes from Saint Peter to Pope Liberius and served as the chronological basis for the first part of the *Liber pontificalis* as well as for Pope Leo I's gallery. However, the *Liberian Catalog* is considered to be reliable only after the second quarter of the third century, as the information given for the previous period is only indicative.

This pictorial cycle is interesting not only as a source of iconography, but also for the information concerning the identities of individual popes considered essential by its commissioner, Pope Leo the Great.

The *imago clypeata* was a style used by the ancient Romans for portraiture. It was used during the Republican and Imperial ages, particularly for holy and solemn purposes. At that time the style was used to honor the memory of a worthy person, especially an ancestor or an emperor, with the intention of immortalizing his memory. In the Early Christian period, the *clipeus* style was used for portraits of the deceased and for images of Christ and the saints.

The complete decorative project in Saint Paul's included three orders of frescoes from the Old and the New Testaments in a composition that was typical of the time of Pope Leo the Great. At the end of the thirteenth century, Pietro Cavallini painted additions to the cycle. The series of portraits was an interpretation of the ideology behind apostolic succession, legitimacy of power, and hierarchical continuity without interruption. It also alluded to the function of the popes as custodians of the Word of God.

These images were the expression of idealized figures, and so they were painted with a rather abstract, schematic uniformity. Each face was rendered with realistic features, brilliant effects using color contrast, and incisiveness marked by dark shady lines. Each portrait displayed an undefined, fixed expression but the artist failed to anchor it to an earthly dimension. The series marked the continuation of the classical Hellenistic-Roman tradition. However, it is also possible to observe the beginning of the Byzantine style in the rigid faces, viewed with a transcendental immobility, which often resulted in stereotypes. These characteristics surpass the physiognomic peculiarities of each individual pope. It is not possible to rule out the artist's use of models painted on wooden tablets or illuminated

manuscripts. In this case, there could be some genuine portraits among the paintings in the series.

Whereas both the Vatican and the Lateran series have been lost, the portraits of popes in Saint Paul's Basilica survived until the fire of 1823. During the project for the reconstruction of the basilica in 1825, Pellegrino Succi detached "the chronological series of 42 pontiffs, for a price of 25 scudos for each painting, composed of two portraits in order to preserve the inscriptions between them." They were then placed "upon slabs of peperine stone covered with bricklayer's plaster." In 1870 Giovanni Battista de Rossi supervised the placement of the frescoes on the walls of a corridor in Saint Paul's monastery. Today only forty of the original forty-two portraits have survived. Most of the inscriptions have been lost and were never restored despite the original plans.

From a historical-documentary point of view, the Saint Paul's series was reproduced in 1634 in the cod. Barb. lat. 4407 (Barberini codex). In the eighteenth century it was the subject of thorough analysis by Pier Francesco Bianchini and, later, by Giovanni Marangoni, who, together with the painter Salvadore Manosili, was responsible for the restoration and reintegration of the missing parts.

The frescoes in Saint Paul's monastery have stratified traces of the numerous restorations that took place during the course of time that are easily recognizable. However, they are not always traceable to interventions from identifiable archival sources.

The image of Saint Peter was found undamaged. It must have lost its left side during the fire, although the inscription is almost intact: Petrus / sed(it) / ann(os) / XXV, m(enses) II, / d(ies) VIII ("Peter reigned for 25 years, 2 months and 8 days"). The features on the apostle's bust repeat a convention that was often used during that period. When it was restored by the Vatican Museums, the fresco was removed from its old frame and attached to a new one made of cadorite. On this occasion traces of blue paint were observed on the gray background. Also found were indications of the direct engraving of circles on the frame and places where paint had been reapplied almost everywhere except on the face and on the false frame. G.F.

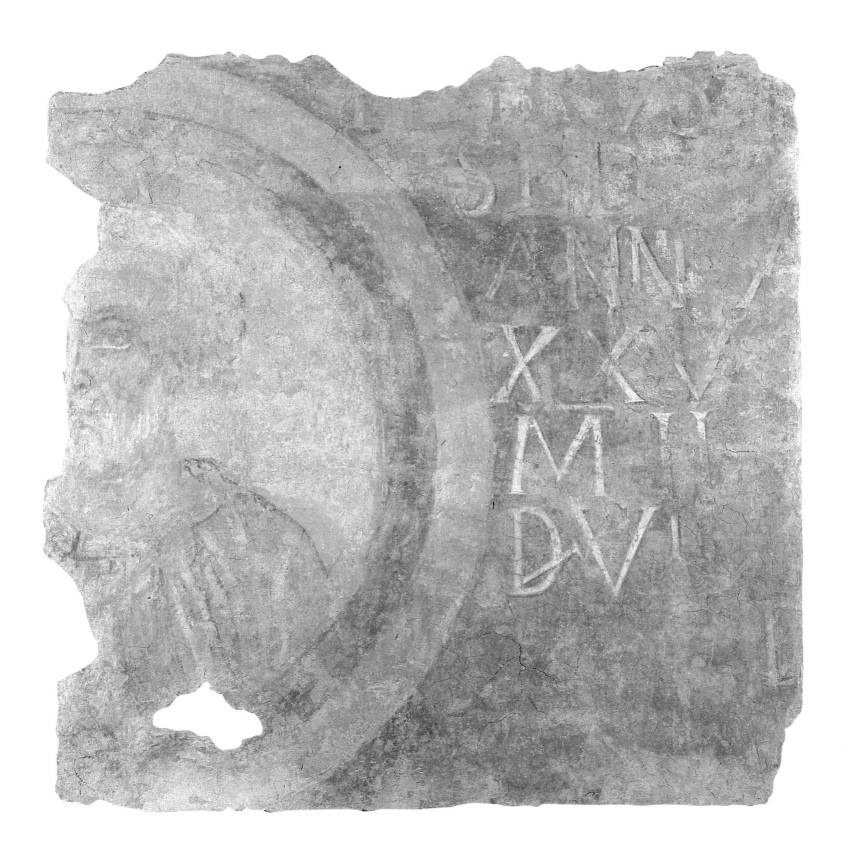

Portrait of Pope Saint Sylvester

Mid 19th century
Eugenio Agneni
Oil on canvas
Diameter 135 cm
Reverenda Fabbrica of Saint Peter, Vatican City State

Little information exists about the life and works of Pope Saint Sylvester I, whose long pontificate exactly coincided with the period of Emperor Constantine's activity in support of the church. This fact itself has had the effect of limiting the information handed down by the sources, first among them the *Liber pontificalis*, a large collection of papal biographies from Saint Peter to 1460. Indeed, rather than describing the mission and works of the pontiff, the documentary sources give lengthy details concerning the prolific energy and activities of Constantine, the first Christian emperor, who accorded the church freedom of profession and worship.

This oil portrait does not represent an exact iconographic likeness but an ideal representation. It forms part of a series of paintings commissioned by Pope Pius IX in 1847 to redecorate the new basilica of Saint Paul's Outside-the-Walls, rebuilt following the devastating fire of the night of July 15, 1823. Between 1848 and 1849, the most famous Roman painters were called to execute more than 260 tondo portraits in oil, the translation of which into mosaics lasted until 1876.

This portrait is the work of Eugenio Agneni and was rendered into a mosaic by Raffaele Castellini between June 1853 and February 1855. A.M.P.

Saint Siricius

6th century
Fresco
131 × 131 × 6 cm
Patriarchal Basilica of Saint Paul's Outside-the-Walls, Vatican City State
Inv. SP 1858

Pope Siricius I succeeded Pope Damasus. He openly declared that the bishop of Rome, as Saint Peter's successor, was responsible for the custody of the universal church. On November 17, 390, as stated on the inscription found on the first column of the left aisle, this pontiff consecrated the Basilica of Saint Paul's Outside-the-Walls. Between 384 and 386, emperors Valentinian II, Theodosius, and Arcadius decided to build the basilica, which remained unchanged until the fire of 1823. The *Liber pontificalis* reports that Saint Siricius made arrangements for his tomb to be in the Catacombs of Priscilla, but up to the present time, this has not received archaeological confirmation.

The portrait of Pope Siricius, the thirty-eighth in the series that has been preserved, was on the southern wall of the basilica. The painting was detached from its old frame and attached to a new one made of cadorite when it was restored by the Vatican Museums. On this occasion it was possible to observe details regarding the successive daily interventions made as the fresco was painted, including restoration of its gray background, the direct engraving of the yellow ring of the frame, the application of yellow paint on top of light red, and other examples of painting over colors. Successive reinforcements to the face, such as to the middle line of the nose, can also be observed. On an aesthetic and formal level, there are differences between this image and the one of Saint Peter with reference to the technique used in strokes as well as pictorial representation. Such disparities are particularly noticeable in the relationship between the bust, its background, and the gaze of the figure. These differences may be explained by an old restoration and modern interventions. An example of this may be found in the substantial remodeling on the lower portion of the bust. G.F.

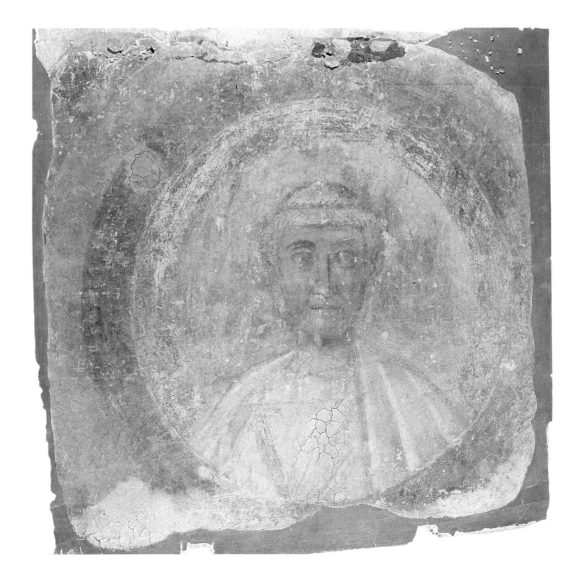

Section of the Old Basilica of Saint Peter's

From *Il Tempio Vaticano e la sua origine* (Rome, 1694),
pl. 91
Carlo Fontana (1634–1714)
Drawing Carlo Fontana
Engraving, Alessandro Specchi (1668–1729)
Print
34 × 47 cm
Reverenda Fabbrica of Saint Peter, Vatican City State

This print shows a longitudinal section of the old basilica prior to its demolition to make way for the new Saint Peter's. This demolition took place in stages over the course of the sixteenth and beginning of the seventeenth centuries. A key identifies the monuments in the basilica and nearby buildings. At the bottom of the sheet is a scale graded in Roman palms.

Built by Pope Sylvester I and the emperor Constantine at the beginning of the fourth century, the first Basilica of Saint Peter's was for more than eleven hundred years a place of constant pilgrimage by devoted faithful from all parts of the Catholic world. The successors of Peter sought to adorn the greatest church of Christendom with works of art of all kinds, and many popes, men of the church, and lay people had the privilege of being buried in the basilica near the tomb of the Peter. For over a thousand years Constantine's basilica – enlarged and continuously restored over the centuries – guarded the patrimony of faith, art, and history that had accumulated in that venerated place. The painful decision to abandon restoration work on the old building and the courageous idea to build a new one dates from the pontificate of Pope Nicholas V, the pope who celebrated the jubilee of 1450. Work was to begin in the apse with the building of a new choir, and the task was entrusted to the architect Bernardo Rossellino. Nonetheless, demolition work only began under Pope Julius II, who placed the first stone of the Renaissance basilica on January 18, 1506. The entire operation – which began in the west and moved east – stretched over the pontificates of seventeen popes

and saw the involvement of some of the greatest architects of the age. Donato Bramante built a structure (Tegurium, or "holy house") to protect Peter's grave, which came to mark the center of the new basilica. Later, Antonio da Sangallo the Younger erected a wall to separate the new building from what remained of the old church where the clergy still officiated. At the beginning of the seventeenth century, Pope Paul V entrusted the fifty-one-year-old Carlo Maderno with overseeing the work of extending the new church some seventy-six meters to the point where the gates of the portico stand today. In a little less than ten years, all trace of the old basilica disappeared and, shortly before his death, Pope Paul V was able to see the new basilica in the form of a Latin cross, its external structure complete and work on the interior decorations well under way. This work would later be magnificently completed by Gian Lorenzo Bernini.

In this and other engravings, Carlo Fontana sought to leave some record of the most important monuments and works of art of the lost basilica. One of these is the bell tower (number 6) built by Pope Stephen III, famous in Rome for its height and the golden sphere with the bronze cockerel that surmounted it. The bell tower was rebuilt on a number of occasions and, in 1575, the pinnacle in the form of a pyramid was replaced with a lead-covered hemisphere. Above the quadriporticus – which tradition has it was built by Pope Symmachus – the number 9 indicates frescos from different periods depicting, among other things, the Virgin and episodes from the lives of the apostles. The number 10 marks the entrance doors to the basilica above which the famous *Navicella* mosaic of Giotto was once positioned. The illustration also depicts the papal altar over Peter's tomb and the finely carved white spiral columns of the presbytery. P.Z.

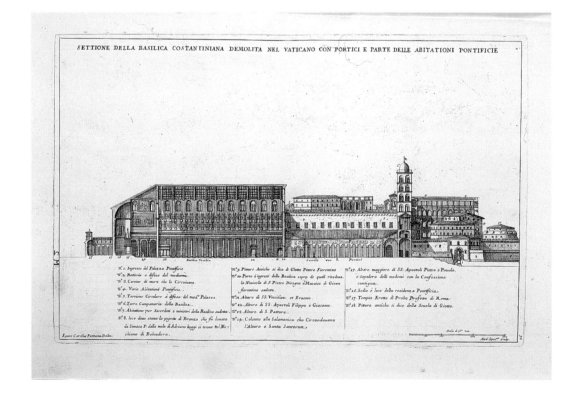

External View of the Old Basilica

From *Il Tempio Vaticano e la sua origine* (Rome, 1694),
pl. 93
Carlo Fontana (1634–1714)
Drawing, Carlo Fontana
Engraving, Alessandro Specchi (1668–1729)
Print
34 × 47 cm
Reverenda Fabbrica of Saint Peter, Vatican City State

Fontana's drawing shows the Renaissance basilica
with the drum complete, the point at which
the building was interrupted by the death of
Michelangelo in 1564. Work on completing the
dome only restarted in 1588 by order of Pope
Sixtus V, who commissioned the architects Giacomo
Della Porta and Domenico Fontana. In the drawing,
the front part of the Constantinian basilica still
survives, separated from the new building by the
so-called dividing wall of Pope Paul III. Of that old
basilica, which would be definitively destroyed
during the pontificate of Pope Paul V, the drawing
shows the great windows that illuminated the
central nave, the slope of the roof of the two
southern naves, and the bell tower that stood out
in the Roman sky, rising above the entrance arch
over the loggia of the blessings.

Behind the obelisk is an apsidal structure
leaning against the side of the old basilica; this
represents the southern elevation of the Choir of
Sixtus IV. To the left of this building is the Rotonda
di Sant'Andrea, a grandiose circular mausoleum
with a diameter of some thirty meters, built on the
track of the abandoned circus during the reign of
the emperor Caracalla. Pope Symmachus turned
the mausoleum into a church, dedicating it to Saint
Andrew. In the fifteenth century, the Rotonda was
dedicated to Santa Maria della Febbre and the
following century, during the pontificate of Pope
Gregory XIII, it became the sacristy of the Vatican
Basilica. The Rotonda di Sant'Andrea was razed
between 1776 and 1777 to make way for a new
and grandiose sacristy designed by the architect
Carlo Marchionni under Pope Pius VI. A similar
circular monument, the tomb of the emperor
Honorius and his wife Maria, was transformed into
the church of Saint Petronilla in the eighth century
and stood alongside the Rotonda di Sant'Andrea
until the beginning of the sixteenth century, when
it was demolished to build the new Saint Peter's.

At the center of Fontana's drawing is the obelisk
that stood on the *spina* of the circus of Caligula and
Nero, where it remained until 1586 when it was
moved by Domenico Fontana to its present position
in Saint Peter's Square. A stone tablet in the paving
of the Piazza dei Protomartiri Romani, between
the first and second arch joining the Vatican Basilica
to the sacristy, marks the original position of the
obelisk, the foundations for which were found
some nine meters below the modern ground level.
On the pinnacle of the obelisk may be seen the
original bronze sphere, which today is housed in
Rome's Capitoline Museums. During the Middle
Ages it was believed that the sphere contained the
ashes of Julius Caesar, a strange legend with no
basis in reality but one that served to increase the
fame of the Vatican obelisk, silent witness to the
most important events of world history. P.Z.

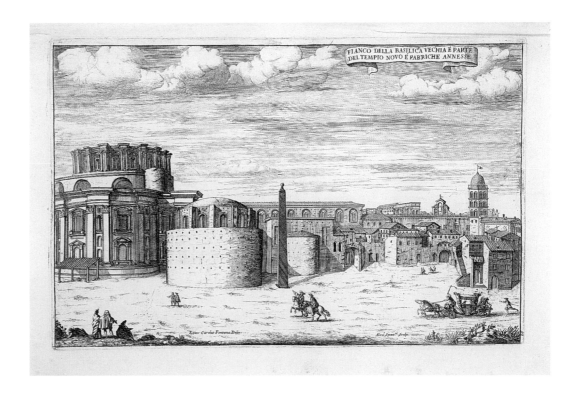

Section and Elevation of the Old Basilica of Saint Peter's

From *Il Tempio Vaticano e la sua origine* (Rome, 1694),
pl. 99
Carlo Fontana (1634–1714)
Drawing, Carlo Fontana
Engraving, Alessandro Specchi (1668–1729)
Print
47 × 34 cm
Reverenda Fabbrica of Saint Peter, Vatican City State

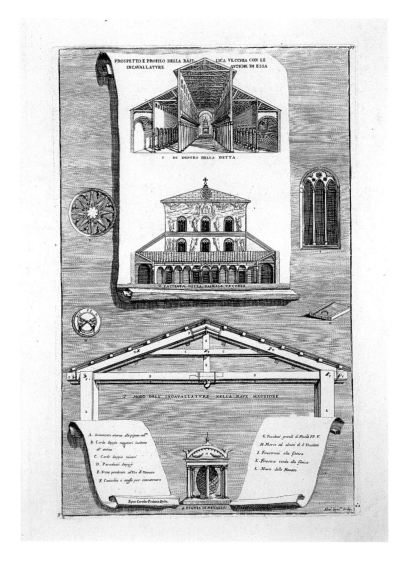

In this plate, the trusses that supported the sloping roof of the nave of the old Basilica of Saint Peter's are depicted. In the text, the author declares that he added this fundamental illustration after having seen a drawing showing the "intelligent" method of fastening the various beams of the roof. The excellent slope of the roof, the quality of the wood, and the perfection of the tiling all contributed to preserving the building. When it was finally demolished, some of the beams that for so many centuries had been part of the basilica were reused in Rome's Palazzo Farnese. Carlo Fontana – who was architect of the Fabbrica of Saint Peter from March 1, 1697, until the day he died on February 6, 1714 – concludes his comments to this plate by affirming that the methods adopted in the old basilica constitute a useful reference for the covering of new buildings. A number of captions in the lower part of the plate describe the construction of the roof truss. The interior of the old basilica appears on a fold-out sheet at the top of the page, its nave and aisles free of their altars and monuments. The arrangement of these altars and monuments is known to us through Tiberio Alfarano's plan of 1571, the "album" of drawings by Domenico Tasselli, and the descriptions collected in the work *Instrumenta autentica*, which the notary Giacomo Grimaldi donated to Pope Paul V on May 29, 1620, for the anniversary of his coronation. The same fold-out sheet also contains an elevation of the old basilica showing the mosaics of Pope Gregory IX, whose pontificate also coincided with the rebuilding of the upper part of the facade.

By way of example a roofing tile is depicted, marked with the stamp of Pope Nicholas V. We know from other sources that tiles were found marked with the stamps of Constantine, of Theodoricus, and of numerous popes, among them Alexander III, Innocent III, Alexander VI, Pius V, and Gregory XIII. The presence of these names stamped into the clay of the tiles is evidence of the frequent restorations to the roof, of which one of the most important was certainly that accomplished in 1341 under Pope Benedict XII. In memory of that undertaking, which cost 80,000 gold florins, a bust of the pope was carved and may still be seen today in room one of the Vatican Grottoes.

Fontana's drawing also shows two of the windows that illuminated the old basilica. There were seven windows in the facade, eleven on each side of the nave and the side aisles, at least sixteen in the transept, and five in the apse. At the bottom of the page is an illustration of the famous bronze pinecone that stood under a baldachino at the center of the quadriporticus in front of the basilica. P.Z.

Atrium of the Old Basilica of Saint Peter's

From *Architettura della Basilica di San Pietro in Vaticano*
(Rome, 1620; repr. 1684), pl. 4
17th century
Martino Ferrabosco (active 1616–1623)
Print
78 × 51 cm
Reverenda Fabbrica of Saint Peter, Vatican City State

This print shows a view of the atrium of the old basilica shortly before Pope Paul V ordered its demolition. Ferrabosco's drawing is clearly taken from illustrations in the "album" of drawings by Domenico Tasselli and from Giacomo Grimaldi's manuscript on the old basilica. A similar scene is also depicted in a fresco by Giovan Battista Ricci of Novara in the Chapel of the Madonna delle Partorienti in the Vatican Grottoes.

The facade, amply restored and decorated with a new mosaic by Pope Gregory IX, was finished with an immense cornice and had a pronounced stringcourse that divided the six great three-light medieval windows into two orders. Two other windows illuminated the two side aisles that were covered by a roof, the highest point of which reached the stringcourse. In the second half of the sixteenth century, volutes joining the lower and upper orders were added at the sides of the facade. The mosaic that covered the entire front elevation was divided into three different sections. In the lowest, Ferrabosco's illustration shows the twenty-four elders of the Apocalypse; in the second section, alongside the windows, are full-length depictions of the Four Evangelists; at the center of the top section is an image of Christ enthroned with the Virgin and Saint Peter. Pope Gregory IX, who commissioned the work, is shown kneeling at the feet of Christ while the symbols of the Four Evangelists are depicted above. The earlier mosaic decoration of the facade had been done during the pontificate of Pope Saint Leo the Great; Pope Sergius I had replaced the image of the Redeemer with that of the Lamb; and later Pope Innocent III had undertaken some important restoration work. This paleo-Christian mosaic is reproduced in an ink drawing from the eleventh century in the Farfense Codex at Eton College, Windsor.

Of the ancient quadriporticus that stood in front of the old basilica, all that remained in the first years of the seventeenth century was the west side – the narthex – with eleven arched openings on columns. On the right of the engraving, in place of the northern colonnade, is the palace built by Pope Innocent VIII in 1485. On the other side and nearest the basilica is the house of the altarista with its adjoining chapel built by Pope Julius II; next to this is the church of the Company of the Most Holy Sacrament, commissioned by Pope Gregory XIII and, under a crenellated wall, the door giving access to the house and garden of the archpriest of the basilica. In front of the wall is the sarcophagus of the emperor Otto II (955–983); its red porphyry cover came from the mausoleum of the emperor Hadrian (117–138) and was used by Carlo Fontana in 1698 to make the baptismal font of the new basilica.

In the center of the quadriporticus was a fountain for sacred ablutions in the form of a great bronze pinecone under a baldachino supported on eight porphyry columns, of which two were decorated with the busts of emperors. The bronze canopy was decorated with four gilded dolphins and at least two peacocks, which, in all likelihood, came from Hadrian's mausoleum. During the Middle Ages, the pinecone, which was some four meters high, aroused great curiosity and interest among both pilgrims and scholars. It is mentioned in the *Divine Comedy* (Inferno XXXI, 59), where Dante likens it to the head of the giant Nembrotto. The *Mirabilia Urbis Romae*, from the second half of the twelfth century, holds that it came from the Pantheon, where it was used as the central ornament of the dome. In 1552 Antonio Labacco imagined it as having a similar function and depicted a reconstruction of Hadrian's mausoleum showing the pinecone at the top. The pinecone was still to be found in front of the basilica in 1610, although it had been placed in a corner of the portico so as to enable work on building the new Saint Peter's to proceed; later it was taken to the Cortile del Belvedere. In 1982, meticulous restoration work was carried out, during which three signatures of its maker (Publio Cinzio Salvio liberto di Publio) were discovered. He created the pinecone by casting over a wax model. P.Z.

The Belvedere Courtyard of the Vatican Museums with the bronze pinecone from the quadriporticus of the Constantinian basilica

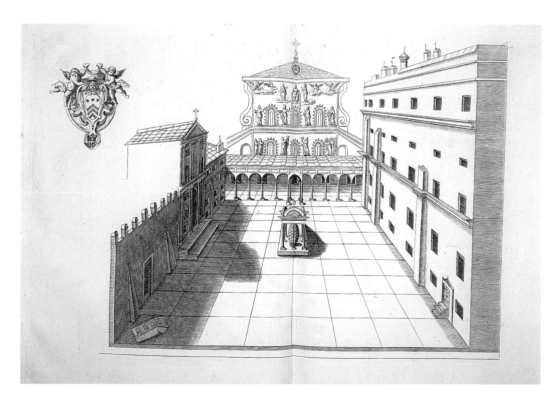

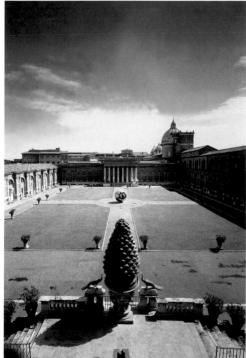

North-South Section of the Old Basilica of Saint Peter's

From *Architettura della Basilica di San Pietro in Vaticano*
(Rome, 1620; repr. 1684), pl. 5
17th century
Martino Ferrabosco (active 1616–1623)
Print
51 × 78 cm
Reverenda Fabbrica of Saint Peter, Vatican City State

This view shows the interior of the old basilica, which was finally and definitively demolished during the pontificate of Pope Paul V to make way for the extension to the new Saint Peter's. The drawing derives from a watercolor illustration in the famous manuscript describing the old basilica written by Giacomo Grimaldi (1568–1623). The same image appears in a fresco by Giovan Battista Ricci of Novara (1537–1627) in the Chapel of the Bocciata in the Vatican Grottoes. Missing from Ferrabosco's engraving is the so-called dividing wall of Pope Paul III, which was built by the architect Antonio Sangallo the Younger at the level of the eleventh column to divide the old church from the building site of the Renaissance basilica. Ferrabosco clearly omitted this detail deliberately so as to highlight the imposing scale of the lost Constantinian edifice.

Constantine's church was divided into a nave with two aisles on either side, separated by eighty marble columns of different styles that had come from some of the most important monuments of imperial Rome. The columns of the nave, with their Corinthian bases and capitals, were more than ten meters high, while the columns in the side aisles exceeded seven meters. A series of arches ran over the latter, while the two colonnades of the nave supported a rectilinear entablature that continued over the interior facade of the building. The frieze above the entablature was decorated with busts of earlier pontiffs, painted within circular medallions and positioned over the axis of each column. A walkway over the cornice was protected by a balustrade, and an imposing cycle of frescos in two orders, one above the other, covered the space between the cornice and the windows. The frescos depicted stories from the Old and New Testaments, on the south and north sides of the nave, while full-length figures of saints and prophets were painted alongside the twenty-two windows that illuminated the center of the basilica. These frescos do not appear in Ferrabosco's drawing, though he does highlight the architectural elements that separated the various scenes. Over the windows, at a height of more than thirty-two meters, are the beams of the sloping roof, which at its highest point reached thirty-seven meters.

From left to right, the four altars depicted at the beginning of the nave were dedicated to Saint Boniface, martyr; Pope Saint Leo IX; Saint Anne; and Saint Erasmus. The first was restored by Pope Boniface VIII, who was buried in a splendid sarcophagus, the work of Arnolfo di Cambio, in the same chapel as Pope Boniface IV. The second was the old "altar of the dead," where the body of Pope Saint Leo IX was laid before being moved in 1606 under the altar of the Crucifixion of Saint Peter in the transept of Saint Joseph. The third was originally dedicated to Saint Anthony Abbot; it was once located in the transept of the ancient basilica but was moved in the sixteenth century to the internal facade of the building and the image of Saint Anne, which had originally adorned the altar of the Holy Spirit, was placed over it. The fourth altar had originally been dedicated to Saint Wenceslas, king of Bohemia (928–935), by Hincone, bishop of Olmütz.

Along the left-hand colonnade of the nave, Ferrabosco's engraving shows the altar of Our Lady of the Column and, farther back, the altar of Saints Simon and Jude, apostles, in the position it was given by Pope Paul III when he assigned it to the chapel of the Most Holy Sacrament. Along the facing colonnade are the organs and the holy-water font of the old basilica, while against the side wall on the right is the ancient altar that housed the venerated "relic of the Holy Face," taken in 1606 to the loggia over the statue of Saint Veronica in one of the four piers supporting the dome. In the left-hand aisle, the tomb of Pope Julius III is visible; it was taken to the Vatican Grottoes in 1608. Behind this monument is the altar of Pope Gregory the Great, over which Pope Pius II built a tabernacle containing a precious reliquary with the head of Saint Andrew.

The emblem of the Fabbrica of Saint Peter's appears on the top of the sheet at the left, while on the right is the coat of arms of Cardinal Giovanni Evangelista Pallotta, archpriest of the Vatican basilica during the operation that saw the final demolition of the old and venerated church. P.Z.

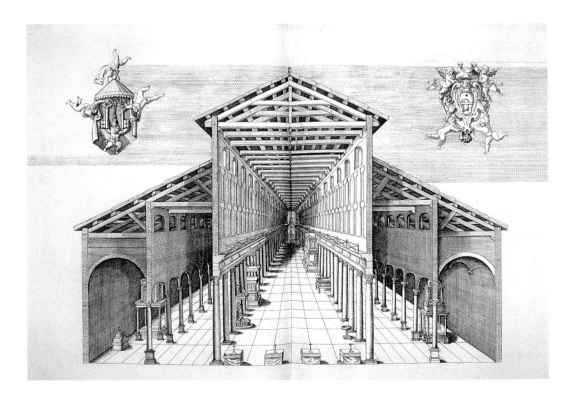

"Ciborium of Sixtus IV"

The ciborium, or baldachino, which covered the main altar of the Vatican basilica during the fifteenth century, stood on four red porphyry columns. In 1605, they were reused to adorn the altars of Simon and Jude (known today as Saint Joseph) and of Processus and Martinian, which stand, respectively, at the left and right of the transept. Those columns had stood over the altar of Saint Peter ever since the time of Pope Leo III, the late eighth-century pontiff who crowned Charlemagne and substituted the early medieval ciborium of Pope Gregory I with a more magnificent and imposing structure.

The ciborium of Sixtus IV stood on these columns, a cubic structure with sides 3.35 meters long decorated with splendid marble reliefs and probably surmounted by a dome. This construction, some six meters high, was a ciborium reliquary of a type that was particularly popular in Rome in the twelfth and thirteenth centuries. During the construction of the new basilica, which began in 1506 with Pope Julius II, the fifteenth-century ciborium was enclosed within the so-called Tegurium of Bramante, an elegant structure with Ionic columns in peperino stone that was built to protect the apostle's tomb and is known to us from the work of the painter Maarten van Heemskerck. After 1590, with the demolition of the Tegurium, the ciborium was dismantled. In 1616, the reliefs were immured in the Chapel of the Madonna delle Partorienti and in the peribolos of Clement VIII, where the statues of the apostles were also placed. Later, these were moved to the Vatican Grottoes. The remaining parts of the ciborium today include four large marble reliefs representing the story of the apostles Peter and Paul, eight narrow panels with relief figures against architectural backgrounds, and the Twelve Apostles sculpted in the round. The statues of the apostles, today in the Clementine peribolos and the Apostolic Palace, may have been originally positioned on the top of the ciborium, around the edge of a circular drum, as on the back of a medallion issued in 1470 during the pontificate of Pope Paul II.

According to many sixteenth- and seventeenth-century writers, the ciborium is to be attributed to Pope Sixtus IV, who celebrated the jubilee of 1475. Giacomo Grimaldi, in his *Descrizione dell'antica basilica di San Pietro in Vaticano* (1619), expressly declares that the work was undertaken by this pontiff, whose coat of arms is visible within the tympanum of the ciborium in an ambiguous illustration in Grimaldi's manuscript. Other writers – on the basis of the testimony of Onofrio Panivino in a mid-sixteenth century document held in the Vatican archives – suggest that Pope Pius II restructured the old medieval ciborium of Honorius III,

fitting it, among other things, with the eight small corner panels, while Pope Sixtus IV completed the work, adding the large reliefs with the stories of the apostles Peter and Paul.

Recently, Francesco Caglioti has suggested Pope Paul II as patron of the ciborium with its splendid marble reliefs. Indeed, on the above-mentioned medallion issued by that pope, the ciborium is shown in 1470 within the "Tribune of Saint Peter," almost as if celebrating work ordered and largely completed by this Venetian pontiff. According to Caglioti, the statues of the apostles were completed during the pontificate of Pope Sixtus IV, who called on such Tuscan artists as Mino da Fiesole and perhaps Matteo del Pollaiolo and other artists of the school of Antonio Rosellino. Caglioti also believes it likely that the twelve marble reliefs of the ciborium of Saint Peter's were executed in the Roman workshop of Paolo di Mariano di Tuccio Taccone da Sezze, better known as Paolo Romano. P.Z.

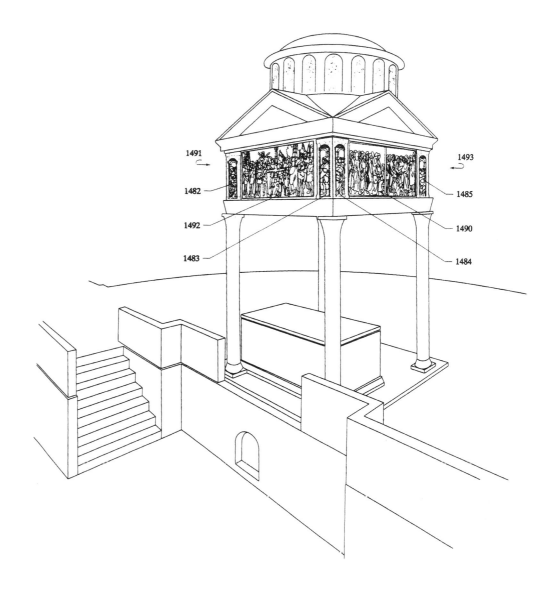

Reconstruction of the Ciborium of Pope Sixtus IV, Fabbrica of Saint Peter, from *La Basilica di San Pietro in Vaticano*, Modena, 2000

Paolo Romano and workshop (1415–ca.1470)

Legend

1482–85
Nero and His Counsellors, Armed Men and Men in Togas

1490
The Consignment of the Keys and *The Healing of the Lame Man*

1491
The Fall of Simon Magus

1482
The crucifixion of Saint Peter

1493
The Capture and Decapitation of Saint Paul

Crucifixion of Saint Peter
from the "Ciborium of Sixtus IV"

Contemporary cast of a 15th-century marble relief
264 × 117 cm
Reverenda Fabbrica of Saint Peter, Vatican City State

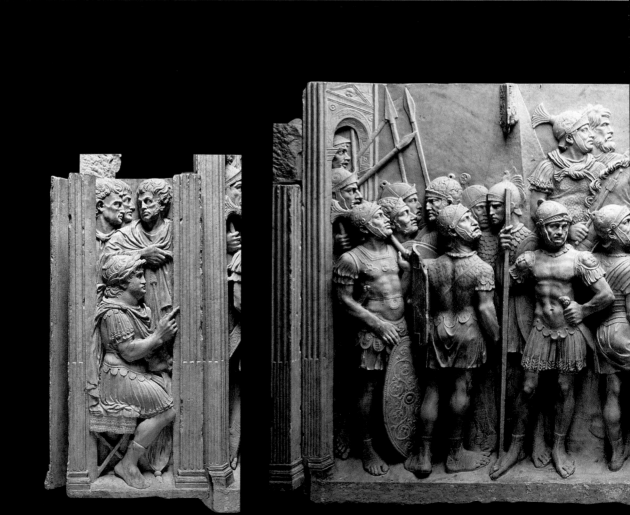

According to the reconstruction of the ciborium suggested by architect Pier Luigi Silvan, in 1984–85, the marble slabs with the crucifixion of Saint Peter were on the east side of the basilica, facing the entrance. This theory is confirmed by a fresco in the Piccolomini Library of the cathedral of Siena, painted by Pinturicchio between 1503 and 1505, that shows the coronation of Pope Pius II in front of the altar of the *confessio* of the old basilica. Clearly visible is the ciborium with its four porphyry columns and architrave with the scene of the martyrdom of Saint Peter.

The relief extends over two vertically joined marble slabs of different widths. The larger of the two slabs has an oblique crack near the right hand of the apostle, who appears at the center, crucified upside down. The scene takes place between two legendary sites: to the left, the pyramid of Gaius Cestius on the via Ostiense; to the right, the other pyramid-shape tomb, since destroyed, believed in the Middle Ages to be that of Romulus. In the background is the tree near which, according to the apocryphal Acts of the Apostles, Peter was buried. The saint's martyrdom is attended by a multitude of men, women, and children, infantry

and horsemen, tuba players and animals: thirty-five figures in all, artfully represented at different levels using a relief that becomes progressively less intense to give the scene greater depth. Some of the faces on the right have grotesque and exaggerated expressions, while the tone becomes more classical and stately toward the center, where the artist even sculpted a small dog at the foot of the cross. In the apocryphal Acts of Peter, the dog represents the "voice of truth that unmasks falsehood." Nearby, two small figures are meant to represent the children who, together with the crowds, followed Simon Magus when he was driven out of Rome. On the left, a group of soldiers contemplate Peter's suffering. The position and stance of some of the figures seem to derive from the Roman reliefs in the Palazzo dei Conservatori, from the eighth scene on Trajan's Column, and from the Arch of Constantine.

In this reconstruction of the marble panels of the old ciborium, the relief representing the crucifixion of Saint Peter is flanked by two soldiers under an arch, at right, and to the left, the emperor Nero, also under an arch. P.Z.

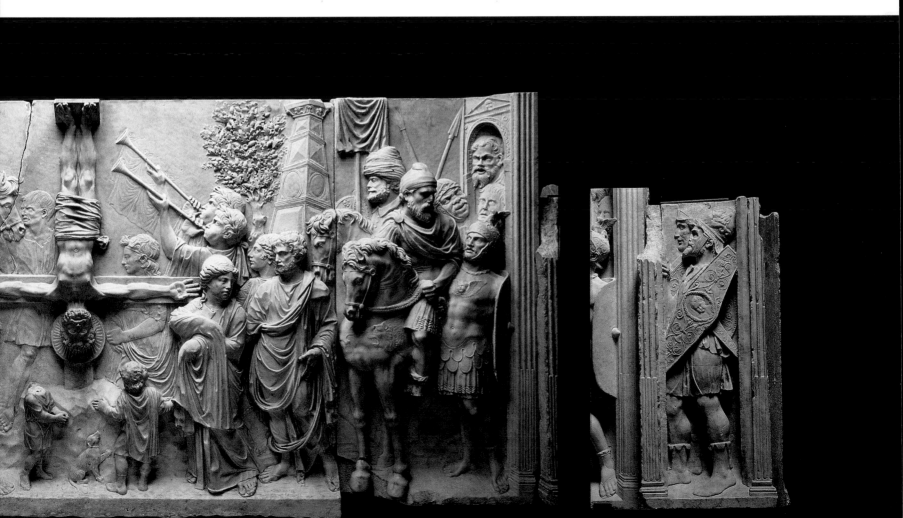

41

Consignment of the Keys and Healing
of the Lame Man
from the "Ciborium of Sixtus IV"

Contemporary cast of a 15th-century marble relief
138 × 90 cm
Reverenda Fabbrica of Saint Peter, Vatican City State

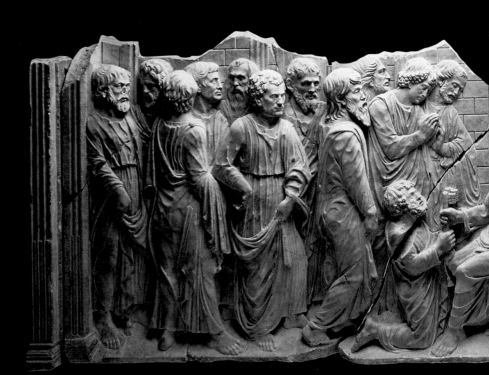

This relief, which, according to the reconstruction suggested by the architect Pier Luigi Silvan, faced the northern arm of the transept, represents two episodes in the life of Saint Peter. The two scenes are separated by a small cable-fluted column on an Attic base.

On the left, Saint Peter kneels before Christ, who gives him the symbolic keys while the other apostles look on. The scene is clearly inspired by this Gospel passage: "I now say to you: You are Peter and on this rock I will build my community. And the gates of the underworld can never overpower it. I will give you the keys of the kingdom of heaven; whatever you bind on earth will be bound in heaven; whatever you loose on earth will be loosed in heaven" (Mt 16:18–19).

The right of the relief depicts the healing of the lame man, a feat accomplished by Saint Peter at the Beautiful Gate of the temple of Jerusalem (Acts 3:1–11). Peter and John the Evangelist are shown with haloes to distinguish them from the other people crowding the scene. The various characters appear at different depths in the relief. Some gaze in amazement at Peter, who with his right hand helps the lame man to raise himself from the ground. Others seem to be commenting on the event, while a dense and curious crowd comes running to the spot through the Beautiful Gate, which can be seen behind the apostles.

Large gaps in the upper part of the relief already existed in the seventeenth century when misdirected restoration work was suggested for the missing parts. The figure of the lame man seems to have been copied from Trajan's Column, which, in one of its lower spirals, depicts a Roman soldier fallen from his horse.

As with the other large panels of the ciborium, this one was sculpted over two marble slabs of differing widths. Today, the relief is made up of seven fragments. P.Z.

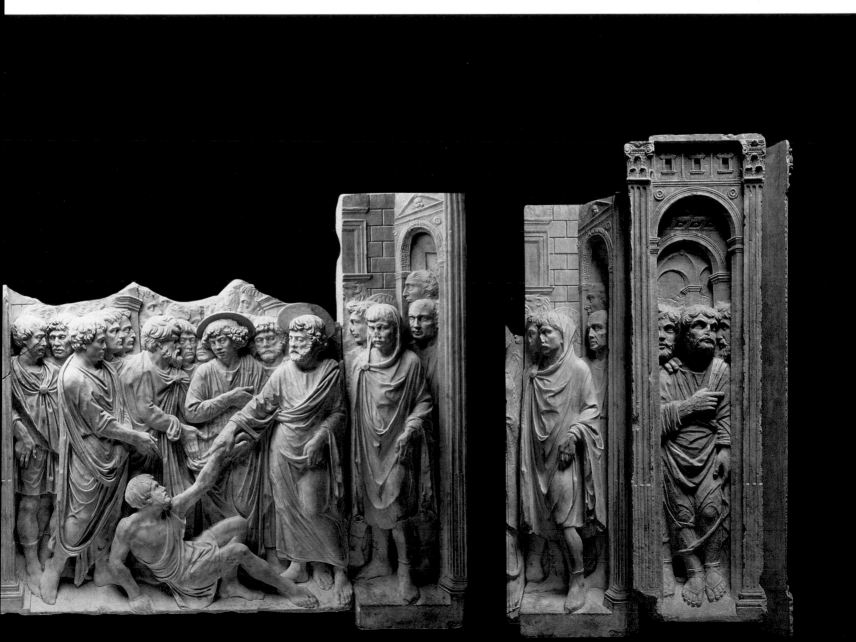

The Fall of Simon Magus
from the "Ciborium of Sixtus IV"

Contemporary cast of a 15th-century marble relief
267 × 109 cm
Reverenda Fabbrica of Saint Peter, Vatican City State

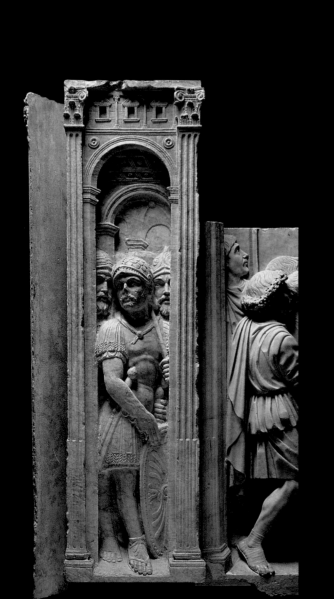
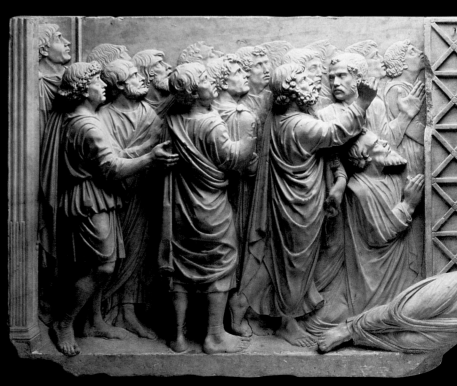

On the architrave of the ciborium facing the southern transept of the old basilica was a marble panel representing one of the most well known and important episodes in the lives of the apostles Peter and Paul. It showed the fall of Simon Magus, a Samaritan magician whom the people called "the great power of God" and who, with the help of Satan, performed great prodigies in Rome. During the reign of the emperor Claudius (AD 41–54), Peter arrived in Rome to prevent the spread of a distorted and superstitious image of Christianity. Simon Magus, angered by the Romans who abandoned him to follow Peter, announced he would ascend to heaven in disgust. A crowd gathered where the emperor Nero, Claudius' successor, had built a great wooden tower, from which the magician would throw himself to be borne up to heaven by angels. Peter prayed to the Lord to unmask the impostor and Simon Magus fell to the ground.

The relief shows the defeated magician at the base of a tall tower that divides the scene in two. On the left is Saint Paul, on his knees in prayer, and Saint Peter standing with the keys. In front of them Simon Magus lies in a position practically identical to that of a dying Dacian on Trajan's Column. The apostles and the other fifteen people who crowd this part of the relief are all looking intently upward to the top of the tower, from where Simon Magus had launched himself an instant before. The right of the scene is dominated by Nero on a tall podium with two armed men beside him. The portrait of the crowned emperor is taken directly from coins and his posture recalls similar reliefs on Trajan's column. Four soldiers look toward the imperial podium, while four other people seem to be discussing the event. Between these two groups are three individuals who seem to be speaking, while in the background is a lightly carved series of heads looking up toward the top of the tower. In all, the scene contains thirty-eight characters. The great dog near the emperor is probably one of the two mastiffs that Simon Magus intended to tear the apostle to pieces before Nero. According to the account contained in the Apocryphal Acts of the Pseudo-Marcellus, Saint Peter tamed these ferocious beasts by offering them the blessed bread. P.Z.

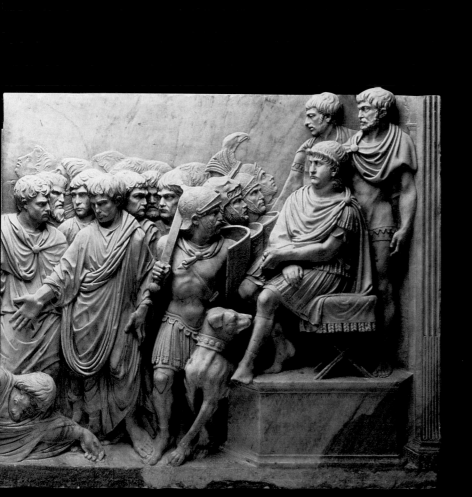

43

The Capture and Decapitation of Saint Paul from the "Ciborium of Sixtus IV"

Contemporary cast of a 15th-century marble relief
265 × 98 cm
Reverenda Fabbrica of Saint Peter, Vatican City State

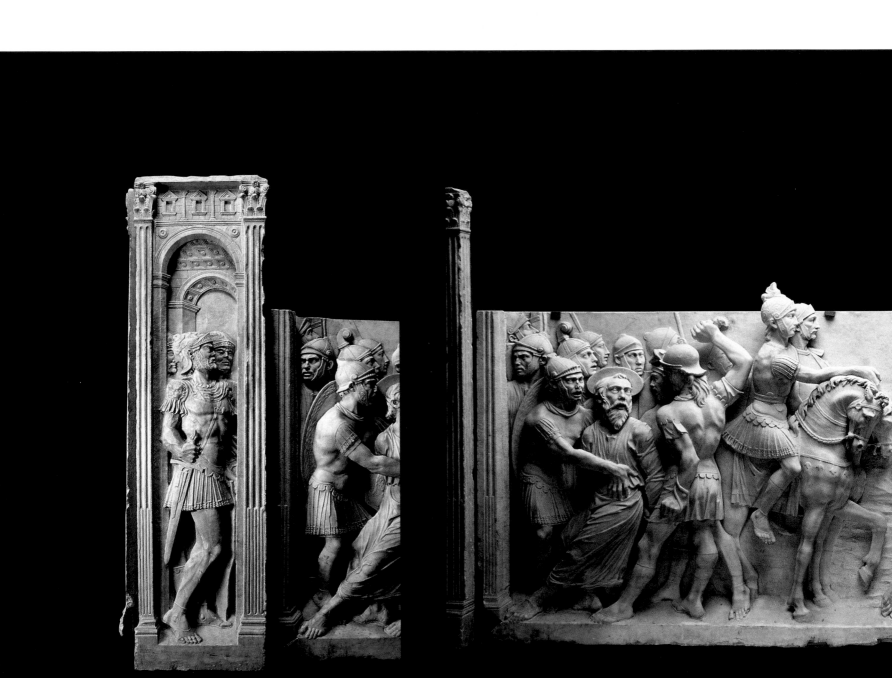

This relief depicts two different moments of Saint Paul's martyrdom. To the left, three soldiers are shown brutally restraining the apostle to take him before Nero. On the right is the scene of his decapitation. Paul is shown kneeling with a halo around his head and his hands joined in prayer; behind him a centurion is about to strike the mortal blow while another points at the condemned man. Two musicians are depicted, and a man with ruffled hair, the only civilian among the soldiers, shouts in the background. Nero, wearing a laurel crown and seated on a marble throne, is surrounded by a platoon of soldiers who seem oblivious to Paul's fate.

Thirty-two characters in various postures appear in the two episodes, all marked by facial expressions that convey their character and mood. The depiction of Nero was clearly inspired by earlier works: his portrait was copied from coins. The two mounted soldiers and the tuba player seem to derive from scenes in the lower spirals of Trajan's Column. P.Z.

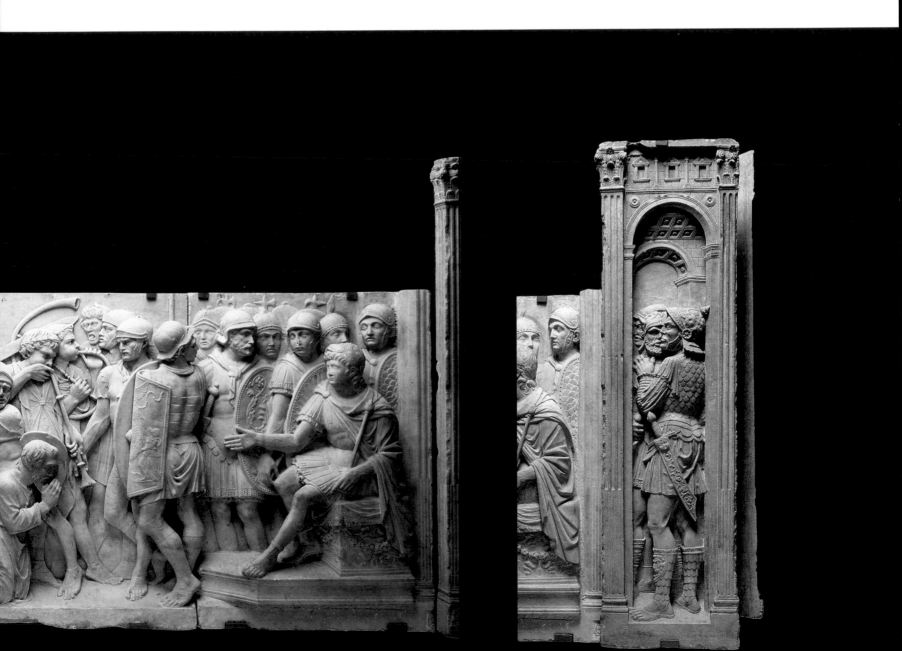

The Mandylion of Edessa

3rd to 5th century
Tempera on linen attached to wood; silver, gold, various stones
65 × 45 × 21 cm
Office of the Liturgical Celebrations of the Supreme Pontiff, Vatican City State

Conservation courtesy of Angela, James, Thomas, Siobhan and James III McNamara

The Mandylion formed the central exhibit in the Vatican Pavilion at the World Expo in Hanover in 2000. Nothing could have better expressed what anniversary was being celebrated in 2000, or what is the yardstick for the time-reckoning of Western civilization, than this image of Christ, which is considered the oldest known representation of Jesus. That this message was successfully disseminated was shown by the reports in the press and on television on the arrival of the spectacular image

from the papal reliquary-chapel in the Vatican. The interest aroused by the image among students and scholars, and the spiritual questions it posed, testify, moreover, that the dialogue on the Mandylion proved fruitful on that occasion.

The Mandylion belongs to those legendary images supposedly not painted by human hand, described in Greek as *Acheiropoietoi*. Various literary and historiographical traditions have developed since its first appearance in the sixth century.

One explanation of the image is that, like the handkerchief of Saint Veronica, it is a physical impression made by the face of Jesus on a cloth, hence its name *Mandylion*, or "holy towel." Another concerns the story of Abgar V, king of Edessa, who was dying of an incurable disease. He had heard of Christ's deeds and so sent his secretary and court painter Ananias to invite him to court. Though Jesus was unable to accede to the request, he instructed his disciple Thaddeus to go in his stead to the king. This was not enough for Ananias, who also painted a portrait of Jesus and brought this image along with a letter from him back to his sovereign, who was cured. Abgar accorded the image a place of honor in his palace, and devotion to it increased. So highly was it venerated that, after it was transferred to Constantinople in 944 together with the letter, it became the Palladium, or banner, of the capital of the Byzantine Empire. It may have been incorporated into a tenth-century triptych, the side panels of which, now in the monastery of Saint Catherine on Mount Sinai, illustrate the Abgar legend. There the king is given the features of Emperor Constantine VII Porphyrogenitos, who had the important relic transferred to Constantinople and instituted a special feast day in its honor.

Following the Venetian conquest of Constantinople in 1204 and the transfer of the Mandylion to the West, its history becomes more obscure. Various traditions emerged. One reports that it had been looted from the palace chapel of Pharos and taken to the West. Another holds that Emperor Baldwin II donated or sold the precious image in 1247; it eventually became the treasured possession of the French king Louis IX, who ordered that it be kept in Sainte-Chapelle in Paris, where it is found mentioned until 1792. Yet a third Mandylion was donated by the Byzantine emperor John V to the Genoese captain Lionardo Montaldo in 1362. After Montaldo's death in 1384, the image was bequeathed to the church of S. Bartolomeo degli Armeni in Genoa, in 1388, where it still remains.

All three traditions that emerged after 1204 are associated with a different image of the Mandylion. Of these, the one in Paris has been lost since 1792, and no information about its appearance has survived. The version in the Vatican and the one in Genoa are almost wholly identical in their representation, form, technique, and measurements. Indeed, they must as some point in their history have crossed paths, for the rivet holes that surround the Genoese image coincide with those that attach the Vatican Mandylion to the cut-out sheet of silver that frames the image. It sheaths the whole panel to which the linen cloth is affixed, only exposing Christ's face. So this silver frame, or one like to it, must also have originally covered the panel in Genoa. The Genoese Mandylion is now contained in a gilt-silver enameled frame in the Palaeologan style of the fourteenth century. The Roman Mandylion, which Pope Pius IX removed to the Vatican just before the conquest of the city by Garibaldi's forces in 1870, is first mentioned by Cesare Baronio in 1587. It was then in the convent of the Poor Clares at San Silvestro in Capito. Its previous whereabouts remain obscure.

The observations about the two Mandylia, and the extant historical data about the fortunes of both, have been combined into a suggestive hypothesis: namely, that the Mandylion in the Vatican is a later replica of the one now in Genoa; that it was produced in the fourteenth century, when the Genoese version, which can be dated back to the tenth century, was given its existing Palaeologan frame; and that it was then placed in the silver frame of the older version. Many questions about such an hypothesis remain unanswered, however.

These doubts were increased by the findings of analyses conducted on the Roman version in the Vatican Museums' chemistry and painting restoration laboratory in early summer 1996. During its restoration, the image was removed from its baroque reliquary, taken out of its silver frame, and detached from the wooden support onto which the linen cloth had been glued. The seal of Pope Pius IX, who had evidently given instructions for the baroque reliquary to be opened in 1870, was then found fastening the silver-sheet frame, which was commissioned by Sister Dionora Chiarucci, mother superior of Poor Clares at San Silvestro in Capito, and made by Francesco Comi in 1623. All the laboratory analyses conducted in 1996 used nondestructive methods, and no original samples of the image were removed for systematic tests; only loose particles on the edge of the image were analyzed, which were not by their very nature conclusive. It was not possible, for instance, chemically to ascertain the binding agent of the pigments or scientifically to confirm the conclusion reached by autopsy that the painting had been executed in tempera. The painted face of Christ was found on a cut-out linen cloth below the above-described silver-sheet frame, its contours exactly following the contours of the image itself. After the painting of the image had been completed it was glued onto a panel of cedar, which could not be specified or dated in any further detail. These findings do not contradict an Anatolian or Syrian origin. The surface, to which the linen cloth was glued, was hewn into the wood with rudimentary tools, as the two raised ledges round the edge of the panel form part of the same block of wood as the panel itself. Residues of the glue and traces of the imprints left in it by the horizontal woven threads of the fine linen cloth could also be detected. The thin layer of pigment showed no traces of overpainting. Only the brownish hue that has given the image its characteristic dark impression was produced by a subsequently applied substance, which was also ascertainable in the fine craquelure and in the small areas of color loss. The overall state of conservation was excellent. It was especially remarkable that alterations in the execution of the nose, mouth, and eyes could be observed in the x-rays and thermographic and reflectographic photographs. In the area of the nose these alterations could be clearly interpreted as a *pentimento*, or correction, as the nose had originally been shorter, so that the image originally must have had a different physiognomy.

The above observations on the state of conservation, and on the technique and process of execution, make it more difficult to interpret the Vatican Mandylion as a mere copy of the Genoese version, in which the features were undoubtedly fixed. The findings of the scientific investigation are also compatible with a more general observation, namely, that the Vatican Mandylion is more vigorous in expression than the more finished, almost mannered or iconically more conventional version in Genoa. Whether its stylistic affinity with East Syrian painting of the third century is sufficient to enable the Vatican Mandylion to be traced back to the very origins of the literary tradition, or whether, in spite of its more forceful character, its kinship with the Genoese version points rather to a parallel creation in the tenth century, is difficult to determine on present evidence.

Although the Mandylion is no longer enveloped today by any legend of its origin as an image made without the intervention of human hands, it continues to exert great fascination on all those who come into contact with it. The answers that these legends once gave lent the image an aura and turned it into a relic. This former certainty, and the clear explanations that devotion once gave, have now given way to the questions posed by modern science. These questions only underline the complexity of the object of research and, in spite of all the technical facilities available, remain for the most part unanswered. In our contemplation of it they arouse in us – perhaps even more powerfully and in a way more suited to our times – a debate on the origin of the likeness of Jesus of Nazareth and on the question of his humanity that is bound up with it. However one may interpret the Mandylion, it remains of central importance for our understanding of Western culture; in that lies the value of any reflection on it. A.N.

Six Statues of Angels
with Instruments of The Passion

Workshop of Gian Lorenzo Bernini
17th century
Wood, partly gilded
Ca. 56 cm
Office of the Liturgical Celebrations of the Supreme
Pontiff, Vatican City State

Conservation courtesy of Mr. and Mrs. James Kelly

Angel with Column; Angel with Sudarium; Angel
with Ladder; Angel with Shroud; Angel with Nail
and Tenaglia; Angel with Rope

These small statues are generally attributed to Gian Lorenzo Bernini's workshop, not to the hand of the master himself. Oral tradition holds that they were made as *bozzetti*, preliminary sketches, for the marble angels on the Ponte Sant'Angelo and presented to Pope Clement X for his approval before sculpting. This hypothesis is at least partially confirmed by the fact that the marble angels currently adorning that bridge strongly resemble these wooden statuettes.

The figures are characterized by the typical sculptural technique of the baroque period and are close to Bernini's own sculptural models. The movement of the drapery and the position of the wings, in particular, suggest Bernini's capacity for animating his works.

The wood was painted to resemble bronze and touched up with gold, which, after conservation by the Vatican Museums in the 1980s, is still visible. These small statues once decorated the inside of the Secret Chapel of the Apostolic Palace and were moved many times according to each pope's devotions or the functional criteria of each new master of ceremonies.

The symbols of Christ's Passion held by the angels suggest spiritual participation in the suffering of Christ. L.O.

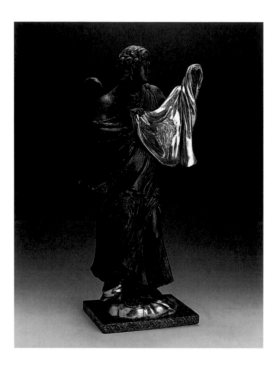
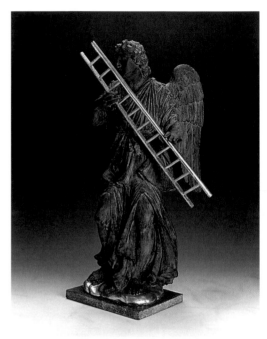
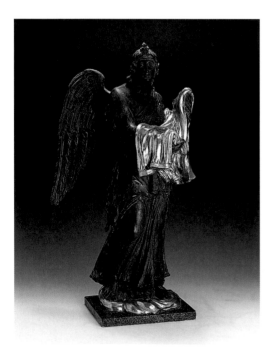
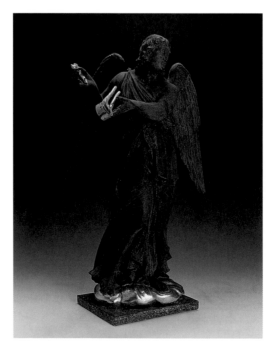
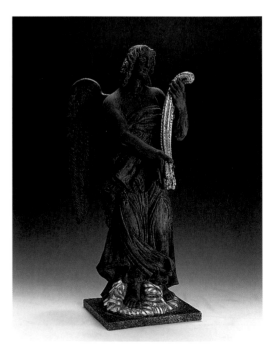

Group of Relief Figures from Majestas Domini (Majesty of the Lord) Portraying Christ Enthroned with Saint Peter, Saint Paul, and Three Apostles

Ca. 1215
French workshop (Limoges) active in Rome during first quarter of the 13th century
Embossed, gilt, and enameled copper
Christ: 41 × 19.5 cm; Saint Peter: 22 × 6.8 cm; Saint Paul: 22.2 × 7.4 cm; Apostle a): 22.6 × 7.4 cm; Apostle b): 22.4 × 7.4 cm; Apostle c): 22.5 × 6.9 cm
Vatican Museums, Vatican City State
Inv. 62430, 62428, 62429, 62431, 62432, 62433

Conservation courtesy of Thomas C. Quick

These figures are all that remain of the antependium that Pope Innocent III gave to the *confessio* of Saint Peter in the Vatican when the presbyterial area of the Constantinian basilica was restored. The project was originally conceived during the early years of his pontificate, and the individual elements of the composition were designed to affirm papal power.

Dating from Pope Gregory the Great, the presbytery comprised the *memoria* or shrine erected by Constantine on Saint Peter's tomb. The apsidal mosaic on the back portrayed Christ enthroned between Saint Peter and Saint Paul and illustrated the theme of *potestas* (authority) that Christ trans-mitted to them, and through them, to the Church of Rome. In the lower part of the composition, the throne between the figures of Pope Innocent III and the *Ecclesia Romana* (female figure representing the Church) referred to the pope's role as intercessor between man and God. The theme of *etimasia* (represented by an empty throne and a cross) symbolized the second coming of Christ and was linked to the concept of supremacy, exemplified by the wood and ivory throne (Saint Peter's, Museum of the Treasury). Although many of its parts were from a later epoch, medieval tradition associated this throne with Saint Peter. The inscription at the base of the concha (half dome over the apse) asserted the apostolic foundation for the Church of Rome, claiming the Vatican basilica's supremacy over all other churches.

Similar concepts were the basis for the layout of the ancient *confessio*, which complemented the decoration of the apse. An antependium with openings for the figures of the Twelve Apostles was found under the altar of Pope Callistus II behind a grating that protected the niche of the *Palli*. These statues were arranged on two levels on either side of Christ, who is represented twice the size of the other figures. Each statue was embossed, enameled, and gilded on copper, and they were then nailed onto a panel; traces of nail holes are still visible. As in the apsidal *Majesty*, Christ is enthroned and raises his right hand in blessing. In his left hand he holds the Gospel. Only five apostles are extant. Each holds a book, but except for Saints Peter and Paul, who are easily recognizable by their respective attributes, the others are not identifiable. The figures can be attributed to the Limoges style of workmanship, famous throughout Europe for its *champlevé* enameling and the formal features of the figures. The stylized treatment of the drapery recalls that of metal sculpture executed in Rhine region at the beginning of the thirteenth century.

An inscription in verse appears on the upper part of the niche and remains legible on the outside of the railing: "Sic cum discipulis bis sex Xps residebit cum reddet populis / cuctis quod quisquis merebit. / Tercius hoc munus dans Innocentius unun sit comes in vita tibi Petre cohisraelita" (roughly meaning: "Thus, with the twelve disciples, Jesus Christ will be given to all peoples according to each one's worth. [We pray] oh Peter, co-Israelite, that Innocent the Third, offering this gift, be your sole companion in life").

During the Middle Ages and part of the Renaissance, the antependium remained in its original place in the basilica. Beginning in 1513, it was incorporated in the *tegurium* (baldachin) built by Bramante to protect the sanctuary. At the beginning of the seventeenth century the thirteen statues were still in their original setting, where they remained until 1750. At that time, the statues were reduced to the six still in existence and transferred to the Museum of Christian Art (Museo Sacro) inaugurated by Pope Benedict XIV in 1753. G.C.

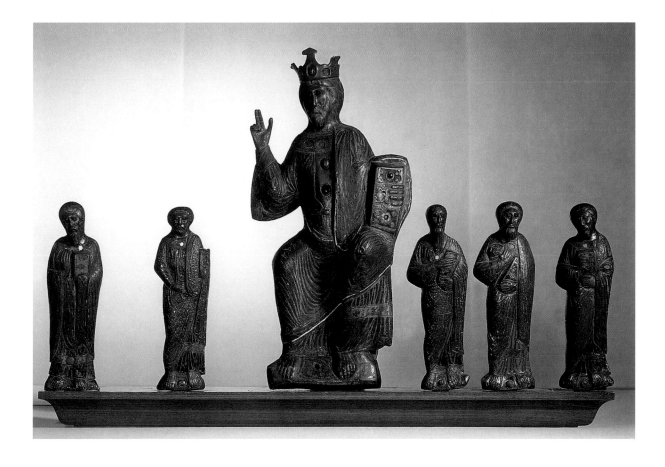

Mosaic Fragment with Image of Saint Paul the Apostle

Ca. 799 (restored by G.B. Calandra in 1625)
Rome, from Lateran Triclinium
Mosaic
47.5 × 40 cm
Vatican Museums, Vatican City State
Inv. 64009

Conservation courtesy of Florence D'Urso in memory of her beloved brother, Father Francis Perkosky, a devoted Sulpician priest who truly followed in the footsteps of Our Lord

This fragment, along with another piece in the Vatican Museums, originally decorated the Lateran Triclinium, the state banquet hall of the so-called *Patriarchio*, the papal Lateran Palace of the Middle Ages. Built with three apses during the time of Pope Leo III, only the main apse, restored under Pope Benedict XIV, remains today. The mosaic underwent a poor renovation in the seventeenth century under Pope Urban VIII and was in a state of ruin. During the restoration of 1743, it was completely renovated by Pier Leone Ghezzi. Although he remained faithful to the original, Ghezzi destroyed the ancient mosaic created under Pope Leo III. Only two fragments of that original mosaic were saved; both, after alternating fortunes, reached the Museum of Christian Art (Museo Sacro), which recently transferred all its collections to the Vatican Museums.

The two lateral apses have also been decorated with mosaics. A seventeenth-century source states that the apse on the left portrayed a banquet scene, perhaps a reference to the Last Supper; nothing is known of the mosaic on the right. In the main apse, Christ stands at the center of the paradisiacal mountain, surrounded by his apostles, whom he sends out, according to the citation at the base of the concha: EVNTES DOCETE OMNES GENTES VAPTIZANTES IN NOMINE PATRIS ET FLILII ET SPIRITUS SANCTI / ET ECCE EGO VOBISCVM SUM OMNIBVS DIEBVS VSQVE AD FINEM CONSUMMA-TIONEM SECVLI ("Go, therefore, make disciples of all nations; baptize them in the name of the Father and of the Son and of the Holy Spirit And look, I am with you always; yes, to the end of time" [Mt 28:19-20]). The inscription on the book Jesus holds also refers to his appearance to the disciples on Easter evening: "Jesus came and stood among them. He said to them, 'Peace be with you'... 'As the Father sent me, so am I sending you'" (Jn 20:19-21). The anachronistic presence of Paul is explained by the need to exclude Judas yet have twelve disciples. In fact, the ecclesiastical community acclaimed Saint Paul as the Apostle of the Gentiles, ranking him on an equal level with Saint Peter.

The apsidal arch depicted two other scenes having both political and religious meaning. On the right, the enthroned Saint Peter presented Pope Leo III with a pallium and Charlemagne with a royal banner. On the left, a seventeenth-century restoration, though probably inspired by the original, depicted an analogous scene of Christ giving the keys to Saint Peter (or Pope Sylvester) and the royal banner to Emperor Constantine. The analogy between Christ and Saint Peter reveals that the latter, as well as his successors, was considered the custodian of the Lord's divine authority. Likewise, Charlemagne was recognized in the role that had been Constantine's, that of *defensor Ecclesiæ*, "Defender of the Church." The inscription along the border, GLORIA IN EXCELSIS DEO ET IN TERRA PAX HOMINIBUS BONE VOLVNTATIS ("Glory to God in the highest heaven, and on earth peace for those he favors" [Lk 2:14]) also appears to refer to the *pax augusta* introduced by the Charlemagne. The two passages from Matthew and Luke even appear side by side in reference to the *pax constantiniana* (peace of Constantine), which promoted the diffusion of the "joyful tidings" of Christianity.

Paul, characterized by his long, pointed beard, is the leader of the group on the right of the *Missio Apostolorum* in the half dome. Mounted on a plaster base, and filled in with tempera, this mosaic has stylistic characteristics that differ greatly from the other fragment on view. At first glance, these differences cause one to question the originality of the work. Moreover, whereas the other head was entirely composed of tesserae made of vitreous paste, consistent with use in the early Middle Ages, here the marble tesserae are used especially for creating the flesh tones of the face. At the time of its restoration in 1625, the mosaic of Pope Leo III was already missing tesserae from the faces of Christ, Paul, and the apostle behind him. A representation of the Triclinium at the beginning of the seventeenth century clearly shows this gap. Thus, it is certain that the restoration of Pope Urban VIII also involved the reconstruction of the missing part. This was done by the talented, respected mosaicist Giovan Battista Calandra, later author of the seventeenth-century mosaics in Saint Peter's Basilica. Although he gave a new interpretation to the portrait, Calandra had to follow the form left by the tesserae on the plaster, some of which are still visible, especially at the top left corner. As chance would have it, it was just this seventeenth-century fragment that would be saved, together with the other original, from the destruction that occurred during the next century. Thus, it has reached us as the only surviving piece of the mosaic of Pope Leo III. The viewer will note, however, the presence of a small number of tesserae in green vitreous paste, on the lower right-hand side, corresponding to Paul's left shoulder, which show the results of devitrification. These are the only original tesserae — approximately twenty — of the image of the Paul in the Lateran Triclinium apse. They are located on the spot where Calandra joined his mosaic to the Carolingian original. U.U.

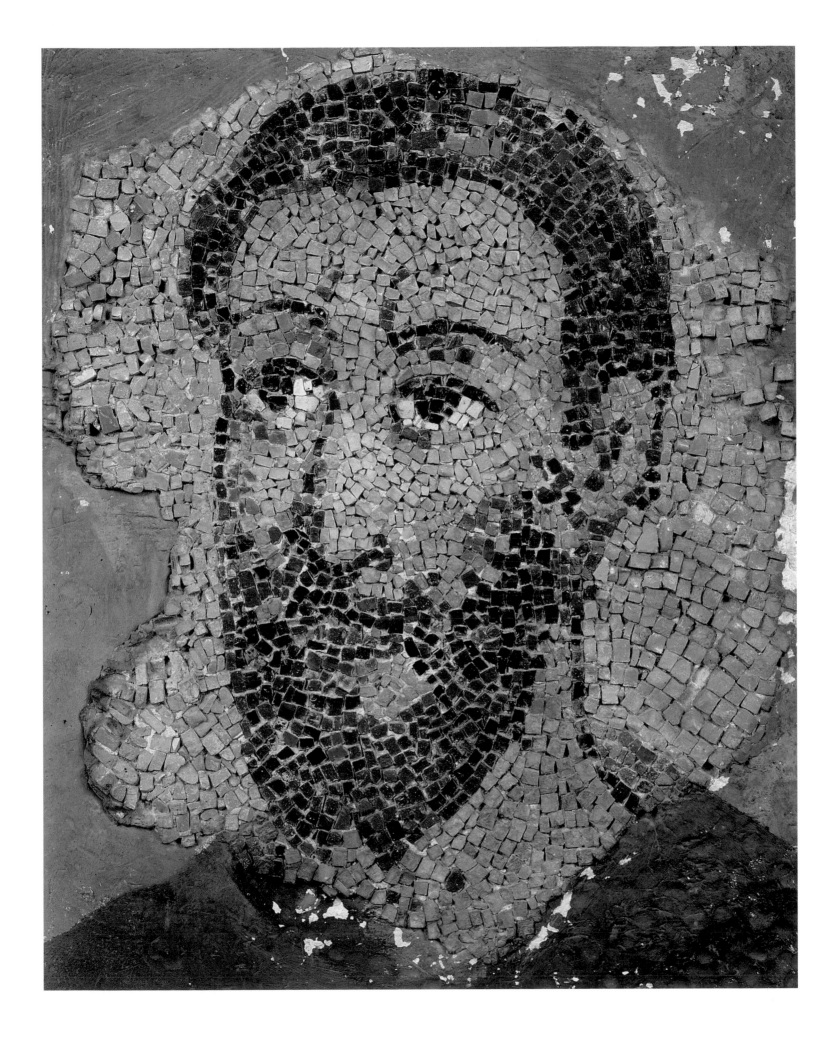

Reliquary of Pope Saint Gregory the Great

1883
Placide Poussièlgue-Rusand (1824–89)
Metal, colored stones, enamel, cut glass
51 × 50 × 26 cm
Office of the Liturgical Celebrations of the Supreme
Pontiff, Vatican City State
Inv. RLQ34

Conservation in memory of
Richard Bourgeios, O.S.B.

The life and works of Pope Gregory, a fragment of whose skull is conserved in this reliquary, were so important for the life of the Church as to earn him the Latin title Magno, "the Great." He was born in Rome and a prefect of that city when, abandoning a brilliant political career, he entered the Benedictine Order and strictly adhered to the founder's Rule. He lived in want and poverty, using his family wealth to build monasteries. Pope Pelagius became aware of Gregory's talents and ordained him a deacon, sending him to Constantinople where he undertook valuable work on behalf of the Church. It was in those years that Gregory became convinced that, for Constantinople, Rome no longer held any religious attraction or political interest. The pontifical see was left to fend for itself.

Upon the death of Pelagius, Gregory was immediately elected pope and, having noted the lack of Byzantine interest in Rome and Italy, sought to distance himself from Constantinople and regain a measure of autonomy. Given the lack of a strong political force, the church became the only point of reference for the people of the Italian peninsula and, through a process of natural progression, slowly assumed the role of guide and arbiter in secular affairs, as well as in spiritual and religious matters. Gregory used this new role exclusively to serve the church and the people. He made the treasures of the church and the wealth of his own family available to feed the hungry. He cleared the pontifical court of all the lay people and deacons who infested the church with their simoniacal

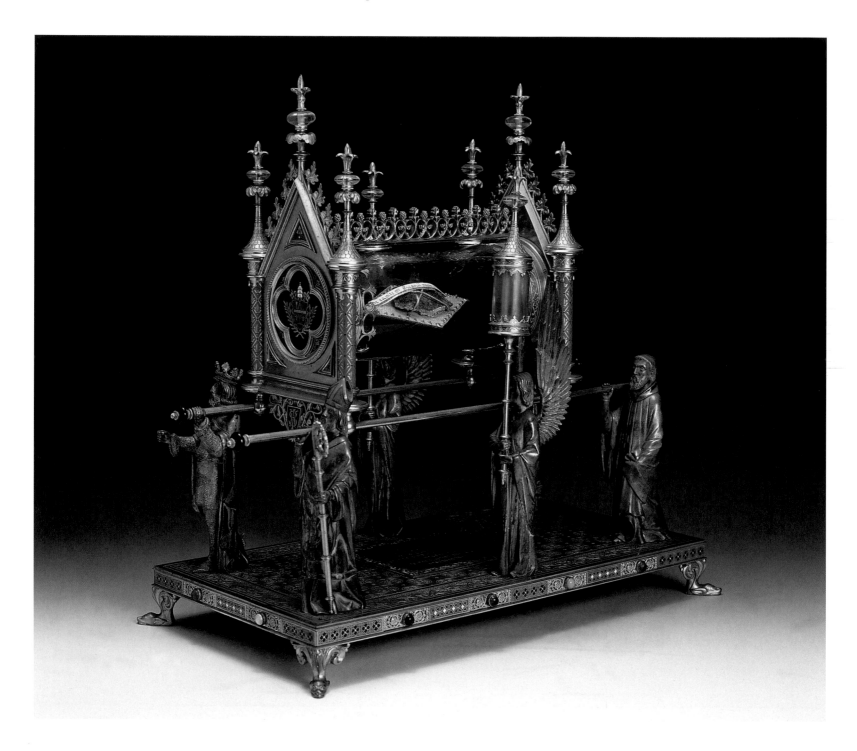

practices, and replaced them with honest and trustworthy Benedictine monks. He also began a huge missionary endeavor aimed at converting the Lombards to Catholicism, and brought the same zeal and commitment to the reorganization of the liturgical life of the church, seeking to reform the missal and enriching divine worship with the Gregorian chants, so-called because of him and still today the basis of many solemn liturgical functions. As a token of humility, he defined himself as the "servant of the servants of God," a definition that other popes after him also adopted.

His reliquary, which is kept in the Pontifical Sacristy, is made of gilded metal and is of a very elaborate Gothic style, with a number of figures supporting the relic. The base is rectangular with four feet in the form of animal heads. The sides are decorated with embossed scrolls and flowers, colored stones, and small rectangular enamel panels with geometric designs and flowers. The top of the base, upon which the statues rest, is entirely chased with garlands of flowers, clover leaves, and small rhomboid forms. At the center, a small plate bears the inscription "Leo XIII Pontifex maximus insignes reliquias capitis S. Gregorii Magni quas anno MDCCCLXXXIV. Victor Bernardou Card. Archiep. Senon dono ei dederat in pontificiae domus Sacrario ad servandas decrevit" (Pope Leo XIII ordered the outstanding relics of the head of Saint Gregory the Great, which in the year 1884 Victor Bernardou the cardinal archbishop of Sens had given to him as a gift, to be kept in the chapel of the pontifical house). There are also two smaller inscriptions. The first reads "Offert a n. s. P.le Pape Leon XIII par l'Archeveque se Sens Victor Felix Bernardou 1883," and the second is the name of the craftsman, "P. Poussielgue-Rusand." Six burnished metal statues stand upon the base — representing a king, a bishop, two angels, and two monks — and seem to allude to the entire church in the person of her most distinguished representatives. The angels each hold a pole supporting a lamplike crystal cylinder, the upper part of which has the form of a spire surmounted by a transparent stone and a stylized lily. The other four figures support two horizontal poles that are finished with dark red stones that serve as a support for the reliquary. The reliquary is a glass cylinder within which, on a bed of red velvet, the bone fragment of the saint may be seen. The ends of the cylinder are closed by two sections of gilded metal that are held in place on the glass by means of supports decorated with leaves. These sections take the form of temple facades with two central rosettes in blue enamel: one displays the coat of arms of Leo XIII; the other branches and leaves. At the side of the rosettes are four columns, each surmounted by a spire with a transparent stone and a stylized lily. R.V.

Woodcut with the Apostles Peter and Paul

18th century (?)
Linden wood
27 × 23 × 8 cm
Reverenda Fabbrica of Saint Peter, Vatican City State

This carving on linden wood represents the apostles Peter and Paul, both bearded and with elongated faces, cloaked in long tunics that fall in elegant folds. They are resting their arms on a pillar engraved with the shield of the Fabric of Saint Peter's and the keys, surmounted by a tiara bearing the letters R.F.S.P.V. (Reverenda Fabbrica di San Pietro in Vaticano). Saint Paul, bearing a sword, appears on the left, while Saint Peter is easily identifiable by his keys, the symbol of temporal power. This wood engraving was used as a stamp either for a book produced by the Fabric of Saint Peter's or for printing the details of a work connected with the activity of the Fabric. The engraving was probably executed in the middle of the eighteenth century, although some scholars have suggested it dates from an earlier period, between the end of the sixteenth and beginning of the seventeenth centuries.

The technique of wood engraving, which was already in use in the fourteenth century to make prints on paper or cloth, consists of carving a block of wood with tools of various kinds and sizes, such as small knives, chisels, or punches. The parts removed from the block correspond to the blank areas of the printed design, while the parts remaining in relief form the pattern marked by the ink. Apart from the linden (or lime) tree, other types of fruit-tree wood were used such as pear, apple, cherry, or walnut. However, if the stamp had to make many copies, boxwood was preferred because of its hard and compact qualities. The engraving could be made either following the grain of the wood or perpendicular to it. This latter technique, adopted and popularized by the English artist Thomas Benwick (1713–1828), was used for this image. P.Z.

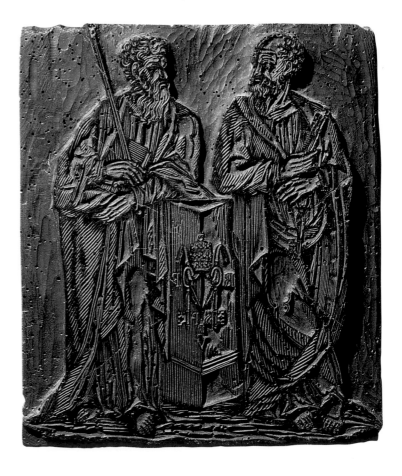

Christ Pantocrator
and Saints Peter and Paul

End of the 14th century
Cretan School
Tempera on cypress
123 × 123 cm
Congregation for the Evangelization of Peoples,
Vatican City State

Conservation courtesy of Helen M. Duston
and Family

This icon is painted on four thin horizontal
cypress boards laid one above the other. It was
once reinforced by three vertical boards nailed
across the back, but these have been lost. As the
back of the boards on which the painting is
executed is decorated with carvings inlaid with
green and red wax, they obviously once belonged
elsewhere.

The painting seems to have been touched up,
most likely in the second half of the eighteenth
century, when it became part of Cardinal Borgia's
collection. The original layers of the painting,
probably of the late fifteenth century, can be seen
beneath the surface. They seem to be in good
condition, except for some missing fragments that
were subsequently inserted.

Christ enthroned between Saint Peter and
Saint Paul is a theme typical of Early Christian and
Oriental art. In Medieval and modern Byzantine
representations, however, it is rare. The inscriptions
that identify the apostles are also unusual, being
quotations from the Vespers of their feast day,
which is celebrated on June 29: *Corifeo dei gloriosi
apostoli* ("Coryphaeus of the Glorious Apostles,"
Saint Peter) and *La bocca del Signore* ("The Lord's
Mouth," Saint Paul).

Emblematic attributes are seldom used for
the saints in the East. The keys have, however, been
associated with Saint Peter since ancient times,

while Saint Paul's sword was introduced from the
West, and only occasionally borrowed by Greek
painting in the post-Byzantine period.

The early post-Byzantine painting of Crete,
which inherited the best Constantinopolitan
traditions, can be recognized by the coexistence
of two styles, one Byzantine of the late period of
the Palaeologi, the other Italian Gothic of the
fourteenth to the early fifteenth century. The use
of this double style is, however, already frequent in
the generation preceding the fall of Constantinople.
It is also expressed in the association in a single
painting of elements entirely executed in one style
or the other.

In this icon Christ on the throne reproduces
an iconographical typology that was widespread
in the second half of the fifteenth century and was
almost certainly formulated by the painter Angelos
in the first half of the century. The figures of the
apostles, on the other hand, are inspired by the
Venetian late Gothic style. Of vague structure,
they are attired in fabrics of delicate hues that fall
in luxuriant folds with golden bands of writing
in pseudo-Arabic letters.

In the various versions of Christ on the throne,
the inscriptions on the Gospel can differ. Here,
on the left-hand page, is written: "… I am the light
of the world; anyone who follows me will not be
walking in the dark" (Jn 8:12). On the right-hand
page, quite unusually, appear the words of the
institution of the Eucharist: "Take, eat: this is my
body that was sent for you in remission of your
sins," a quotation borrowed from the frequent
representation of Christ as King of Kings and
High Priest. J.L.O.

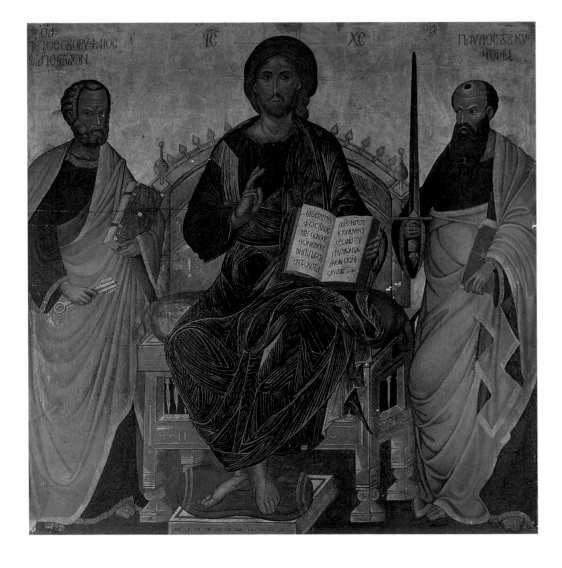

Bust of an Angel

1310–1313?
Giotto di Bondone (1267?–1337)
Polychrome mosaic
80 × 90 cm
Reverenda Fabbrica of Saint Peter, Vatican City State

Conservation courtesy of Elizabeth M. Bowden and
Col. Charles W. Bowden Jr.

Surely no work in the history of medieval art has
known the fame and popularity that Giotto's
Navicella has enjoyed ever since the years immedi-
ately following its creation. What can be seen
today on the counter-facade of the atrium of the
Vatican Basilica, over the main entrance, is all that
remains of the original work, commissioned from
Giotto sometime after 1304 by Cardinal Jacopo
Stefaneschi, the most important patron of the
arts in early fourteenth-century Italy. Originally,
the mosaic was of rectangular form and was
positioned in the portico of the Constantinian
basilica where it exercised an enormous influence
on contemporary artists. Following four
unfortunate transfers — which began in 1610
with the construction work on the new facade and
which saw the mosaic disassembled, recomposed,
and restored — it was finally placed in the atrium
by Orazio Manenti on the instructions of Pope
Clement X Altieri. This work was still unfinished
when the mosaic was put on display to the
public for the jubilee of 1675, six days before
the opening of the holy door.

The scene depicted is inspired by the Gospel of
Matthew (14: 22-32): Jesus walks upon the water
to reach the boat of the apostles, which is laboring
against a heavy wind and beaten by the waves;
he calms Peter's fears and encourages him to have
faith. The boat of the apostles is a symbol of the
Church: she is continually threatened by the storm,
but can never sink because she is held up by her
founder, represented as a majestic figure standing
erect on the tempestuous waves, his right hand
stretched out toward a kneeling Peter. In the lower
right-hand corner is a small-scale representation
of the cardinal who commissioned the work for
the considerable sum of 2,200 florins.

This figure of an angel is a surviving fragment
from Giotto's original work. Together with a similar
piece — today in the church of S. Pietro Ispano at
Boville Ernica — it formed part of the inscription
under the mosaic. Their existence only came to
light in 1924, because in 1728 Pope Benedict
XIII had had them covered with another mosaic
(also representing an angel), in front of which
he ordered some relics to be placed. After the
discovery, both Giotto's mosaic and the eighteenth-
century mosaic that had covered it were placed
along the left-hand wall of the chapel of the
Madonna delle Partorienti (Our Lady of Women in
Labor) in the Vatican Grottoes, near a frescoed panel
by Giovan Battista Ricci da Novara that reproduces
as much of Giotto's original work as could still be
admired in the seventeenth century. A.M.P.

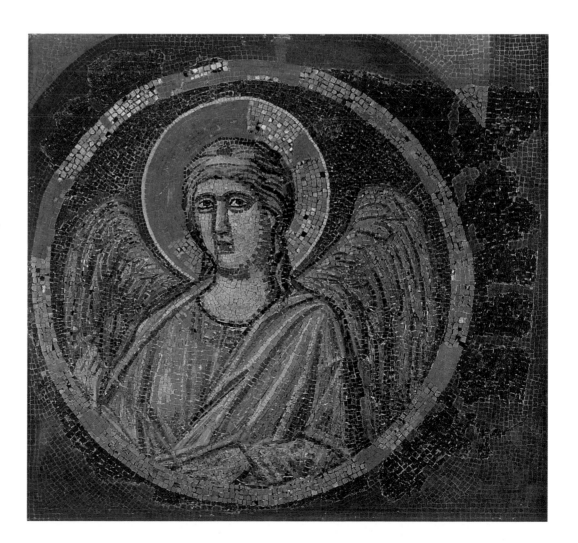

Four Papal Portraits from Saint Paul's Outside-the-Walls

Ca. 1277–80
Pietro de Ceroni, known as Cavallini (1273–1321)
Fresco on cadorite
80 × 80 × 3 cm
Patriarchal Basilica of Saint Paul's Outside-the-
Walls, Vatican City State

Conservation courtesy of the Philadelphia Patrons
of the Arts in the Vatican Museums

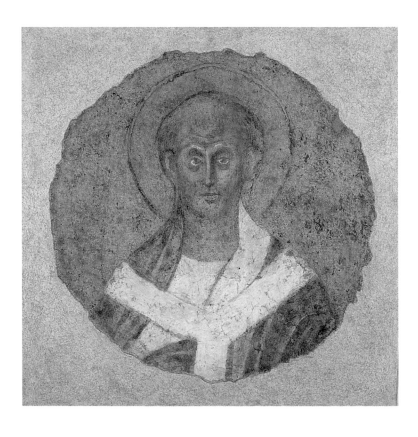 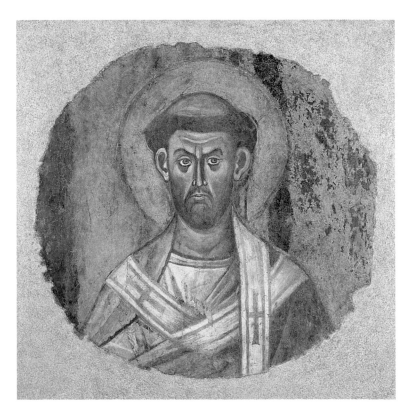

Saint Paul's Outside-the-Walls, on the via Ostiense, was built on the site where the apostle was martyred. The church was the only great Roman basilica that preserved its original Early Christian and medieval appearance virtually intact into the nineteenth century. All the more tragic, therefore, was the catastrophic fire that, on the night between 15 and 16 June, 1823, destroyed the basilica and left it a gutted shell. These four papal roundels are the only surviving remains of its medieval mural paintings. They belonged to a series of painted busts of the popes, set in circular medallions, that, according to the account of Ptolomaeus of Lucca, were commissioned by Pope Nicholas III, together with two similar series of papal images in Saint Peter's and Saint John Lateran.

The papal roundels in Saint Paul's in part repeated – as did those in Saint Peter's – an earlier and significantly more extensive sequence of popes. This latter series, as the *Liber Pontificalis* reports, had been begun under Pope Leo I the Great, who had in large part renovated the basilica after an earthquake had severely damaged it in 442. This Early Christian (or early medieval) row of papal busts was presumably no longer sufficiently visible in the thirteenth century, not only because of its state of conservation but also its considerable height above eye level. That would explain why Pope Nicholas III preferred to commission a new series altogether, and place it in a new site within the basilica, rather than have the old pictures overpainted or restored.

All the papal busts that survived the fire are now devoid of their accompanying inscriptions that would have specified the names of the popes in question and the duration of their pontificates. In 1934, however, Luciano de Bruyne securely identified them as Anaclete I (76–88), Sixtus I (115–125), Telesphorus (125–136), and Hyginus (136–140). All four popes have a round halo, a prominent tonsure, and are bearded. The hair and beard of Anaclete are reddish in hue, and gray in the portraits of the other three popes. With the exception of Sixtus I, who wears a red chasuble, the popes are dressed in a white tunic and a russet pallium. All four wear over it the pontifical pallium (attested only from the sixth century); it is represented in its early form as a simple scarflike vestment worn round the neck and over the breast. In the roundel of Anaclete I two crosses can still be detected on it.

The artists based the frescoes on the existing papal images as regards to hairstyle and beards, as well as hair color. But as far as clothing is concerned, they followed contemporary high medieval conventions. The composition and figural style of the roundels are firmly in the artistic tradition of the thirteenth century, as is apparent in the purely frontal perspective, rigid and rather stereotyped physiognomies, and the more graphic use of contrasting colors and strong contour lines. T.B.

Model of The Old Basilica of Saint Peter's

2002
Wood
179.5 × 103.5 × 67 cm
Reverenda Fabbrica of Saint Peter, Vatican City State

This model of the old basilica of Saint Peter's was specially made for this exhibition. It was built by Geremia Russo with the help of Professor Corrado Bozzoni, who acted as technical consultant and also supplied the designs for creating the facsimile on a scale of 1:150.

The model is partially sectioned on the northern side so as to show the interior with part of the nave, the presbytery, and the transept. The oldest parts of the Constantinian basilica, dating from the fourth and fifth centuries, have been rendered in walnut, while the parts that were added later and others, the original form of which is unclear or disputed, are in lighter-colored pear tree wood. The structures that were added at a later date were included because they are recognizably represented in historical depictions of the monument. In some cases, these structures cover parts of the ancient basilica of which little or nothing is known and

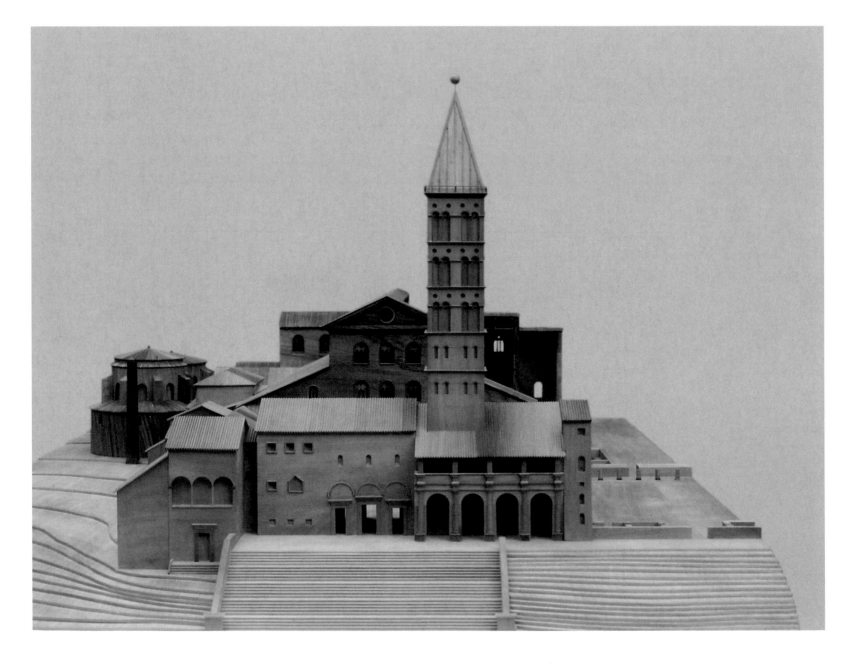

Model of The Old Basilica of Saint Peter's

which, consequently, are difficult to depict. An even lighter-colored wood was used for the base, which reproduces the relief of the terrain.

The model aims to show the basilica of the fourth and fifth centuries insofar as its various elements are known or can be reconstructed. Thus, in the center of the transept, the monument built by Constantine over the tomb of Peter may be seen; its form was established based on information gathered during archaeological excavations of the last century (1939–49) and on the famous image of the Constantinian monument on a casket dating from about 440, discovered at Samagher near Pola and today housed in the National Museum of Venice. These parameters necessitated the exclusion of the presbytery, as it was transformed between the pontificate of Pope Pelagius II and that of Pope Gregory the Great.

In keeping with a hypothesis suggested by sixteenth-century drawings, the transept is shown as being lower than the longitudinal body of the basilica. Sixteen windows open onto the transept: four on the east side, four on the west side, and four on each of the end walls. Eleven windows are on the south side of the nave, under which may be seen, inside the basilica, a schematic reproduction of the paintings that appear in the drawings of Giacomo Grimaldi (1598–1623) and Domenico Tasselli. Also visible inside the basilica are some of the eighty-eight columns of various marbles that divided the basilica into a central nave with two aisles on either side. Six windows in two orders open onto the facade, and two smaller openings admit light to the side aisles.

On the exterior, the structures built against the southern side of the basilica are shown in the form in which they appear in the plan of Tiberio Alfarano (died 1596). Among these the Choir of Pope Sixtus IV is recognizable behind the obelisk of the old Vatican circus. To the west of the obelisk is the Rotonda di Sant'Andrea or Santa Maria della Febbre and, nearby, a similar circular monument, the Rotonda di Santa Petronilla, which was originally the tomb of the emperor Honorius (395–423) and his wife Maria (died 407/8). Only the plan of the structures on the other side of the basilica (the north side) is shown. The front of the atrium and the bell tower are shown as they appear in sixteenth-century drawings, while the Loggia of the Blessings is shown only up to the first order, which is how, in all probability, it appeared and was used before the two upper floors were completed.

P.Z.

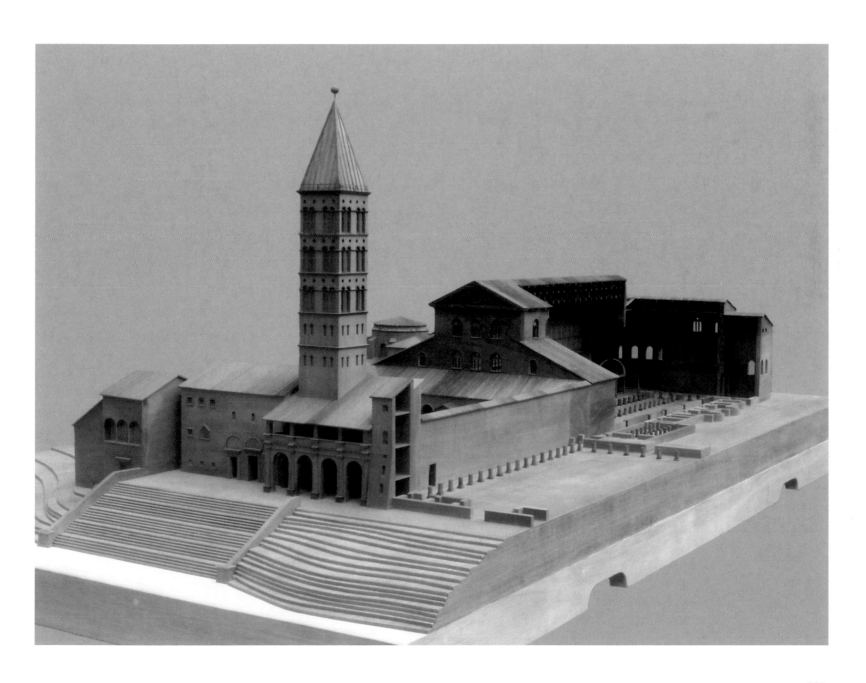

The Renaissance Basilica

In March 1505, Pope Julius II tried to build a chapel beside the old Vatican Basilica to be his mausoleum. In the summer of that year he realized that the basilica would have to be rebuilt. The plans for the new edifice were entrusted to Bramante, who was commissioned to "surpass all the other churches in magnificence and grandeur," as the pope himself said in the bull of February 19, 1513. The first stone of the new basilica was laid on April 18, 1506, in the place where Saint Veronica's pillar rises today. The following words were inscribed on the white marble: "In 1506, the third year of his pontificate, Pope Julius II of Liguria had this Basilica rebuilt over its former ruins." From that day, twenty-five hundred workmen were employed to demolish the old church and build the four piers upon which Michelangelo's dome rests today. The new construction was placed directly over the floor of the basilica of Constantine.

Julius II and Bramante died within a year of each other (1513–14), and the design of the basilica went through a number of long and complex changes. The architects followed one after the other with different ideas and added to the work of the building itself. Illustrious names alternate as construction managers, among them Raphael Sanzio, Giuliano da Sangallo, and Antonio da Sangallo the Younger. Instead of the Bramante's original design of a central floor plan, the basilica was envisaged as a Latin cross.

To further complicate things and add to delay, the city of Rome was sacked by the troops of the emperor Charles V in 1527, which halted the work for seven years. Pope Paul III then gave a new impetus to the construction of the basilica. In 1546 he commissioned Michelangelo Buonarotti, who was then seventy-two years old. In an official document dated 1547, the pope gave Michelangelo the power to build, renew, and enlarge or reduce the project as he judged best. As a further confirmation of his faith in him, on October 11, 1549, Pope Paul III nominated Michelangelo architect for life of the Building of Saint Peter.

Michelangelo died on 18 February, 1564. The drum of the dome was almost completed, as was the north transept. The south transept of the basilica had been completed. The dome was completed only during the reign of Pope Sixtus V.

Pope Paul V, assisted by the architects Giovanni Fontana and Carlo Maderno, decided to give substance to the idea of the definitive form of the basilica as we know it today. The first decision was to enlarge it into the form of a Latin cross. Work began on March 8, 1607, and on Palm Sunday, April 12, 1615, the basilica was presented for the admiration of the faithful.

One hundred and sixty years passed between the birth of the initial idea to substitute the Constantinian Basilica, and twenty six Popes had been on the throne of Saint Peter. From the front door to the back of the apse the Basilica measures 186.68 meters, the largest church in the world.

More years were to pass until the interior decoration was completed, and the famous colonnade in the Square of Saint Peter's was finished. These were principally the work of the great architect Gian Lorenzo Bernini (1598–1680).

Facade of the New Basilica of Saint Peter's with the Two Bell Towers

From *Architettura della Basilica di San Pietro in Vaticano*
(Rome, 1620), pl. 12

17th century
Martino Ferrabosco (died 1638)
Print
51 × 78 cm
Reverenda Fabbrica of Saint Peter, Vatican City State

This plate shows a fine view of the basilica, with the additional element of the two bell towers that Carlo Maderno (1556–1629) had planned for the new Saint Peter's. The original idea was most likely for the two bell towers to be built over the most easterly of the chapels in the two side aisles. The addition of the towers, which profoundly modified both the plan and elevation of the new church, was planned about 1611, when a painting in the Vatican Library by Giovan Battista Ricci of Novara (ca. 1540–1627) shows the basilica without the towers. A similar image appears in an engraving by Giovanni Maggi in 1608, in which the four great windows of the mezzanine are also missing.

In Maderno's original project, the proportions of the facade – dictated by the height of the Renaissance building and by the desire to include all the old basilica within the perimeter of the new one – were considered inadequate and too small with respect to the rest of the building. This was a view shared by Pope Paul V who, on September 2, 1612, gave the order to build the two bell towers at either end of the facade. Maderno's plans envisaged a limited use of solid brickwork and open arches in the upper portions of the structures so as to reduce the weight on the foundations. Engravings by Matthaus Greuter, Giovanni Maggi, and Alessandro Specchi also show the bell towers.

Work began on the northern tower in December 1612, and six years later on the southern tower. There it was necessary to build bigger foundations, as the underlying terrain was particularly marshy.

At the time of Pope Paul V's death in 1621, the first cracks in the foundations had begun to appear and work on the bell towers stopped. Twenty years later, and for the same reasons, Gian Lorenzo Bernini, who was to complete the project, was forced to abandon the enterprise and demolish the tower he had built at one end of the facade, giving rise to concern about the stability of the entire basilica.

Without the bell towers, which were intended to soar upward and lighten the front of the basilica, the horizontal element of the facade is emphasized. This effect is accentuated by the two side arches, which were supposed to be the base of the bell towers but became an extension of the front elevation of the basilica.

The original facade, the part enclosed by the pilaster strips, is preceded by the stairway built by Maderno in 1617 and limited at the top by the inscription to Pope Paul V dated 1612, the year in which the main lower orders and general structure of the facade were inaugurated. Between 1613 and 1614, the cornice, attic story, and balustrade were completed. The inscription on the frieze, the letters of which are more than a meter high, is faithfully reproduced in Ferrabosco's drawing, which also shows the Borghese coat of arms at the center of the tympanum, the projection of the tetrastyle central body, and the differing levels of protrusion of the great pilaster strips and of the columns, all surmounted by Corinthian capitals some three meters high. The five entrances to the atrium are visible, flanked by marble Ionic columns and each corresponding to one of the doors of the basilica. The niches at either end of the facade held the statues of Saint Peter and Saint Paul, which were later moved to another location. Above the entrances are the windows that illuminate the interior, with the marble relief by Ambrogio Buonvicino (ca. 1552–1622) in the central opening. Above the entrances are the five "Loggias," elegantly framed by Ionic columns. Above the entablature is the attic story with its great oblong windows separated by pilaster strips decorated with seraphim. The dome of Michelangelo is framed by the two bell towers and by the smaller domes of the Clementine Chapel (left) and the Gregorian Chapel (right).

In the square, at either side of the stairway leading up to the basilica, are the two symmetrical buildings planned by Maderno in 1613 to form the sides of a courtyard closed at the back by the facade. The building on the left was supposed to become the new residence for the archpriest of Saint Peter's, while the building on the right was to be the entrance to the Apostolic Palace.

In the upper part of this engraving are the coats of arms of Pope Paul V and Cardinal Scipione Borghese, the pontiff's nephew and prefect of the "Holy Congregation for the Reverend Fabric of Saint Peter's." P.Z.

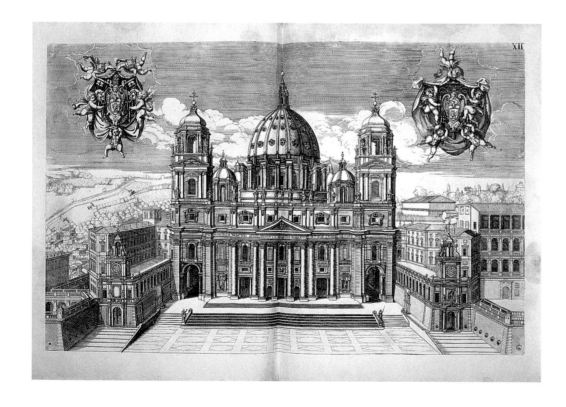

Tiberio Alfarano's Plan of the Old Basilica of Saint Peter's

17th century
Carlo Fontana (d. 1638)
Print
77 × 50 cm
Reverenda Fabbrica of Saint Peter, Vatican City State

Tiberio Alfarano di Gerace (died 1596) was canon of Saint Peter's Basilica for more than forty years. Perhaps from as early as 1544 he lived in the shadow of the old medieval church, which in those years was being demolished to make way for the new Renaissance building. A cultured man with an interest in architecture and having great feeling for that immense heritage of faith, art, and history, Alfarano understood the importance of documenting with notes and drawings the venerated remains of the old basilica that were destined to disappear forever. In his will he arranged that his manuscripts be left to the Chapter of Saint Peter's and his library to the Jesuit Penitentiaries of the basilica.

The original of Alfarano's plan was conserved in the capitular archive and only after its restoration was it transferred to the general archive of the Fabric of Saint Peter's, where it is housed today. The paper plan is glued to three boards of fir held together by two crosspieces of poplar; its exact dimensions are 117.2 centimeters by 66.6 centimeters. The plan of the old basilica is inserted within that of the basilica of Michelangelo, with the oratories and surrounding buildings shown in sepia and red watercolors. The exterior wall of the old basilica is delineated with gilding done in gold leaf, while the outline of the Renaissance church is highlighted in a light turquoise in tempera on a white lead background.

The plan held by the general archive of the Fabric of Saint Peter's is probably a "working copy" on which Tiberio Alfarano reproduced corrections and additions. To this end he used a grid traced in graphite pencil in the upper part of the plan. As an aid in drawing Michelangelo's basilica he used the plan designed by Vignola and engraved by Étienne Du Pérac in 1569. In all probability Alfarano was able to draft his first clean copy of the plan in 1571, but it was only in 1589, during the pontificate of Pope Sixtus V, that he managed to print it at his own expense. The engraving for the publication was done by Natale Bonifacio da Sebenico, the same artist who produced the plates for Domenico Fontana's book on the "transfer of the Vatican obelisk." The plan was dedicated to Cardinal Giovanni Evangelista Pallotta, archpriest of the Vatican basilica, and the pope recognized Tiberio Alfarano's copyright, prohibiting the publication of the plan without the prior authorization of the author.

Later, Martino Ferrabosco made an engraving of Alfarano's plan for his book *Architettura della Basilica di San Pietro in Vaticano*, first published in Rome in 1620 and reprinted in 1684. P.Z.

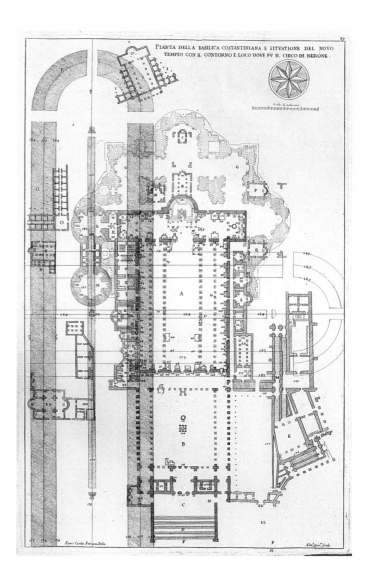

Southern Elevation of the New Basilica of Saint Peter's

From *Architettura della Basilica di San Pietro in Vaticano* (Rome, 1620), pl. 13

17th century
Martino Ferrabosco (died 1638)
Print
51 × 78 cm
Reverenda Fabbrica of Saint Peter, Vatican City State

This plate shows an elevation of the left side of the new basilica including the smaller domes and the bell tower. The tower appears as it was imagined by Ferrabosco and is different from that planned by Carlo Maderno in 1613 and known to us through engravings by Matthaus Greuter, Giovanni Maggi, and Alessandro Specchi.

The southern elevation of the basilica is shown in all its majestic beauty, for its overall length of approximately 216 meters. The balustrade over the attic is 48 meters above the ground, the external diameter of the dome is 58.9 meters, and the cross over the lantern stands 133 meters high. The form, sequence, and dimensions of the niches on the travertine outside wall were designed by Michelangelo, who thus also effectively determined the external appearance of that part of the basilica added by Carlo Maderno. Pilasters surmounted by three meter-high Corinthian capitals support the entablature. Above that is the attic story surmounted, in Ferrabosco's engraving, by a balustrade of columns, which does not exist. The spaces between the pilasters are each occupied by a great niche (below) and a loggia with a nonprojecting balcony (above), surmounted by triangular and semicircular pediments. The loggias are flanked by Ionic columns that stand upon bases the same height as the balustrade. In the smaller spaces between the pilasters are two semicircular niches, a loggia with balcony, and a square window at the same height as the capitals. Along the attic story, windows with an architrave alternate with decorative niches crowned with the tiara and keys, symbol of the Fabbrica of Saint Peter.

Michelangelo's dome rises majestically, in line with the apse at the southern extreme of the transept. The dome itself is beautifully illustrated in plate 20 of Martino Ferrabosco's work, also in this exhibition. P.Z.

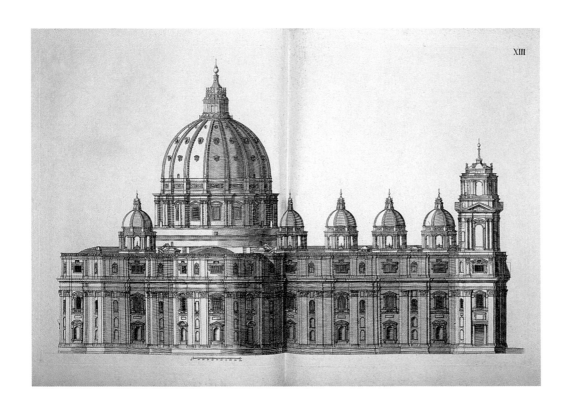

XIII

Sectional View of the New Basilica of Saint Peter's

17th century
From *Architettura della Basilica di San Pietro in Vaticano*
(Rome, 1620), pl. 14
Martino Ferrabosco (died 1638)
Print
51 × 78 cm
Reverenda Fabbrica of Saint Peter, Vatican City State

Martino Ferrabosco depicts a longitudinal section of the new basilica with the intention – as he declares in the text – of showing the dimensions of the greatest church in Christendom. A scale graded in Roman palms appears in the lower margin of the sheet, with which it is possible to ascertain the overall internal length of the basilica (186.36 meters) and the height to the top of the vaulted roof of the nave (45.5 meters). The Corinthian pilasters are about 25 meters high and the great arches supporting the dome are 23 meters wide and 44.8 meters high. The internal diameter of the dome is 41.5 meters and the vault of the lantern stands 117.57 meters above the floor level of the basilica.

Under the floor of the nave is the vaulted roof of the Vatican Grottoes, the origins of which date back to an initiative of Antonio da Sangallo the Younger. At the death of Raphael, Sangallo presented Pope Leo X with a proposal for raising by thirteen and a half palms (a little more than three meters) the floor of the basilica then being built, so as to keep the harmonious gravity he perceived in the buildings of ancient Rome. The result of this floor raising was the creation of the Vatican Grottoes. The eastward extension of the Grottoes came to a halt at the level of the "dividing wall," ordered by Pope Paul III to separate the building site of the new basilica from what remained of the old church.

When Pope Paul V ordered the Renaissance basilica be lengthened, Carlo Maderno placed the floor of the new building beyond the "dividing wall" on solid earth and not on vaults as Sangallo had done.

Ferrabosco's engraving shows the mosaic decorations of the dome, completed between 1603 and 1613, and the figures of the Virtues on the spandrels of the arches of the nave. The stucco statues of the Virtues, some six meters in length, actually date from different periods (between 1599 and 1717) and are the work of different artists; their presence in Ferrabosco's drawing of 1620 indicates that their appearance and position must already have been defined and approved, at least in general terms. Although the scale of this engraving is too small for an adequate portrayal of the attributes of each statue, it is nonetheless possible to recognize, on the spandrel of the fourth arch beyond the entrance to the basilica, the two Virtues (Faith and Charity) made by Ambrogio Buonvicino (1552–1622) during the pontificate of Pope Clement VIII.

This drawing differs from the current appearance of the basilica in its depiction of the minor domes and the bell tower, visible above the section of the portico and the Hall of Blessings. The tower, the form of which differs from that actually planned by Maderno, is a variant of that illustrated by Ferrabosco in plate 12 of his book. P.Z.

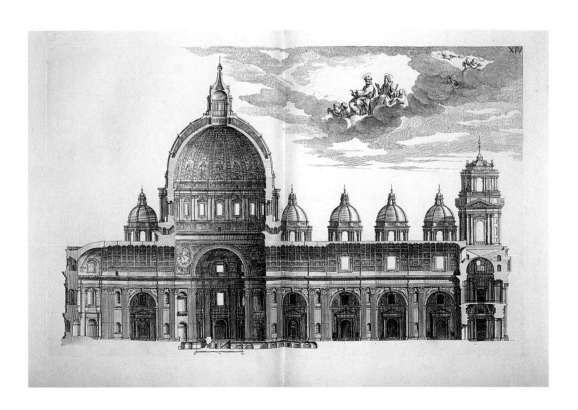

Elevation and Section of the Dome

From *Architettura della Basilica di San Pietro in Vaticano*
(Rome 1620; reprint 1684), pl. 20
1620
Martino Ferrabosco (died 1638)
Print
51 × 78 cm
Reverenda Fabbrica of Saint Peter, Vatican City State

This engraving is from *Architettura della basilica di San Pietro in Vaticano. Opera di Bramante Lazzari, Michel'Angelo Bonarota, Carlo Maderni, e altri famosi Architetti, da Monsignore Giovanni Costaguti Seniore, Maggiordomo di Paolo V. Fatta esprimere e intagliare in più tavole da Martino Ferrabosco e posta in luce l'Anno M.DC.XX.* Following this first edition, which cannot be found today, the work of Ferrabosco (or Ferraboschi) was republished in Rome in 1684 by the Apostolic Chamber and dedicated to Pope Innocent XI.

This print presents an interesting view of the dome, showing it in the form in which it was built by the architect Giacomo Della Porta and his assistant Domenico Fontana between 1588 and 1590, during the time of Pope Sixtus V. The drawing shows neither the drum, completed by Michelangelo before his death in 1564, nor the lantern, which was added to the dome between 1590 and 1593, during the pontificate of Pope Clement VIII. On the left of the drawing the external elevation may be seen, with the protobaroque windows, the lead covering, and the elegant ribs that divide the dome into sixteen segments. In completing Michelangelo's work, Della Porta gave the dome a more slender ogival form, reducing the more rounded curve of the original plans. This was particularly appreciated by Ferrabosco, who appends the following comment to this plate: "Looking from the exterior one may see how fine is the crafting of the curve of the dome—which has been imitated by so many made since—giving appropriate form to the inside and to the outside. And to preserve that form, how commendable it was to think of duplicating the vault; for this great artifice is divided into two vaults, one within the other."

The space between the two shells, growing progressively larger toward the lantern, may be seen on the right of the illustration, which also shows the internal decoration of the dome, made up of sixteen segments each divided into six sections giving a total of ninety-six figures in trapezoidal and round backgrounds. The mosaic decorations, in which blue and gold tesserae predominate, were executed between 1603 and 1613 by the most distinguished mosaic artists of the time under the guidance of Marcello Provenzale. Giuseppe Cesari, known as the Cavalier d'Arpino, drew the cartoons on the basis of indications furnished by Cardinal Cesare Baronio. The design had to constitute a hymn of praise to the Lord. To the right of the plate, a scale graded in Roman palms draws the observer's attention to the extraordinary dimensions of the dome of Saint Peter's. Its internal diameter is 41.5 meters; the external diameter, 58.9 meters; and the height from the floor to the small vault of the lantern, 117.57 meters. P.Z.

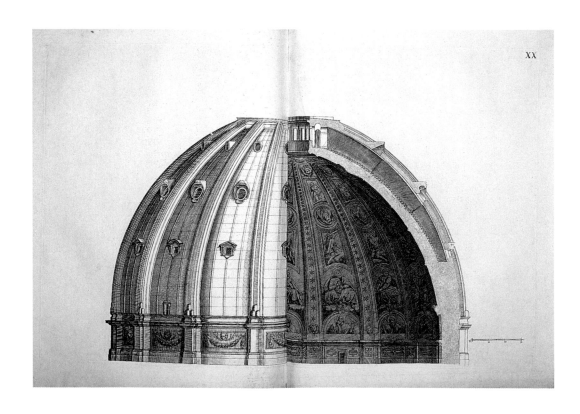

Elevation and Section of the Dome

Funerary Monument To Pope Paul III

From Architettura della Basilica di San Pietro in Vaticano
(Rome, 1620; reprint 1812), pl. 32
17th century
Martino Ferrabosco (after 1623)
Print
53 × 73 cm
Reverenda Fabbrica of Saint Peter, Vatican City State

The last of the engravings that illustrate the 1812 edition of Martino Ferrabosco's book shows the funerary monument erected to Pope Paul III. A patron of arts and literature, Pope Paul III gave a renewed impulse to the construction of the new Saint Peter's, entrusting the task to Michelangelo following the death of Antonio Sangallo the Younger. He was the first pope to have a funerary monument in the new basilica. The project was charged to Guglielmo Della Porta of Milan, and Pope Paul III came to an agreement with the sculptor whereby a bronze statue would be placed atop the monument and a series of allegorical figures at the sides. At the death of the pontiff, his nephew, Cardinal Alessandro Farnese, took over the project, following the advice of his secretary Annibal Caro.

In 1550, Guglielmo Della Porta made a wooden model of the grandiose mausoleum, which, it was intended, should be placed in an isolated location and decorated with sculptures and reliefs in marble and bronze, among them eight allegorical statues in reclining positions. Michelangelo considered the project too cumbersome, however, and suggested the statues be reduced from eight to four and that a smaller monument be made and placed against the northeast pier of the building. In May 1553, the bronze statue of the pope, more than three meters high, was complete and in 1558 the marble sculptures of Justice, Prudence, Peace, and Abundance were also finished.

In 1559, the statue of Pope Paul III was placed on a small marble base in the location Michelangelo had indicated. This was a provisional arrangement, and in 1574, in the middle of the Gregorian chapel, a great monument was built that comprised the statue of the pope and the four allegorical figures, the whole reaching a height of some nine meters; four years later, in 1578, it was dismantled and rebuilt in the form of a wall monument near the niche of the southeast pier of the basilica, where it remained for half a century. In 1628, the monument to Pope Paul III was dismantled for the last time to place the four statues of Saint Andrew, Saint Longinus, Saint Helena, and Saint Veronica in the niches of the piers supporting the dome. Gian Lorenzo Bernini had the monument rebuilt in a privileged position, within a niche specially prepared by Agostino Radi and Francesco Borromini on the left side of the apse, facing the spot that Pope Urban VIII had chosen for his own grave. Eighty years after his death, Pope Paul III's grave had finally found its definitive location within the new basilica.

Martino Ferrabosco's engraving is a faithful reproduction of the monument, which stands upon a double base of veined African marble on which rest two ornamental tables with the allegorical figures of Justice (left) and Prudence (right). The statues of Peace and Abundance were removed to Rome's Palazzo Farnese, where they were used to decorate a fireplace. Justice is shown as a young woman with the fasces and the lance in her left hand and the flame, symbol of truth, in her right. Her painted metal vestments were added in 1595 at the order of Pope Clement VIII by Teodoro Della Porta, Guglielmo's son. Prudence appears as an elderly woman who sees her image reflected in the mirror she holds in her right hand while, in her left, she bears a book on which Della Porta's name is inscribed. An exquisite mask of Saturn in black portoro marble completes the decoration of the base. On the front of the sarcophagus is an inscription with gold letters set in a black marble oval within a winged scroll. The decoration is enriched with bronze volutes with Bacchic masks and two putti made by Antonio Gentili da Faenza for the tomb of Francesco de Solis, bishop of Bagnoregio (died 1545). The two bronze bas-reliefs at the sides of the base also come from the same tomb, though they are not very visible in their present position. The sitting statue of the elderly pontiff who died at the age of eighty-one is placed at the top of the monument. His right hand is stretched out, his head bare, and his gaze turned thoughtfully downward: the solemn and powerful stance of a pope noted among his contemporaries as a man who knew how to dominate himself and others. P.Z.

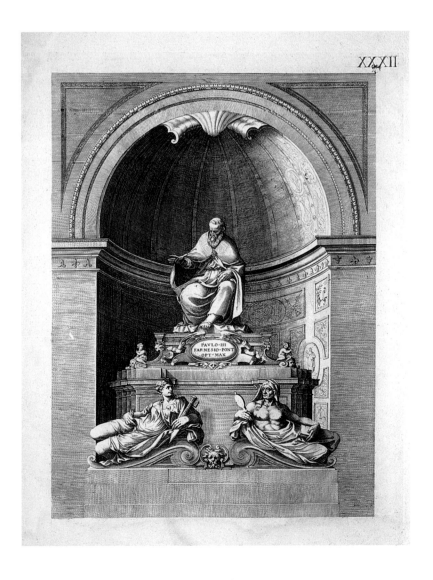

Drawing of a Ciborium for the Altar of the Apse of the Basilica of Saint Peter's

From *Architettura della Basilica di San Pietro in Vaticano*
(Rome, 1620; reprint 1638), pl. 27
17th century
Martino Ferrabosco (d. 1638)
Print
51 × 78 cm
Reverenda Fabbrica of Saint Peter, Vatican City State

This plate is inspired by the ciborium built by Carlo Maderno over the altar that stood at the entrance to the apse of the new basilica. Work began in 1606, when Pope Paul V ordered the construction of a ciborium for the new altar table in the apse and of a temporary baldachino for the high altar built by Pope Clement VIII over the tomb of Saint Peter. Of these two structures, the former also had the function of separating the apse from the rest of the church by means of a balustrade or "railing" on steps. The temporary baldachino was planned as a painted canopy held up by slim columns supported by four angels in stucco, a provisional structure that anticipated the grandiose bronze baldachino.

Ferrabosco's engraving shows a ciborium with two side structures and a balustrade along the bottom. The architectural order is composed of spiral columns with a continuous cornice supporting an attic story. The columns, surmounted by Corinthian capitals, stand upon bases that are the same height as the balustrade. The two side structures each have a central arch flanked by narrower openings. The ciborium has a dome supported by four great arches, alternating with four oval windows and a pediment above. On the attic story over each side arch is a bas-relief surmounted by a semicircular pediment over which two angels bear a coat of arms with the heraldic emblems of the family of Pope Urban VIII.

It is interesting to contrast this engraving with two designs attributed to Francesco Borromini (Hibbard 2001, fig. 192) and Carlo Maderno (Hibbard 2001, fig. 193), both held in the Albertine Museum in Vienna. They show a simpler colonnaded structure with less exuberant sculptures and do not include the attic story above the entablature at the sides of the ciborium. Borromini shows the balustrade linking the bases of the columns. The same structure also seems to be represented in another drawing by Borromini, a sketch by Derand, and a design by Guerra (Hibbard 2001, figs. 188, 189, 191).

In all probability this structure, built in the apse at the orders of Pope Paul V and demolished by Pope Urban VIII, had ten spiral marble columns that had once constituted the "pergula" of the old basilica and four other similar columns specially made of wood. Indeed, a bill signed by Carlo Maderno on November 19, 1606, and today held at the general archive of the Fabric of Saint Peter's (ARM. 6, B 368, f. 6) records payment for the making of fourteen bases with stucco decorations for the eight spiral columns around the altar and the six side columns. P.Z.

XXVII

Illustrated Book showing Towers and Staging used in Saint Peter's

Rome, 1824 (second edition)
Nicola Zabaglia
Printed book
60 × 96 cm (open)
Reverenda Fabbrica of Saint Peter, Vatican City State

In centuries past, any construction or decoration work of the Vatican Basilica required the use of such equipment as staging, trusses, scaffolding, towers, winches, and ladders. Throughout classical antiquity and until the Industrial Revolution, these structures were wooden. Such work called for special qualifications and, above all, for men with great inventive and organizational powers, capable of finding imaginative solutions to compensate for the inferior material. Among these men, a preeminent position must be reserved for Nicola Zabaglia, resourceful inventor and author of *Castelli e Ponti di Maestro Nicola Zabaglia con alcune ingegnose pratiche e con la descrizione del trasporto dell'obelisco Vaticano e di altri del Cavaliere Domenico Fontana*. The work in Italian and Latin language was published in Rome 1743 and reprinted in 1824 by the Fabbrica of Saint Peter with some additions and a bibliography of the author written by the lawyer, Filippo Maria Ranazzi

Nicola was born in Rome in 1664 to a Tuscan family. His father was Alessandro Zaballi, one of the three master builders of the Fabbrica of Saint Peter in 1679. In 1686, when he was twenty-two, Nicola's name appears for the first time in the registers as a builder working on the restoration of the roofs and screens of the basilica. It was the beginning of a rapid and brilliant career that would see him involved in the most important works to be carried out in Saint Peter's over a period of some sixty-four years. Although he was illiterate, Nicola Zabaglia was blessed with acute powers of observation and exceptional practical capabilities that enabled him to invent, plan, and build towers, staging, and other structures for the various requirements of the basilica. Some of his works were inspired by those of other great masters such as Luigi Bernini, Gian Lorenzo's younger brother, who built the huge scaffolding for the baldachino and the monument to the *cathedra*, and Luigi Vanvitelli who, in letters sent to the canon of the church of San Giovanni dei Fiorentini in Rome, claimed to have invented some of the staging that Zabaglia had presented in his own book.

All this, however, does not diminish Zabaglia's achievements. In 1703 he took just three months to place fifty statues on top of Bernini's colonnade with his so-called antenna, a mobile, cranelike structure of his own invention. Similar machines were used in 1713 to position ten statues of saintly founders of religious orders in the upper niches of the basilica. Among other enterprises, he also participated in placing the equestrian statue of Charlemagne in the portico of the basilica (1724), building the scaffolding for the restoration of the dome (1744), and the excavation and transferal of the obelisk of Augustus in the Campus Martius (1748).

The illustration on view here is taken from the second edition of Zabaglia's book, which was originally published in 1743. The title of the drawing appears at the bottom together with the name of the engraver, Giacomo Sangermano, and the dedication to "Sua Eccellenza Reverendissima Francesco Caffarelli Segretario Economo della Reverenda Fabbrica." The plate (number 59) shows the staging designed by Pietro Albertini built over the cornice of the nave of the basilica on November 26, 1773, and raised into place using six winches. This difficult enterprise would not have been possible without the experience of Nicola Zabaglia, who was the first to devise such daring projects and was an inspiration for later generations. P.Z.

Facade of the Basilica of Saint Peter's with the Bell Tower

From *Il Tempio Vatican e la sua origina* (Rome, 1694), pl. 267
Carlo Fontana (1634–1714)
Print
47 × 34 cm
Reverenda Fabbrica of Saint Peter, Vatican City State

This shows a fine view of Saint Peter's Basilica with the bell tower built by Gian Lorenzo Bernini (1598–1680) at the southern end of the facade

The ill-starred saga of the bell towers of Saint Peter's began in September 1612 when Pope Paul V modifying the original plans of the architect Carlo Maderno (1556–1629), ordered the construction of two towers, one at either end of the facade. Work on the right-hand bell tower began three months later (and it immediately became necessary to introduce some alterations to the shape of the corner of the tower), while the foundations for the left-hand (southern) bell tower only got under way in 1618. The precarious nature of the terrain at this end of the facade made it necessary to consult Bignago, considered one of the greatest professional men of the age in such work. Deep wells were excavated and channels created to drain away the water from the phreatic stratum below. The pope himself, visiting the site in September 1618, was made aware of the difficulty and complexity of the work. When Pope Paul V died in 1621, the bell towers had reached the height of the facade and the two great arches had been built, still visible today at either end of the facade.

During the pontificate of Pope Urban VIII work began again, this time entrusted to Gian Lorenzo Bernini who, in 1636, presented the pope with a wooden model showing how the bell towers should be completed. The new project envisaged heavier towers and an expense of some 70,000 scudos, as compared to the 30,000 scudos for which Maderno had originally budgeted. Work began on the southern bell tower in 1638, the first order above the attic story was completed by 1639, the second in 1640, and the following year the ashlars were being prepared to support the upper "pyramid." A life-size wooden model of this "pyramid" was presented to Pope Urban VIII who, however, did not like it. Later when some of the planned sculptures had already been ordered and the northern bell tower near the Apostolic Palace was already under way, work was suspended because cracks had begun to appear at the southern end of the portico and on the facade.

In 1645, five sittings of the Congregation for the Fabric of Saint Peter's were held in an attempt to find a solution that would redress the situation and enable an enterprise that had already cost so much effort to be completed. The opinions of the most famous architects of the age were heard: called in one at a time to the assembly of cardinals, each had the opportunity to give his own opinion as to the causes of the subsidence and the best remedy to adopt. Old master builders (Colarmeno and Drei) who had worked on the foundations under Maderno were also interrogated. Those consulted suggested the bell towers be "repaired," using a variety of different solutions documented in letters, drawings, and technical reports. Of these reports, one of the most interesting is the "Discorso" of Martino Lunghi, who proposed creating extended foundations for the entire facade and who is also mentioned in Carlo Fontana's book. The opinions of the experts did not alleviate the fears of the Congregation for the Fabric of Saint Peter's that the stability of the entire basilica was at risk and so, on February 23, 1646, Pope Innocent X ordered the bell tower be demolished. He was at first inclined to insist the work be financed by seizing Bernini's assets, though this sanction was probably never applied, part of the expense being met by the sale of travertine from the tower.

Carlo Fontana criticizes Maderno for not having created adequate foundations for the southern end of the facade where, instead of building "sack foundations with uncut chunks of travertine and poor quality mortar," he should have used cut stone placed in such a way as to form a solid base. Fontana is also critical of Gian Lorenzo Bernini, guilty of not having checked the quality of the foundations before starting work on the heavy bell tower. In keeping with the opinions of most of the contemporary architects, Carlo Fontana felt it would have been possible to repair the bell tower; this is clear from the engraving on display here,

particularly from the plan shown under the elevation of the basilica. It would first of all have been necessary to reinforce the four pillars (letter "A") that supported the tottering bell tower with six great walls linked together with a structure "in the form of great niches." The stability of the tower would not have been compromised by the inevitable removal of earth because the "foundation ditches" would have been excavated and filled in progressively. P.Z.

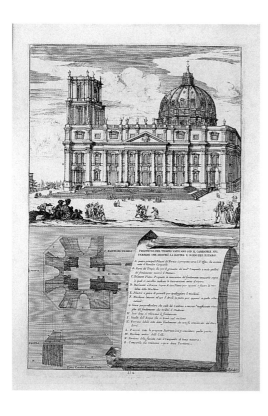

Dome of Saint Peter's

From *Il Tempio Vatican e la sua origina* (Rome, 1694), pl. 311
Carlo Fontana (1634–1714)
Drawing, Carlo Fontana
Engraving, Alessandro Specchi (1668–1729)
Print
47 × 34 cm
Reverenda Fabbrica of Saint Peter, Vatican City State

Fontana's drawing shows the dome as it appears today, with a more slender form than that of the original plans, which had allowed for a more rounded curve. The majestic structure rises from a pedestal that is marked in three points with the letters B, D, and F. The eight buttresses around the drum are made up of double columns that enclose windows with alternating triangular and semicircular pediments. The attic, over the entablature supported by the flying buttresses, is decorated with panels with vegetable garlands; at the base of each rib may be seen the sculpted coat of arms of Pope Sixtus V. The dome is shown in all its well-proportioned elegance with its lead covering and the protobaroque windows that allow light to penetrate the space between the two shells. The lantern with its twin columns on high pedestals, the corresponding volutes in the middle section, the candle holders, and the pinnacle surmounted by the bronze sphere and the cross draw the whole structure upward with incomparable solemnity and beauty.

Over the buttresses to the right of the drum the statue of a prophet may be seen, one of the sculptures that was intended, perhaps in Michelangelo's mind, to decorate the attic. Fontana himself hoped those statues would be placed over the thirty-two columns of the drum in such a way as to form "a delicate and most noble crown" around the base of the dome (Fontana, book V, ch. 8, p. 305). Clay models of

these statues were made by Antonio Corradini in 1743 to be fixed to the wooden model of the dome that Michelangelo had had made between November 1558 and November 1561. That model, built on a scale of 1:15 and today conserved by the Fabbrica of Saint Peter in the octagon of Saint Basil, would serve as a guide for later architects.

Work on the dome came to a halt with the construction of the drum following the death of Michelangelo in 1564. In January 1587, Pope Sixtus V charged the architect Giacomo Della Porta and his assistant Domenico Fontana with the task of completing the dome. Work began in 1588 and proceeded apace with more than eight hundred builders involved in the operation. By the summer of 1590, after twenty-two months of intense labor, the dome was finished and the moment was celebrated with a mass of thanksgiving and fireworks. During the pontificate of Pope Clement VIII, the construction of the lantern was completed and lead covering was applied to the dome. On November 18, 1593, the gilded bronze sphere and cross, the work of Sebastiano Torrigiani, were put in place atop the lantern. Pope Clement VIII ordered that this great operation dedicated to the glory of Saint Peter by his illustrious predecessor be recalled by an inscription around the ring on the inside of the lantern within the basilica: "S. PETRI GLORIAE SIXTUS PP. V. A. MDXC PONTIF. V" (To the glory of Saint Peter, Pope Sixtus V, in the year 1590, fifth of his pontificate).

P.Z.

Facade of the Basilica of Peter's

From *Il Tempio Vatican e la sua origine* (Rome, 1694), pl. 417
Carlo Fontana (1634–1714)
Drawing, Carlo Fontana
Etching, Alessandro Specchi (1668–1729)
Print
47 × 34 cm
Reverenda Fabbrica of Saint Peter, Vatican City State

This view of the eastern elevation of the basilica is executed in such a way as to show the drum in its entirety, the dome of Michelangelo, and the two smaller domes over the Clementine Chapel (to the south) and the Gregorian Chapel (to the north). With the exception of one or two details, the drawing represents the present appearance of the basilica. The two clocks at opposite ends of the facade are, of course, missing from the drawing; they were put in place by the architect Giuseppe Valadier during the pontificate of Pope Pius VI. The facade was built between 1607 and 1614 by Carlo Maderno, who, in planning this extension of the new Saint Peter's, was obliged to respect the limits imposed both by the height of the side elevation of the Renaissance building and by the dimensions of the old basilica, which was intended to be enclosed within the perimeter of the new church. Maderno also began work on two bell towers over the two arches at either end of the facade, but the land beneath gave way and the project had to be abandoned. Work on the facade took place during the pontificate of Pope Paul V, whose name is immortalized in the mosaic inscription on the frieze; above the inscription is the triangular pediment enclosing the papal coat of arms in marble. Fontana's drawing shows the facade in full detail over its entire extension (118.6 × 43 meters). Eight gigantic columns with Corinthian capitals flank the five openings that give access to the atrium; these correspond to the five doors to the basilica. Above are nine windows, enclosed by columns that support alternating semicircular and triangular pediments. The central window gives onto a loggia used by the pope for imparting solemn blessings. Between this Loggia of the Blessings and the central opening of the facade, Fontana's drawing even includes, though in stylized form, the marble bas-relief of Ambrogio Buonvicino (1552–1622) representing Christ giving the keys to Peter. The attic over the entablature is marked by large square openings. Thirteen travertine statues, about six meters high and made between 1612 and 1614, were placed on the balustrade: the statue of the Redeemer stands in the center with Saint John the Baptist to his right followed by the figures of the apostles.

Statues of Saint Peter and of Saint Paul may be seen in the square in front of the facade, to right and left, respectively, as one faces the basilica. The statues that appear in Fontana's drawing are those made after the middle of the fifteenth century by Paolo di Mariano, known as Taccone, and by his workshop. Pope Pius IX ordered that they be removed and taken to a room of the Apostolic Palace. They were replaced with the marble statues of Saints Peter and Paul that may be seen today, the work of Giuseppe de Fabris and Adamo Tadolini, respectively. P.Z.

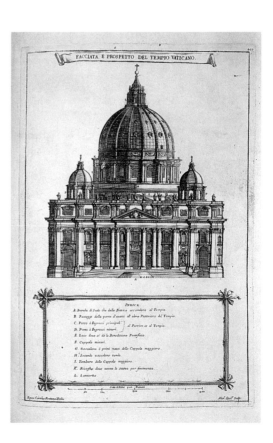

Model for the Illuminations of the Basilica of Saint Peter's

18th century
Tempera on canvas
197 × 142 × 91 cm
Reverenda Fabbrica of Saint Peter, Vatican City State

The newly restored model, on public display for the first time, shows the left facade of Saint Peter's Basilica, the southern flank, and the back elevation of the so-called Arch of the Bells. All the architectural features are painted in tempera on a canvas specially treated with a light priming of glue and plaster. The canvas is nailed to a poplar-wood structure with uprights linked by a horizontal frame at the top and bottom. The only part of the model that juts out in relief is the upper cornice formed by a molded wooden ledge covered with canvas. The baseboard protudes from the perimeter with the exception of the sectioned right side. All the essential features of the facade are depicted, although the gates of the portico are not shown and neither are the statues above the attic story or the inscription on the frieze. The balustrade extends round the left side of the basilica, covering the part of the facade later occupied by the so-called clock *all'italiana*, the work of the architect Giuseppe Valadier (1762– 1839) in 1789. The southern flank of the basilica, which was not illuminated, is shown only schematically and there is no indication of the so-called "Charlemagne Wing" that links the atrium to the colonnade built by Bernini during the pontificate of Pope Alexander VII. At the center of the side elevation, instead of the loggia and niche surmounted by a triangular pediment, are the niches that appear on the oblique edges of the facade, while the oblique edges themselves, on this model, are undecorated.

Built on a scale of 1:33, the model was created to give an idea of how a project for illuminating the facade would look. To this end the points where supports for torches and lanterns were to be fixed are precisely indicated. The torches were recognizable by a bright red flame, apparently moved by a light breeze blowing from the north, while the lanterns are shown as small red and white cylinders. On the basis of the lights shown on the model, it is possible to calculate that the entire facade had more than one hundred torches and eighteen hundred lanterns. The lanterns, placed not only on the overhang of the cornice and the balustrade but also on the pilaster and columns, highlighted the lines of the facade, which in the dark must have seemed like "fine silver embroidery," to use the graceful expression of Francesco Cancellieri (1751–1826), author of works on Saint Peter's and the Vatican sacristy. This was probably the effect intended by using lanterns as the main element of the illuminations; they emitted a pale and dim light but, all together, they traced the elegant outline of the basilica against the sky. Even more spectacular than this must have

been the project for illuminating the basilica designed by the architect Luigi Vanvitelli (1700– 1773) for the jubilee of 1750, a splendid model of which is still conserved by the Fabric of Saint Peter's. Vanvitelli's plan envisaged the sudden and simultaneous ignition of numerous torches, the glare of which would dim the light of the lanterns.

Such double illuminations required great expense and a lot of men (as many as four hundred), and were reserved for important events and solemn feast days. For less important celebrations the facade was more simply illuminated with lanterns. More or less spectacular illuminations were organized for papal coronations, canonizations, and the visits of princes and rulers. In addition to these occasional or exceptional moments, the basilica was also lit up every year on the nights of June 28 and 29 for the feast of Saints Peter and Paul.

By studying the numerous documents held in the general archive of the Fabric of Saint Peter's, it is possible to follow the history of the external illumination of the basilica from the beginnings in the seventeenth century until the last occasion it was lit up with torches and lanterns, on November 1, 1950, for the proclamation of the dogma of the Assumption by Pope Pius XII. For each period, these precious records give a detailed analysis of costs for the particular materials used. Thus we come to know that the oil lanterns had a wick made of rags soaked in resin, and that the torches had the form of metal receptacles ("*pans*") wherein tallow was melted, a loop of old rope was coated in the tallow and attached to a wick soaked in tar. There were also windproof torches, tallow candles, and different kinds of support for each type of light. It is clear from the documentation that the illuminations of Saint Peter's were often planned by famous architects who also directly superintended the activities of the original groups of workmen as they quickly

and skillfully undertook the complicated task of lighting the torches. The illumination of the basilica reached its height of splendor and elegance in the eighteenth century, which is also the period in which the model on display here was made. The same century saw the introduction of colored lanterns to replace those made of white paper. In 1767, Giuseppe Brugiadori presented the Congregation for the Fabric of Saint Peter's with an invention intended to render the illuminations "clearer, more limpid and smokeless" and, also in the eighteenth century, special devices and supports for the "pans" were devised so as to facilitate the simultaneous ignition of the torches.

All this helped to add to the attraction exercised by the illuminations of Saint Peter's, which became required on the itinerary for anyone traveling to Italy. Johan Wolfgang Goethe recalls his own visit to Saint Peter's Square on the evening of June 28, 1787, in these words: "The sky was completely clear and the moon shone, its brightness gently subdueing the flame of the lamps.
Only at the end, during the second illumination when all was one great blaze, even the light of the moon was dimmed… To contemplate the beautiful outline of the church and the dome in a vision of fire is a grand and captivating sight." P.Z.

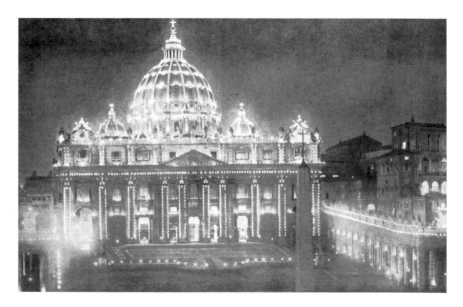

Illumination of Saint Peter's Basilica, early twentieth century

243

Document Signed by Antonio da Sangallo the Younger

1529
Paper
30 × 21 cm
Reverenda Fabbrica of Saint Peter, Vatican City State

This document, a letter written by Antonio da Sangallo the Younger to "Magnifico Messer Eusebio" and "Signori Deputati della Fabbrica di San Pietro," was taken to Rome by one "maestro Pierino del Capitano." It was written on January 30, 1529, during the pontificate of Pope Clement VII. From the letter we learn that Sangallo was engaged in the fortification of Orvieto, where the pope, together with his entire court and the apostolic see, could take refuge in case of need. In it he speaks of the construction then under way of two "large and deep" wells capable of supplying the population with potable water in the case of a prolonged siege, thus precluding the possibility that a single soldier could interrupt the town's water supply by demolishing part of the aqueduct that then existed. This information is particularly important if related to the famous well of San Patrizio, that great work of civil engineering mentioned by Giorgio Vasari (1511–74) and carried out by Antonio da Sangallo the Younger between 1527 and 1535. At the end of his letter, the Florentine architect asks the Fabbrica of Saint Peter for 175 ducats as payment for seven months work (July 1528 to January 1529). At the bottom of the sheet is his signature ("ant.[oni]o da Ssangallo").

"Sangallo" was the name of the area of Florence where one of the most important sixteenth-century families of architects originally lived. The leading members of this family were the brothers Giuliano and Antonio Giamberti, and Antonio Cordiani, known as Antonio da Sangallo the Younger to distinguish him from his maternal uncle of the same name. The names of both Giuliano da Sangallo (ca. 1445–1516) and Antonio da Sangallo the Younger came to be associated with the Vatican basilica, which was then under construction.

Theorist and builder, planner and researcher of antiquities, contractor and business man, Antonio da Sangallo the Younger created numerous works of civil and military architecture all over Italy, assisted in his enterprises by a group of talented helpers. In Rome, he began Palazzo Farnese, and his undertakings over the twenty-six years he was director of works at the Fabbrica of Saint Peter proved to be of fundamental importance for the basilica. It was he who determined the floor level of the present building; the plans of Bramante, Fra' Giovanni Giocondo, Giuliano da Sangallo, and Raphael all placed it at the same level as that of the Constantinian basilica. With the approval of Pope Leo X, Sangallo the Younger raised the floor of the new church some three meters, supporting it by a series of galleries with semi-cylindrical or "barrel" vaults. The space thus created, initially used for slaking lime, was later converted into the Vatican Grottoes. The plans of Antonio da Sangallo the Younger show the definitive aspect that the new basilica was expected to have at the time of Pope Paul III. However, with the arrival of Michelangelo in 1546 the project was altered once more. P.Z.

Document Signed by Giacomo Della Porta

1585
Paper
21 × 30 cm
Reverenda Fabbrica of Saint Peter, Vatican City State

This document is a bill, dated March 14, 1585, and signed by the architect "Jac[om]o delaporta" (Giacomo Della Porta) and the bookkeeper "Vinc[enti]o Cast[oni]o" (Vincenzo Castronio), for a payment to Giovanni Sbrigola and his son-in-law Lorenzo. Giovanni Sbrigola was a "quarrier" of travertine from Tivoli and supplier to the Fabbrica of Saint Peter. Chips of travertine and other stone were used in the production of lime for cement, while dressed blocks and flags were used in the external cladding and other visible portions. This material, indispensable for the various needs of the Fabbrica, came both from natural quarries and ancient monuments and used to arrive daily at Saint Peter's Basilica. Apart from travertine from Tivoli, the ledgers also record the supply of the same material from the Alban Hills, Monterotondo, and Fiano Romano.

The signature in the lower left corner is that of Giacomo Della Porta, one of the most famous and important architects of the second half of the sixteenth century. Of Lombard origin, he spent most of his life in Rome where he was a follower of Giacomo Barozzi da Vignola. Upon the latter's death he took over the direction and completion of works his master had begun and thus contributed to Saint Peter's, the Capitoline, Palazzo Farnese, and the church of Gesù. He designed buildings and churches, among them S. Atanasio dei Greci, the facade of S. Luigi dei Francesi, and the Villa Aldobrandini at Frascati outside Rome.

Between 1573 and 1588, as architect of the Fabbrica of Saint Peter, he superintended the construction of the new western apse and built the minor domes over the Gregorian and Clementine chapels. Over the same period he completed the demolition and removal of the remains of the old basilica in the area of the transept and the "old tribune."

On May 1, 1585, Pope Sixtus V assigned the architect Domenico Fontana to be Della Porta's assistant for the completion of the dome, a project which had been dormant for twenty-one years.

In 1586, the pope approved Della Porta's design for the dome, the dimensions and curve of which differed from Michelangelo's model. Construction began in 1588 and continued apace with the involvement of eight hundred workmen. In the summer of 1590, Pope Sixtus V celebrated a solemn mass of thanksgiving for the closure of the upper ring of the dome amid festivities that also included displays of fireworks. Later, during the pontificate of Pope Clement VIII, the lantern was completed and the dome was covered with lead sheeting. Thus, it may be seen that some of the most important and complex works in the building of Saint Peter's are due to Giacomo Della Porta. P.Z.

Document Signed by Carlo Maderno

1625
Paper
30 × 21 cm
Reverenda Fabbrica of Saint Peter, Vatican City State

This document, dated October 30, 1625, for painting and gilding work done by Simone Leggi on the temporary baldachino over the altar of Saints Peter and Paul, bears the approval and signature of Carlo Maderno: "Carlo Maderno † mano p[ro]pria."

Carlo Maderno was appointed as architect to the Reverend Fabbrica of Saint Peter on January 1, 1603. Of the twenty-six years he held the post, sixteen were spent in the service of Pope Paul V, two in that of Pope Gregory XV, and eight with Pope Urban VIII. The oldest child of a large family, Maderno was born in 1556 at Capolago, south of Bissone on Lake Lugano, to Paolo Maderno and Caterina Fontana. His mother was the sister of Domenico and Giovanni Fontana, architects of the Fabbrica of Saint Peter from the time of Pope Sixtus V. At the age of twenty he was working in Rome as assistant to his uncle Domenico from whom he learned the art of stucco work. The Fontana brothers involved their nephew in the works being undertaken by the Fabbrica of Saint Peter, and in

1585 Domenico called on his help for the famous enterprise of moving the Vatican obelisk. Three years later he obtained Roman citizenship, both for himself and his brothers. Apart from his work as architect, Carlo Maderno ran his own business transporting travertine from Tivoli to Rome.

Maderno's contribution to Saint Peter's was truly extraordinary. In 1607 he won the competition for the completion of the new basilica; he was, then, fifty-one years old when Pope Paul V entrusted him with one of the most difficult and imposing tasks in the history of architecture. Work on extending the basilica began on March 7, 1607, with the blessing of the first stone by Cardinal Giovanni Evangelista Pallotta (1548–1620), archpriest of Saint Peter's and the man responsible for administering the mammoth operation. Excavations to create foundations for the new structures started immediately, while the painful process of demolishing the only surviving part of the old and venerated basilica also began. By 1612, the main lower order of the facade was complete and work was proceeding on the vaulted roof of the atrium. In 1614, the immense interior nave was also covered with a vault, and in 1615 the first stucco decorations of the basilica were executed. In the same year work began in the area of the main altar. In 1617, the great stairway in front of

the basilica was built and by May 1618 a group of workers from the Canton Ticino was at work on stucco decorations of the atrium. Once the work was finished, in 1619, the doors of the basilica were mounted. At the time of Pope Paul V's death in 1621, the external structures of the greatest church in Christendom could be considered to be complete, while the interior decorations were well under way.

The memory of this undertaking, which involved more than seven hundred workmen and untold multitudes of suppliers, is conserved in the documents of the archive of the Fabbrica of Saint Peter, where the name and signature of Carlo Maderno are frequently to be found on letters, ledgers, and contracts. P.Z.

Charity with Four Putti

Ca. 1627–28
Gian Lorenzo Bernini (1598–1680)
Terracotta; traces of gilt
39 cm
Vatican Museums, Vatican City State
Inv. 662423

Conservation courtesy of Florence D'Urso, with love, in memory of son David, and in honor of her children Donna, Lisa, and Mark

Work on Pope Urban VIII's tomb in Saint Peter's Basilica was begun toward the end of 1628 and kept Gian Lorenzo Bernini occupied for approximately twenty years. During this time, striking changes occurred in the history of style that caused the artist to modify the original. Like the magnificent baldachin on the papal altar (1624–33), the enormous "edifice" was intended to celebrate the glory of the pontificate. Designed for one of two niches to be situated opposite each other in the apse, the tomb was originally planned to be across from the funeral monument of Pope Paul III, built between 1549 and 1575 by Giacomo della Porta. The latter monument would be transferred from its original setting at the pillar currently known as Saint Andrew's. Bernini's new creation was designed as a triangular scheme: the central figure at the top represented the pope; two virtues for which Pope Urban VIII wished to be remembered, Justice and Charity, were positioned on either side of him at the bottom; and Death, symbolized by a winged skeleton writing the pope's name in an open book, was placed in the middle of the sarcophagus lid.

Bernini worked on the tomb from the spring of 1628 until the beginning of 1647, three year's after the pope's death. During this period, he was assisted by his brother Luigi as well as a number of apprentices and stonemasons who supervised the various tasks of hewing, transporting, and assembling the blocks of marble. The monument as it appears today was unveiled on February 9, 1647, in the presence of Pope Innocent X.

The model on view is one of the first studies for the statue of Charity. A bare-headed woman nurses a child in her arms while turning her head toward another on her right who is crying and clutching at her gown. In the lower right-hand corner, two putti embrace. Wind blowing over the figure creates a swirl in the drapery of her gown. A second model, also in the collection of the Vatican's Museum of Christian Art (inv. 62422), reflects a transitional stage closer to the definitive version. In the second study, the number of putti is reduced to two and the folds of the fabric fall in a more orderly fashion.

Two designs dated 1627 are in Vienna and Windsor Castle. Each shows a child drying his tears, a theme that was rejected when the statue was executed in marble. This would suggest an analogous date for the corresponding model, and its execution is usually placed between 1634 and 1639. This chronology would reflect the gradual simplification of the idea as well as imply a stylistic updating deemed necessary after the resumption of work in 1634 after a long pause.

Both terracotta models are of high quality and thus are attributed to Bernini. The one on view was given to the Vatican in 1923 on the occasion of the bequest of the Chigi Library by the State of Italy, which had purchased it with the Chigi Palace in 1917. Previously this statue and its companion were part of Cardinal Flavio Chigi's collection in his villa at the Quattro Fontane, as mentioned in the inventory of 1692. In 1980–81 the statue was restored in the workshop of the Vatican Museums, and the blackish tint that covered its surface was removed. The paint, present on other terracottas of the same origin, may have been applied in the nineteenth century after an evolution in taste. At that time it was considered preferable to disguise the fact that a statue was a study by transforming it into a false bronze. Traces of a previous gold patina, found underneath the black, are preserved along the drapery's borders. G.C.

Gian Lorenzo Bernini, *Monument to Pope Urban VIII* 1647. Basilica of Saint Peter, Vatican City State

Document signed by Gian Lorenzo Bernini

1629
Paper
30 × 21 cm
Reverenda Fabbrica of Saint Peter, Vatican City State

"1629 / A di 18 dicembre 1629 / Lavori di intaglio fatti dal Sig. r Agostino Radi per l'Arme sotto / la Navicella, di N[ostro] Signore Papa Urbano VIII. / Per l'arme sudetto di trevertino fatta per metter sotto sudetta / Navicella alta palmi 17 larga palmi 9, l'altezza sino le chiavi, / importa moneta scudi 125 / Gio Lorenzo Bernini Architetto / Agostino Ciampelli Soprastante."

The document is a bill dated December 18, 1629, for engraving work done by Agostino Radi, who carved the travertine coat of arms of Pope Urban VIII under the *Navicella*, the mosaic which in that year was positioned over the central door inside the basilica. The invoice for 125 scudos bears the signatures of the architect Gian Lorenzo Bernini and the overseer Agostino Ciampelli. Other documents record that payments had been made to Radi for the same work since July of the same year.

Records of the staff of the Fabbrica of Saint Peter show that Agostino Radi (died 1650) was "master engraver" for almost twenty years, beginning in 1627; Agostino Ciampelli was overseer from 1629 to 1630; and Gian Lorenzo Bernini was appointed "architect of the Fabbrica of Saint Peter" by Pope Urban VIII following the death of his the previous architect, Carlo Maderno. For more than fifty years, from 1629 to 1680, Bernini had responsibility for all work carried out in Saint Peter's and his tireless creativity found expression during the pontificates of at least six popes.

The *Navicella*, which today is in the atrium of Saint Peter's, is a seventeenth-century reworking of the famous mosaic done by Giotto (1276–1336) for the portico of the ancient basilica. The great Florentine artist, working on commission for Cardinal Jacopo Stefaneschi and inspired by the Gospel of Matthew (14:24-32), depicted Peter's boat at the mercy of the winds on a stormy sea. Over the course of time, the mosaic was moved several times, undergoing a number of restorations. In 1610, during the extension of the Vatican Basilica by the architect Carlo Maderno, the *Navicella* was removed from the inside wall of the quadriporticus in front of the facade. It was broken into three pieces and probably left in storage before being restored by the painter Marcello Provenzale between 1617 and 1618. In 1619, by order of Pope Paul V, the mosaic was placed over a fountain on the side wall of the old entrance to the Apostolic Palace, to the right as one faces the basilica. Less than ten years later, in 1628, it became necessary to remove the mosaic once more to protect it from the elements. Gian Lorenzo Bernini was called in to supervise this operation, which involved again breaking the mosaic into a number of pieces. However, prior to the work, Pope Urban VIII had a drawing done by Cosimo Bartoli and a copy painted by Francesco Berretta. This painting, which covers four large canvases, was donated to the church of the Capuchins in Rome; it was taken to the Petrine Museum in 1925 and today is in the Reverenda Fabbrica of Saint Peter. In 1629, following inevitable restorations, the *Navicella* was positioned over the central door of the basilica, as may be seen in a drawing held in the Vatican Apostolic Library (Vat. lat. 11257, f. 3), where the mosaic appears above the coat of arms of Pope Urban VIII. According to the Roman diary of

Giacinto Gigli, Pope Innocent X was dissatisfied with the mosaic in that position and, in 1649, had it moved to the courtyard in front of the entrance to the pontifical palace. These restorations were done by Guidobaldo Abbatini of Perugia. In 1660, Pope Alexander VII removed the *Navicella* from that location. Between 1673 and 1674, the mosaic was again restored, this time by the painter Orazio Manenti, who adapted it to fit into the lunette over the central entrance of the atrium, where it can still be seen today.

The *Navicella* mosaic as it appears today after the restorations of Provenzale, Abbatini, and Manenti still respects the original composition of Giotto, as can be seen in fifteenth- and sixteenth-century drawings. P.Z.

After Giotto, *La Navicella*, mosaic, Atrium of Saint Peter's Basilica

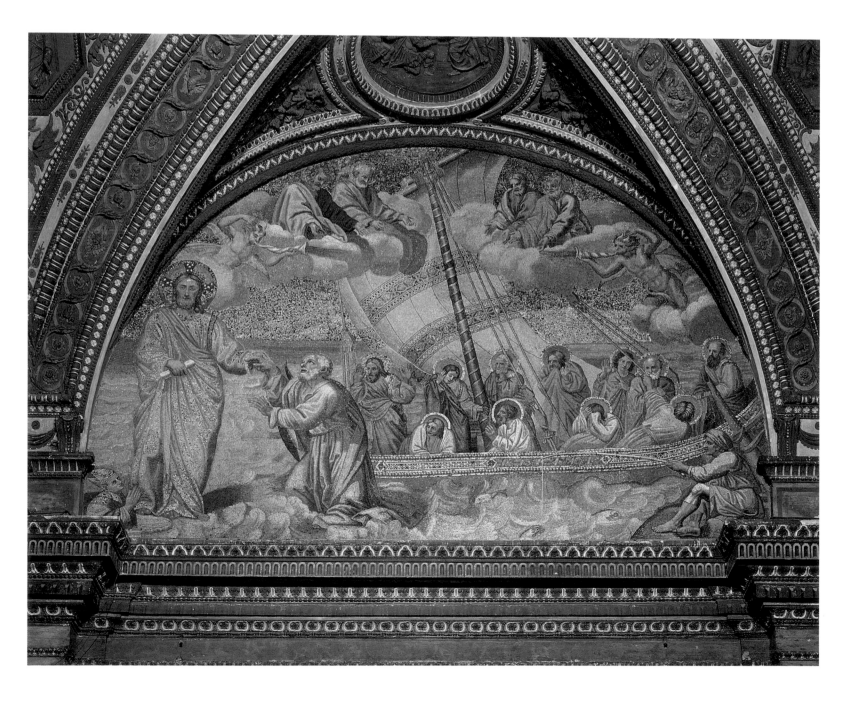

84

Processional Cross

15th century
School of Nicola Guardiagrele (14th–15th century)
Gilded metals
156 × 87 × 23 cm
Patriarchal Basilica of Saint Paul's Outside-the-Walls, Rome

Conservation courtesy of Helen Anne Bunn in memory of Bishop Leo T. Maher

The cross is made of various materials, with alterations dating from different periods. The side band is of white metal and is decorated with a circular stylized floral motif. The arms of the cross each have two gilded metal, probably brass, plates, with decorations in relief. The adornment is completed by a frontal decoration in chased work.

On the front, clockwise from the top, are sculptures of Saint John with a band bearing the inscription "Alleluja"; Saint Mark with a lion and a band with the inscription "Vicit leo" (The Lion has conquered); Saint Luke with a band that reads "Radix Jesse" (The root of Jesse); and Saint Matthew with a band reading "De tribu Juda" (From the Tribe of Jude). In the center is a sculpture of Jesus with a tablet bearing the words "EGO SUM RESURRETIO ET VITA" (I am the Resurrection and the Life). Between Christ and Saint Luke is an angel, and under Luke is the inscription "G:GALLI" (probably the name of the craftsman). All the statues are made of gilded metal. The inscription behind Christ skirts the statue, suggesting that the statue and inscription date from the same period. The plaques under the other figures, however, are decorated even in places that are hidden from view, which suggests that the statues were added at a later date.

The back of the cross presents scenes from the Resurrection, with Jesus and the soldiers, Mary Magdalene and the Virgin, and a Pietà with the inscription "ECCE CRUCEM DOMINI-FUGITE PARTES ADVERSAE" (Behold the Cross of the Lord — enemy factions, take flight) and a date, "MCM" (1900), almost certainly the year in which these gilded metal decorations were added.

Toward the center of the cross is a swan and a cross of thorns in gilded metal, probably brass, supported by a rock with a skull.

For more precise knowledge on the materials used and the period in which the cross was made and embellished it would be necessary to take a small sample of each metal. The workmanship is, in any case, particularly outstanding and the whole has been constructed with great expertise, especially the relief decorations. P.L.

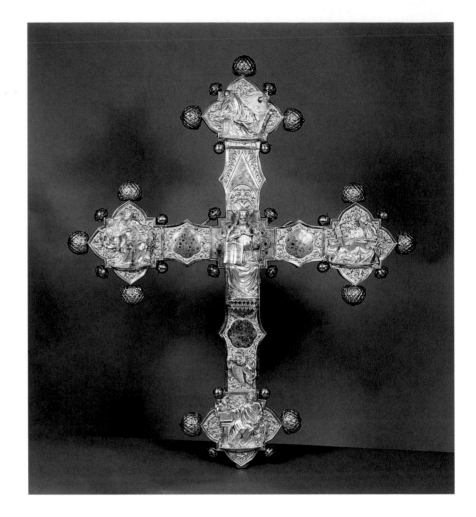

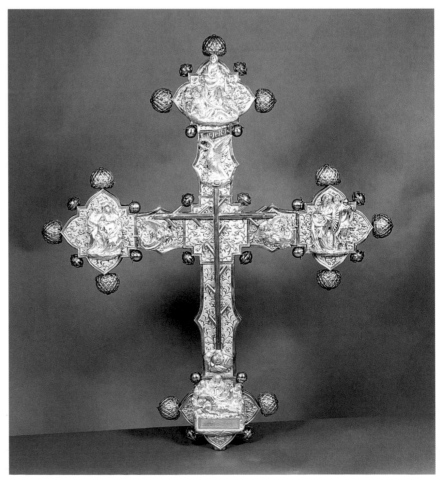

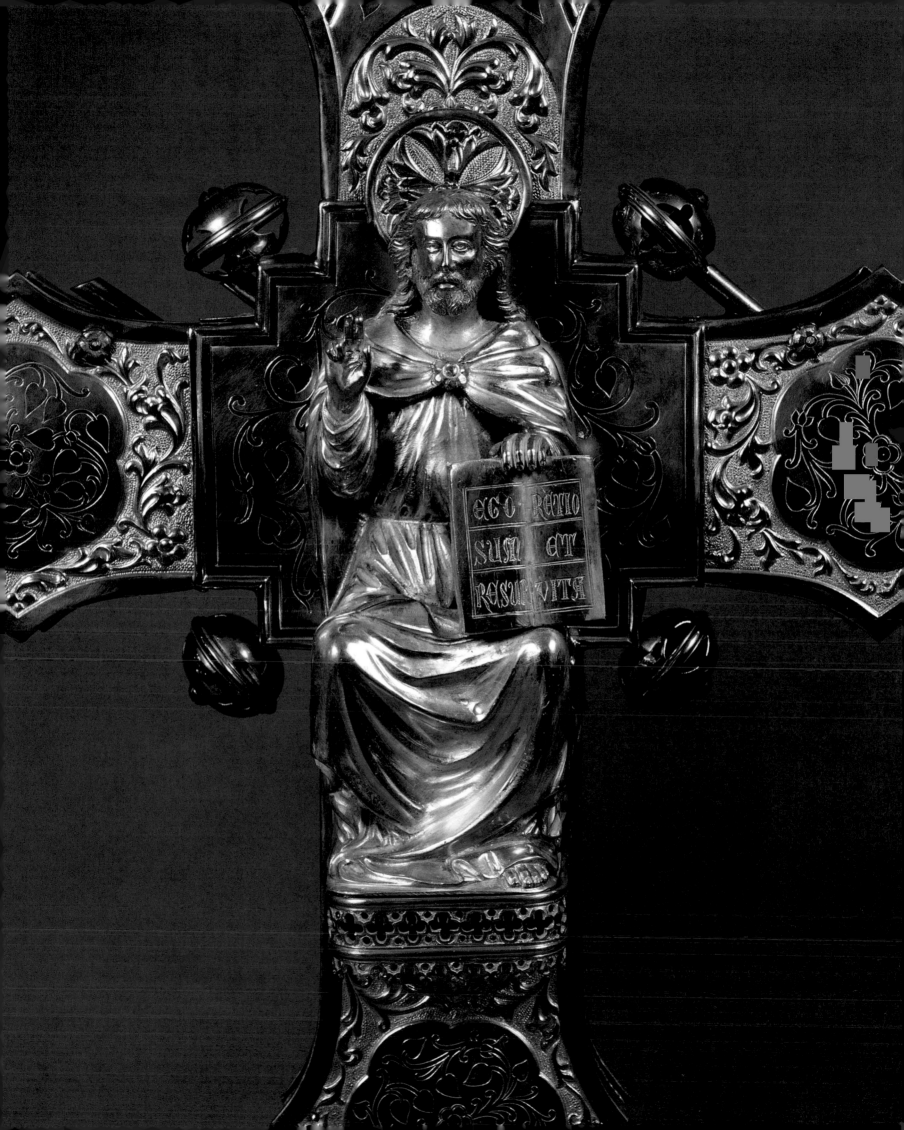

Angels

17th century
Giacomo Zoboli (1681–1767)
Oil on canvas
200 × 400 cm
Reverenda Fabbrica of Saint Peter, Vatican City State

Conservation courtesy of Lucia Nielsen Musso

Chapel of Our Lady of the Column (detail), designed by
Giacomo Zoboli, Basilica of Saint Peter, Vatican City State

Within the Vatican Basilica, angels dominate the scenes painted on the dome of Michelangelo and those of the four smaller domes that surround it. This celestial hierarchy draws inspiration from the *Caelestis Hierarchia* of Dionysius the Pseudo-Areopagite, but, above all, represents a free and imaginative reworking by artists to adorn the vaults with images dear to popular devotion.

These angels are cartoons by the Modenese painter Giacomo Zoboli. He began work on them in May 1742 with a view to decorating the inside of the dome over the Chapel of Our Lady of the Column, so called because of the ancient and venerated image of the Virgin painted on a block of *portasanta* marble that had once been in the Constantinian basilica. This forty-two-meter-high dome was the last of the four to be completed. It is divided into eight segments and is entirely covered with mosaics representing allegories and symbols of the Virgin taken from Holy Scripture, the liturgy, and the Litany of Loreto. In the tripartite scheme of the dome, sixteen angels rest on the frames of the lunette windows. The angels support large gilded tondos, while, further up and on a smaller scale, a similar number of small putti hold vertical panels that are closed at the top by angel faces with open wings.

The canvases on view here are cartoons, the design of which would be transferred into a mosaic. The term cartoon does not refer to a rough sketch but to a complete painting, frequently characterized by full stylistic qualities, which would guide the mosaic artist in arranging the tesserae and achieving the appropriate color shading.

Giacomo Zoboli took great care to differentiate his figures by their dress and by their expressions. Work on the mosaic lasted from 1751 to 1757, and these cartoons served to guide the hands of the artists of the Vatican's mosaic studio such as Liborio Fattori, Domenico Gossoni, Bernardino Regoli, Guglielmo Paleat, Giuseppe Ottaviani, Pietro Polverelli, and Andrea Volpini. A.M.P.

Portrait of Pope Sixtus V

Ca. 1590
Roman school
Oil on canvas
160.5 × 108.9 cm
Vatican Museums, Vatican City State
Inv. 40456

Conservation courtesy of Lorna Richardson in
memory of her son Robert Jelly

This painting, purchased by the vicar of the
apostolic palaces in 1869, is part of the collection
of portraits in the Vatican Historical Museum
dedicated to papal iconography.

Pope Sixtus V is seated and facing the viewer.
He is dressed in papal attire: rochet and mozzetta
with the *camauro* (red velvet and satin cap) on his
head. Showing remarkable ability to penetrate
the psychology of his subject, the artist astutely
captured the awesome nature of this man known
for his headstrong, authoritarian character and
inflexibility.

Felice Peretti was born into a very humble
family. He spent his childhood working in the
fields, as there was not enough money to send
him to school. Through the intercession of his
uncle, a Franciscan friar, he became a novice at the
Minorite convent in Montalto at the age of twelve.
There he specialized in theology and received a
good education. Having achieved a reputation as
a great preacher, he began a brilliant career in the
curia that led to his appointment as cardinal of
Montalto in 1570. After Pope Gregory XIII died
in 1585, Peretti was unanimously elected his
successor. He chose the name Sixtus in honor of the
last Franciscan to occupy the throne of Saint Peter.

Although his papacy lasted only five years,
he left an indelible mark on history as a result
of his indomitable energy and determination.
Immediately he concentrated his efforts on
defending the faith and restoring the pontiff's
spiritual authority. He also brought order to the
temporal state by mercilessly exterminating the
system of brigandism that had reached immense
proportions, terrorizing the entire population.
Pope Sixtus V was also successful in replenishing
the state treasury. Like all his great predecessors in
the Renaissance, he distinguished himself by
persevering in the conservation of culture and
promotion of the arts.

Pope Sixtus V set out to restore Rome to its
former splendor and make it a worthy seat for the
flourishing papacy. With the help of his favorite
architect, Domenico Fontana, he worked tirelessly
to initiate undertakings that would radically change
the image of the city. Demonstrating a genius for
town planning, he devised a system of artery
roads that would enable pilgrims to easily reach
the basilicas. He undertook the tremendous task
of restoring the aqueduct built by the Roman
emperor Alexander Severus to supply the city with
water, called "Acqua Felice" in his honor. He also
ordered obelisks and great buildings to be erected.
Pope Sixtus V completed and enlarged the Quirinal
Palace, where he took up residence and later died.
He had another palace built adjacent to the Basilica
of Saint John's in Lateran, added the Loggia delle
Benedizioni (Balcony of Blessings) to the northern
facade of the basilica, and had the Scala Santa
(Holy Stairs) moved. He also built a portico and
two chapels on the side of the Sancta Sanctorum
(the pope's private chapel). Inside Vatican City
he began construction on a new palace, which
remains the papal residence today, and had a new
building constructed to host the Apostolic Library.
He also succeeded in bringing to completion two
phenomenal enterprises: the Basilica of Saint Peter
and the obelisk. Both appear in the upper left-hand
corner of his portrait, framed by a window that
is not a simple backdrop, but rather a device
to direct the viewer's attention toward these
central elements.

The *guglia* (needle), as the obelisk is called, was
transported to Rome from Egypt. It was positioned
in the center of the circus of Caius and Nero on
the spot where the first Christians, including Saint
Peter, were presumably martyred. In 1586 Pope
Sixtus V ordered the obelisk to be moved to the
center of Saint Peter's Square. Domenico Fontana
succeeded in an endeavor that even Michelangelo
had considered impossible. The scene is depicted in
a fresco in the Apostolic Library: the giant monolith
was moved by using ropes mounted on tracks and
employing 44 winches, 140 horses, and 900 men.

It took Pope Sixtus V's will of iron to finally
succeed in crowning Saint Peter's Basilica with
a dome; at the base of its lantern his name is
inscribed in mosaic. After Michelangelo's death,
no one had dared to undertake the project because
everyone was convinced that it would take ten years
of work and a million gold ducats to complete. It
took almost a miracle to bring the most daring
architectural enterprise of the Renaissance to
completion after a twenty-four-year pause. This
great accomplishment took twenty-two months
of uninterrupted work employing eight hundred
workers and cost only two hundred thousand
gold ducats. Giacomo della Porta, with the
assistance of Domenico Fontana, was able to realize
Michelangelo's design inspired by the Pantheon.
The great mass of the dome no longer "lay on the
ground" but was raised and "lifted to the sky."
It had been positioned above the Tomb of the
Apostle, which for centuries had been the favorite
destination of pilgrims from all over the world.
It stands silhouetted against the skyline as the
symbol of Christianity.

Sources at the time reported that on May 21,
1590, Pope Sixtus V was requested to look out the
window of his residence in the Quirinal Palace in
order to view the finished work. An impressive
event was organized to celebrate its completion
with a solemn mass, cannon salute, fireworks
display, festive lights, and generous donations
of bread to the people. The date of this historical
occurrence constitutes a valid post quem for
establishing the chronology of this portrait.
There is no doubt that it was painted by one of
the many artists active in Rome during that period.
They came to work on the numerous activities
that had sprung up all over the city, created not
only by the pope's initiatives, but also by those
of cardinals, religious orders, aristocrats, and the
emerging classes. M.S.C.

View of Saint Peter's Square with the Vatican Obelisk

From *Il Tempio Vaticano e la sua origine* (Rome, 1694),
pl. 205
Carlo Fontana (1634–1714)
Drawing, Carlo Fontana
Engraving, Alessandro Specchi
Print
53 × 63 cm
Reverenda Fabbrica of Saint Peter, Vatican City State

This plate shows a fine view over Saint Peter's Square. The northern arm of Bernini's colonnade is in the background and the obelisk is in the center. The exceptional height of the latter (over thirty three meters including the base) is surpassed in Rome only by the Lateran obelisk. At the top of the granite column, Pope Sixtus V had the original bronze sphere, which he donated to the city of Rome, replaced by a cross over the papal insignia of the star and the three mounds. Both cross and obelisk were blessed by the pope during a ceremony that took place on September 26, 1586, twelve days later than the planned date of September 14, feast of the Exaltation of the Cross. Between the base and the smooth sides of the obelisk are four bronze lions that appear almost to be supporting the huge monument. These lions, each with one head and two bodies so as to be visible from all sides, are the emblem of the pope's family, the Peretti. At the same time, they recall a medieval tradition that held that these animals decorated the astragals placed under the obelisk in antiquity. The lions were modeled by Prospero Bresciani and Francesco da Pietrasanta and were cast in bronze by Ludovico del Duca. Fontana's drawing does not show, above the lions, the four bronze garlands and eagles, heraldic emblems of Pope Innocent XIII, because they were crafted later, in 1723, by the sculptor Lorenzo Ottoni. The drawing does show the Latin inscriptions, both on the obelisk and on the base. The one on the sides of the obelisk facing east and west is a dedication to the Divine Augustus and Tiberius,

predecessors of the emperor Caligula (AD 37–41) who, according to the account of Pliny the elder (*Naturalis Historia*, 36, 70), had the obelisk brought from Egypt on a huge ship with a ballast of 120 bushels of lentils. The second inscription, carved on the base in beautiful letters designed by Luca Orfei da Fano, recalls the consecration of the obelisk by Pope Sixtus V in 1586.

The obelisk is not exactly in line with the central door of the basilica but stands a little to the north, slightly to the right as one looks at the facade. According to Carlo Fontana, this "error" is due not to Domenico Fontana but to Carlo Maderno who, in extending the new Basilica of Saint Peter's on the orders of Pope Paul V, shifted the axis of the building slightly to the south. Fifty years later, when Gian Lorenzo Bernini was planning the new square within the two grandiose semicircles of quadruple rows of columns, he thought of moving the obelisk to the exact center of the oval space he had created. This project, however, was never carried out.

In the foreground is the monumental fountain built by Carlo Fontana after 1670 under the guidance of Bernini. The coat of arms of Pope Clement X may be seen on the base. He commissioned the fountain as a copy of the other, visible on the opposite side of the square behind the obelisk, which was built by Pope Innocent VIII in 1490, renewed by Carlo Maderno in 1614, and moved to its present location by Gian Lorenzo Bernini. P.Z.

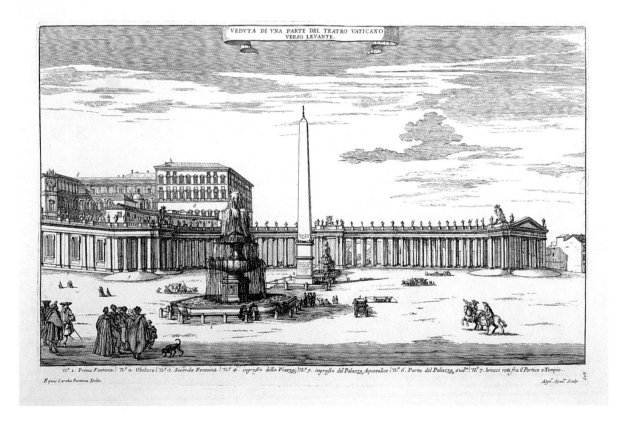

Pope Alexander VIII

Ca. 1691
Attributed to Domenico Guidi (1628–1701)
Marble
107 × 76 × 35 cm
Congregation for the Evangelization of Peoples,
Vatican City State

Conservation courtesy of Mr. and Mrs. Stanley
Mortimer

Pietro Ottoboni was born in 1610 into a Venetian noble family that originally came from Padua or Dalmatia. He studied in Padua, where he took his doctoral degree in law at a young age. At the conclave following the death of Pope Innocent XI in 1689, he was unanimously elected as pope Alexander VIII.

His pontificate was entirely fraught with the problem of relations with France, due to the question of the nomination of bishops and the widespread advocacy of Gallicanism. He also took a firm stand in the defense of Catholic orthodoxy, fighting the other three great religious controversies of the century: Quietism, Laxism, and Jansenism. In the administration of the Papal States he endeavored to meet the needs of the people, ordering tax reductions on beef and flour and liberalizing the sale of cereals. In the cultural field he was an avid collector of manuscripts and rare books.

He died on February 1, 1691. The sumptuous tomb his nephew Cardinal Rubini erected for him was constructed by Angelo de Rossi in Saint Peter's and faithfully follows the structure of the Bernini prototype, except for the addition of a high pedestal with a narrative relief.

This bust, on public view for the first time, is closely related to the late baroque style developed by Bernini. Until the recent cleaning this was always thought to be a portrait of Pope Urban VIII. It also bears a particular resemblance to the model of Innocent X (1648, Rome, Odescalchi Palace) by Alexander Algardi: the pope is wearing the typical cap (*camauro*) and a stole draped over his short cape (mozzetta). The decoration along the stole shows, from top to bottom, the keys; the figures of Peter and Paul; and the two-headed eagle resting on the globe, an Ottoboni heraldic emblem. This marble prototype recalls the bronzes of Pope Alexander VIII in the Victoria and Albert Museum in London and in the Ottoboni collection in Rome, as well as the painted terra-cotta bust in the Los Angeles County Museum attributed to Domenico Guidi by Bershad. Guidi (1628–1701) was the chief collaborator of Alexander Algardi and inherited his studio when he died.

In a work on Guidi's life (Florence, National Library, ms. Cl XVIII, 11, fol. 57r), Francesco Saverio Baldinucci reports that "[Guidi] had Pope Alexander VIII pose for a clay portrait which he had cast in metal for His Eminence Cardinal Ottoboni and one for His Eminence Cardinal Albani" (Bershad 1970, 805). This model was the prototype for four versions, one in marble and three in bronze.

The vestments here are characterized by sharp lively folds alternating with a sudden sagging of the material. This contrast lends a vibrant dimension to the work (note the deep horizontal depression to the right on the mozzetta and the vertical crimping on the left) and almost constitutes a signature for Domenico Guidi. It is the distinctive trait of his sculpture, in particular in the last stage of his work, which dates back to the last quarter of the seventeenth century.

Guidi is perhaps one of the few baroque sculptors who was immune to the direct influence of Bernini and, having a vast clientele of his own, only rarely participated in joint commissioned work with Ferrara or Raggi. Born in Carrara in 1628, he followed his uncle Giuliano Finelli to Naples, where he collaborated in work on the Chapel of the Treasure of Saint Gennaro. After the rebellion of Masaniello (1647), he began work in Algardi's studio.

The bust is in the collection of the Congregation for the Evangelization of Peoples, of which Alexander VIII was a member. As pontiff he was sensitive to the problems concerning evangelization and paid close attention to them. The bust may therefore have been commissioned within the ecclesiastical circles of the Congregation to honor a cardinal who had been a member and then became pope.

Pietro Rossini, in *Mercurio Errante* (1693), a guide to Rome, described the Ottoboni Palace as one of the most active and lively courts in Rome. In particular, the Riaria room was said to be embellished with paintings and graced with magnificent furnishings and decorations. This may have been the original setting of the bust and the supporting pedestal. M.N.

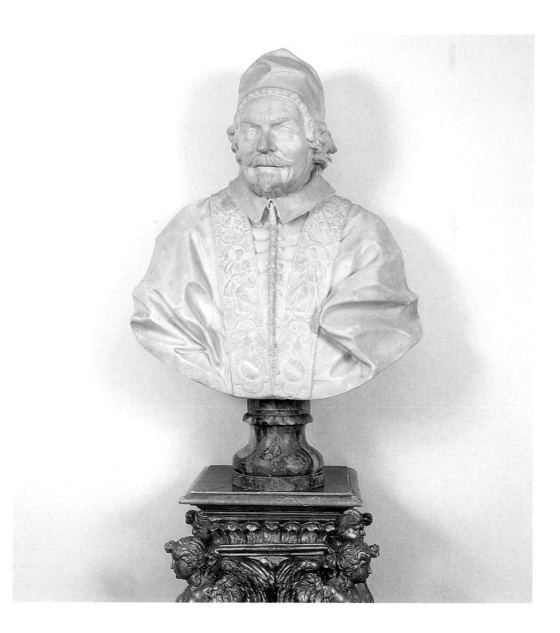

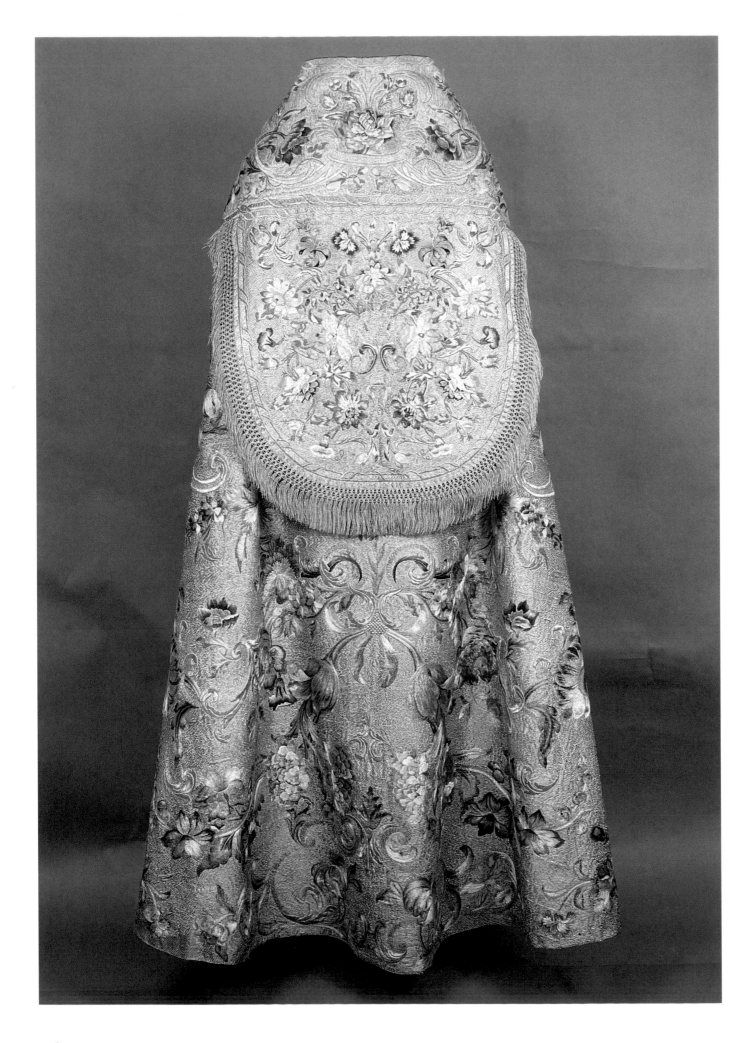

Cope with Stole of Pope Urban VIII

First half of 17th century
Silver leaf, silk, gold thread
Cope: 155 × 305 cm; stole: 120 × 25 cm
Office of the Liturgical Celebrations of the Supreme
Pontiff, Vatican City State
Inv. PV 2

Conservation courtesy of Michael Novarese and
Robert Nelson

The cope can be traced back to the ancient Roman
lacerna civile, which was a loose mantle pinned
together across the chest. Some historians of
liturgical dress believe it to derive from the capes
worn by monks in the eighth and ninth centuries,
though this was not a religious vestment as such.
Whereas formerly the cope was equipped with a
hood that served as a true covering for the head,
today the hood is reduced to a shieldlike device
serving merely as ornament. Often the cope carries
the insignia of the wearer, which usually appear
at the bottom of the orphrey.

When a cope belongs to a complete set of
liturgical vestments, as the present one does, the
fabric and colors of the various accessories usually
match those of the vestments they accompany.
As can be seen in this example, the orphrey has
the same richly embroidered floral patterns as
the cope, and likewise the shield, with its golden
fringe, carries the same flower motif.

This cope belonged to Pope Urban VIII, a
member of the noble Barberini family. The pontiff
was noted for his patronage of the arts and especial-
ly for his continued support for the sculptor and
architect Gian Lorenzo Bernini. The magnificence
of the material and the embellishments of this cope
reflect the Barberini pope's profound appreciation
of all things beautiful.

The cope is part of a complete set of the
liturgical vestments required for papal ceremonies.
Of all the pieces of the set, the cope is usually the
most striking, if only for its size. R.Z.

Maniple, Stole, and Chasuble of Pope Urban VIII

Early 17th century
Silver foil, leaf, gold thread
Chasuble: 111 × 69 cm; maniple: 37 × 33 cm
Office of the Liturgical Celebrations of the Supreme
Pontiff, Vatican City State
Inv. PN4

Maniple and Stole: conservation courtesy of
Michael Novarese and Robert Nelson

Chasuble: conservation courtesy of the Minnesota
Patrons of the Arts in the Vatican Museums

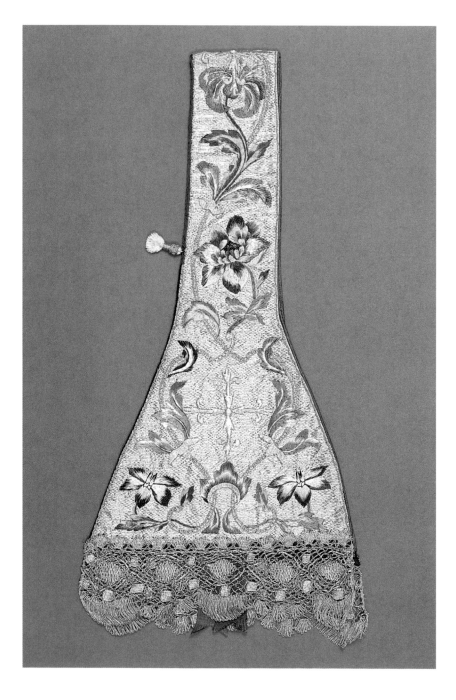

The chasuble is emblematic of the office of the priest. Originally much larger, the chasuble took the form of a circular cloak with a single opening to go over the celebrant's head. For practical purposes, the vestment's shape has gradually altered over the centuries, reaching the more manageable form exemplified by the one on exhibit here.

After the reforms introduced by Vatican Council II, the chasuble returned to its earlier form. Previously, a small piece of cloth, known as the maniple, was attached to the left forearm of the celebrant, which was used to wipe away perspiration during the service; later this article became merely ornamental. One of the reforms of Vatican Council II was the discontinuation of the maniple.

The chasuble on exhibit here, with its matching stole and maniple, belonged to Pope Urban VIII. The backing fabric for the entire set is an off-white silk woven with silver thread and richly embellished with silk and gold embroidery. The chasuble has five large colored flower designs with three fields divided vertically by gold braiding and is edged with additional gold braid; the back carries the same design and the edging. Likewise, the embroidery on the stole and maniple is similar to that on the chasuble. R.Z.

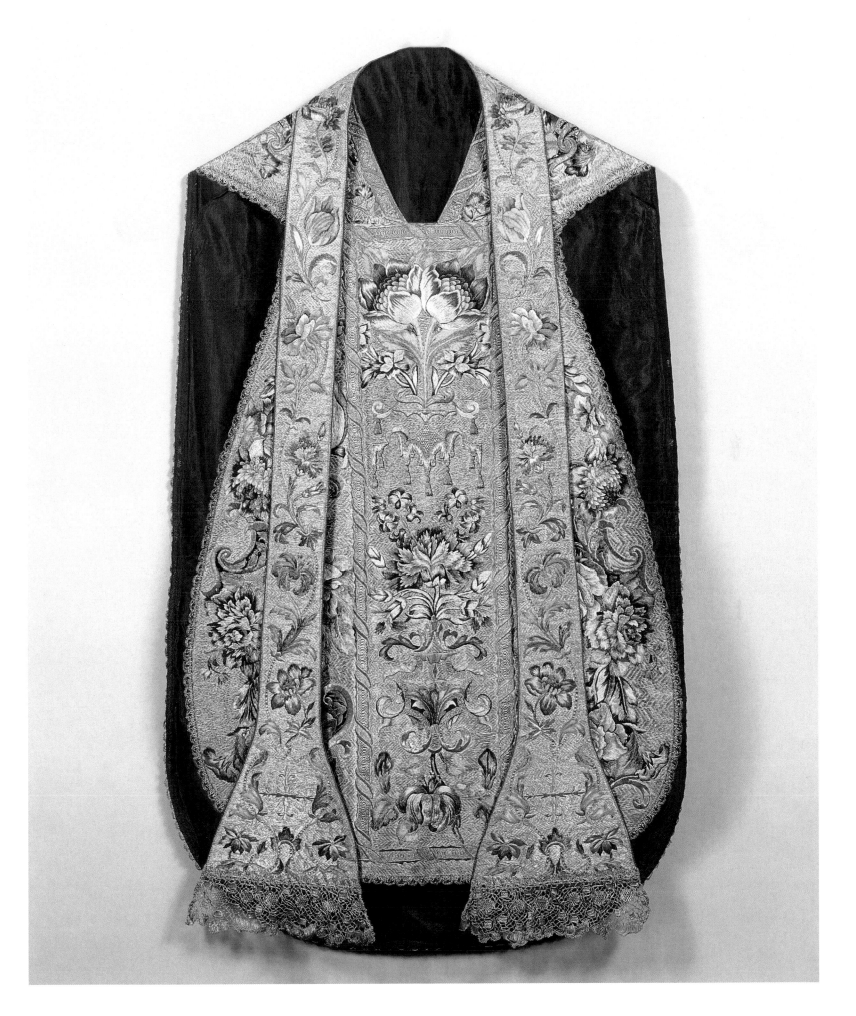

261

Dalmatic and Stole of Pope Urban VIII

Early 17th century
Silver leaf, silk
Dalmatic: 120 × 132 cm; stole: 120 × 25 cm
Office of the Liturgical Celebrations of the Supreme Pontiff,
Vatican City State
Inv. DL4a

Conservation courtesy of Michael Novarese and Robert Nelson

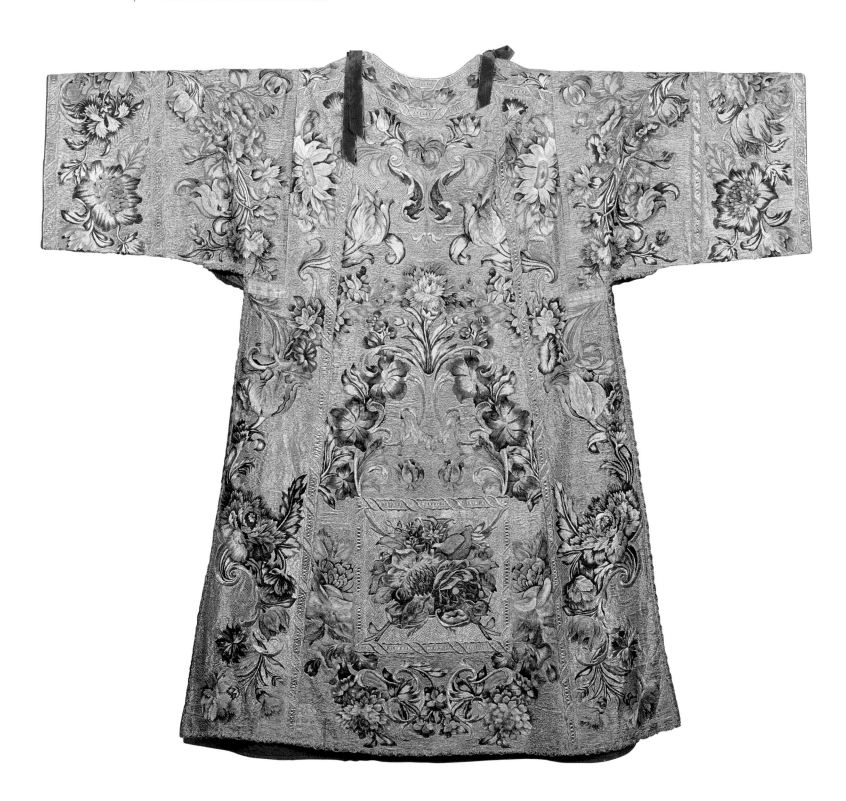

The dalmatic is a mid-length, wide-sleeved garment worn over the alb by a deacon at the celebration of mass or other special religious functions. The vestment derives from the Roman tunic worn by both men and women; by the second century, the tunic had become a floor-length garment.

The traditional vestment of the deacon — whose name stems from the Greek word *diakonos*, meaning attendant — the dalmatic represents joy and the deacon's calling, and is also considered symbolic of the Passion and the Resurrection.

As a liturgical vestment, the dalmatic was first adopted in Rome toward the mid-fourth century at the wish of Pope Saint Sylvester I. Originally only used by the pontiff, the right to wear the dalmatic was later conceded to the deacons, and in the fifth and sixth centuries this privilege was extended to the bishops.

The dalmatic reached its present form between the sixteenth and seventeenth centuries, and its liturgical colors are the same as those adopted for the chasuble and cope, which, together with the tunic, form the complete set on exhibit here. The colors conform to those indicated by the liturgical calendar. R.Z.

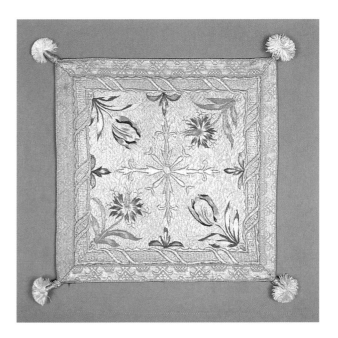

96 – 97

Chalice Veil and Burse of Pope Urban VIII

Early 17th century
Silver leaf, silk, gold thread
Burse: 29 × 29 cm; chalice veil: 60 × 60 cm
Office of the Liturgical Celebrations of the Supreme Pontiff, Vatican City State

Burse: conservation courtesy of Alice Benvenuti
Veil: conservation courtesy of Gareth, Barbara and Charles Genner

To emphasize the sacred nature of the chalice in which the consecrated wine is held for the celebration of the Eucharist, particularly before the revisions introduced by Vatican Council II, the chalice was covered with a veil. Placed on top of the chalice and veil was a burse containing the special square of folded linen, or corporal, which was opened on the altar during mass to catch any drops of the consecrated bread and wine. Neither the burse nor the chalice veil are much used today, though they were not abolished by the revisions of Vatican Council II. Owing to its eminently practical function, the corporal has kept its place among liturgical items. R.Z.

Drawings by Michelangelo

Although he described himself as a sculptor, Michelangelo accomplished truly extraordinary achievements in architecture and in painting, evidence of which may be seen in the dome of Saint Peter's Basilica and the frescoes of the Sistine Chapel.

The harmony of form he conceived in elegant Renaissance buildings and, above all, in the study of the human body in sculpture and in the powerful characters of the Sistine frescoes, are a sign of Michelangelo's artistic explorations into the plasticity of form and the study of bodies and their movement.

The drawings, independent of the specific purpose for which they were intended, are important for understanding the soul of a man who, though continually tormented by the quest for perfection, left us works for which it would be hard to find equals in the history of humanity's longing for the absolute.

98 (recto)

Studies of Roman Monuments

Ca. 1516
Michelangelo Buonarroti (1475–1564)
Red pencil
28.5 × 42.5 cm; 28 × 43.3 cm
Casa Buonarroti, Florence
Inv. 1 A (recto); inv. 4 A (verso)

Through his contacts with the architect Giuliano da Sangallo at the start of work on the facade of San Lorenzo in Florence, Michelangelo came into possession of a book of drawings with studies of ancient monuments. This so-called Coner Codex, which has been plausibly credited to Bernardo della Volpaia, a collaborator of the Sangallo family, provides a comprehensive view of the principal achievements of ancient and contemporary architecture, complete with detailed measurements and topographical indications. The codex is now in the Soane Museum, London.

On a series of sheets that form a group in terms of size, watermark, technique, and subject (now divided between Casa Buonarroti and the British Museum), Michelangelo copied approximately one hundred elements of the Coner Codex, giving great emphasis to the details of classical ornamentation (entablatures, capitals, etc.). The artist added a profoundly personal touch to his copies, eliminating the measurements and writing and giving a less analytical representation of the ornamental parts. The details of ancient architecture, thus deprived of their antiquarian minutiae, become more imposing; his freehand use of red pencil, rather than pen, reduces the precision of the design but notably increases its visual impact. The ancient and modern buildings from which these architectural details are taken can be identified, with a high degree of certainty, from the inscriptions of the Coner Codex, and are mostly in Rome and the surrounding areas.

These studies, drawn by Michelangelo at the beginning of his activity as an architect, were not to prove fruitless in his future career. The windows of the New Sacristy at San Lorenzo in Florence, for example, appear to derive from those of the Temple of Vesta in Tivoli, which appear on one page of the Coner Codex. Similarly, we could compare the exhibit 1 A recto with another famous design from the collection of Casa Buonarroti, inv. 10 A, which shows sketches for pillar bases and which can also be dated to the period in which the New Sacristy was being planned. In fact, Michelangelo's drawing from the Coner Codex presents a striking similarity with the profile of the base at the lower right of 10 A, transformed by the artist into a human profile, perhaps a caricature. P.R.

99 (verso)

Study of a Nude for the Ceiling of the Sistine Chapel

1508–9
Michelangelo Buonarroti (1475–1564)
Pencil
11.4 × 6.6 cm
Casa Buonarroti, Florence
Inv. 49 F

This drawing, mounted on a backing, is a small cutting that was, in all probability, taken from a larger sheet after its artistic merit had been recognized. Careless operations of this kind were by no means rare in collections of old graphic art and constitute part of a history that is extremely difficult to write. Be that as it may, the vigorous and compact figure at the center of this sketch has long been judged authentic by the most authoritative critics of Michelangelo, who also agree in associating the design with two nude figures on the Sistine Chapel ceiling: the upper part with the figure on the right of the ceiling, above the Prophet Isaiah, and the position of the legs with the figure of the Cumaean Sybil, on the left. The drawing, a preparatory sketch for those figures, was dated accordingly once this link was established. Of Michelangelo's colossal undertaking – preceded without doubt by a long series of studies and drawings – only a few sketches are extant. Indeed, it is well known that Michelangelo often destroyed his designs so that none of his uncompleted works would remain.

Michelangelo painted the ceiling of the Sistine Chapel in two phases. Between the summer of 1508 and that of 1510, he completed the first half of the enterprise, up to and including the *Creation of Eve*. It is in this section that the two nudes associated with this sketch may be seen. Michelangelo began working from the door of the chapel and progressed toward the altar so as to allow, at the beginning of the task, liturgical activities to continue. For this reason the scenes painted first are, iconographically speaking, the latest; in other words, he began with the story of Noah and moved to that of the Creation. Scaffolding for the second half of the roof was constructed in the spring of 1511 and work progressed rapidly until October 1512. In considering the continuity of the fresco as a whole, it is clear that the second phase is marked by a progression in dramatic impact: the dimensions of the figures increase and the compositions are more freely delineated, while the use of gold – one of the last vestiges of the fifteenth-century workshops – dwindles to almost nothing. P.R.

Four Epitaphs in Honor of Cecchino Bracci, Sent to Luigi Del Riccio

1544
Michelangelo Buonarroti (1475–1564)
Pen
21.6 × 23 cm
Casa Buonarroti, Florence,
Buonarroti Archive, XIII, 33

42 Deposto à qui Cechin sì nobil salma
 per morte, che 'l sol ma' simil non vide.
 Roma ne piange, e 'l ciel si gloria e ride
 che scarca del mortal si gode l'alma.

43 Qui giace Braccio e men non si desia
 sepulcro al corpo, a l'alma il sacro ufitio.
 Se più che vivo, morto à degnio ospitio
 in terra e 'n ciel, morte gli è dolce e pia.

44 Qui stese il Braccio e colse acerbo il fructo
 morte anz' il fior c[h]'a quindic'anni cede.
 Sol questo sasso il gode che 'l possiede,
 e 'l resto po' del mondo il piange tucto.

45 L'fu' Cechin mortale e or' son divo:
 poco ebbi 'l mondo e per sempre il ciel godo
 di sì bel cambio e di morte mi lodo,
 che molti morti e me partorì vivo.

Perché la poesia stanocte è stata in calma, vi mando quactro berlingozzi pe' tre berriquocoli del cacastechi. E a voi mi rachomando. Vostro Michelagniolo al Macel de' [Corvi].

Cecchino Bracci, beloved nephew of Luigi del Riccio, died in Rome on January 8, 1544, at the age of fifteen. Michelangelo was also deeply attached to the boy but it was Luigi del Riccio, administrator in Rome for the Florentine bank of Strozzi-Ulivieri and at the time secretary to Michelangelo, who, with a repeated promise of choice foods, compelled the artist to compose in just a few months no fewer than fifty epitaphs (forty-eight quatrains, one madrigal, and one sonnet) for the boy. Michelangelo also planned Cecchino's tomb, again commissioned by Luigi del Riccio, built in 1545 in the church of Santa Maria in Aracoeli, where it may still be seen today. Two Latin epigraphs at either side of the bust reiterate in agonizing words the uncle's grief as he sheds the tears that should have been shed for him. Casa Buonarroti in Florence conserves a sixteenth-century drawing of this funerary monument.

This sheet includes the four quatrains, which bear the numbers 42–45 in the list of fifty epitaphs.

In the marginal note, the famous sketch of a crow that playfully closes Michelangelo's words to his friend stands for the name of the Roman street where, in 1532, the artist bought the house in which he lived until his death. On the subject of the note, Cesare Guasti writes: "It would appear that berlingozzo was used to mean a rough draft. Vasari, in one of his letters, uses the word to refer to his own paintings: 'que pochi berlingozzi ch'io fo.' Michelangelo likens his compositions to berlingozzi in contrast to berricuocoli, which were finer pieces of work. The three berricuocoli Michelangelo claims to have received were either really from Riccio or might be a reference to superior compositions on Bracci written by someone else (perhaps by Giannotti or perhaps by Riccio) to whom Michelangelo refers as cacastechi (meaning miserly, of little worth) precisely because, compared with Michelangelo, he produced fewer verses and with difficulty." P.R.

Elevation and Plan for the Wall Tombs of Leo X and Clement VII in the Choir of the Basilica of San Lorenzo in Florence

Ca. 1526
Michelangelo Buonarroti (1475–1564)
Black pencil, pen, brown wash
39.9 × 27.4 cm
Casa Buonarroti, Florence
Inv. 128 A

On May 23, 1524, Giovan Francesco Fattucci, chaplain of Santa Maria del Fiore in Florence and Michelangelo's representative in the Vatican, notified the master that Pope Clement VII wished the tombs for himself and for the other Medici pope, Leo X, to be erected in the New Sacristy of San Lorenzo, which had already been designed to accommodate the tombs of other members of the Medici family. Michelangelo declined the pope's proposal and suggested, instead, that the papal tombs be installed in another area of the San Lorenzo complex, that of the "lavamani dove è la scala" (the lavabo where the stairway is situated). By this he probably meant a small room to the left of the choir of the New Sacristy. The artist also supplied Clement VII with a drawing containing a project for these tombs that met with favor. The pope expressly requested that the two tombs be realized without skimping on cost, in fear the tombs of the Medici dukes Giuliano and Lorenzo (already sculpted by Michelangelo for the New Sacristy of San Lorenzo) be "più belle… che quelle de' papi" (finer than those of the popes).

On July 9 Michelangelo was authorized to seek the marble for the papal monuments, but by the following month Clement VII already began to have doubts about the reduced dimensions of the room in which the tombs were to be installed. The pope now set about seeking a "luogo onorevole et più largo" (a more dignified and spacious site) "in chiesa, in coro, o altrove" (in the church, in the choir, or elsewhere). By June two years later, no satisfactory solution had been found: it was then that the pope even suggested to Michelangelo that he erect a building ex novo, circular in plan, to house the two funerary monuments close to the basilica of San Lorenzo. Still being discussed in September 1526, the enterprise was interrupted by the dramatic events of 1527 culminating in the Sack of Rome and the installation of the anti-Medicean Republic in Florence.

After the death of Clement VII, in 1534, the project for the papal tombs passed, through the mediation of Cardinal Ippolito de' Medici, to the Ferrarese sculptor Alfonso Lombardi, who produced a model with figures in wax for the wall tombs, inspired by Michelangelo's sketches; the intended site for their installation was the basilica of Santa Maria Maggiore in Rome. The vicissitudes of the project were not over, however, because in 1535 the commission was transferred to yet another sculptor, Baccio Bandinelli, as attested by a contract of 25 March of that year, which once again specified Santa Maria Maggiore as the intended site for the two funerary monuments. The two wall tombs, however, would eventually end up in another church altogether: the choir of the church of Santa Maria sopra Minerva in Rome. The architectural part was executed by Antonio da Sangallo the Younger and the sculptural part by Bandinelli, assisted by Raffaello da Montelupo and Nanni di Baccio Bigio. Work on the monuments was completed no earlier than June 1542.

Some drawings of Michelangelo have been linked with the troubled affair of the tombs of Leo X and Clement VII. They include the controversial 52 A of the Casa Buonarroti, which shows a tomb in three bays with the statue of a blessing pope at the center. Of great interest, and undoubtedly an autograph of the master, is this drawing, no. 128 A. It testifies to a later stage in Michelangelo's elaboration of the project, once the small room adjacent to the New Sacristy had been jettisoned and the pope and Michelangelo were seeking a new site for the tombs in San Lorenzo. At this point the idea likely took shape of situating the tombs in the choir, which could easily have accommodated as ambitious an architectural scheme as the one in this drawing.

Of the three bays planned for the monument, Michelangelo has limited himself to representing only two, both in elevation and in plan, the central one and the one to the left. The one to the right was evidently meant to be symmetrical. The drawing, highly polished in execution, was first drawn in black pencil and then retraced with pen and brown wash. Numerous pentimenti can be noticed by closely observing the underlying pencil drawing. Curiously the one part of the drawing that was not retraced with the pen is the sarcophagus. Combining the information that may be gleaned from the other drawings connected with this project, one has the impression that Michelangelo planned to insert only one statue, that of the blessing pope, in each monument.

The project represented in this drawing reveals considerable similarities, in its use of recessed columns and projecting wall masses, with the elevations of the vestibule of the Biblioteca Laurenziana, also designed by Michelangelo within the San Lorenzo complex. The artist shows considerable ingenuity in interpreting the theme of the wall tomb, concealing its funerary destination behind an essentially secular mise-en-scène resembling the facade of a sumptuous private palace. P.R.

Study for a Male Figure

1530–31
Michelangelo Buonarroti (1475–1564)
Red pencil
23.5 × 8.2 cm
Casa Buonarroti, Florence
Inv. 62 F

This drawing, together with a sheet in the Archivio Buonarroti (I, 74, 203 verso), represents a document of some rarity. Both are in red pencil. In the view of most art historians of the period, these are the only autograph preparatory drawings that have come down to us for the figure of the lost cartoon executed by Michelangelo in Florence in 1531 representing "a Christ appearing to the Magdalen in the garden." In the two drawings Jesus is represented naked, according to a traditional practice in Renaissance *botteghe*, and not only in Florence: Leon Battista Alberti (*De Pictura*, II, 36) had recommended that figures first be drawn nude, and then clothed, as only thus could a correct understanding of the anatomy of the human body be achieved. The theme of the naked male figure was, of course, particularly congenial to Michelangelo.

The cartoon with the scene of the *Noli me tangere* was immediately translated into painting by Pontormo, on the suggestion of Michelangelo himself, who closely followed the work; indeed, it was painted in his own house. The painting had been commissioned by Alfonso d'Avalos, *marchese of* Vasto and general of Charles V, on behalf of his aunt Vittoria Colonna. That the choice of the *Noli me tangere* was Vittoria's seems clear. The poetess had a predilection for Mary Magdalene, which probably sprang from the circumstances of her own life: her own abandonment of a worldly life following the death of her husband led her almost to identify with the Magdalene's redemption.

Pontormo's *Noli me tangere* is now in a private collection in Busto Arsizio, and corresponds to the testimony of the sources in its high quality, its *colorito* (praised by Vasari), and more especially for its measurements, which are well adapted to the reduced dimensions requested by the patron. P.R.

Letter Written in Rome to His Nephew Leonardo in Florence

December 28, 1563
Michelangelo Buonarroti (1475–1564)
Pen
29.5 × 21.5 cm
Casa Buonarroti, Florence, Buonarroti Archive,
IV, 182

This is the last letter written by Michelangelo in his own hand to his best-loved nephew, just two months before the artist's death. It is the last testimony of a long correspondence – composed, on the part of the uncle, of advice, rebukes, and affection – and is moving for the gratitude expressed over what in reality was a modest gift (*marzolini*, small cheeses with a delicate flavor). The greatest emotion, however, is aroused by the words: "Altro non m'achade" (nothing else befalls me), a stock phrase not uncommon in letters of the period but here weighted with a sense of abandonment and solitude at the end of a letter in which, in truth, nothing happens; a solitude little studied by biographers and scholars of Michelangelo, the humble and remorseless solitude of old age.

The few lines of the letter are characterized by pen strokes that, though still clear and incisive, nonetheless incline visibly downward. The note also has particular biographical importance because the elderly artist expresses the melancholy thought that from then on he will only be able to sign letters written by others on his behalf.

Indeed, the following letter from Rome, which reached Leonardo a month and a half later (February 14, 1564), brought alarming news, written now in the hand of Michelangelo's faithful friend Daniele da Volterra. Only four days of life remained to the artist as he added his weak and trembling signature to the note expressing his desire to see his nephew for one last time. It is known that his wish was not met: by the time Leonardo arrived in Rome his uncle had been dead some days and the funerary rites had already been held at the church of the Santi Apostoli. His only heir, thus, undertook the famous theft of the body, which was carried to Florence, as we learn from Vasari, disguised as "merchandise." There, at the church of San Lorenzo, Michelangelo was honored by artists and the city before being definitively buried in the church of Santa Croce.

The letter of February 14 was sent by Diomede Leoni who, together with Tommaso dei Cavalieri and Daniele da Volterra, assisted Michelangelo in the last months of his life. Leoni has left us an affectionate portrait of the infirm old man who still did not want to abandon his daily habits: "a little while ago I left him awake, attentive and in good spirits but much oppressed by continuous somnolence which, in order to drive away, […] he thought to go out for a ride as is his wont every evening when the weather is fine. Yet the cold of the season and the weakness in his head and legs prevented him from carrying out his design, and thus he returned to the hearth, sitting in a chair where he would much more willingly be than in bed." P.R.

105

Study of Figures in Movement

1534
Michelangelo Buonarroti (1475–1564)
Pen
9.7 × 9.2 cm
Casa Buonarroti, Florence
Inv. 17 F

106

Study of Figures in Movement

1534
Pen
9.2 × 10.6 cm
Casa Buonarroti, Florence
Inv. 18 F

107

Study of Figures in Movement

1534
Pen
11.2 × 10.6 cm
Casa Buonarroti, Florence
Inv. 67 F

108

Study of Figures in Movement

1534
Pen
10.5 × 11 cm
Casa Buonarroti,Florence,
Inv. 68 F

105

106

These four pen-and-ink drawings, together with another in the Casa Buonarroti (inv. 38 F) and a sheet in the Ashmolean Museum in Oxford, form a homogeneous group. Though various opinions have been expressed about their date and purpose, their autograph status has never been doubted. There is also general agreement that these drawings are suggestions made by Michelangelo to artist friends. This particular way of demonstrating his generosity was indeed a thread that runs through the whole of his career: ever since his youth he had furnished them with cartoons or models. He lavished his wonderful inventions not only on great contemporaries such as Sebastiano del Piombo and Pontormo, but also on minor artists, to whom he was equally generous and showed equal condescension.

Some art historians relate this group of drawings to the *Transfiguration* commissioned from Sebastiano del Piombo for the Borgherini Chapel in the church of San Pietro in Montorio in Rome in 1516. Others connect them with the *Martyrdom of Saint Catherine* painted by Giuliano Bugiardini for the church of Santa Maria Novella in Florence. Both artists, though very different in level, enjoyed a long-standing friendship with Michelangelo. In the Venetian painter Sebastiano Luciani, who had arrived in Rome in 1511 and later acquired the

cognomen del Piombo after assuming the post of pontifical *piombatore* (seal maker) in 1531, Michelangelo found a valuable ally in the rivalry that opposed him to the party of Raphael and his followers. The relationship with Bugiardini, on the other hand, was based on a friendship that goes back to his adolescence and was never interrupted. It would be Giuliano Bugiardini who would portray Michelangelo at work, in one of the few images of the artist drawn from life.

No close similarities exist between the figures sketched in this group of drawings and those that appear either in the *Transfiguration* or in the *Martyrdom of Saint Catherine*; nonetheless, as Henry Thode was the first to suggest, their link with the altarpiece in Santa Maria Novella seems the more probable. It is enough to point out that in Sebastiano's lunette in San Pietro in Montorio, of the three apostles who witness, immobile, the revelation of the divine nature of Christ, two are placed to the far left of the scene and one to the far right; in Michelangelo's sketches, by contrast, the figures are all placed closely together and in a state of violent agitation. An expressive situation of this kind is better suited to the dumbfounded soldiers who occupy the foreground of Bugiardini's altarpiece, where the angel that frees Catherine from the wheel gives rise to a series of emotional reactions. It was Vasari

who recorded Michelangelo's involvement in this particular project, commissioned from Bugiardini by Palla Rucellai and intended to adorn the family chapel in Santa Maria Novella. It took the artist more than twelve years to complete (it was finished ca. 1540). Apart from Michelangelo, the sculptor Nicolò Tribolo also came to Bugiardini's aid, furnishing him with three-dimensional models so that he could better study the distribution of light and shade.

Michelangelo's assistance, which also included, according to Vasari, a direct intervention on the altarpiece, must be chronologically placed prior to the artist's final departure for Rome in September 1534. Such a dating is corroborated by the evident consonances between the figures of the foreground soldiers in Bugiardini's altarpiece and some figures in the *Last Judgment* in the Sistine Chapel, commissioned by Michelangelo in the spring of 1534, when the master was still in Florence. Hence the dating of the Casa Buonarroti sheets also to 1534. P.R.

107

108

Studies of a Figure for the "Crucifixion of Haman" on the Sistine Chapel Ceiling

1511–12
Michelangelo Buonarroti (1475–1564)
Red pencil
15.9 × 21.8 cm
Casa Buonarroti, Florence
Inv. 12 F

There is still some debate as to whether this drawing is to be attributed to Michelangelo. What is certain is its association with the crucifixion of Haman, the depiction of which occupies the center of a spandrel on the Sistine Chapel ceiling. In his representation of the scene, Michelangelo distanced himself from Old Testament tradition in choosing to depict the character as being crucified and not hanging from a gallows. In the Bible, the story of Haman is part of the Book of Esther. Chief minister to the Achaemenid king Xerxes, Haman organized anti-Jewish persecution; unmasked, he was executed with his children and supporters. In this scene, as on the other spandrels (Judith and Holofernes, David and Goliath, Moses and the Brazen Serpent), Michelangelo has represented a moment of difficulty for the Jewish people, a moment finally overcome. In Jewish religious tradition, the victory over the persecution of Haman is recalled by the feast of Purim, held between February and March. For the occasion, it is still customary to make a kind of sweet known as "ears of Haman."

The dating of this drawing is based on the fact that the scene was painted in the concluding phase of Michelangelo's work on the ceiling, between 1511 and 1512.

On the right side of the drawing is a thoughtful figure intent upon reading, clearly associated with the figure in the scene of the crucifixion of Haman, next to the bed in which King Xerxes is lying. The arm at the center of the sheet, the hand partially delineated in ink, corresponds to the right arm of the young man dressed in yellow who, in the same episode, descends the stairs. It is worth noting that in the finished scene in the Sistine Chapel the arm is clothed, while in the design it is bare. The hand in the lower-left corner is a repetition of the left hand of the reading figure on the right of the sheet.

Of all the episodes on the Sistine Chapel ceiling, the punishment of Haman is the one for which the greatest number of designs have survived. This fact becomes more significant if one considers the great quantity of autograph drawings that have been lost, largely destroyed by Michelangelo himself over the course of his life and especially in extreme old age. The pile of studies and sketches that remains in this case may give some idea of how much intense preparatory drawing must have accompanied Michelangelo's work. P.R.

Letter Written in Rome to His Brother Buonarroto in Florence

September 18, 1512
Michelangelo Buonarroti (1475–1564)
Pen
29 x 21.5 cm
Casa Buonarroti, Florence
Buonarroti Archive, IC, 25

"*Buonarroto, io intesi per l'ultima tua chome la terra stava in gran pericolo, onde n'ò avuta gran passione. Ora s'è decto di nuovo che la case de' Medici è 'ntrata in Firenze e che ogni cosa è acconcia; per la qual chosa chredo che sia cessato il pericolo, cioè degli Spagnoli, e non credo che e' bisogni più partirsi. Però statevi in pace, e non vi fate amici né familiari di nessuna, se non di Dio, e non parlate di nessuna né ben né male, perché non si sa el fine delle cose. Actendete solo a' chasi vostri.*

E' quaranta ducato che Lodovicho à levati da·sSanta Maria Nuova, io vi scrissi l'altro dì una lectera che in chasi di pericholi della vita voi ne spendessi non che quaranta, ma·ctucti; ma da questo in fuora, io non v'ò dato licenzia che voi gli tochiate. Io v'aviso che io non ò un grosso, e sono si può dire scalzo e gnudo, e non posso avere el mio resto, se io non ò finita l'opera; e patisco grandissimi disagi e fatiche. Però, quando voi anchora sopportassi qualche disagio, non vi incresca, e i' mentre che voi vi potete aiutare de'vostri danari, non mi togliete e'mia, salvo che in casi di pericoli, come s'è detto. E pure quando avessi qualche grandissimo bisognio, vi prego che prima me lo scriviate, se vi piace.

Io sarò costà presto. Non mancherà a modo nessuna che io non facci l'Ogni Santi costà, se a Dio piacerà.

Michelagniolo scultore in Roma

*A dì 18 di sectembre
A Buonarroto di Lodovicho Simoni in Firenze*"

Buonarroto, I understood from your last letter that the land was in great danger, which filled me with great anxiety. Now it's said that the house of Medici has returned to Florence once again and that everything is settled; for which reason I think that the danger, i.e., that of the Spaniards, has ceased, and I don't think there's any more need [for you] to leave. But lead a quiet life, and don't make friends or be familiar with anyone, unless with God, and speak neither good nor ill of anyone, because it's still unclear how things will end. Only wait at home.

It's forty ducats that Lodovicho withdrew from [the hospital of] Santa Maria Nuova. I wrote a letter to you the other day saying that in the event of your life being in danger you should spend no more than forty [of this money], [….]; but otherwise I did not give you permission to touch it. I must tell you I don't have a cent, and am you can say penniless and broke. I can't have the rest [of my money], before I've finished the work; and am suffering from the greatest hardship and exhaustion. But if you should still have to support some hardship, you shouldn't complain of the fact,

and so long as you can help yourself out with your own money, don't remove mine, unless, as I said, in case of danger. And even if you should have some very great need, I ask you to please write to me about it first.

I'll be there [in Florence] soon. Nothing, God willing, will stop me from being there in time for All Saints.

Michelangelo sculptor in Rome

18 September [1512]
To Buonarroro di Lodovicho Simoni in Florence

To grasp the meaning of this letter, we must briefly summarize the events that had characterized Florentine life in 1512, a crucial year in the city's history. Earlier that year Pier Soderini, the chief magistrate or governor of Florence, had been deposed and exiled because of his pro-French leanings. That was after the army of the French king Louis XII had been defeated by the Holy League, and Cardinal Giovanni de' Medici, who was destined to become Pope Leo X and was then legate of Pope Julius II, had done all in his power to have Soderini banished. With the flight of Soderini and the return of Giuliano de' Medici, the cardinal's younger brother, a new political order was created in the city. It facilitated the return of the supporters of the Medici family expelled from Florence in 1494.

But the situation still remained unstable and dangerous, particularly for the Buonarroti family. The close relations between Michelangelo and the Florentine Republic headed by Soderini were well known; the republic had commissioned various works from him, including the colossal statue of *David* and the fresco of the *Battle of Cascina* that was supposed to adorn the Sala del Maggior Consiglio in the Palazzo Vecchio (seat of the Florentine government), but that never progressed beyond the cartoon stage. Michelangelo, therefore, had well-founded reasons for fearing for his brother's life and urging him to use, in case of necessity, all the money he had deposited at the Arcispedale di Santa Maria Nuova in Florence, which was not only a hospital but a savings bank, with more than seven hundred customers, including Leonardo da Vinci. Michelangelo had opened an account there on 27 February 1505, shortly before his departure for Rome, where he had been called by Julius II to design the pope's grandiose tomb. This enterprise was later interrupted, to the bitter disappointment of the artist, because three years later the pope shifted his attention to the decoration of the Sistine Chapel ceiling: a superhuman task that Michelangelo accepted only with reluctance, and succeeded in completing almost single-handedly in five years, at the cost of the "grandissimi disagi e fatiche" he mentions in his letter.

In the letter on view, Michelangelo complains about his lack of money. This was perhaps due in part to his proverbial parsimony, but also because (as he points out) the last papal payment was slow in materializing: only once the work had been almost completed, on 17 December 1512, did Julius II decide to settle his account with the artist.

We should also note the artist's telltale way of signing his letter: "Michelagniolo scultore in Roma." He continued to repeat, almost obsessively, throughout his work on the Sistine ceiling, that he was not a painter, but a sculptor. It was as a sculptor, indeed, that he had been hired by the pope and had been working since 1505 to assemble the huge pile of marble that Julius II had ordered him to erect as his mausoleum: a colossal enterprise, destined to drag on for years and to end in disappointment for the artist. A story without an end that the artist branded with the famous expression: "the tragedy of the tomb." P.R.

Bust of Pope Alexander VII

1667
Circle of Melchiorre Caffà (1631?–67)
Marble
105 cm
Vatican Museums, Vatican City State

Cardinal Fabio Chigi, later Pope Alexander VII, was a member of the eminent family, which, in the sixteenth century, also gave birth to the banker Agostino, Raphael's patron of the renowned Villa Chigi on the Tiber River. Born in Siena on February 13, 1599, Fabio Chigi received a scholarly, humanistic education from his tutor Celso Cittadini that would bear fruit during the splendid years of his papacy. After beginning his ecclesiastical career in Rome, he was appointed vice legate of Ferrara and later apostolic inquisitor of Malta. He was promoted to the nunciature of Cologne, where he was called upon to deal with the controversy that ensued after Jansen's writings were condemned as heretical in 1639. As envoy extraordinary to the Conference of Münster, he was credited with the partial success of Roman Catholic interests, even though his brilliant ability as a mediator was not sufficient to avert the threat of a conflict with the Protestant bloc. Upon his return to Rome, Pope Innocent X appointed him secretary of state, and on February 19, 1652, made him cardinal. In the conclave that followed Pope Innocent X's death, Cardinal Chigi was elected pope and he chose the name Alexander in honor of the third pope of that name who also came from Siena. From a doctrinal point of view, his papacy was characterized by fervent opposition to Jansenism. Politically, it was memorable for limiting the expansion of the Turks, who were already threatening Vienna. The abdication of Queen Christina of Sweden, and her subsequent conversion to Catholicism, impressively confirmed the pope's personal prestige among rival factions. The arrival in Rome of the daughter of Gustavus Adolphus (Gustavus II), the king who was most active in defending the Protestants' interests, earned new support for the Catholic cause by linking it with the image of intelligent patronage promoted by the Swedish gentlewoman in her Roman residence.

Among the pope's cultural projects was the completion in 1660 of the new premises of the University of Rome, known as "la Sapienza," which he endowed with a magnificent library, called "l'Alessandrina" in his honor. He was also responsible for extensive additions to the Vatican Library, including the purchase of books from the substantial estate of the dukes of Urbino in 1658. In the sphere of the arts, Pope Alexander VII's versatile personality found a channel for realization. Collaborating with talented artists of the caliber of Gian Lorenzo Bernini, Francesco Borromini, and Pietro da Cortona, he initiated one of the most glorious seasons in art history, with consequences that would have a lasting impact on the city's public image. His projects for the layout of Saint Peter's Square (1656–57), Piazza del Popolo (1655; 1662–79), and the Minerva (1667) are only a few of the interventions of providence and urban restoration that he studied in an effort to assure Rome's stature as the capital of Christianity.

This bust reflects the artist's intense assimilation of Bernini's style, visible in the vitality of the carving and the animated spirit of its psychological observation. Though modeled in a conventional pose, the dynamic flow of the drapery and the slightly foreshortened position of the head suggest vigilant attention to the individual as well as a profound awareness of his role. The softened rendering of the chiaroscuro effect denotes the influence of Giovan Battista Gaulli, called "il Baciccio" (1639–1709). The Genoese artist's work set a standard for portraiture for both painters and sculptors in Rome during the 1660s. Wittkower (1955, 227) was the first to note a possible relationship between this marble sculpture and a bronze portrait in the cathedral of Siena. He did not make any conjectures as to its authorship, however, and, at that time, did not mention the theories of Frittelli (1922, 58) and Martinelli (1953, 136), which identified Bernini's hand in the prototype. Two years later, Martinelli changed his opinion and attributed the work to the Maltese sculptor Melchiorre Caffà (1631–67), a student of Ercole Ferrata (1610–86). He linked the artist with a payment made on April 8, 1667, for a bronze bust of Alexander VII, cast by Giovanni Artusi and commissioned by Cardinal Flavio Chigi (Martinelli 1955, 52; cf. Golzio 1939, 301–2). Martinelli's theory was confirmed a few years later by Wittkower's publication of an article referring to a second bronze version at the Metropolitan Museum of Art in New York, dated 1667 and signed by Caffà (Wittkower 1959, 197–204). Both the portrait in Siena and the one in New York are related to the terracotta model kept *ab origine* in the Chigi palace of Ariccia, where "it was used to cast metal and, later stayed in the Chigi home, serving to mold and cast many more" (Pascoli 1734–36, 1992 ed., 354, 358, nn. 111–12). Therefore, it is probable that the Vatican bust, which came from the other palace of the Chigi in Rome (Fraschetti 1900, 289), was obtained from the same source. However, the work's didactic composition (the coat of arms motif with its stars and "mountains") and less refined workmanship suggest that it is not by Caffà but to someone in the circle of his school.

Recently a hypothesis has been made that this bust is the work Bernardo Fioriti (Bernard Fleury, news from 1643–73), who had received various commissions from the Chigi family, including many portraits of Pope Alexander VII (Petrucci 1993, 91–98). Ferrari and Papaldo find this attribution convincing, and date its execution in the early 1670s (1999, 590).

This sculpture was given to the Vatican by the State of Italy in 1923, together with the bequest of the Chigi Library, as a first conciliatory act in anticipation of the concordat of 1929. G.C.

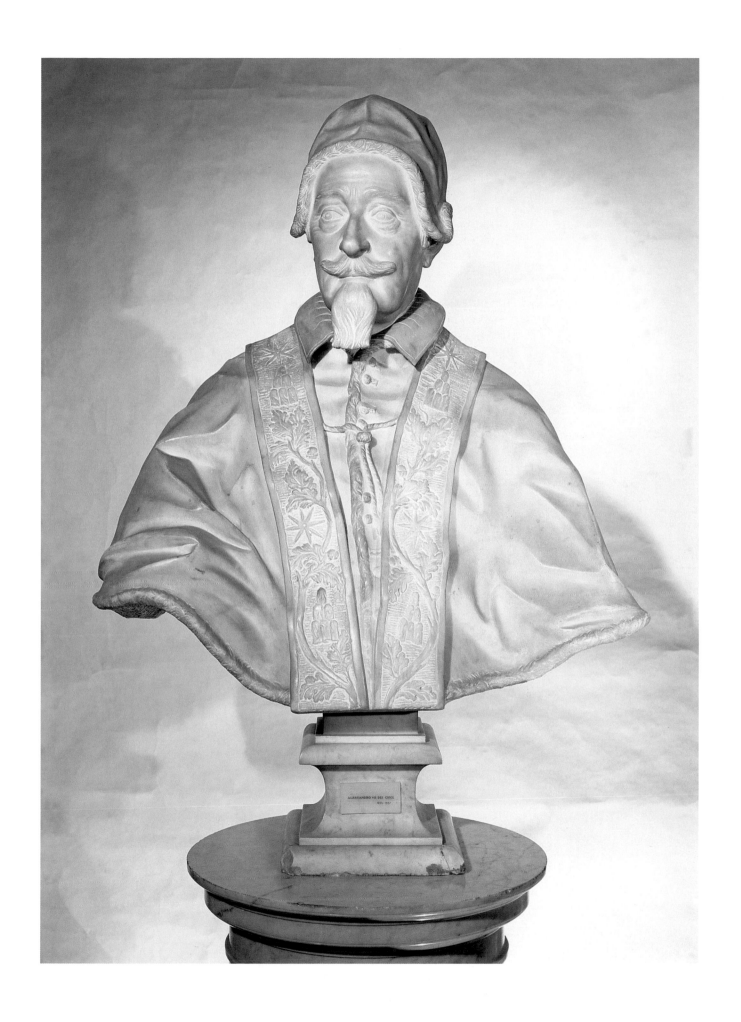

277

Model of a Wooden Tower used for Raising Columns

18th century
Pietro Albertini (died 1797)
Wood
160 × 100 × 80 cm
Reverenda Fabbrica of Saint Peter, Vatican City State

Conservation courtesy of The Oregon Chapter
of Patrons of the Arts of the Vatican Museums

Throughout the history of architecture, models have been used to show clearly and effectively the intended outcome of a project or to illustrate, perhaps for educational purposes, the characteristics of a work already completed. Between the first and second centuries, Plutarch (*Moralia*, III, 293, 1) mentions the custom of presenting models at public tenders for the building of new temples, while a Greek inscription (*Inscriptiones Graecae*, II, 2, 1668) concerning the building of storehouses at Piraeus speaks clearly of the models used in the project. Most models, being made of perishable materials such as wood or wax, were not preserved; exceptions to this are the marble models for Hadrian's Villa at Tivoli, the tetrastyle temple at Ostia, and the Niha sanctuary in Lebanon. To these three examples from the early imperial period must be added models conserved on coins, in marble reliefs, and, later, in mosaics and wall paintings. Renaissance architects used to communicate their ideas through scale models built by a "faber lignarius" or "woodworker."

The Fabbrica of Saint Peter conserves some project models, among them one of the basilica planned by Antonio da Sangallo the Younger, the dome of Michelangelo, those presented in 1715 at the competition for the building of the new Vatican sacristy, and one by Luigi Vanvitelli for the illumination of Saint Peter's in the jubilee of 1750. In addition to those are ones of the scaffolding and staging used in the various projects undertaken by the Fabbrica. Of these, one of the most interesting is certainly this model of a tower used for raising large columns.

The external structure has six uprights made of strips of pine held together with hemp cords and strips of lead. The smaller internal crosspieces are made of chestnut and poplar wood. At the bottom, slightly off center with respect to the central axis, is a plinth with an Attic base on which the column would rest once raised to a vertical position by the pulleys at the top of the tower. Very likely the model presented here is included on a "list of models and drawings of the Vatican Basilica" dated July 18 1787. In particular on the document from General Archive of Saint Peter's Fabric (ARM. 12, D. 3, no. 2, f. 46v) the idea of the work is assigned to Pietro Albertini, "soprastante" of the Fabric from 1788 to 1793. The structure was made in order to raise in the courtyard of Innocenzo XII in the Curia of Montecitorio, a large column of cipollino marble "discovered under the foundations of a building belonging to the Benedettine nuns in campo Marzio" (ARM. 12. D. 4 Bis. f. 1055v). For the accomplishment of this task, Albertini had certainly made suggestions based on the scaffolding done in the year 1705 for raising the Antoninus Pius column. This work has been wonderfully shown with an engraving done by A. von Westerhout.

Nicola Zabaglia (1664–1750) was a resourceful inventor of machines, towers, and staging, and author of a book wherein his amazing creations are described and illustrated. In the second edition of that work, the lawyer Filippo Maria Renazzi wrote a biography of Nicola Zabaglia explaining that from the very beginning of his activities Zabaglia, who could neither draw nor write, used to make wonderful models of the structures he had planned – using "sticks, boards and bits of wood cut to measure" – structures that would later be built life-size. During the pontificate of Pope Clement XI, Zabaglia obtained permission from Msgr. Ludovico Sargardi, bursar general of the Fabbrica, to use a room in the upper levels of the dome where he could work undisturbed, producing a copious assortment of models and in a very short time transforming that "studio" into a sort of "museum" or "gallery" of mechanics. The fame of his ingenious inventions even reached the pope, who ordered that all Zabaglia's models be kept in a room in the Vatican Palace. At the same time, designs were drawn to be used for engraving the copper plates necessary for printing Zabaglia's book. That work was only finally published in Rome in 1743 at the wishes of Pope Benedict XIV, who ordered that the engraving of the models that had begun twenty years earlier be completed.

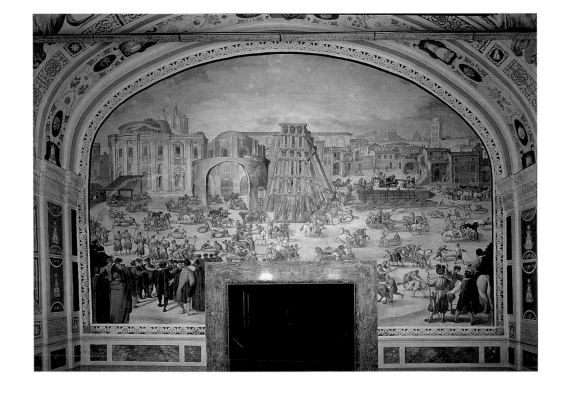

C. Nebbia, *Transportation of the Obelisk from the Circus of Nero to Saint Peter's Square*, 1590, fresco, Vatican Apostolic Library

The destruction of many of the models and the loss of many of the copper plates (perhaps stolen and sold as scrap metal) meant that Zabaglia's book had to include other engravings showing the transfer of the Vatican obelisk by Domenico Fontana during the pontificate of Pope Sixtus V. Some of these plates show the great tower built in 1586 to lower and raise the Vatican obelisk, a structure that appeared in engravings by Natale Bonifacio and Pietro Albertini used as inspiration for the model on display here.

The transfer of the colossal Vatican obelisk had given rise to immense admiration, and later generations continued to make constant reference to that event. Zabaglia had twice planned and built a scaffolding tower around the obelisk, reawakening the curiosity and interest of his contemporaries: once, in 1723, when the obelisk was surrounded by a balustrade and the base was adorned with the bronze garlands and the heraldic eagles of Pope Innocent XIII, the work of the sculptor Lorenzo Ottoni, and again in 1739 when it became necessary to restore the cross, which was in danger of falling from the top of the obelisk, where it had been placed by Pope Sixtus V to replace the original bronze sphere.

In 1925, Nicola Zabaglia's surviving works – and the wooden model of Pietro Albertini which was restored for this exhibition – were put in display in room "P" of the Petrine Museum, where they remained until 1966. P.Z.

Wooden Tower used to Hoist and Lay Flat the Vatican Obelisk

From *Il Tempio Vaticano e la sua origine* (Rome, 1694),
pl. 135
Carlo Fontana (1634–1714)
Drawing, Carlo Fontana
Engraving, Alessandro Specchi
Print
47 × 34 cm
Reverenda Fabbrica of Saint Peter, Vatican City State

This print shows the tower used to hoist the Vatican obelisk. For more than fifteen centuries, the obelisk had been in its original position on the *spina* of the circus built by the emperor Caligula (AD 37–41). During the Middle Ages, the obelisk – or "guglia" (spire), as it was commonly known – had become a symbol of the church and of the Roman Empire. Indeed, it was in the shadow of the obelisk that Saint Peter and the Roman protomartyrs had suffered and died, and popular belief held that the ashes of Julius Caesar were preserved in the bronze sphere at the top. The district that arose around the monument, along the southern side of the old basilica, thus came to be called *Aculia* or *Agulia*.

The idea of moving the obelisk to the square in front of the basilica was first suggested by Pope Nicholas V. The humanist pontiff's idea was to support the Egyptian monolith with statues of the Four Evangelists and to substitute the bronze sphere with a statue of Christ holding a gold cross in his right hand. The project was never carried out because the pope died, but it was taken up again by Pope Paul II and Pope Sixtus IV. In the end, the obelisk was not moved during the fifteenth century, although the first excavations did take place to reveal the base. At the beginning of the following

century, Donato Bramante even suggested altering the orientation of the new basilica on the basis of the position of the obelisk. Various other projects were proposed and, during the reign of Pope Gregory XIII, the architect Camillo Agrippa invented a wooden structure to carry the obelisk to Saint Peter's Square. The project was elucidated by Agrippa with illustrations and models in a forty-eight-page tract published in 1583. The obelisk, however, was only moved during the pontificate of Pope Sixtus V. A competition arranged to arouse interest in the enterprise was won by Bartolomeo Ammannati of Florence and, in the summer of 1585, the pope entrusted the delicate task to his favored architect, Domenico Fontana, who was helped by his elder brother Giovanni and his twenty-two-year-old nephew, Carlo Maderno.

The illustration on view here shows the first stage of the work of raising the obelisk. To the left is the so-called Rotonda di Sant'Andrea, a circular Roman mausoleum dating from the third century. An opening may be seen in its wall, which was ordered by Domenico Fontana so as to have enough space to lay the obelisk flat and to house three of the forty winches used to move the monolith. A similar opening was made on the opposite side of the Rotonda. Houses in the area had to be destroyed to accommodate the maneuvers, which involved 907 men and 75 horses. Once the square had been leveled and solid foundations laid, the great tower was built; this may be seen on the right of the illustration, depicted in great detail by Carlo Fontana. Within the tower, the obelisk is visible; it is without its bronze sphere, which was removed at that time, closely examined, and taken, in 1589, to Rome's Palazzo dei Conservatori, where it can still be seen today. This engraving by Alessandro Specchi also appears in the book by Nicola Zabaglia (see previous entry) and derives from the sixteenth-century prints of the painter Giovanni Guerra, engraved by Natale Bonifacio and with copious notes by Domenico Fontana. P.Z.

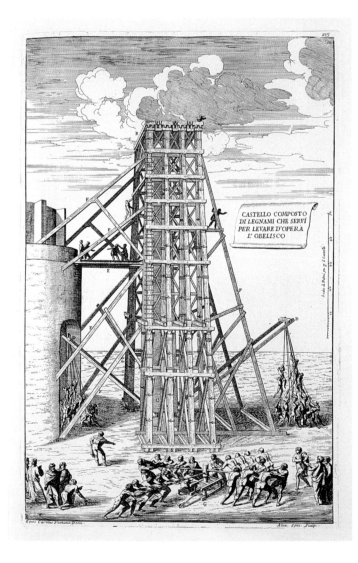

CASTELLO COMPOSTO DI LEGNAMI CHE SERVÌ PER LEVARE D'OPERA L' OBELISCO

Removal of the Vatican Obelisk
from its Original Position

From *Il Tempio Vaticano e la sua origine* (Rome, 1694),
pl. 143
Carlo Fontana (1634–1714)
Drawing, Carlo Fontana
Engraving, Alessandro Specchi
Print
47 × 34 cm
Reverenda Fabbrica of Saint Peter, Vatican City State

Groundwork for the removal of the Vatican obelisk
from its original position lasted seven months,
ending on April 28, 1586. The architect Domenico
Fontana had accurately calculated that the obelisk
weighed about 330 tons and had devised a plan
for its removal, complete in every detail. He had
sent his assistants to Foligno to obtain the hemp
necessary to weave the ropes that would raise and
lower the monolith; metal braces were prepared
at Subiaco and Ronciglione, while the wood for
building the thirty-meter-high tower came from
Campomorto, Terracina, and Santa Severa.

Following the celebration of mass on the
morning of April 30, 1586, 907 men awaited the
signal to begin work, which, it was ordered, had
to be carried out in absolute silence and perfect
harmony. A blast on the trumpet and operations
began. The obelisk was raised "and in that first
movement it was as if the earth shook and the
tower gave a mighty tremor." Indeed, one of
the metal braces holding the obelisk broke and
the sound of a bell announced the immediate
suspension of the maneuvers to repair the damage.
Following this incident, the workers set to once
more and were eventually able to place the obelisk
on the "strascino," a kind of raft mounted on
rollers. Thus, to the joy and amazement of the
crowd, the first phase of work was completed
without harm or injuries.

This plate shows the great wooden tower
containing the obelisk resting on one side. The
obelisk is shown suspended from thousands of
ropes and four poles, marked with the letter D,
which were used as props in lowering the
monolith. The obelisk is protected by a covering
of mats and wooden boards strengthened with
metal braces and held in place with nine iron
brackets. In the foreground are two of the forty
winches used for keeping the ropes in tension
via blocks and pulleys. Under the obelisk, the
"strascino" may be seen on its wooden rollers.
From Domenico Fontana's own account in his
book *Della trasportazione dell'obelisco in Vatican* (Rome,
1587), we know that on Wednesday, May 7, 1586,
after twenty-two hours of work, the spire was
fully lowered.

Carlo Fontana's illustration is taken directly
from the sixteenth-century engravings of Natale
Bonifacio from drawings by Giovanni Guerra.
Guerra is also credited with the fresco in the
Sistine Hall of the Vatican Museums showing the
transportation of the obelisk. The fresco shows
the same tower and spire tilted at an oblique angle
with, to the left, the Rotonda di Sant'Andrea, which
the artist has depicted with a great central opening
so as to show the inside of the building where
workers are intent upon the three winches. P.Z.

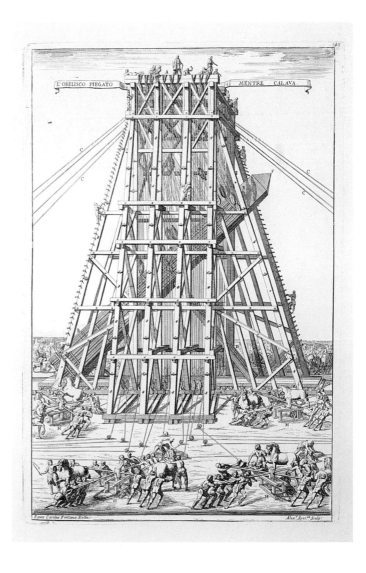

Transferal of the Vatican Obelisk to Saint Peter's Square

From *Il Tempio Vaticano e la sua origine* (Rome, 1694), pl. 146
Carlo Fontana (1634–1714)
Drawing, Carlo Fontana
Engraving, Alessandro Specchi
Print
47 × 34 cm
Reverenda Fabbrica of Saint Peter, Vatican City State

One of the many plates dedicated to the memorable enterprise of the transfer of the Vatican obelisk in Carlo Fontana's book shows a foreshortened image of the tower with the obelisk lying upon the "strascino," the great "raft" with wooden rollers. The obelisk is shown with its point facing east, toward its destination in Saint Peter's Square. Within the tower, the many ropes used to lower the Egyptian monolith are still held under tension by the stays fixed into the top of the structure and into the brackets around the obelisk. A group of workers is removing the rope from the drum of the winch

while a man holding a roller in his hands is sitting on one of the beams of the "strascino." In front of him is the figure of the architect Domenico Fontana imparting his final orders for sliding the obelisk forward and dismantling the tower. Four full working days were needed just to dismantle the stays and winches and more time was taken up in disassembling the tower, conserving each piece separately so as to be able to rebuild the same structure in the square. Once this operation was finished, excavations began to recover the two parts of the base of the obelisk, under which was a double bed of travertine over flint foundations. In the meantime, as there was a nine-meter height difference between the old and new positions of the obelisk, Domenico Fontana ordered the building of earthworks shored up with beams, so as to be able to drag it to the right level and facilitate its erection. These earthworks, as described and illustrated by Domenico Fontana, are shown in plate 151 of his book and also appear in Nicola Zabaglia's volume of 1743. Zabaglia's work also contains the illustration described here.

P.Z.

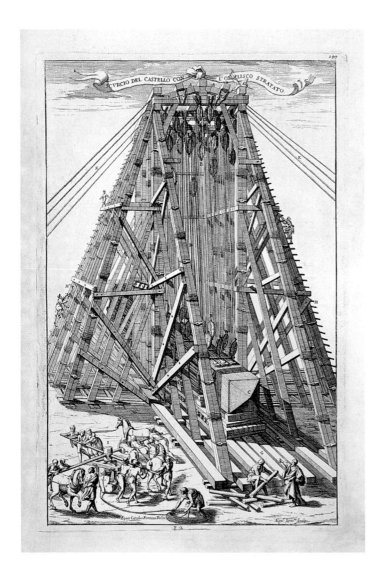

Erection of the Vatican Obelisk in Saint Peter's Square

From *Il Tempio Vaticano e la sua origine* (Rome, 1694), pl. 169
Carlo Fontana (1634–1714)
Drawing, Carlo Fontana
Engraving, Alessandro Specchi
Print
47 × 72 cm
Reverenda Fabbrica of Saint Peter, Vatican City State

Carlo Fontana, architect of the Fabbrica of Saint Peter, was the great grandson of the famous Domenico Fontana who, in 1586, moved the Vatican obelisk from the position it had occupied for more than fifteen centuries, in what had been Caligula's circus.

This engraving by Alessandro Specchi shows the square in front of Saint Peter's Basilica with the houses of the Borgo in the background and Castel Sant'Angelo to the left. In July 1586, Pope Sixtus V had expressed the desire to knock down some of the buildings that would prevent the obelisk, in its new position, from being seen from the Tiber; a similar project to that was finally carried out in 1937 when the so-called Spina di Borgo was demolished to make way for the modern via della Conciliazione.

In this illustration, the square is shown full of people who came from all over to attend the memorable event that had begun at dawn on Wednesday, September 10, 1586. Preparations had been made to ensure that the multitudes of people — on foot, on horseback, or in carriages — caused no disturbance to the operation. A fence patrolled by armed guards separated the crowd of onlookers from the 800 workers and 140 horses involved in the maneuvers. Severe penalties had been established for anyone who crossed the barricade or broke the injunction to maintain the most rigorous silence.

In this plate Carlo Fontana shows the first moments of the operation with the obelisk still lying within the tower that had been built on top of the "hanging square" (marked with the letter A). This "hanging square" is connected to the earthworks, along which the "strascino," or platform on wheels (letter C), had been pushed. At the base of the ramp (G), in the direction of the city, is the wooden structure (E) whence Domenico Fontana — architect and director of works — supervised the effort. As with the earlier operation of lowering the obelisk, each step was announced with a blast on the trumpet, while the ringing of a bell indicated that work had to halt immediately. A total of forty-four winches are shown, operated by men and horses; everything was carefully calculated on the basis of the deployment and function of each machine. The foremen, the laborers at the ropes, the workers on the staging, and the overseers

may all be recognized in the drawing. The letter L marks the four winches held ready to be used in case of need, while the letter O indicates the reserve horses. Near the buildings of the city, Carlo Fontana also depicted the procession that was held to favor a happy outcome to the enterprise (R). Work finished on September 10, 1586, "when the spire (obelisk) was upright on its pedestal," though still attached to the "strascino," which was only removed six days later. On September 27, the obelisk could be seen free of the mats and boards that had protected it during the course of the work.

The entire enterprise lasted thirteen months and cost 37,975 scudos, not counting the metal supplied by the Apostolic Camera to make the cross, the ornaments, and the lions. The wood, ropes, winches, stays, iron, and other material recovered at the end of the operation were later used in other undertakings of the Reverenda Fabbrica of Saint Peter. P.Z.

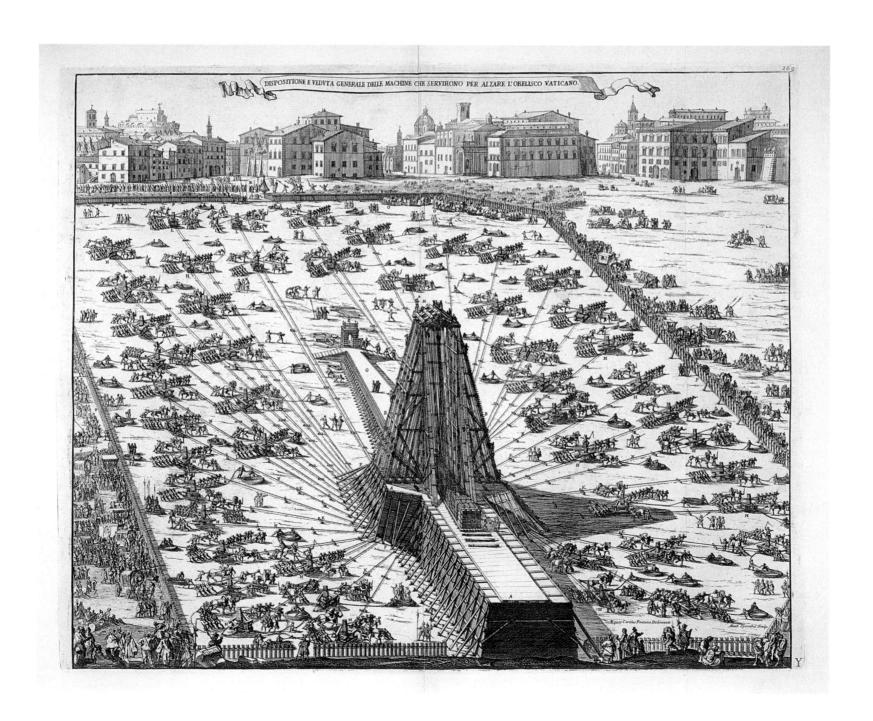

The Sistine Chapel
and the Election of the Pope

The beginning of a pontificate takes place in the Sistine Chapel. "It is here, in this sacred space that the Cardinals gather, to await the manifestation of the will of Christ regarding the person who will be successor to Saint Peter" (John Paul II at the inauguration of the restoration of the Michelangelo frescoes in the Sistine Chapel on April 8, 1994).

The election of the pope takes place with a solemn ceremony, following precise rules that have been established during the course of centuries. The procedure for voting and counting the ballots takes place inside the Sistine Chapel with only the cardinal electors present. There are four votes a day, two in the morning and two in the afternoon, until the pope is elected. There is an ancient tradition that the outcome of each ballot be communicated by means of a smoke signal to the faithful gathered in Saint Peter's square. After each ballot the votes are burned inside the Sistine Chapel. Black smoke from the chimney of the chapel means that a pope has not yet been named. White smoke signals that a new pope has been elected.

Tradition requires that after his election the new pope receives the obedience of the cardinals inside the Sistine Chapel. He is then dressed in the traditional white cassock and proceeds to the central balcony overlooking the square to give his first benediction, "Urbi et Orbi," for the city of Rome and the rest of the world.

In this section of the catalogue, the objects shown and presented refer to particular conclaves of which they are silent witnesses. The value of these objects is not in the materials of which they are made, but rather in the memories that they represent. Each evokes an important moment in the history of the church that, in succession, reconnects each pope to Saint Peter.

Portrait of Pope Julius II Della Rovere

1848
Vincenzo Canterani
Oil on canvas
Diameter 136 cm
Reverenda Fabbrica of Saint Peter, Vatican City State

This tondo portrait shows Giuliano Della Rovere, nephew of Pope Sixtus IV, who was himself elected in November 1503 as Pope Julius II. Of a decisive and energetic personality, he sought to stem the disorder of the pontifical court, strengthen the papacy, and fight against interference from European powers opposed to the Holy See. His name is linked to the rebuilding of the Vatican basilica. On April 18, 1506, having decided to destroy the Constantinian edifice, he placed the first stone in the foundations of the pier of Saint Veronica and thus initiated construction of a more majestic and modern building. When he died, on the night of February 20–21, 1503, his body was displayed, dressed in pontifical robes, in the still-unfinished basilica. Paris de Grassis, papal master of ceremonies, noted the event in his diary in the following words:

> For the forty years I have lived in this city, I have never seen such extraordinary crowds at the death of a pope. Everyone, great and small, old and young, wanted to kiss the feet of the dead man, although the guards sought to prevent them. Amidst the tears, they prayed for the well-being of the soul of he who had truly been pope and Vicar of Christ, defender of justice, and who had enlarged the apostolic Church, persecuting and dominating tyrants. Even those for whom, according to all appearances, the death of Julius II may have seemed desirable, broke into tears and exclaimed: this pope managed to avert the yoke of the French and the Barbarians for all of us, for the whole of Italy and for the entire Christian world.

This oil portrait is part of a series commissioned in 1847 by Pope Pius IX to decorate the new basilica of Saint Paul's Outside-the-Walls, following the devastating fire that destroyed the old basilica in 1823. The artist was Vincenzo Canterani and the work was transferred onto a mosaic by Cesare Castellini between October 1849 and March 1851. A.M.P.

Twelve Portraits of Popes

21st century
Cecco Bonanotte (born 1942)
Bronze
Each: 46 cm

Casts from the collection of the Artist

The coat-of-arms of Pope John Paul II above the exterior of Bonanotte's monumental bronze doors at the new entrance to the Vatican Museums

The year 2000 marked the celebration of the great jubilee, and the Vatican Museums sought to respond to the many requirements imposed by the importance of the occasion. One of the biggest projects involved the construction of a new entrance, a monumental undertaking that also comprised expansion and modernization, so as to facilitate access to one of the world's most visited museums. The so-called New Door was constructed, the work of the sculptor Cecco Bonanotte. His creation seeks to welcome visitors as they pass through the walls of Michelangelo's bastion on a journey through the history of civilization, in the spirit and mind of man.

Cecco Bonanotte was born in Porto Recanati, Italy, in 1942. After early studies at Macerata, he moved to Rome where he attended the Academy of Fine Arts. In the mid 1970s he began working as a sculptor, both in Italy and abroad, establishing particularly strong links with Japan. The artist's dealings with the Vatican began in 1975, when he made the casket that held the document marking the closure of the holy door of the Basilica of Saint Paul's Outside-the-Walls, and a votive lamp in commemoration of that holy year. In 1985, Pope John Paul II donated one of Bonanotte's sculptures depicting the Travels of Saint Paul to the United Nations building in Nairobi, Kenya. In 1999 he was commissioned to make the New Door for the entrance to the Vatican Museums, and in 2000 the Senate of the Italian Republic made a gift to the Holy Father of Bonanotte's work *Ascension*, today in the Vatican gardens.

The choice of Bonanotte was determined by a number of considerations, not least his long-standing and profound familiarity with bronze, a medium to which he dedicates himself almost exclusively. The first four models presented by the artist make it apparent that the compositional structure of the new doors was clear right from the start: a modular composition of 208 square panels subdivided into two leaves, closed at the center by a large, circular medallion.

The content and poetic horizon of the work were equally clear: not the celebration of the Vatican Museums, nor the glorification of an individual work, nor the commemoration of a specific period, culture, or personage, but the desire to represent, or rather evoke, a place that houses the most diverse testimonies, the spiritual and physical sources of all forms, all thoughts, all cultures, and civilizations. Not by chance did Bonanotte spend whole days in the Sistine Chapel, symbolic heart of the Vatican Museums, almost as if he wished to assimilate the power with which that pictorial space contracts and dilates to the point of subverting any rational presupposition.

An extreme formal synthesis was already apparent from the first model that Bonanotte presented, one characterized by material elements: concave and convex ovoid forms delineated a

surface marked by the delicate fissures of lines, incisions, and scratches. An immense cosmic space was represented, its infinite expansion conveyed by sporadic and fragmented formal elements with no detailed iconography. This first idea – following a number of intermediate passages in which figurative and descriptive elements appeared and disappeared in the search for a purity and essence of form and content – was the basis of the final project. His refined casting technique enabled the bronze to adopt chromatic and pictorial shades, to take on different consistencies and thicknesses, to evoke spaces and breadths rare for a work of sculpture.

Bonanotte does not completely renounce human and natural figures, however; indeed, the two elements are constantly present throughout his artistic production and are absolutely central to the place to which the door gives access. Thus, the sculptor created a great central medallion closing and covering the two leaves, and he fashioned two figures, a man and a woman, in shallow relief, who converge on the center: they reach out to each other, their arms outstretched, their hands barely touching. Bonanotte here adopts a very low relief which, by depriving the forms of any plastic

significance, is in perfect harmony with the forms of the material. Nature is introduced by the sculptor in the upper part of the left-hand leaf: two birds seem to be about to take flight from a cylindrical pivot, their bodies almost deformed by the tension of launching themselves upward. It represents a long-range dialogue between nature and humanity, in this case a dialogue expanded into the vastness of the space that surrounds every created being.

The installation brought to light a problem concerning its relation to the opening in the wall into which it was supposed to fit. The inclination of the splay and the thickness of the wall called for a more comprehensive intervention, one capable of bringing together all the existing elements: the walls, the opening, the pronounced torus running horizontally above the lower part of the bastion, and the door itself. Bonanotte conceived the idea of a kind of coping or superstructure, like the door to be made of bronze and to have a modular structure (a grid of square panels). Fixed above the door, the coping was to have an irregular form, jutting outward and following the inclination of the splay.

The coping rises upward to touch the travertine torus and is adorned in the center with the coat of

arms of Pope John Paul II. In creating this element, the artist did not adopt traditional elements but used a highly simplified form: the rectangular coat of arms is enriched with a dentil motif and surmounted by the papal symbols, the tiara and crossed keys, also elegantly stylized.

On the back of the door, Bonanotte created a series of small-scale sculptures showing the twelve popes who, over the course of the centuries, made particularly important contributions to the life and development of the Vatican Museums. In this way he evokes the history of the priceless collections housed within the museums, which thus becomes part of the door through the sculpted images of the pontiffs, each of whom the artist studied individually with the aim of making their particular personality stand out by means of a concise silhouette. Bonanotte devised each individual figure, giving special emphasis to their stance, the folds of their vestments, the position and gestures of their hands, the inclination of their heads. The features are not realistic, but the whole represents a perfect synthesis of the value and qualities specific to each pontiff, so as to show their personality rather than simply faithfully reproducing their features.

118

The Renaissance Pope Julius II was famous for his patronage of the arts. In 1508, he commissioned the frescos by Raphael in the *Stanze* and those by Michelangelo in the Sistine Chapel. During his pontificate demolition of the old basilica of Constantine began to make way for a new and grandiose basilica dedicated to Saint Peter, which the pope had commissioned from Bramante. He also placed ancient statues from his own collection into the interior courtyard of the Belvedere pavilion, known today as the Octagonal Courtyard. Among the statues is the famous marble group of Laocoön, discovered in 1506, and the Apollo Belvedere. This marked the beginning of the Vatican's collection of classical sculptures.

119

Pope Leo X was another patron of the arts, employing such artists as Giuliano da Sangallo, who took over the project of the new Saint Peter's following Bramante's death, and Raphael, who finished the frescos in the *Stanze*, drew the cartoons for the tapestries in the Sistine Chapel, and decorated the Loggia. Pope Leo X was also concerned to find new and prestigious works to enrich the collections of the Vatican Library, founded by Pope Nicholas V in 1451.

120

Pope Clement VII dedicated himself to completing some of the most important works begun by his predecessors, and in 1523 instituted a permanent commission to oversee the building and administration of Saint Peter's Basilica. During his pontificate, the last of the Vatican *Stanze* and the Hall of Constantine were decorated by painters of Raphael's school; the Cortile di San Damaso was completed; the niche in the Cortile del Belvedere was built on a design by Michelangelo; and the Vatican Library was considerably expanded. In 1534, the year of his death, Pope Clement VII commissioned Michelangelo to decorate the wall behind the altar in the Sistine Chapel with a fresco depicting the Resurrection. This commission was carried out under Clement VII's successor, Pope Paul III, who decided to substitute the Resurrection with the Last Judgment and also gave Michelangelo the task of decorating the Pauline Chapel.

121

Pope Clement XI, archaeologist, collector of antiquities, and lover of arts, sciences, and literature, is to be credited with the creation of an ecclesiastical museum, housed near the Octagonal Courtyard but dispersed in 1716. He also renewed interest in the collection of works of classical antiquity in the courtyard of the Belvedere pavilion and restored the interior decorations of the same building, where he founded a museum of sketches and wooden models. He paid particular attention to the Vatican Library and enriched it with important collections of Greek and Latin authors.

122

Pope Benedict XIV, a passionate scholar of the law, gave particular attention to literary and scientific academies. He gave a renewed stimulus to the Vatican Museums, expanding the collections with new acquisitions and founding the new Sacred Museum of the Library, which was intended to house works and documents that provided historical confirmation of Christianity. He also significantly expanded the Vatican Library through the acquisition of the vast Ottoboni library, which had belonged to the pope of that name, Alexander VIII, and to which he assigned the items of the collection donated by Count Francesco Carpegna. Pope Benedict XIV was also the first pontiff to organize the inscriptions housed in the northern arm of Bramante's corridor.

123

Pope Clement XIV founded the Clementine museum with the idea of using it to house works of art he was able to acquire that were at risk of being exported. As a site for his new museum, the pontiff chose the Belvedere pavilion of Pope Innocent VIII, which was altered for the purpose by the architect Alessandro Dori and, later, by Michelangelo Simonetti. Pope Clement XIV also expanded the collection of inscriptions and enlarged the Vatican Library with numerous valuable books and increased the available space by ordering the building of a new room, decorated by Raphael Mengs.

The pontificate of Pope Pius VI, marked by the invasion of the Papal States by French troops and by the arrest of the pontiff and his death at Valence, was nonetheless a particularly fortunate time for the Vatican Museums. As counselor to Pope Clement XIV, he had already played a leading role in the creation of the Clementine museum. He was a central figure in the field of archaeological studies and had promoted various important excavations. Once he became pope he dedicated a great deal of energy to completing and expanding the museum founded by his predecessor, which is today known as the Museo Pio-Clementino. He commissioned Michelangelo Simonetti and Giuseppe Camporese to create the Gallery of the Candelabra, while Camporese is to be credited with having completed the atrium of the Quattro Cancelli (Four Gates) at the entrance to the Museo Pio-Clementino. Pope Pius VI founded the Vatican Picture Gallery in the modern-day Gallery of Tapestries; it was moved to its present definitive location only in 1932. Like his predecessor, Pope Pius VI turned his attention to the Vatican Library, also with a view to improving the museums to which it adjoins.

Pope Pius VII had many merits, not only regarding his contributions to the Vatican Museums, but also at a more general level in his attempt to rebuild the Roman artistic heritage in the wake of the removal of many works of art by Napoleon. Pope Pius VI's pontificate had ended with the arrival of the French in Rome and the signing of the Treaty of Tolentino. Among other things, the treaty had stipulated that a war indemnity be paid in works of art and even the Vatican Museums had been forced to surrender their most important pieces. Pope Pius VII initiated a full recovery plan, first by establishing a ban on the exportation of works of art from the Papal States, and also by encouraging new acquisitions and archaeological excavations. Not only were the great depredations in the Museo Pio-Clementino restored, but it even became necessary to create a new museum, called Chiaramonti after the pope and created and arranged by Antonio Canova, then Inspector General of Antiquities and Fine Arts. The collection of inscriptions was enlarged and reorganized in this period, and the Vatican Picture Gallery was transferred to the Borgia Rooms.

Following intense archaeological excavations in the most important sites of southern Etruria during the early decades of the nineteenth century, Pope Gregory XVI decided to create the Etruscan Museum (Museo Gregoriano Etrusco), which he inaugurated in 1837. It was later enriched by further acquisitions and donations to the point that it became one of the most important collections of Etruscan art. The foundation of the Egyptian Museum (Museo Gregoriano Egizio) in 1839, on the other hand, may be attributed to the increasing interest in Egyptian antiquities that followed the deciphering of hieroglyphics by Jean-François Champollion in 1822. The Museum of Pagan Antiquities (Museo Gregoriano Profano) was opened in 1844; initially housed in the Lateran Palace, it was moved to the Vatican at the orders of Pope John XXIII and opened in 1970. The museum was created to house architectural fragments, statues, reliefs, sarcophagi, urns, and portraits from excavations carried out in the Papal States. Pope Gregory XVI's pontificate also saw the restoration of the Pauline Chapel and the reconstruction of the Basilica of Saint Paul's Outside-the-Walls, destroyed by a great fire in 1823.

In the cultural field, Pope Pius IX's name remains strongly associated with archaeological enterprises. Evidence of this is the start of excavations at Ostia Antica and, within the Vatican Museums, the founding in 1854 of the Christian Museum (Museo Pio Cristiano), which followed the creation, in 1852, of the Commission for Sacred Archaeology, tasked with oversight of the catacomb excavations. The Christian Museum was founded to house the Christian antiquities unearthed during the course of excavations there. Originally located in the Lateran Palace, the Christian Museum was moved to the Vatican in 1963.

Pope Pius IX's pontificate also saw other events: the collections of ancient paintings, inscriptions, and glyptic works were enlarged; the Vatican Picture Gallery was moved again to the Bologna hall and surrounding rooms; in 1870 the Gallery of Saints and Blesseds canonized by the pope was opened. He also commissioned Francesco Podesti to paint the frescos in the Hall of the Immaculate Conception near the Borgia Tower with scenes relating to the Dogma of the Immaculate Conception, promulgated by the same pontiff on December 8, 1854.

Under Pope Pius XI, a man of great culture and an enthusiastic patron of the arts, the Vatican Museums again underwent alterations. In 1925, following the inauguration in 1924 of the Museum of Saint Peter, the Etruscan Museum was significantly reorganized. Also in 1925, in the wake of the Missionary Exhibition, the Ethnological Missionary Museum was founded to safeguard art and artifacts relating to the religions of non-European peoples.

In 1932, the architect Giuseppe Momo was commissioned to begin work on a new entrance to the Museums opening onto the Viale Vaticano. In the same year, the Vatican Picture Gallery – which had been enlarged with new acquisitions ever since the earliest years of Pope Pius XI's pontificate – was definitively moved to a new building planned by the architect Luca Beltrami.

Pope Pius XI also encouraged specialized scientific research and established permanent restoration workshops within the Vatican Museums. As for the Vatican Library, it was considerably enlarged and he had a new repository built to house the books.

Pope Paul VI inaugurated two new Collections in 1973: the Gallery of Modern Religious Art and the Historical Museum. Apart from a series of papal portraits, the Historical Museum contains arms, uniforms, and equipment from disbanded pontifical military corps, written and photographic documentation, as well as carriages and the first motor cars used by popes once kept in the papal stables.

Pope Paul VI also inaugurated three museums that had once been housed in the Lateran Palace (the Gregorian Museum of Pagan Antiquities, the Christian Museum, and the Ethnological Missionary Museum) after their transfer into a new building in the Vatican designed by the brothers Vincenzo, Fausto, and Lucio Passarelli. During his pontificate, the independent periodical *Bollettino dei Musei e Gallerie Pontificie* (Bulletin of Pontifical Museums and Galleries) was first published, giving an annual account of the activities of the various departments of the Museums. M.F., M.B.

Ceremonial Hammer for the Verification of the Death of the Pope

20th century
Ebony, silver gilt
22 × 9 × 2 cm
Office of the Liturgical Celebrations of the Supreme
Pontiff, Vatican City State
Inv. VR12

Conservation courtesy of Johan M.J. van Parys,
Ph.D., in gratitude for the Basilica of Saint Mary
in Minneapolis

Before the death of a pope was publicly declared,
a special and wholly unique ritual used to be
performed. With the assistance of the *camerieri segreti*
(valets to the Papal Apartments) and accompanied
by a group of Swiss Guards, the chamberlain—who
was also a cardinal—would approach the recently
deceased pontiff on his deathbed and touch his
forehead lightly with the small gilded hammer,
solemnly calling him three times by his Christian
name. When no answer was forthcoming with the
third call, the pontiff was officially declared dead.

Although this ritual is no longer practiced, the
cardinal chamberlain continues to confirm the
pope's death officially. The last time the ceremonial
hammer was used was upon the death of Pope John
XXIII, though this remains debatable. More certain-
ly verifiable is the report of the rite having been
performed on the body of Pope Leo XIII in 1903.

R.V.

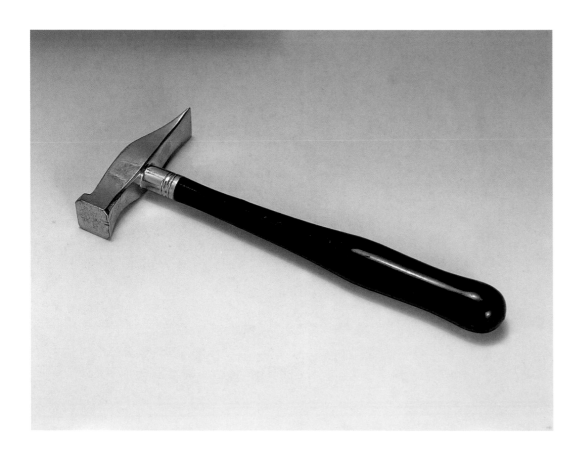

Scepter (Baculus) of the Protodeacon of the Holy Roman Church

20th century
Gilded metal covered with red velvet
61.5 × 4 × 4 cm
Office of the Liturgical Celebrations of the Supreme
Pontiff, Vatican City State
Inv. VR56

This baculus, or scepter, made for the protodeacon of the Holy Roman Church, was last used on March 25, 1985. The upper part is a gilded-metal cylindrical bar that terminates in three conjoined female heads crowned with a small flower design. Descending from the cylinder is a twin cord that ends in two bows. The lower part is likewise composed of a metal cylinder, gilded and grooved. The entire piece is covered in red velvet.

Upon the death of the pope, the chamberlain appointed by the papal consistory and chosen, from the fifteenth century onward, from among the College of Cardinals, assumes the duties of the protodeacon during the *Sede Vacante*. In the course of his tenure, the chamberlain is responsible for administering the temporal assets and laws of the Holy See, with the assistance of the *cardinali assistenti*.

The chamberlain oversees the drafting of the pope's death certificate, seals his private apartments, and takes possession of the Apostolic Palace, the various Lateran palaces, and those of Castel Gandolfo. In agreement with the *cardinali capi* of the three orders, he establishes the formalities to be observed for the funerary rites, should the pope not have left specific requests for his estate, and assumes responsibility in the name of the consensus of the College of Cardinals for everything necessary to uphold the rights of the Apostolic See and ensure its correct administration. R.V.

Formulae Juramentorum Omnium Pro Conclavi Gregorii XVI

(Formulas for Oaths for the Conclave
of Gregory XVI)
1831
Giuseppe Negri
Paper
36 × 28 × 1.5 cm
Office of the Liturgical Celebrations of the Supreme
Pontiff, Vatican City State
Inv. 270

This volume contains formulas of oaths for the swearing in of all people involved with functions regarding the conclave.

The conclave is the most exalted moment during which the church collects itself in prayer, with the awareness that the election of a pope is the work of the Holy Spirit. Thus, on this occasion, the cardinals who vote and all others involved must swear an act of faith to the church and its ministers, as well as commitment before God and humanity, to follow absolutely the prescribed regulations. In particular, this involves secrecy in regard to everything concerning the election.

The first two pages of the volume narrate the beginning of the Gospels. They are followed by formulas for the following oaths: the cardinals on the occasion of the First General Congregation and their entrance into the conclave; the governor of Rome in the First Congregation; the prefect of the sacred apostolic palace, governor of the conclave; the marshal of the conclave; the patriarchs, archbishops, bishops, apostolic protonotaries, auditors of the H.R. Rota, clerics of the apostolic chamber, electors of the Supreme Ecclesiastical Court… and other prelates of the Roman curia in charge of security; the conservators of the city of Rome (so that the conclave is not disturbed); the prefect of Castel Sant'Angelo; the cardinals who are to enter the conclave after hearing the election announcements; the ill cardinal who voted a ballot by proxy; the cardinals who must enter after the conclave has been closed; the secretaries and officials; the cardinal electors; the chief general of the pontifical troops before the College of Cardinals; and the cardinal who enters after the mass of scrutiny.

At the end is a report containing formulas for the voting. L.M.

Documents of the Conclave of Pope Pius X

1903
Nicolò D'Amico
Paper
24 × 17 × 3 cm
Office of the Liturgical Celebrations of the Supreme
Pontiff, Vatican City State
Inv. 824

This is a collection of documents, announcements, and directions that accompanied the diary of the master of ceremonies at the time, Monsignor D'Amico, during the conclave resulting in the election of Pope Pius X.

The patriarch of Venice, Giuseppe Sarto, was elected after four days of voting and was crowned with solemnity in the Vatican Basilica. He immediately gave his ministry an objective: *instaurare omnia in Christo* ("base all things on Christ"). As pope, he introduced important reforms: the code of canon law, the catechesis of the Catholic Church, and the renewal of several institutions of the Roman curia. Placing the Eucharist at the center of his apostolic activity, he advised the bishops to make appropriate arrangements for bringing children to Holy Communion as early as possible. He also granted the power to administer sacramental confession and absolution to children even before their First Communion. Pope Pius X definitively regulated the juridical form of the marriage ceremony, and invited believers to receive the nourishment of the Lord's Body daily. He updated the missal and the Divine Office, and founded the Institute for Biblical Studies. In issuing guidelines for the composition of music, he advised that only sacred texts be used for inspiration. He ordered that new churches and chapels be built in the Roman countryside. As much as possible, Pope Pius X attempted to nurture the flock entrusted to him: the people of Rome. He not only initiated these reforms, but he participated in their implementation. The premonition of the conflict that soon would afflict the best part of Europe caused him a great deal of suffering. In precarious health due to bronchitis that degenerated into pneumonia, he died on August 20, 1914, at the age of seventy-nine. He was first proclaimed blessed by Pope Pius XII on June 3, 1951, and then saint on May 29, 1954. L.M.

The Sistine Chapel prepared for the conclave that elected Pope Pius X, August 1903, *L'Osservatore Romano*

Diary of the Conclave of Pope Benedict XV

1914
Nicolò D'Amico
Paper
24.5 × 18 × 3.5 cm
Office of the Liturgical Celebrations of the Supreme
Pontiff, Vatican City State
Inv. 827

These diaries were written by the master of ceremonies Nicolò D'Amico and detail the events of the last days of Pope Leo XIII and Pope Pius X, and the election of their successors.

At that time, as soon as the supreme pontiff passed away, the master of ceremonies notified the cardinal camerlengo, who entered the room of the deceased and recited a brief prayer. Assistants unveiled the face of the pope, which had been covered with a white handkerchief. Using a silver mallet, the cardinal knocked lightly three times on the pope's forehead and called him by his baptismal name. He then addressed those present and informed them of the death, before reciting the psalm *De Profundis*, a prayer, and sprinkling the body with holy water.

Next, the master of the chamber presented the cardinal camerlengo with the fisherman's ring. Immediately the notary drew up an act regarding the recognition of the corpse and receipt of the ring. The pope was then dressed in his pontifical clothes, all red and gold silk.

Once the pope was dressed, the master of ceremonies, preceded by four Swiss Guards, twelve grooms, twelve Vatican penitentiaries, and the president, processed to the Vatican. The coffin was borne by the gestatorial chair-carriers, surrounded by the Noble Guard and the vergers. They were followed by the major-domo, the master of the chamber, the almoner, the pontifical sacrist, the nephews, and four secret servants; along the way, the procession was joined by cardinals, the Diplomatic Corps, the Knights of Malta, the bishops, and the Palatine Guards. The procession

then reached the portico of the Vatican basilica going down the royal staircase.

In front of the main entrance, the archdeacon of the basilica sprinkled the body with holy water. It was then taken in procession to the funeral chapel, which had been prepared in the Chapel of the Blessed Sacrament, for public exhibition.

The catafalque was covered with red velvet; the pillows were made of red satin with gold tassels and lace. Two pontifical hats, one of red velvet and the other of red satin, were set in place. Candlesticks and torches surrounded the catafalque. Four Noble Guards as well as other palatine and Swiss Guards stood at attention on all sides.

After three days, the burial took place. The body of the pope was taken to the Chapel of the Choir, where three coffins had been placed. The deceased was placed inside the first coffin made of cypress. The major-domo spread a veil of white silk over the face, then three red velvet bags of gold, silver, and bronze coins, equal to the number of years of the pontificate, were placed inside the coffin. The corpse was then covered with a long veil of red silk. The notary of the Vatican Chapter read the deed and then placed it inside the coffin, which was then closed and affixed with seals of black wax.

The second coffin was composed of sheets of lead that were soldered around the first, and it also was affixed with seals. It was then put inside the third coffin, made of polished wood with a gilt metal coat of arms, and screwed shut.

The coffin was then placed on a trolley and wrapped in red velvet before being lifted on top of the "temporary loculus," a masonry construction. Later it was transported to the Sistine Chapel, where the solemn obsequies ending the nine days of mourning took place.

On the sides of the tomb were four epigraphs about the most important episodes of the pontificate.

Once the obsequies were completed, the body was taken to the Vatican Basilica for final burial.

Following the funeral, the conclave took place as described in detail in these diaries, including the voting and the counting of ballots. C.P.

Diary of the Conclave of Pope Benedict XV

1914
Nicolò D'Amico
Paper
34.5 × 24 × 5.5 cm
Office of the Liturgical Celebrations of the Supreme Pontiff, Vatican City State
Inv. 828

This volume includes documents and texts relating to the conclave of 1914, during which Cardinal Giacomo della Chiesa was elected pope. Born in 1854 to a noble family in Genoa, he was appointed to the College of Cardinals by Pope Pius X just three months before his election to the pontificate as archbishop of Bologna. The new pope took the name Benedict XV, in memory of one of his illustrious predecessors who had also been elected pope from the see of Bologna: Cardinal Lambertini, who became Benedict XIV.

Almost all his pontificate was spent during World War I. The pope's commitment to war prisoners and victims of every nationality won him recognition from all the world powers, even after his death on January 22, 1922. A humble pope, he was extremely generous in his solicitude toward the needy. Without hesitation, he ordered that some of the papal sacristy's properties be sold to help the unfortunate. In the sphere of doctrine, he endeavored to spread the faith, promulgated the code of canon law that his predecessor had begun to reform, and founded the Congregation for Eastern Churches.

The first documents here regard the serious illness of Pope Leo XIII, in the first volume, and that of Pope Pius X in the second. They also cover the deaths of the two popes, beginning with exhortations for prayer addressed to the clergy and the faithful of Rome. Also included are all the acts addressed to the Roman curia concerning dispositions, orders, summons, rules, tickets, etc., relative to the period of the vacancy of the Holy See and the pontiff's solemn obsequies.

The section regarding the conclave mainly consists of lists of the cardinals and the staff admitted to the conclave. The minutes of the election are documented by voting ballots, lists for vote counting, various notes addressed to the cardinals, instructions regarding articles of dress, formulas for the oaths of conclavists and the newly elected pontiff, and the document in parchment attesting to the election of the pope. These documents are followed by everything that refers to functions not directly concerned with the voting. Nonetheless, they are important as they regard the correct functioning of the conclave and its occupancy by the cardinals and their assistants in the reserved areas. Thus, the following is included: ground plans, inventory of furniture and furnishings found in the cells, many internal regulations regarding security, entry permits, meals, accommodations, and the like. L.M.

Skull Cap and Biretta of Cardinal Wojtyla
(Later Pope John Paul II)

20th century
Silk
Skull cap: 8 × 18.5 × 18.5 cm; biretta: 13.5 × 18 × 18 cm
Office of the Liturgical Celebrations of the Supreme
Pontiff, Vatican City State
Inv. PVR2a; PVR24b

The biretta that each ecclesiastic wears to indicate
his rank within the clergy can vary in both form and
color. Although it is not often worn today, its use has
not been suspended.

The biretta is generally four-sided, with a crown
composed of three segments and, with the exception
of the cardinals, the rank of the wearer is denoted by
a tassel. The priest's tassel is black, like the rest of
the hat; the monsignor's is red on a black biretta;
that of the bishop and archbishop is purple on purple.
The red biretta is usually bestowed upon a newly
elected cardinal, together with the cardinal's ring,
by the pope. Alternatively, the consignment may be
performed by the dean of the Sacred College upon
papal mandate, or entrusted to another cardinal if
the new cardinal is a papal nuncio (ambassador or
representative) in service abroad. This happened
in the case of Pope John XXIII, when he was the
papal ambassador to France, before being elected
patriarch of Venice.

After the election of Karol Wojtyla as pope
(October 22, 1978), the biretta and skull cap on
exhibit here were put in the custody of the Office of
the Liturgical Celebrations of the Supreme Pontiff.

R.Z.

After his election, Pope John Paul I greets
Cardinal Wojtyla (who would succeed him
as pope), August 1978, *L'Osservatore Romano*

Skull Cap of Cardinal Albino Luciani

1978
Silk
8 × 16.5 × 16.5 cm
Office of the Liturgical Celebrations of the Supreme
Pontiff, Vatican City State

This zucchetto, or skull cap, has special historical
importance and also a certain poignancy. It
belonged to Cardinal Albino Luciani, who was
elected pope on August 26, 1978, and took the
name John Paul I, but died suddenly on September
28 that same year, ending a pontificate that lasted
a mere thirty-three days. The statement made by
a newly elected pope in his homily at the first
public mass heralding his pontificate is of the
utmost significance, as it outlines the principles
according to which he intends to carry out his
pastoral mission. In the case of this pope, John
Paul I declared: "Before it may be considered a
juridical institution, the primacy of Peter is a
charism. A charism that leads the pontiff to place
himself at the service of his fellow men, and by
which he invites his brother bishops to behave
toward him with the love and respect due to an
elder brother" (September 3, 1978).

By tradition, the newly elected pope would pass
his own cardinal's skull cap to the secretary of the
conclave that elected him, as a sign of esteem and
gratitude. The secretary was usually a bishop, and
upon this gift was automatically made a cardinal.
In compliance with this tradition, therefore, as
Cardinal Luciani was vested with the robes of the
pope, he placed the cap on the head of Monsignor
Ernesto Civardi and appointed him cardinal. R.Z.

Folding Desk Blotter for the Papal Conclave used by Cardinal Luciani

1978
Plastic
1.5 × 51 × 35.5 cm
Office of the Liturgical Celebrations of the Supreme
Pontiff, Vatican City State
Inv. VR81

During the voting sessions held in the papal
conclave—the name of which comes from the
Latin *cum clave*, meaning "under lock and key"—
each cardinal has a personal *cartella*, or folding
desk blotter, at his place in the Sistine Chapel,
where the secret ballots are placed.

This blotter belonged to Cardinal Luciani,
who would subsequently be elected pope with
the name of John Paul I (August 26, 1978).
His pontificate was tragically brief, however, as
he died thirty-three days later.

Pope John Paul I was a man of great humility
and simplicity. Owing to the brevity of his
pontificate, he was unable to perform any official
deeds of note, though he was the first pope to take
a double name and to forgo the papal coronation
ceremony, preferring a simple celebration to mark
the start of the new pontiff's pastoral duties as
leader of the Roman Catholic Church. R.Z.

Cardinal Luciani (Pope John Paul I)
enters the conclave before being
elected pope, August 1978,
L'Osservatore Romano

Chalice, Paten, and Ciborium for the
Election of the Pope

Early 20th century
Gilt metal
Chalice: 42.5 × 24.5 × 24.5 cm; paten: 0.5 × 30.5 × 30.5 cm;
ciborium: 56.5 × 30.5 × 30.5 cm
Office of the Liturgical Celebrations of the Supreme Pontiff,
Vatican City State
Inv. VR129

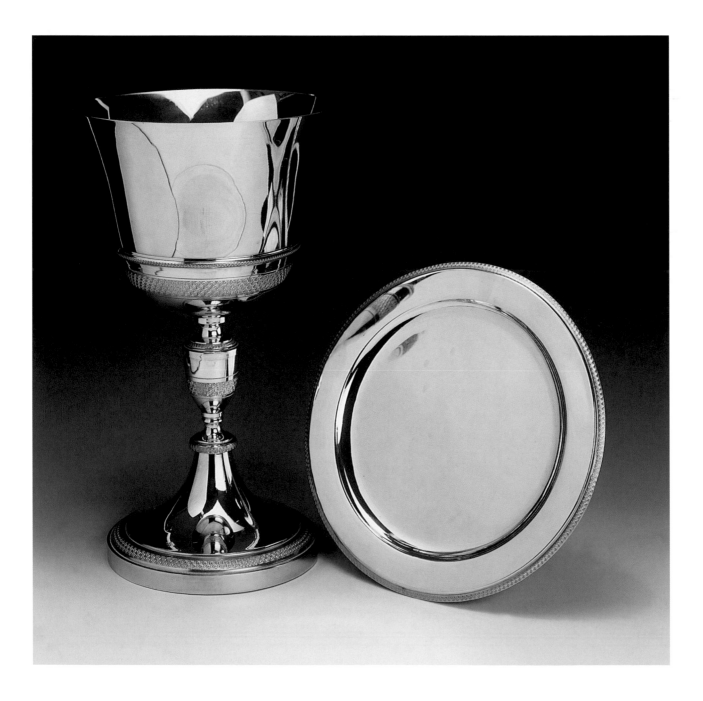

At the beginning of the conclave that elects the new pope, the cardinal electors are locked in the Sistine Chapel, where they remain for the duration of the voting process and subsequent counting of the ballots. The strict rules for the entire operation are laid down in an apostolic constitution, and have been changed by successive popes. The latest changes were made in 1996 by Pope John Paul II. This chalice and ciborium were used to contain the ballots of all the conclaves of the twentieth century.

Briefly, the election process is as follows. First, the voting takes place behind closed doors in the Sistine Chapel, and the only persons allowed to be present are the members of the College of Cardinals. The voting is done without speech or debate. Each cardinal receives a ballot on which he writes the name of the person he has chosen and folds the card while holding it so that it is visible to all. He then proceeds with it to the altar, where a large chalice covered with a paten is placed to collect the ballots. Having approached the chalice, the elector cardinal recites the following oath: "I call as my witness Christ the Lord who will be my judge, that my vote is given to the one who before God I think should be elected." After this the cardinal first places the ballot card on the paten, and then lets its slide into the chalice.

Should one of the cardinals, for reasons of infirmity, for example, be unable to make his way to the altar, the last of the examiners approaches him and, when the latter has recited the solemn oath, gives the folded ballot to the examiner, who then takes it in full view to the altar and, without pronouncing the oath, places it first on the paten and then lets it slide into the chalice.

The ballots are burned twice a day, at the end of the morning and again at the end of the afternoon session. To ensure the utmost secrecy of the conclave's deliberations, any written material the cardinals have with them is burned along with the ballot cards. Following a successful election, a chemical is added to the burning ballots that turns the smoke pure white as a signal to the faithful assembled in Saint Peter's Square that the announcement of the new pope is imminent. R.Z.

Election of Pope Urban VIII, mid-seventeenth century, Barberini Tapestry Works, Vatican Museums

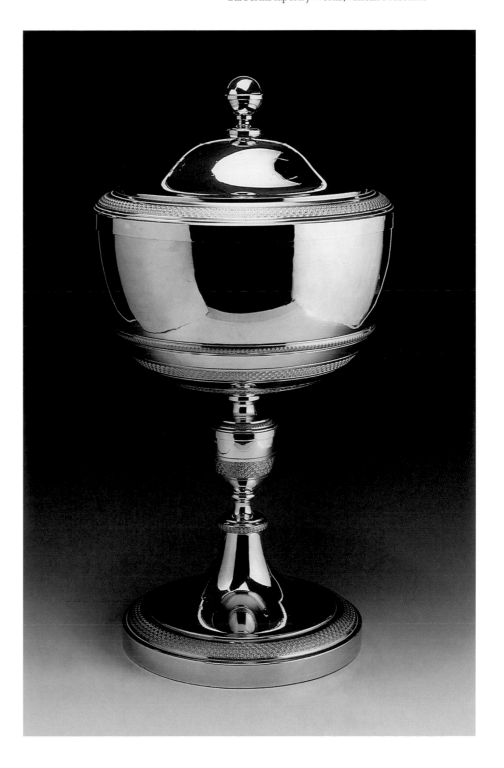

303

Ballot used for the Election of the Supreme Pontiff

1978
Paper
14 × 12 cm
Office of the Liturgical Celebrations of the Supreme Pontiff, Vatican City State

This is a ballot card from the last papal election, which took place in October 1978. Inside, the card carries a simple sentence in Latin: "eligo in summum pontificem" (I elect as Supreme Pontiff), under which, at the moment of the vote, each cardinal is to write the name of the person whom he believes deserves to be elected pope. The voting card is then folded and placed in a special chalice large enough to hold all the completed ballots. This is precisely what took place in the last papal election, and by decree of the present pontiff, Pope John Paul II, the procedure will be followed in the next conclave. As is the custom, after the secret vote, the ballots are burned. R.Z.

Eligo in Summum Pontificem

Closing of the door of the Sistine Chapel at the beginning of a session of the conclave that would elect Pope John Paul I, *L'Osservatore Romano*

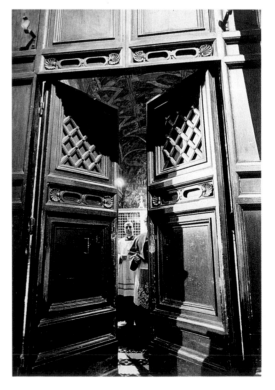

Cylinders for the Stove used in a Papal Conclave

1978
Cardboard, smoke powder
13 × 5 × 5 cm
Office of the Liturgical Celebrations of the Supreme
Pontiff, Vatican City State

Similar cylinders were last used during the conclave of October 1978, when Cardinal Karol Josef Wojtyla, then archbishop of the city of Cracow (Kraków) in southern Poland, was elected pope and chose the name John Paul II in deference to his predecessor, who had died a mere thirty-three days into his pontificate.

Pope John Paul II thus became the first non-Italian pontiff in more than four centuries—that is, since the election in 1522 of Pope Adrian VI, from Utrecht in the Netherlands—and the first pope of Slavic origin in the history of the Catholic Church.

Once balloting is completed, in the morning and again in the afternoon, one of the cardinals ignites the special smoke cylinder so that white or black smoke issues from the chimney of the stove temporarily installed in the Sistine Chapel. This alerts the crowd gathered in Saint Peter's Square to the outcome of the balloting.

The cylinders on exhibit here contain the remains of a special mixture of chemicals that upon contact with the burning ballots gives off a large quantity of smoke: black to denote that the voting has not been conclusive and white to announce the successful election.

Previously, dry or wet straw was added to the burning ballots to produce the smoke, but the results were often confusing. Hence the use of a chemical to produce the color of the smoke today.

The use of a smoke signal to proclaim the ballot's outcome to the world has its roots in the distant past and happily has survived to this day.

R.Z.

Smoke from the Sistine Chapel during the burning of the ballots, *L'Osservatore Romano*

The stove in the Sistine Chapel used to burn the ballots, *L'Osservatore Romano*

Sic transit gloria mundi

20th century
Brass
224 × 25 × 25 cm
Office of the Liturgical Celebrations of the Supreme
Pontiff, Vatican City State
Inv. VR50

Conservation courtesy of Timothy James Heney

This striking and unusual instrument is known
as a "Sic transit gloria mundi" (So passes worldly
glory) and was part of the ritual apparatus of
the pope's coronation ceremony until 1963. The
stafflike instrument was brought into play during
the moment in which the new pontiff was crowned
with the papal tiara. The ceremony would begin
with a solemn procession from the Apostolic Palace
to the confessional altar in Saint Peter's. Along the
way a papal master of ceremonies would fall to
his knees three times before the pope, carrying
a staff of silver or gilded brass, like the one here, at
the top of which a small brazier contained a piece
of smoldering cloth; for three times in succession
the man would recite "Sante Pater, sic transit gloria
mundi," each time in a louder voice, as a reminder
to the pope of the transitory nature of life and
earthly honors. The instrument is named for the
master of ceremonies' words. R.V.

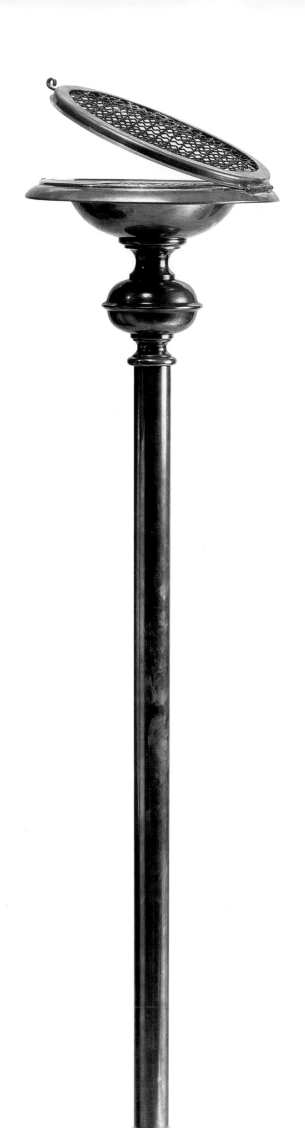

The Keys of Saint Peter

1903
G. Landi
Silver, silver gilt
37 × 12.5 × 2.5 cm
Office of the Liturgical Celebrations of the Supreme
Pontiff, Vatican City State
Inv. VR6

In the ancient rite of papal coronation, the new
pope was presented with a pair of keys symbolizing
his powers: the gold one indicated his power to
open "the doors of Heaven," and the silver one
his power to open "the doors of the Earth." This
symbolism is traced back to Christ's words to
Peter, when he bestowed upon him his duties as
vicar on Earth.

The keys follow the traditional shape: the part
that would normally engage the lock is designed
with an openwork cross, while the handle is
embellished with decorative work surrounding
a Greek cross, sections of which alternate with
sprigs of flowers. Both keys are fashioned from
solid silver, though only one is gilded.

The presentation of keys during the pope's
coronation ceremony is no longer celebrated
and has been replaced with a prayer having the
same significance.

These keys were donated by the diocese of
Ferrara to Pope Leo XIII for his jubilee in 1903.
They are kept in a hinged box lined with red
velvet. The lid is emblazoned with the arms of
Leo XIII traced in gold, with the writing "Giubileo
Pontificale 1878–1903." The inside of the box is
inscribed with the name of the artist and his
place of birth, "G. Landi Ferrara." R.V.

Miter of Pope Pius IX

1854
Cloth of gold, gold braid
36 × 33 cm
Office of the Liturgical Celebrations of the Supreme
Pontiff, Vatican City State
Inv. MI 1

The miter is a liturgical vestment used by bishops, cardinals, and other prelates. Ever since Pope Paul VI abandoned the use of the papal tiara in 1963, the miter is also often used by the pope.

In the early centuries of the church, the miter was a simple strip of cloth tied around the forehead of the bishop; later it became a kind of conical hat. In the tenth century it assumed the form that it still has today. The headdress curves up to form two points, one in front and one behind. There is a headband around the bottom that joins the two halves together, a vertical strip on each of the two faces, and two bands of cloth, known as *infulae*, that hang down the back of the wearer. The symbolic significance of the miter relates to purity and control of the senses, and the *infulae* signify the weight of the law of God.

The cloth may be either white or colored, depending on when it is worn, and the embroidery can be extremely rich, even adorned with precious stones. In modern church ceremonies however, the miter is always white, even when worn during funeral services; in that case, however, it carries no embroidery.

At the bottom of the *infulae* it is customary to show the coat of arms of the bishop or pope who ordered the miter or to whom it was donated. This one was commissioned by Pope Pius IX on the occasion of the proclamation of the Dogma of the Immaculate Conception on December 8, 1854.

On the back of this traditional miter, Jesus, the Good Shepherd, carries a lamb over his shoulders and is accompanied by sheep on either side. The front bears an image of Mary Most Holy, her feet resting on a globe and a half-moon, supported by two angels. The miter is entirely embroidered with gold thread on a cloth of gold. It is still sometimes used by popes for the feast of the Immaculate Conception. The *infulae* are also embroidered in gold with floral designs while, at the bottom, the coat of arms of Pope Pius IX may be seen, also embroidered.

The miter was worn in various circumstances by Pope Pius IX as well as by his successors. Pope John Paul II chose to use it during the Marian year of 1988 and had it adapted to fit his own head; for this reason two additional gilt strips are visible at the sides. R.V.

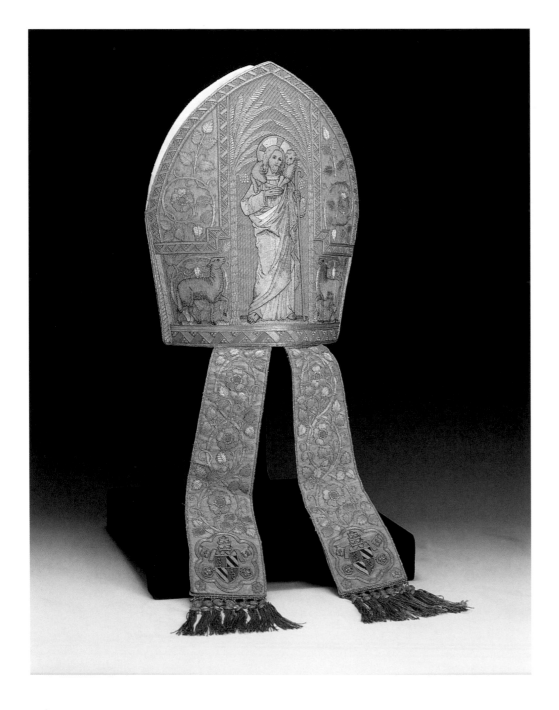

Miter of Pope Pius IX

Papal Tiara of Pope Leo XIII

1903
A. Milani, Bologna
Cask: silver; crown and top: gilded metal,
woven thread of gold and silk
35 × 22.5 × 22.5 cm
Office of the Liturgical Celebrations of the Supreme
Pontiff, Vatican City State

Conservation courtesy of Mr. and Mrs. William
Martin

The papal tiara symbolizes the pope's sovereign
powers on Earth. It has been assumed by each
pope since the Middle Ages during the coronation
ceremony, and is also worn whenever the pope
presides over ceremonies in the Basilica of Saint
Peter, seated in the *sedia gestatoria*.

The three sections that compose the crown
represent the supreme authority of the pontiff
over the Church of the Lord Christ, and have been
interpreted to symbolize, respectively, the church
of the living (Militant), the dead (suffering in
Purgatory), and in heaven (Triumphant), or
the Trinity.

This tiara was a gift from the Catholic
community of Bologna to Pope Leo XIII in honor
of the twenty-fifth year of his pontificate in 1903.
Made entirely of metal, the three tiers are separated
by ornamental bands of gold carved with olive
motifs. In the lower part, four of the six medallions
are carved with portraits of Pope Pius IX and Pope
Leo XIII, Saint Peter, and an angel; the two other

Pope Pius XII wearing the papal tiara in procession
seated on the *sedia gestatoria*, *L'Osservatore Romano*

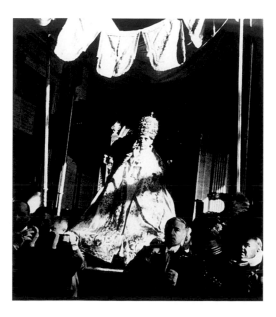

medallions are engraved with inscriptions: *leoni xiii
anno xxv sacri principatus feliceter complenti* and *x cal. mart.
anno mdcccciii collata cattolicorum stipei.*

The middle tier carries two medallions carved
with the Good Shepherd, the Cross of Glory, and
the words *vivie tegnat imperat iesus christus deus homo.* The
three silver crowns are elaborately decorated with
lilies; each band carries an inscription, in ascending
order: *iure sacerdos maximus in terris divino; nescimus errandi
fidei morumque magister;* and *pastorum pasto olive omne
regis christi.*

The orb and cross at the top are encrusted
with pink diamonds. The lappets are bordered
with a gold braid of olive leaves and at the bottom
carry the coat of arms of Pope Leo XIII in silk
embroidery. The iconography is particular to the
reigning pope, and the figures of Saint Peter

and the angel that appeared to him during his
imprisonment allude to the voluntary confinement
of the pope in the Vatican after the fall of the Papal
States in 1870.

Although the tiara is somewhat worn through
usage, the overall handling of the engraved sections
and an uncommon craftsmanship of the rendering
is still apparent.

Pope Leo XIII did not have many occasions
to wear the tiara, as he died shortly after it was
donated, but it was subsequently used during the
pontificates of Pope Pius X and Pope Pius XI. R.V.

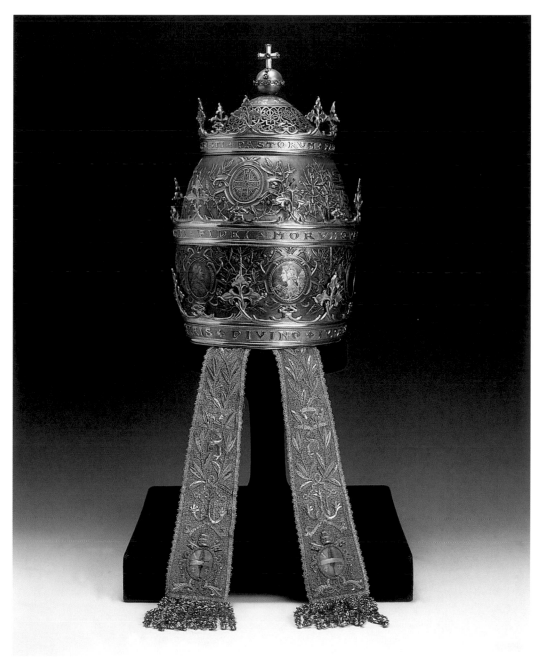

Pallium and Fibulae of Pope John Paul II

Pallium:
Wool
40 × 47 × 6 cm
Office of the Liturgical Celebrations of the Supreme
Pontiff, Vatican City State
Inv. PL1

Fibulae:
1998
Manlio del Vecchio
Silver gilt
8 × 2 × 0.5 cm
Office of the Liturgical Celebrations of the Supreme
Pontiff, Vatican City State

The pallium is a distinctive stole about six centimeters wide. It is draped around the shoulders, with the two ends hanging some thirty centimeters down the front and the back of the wearer. Worn exclusively by the pontiff and by the metropolitan archbishops, the pallium denotes the wearer's priestly status. In the case of the pope it denotes his supreme office, and in that of the metropolitan archbishops it is a token of their status as prelates who have jurisdiction over a diocese. The pallium is made of pure lambswool, which is provided by the chapter of the Lateran basilica after being blessed in a ceremony held on the feast day of Saint Agnes (January 21) in the basilica named in her honor in Rome on the via Nomentana, where she is buried.

That the pallium is made from lambswool has a deeper significance, dating to Early Christian practice, when the stole was laid around the bishop's shoulders as a ritual evocation of the lamb in the parable of the Good Shepherd (Jn 10).

Once they are finished and ready to wear, the pallia are blessed by the pope in the Basilica of Saint Peter following the first vespers of the feast day of Saint Peter and Saint Paul (June 29), after which they are laid upon Saint Peter's tomb, awaiting their distribution to those who are entitled to wear them.

The pallium on exhibit here is decorated with six Greek crosses in black silk embroidery; those on the chest, back, and left shoulder have loops fixed with three ornamental metal pins so that they can be worn during liturgical ceremonies.

The pins created by the papal silversmith Manlio del Vecchio for the pallium of Pope John Paul II are made of gilded silver and were given to the pontiff on Christmas 1998 by Mario Giovanielli and two of his colleagues, on behalf of the Roman municipal council.

The upper part of each pin is oval and has a small repoussé design symbolizing the donor. They are kept in a square container covered with brown satin and lined with yellow velvet. R.Z.

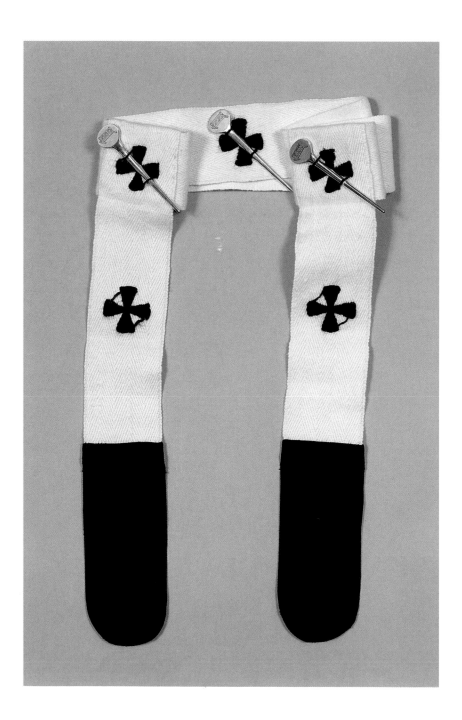

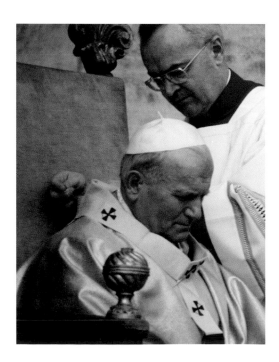

Pope John Paul II receiving the pallium at the ceremony marking the beginning of his pontificate

Cassock and Zuchetto of Pope Pius XII

Early 20th century
Wool, silk
Cassock: 150 × 70 cm;
skull cap: 7 × 16.5 × 16.5 cm
Office of the Liturgical Celebrations of the Supreme
Pontiff, Vatican City State
Inv. PVR15, PVR4

Together with the familiar small white zucchetto, or skull cap, the white cassock with its sash has been the daily dress of the popes for centuries, beginning with Pope Saint Pius V in the sixteenth century.

Papal robes like this one are made mostly of white wool, with the sash and lining in silk. The sash on exhibit is richly embroidered with gold thread and different colored silk. Missing from the set here is the small mantle, in the same white as the cassock, which the pontiff wears around his shoulders. The set is complemented by the zucchetto, a small white cap composed of a dome-shaped crown of radial segments that covers only the top of head. The color of the skull cap denotes the wearer's rank: white is reserved for the pope; red for cardinals; violet for bishops; and black for the rest of the clergy, with certain exceptions.

The history of the zucchetto cannot be traced precisely, though records show that an earlier version was wider and had a looser fit, sometimes covering the head entirely, with a lappet hanging down at either side to cover the ears.

This skull cap belonged to Pope Pius XII and was a gift from an otherwise unidentified "Societas Mariae Reparatricis," whose name is on a label sewn inside. R.V.

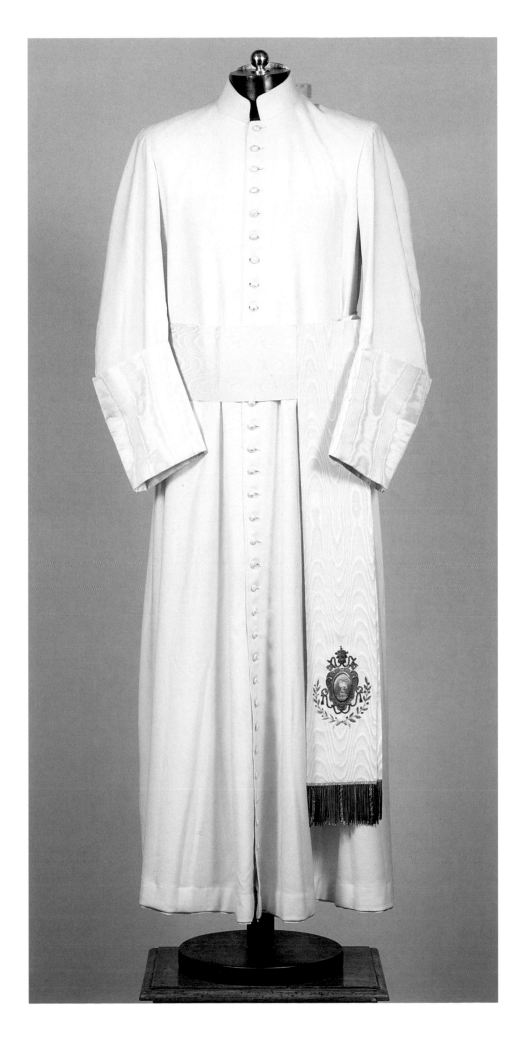

Ivory Crosier of Pope Pius IX

1870
Munich, Germany
Ivory, gilded metal, precious stones
205 × 20 × 8 cm
Office of the Liturgical Celebrations of the Supreme
Pontiff, Vatican City State
Inv. PAS20

Conservation courtesy of The Florida Chapter of
the Patrons of the Arts in the Vatican Museums

The bishop, as pastor of his flock, carries a visible symbol of his authority, namely, the crosier. The bottom of the staff is pointed because the "shepherd of souls [the bishop] has to prod the lazy and defend the weak." The upper end is curled over into a crook to "gather in the strays." As early as the sixth century, crosiers were a bishop's sign of office, usually made of wood but sometimes of metal or ivory, with a small T-shaped crossbar. From the fifteenth century onward, crosiers in the Western world always had a spiral or crook at the top. The crook of Romanesque crosiers terminated with fabulous forms of symbolic animals or with a snake, later substituted by the lamb. In the Renaissance, the crook took the form of a question mark. Starting with Pope Paul VI, the pastoral staff became a cross; it has also been modified by the current pope.

This crosier is made of ivory, enamel, emeralds, amethysts, and gemstones, and is composed of four parts that may be screwed together. The rod, fluted along its length, has two ivory rings, and its lower end terminates in a point. The upper part is made of ivory; its lowest extremity is a convex ivory sphere with embossed decorations of four sheep and four inlaid rectangular amethysts. Immediately above is a short grip with a raised rhomboid pattern. The crook of the pastoral staff rests on a small quadrangular ivory temple, which has at its base the four symbols of the evangelists and four inlaid green stones. The temple has four niches, each topped with a spire; the niches contain the images of Saint Benno, Saint Rupert, Saint Charles, and Saint Corbinian. Each spire is decorated with a tondo, with amethysts and a small white gemstone. The crook is rectangular in section; it is entirely embossed with grape vines and ears of wheat on its external faces, with fourteen stones of various colors and sizes. At the center of the volute is a bust of the Virgin holding Jesus, his arm raised in blessing. The back face of the crook is decorated with six more red oval gemstones on an embossed background of leaves and flowers, with the inscription "CA – AE – MF" at the base. The internal face of the crook is embossed with the image of Jesus and, below him, Saint Peter among the sheep. The crosier was donated to Pope Pius IX by Cardinal Karl August von Reisach, bishop of Freising, cardinal of Saint Anastasia and bishop of Sabina. R.V.

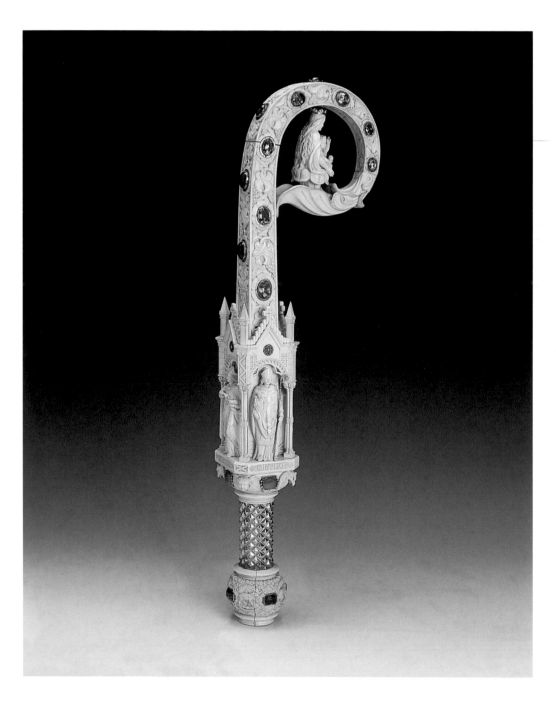

Crosier of Pope Leo XIII

Late 19th century
Gilded metal, enamel
200 × 20 × 7.5 cm
Office of the Liturgical Celebrations of the Supreme
Pontiff, Vatican City State
Inv. PAS35

Conservation courtesy of The Minnesota Chapter of
the Patrons of the Arts in the Vatican Museums

This crosier was probably made during the last
century, using a Gothic model. The crook consists
of a series of volutes that give it the traditional
shape, and the last volute carries the decorative
element onto the handle of the staff, ending
between the opened wings of an angel. The angel
is sculpted in the round, with hands joined in
prayer, while the outer curve of the spiral is
decorated with playful cherubs.

The symbolism of this crosier is closely linked
to Saint Michael's role as protector against the
temptations of the devil. Inside the curve of the
crook, Saint Michael can be seen slaying the
dragon, probably referring to a special devotion
to the archangel by the patron who commissioned
the work or the bishop for whom it was made.
Saint Michael is shown full face, looking toward
the carrier of the staff, another indication that it
was a special devotion to the saint.

Below the crook is a hexagonal section, carved
and sculpted in the round and divided into panels,
some of which have coats of arms. This section is
supported by winged angels' heads. A ribbed staff
adds to the distinction of the crosier, as does the
rich enamel work.

Crosiers symbolize a bishop's juridical and
doctrinal power and are usually about 160 cm
(63 in.) high. The bottom of the staff is pointed
because the "shepherd of souls [the bishop] has
to prod the lazy and defend the weak," according
to the Bishop's Ceremonial, which also specifies
that the crook serves to "gather in the strays."

As early as the sixth century, crosiers were a
bishop's sign of office, usually made of wood but
sometimes of metal or ivory, with a small T-shaped
crossbar. From the fifteenth century onward,
crosiers in the Western world always had a spiral
or crook at the top. When a bishop is in his
own diocese, he carries the staff with the crook
pointing outward, symbolizing his care for his
flock, whereas in other dioceses the crook must
point inward. L.O.

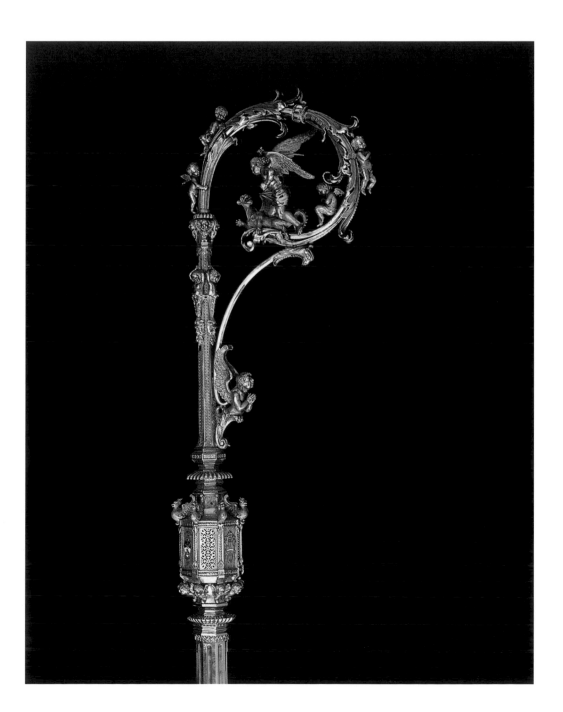

Processional Cross of Pope Leo XIII

1887
Poussièlgue-Rusand et fils, Paris
Gilt bronze, gilt silver, garnet, enamel
186 × 27 × 9 cm
Office of the Liturgical Celebrations of the Supreme
Pontiff, Vatican City State
Inv. CRP 10

Conservation courtesy of Florence D'Urso in
honor of our beloved Pontiff, Pope John Paul II,
who brings the way of the cross to his people
throughout the world

This cross was a gift to Pope Leo XIII from the
Parisian goldsmiths Poussièlgue-Rusand et fils to
mark the jubilee of his pontificate in 1887.

The cross with three horizontal bars symbolizes
the Trinity and derives from the tradition of the
Eastern Church. The arms of the one on exhibit
here are mounted on a staff of gilded bronze and
are embellished with filigree studded with cabo-
chon-cut garnets; each arm terminates in a bilobate
leaf bud. Each intersection is set with a two-sided
enameled medallion. On the front is the Dove of
the Holy Spirit, the Chi-Rho, and the arms of Pope
Leo XIII. The back depicts the cross of salvation
with a serpent twined round its foot, a fountain
with two doves, and the inscription DON DE
POUSSIELGUE-RUSAND ET FILS / OFREVRES DE
SA SAINTETE/A PARIS (Gift of Poussièlgue-Rusand
and Sons, silversmiths to His Holiness, Paris).

Pope John Paul II used the cross during the
ceremonial opening of the holy door in the special
holy year of redemption in 1983. R.V.

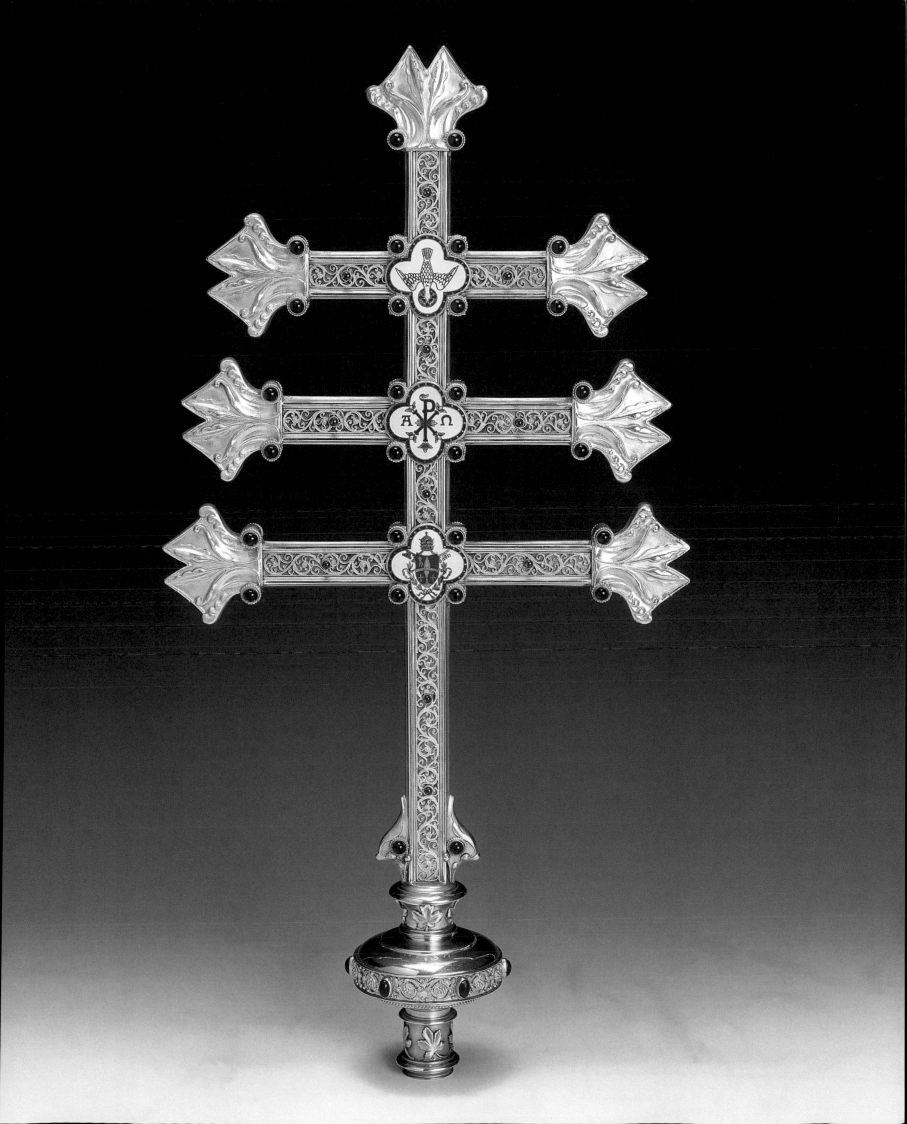

Pectoral Cross of Pope Saint Pius X

19th century
Gold, aquamarine
13 × 8 × 1.5 cm
Office of the Liturgical Celebrations of the Supreme
Pontiff, Vatican City State
Inv. CR3

This traditional pectoral cross has had a curious
history. Originally a personal gift to Pope Leo XIII,
he gave it to the then Monsignor Giuseppe Sarto as
a token of his esteem and affection. When the latter
was subsequently elected pope in 1903, taking

the name of Pius X, he used the cross on various
occasions for pontifical ceremonies before making
a personal gift of it to his beloved sister Maria
Sarto. When Maria died, her nephew Monsignor
Giovanni Parolin returned it to the then pontiff,
Pope Pius XI, in memory of his aunt.

The cross is made of gold and set with six
natural beryl stones in a superb tone of
aquamarine; each is facet cut with a rectangular
perimeter and canted corners. The four arms
end in small cherubs. Fixed to the uppermost part
of the vertical bar is a loop device attached to
another tiny Greek cross with small spherical
terminals. L.O.

Ring of Pope Leo XIII

19th century
Gold, pearls, amethysts
3.2 × 2.7 × 2.5 cm
Office of the Liturgical Celebrations of the Supreme
Pontiff, Vatican City State
Inv. AN10

This ring is one of the many gifts donated to Pope
Leo XIII on the occasion of the jubilee year of his
pontificate, as is attested by the inscription inside
the ring. It has a tiny compartment containing
two holy relics, one of Saint Ambrose of Milan,
the other of an unidentified saint. Besides the
inscription, no information on the donor or
goldsmith is available.

The elaborate gold setting is mounted with
a large amethyst surrounded by eighteen pearls,
while the band carries floral designs where it
joins the setting. R.V.

Reliquary of Pope Saint Pius V

Silver
47 × 10 × 10 cm
Office of the Liturgical Celebrations of the Supreme
Pontiff, Vatican City State
Inv. RLQ99

Before becoming pope, Pius V was a Dominican
friar, and all the time he was head of the church
he never abandoned his rigorous, ascetic ways.
One of the first objectives of his papacy was
to apply the decrees of the Council of Trent
(1545–63) and dedicate himself in particular
to bringing back order and discipline within
the church, the lack of which had given rise to
the Protestant Reformation.

His name will always be closely linked to
another momentous event in the history of the
church and of the West, namely, the Battle of
Lepanto in 1571, in which the Christian fleet
defeated the Ottoman Turks, heralding the start
of the definitive decline of Islamic power in
western Europe. In memory of the victory, Pope
Pius V made October the month of the Holy
Rosary. Canonized in 1712, the saint's body is
venerated in the Sistine Chapel of Santa Maria
Maggiore in Rome.

The reliquary on exhibit is made of gilded
silver. Rising from a square foot, the cylindrical
plinth supports a small statue of an angel; the
inscription around the rim of the statue's base
reads "Digitus et annulus S. Pii V" (Finger and
ring of Saint Pius V). The angel is holding up an
oval receptacle with a finely carved surround
embellished with cherubs and volutes and
crowned with the papal emblem. The relic
conserved in the receptacle is the ringed finger
of the pope. R.V.

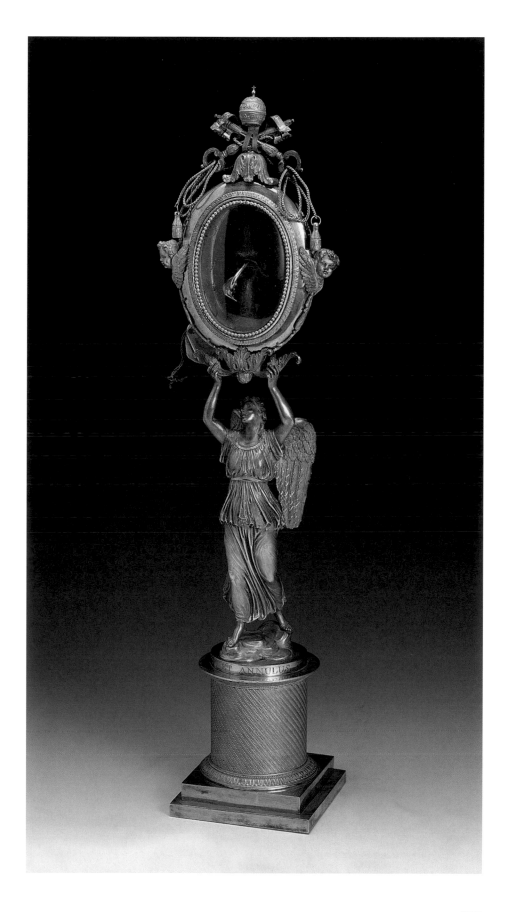

Papal Seals

Pius IX (1846–1878), iron, 18 × 6.5 × 6.5 cm
Leo XIII (1878–1903), iron, 11 × 5.5 × 5.5 cm
Pius X (1903–1914), iron, 11 × 7 × 7 cm
Paul VI (1963–1978), iron, 5.5 × 5 × 5 cm
Paul VI (1963–1978), brass, 10 × 4 × 4 cm
Office of the Liturgical Celebrations of the Supreme
Pontiff, Vatican City State

In ancient times, at least until the Middle Ages, the papal seal was related to the papal ring, the face of which was incised. The seal-ring was used by the popes to authenticate their official acts. This particular ring bore the name of the pope and, from the middle of the fifteenth century to the days of Pope Nicholas V, also the figure of Saint Peter casting or hauling in fishing nets. The image referred both to the work the apostle Peter did before being called to follow Christ and also to the words of the Lord Jesus, who when he called Peter, promised to make him a "fisher of men" (cf. Mt 4: 19). This type of ring was therefore called Anulus Piscatoris ("ring of the fisherman"). Only a few of these antique rings have remained, such as that belonging to Clement IV, of whom a letter dated March 7, 1265, sealed with the ring, is preserved. Subsequently, the ring of the fisherman lost its form to assume that of a seal, and this seal continued to be called the Anulus Piscatoris.

The rings of four popes – Pius IX, Leo XIII, Pius X, and Paul VI – are on exhibit. As can be noted, particularly on the face of the brass seal of Paul VI, it is as though the seals have been canceled, that is, incised so as to make them unserviceable. It was customary that on the pope's death linear incisions be made to cross out the seal so that no documents could be drawn up until the election of the next pope, who would sign the official documents with his new Anulus Piscatoris.

After the death of John XXIII in 1963 the ring of the fisherman fell out of use. R.Z.

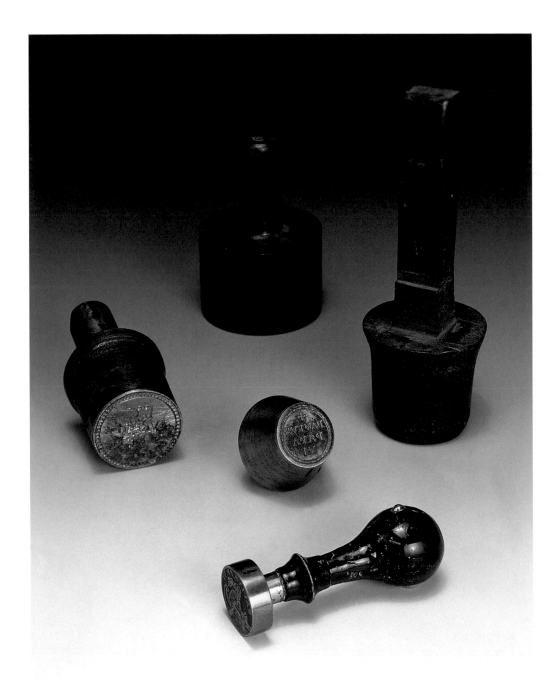

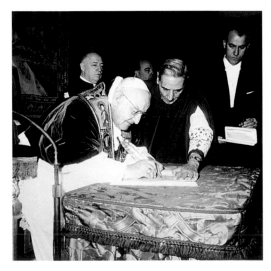

Pope John XXIII signs and seals his encyclical
"Pacem in terris," April 1963, *L'Osservatore Romano*

Stole of Pope Gregory XVI

First half of 19th century
Silver leaf, gold thread, silk, semiprecious stones
118 × 27 cm
Office of the Liturgical Celebrations of the Supreme
Pontiff, Vatican City State
Inv. ST4

The stole dates back to the early days of Christianity, when the deacons wore it as a symbol of office. It was later adopted also by the priests and bishops, though worn in a different manner. Basically a form of scarf, the stole derives from the Roman orarium, which was worn as a sign of dignity. The present name for the stole (from the Greek, *stolé*, meaning towel) was adopted in the sixth century. At first it consisted of a strip of linen folded in two, but by the eleventh century it had already largely assumed the form it has today. Made from the same fabric as the chasuble, the stole also conforms to the colors of the liturgical season. Some stoles are a made of two strips sewn at the center and fixed with a cross, or consist of a single, long strip. The ends of the piece are either cut straight or diagonally, and in both cases they carry a cross, either embroidered or applied.

This stole has the traditional form of two near-identical halves that differ only in the two lower ovals embroidered into the cloth, one carrying a portrait of Saint Peter, the other of a bishop. The upper part is decorated at either side with a dove in dark silk embroidery holding up a shield emblazoned with the three Petrine keys in gold thread. Below these are two identical shields bearing the coat of arms of Pope Gregory XVI. The tails of the stole widen toward the bottom to accommodate two large central radiating crosses and end in a fringe of tiny golden tassels.

This stole was worn by Pope Gregory XVI. Though considered conservative in his views and actions, the pontiff was deeply concerned about public welfare. Among the changes he urged were better conditions for the Jews of Rome, and a reduction of the age of consent from twenty-five to twenty-one. Across the Papal States he promoted important public works such as a land reclamation scheme along the Aniene River and major improvements to the Tiber estuary, and had new port facilities built at Civitavecchia, while also endorsing the repairs to the destroyed Basilica of Saint Paul's Outside-the-Walls. His interest in cultural heritage prompted him to endow the capital with a new museum for Etruscan and Egyptian art, and promote excavation works in the Roman Forum and in the catacombs outside the city of Rome.

R.Z.

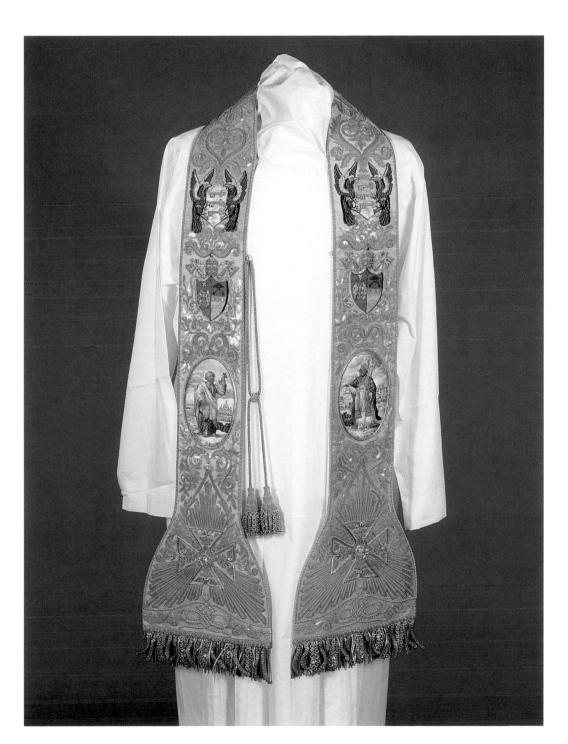

Hat of Pope Pius XII

First half of the 20th century
Antica Cappelleria Ecclesiastica A. Berbiconi, Rome
Velvet, leather, gold thread
12 × 34 × 37 cm
Office of the Liturgical Celebrations of the Supreme
Pontiff, Vatican City State
Inv. PVR3

The shape of this striking hat stems from the
traditional Roman one fondly known as the
"cappello a Saturno," after the planet Saturn,
owing to its broad, ringlike brim. A similar
version in black was once required dress for all
clerics in Rome. The ornamental band encircling
the crown is made from satin embroidered with
delicate floral patterns in gold thread, and has
a small strip across the brim to indicate the
direction it is to be worn. The brim is also edged
in gold thread.

Sewn inside the hat band are two twinned
cords also made of gold thread, a pair adorning
either side, each with a knot and metal fastener
at one end and the traditional acorn ornament
at the other.

The hat is in good condition although it was
frequently used by Pope Pius XII, who wore it
regularly not only for protection against the sun
while strolling through the Vatican gardens, but
also for official outings from the Vatican and for
trips to the papal residence at Castel Gandolfo.
It is still occasionally used by the present pontiff,
Pope John Paul II. L.O.

Pope Paul VI leaving an airplane wearing his papal hat,
October 1967, *L'Osservatore Romano*

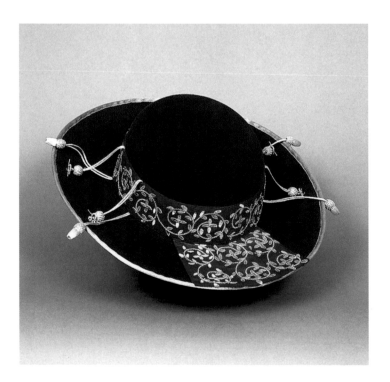

Mantle of Pope Saint Pius X

Early 20th century
Wool, silk
148 × 109 cm
Office of the Liturgical Celebrations of the Supreme
Pontiff, Vatican City State
Inv. PVR9

This cape, which is part of the pontiff's official
vesture, belonged to Pope Saint Pius X and is the
traditional type of mantle worn over the cassock.

A similar mantle, either red or purple, was
respectively worn by cardinals and bishops to
denote their rank. Stitched to the shoulders of
the main mantle was a second smaller covering
trimmed with gold thread braided with red silk,
as in this mantle. Despite their rich fabrics and
wealth of embroidery, the papal vestments are
symbolic of the pope's role as pastor of the Catholic
Church. This is a role epitomized by Pope Saint Pius
X, who concentrated his ministry on defending the
doctrine and on apostolic issues and who showed
unwavering generosity of spirit toward the poor
and disinherited in particular. When asked by
Emperor Joseph of Austria to bless his troops,
the pontiff replied that he "only blessed peace,"
and despite his every effort to ward off the threat
of war in Europe, international conflict broke
out in 1914 and the pontiff died almost as it
was announced. His body lies in the Basilica of
Saint Peter. R.Z.

Pope John Paul II wearing the papal mantle,
L'Osservatore Romano

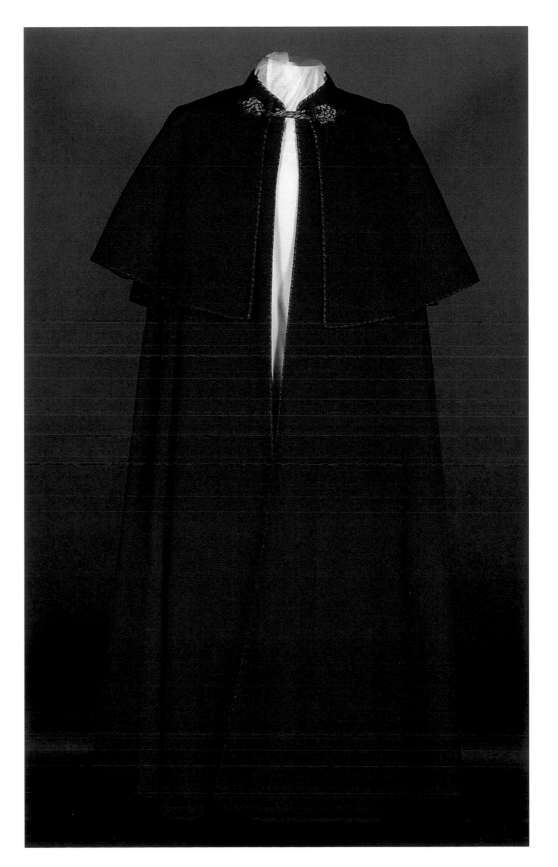

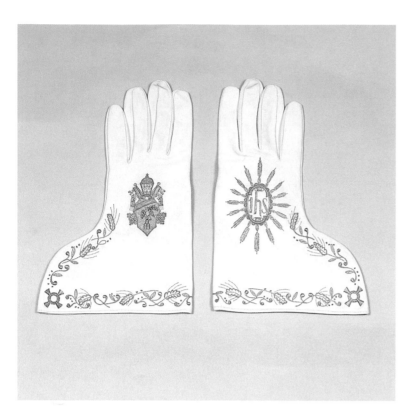

167

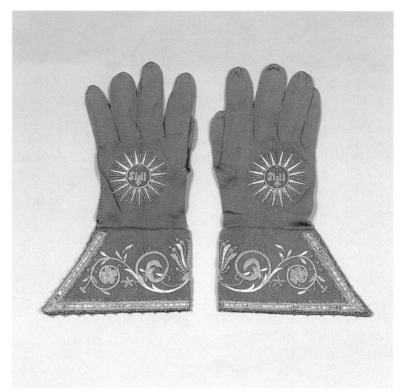

168

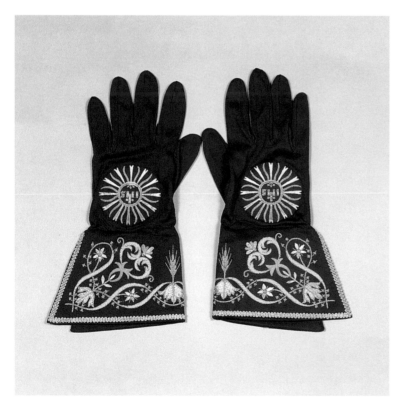

169

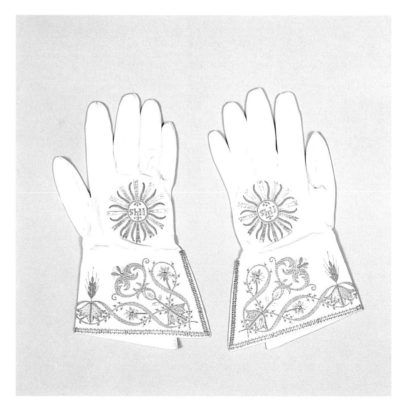

170

Papal Gauntlets of Pope Pius XII, Pope John XXXIII, Pope Paul VI

20th century
Leather, gold thread
(167) 30 × 19 cm (Pope Pius XII) 1 pair of gloves
(168) 30 × 16 cm (Pope John XXIII) 1 pair of gloves
(169, 170) 30 × 15 cm (Pope Paul VI) 2 pair of gloves
Office of the Liturgical Celebrations of the Supreme
Pontiff, Vatican City State
Inv. GNT40a-b

Known as gauntlets, the large ornamented gloves
worn during liturgical celebrations by prelates,
bishops, and the pope vary in color according
to the liturgical calendar. They are generally
embellished with crosses or other symbols,
emblems, and delicate floral designs, all finely
embroidered in gold thread. This type of glove
covers the hand and extends almost to the elbow.
As gauntlets were worn in many ceremonies, any
rings to be worn on the occasion were made one
size larger to fit over the gloved finger.

The elaborate gloves in white leather lined with
white silk belonged to Pope Pius XII and are delicate-
ly embroidered around the border with a running
motif of leaves and ears of wheat in gold thread and
colored silk, with a cross at the corner. The right glove
is emblazoned with the symbol of the Eucharist
encircling the letters IHS (the abbreviation of the
Greek name for Jesus), and the left glove carries the
coat of arms of the pope.

Both gloves of the second pair, which belonged to
Pope John XXIII, are of green silk and decorated with
gold embroidery and the symbol of the Eucharist
enclosing the letters IHS; the borders are trimmed
with a spiraling fillet in gold thread and the parts
covering the wrists are decorated with various floral
motifs.

The third pair of gloves, in deep red silk embla-
zoned with a radiating Eucharist symbol encircling
the letters IHS, were used by Pope Paul VI; a gold fillet
around the border encloses an elaborate design of
vine tendrils, lotus flowers, and ears of wheat. A pair
of off-white silk gloves with an identical pattern to
the preceding pair were also used by Pope Paul VI, the
last pope to wear the gauntlets during liturgical
ceremonies. R.V.

Papal Liturgical Slippers of Pope Paul VI

Second half of the 20th century
Red satin, silk, gold thread, leather
27.5 × 10 × 13 cm
Office of the Liturgical Celebrations of the Supreme
Pontiff, Vatican City State
Inv. PNF21a–b

These red satin slippers, worn by Pope Paul VI, are
embellished with floral patterns and a radiating
cross motif at the center. Serving as laces are two
broad silk ribbons that end in a gold tassel. Pope
Paul VI was the last pontiff to wear papal footwear
for liturgical purposes; they have been replaced
with regular slip-on leather shoes for ease of
movement during celebrations. R.Z.

Clasp of Pope Benedict XIII

1729, Rome
Gold, silver gilt, amethysts, emeralds, red precious
stones, diamonds
14.5 × 15 × 3.5 cm
Office of the Liturgical Celebrations of the Supreme
Pontiff, Vatican City State
Inv. RA8

Conservation courtesy of Helen and Harold P.
Bernstein

This clasp was used by Pope Benedict XIII. He
was a member of the noble Orsini family and had
renounced the inheritance that was due to him as
the first-born son in order to join the Dominican
Order. He was a brilliant preacher and was made a
cardinal at the age of twenty-three. At seventy-five
he became pope, accepting his election out of
"obedience" and continuing to wear his monk's
habit and follow monastic customs. His greatest
concern was for his spiritual ministry.

The greater part of this clasp is occupied by
an image of the Dove of the Holy Spirit emanating
rays in diamonds on a background of blue enamel.
This section is surrounded by numerous cut
stones arranged in geometric patterns. The back
is decorated with four figures surrounded by
engraved arabesques and branches. At the top is
Our Lady of the Rosary, at the bottom the coat
of arms of the Order of Preachers (Dominicans),
and on either side, Saint Philip Neri and Saint
Dominic. On the underside of the fastening is the
shield of the Orsini, the family to which this pope
belonged, together with the inscription "ANNO
DNI MDCCXXIX" (Year of the Lord 1729).
The Dominican iconography reminds us that Pope
Benedict XIII was himself a friar preacher. R.V.

Lace Surplices

First half of the 20th century
Linen, lace
158 × 50 cm
Office of the Liturgical Celebrations of the Supreme
Pontiff, Vatican City State

The surplice, a full-length white tunic worn by the
clergy at liturgical celebrations, is usually made of
linen or cotton with trimming around the sleeves
and along the hem, and sometimes with long
delicate lace work as in the examples exhibited
here. Historically, this type of liturgical garment
goes back to the early Christians and is documented
in the Middle Ages as being made of cambric, a
finely woven white linen.

The white surplice symbolizes innocence and
simplicity, qualities becoming to the office of the
priest. In the past, the surplice also represented a
cleanliness of spirit, and the prayer the ecclesiastic
offered up as he donned the garment was an
evocation of this, as he prepared himself for
celebrating the mass or the other sacrament of the
Church.

The garment is worn over the amice, an oblong
piece of white linen worn around the neck and
shoulders, and is gathered at the waist by a simple
cord with tassels, known as a cincture, designed
to keep the stole in place.

Nowadays the surplice is not usually embel-
lished with sections made of fine lace, but the
material itself is embroidered, often with the
same liturgical colors as the chasuble or dalmatic.
The neck of the surplice often used to have a yoke-
type of cut, but in time this has been altered, and
some models are now fitted with a stand-up collar.

Owing to their elaborate needlework, the
precious surplices on exhibit here are kept in
the Pontifical Sacristy and are no longer in use.
Nothing is known of their provenance. R.Z.

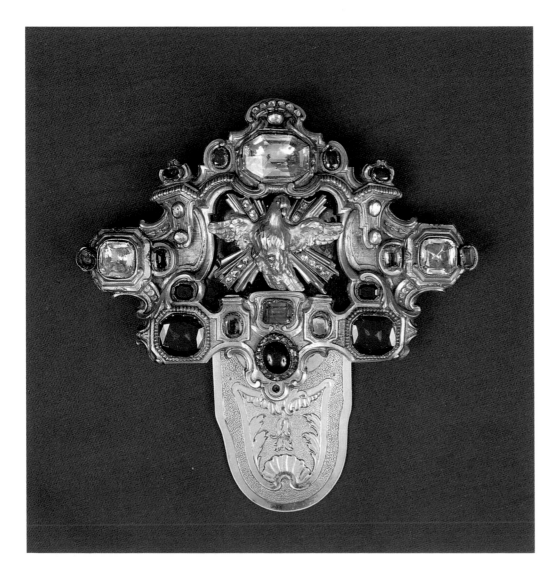

Cope

Gold leaf woven with red thread, gold thread,
sequins, gold fringe
294 × 150 cm
Office of the Liturgical Celebrations of the Supreme
Pontiff, Vatican City State
Inv. PV42

An elaborate design of ovals with gold studs and
leaves runs down the borders and back shield
of this cope. The floral pattern includes corollas,
leaves, bows, festoons, and small stars inside circles,
bordered by thin stems with tiny leaves. The center
of the shield is most flamboyant, as it represents
a double festoon with a large bouquet of flowers
trimmed with a fringe of gold thread. Small
bouquets of flowers against a red ground cover
the rest of the mantle.

The cope has a rectangular fastening of two
metal hooks and six eyes that must have been
replaced fairly recently.

The lining is of crimson taffeta. Although
the interior has been mended, on the whole,
the object is in a good state of conservation. L.M.

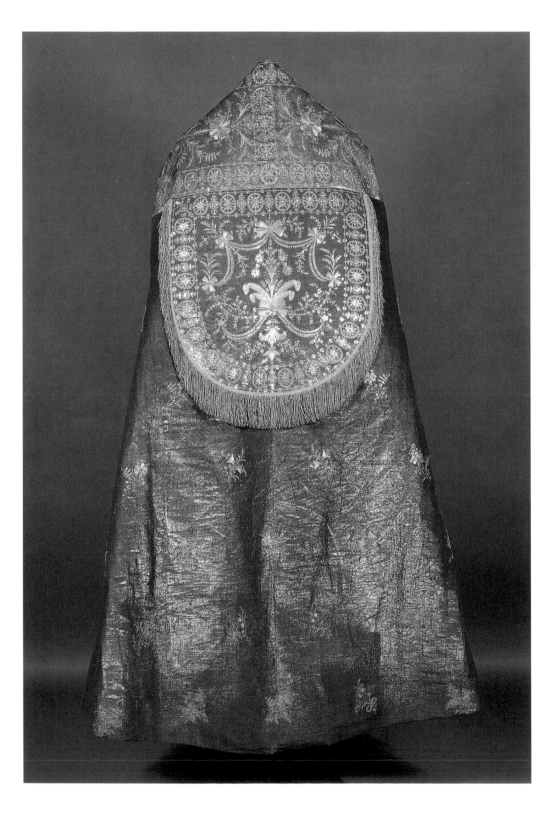

Altar Frontal of Pope Clement VIII

1593–97
Guasparri di Bartolomeo Papini (1535–1607)
Silk, silver thread
102 × 371 cm
Vatican Museums, Vatican City State
Inv. 62780

The use of special hangings in the Sistine Chapel during Advent and Lent dates back to Pope Gregory XIII, who in a letter of 1577 to Cardinal Ferdinando de' Medici expressed his intention to replace the tapestries designed by Raphael—which were considered more appropriate for the more important feast days in the church calendar—and to have new ones made specifically on Passion themes, which were to be woven by the Florentine tapestry workshop of the Grand Duke Francesco de' Medici.

The subjects for the new illustrated hangings would be taken from a set of drawings made by Giorgio Vasari. The pope himself was prepared to pay for the work, should the grand duke withdraw his offer to sponsor production. The artist and historian Vasari had long been a major contributor to the decoration of the Vatican Apostolic Palaces. For a while the project for the new hangings was set aside, but then when the Grand Duke's brother Ferdinando succeeded to the duchy, he took up the project once more and entrusted the commission to Guasparri di Bartolomeo Papini, head of the Medici tapestry works from 1587 until his death. This time the artist chosen to produce the cartoons was Alessandro Allori, one of the leading court painters who had been supplying various Florentine tapestry workshops with subjects since 1575.

There is no documentation on the original set of hangings, but the parts that survive comprise an antependium, or altar frontal; a chasuble; two dalmatics; a cope; a burse for the corporal; a chalice veil; three missal covers; a stole; a maniple; and a clasp.

The overarching theme of the works is the story of salvation through the sacrifice of Christ, which is illustrated through selected episodes from his Passion and imbued with complex symbolism tied to the Old Testament idea of redemption. On January 4, 1595, Allori is recorded as having received payment for drawings relating to the new hangings, and in the early months of the following year the weaving was complete and the hangings were ready. In 1602 the finished hangings were sent as a gift to Pope Clement VIII; they were in place in the Sistine Chapel at least until the end of the nineteenth century, when the frontal was still being used for the altar during the Holy Thursday celebrations.

The set of hangings underwent their first restoration in 1789, during which the fronts and backs of the two dalmatics were divided to enable them to be exhibited separately. A second restoration took place in 1978 and again in 1981 prior to their exhibition in the United States in 1983–84. The presence on most of the works of the Medici coats of arms combined with that of the House of Lorraine would indicate that the entire program had been conceived as a joint tribute to the Grand Duke Ferdinando and his wife, Christine of Lorraine, whom he married in 1589.

The works first appear in the inventory of the Pontifical Sacristy in 1728, and remained there until 1935, when they were transferred to their current place in the Sacred Museum (Museo Sacro) of the Vatican Apostolic Library.

The central section of the altar frontal, the manufacture of which was largely complete by 1593–95 (as suggested by the presence of the combined Medici-Lorraine insignia surmounted by the Aldobrandini emblem), shows the Dead Christ tended by angels inside the sepulcher, and before him a basin containing the symbols of the Passion. The presence of the nails, crown of thorns, and thurible for the burial emphasize the Agony on the Cross in the Redemption, whereas the chalice of the Eucharist is an image particular to the Eastern Church, namely the *mèlismos*, symbolizing the sacrifice of the body of Christ. In the panels at either side of the main field are scenes representing the Descent into Limbo, and the Christ at Emmaus, both images pointing to the paschal theme of the Resurrection, which is linked in turn to the dedication to the chapel of the Virgin of the Assumption.

In terms of the expression, the hangings are strongly indebted to the artist's training in Florence, with its roots in Michelangelo's spirit filtered through the Roman mannerism of Raphael and Francesco Salviati. The composition of the *Lamentation* borrows openly from a similar work in the chapel in Palazzo Salviati in Florence (executed 1578–80), adopting a grouping of figures that would gain popularity in many religious works. The lateral panels reflect manuscript illumination, with an archaizing handling of the subject that would subsequently be superseded by post-Reformation mannerism.

G.C.

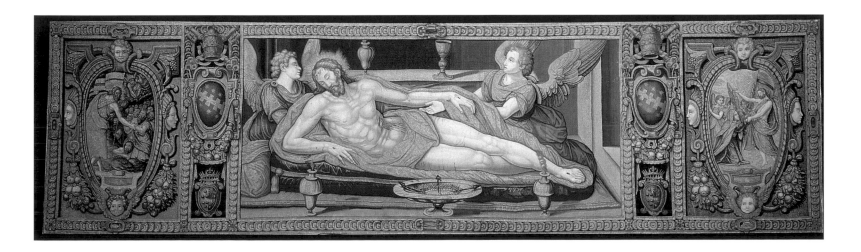

Crucifix

18th century
Silver
134.5 × 22.5 × 21 cm
Office of the Liturgical Celebrations of the Supreme
Pontiff, Vatican City State
Inv. CAN1g

Conservation courtesy of The Kane Family in loving
memory of Roger K. Kane Sr.

This solid silver crucifix has the same base
and overall design as the matching candelabra
(next entry). The faces of the triangular section
above the base carry scallop motifs, and the corners
rise into relief scrolls. Four sets of gilded rays
emanate from the center of the cross around the
figure of Jesus.

Given the excellent workmanship of the cross
and its candelabra, the set is frequently used when
the pope celebrates mass.

The shape of the cross is typical of the
eighteenth-century style and was designed to be
placed at the center of the altar. During that period
the altar was placed against the back wall of the
sanctuary, with the crucifix facing both the
celebrant and the congregation. In this way the
cross took pride of place on the altar and was a
point of continual reference throughout the mass
and a constant reminder of the sacrifice and
Resurrection of Jesus. R.V.

Candelabra

18th century
Silver
83 × 22.5 × 21 cm
Office of the Liturgical Celebrations of the Supreme Pontiff, Vatican City State
Inv. CAN1c-f

Conservation courtesy of The Kane Family in loving memory of Roger K. Kane Sr.

This candelabra is fashioned in the baroque style of the late 1700s. The wide, ornate three-footed base is elaborately sculpted, with one face bearing the image of a deacon saint (either Saint Stephen or Saint Lawrence) holding a frond of laurel or palm, symbolizing martyrdom, surrounded by volutes and other motifs resembling lilies. The other two faces are concave and carry a shield also encircled with volutes and lilies. The corners of each triangular base are scored with two grooves. The base supports an inverted triangular section variously sculpted with festoons and volutes, a large shell, and a repoussé floral motif. The upper section, also three-sided, starts with a series of repoussé leaves that frames a shell motif on each face. A circular disk below the dish for catching the falling wax is curved slightly downward and rests on a small vaselike section sculpted with lilies.

The candle's flame symbolizes the light of Christ, and that light refers to Christ's own invitation to his followers to lead the way as the light of the world: "You are the light of the world. A city built on a hill-top cannot be hidden. No one lights a candle to put it under a tub; they put it on the lamp-stand where it shines for everyone in the house. In the same way your light must shine in people's sight, so that, seeing your good works, they may give praise to your Father in heaven" (Mt 5:14-16). R.V.

Reliquary of Various Saints and Blesseds

Ca. 1660
Metal, colored stones
55.5 × 30 × 10 cm
Office of the Liturgical Celebrations of the Supreme
Pontiff, Vatican City State
Inv. RLQ172

Conservation courtesy of Florence D'Urso in
loving memory of her dearest parents, Anna and
Anthony Perkosky

It is not uncommon for a single reliquary to
contain disparate relics, as is the case here.
There can be various reasons for this: perhaps a
specific devotion for all the saints whose relics
are preserved in the same reliquary, or the fact
that the saints contained therein had something
in common, such as being members of the same
religious order or all enjoying, at the time the
reliquary was made, particular popular devotion.
Nothing is known about this particular reliquary
other than the fact that it belonged to Pope
Alexander VII.

This gilded metal reliquary takes the form of
an obelisk, which narrows at the top and is
adorned with the colored coat of arms of Pope
Alexander VII, a member of the Chigi family.
The base has the shape of an urn and rests upon
feet that take the form of shells; it contains a bone
fragment of Blessed Peter Levita as well as relics of
Blessed Francis Pat., Pope Saint John I, Blessed John
Colombo, and Blessed Andrea Galler. The base also
supports two cubes, each surmounted by a putto
in gilded silver. One of the cubes contains a
fragment of clothing of Blessed Veronica Giuliani
and the other a relic of Saint John da Capistrano.
The center of the base supports the obelisk,
which rests on four transparent spheres and itself
contains six small niches with the relics of Blessed
Franchi, Saint Anfani m., Blessed Ambrose S.,
and Saint Bernardino da Siena. At the top of the
obelisk is a small gilded sphere and a large cross
inlaid with colored stones. The sides are adorned
with rhomboid and oval shapes inlaid with blue
stones. R.V.

Papal Throne

20th century
Fir, gilt walnut, red velvet, bronze
160 × 80 × 80 cm
Apostolic Floreria, Vatican City State

Conservation courtesy of Mario di Paolo in honor
of his parents, Diodato Di Paolo and Antonina
Piccoli Di Paolo, Washington Chapter

In his role as prince of the church and lord of
the powerful, a pontiff's majesty is manifested by
vestments and furnishings used during ceremonies.
The throne is certainly one of the most important
symbols of his position. It has always been a
symbol of royal power, but the throne of the
pope expresses an authority that is primarily of a
spiritual nature. Thus, his throne needs to represent
this characteristic, rather than merely exhibit the
magnificence of worldly goods.

The papal throne on view was the official one
used in the Vatican Apostolic Palace in Saint Peter's
Basilica and during pastoral visits. It has extremely
simple lines: the seat is made of fir; the legs and
back are of walnut covered with gold leaf. There
is a minimum of decoration, with spirals and
floral designs in the neoclassic style. The throne is
upholstered in red velvet with embroidery and a
fringe of gold thread. As ceremonies and audiences
are often extremely long, it must be comfortable.
The back is embellished with two emblems in gilt
bronze bearing the coat of arms of the reigning
pope, which can be unscrewed and replaced. On
exhibit with the throne are emblems belonging
to the popes Leo XII, Gregory XVI, Benedict XV,
Pius XI, and John XXIII. This throne is in perfect
condition and can be dated to the third decade
of the nineteenth century by Pope Leo XII's coat
of arms, its style, and the restored rungs between
its legs. It has been reupholstered several times:
the present upholstery probably dates back to
the pontificate of Benedict XV, as the velvet and
embroidery are identical to those found on the
papal footrest also seen here. G.P.

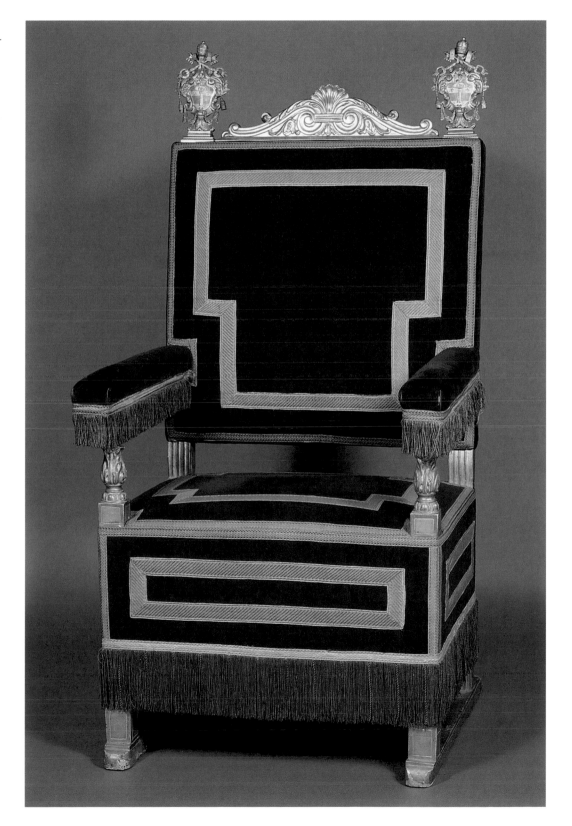

Faldstool of Pope John XXIII

1959 (?)
Venuti
Gilt wood, red velvet
91 × 89 × 73 cm
Office of the Liturgical Celebrations of the Supreme
Pontiff, Vatican City State
Inv. FD4b

The faldstool is a backless cushioned seat, made of wood or metal, composed of two pairs of crossed legs that originally pivoted at the intersection. Its seat is reserved for high-ranking clergy taking part in liturgical celebrations. It is also frequently used as an armrest for the celebrant when he is kneeling.

Made by a certain Venuti for Pope John XXIII at the start of his pontificate and put to regular use, this faldstool is made of gilded wood superbly carved with elaborate vegetal motifs. At the point where the two folding legs intersect is a large shield bearing the pope's coat of arms. Each arm terminates in a large volute, as do the feet. The connecting shaft between the two legs is composed of five cylinders carved with leaf patterns, and the seat is upholstered in red velvet. R.Z.

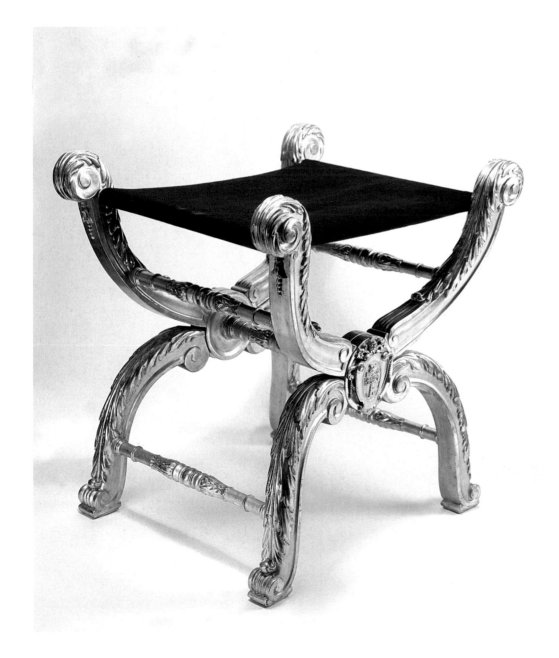

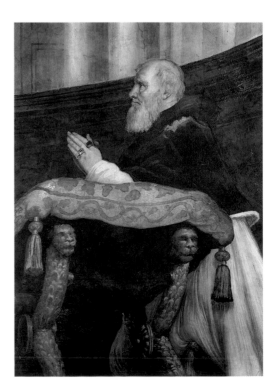

Raphael, *The Mass of Bolsena*, (detail), c. 1512, fresco, Vatican Museums

Liturgical Hassock

19th century
Velvet, silk, gold thread
62 × 34 × 16 cm
Office of the Liturgical Celebrations of the
Supreme Pontiff, Vatican City State
Inv. CSN14

Conservation courtesy of Ann and Mark Hardaway

The purpose of the hassock, a type of large cushion used in
church, is primarily to sit, kneel, or rest upon during liturgical
celebrations, especially on marble thrones, faldstools or altar
steps. Such cushions conform to the requirements of other
liturgical apparatus and are usually made with rich, highly
ornate fabric elaborately embroidered with biblical scenes,
coats of arms, or other insignia. The papal cushion usually
bore the personal emblems of the incumbent pope, and while
the reforms of Vatican Council II imposed many changes to
liturgical practices, these cushions—owing to their eminently
practical purpose—have not been eliminated, though they
are now less elaborate.

 This cushion is embellished with superb needlework
designs that stand out against a ground of deep red fabric.
The upper part is made of velvet and is divided into five
fields, each filled with delicate floral patterns flowing around
a circular insert bordered with golden braid. The central
insert contains Christ's monogram, the Chi-Rho symbol,
embroidered in gold thread against a white ground, while
the others enclose portraits of the Four Evangelists in multi-
colored silk. Running around the border of the cushion is a
golden braid, and each corner ends with a large tassel fringed
with silver thread and silk; one tassel is missing. R.V.

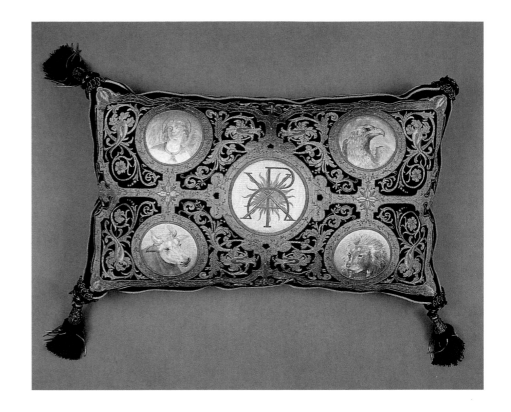

183

Hassock with Coat of Arms
of Pope Leo XIII

19th century
Silk, velvet, gold thread, precious stones
81 × 51 × 26 cm
Office of the Liturgical Celebrations of the Supreme Pontiff,
Vatican City State
Inv. CSN17

Conservation courtesy of Amalia Rivera and Juan Mireles

This cushion in dark red velvet carries a shield with the coat
of arms of Pope Leo XIII, embroidered with silk thread of
different colors with various precious stone inserts embellish-
ing the upper part of the shield. The wreath of golden leaves
encircling the shield is threaded with ribbons and cords
trailing from the papal keys. Each corner carries a polychrome
scallop with a small metal stud. The inscription down the sides
reads "España. Convento de Nuestra Señora y enseñanza de
Lerida. A su S. Leon XIII en sus bodas de oro" (Spain. Convent
of Our Lady of Lerida. To His Holiness Leo XIII on his golden
jubilee) and is bordered with intertwined braids and a tassel
at each corner with seven small polychrome columns. R.V

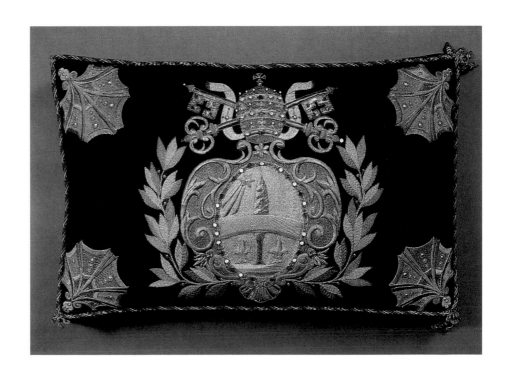

Papal Liturgical Celebrations

The liturgy is the most important instructive moment in the life of the church. Through the senses of sight, sound, and touch, the liturgy puts us in direct contact with Jesus Christ, the invisible God who took upon himself the appearance and nature of man and shared his existence from birth to death. For this reason the church has dedicated special attention to the celebration of the liturgy and to its objects and vestments. The beauty and preciousness of these objects have always had the purpose of helping the spirit to raise itself up to the beauty and greatness of God.

This, however, is not only valid for the Catholic form of worship. In every culture and religion forms of divine worship have always been surrounded with special attention, and the clothing and liturgical objects were and are the manifestation of a solemnity and wealth that distinguishes them from those of our ordinary daily lives. It is not difficult to understand the underlying principle. If rendering worship to God means, above everything else, recognizing his power over everything, it is natural that the relationship with him should be of the highest quality and everything used in the veneration of God should, in consequence, be as beautiful and important as anything we possess.

The holy objects conserved in the Pontifical Sacristy are very richly made. With a few exceptions, however, they almost all belong to the last two centuries. Many objects from previous centuries have been lost or stolen. After the liturgical renewal and reforms brought about by the Second Vatican Council (1962–65), some objects, like the papal tiara, are no longer used in the liturgical celebrations.

Flabella with the Staff of Pope Pius VII

First half of the 19th century
Wood
86 × 88 cm
Vatican Museums, Vatican City State
Inv. 30594, 30595

This fanlike object, known as a flabellum or *muscatarium*, was used during mass to protect holy objects and the celebrant from insects. It had its place among the assorted liturgical apparatus from as early as the fourth century. One such fan-shaped device from the ninth century, originating from the abbey of Tournus, France (now in the Bargello, Florence), bears an inscription indicating its specific function: "Sunt duo quae modicum confert aestate flabellum: infestas abigit muscas et mitigat aestum" (two benefits are conferred by the flabellum in the summer: it keeps annoying flies away and mitigates the heat).

By the end of the fourteenth century, use of the flabellum waned and it became a mere ornament or part of the symbolic apparatus. By the seventeenth century, it had evolved into a huge fan of white ostrich and/or peacock feathers, joined and attached to a long, decorated staff conforming to the pontifical colors of crimson (velvet) and gold (gilded braids or gilded metal studs).

The flabellum accompanied the pontiff while he was borne along in the *sede gestatoria*, or in the thalamus, the special chair used in the Corpus Domini procession. It was eventually abolished by Pope Paul VI in 1964. P.A.

Flabella with the Staff of Pope Pius VII

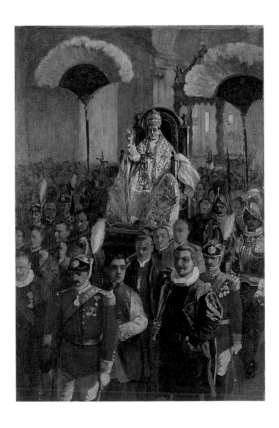

Anonymous artist, Pope Gregory XVI on the *sedia gestatoria*, 1914, oil on canvas,
Vatican Historical Museum

Sedia Gestatoria of Pius VII

Early 19th century
Wood, velvet, gilt fringe
183 × 97 × 117 cm
Vatican Museums, Vatican City State
Inv. 30577

Conservation courtesy of Mr. and Mrs. Brent
McAdam, in honor of their godchildren

An inscription on the back of he chair – PIUS VII /
PONT. MAX. / AN. V – states that this *sedia gestatoria*
dates from 1805, the fifth year of Pius VII's
pontificate. It was a gift from the people of Genoa.

 The chair was also used by Pius IX, as can be
seen from the exterior of the seat back, which is
upholstered in crimson velvet and embroidered in
gold thread with that pope's emblem. This was in
conformity with the practice at the time, by which
the reigning pontiff's emblem was emblazoned
on the chair's back. In 1856 the writer Gaetano
Moroni witnessed and documented what appears
to be this very chair: "The chair is decorated with
elegant lacework and consummate embroidery
in gold, forming in the midst of the outer part of
the postergale the emblem of the pope, equally
wrought with superb golden embroidery"
(Moroni 1856, LXIII, p. 196).

 A fully portable throne, the *sedia gestatoria* was
used by the pontiffs during solemnities and public
functions so that they might be clearly seen by the
crowd. The chair was borne on the shoulders of
twelve *sediari*, or official chair-carriers, each dressed
in plush red livery emblazoned with the tiara-and-
keys device of the Holy See. The use of the chair was
terminated in September 1978, during the brief
pontificate of John Paul I, the last pope to use it. P.A.

Pope John XXIII seated on the *sedia gestatoria*, 1958
L'Osservatore Romano

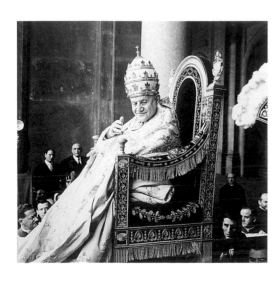

Miter

20th century
Gold leaf, pearls, silk
33 × 33 cm
Office of the Liturgical Celebrations of the Supreme
Pontiff, Vatican City State
Inv. MI10

This short, triangular miter is modeled in the style of the Western Church. The front is decorated with gilded silver leaf and embroidered with a pattern of oak sprigs and acorns. The field at the center carries a large, finely embroidered figure of Christ crucified, with the Virgin Mary and Saint John at either side. Along the bottom edge a red band carries three embroidered medallions representing the evangelists Matthew and John, with Saint Peter occupying the central one. The peak of the miter ends with a gilded cross. The reverse side is worked with the same pattern, and at the center stands a large Sacred Heart surrounded by small flames; along the bottom band are medallions symbolizing the evangelists Mark and Luke, with Saint Paul in the central one. The lappets have the same embroidered patterns and are edged with two rows of pearls. R.V.

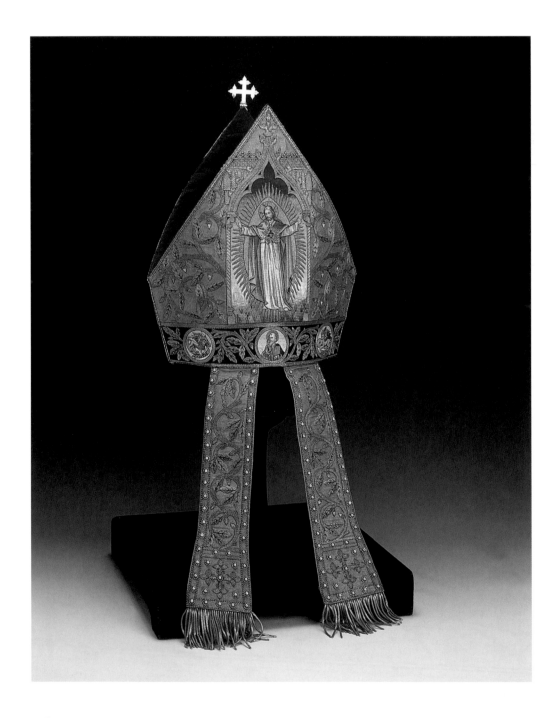

Stole of Pope Leo XIII

End of 19th century
Velvet, gold thread, silk
114 × 24 cm
Office of the Liturgical Celebrations of the Supreme
Pontiff, Vatican City State
Inv. ST19

An essential part of liturgical vesture, the stole
connotes the rank and office of the wearer.
The superb example here was a gift to Pope
Leo XIII and is still worn on official occasions
by the present pope.

The fine brocaded designs feature four saints
of the church: at the top, Saint Anne and Saint
Joachim, the parents of the Virgin Mary, who is
pictured as a child with her mother; below this

is the figure of Saint Peter, who asks the question
"Quo vadis?" (Where are you going?) to Christ
bearing the Cross. The reference is to an apocryphal
story of the saint who had a vision of Christ,
allegedly on the Appian Way, where there is now
a small church commemorating the event. In
the vision, Christ admonishes the fearful Peter
for fleeing from the persecution of Nero's forces,
saying that he was on his way to Rome to be
crucified for the second time. R.Z.

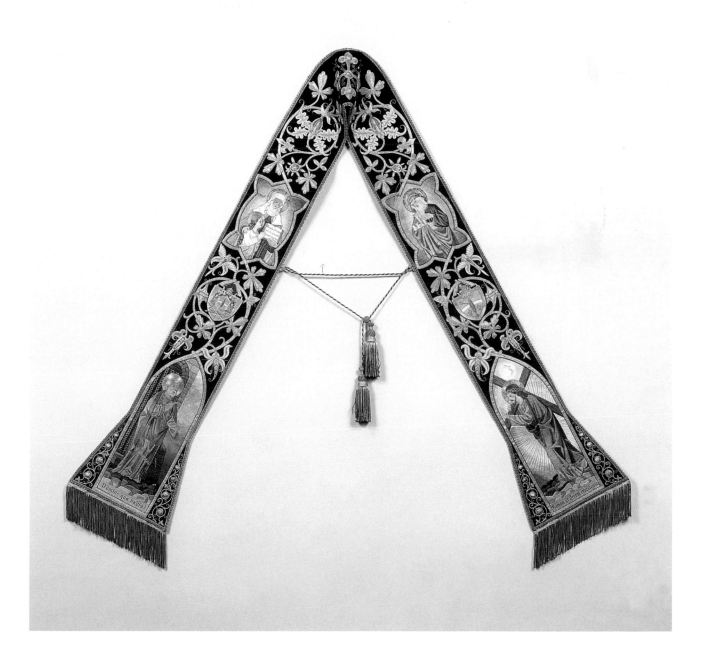

Mace of the Mace-Bearer of Pope Pius VI

18th century
Silver
74 × 16.5 × 16.5 cm
Office of the Liturgical Celebrations of the Supreme
Pontiff, Vatican City State
Inv. VR57

Conservation courtesy of Frank, Sally and
Elizabeth Hanna

The papal *mazzieri*, or mace-bearers, took their name
from the wrought-silver mace carved with the
bearings of the pope who had appointed them.
The mace-bearers, usually nine in number, were
chosen from among those close to the pope and
were constituted into a college headed by a deacon.
They were at the service of the Cappella Pontificia
and answered to the masters of ceremonies. Their
origins may go back to the ancient *servientes armorum*,
a security corps created by the Roman popes to
ensure their safety and to serve as custodians of the
apostolic palaces. While papal ceremonies were
taking place, the mace was carried high on the
right shoulder, resting in the palm of the right
hand; when not in use it was tilted downward
under the left arm. Two of the mace-bearers were
appointed the honorary role of attending the
episcopal consecrations held in Rome and headed

the procession leading the newly elected bishop
through the church while the "Te Deum" was
being sung.

The mace-bearers' costume consisted of black
livery bordered with black velvet and a purple
soprana trimmed with lacework; from their
shoulders hung fake sleeves of cloth or twill;
another piece of velvet garnished the headdress
and a sword hung at their flank. The duties and
category of the mace-bearers were abolished in
1968 by Paul VI as part of widespread changes to
the Casa Pontificia.

The mace included in this exhibition is made
of silver and bears the emblem of Pius VI in
eighteen-carat gold at the crown. The head of the
mace is a flattened sphere, with circular embossed
indentations and downward-curving leaves; the
lower part of the head is vase-shaped. The shaft has
two rings and is embellished with finely chiseled
leaves and whorls; the lower section is gilded and
ends in an inverted bell shape. The mace was used
during the pontificate of Pius VI and Paul VI. R.V.

Cope of Pope Pius IX

Second half of the 19th century
Red silk, gold and silver thread, metal inserts
280 × 120 cm
Office of the Liturgical Celebrations of the Supreme
Pontiff, Vatican City State
Inv. PVM15

This cope, which belonged to Pope Pius IX, is
made of woven red silk embellished with relief
scroll patterns in gold, silver, and silk thread of
varying weave. The orphrey, or large band of
embroidery running down the front, is richly
worked with relief patterns of flowers and leaves
interspersed with angels' heads and six large ovals
respectively bearing representations of Jesus, the
Virgin Mary, Saint Peter, and Saint Paul. The two
lower shields are quartered with the coat of arms
of the pope. The clasp is rectangular, with four
rings and two metal fasteners. The shield is
decorated with scrolls, flowers, and leaf motifs,
and is trimmed with a gold fringe of mixed
simple, twined, and chain-link tassels, the latter
adorned with metal inserts.

The cope is so large that while the pope is seated
at least three persons must assist in adjusting the
large folds of material at the sides. R.Z.

Francesco Podesti, *Pope Pius IX, Proclamation of the Dogma
of the Immaculate Conception*, (detail), 1870,
Vatican Museums

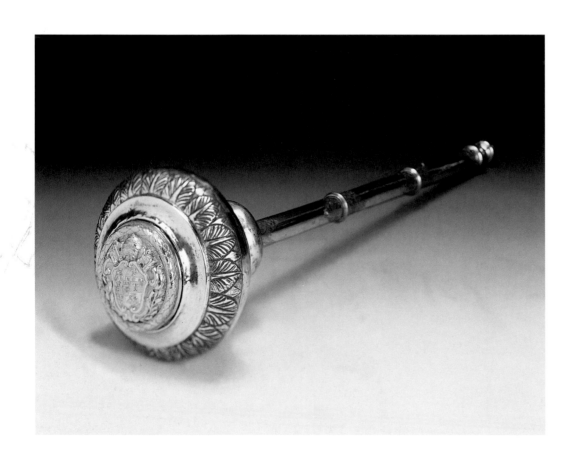

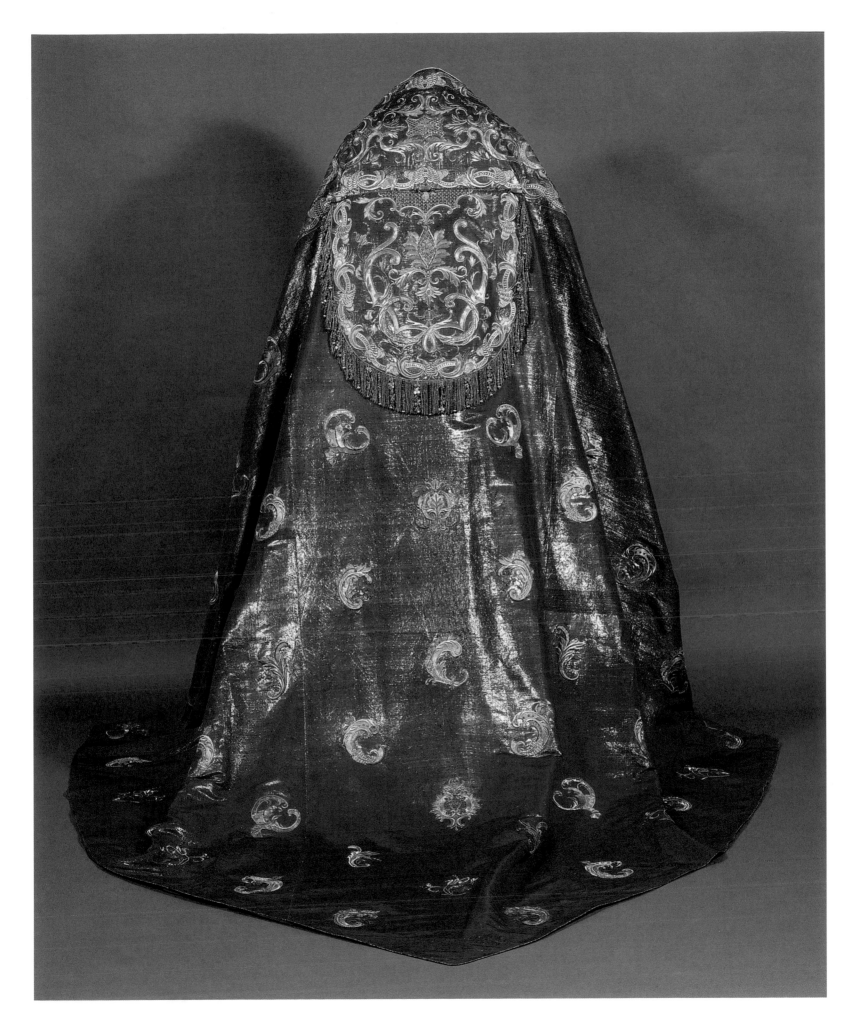

Cope of Pope John XXIII

Red silk, gold and silver thread, pearls
250 × 250 cm
Office of the Liturgical Celebrations of the Supreme
Pontiff, Vatican City State
Inv. PVM11

This cope is made of red satin richly embroidered
with lilies in gold and silk thread, and belonged
to Pope John XXIII. Woven into the cloth is a
panel in the form of a stole, the outer bands of
which are embellished with a running motif
of intertwining flowers, leaves, and scrolls in gold
thread. The central field carries the papal coat of
arms elaborately worked in a mixture of gold and
silver thread, silk, and pearls. The rectangular clasp
is decorated with the same braided pattern as the
embroidered panel, and has four rings and two
fasteners in gilded metal. The shield is embroidered
with floral patterns and has a border in gold thread
from which hang elaborate twined and plaited
fringes. The stole also has braiding around the
border, with the same patterns ranged with three
floral crosses with radials. The two sections of the
stole are held together by a small cord woven from
gold thread, with a fringed tassel at each end. R.Z.

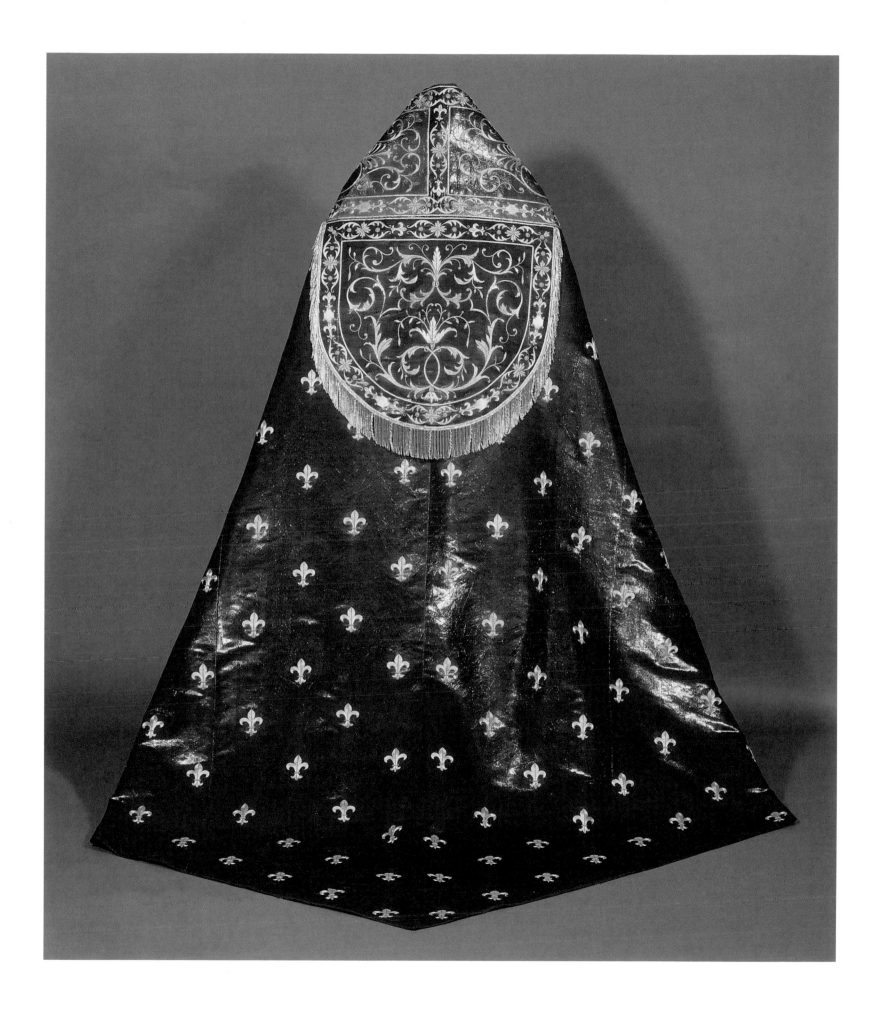

Clasp of Pope Leo XIII

1888
Silver gilt, pearls, diamonds
18 × 15 × 6.5 cm
Office of the Liturgical Celebrations of the Supreme
Pontiff, Vatican City State
Inv. RA4

One of the numerous gifts given to Pope Leo XIII in
1888, on the fiftieth anniversary of his ordination
as a priest, was this clasp, donated by the Order of
Hermits of Saint Augustine. Tradition has it that the
origins of such a clasp go back to the Bible, which
describes a plaque of precious metal that the Jewish
high priest wore on his chest. Even today the
pope wears the clasp to close the two parts of
the cope, which is worn during certain liturgical
celebrations.

This clasp is decorated in the Renaissance style
with arabesques and small angels in embossed
and chased work. The three traditional pinecones
arranged to form a triangle are adorned with five
series of pearls. In the center, "LEO XIII P.M."
appears written in diamonds. The back face bears
the dedicatory inscription "IL L SACERDOTII ANNO
ORDO EREM S. AUGUSTINI" (In the fiftieth year
of priesthood, the Order of the Hermits of Saint
Augustine). The fastening at the back of the clasp
is in openwork. R.V.

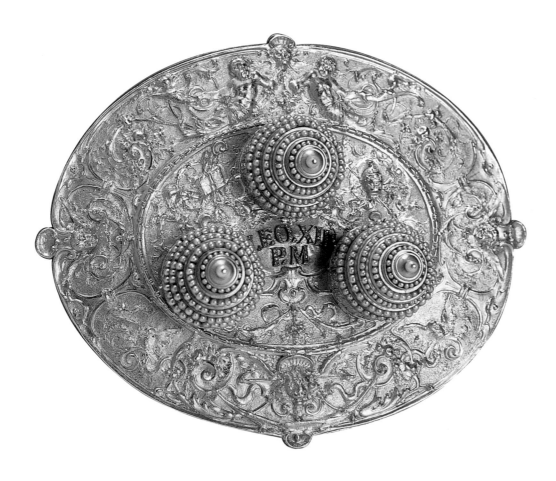

Papal Tiara of Pope Pius VII

Ca. 1820
Lyon, France
Woven cloth and silver thread, gilt metal, gold
32 × 22 × 22 cm
Office of the Liturgical Celebrations of the Supreme
Pontiff, Vatican City State
Inv. TR2

Conservation courtesy of Michael Novarese and
Robert Nelson

When the papal treasures were seized by the French
troops in 1796, all the tiaras were taken to Paris to
be melted down to pay for Napoleon's campaigns.
As a result, the pope was left without the symbol
of his power.

Upon the death of Pope Pius VI in 1799, the
conclave gathered in Venice. Pope Pius VII was
elected, but no coronation ceremony took place.
When he was finally able to return to Rome,
which had in the meantime been liberated, the
new pontiff was received with great enthusiasm.

It was in this festive atmosphere surrounding
the pope's return that the present papal tiara came
into being. Allegedly, it was crafted by a local
artisan and donated to the pontiff by the people
of Rome. That said, recent studies have shown that
the tiara was actually produced in a goldsmith's
workshop of the city of Lyon in about 1820.

The tiara is in silver cloth with a striped pattern.
The three crowns are fashioned in a gold braiding,
over which are embroidered stylized flowers in
gold thread adorned with vermeil piping and faux
gems. Embroidered on the flowers of the lower
crown are triangles representing the Holy Trinity
and the papal tiara with crossed keys. The Lamb
of God with a cross adorns the middle crown, and
the top one is embroidered with bees. The fanons,
or lappets, are also in silver cloth edged with gold
braiding. At the top of the tiara is a silver cross,
the arms of which end in fleurs-de-lis. Polished
enamel pastilles in red and white give the illusion
of cut gemstones, a technique typical of French
embroidery design at the beginning of the
nineteenth century.

Owing to its unsophisticated shape and use
of simple materials, Pope Pius VII was very fond
of this papal tiara; after his pontificate, however,
it was never worn by later popes. R.V.

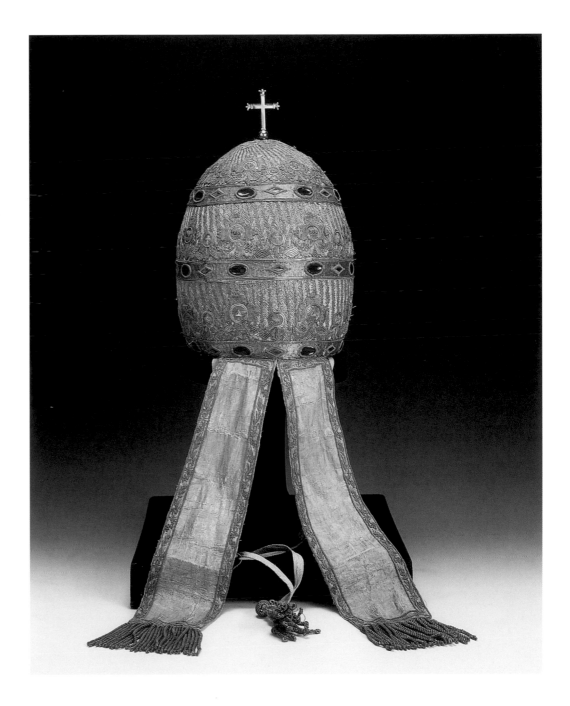

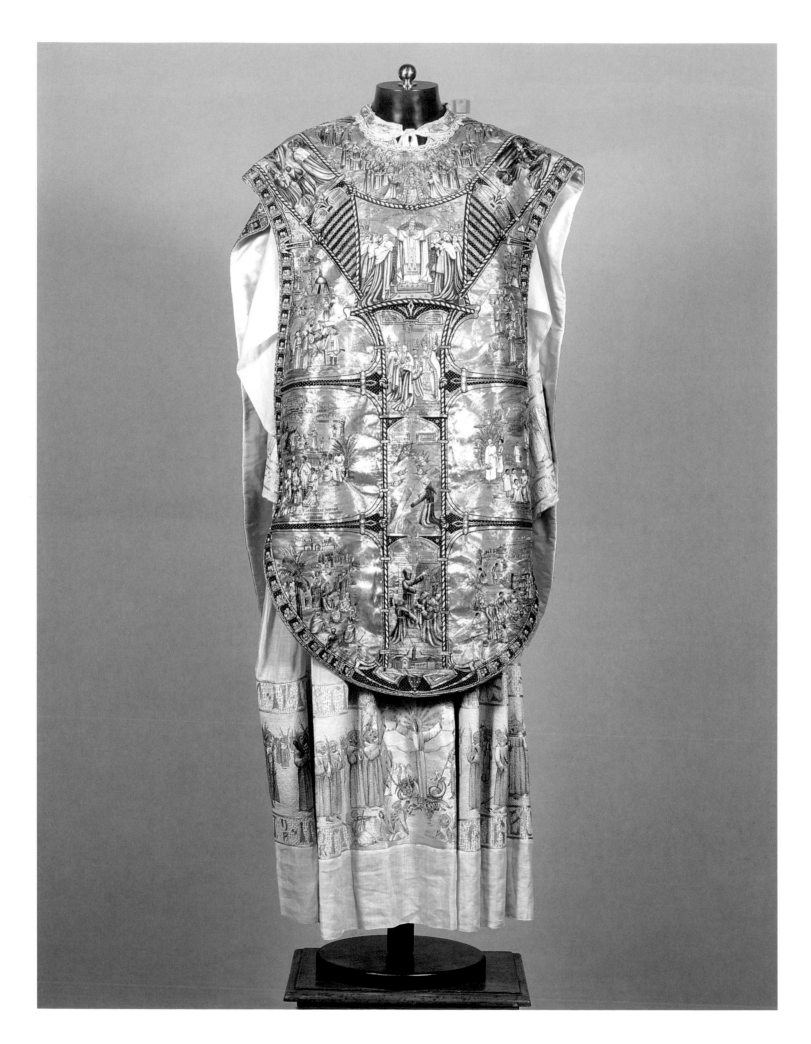

Chasuble, Alb and Stole of Pope Pius XI

20th century
Multicolored silk, gold thread
Alb: 153 × 90 cm; chasuble: 105 × 61 cm;
stole: 112 × 14 cm
Office of the Liturgical Celebrations of the Supreme
Pontiff, Vatican City State
Inv. PN66

This liturgical vestment was made by the Franciscan Order
of Poor Clare nuns as a gift for Pope Pius XI in 1926, the
year of the seven-hundredth anniversary celebration of the
foundation of the first Franciscan Order. The Franciscan
Rule was approved by Pope Innocent III and confirmed by
his successor Pope Honorius III on November 29, 1223.
It established that the Friars Minor should observe the
Gospel and take vows of obedience, poverty, and chastity.
Saint Francis was the first founder of a religious order to
adopt missionary values in its Rule. From the very begin-
ning, many Franciscan friars set out with the intention of
evangelizing people throughout the globe. Their activity,
bringing the word of God to the Far East and Africa, is
still fundamental today in the field of Christian missions.
On October 1, 2000, during a jubilee celebration in Saint
Peter's Square, Pope John Paul II canonized more than
one hundred martyrs who fell in the name of Christ.

This chasuble is richly and delicately embroidered with
multicolored threads of silk and gold filaments. Divided
into sections, it portrays episodes characteristic of many
of these missions during seven centuries. Franciscan saints
and martyrs are embroidered in detail along the edge of
the chasuble as well as on other parts of the vestment.

On the front, around the chasuble's neckline, a section
is dedicated to Mary. Below, in the center, Pope Pius XI
proclaims the Dogma of the Immaculate Conception.
Below these images are other scenes depicting events
in Franciscan history. On the back, around the neckline,
Saint Francis is welcomed into Heaven by angels and
saints. Along the sides the Nativity is depicted, as is Saint
Francis, dying, as he blesses the East, symbol of future
missions. Immediately below is a ship, bearing Pope Pius
XI's coat of arms. It is shown as it conducts the Basilica of
Saint Peter's that represents the church transporting its
faithful toward Salvation. Beneath this, almost in the center
of the chasuble, is an embroidery of the pontiff. Below
him are three scenes depicting the bishop of Assisi's
reception of Saint Francis, Pope Honorius III's confirma-
tion of the Rule, and three angels offering the symbols of
the Franciscan Orders to God in the saint's presence.

Made of linen and decorated with multicolored silk
embroidery, this alb is one of the sacred vestments
made by the Franciscan Poor Clare nuns in 1926 for
Pope Pius XI.

A silk braid with a pattern depicting the heads of
winged angels runs along the shoulders and neckline.
The galloon continues down the front forming a V at the
neck; it is fastened in the back with a white-satin tie. The
motif on the braid is of the order's saints and blessed, the
symbols of the Franciscan Orders, and Pope Pius XI's coat
of arms. There is extensive embroidery between two braids

on the cuffs depicting Poor Clare nuns as missionaries
and martyrs.

The largest portion of the embroidery, representing
Franciscan saints and martyrs, is on the lower part of the
alb. Some carry the emblems and terrible instruments
of their martyrdom; the palm leaves, too, symbolize
martyrdom. In the center, Saint Francis with the stigmata
is portrayed in a contemplative pose. He is surrounded
by four angels with halos bearing the foundations of the
Franciscan Rule: obedience, poverty, humility, and chastity.

The stole is embroidered with several missionary
scenes, the papal symbols, and a cross. The two edges
are trimmed with gold fringe. C.P.

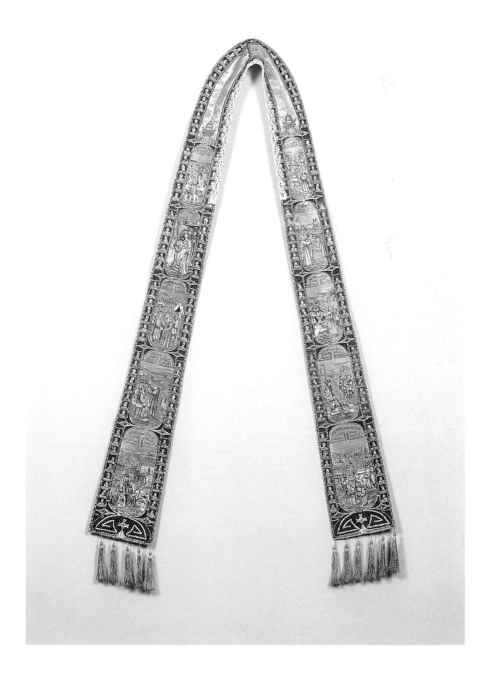

Cope of Pope Pius XII

First half of the 20th century
Silk, gold thread, pearls, metallic bosses
280 × 120 cm
Office of the Liturgical Celebrations of the Supreme
Pontiff, Vatican City State
Inv. PVM10

This large ecclesiastical vestment, known as a cope, was worn by the pope during solemn celebrations and when he was seated in the *sedia gestatoria*. The voluminous robe not only covered the pontiff's shoulders, but was arranged over the back of the chair as well, giving him a more solemn and magisterial appearance to the public eye.

Originally belonging to Pope Pius XII—whose emblem, a dove with an olive sprig in its beak, is embroidered into the cloth—the cope on exhibit here was last worn officially by Pope John XXIII. Its use by different popes is attested to by the coats of arms adorning the orphrey, a band of elaborate embroidery decorating the front. The fabric is white woven silk with floral brocading in gold thread and is embellished with an elaborate sashlike band bordered by running embroidered festoons of flowers, volutes, and leaves interspersed with tiny metal studs and trimmed at either side with a golden braid. Among the figures in the highly ornate central band, which includes pearl inserts, are two papal coats of arms embroidered with gold and silver thread, various colored silk, and stone inserts of different hues. The clasp is rectangular and is embroidered with flowers and volutes, with four rings and two fasteners in gilded metal forming a braided pattern. The shield emblazoned on the band is filled with embroidery and floral designs in gold thread, leaf, metal studs, describing volutes and needlepoint meshes, while the bottom hem of the band is finished with simple fringe of spirals and flourishes. The stole is also embroidered with gold thread with ornaments and fields in needlework meshes, volutes, and floral motifs, and three floral crosses with sunburst pattern. The cord is made of gold thread with spiraling tassels and fringes in gold thread and yellow silk. R.Z.

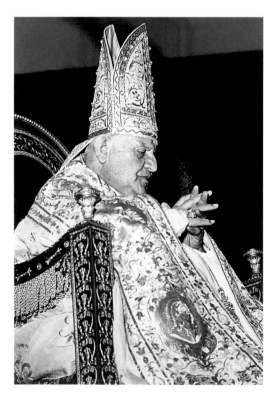

Pope John XXIII wearing the papal cope seated
on the *sedia gestatoria*, *L'Osservatore Romano*

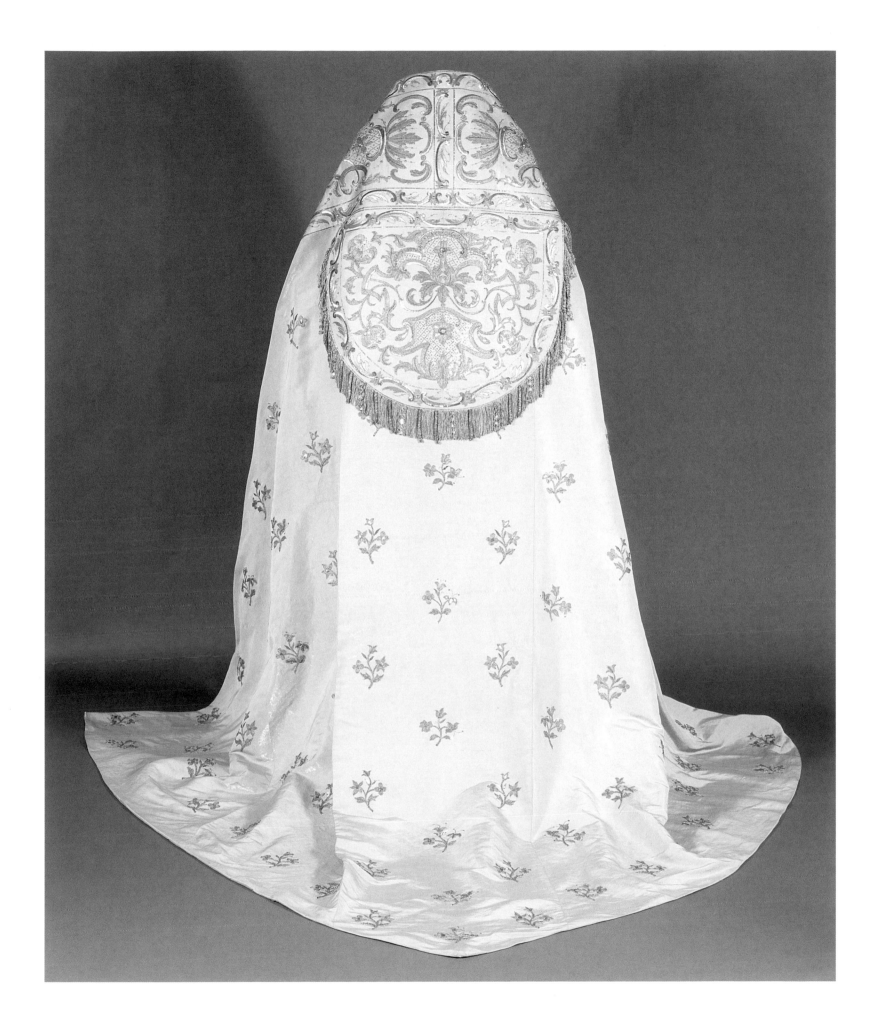

Miter of Pope Pius XI

1929
White satin, silver, amethysts, gold braid
49 × 38 × 16.5 cm
Office of the Liturgical Celebrations of the Supreme
Pontiff, Vatican City State
Inv. MI49

This miter was donated by Benito Mussolini, leader of the Italian government and signatory of the Lateran Treaty (February 11, 1929), to Pope Pius XI as a sign of homage for the successful outcome of the agreement with the Holy See.

The markedly imposing design and form of this miter give some indication of the tastes that prevailed in Italy between the years 1920 and 1940. It does not appear that the miter was ever actually used, perhaps because of its considerable weight or because its excessive height rendered it unstable on the wearer's head.

The miter is long and narrow, after the central European fashion, and is made of white satin. On the front face, over a background of raised gold embroidery, is a large silver crucifix with radiating rays of silver. Below are the symbols of the evangelists Matthew and John in raised gold embroidery. On the back face, within a large oval of raised gold embroidery, is a silver image of the Virgin with Jesus in her arms and a half-moon with stars at her feet. Below this are the symbols of the evangelists Mark and Luke. A band of gold brocade with large amethysts inlaid in burnished silver settings is at the bottom. This band is surmounted by a large silver crown, and at the sides by two half crowns, also in silver. The *infulae* are of white satin with three designs of raised gold embroidery and three large amethysts set in burnished silver. At the bottom, also in gold brocade, is the papal tiara and keys, while the *infulae* end in a rich golden fringe.

R.V.

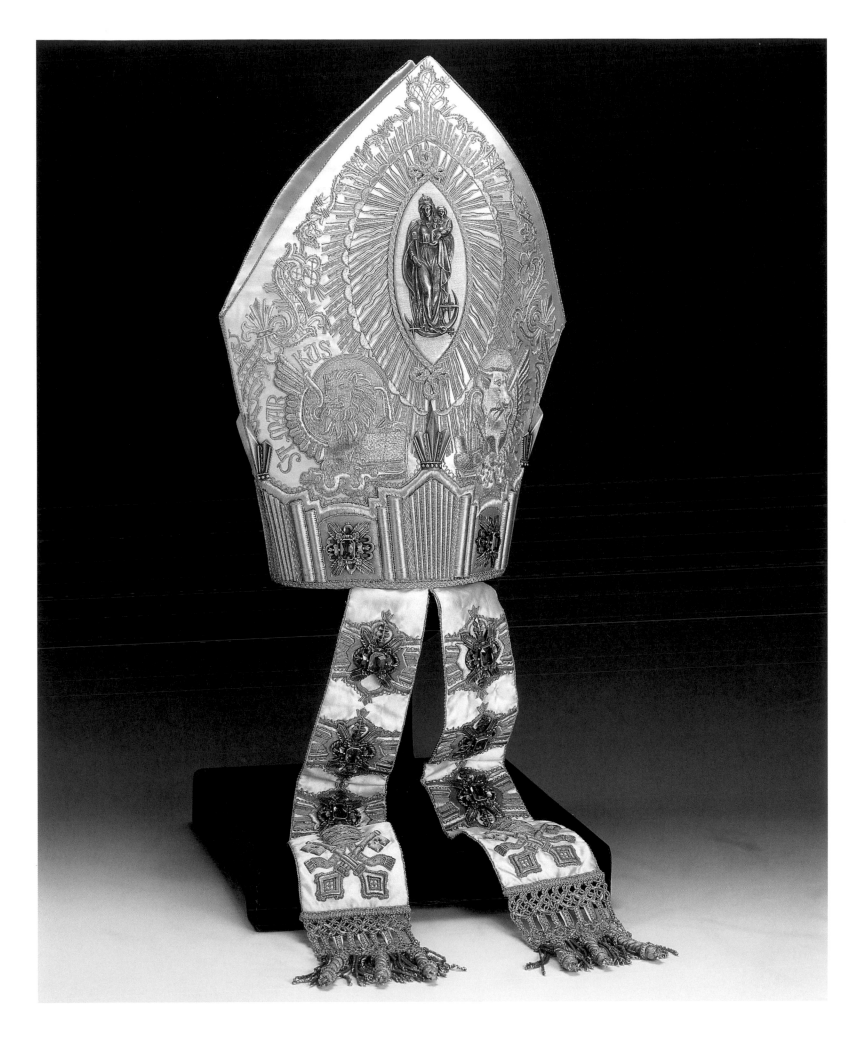

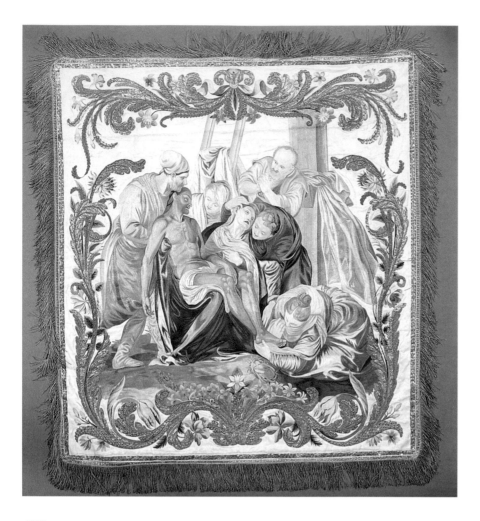

Humeral Veil

1852–61
Istituto G. Mazza, Verona
Silk, metal inserts, gold leaf, silver thread, taffeta
271 × 71 cm
Office of the Liturgical Celebrations of the Supreme
Pontiff, Vatican City State

Conservation courtesy of Susan Sullivan

The term "humeral" derives from the Latin *omerus*, mean-
ing shoulder, and here it refers to the way this special veil
is worn, that is, draped over the shoulders and reaching to
the knees. As part of the liturgical vesture, the humeral veil
testifies to the profound respect that surrounds the cele-
bration of the Eucharist: the veil enabled the priest to avoid
direct physical contact with the consecrated chalice and
the paten.

The veil on exhibit here is a work of extraordinary
beauty. The central scene, which is derived from Raphael,
portrays the moment in which Jesus gives the keys to Saint
Peter, symbolizing the foundation of the Church. While
there are slight defects in the rendering of perspective, the
needlework detail is superb throughout, the shading and
tones are subdued but not dull, and the entire piece is
richly enhanced by varied floral devices and edged with a
gold fillet of delicate braided openwork. R.V.

199

Chalice Veil

1852–61
Istituto G. Mazza, Verona
Silk, metal inserts, gold leaf, silver thread, taffeta
82 × 69 cm
Office of the Liturgical Celebrations of the Supreme Pontiff,
Vatican City State

Conservation courtesy of Susan Sullivan

As its name suggests, the chalice veil is a special cloth used to
cover the sacred vessel that contains the consecrated wine dur-
ing the celebration of the Eucharist. Although revisions to the
liturgy have not abolished it, the chalice veil is little used today.
The needlework of this superb veil is varied in tone and highly
realistic in its rendering of both the embroidered scene and
the elaborate floral decorations that frame it.

The scene represents the Deposition from the Cross, and its
composition is very close to a painting by Paolo Veronese
(Honolulu Academy of Arts). The traditional figures are pres-
ent, with the dead Christ cradled by a young man (Saint Joseph
of Arimathea), while at his feet the Virgin Mary is comforted
by Saint Mary Magdalene. The definition of the folds of the
clothing, of the flesh and muscles, and of the emotional
expressions of the figures is astonishingly realistic, so much so
that on observing the hangings, an erudite visitor to the insti-
tute declared that the women's needlework had "rivaled the
painter's brush" in excellence. R.V.

Burse for a Corporal

1852–61
Istituto G. Mazza, Verona
Silk, paillettes, thin gold, silver thread, taffeta
31 × 31 cm
Pontifical Sacristy, Vatican City State

Conservation courtesy of Maureen A. Kucera in honor of Robert C. Kucera

The liturgical burse is a special pocket of embroidered cloth designed to contain the corporal, a square of white linen that is laid on the altar table beneath the chalice and paten, and symbolizes the shroud in which the body of Christ was wrapped for burial. Its practical purpose is to catch any particles of the consecrated bread, or Host, which may scatter when the bread is broken before the communion rite.

The embroidered scene on this liturgical burse is framed by two golden volutes entwined with climbing roses, and shows a rock-carved tomb from which the Resurrected Christ has just emerged, as he hovers in a gesture of benediction above the two alarmed Roman soldiers left on guard. The distinction between the divine and the earthly, the heavenly and the worldly, is perfectly captured by the exquisite needlework, the former quality depicted in the diaphanous figure of Christ, drawn with delicate pale threads that give the effect almost of a light issuing from within the figure. The command of tone and perspective is also superlative and so minutely rendered that there is even a sense of movement, as if the air were disturbed by the resurrected body of Christ. R.V.

Papal Liturgical Slippers of Pope Pius VII

Early 19th century
J. Vergne, Montpellier (France)
White silk, gold thread, emeralds, diamonds,
leather
27.5 × 10 × 13 cm
Office of the Liturgical Celebrations of the Supreme
Pontiff, Vatican City State
Inv. PNR17a–b

These white silk slippers, in excellent condition,
probably belonged to Pope Pius VII. Each one is
finely embroidered with floral patterns and a
central Greek cross motif set with a central emerald
and a diamond on each arm. A gold braid runs
around the welt, and the laces are white silk
ribbons with fringed ends. Impressed on the
leather sole is the name of the maker: "J. Vergne,
Montpellier." R.Z.

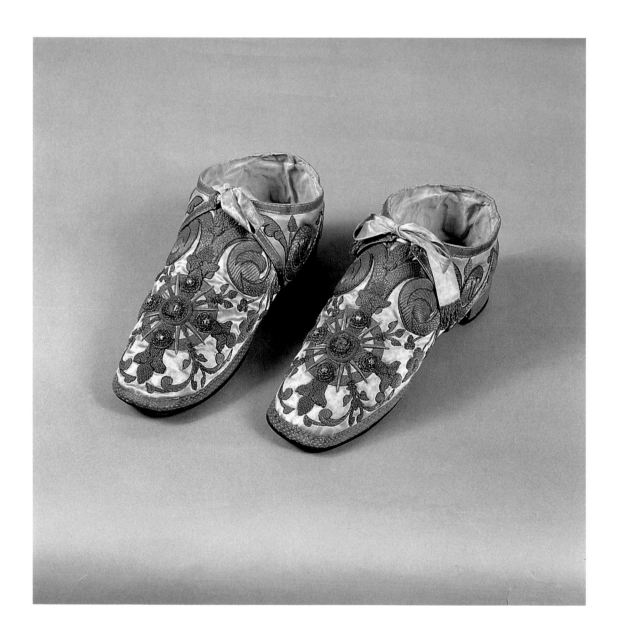

Papal Shoes of Blessed Pope John XXIII

Mid-20th century
White satin, silk, gold thread, leather
29 × 10 × 8 cm
Office of the Liturgical Celebrations of the Supreme
Pontiff, Vatican City State
Inv. PNF 14 a-b

These white satin shoes, silk inside and out,
belonged to Blessed Pope John XXIII. Shoes of
this type were worn by the popes in liturgical
celebrations during the periods of Christmas
and Easter and in feasts of the Blessed Virgin Mary
and non-martyr saints. Originally the shoes
had laces. R.Z.

Ring of Pope Pius IX

1871
Gold, aquamarine, garnet
3.6 × 2.8 × 2.6 cm
Office of the Liturgical Celebrations of the Supreme
Pontiff, Vatican City State
Inv. AN2

This particular type of ring is worn by bishops
and also the pope. The band is made one size larger
than the circumference of the wearer's finger, as it
used to be worn over a liturgical glove.

So as not to require two separate rings, one
worn on the naked finger and another over a gloved
finger, some of these rings were equipped with a
springlike mechanism that allowed them to be
worn with or without gloves.

This type of ring has become obsolete because
gloves are no longer worn in liturgical celebrations,
as a result of changes introduced by the Second
Vatican Council. R.V.

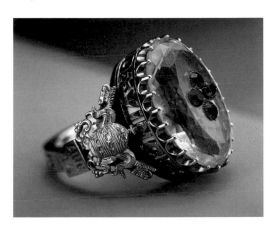

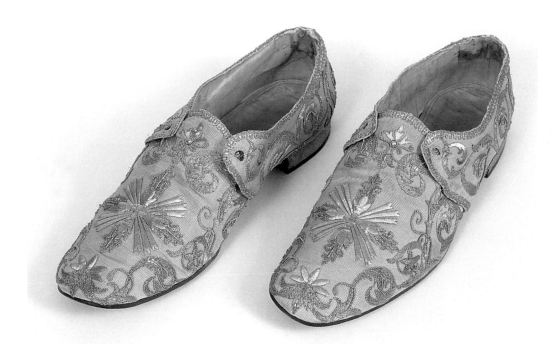

Monstrance

Early 20th century
Gilt silver, gilt bronze, amethysts, greenstones,
cut glass
35 × 13 × 12 cm
Office of the Liturgical Celebrations of the Supreme
Pontiff, Vatican City State
Inv. OST1

Conservation courtesy of Bruce Allen Sutka in
memory of Robert H. Sutka

Another term for monstrance, *ostensorium*, stems
from the Latin verb *ostendere* (to show), and as
applied here it refers to the specific purpose that
this article serves in the liturgy, which is to make
the Host visible to the congregation for adoration.

This monstrance is small and appears to have
been studiously designed so that there is nothing
to distract attention from the central compartment
that encloses the sacred Host. The base on which it
stands is round and the upper surface is delicately
carved with chain fretwork around the rim and
with Greek crosses toward the center. Adorning
the rim are four purple amethysts set in circular
mountings with a braided ridge. The lower part
of the shaft is triangular in section and has fine
repoussé scalloping and other chased leaf and
scroll designs. The shaft is interrupted midway by
an indented section, the upper segment of which
has a series of scroll repoussé reliefs. The open
compartment for the Host is encircled by a ring
of gilded rays of varying lengths, and at its crown
is a purple amethyst set in a braided surround
surmounted by a Greek cross. The gilded inside
of the monstrance contains the crescent-shaped
holder for the Host and is fitted with a removable
glass window. The front surround is studded with
green semiprecious stones mounted in circular
settings. The reverse is decorated with the symbol
of the Eucharist. R.V.

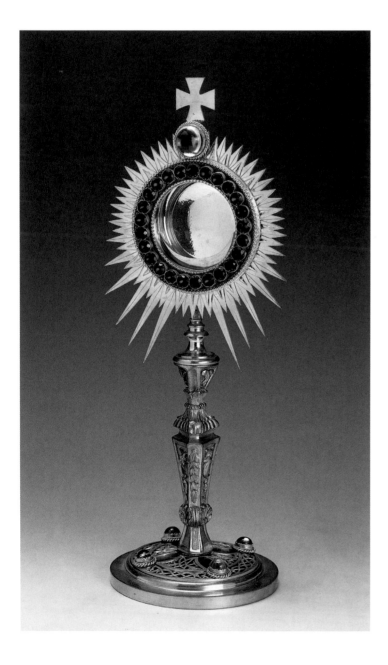

Throne for a Monstrance with Pair of Two-Branched Candlesticks

19th century
Gilt wood
159 × 124 × 37 cm
Apostolic Floreria, Vatican City State

Conservation courtesy of The Washington
DC/Baltimore Chapter of the Patrons of the Arts
in the Vatican Museums

During the seventeenth century the faithful
received new, strong motivation to participate
in the life and rituals of the church. Oratories,
structures designed for preaching and catechesis,
were developed on a large scale. During this period,
important schools for singing and sacred music
also arose. Religious holidays and processions,
however, continued to be events involving the
greatest participation by the people. In particular,
they were appreciated because they allowed
believers to bring worship into the streets and
homes, into the spaces reserved for everyday life.
Thus, special machinery was devised so that relics
and sacred objects could be exhibited outside.

Made in the nineteenth century, this throne
for a monstrance was derived from those elegant
baroque structures. Actually, it is a processional
machine that has been transformed: originally
only the upper framework that supported the
monstrance containing the consecrated host
existed. It had horizontal handles permitting it
to be carried on the shoulders of four or more
bearers. Two candlesticks with two branches each
were attached to the sides of the framework.
Notches made by lamps that protected the flame
from wind are still visible on the plates of the
candleholders. Later, it was transformed into
a stationary structure used only in interiors.
The handles were dismantled, and the framework
was attached to a gilt wooden base painted to
look like marble. Often these objects, as well as
the decoration of the churches themselves, made
a pretense of appearing much more splendid than
they actually were.

Talented painters were capable of perfectly
reproducing the appearance of any kind of marble.
This particular base is an imitation of serpentine
green, an extremely rare and precious marble that
was a favorite of the Roman emperors; its name
comes from its similarity to a snake's scales. G.P.

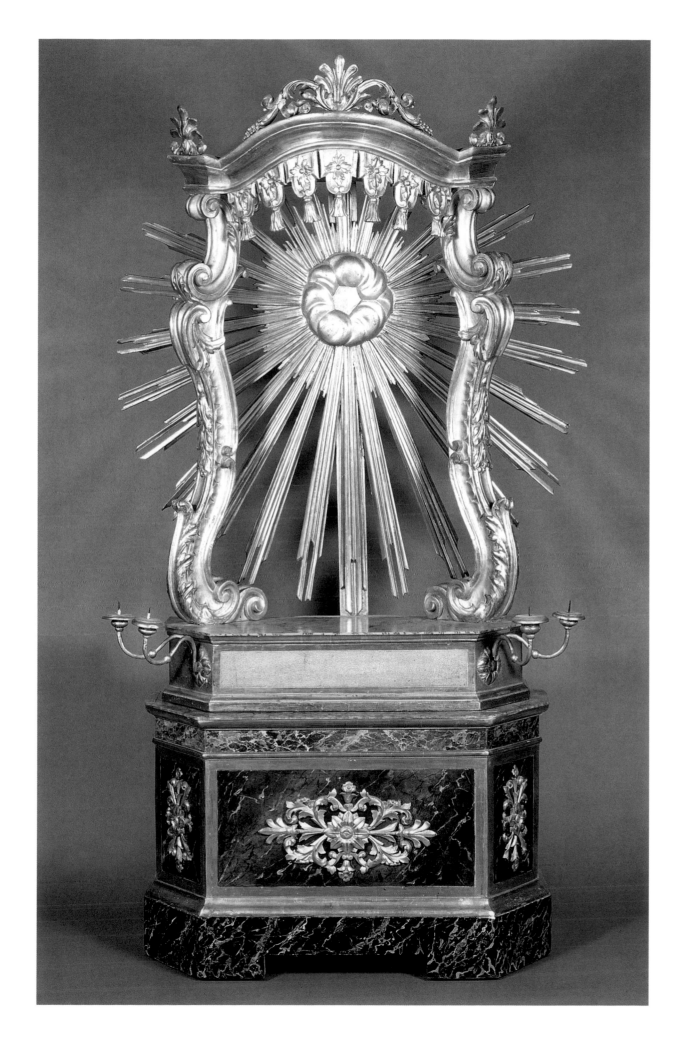

Handbell of Pope Leo XIII

1887
Bronze
19.5 × 9.5 × 9.5 cm
Office of the Liturgical Celebrations of the Supreme
Pontiff, Vatican City State
Inv. CP6

Bells have always had deep symbolic significance beyond their mere practical application. Even a handbell such as this may be full of special meaning and symbolism. The handbell in particular harks back to the town-crier's appeal "Hear ye! Hear ye!," but in this case the appeal is to the faithful, to exhort them to celebrate the divine mysteries during the important moments of the celebration of Mass and hearken to the word of God.

Church bells are normally contained in a campanile or belfry, and in addition to inviting the public to attend prayer services such as the Divine Office and mass, they ring out the passing day, hour by hour.

The bell on exhibit here is of bronze; its handle is in the form of a spire. The upper part of the bell is embellished with four round medallions with chased clover motifs; below this is a band with four niches containing saints alternating with an inscription "Societas operaria a S. Gregorio VII Mediol. / Vota reddens sua gratulantes D.D / Exeunte decembri an. MDCCCLXXXVII / Quinq. Sacerdoti Leonis P.M." (The Society of workers of Saint Gregory VII of Milan / with heartfelt felicitations / in December of 1887 donates this to Pope Leo XIII on the 50th anniversary of his priestly ordination). Along the rim of the bell runs another inscription: "Audite me magnates / et omnes populi / et rectores Ecclesiae auribua percipite" (Listen to me, important public figures, presidents of the assembly, give ear!; Eccl 33:19).

R.V.

Mass Cruets

Early 20th century
Silver gilt
Flasks: 13.5 × 8.5 cm; tray: 20 × 30 × 3.5 cm;
handbell: 11.5 × 6.5 × 6.4 cm; spoon: 8.5 × 1.5 cm

Office of the Liturgical Celebrations of the Supreme
Pontiff, Vatican City State
Inv. AM13

Conservation courtesy of Marie-Louise Brulatour
Mills in loving memory of her parents, Yvonne and
Harry C. (Buster) Mills

Although there is little information on either the craftsman or the date of manufacture of this cruet set, it appears to have been made around the beginning of the twentieth century.

While the purpose of the two small flasks and the tray that carries them is clear enough — they are for the wine and water for the Eucharist — the function of the bell and the spoon may not be obvious. The bell is rung to mark the stages of the celebration of the Eucharist, and the teaspoon is used to take a few drops of water to add to the consecrated wine before it is converted.

The prayer spoken by the priest as he added the water to the chalice are the same as those recited today, only the water is now poured directly from the flask. The prayer evokes the merging of the dual natures of Christ: the wine represents his divine nature, and the water his human nature, thereby united in the Son of God.

The set on exhibit is made of gilded silver. The spout of the wine flask is embellished with a bunch of grapes, that of the water flask with a shell. The handle is a volute decorated with five leaves. The body of the flask carries eight tabernacles containing, respectively, the Sacred Heart of Jesus, the symbol of Christ, the Sacred Heart with the nails of the Passion, alternating with chased designs of capitals with clover leaves. The upper part of the flasks is decorated with repoussé flower patterns and a running chain motif. The tray is oval and embellished with varied carved details of tabernacles and trefoils and carries four oval medallions depicting representations of the cross in enamel. The upper side of the tray has two raised rings to hold the flasks in place. The bell is carved with the same symbols as the flasks. The spoon is also embellished with detailed chased leaf motifs. R.V.

Lavabo Pitcher and Plate of Pope Pius IX

1864–67
Pierre Bossan (1814–88), Lyon, France
Gilded silver, gilded bronze, multicolored enamel
38 × 15 cm
Office of the Liturgical Celebrations of the Supreme
Pontiff, Vatican City State
Inv. LA4

For the jubilee of Pope Pius IX in 1877, Bishop Oreux-Brézé of Moulins, France, and the marquis d'Aubigny presented him with a magnificent service for the celebration of mass. The gift included a chalice, ciborium, cruets, a pitcher and plate, and a candleholder. The original pastoral staff or crosier, although generally considered as part of the same set, was donated to the pope separately. Even today, the chalice and ciborium are still frequently used by the pontiff and, for this reason, are not part of the exhibition.

In liturgical celebrations involving the pope and the bishops, a pitcher and basin of silver- or gold-plated metal are used for washing the hands. These have an eminently practical function as, prior to the celebration, it is appropriate that the celebrant's hands be washed as he will have to touch the Eucharist and distribute it to the faithful. This practical use has given rise to a symbolic meaning wherein the idea of cleanliness has become that of the purification of the soul of he who prepares for the divine sacrifice.

The rounded body of the pitcher is decorated with an enamel band with gold branches embossed with winged deer. At the base of the neck a heraldic lion may be seen, bearing the coat of arms of Pope Pius IX. The long, fluted neck of the pitcher rises to form a wide spout and supports the handle, which is of vegetable motifs surmounted by a reptile. The basin is round and its wide central bowl is decorated with foliage that indicates the four cardinal points and serves as the background for the image of a triton. In the center is an engraving of the boat of Saint Peter. Both the pitcher and the basin are decorated with aquatic creatures, and the symbolic quality of water is evoked by the green and blue tones of the enamel. The deer that adorn the pitcher also have a spiritual dimension: the deer that longs for cooling streams represents the Christian who thirsts for God. The purifying ideal of the water is further represented by the reptile that sheds its skin in the spring. R.V.

Candleholder of Pope Pius IX

1864–67
Pierre Bossan (1814–88), Lyon, France
Gilded bronze, gilded silver, enamel
39.5 × 18.5 cm
Office of the Liturgical Celebrations of the Supreme
Pontiff, Vatican City State
Inv. BUG1

This type of low candleholder, known as a *bugia*, has no shaft and only the lower dish to collect the melted wax. It was used in the past during the eucharistic celebrations of the pope and the bishops, when it would be carried by an assistant who followed all the movements of the celebrant during mass.

The candleholder and candle had an eminently practical function. The lack of illumination in church buildings rendered it necessary for some form of light to be directed at the liturgical texts in order for them to be read. The symbolic significance is linked to the very idea of light, the light that is God himself, whom each man and woman announces through good works. R.V.

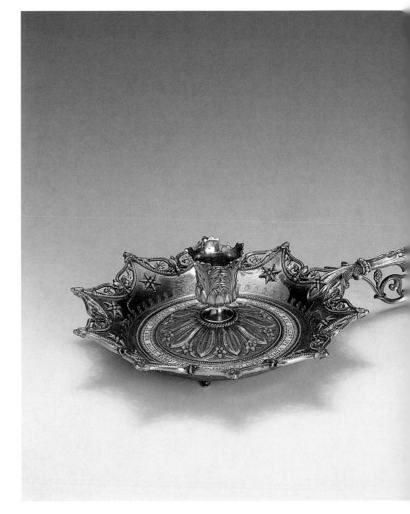

That idea is expressed in this particular candle-holder, which bears a Latin inscription that reads: "In the same way your light must shine in people's sight, so that, seeing your good works, they may give praise to your Father in heaven" (Mt 5:16).

The dish has ten points, each of which is decorated with a lapis lazuli star. The stars are linked by a fretwork design of branches, each adorned with a golden bee. The bell-shaped support for the candle stands in the center of the dish. At the base of the support are ten green enamel leaves arranged in a rosette, and between each leaf is a flower. The handle is covered with a design of foliage and terminates in a flower bud that resembles the arms of the cross. The stars represent the idea of light, which is also hinted at by the bees and the inscription; the flowers represent remembrance. R.V.

Plate, Bell, and Cruet of Pope Pius IX

1867
Pierre Bossan (1814–88), Lyon, France
Gilded silver, gilded bronze, cut glass, enamel, amethysts
25.5 cm
Office of the Liturgical Celebrations of the Supreme Pontiff, Vatican City State
Inv. AM4

Conservation courtesy of Jo Campbell in honor of the Campbell Family

The elements of this altar service were donated to Pope Pius IX for his jubilee in 1877, the year before he died.

The cruets hold the wine and water used during the liturgical celebration. The bell serves to highlight, by means of a brief ring, important moments during the Mass. In Catholic eucharistic celebrations, the wine is poured into the chalice, where it is destined to become the blood of Christ. The water is used to purify the chalice, and a few drops of it are also added to the wine contained

therein to indicate the unity of the two natures, divine and human, in the single person of Jesus Christ.

Each cruet rests on a base of four dolphins. The lower section of the vessel is surrounded by a ring of enamel hearts with three golden doves. The rest of the vessel has a green background with a design of golden branches that spiral up the neck; on the wine cruet they represent grape vines, and on the one for water they take the form of water lilies. At the very top, an angel prepares to open the cover of the spout, while at the base of the handle — which has a twisting foliage motif — a snail may be seen. The oval plate has a border of enamel hearts, and each of the four cardinal points is decorated with the figure of a fabulous beast: two eagles, a dragon, and a chimera. The center of the plate has a chased design representing the washing of the feet. The bell is surmounted by a cockerel. The theme of water is represented by the dolphins, the aquatic animals, and the lilies, and the spiritual symbolism is represented by the doves, symbol of peace and of the Holy Spirit, the dolphin, symbol of the Christian, and the snail, symbol of "the slothful Christian, enslaved to the world." R.V.

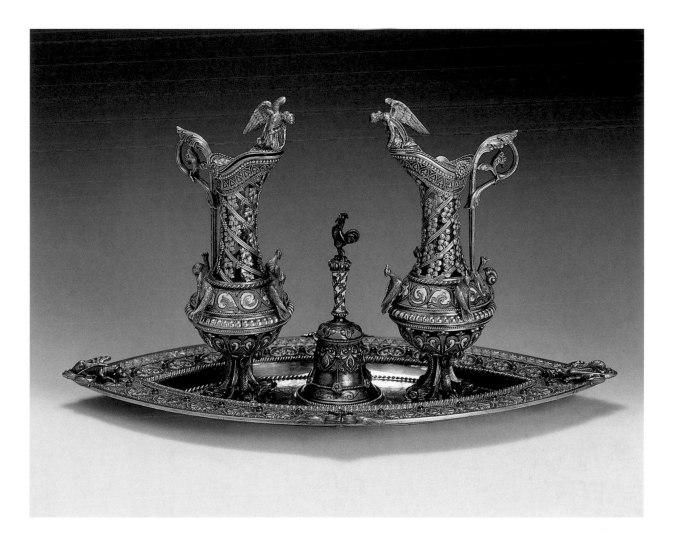

Aspersorium and Aspergillum of Pope Pius IX

1858
Gilt metal
Aspersorium: 17 × 18 × 18 cm;
aspergillum: 32 × 6.5 × 6.5 cm
Office of the Liturgical Celebrations of the Supreme Pontiff, Vatican City State
Inv. SEC3

This aspersorium and its aspergillum were donated to Pope Pius IX in 1858 on the twelfth anniversary of his election to the Papacy. The aspersorium holds holy water, and the aspergillum is used to gather and sprinkle that water. Rites involving the sprinkling of water are ancient and go back to the earliest years of Christianity. At first, the faithful were sprinkled as a sign of purification using sprigs of olive, myrtle, or hyssop; the aspergillum came into being in the later Romanesque and Gothic period. Almost all signs of liturgical blessing — with the exception of the sign of the cross — involve sprinkling with holy water.

The aspersorium and aspergillum on view are made of richly decorated gilded metal. The handle of the aspersorium is composed of two mythological animals bearing two small entwined cylinders in their mouths, the fastening of which is formed by two lions' heads. Along the upper part of the aspersorium, which has the form of a bucket or pail, is an embossed band of triangles and other shapes. Six figures may be seen, each sitting within a niche: Christ with a book, his hand raised in blessing; Saint Matthew; Saint Mark; Saint Peter; Saint Luke; and Saint John. Above and between each niche are angels with open wings. Below an inscription reads "Asperges me Domine — Et mundabor. Lavabis me et super nivem dealbabor. Miserere mei Deus" (You will sprinkle me O Lord, and I shall be cleansed. You will wash me and I shall be whitened beyond snow. Have mercy upon me God). The base is circular and adorned with a chased design of pointed ovals.

The aspergillum is richly decorated. The upper part is formed of two joined semicircles, the higher of which is perforated while the lower is embossed with a pattern of foliage. The handle, which is long and narrow, is made up of two slender fretwork columns with vines and bunches of grapes and two long chased leaves. At the end of the handle is a double tondo inscribed "Pio PP. IX — Anno XII" (To Pope Pius IX — in the 12th year), adorned with a fretwork design of tiny angel heads. R.V.

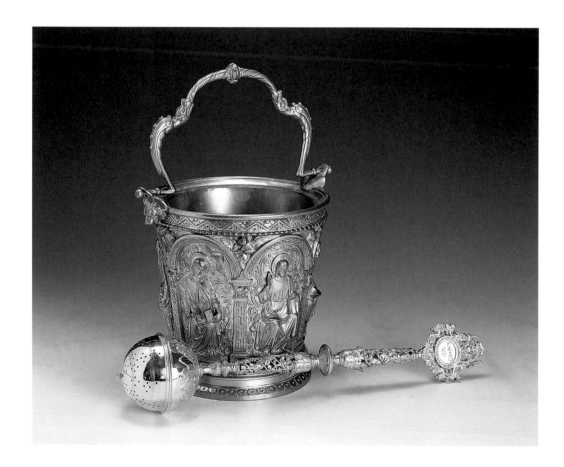

Thurible, Incense Boat, and Spoon

Various periods
Silver
Thurible: 35 × 16 × 16 cm;
incense boat: 13 × 20.5 × 8.5 cm;
spoon: 11.5 × 2.5 × 1 cm
Office of the Liturgical Celebrations of the Supreme
Pontiff, Vatican City State
Inv. TU4/NA7

Conservation courtesy of The Florida Chapter of the
Patrons of the Arts in the Vatican Museums

These three objects, although used together in
papal ceremonies, do not belong to the same
group. The thurible is, perhaps, from the eighteenth
century, but nothing else is known about it save the
name of the silversmith, from the inscription "Fu
fato soto M. Zvanne Nodaro Lo." The incense boat is
also eighteenth century, the work of a Neapolitan
silversmith: "ABB. Napels." The beautifully crafted
silver spoon was given to Pope John Paul II on
January 31, 1989, on the occasion of a visit granted
by the pope to the town council of Rome. Despite
their diverse provenance, the three pieces go
together well.

The silver thurible is tall and has a dome-shaped
lid. The base is small and round, and its external
border is decorated with a chased pattern of dotted

squares; at the center is a band with a chased
radiating pattern. The bowl of the censer is wide
and has embossed decorations of scrolls and leaves
with ovals representing the Blessed Virgin, Saint
Peter, and the inscription of the silversmith. The
fastenings for the three chains take the form of
cherubs' heads. Around the lowest extremity of
the lid is a circular band with three soldered rings
through which the chains pass; further up is a
chased bombé and fluted design, and above that
are two fine pieces of openwork in the form of
windows and hearts. At the top is a small squat
column with embossed decorations on a perforated
support. The chains are joined in a bell-shaped
canopy, embossed with scrolls and leaves, with
a large movable ring at the top.

The base of the incense boat is round and has a
raised border decorated with a round chased half-
moon design along the edge. The stem is short and
round with an embossed decoration of alternating
shields and leaves. At the center a wreath of flowers
is represented. Each of the two upper extremities
of the incense boat is decorated with a small cherub
head and another small head among a chased
design of scrolls and flowers. One part is fixed
while the other is hinged and may be opened.
This latter part is decorated with the Resurrection
of Christ surrounded by scrolls, while the fixed half
shows the crucified Christ surrounded by scrolls,
leaves, and clouds. R.V

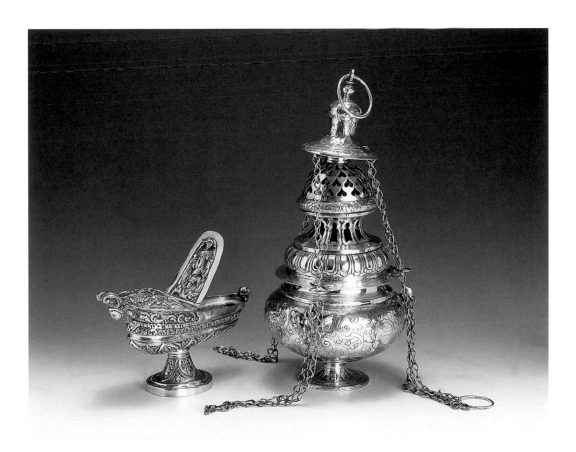

Pax for the Rite of Peace

Francesco Juvarra, goldsmith, Rome (1722–59)
Gaetano Gelpi, jeweler, Rome (1690–1780)
Gilt metal, silver, quartz, red and green
precious stones
19 × 16 × 10
Office of the Liturgical Celebrations of the Supreme
Pontiff, Vatican City State
Inv. PC3

Conservation courtesy of Florence D'Urso, in honor
of a very special friend Father Allen Duston, O.P.,
Patrons of the Arts in the Vatican Museums. We
celebrate his 25 years of dedication as a priest of
the Church

This liturgical object, known as a pax (from
the Latin for "peace"), is composed of a plate in
precious metal or other material framed in an
elaborate surround and fitted with a handle to
allow it to be passed easily during the mass. The
faithful kiss the plate in turn as a sign of reciprocal
peace and thanksgiving.

The pax on exhibit here was a gift to the pope
from Henry Stuart, cardinal of York (1725–1807),
archpriest of Saint Peter's. The slab of agate is
encased in a gilded bronze frame decorated
with carvings of superb workmanship in which
cherubs wings' intertwine with acanthus leaves.
The cardinal's emblem adorns the bottom of the
frame, and at either side the border is encrusted
with red and green semiprecious stones. The
image engraved into the agate represents Christ
rising from the tomb as three soldiers look on in
astonishment.

The pax is no longer in use and has been
replaced by a simpler sign of peace exchanged
among the members of the congregation. R.Z.

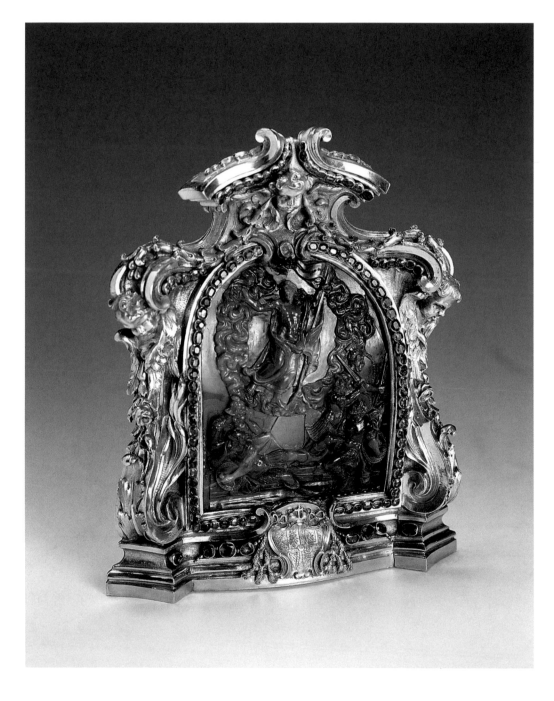

Pax for the Rite of Peace

1872
G. Bellezza, Milan
Silver, turquoise, red precious stones
25 × 17 × 11 cm
Office of the Liturgical Celebrations of the Supreme
Pontiff, Vatican City State
Inv. PC4

Conservation courtesy of Florence D'Urso, in
memory of all who died on September 11, 2001.
Let us pray for peace in the world

This magnificent silver pax was donated to Pope
Pius IX in 1872. The work is in the form of an
arched tabernacle, divided into two sections.
The outer rim of the arch is embellished with
delicate openwork volutes and crowned with the
sacrificial lamb. In the archivolt, against a delicately
patterned background, six turquoise inserts
alternate with small relief medallions of the Four
Evangelists, with the Dove of the Holy Spirit at
the center. The outer band is decorated with tiny
carved shields and around the inner band runs an
inscription "Gloria in excelsis Deo et in terra pax"
(Glory to God in the highest and peace on earth
Lk 2:14). The semicircular field below shows an
embossed scene of the Nativity. The narrow frieze
over the main section is decorated with alternating
ovals and rhombuses and set with three tiny red
gemstones. At the top of each pilaster is a small
green shield with a cross; the instruments of the
Passion and other symbols are featured down each
side, and at their base are two rectangular inserts
with crosses. The central field carries a finely
carved representation of the Deposition. The
inscription along the bottom of the tabernacle
reads "Redemisti nos Deo in sanguine tuo" (You
have redeemed us, God, by your blood). Fixed
to the base is a carved cherub's head with long
volutes; the two small silver statues positioned
on either side represent Isaiah, the prophet who
wrote in most detail about the advent of the savior,
and David, king of Israel, from whose line Jesus
himself would descend. The handle at the back is
removable; a plaque with the symbol of peace
and two openwork crosses are placed at the top
and bottom. An inscription on the base reads
"G. Bellezza mil. f. 1872." R.V.

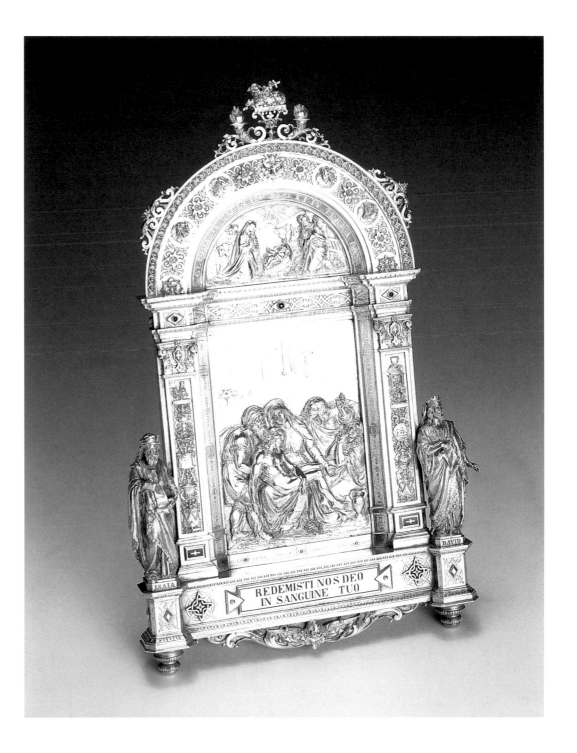

Pax of Pope Leo XIII

19th century
Gilded silver
28.5 × 18.5 × 8 cm
Office of the Liturgical Celebrations of the Supreme
Pontiff, Vatican City State
Inv. PC16

This instrument for the rite of Peace rests on a base with a variegated form and raised border, decorated with cast reliefs. The coat of arms of Pope Leo XIII is in the center, and on either side are leaves that cover most of this area; on top are the usual pontifical emblems of the keys and the tiara. Two graceful cherubs, sculpted in the round, rest on the base. They support a small temple decorated with garlands and architectural motifs; two acanthus leaves are on either side of the temple. A medallion showing the resurrected Christ is in the center, surrounded by incredulous bystanders who move in a space defined by three arches.

Above the medallion is a semicircular area topped with two pseudo-baroque decorative elements. On either side are two angels, sculpted in the round, who kneel, worshiping a chalice with a Host on top of it that represents the sacrament of the Eucharist.

The pax is a metal sheet framed by artistic ornamentation with a handle on the back. During the mass it was passed among the faithful, who kissed it as a sign of mutual solidarity. Today this practice is virtually obsolete, although some non-Latin rites of the Catholic Church do still use it. During papal high masses, the pax was kissed by the pope first, then by the clergy, and finally was passed to the congregation.

The presence of angels on this instrument generally symbolizes its mystical quality, embodying the passion for God who descended from heaven to establish real peace in the heart of humankind.

The back bears the following Latin inscription: "Leoni XIII P.M. natali L sacerdotii sui pacale symbolum pacis auctori venerabundi donum dedimus VI viri a sacris eius. Augustinus Falcioni Iacobus Boncompagni Vincentuis Ungherini Nazarenus Marzolini Raynaldus Angeli Adrianus Zecchini Pacificua Fontana Raphael Cappucci-Aiutores " (To Pope Leo XIII on the fiftieth anniversary of his priesthood, we six men assigned to his ceremonies in veneration gave a peace symbol to the author of peace: Augustinus Falcioni, Iacobus Boncompagni, Vincentuis Ungherini, Nazarenus Marzolini, Raynaldus Angeli, Adrianus Zecchini: Pacificua Fontana, Raphael Cappucci being the helpers). L.O.

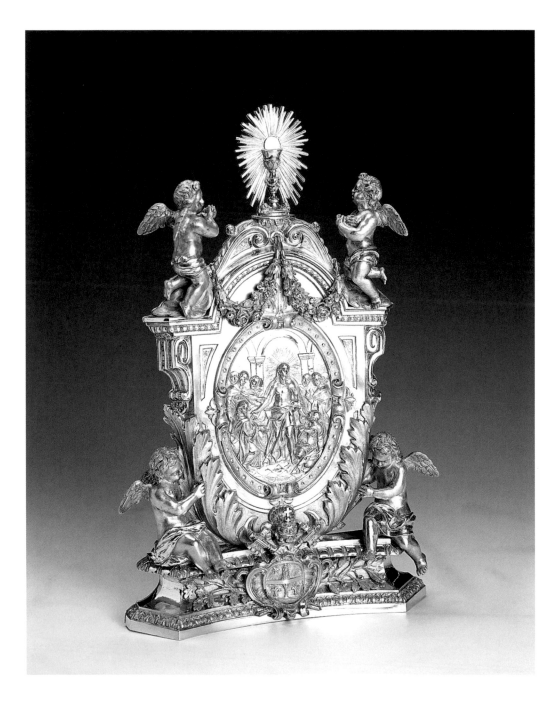

Chalice and Paten of Pope Pius IX

1877
F. Cabos, Barcelona
Gold, gilt silver, emeralds, rubies, diamonds,
pearls, enamel
Chalice: 26 × 17.5 × 17.5 cm; paten: 18 × 18 cm
Office of the Liturgical Celebrations of the Supreme
Pontiff, Vatican City State
Inv. CA8

Conservation courtesy of Florence D'Urso, in
honor of His Eminence, Edward Cardinal Egan,
a most prayerful petitioner of priestly vocations,
and a very dear special friend

From the very first days of Christianity, the chalice,
the name of which derives from the Greek word
càlus (cup), has held a place of primary importance
in the liturgy. It acquired its special significance
from Christ, who used such a vessel during the
Last Supper, thereby initiating the rite of consecra-
tion that would become a keystone of Christian
liturgical practice. For many years afterwards
the apostles and their successors used ordinary
domestic cups for celebrating the Eucharist; these
were followed by ritual goblets made of glass,
pottery, ivory, metal, or even wood.

In time, the humble receptacles used for the
liturgy in the Early Christian basilicas were
gradually replaced with vessels fashioned from
fine metal. Tradition has it that in 333 the emperor
Constantine donated forty gold chalices to the
basilica of Saint John Lateran and to Saint Peter's
an additional forty-five gold chalices studded
with emeralds, together with twenty silver goblets.
The *Liber Pontificalis* relates that Pope Urban II
ordered all new chalices to be made from silver.

The chalice and paten on exhibit here were gifts
from the diocese of Barcelona to Pope Pius IX to
mark the silver jubilee of his pontificate. The chalice
is crowned with a deep bowl-shaped cup to contain
the consecrated wine during the celebration of
the mass. It is fashioned in the neo-Gothic style
and is richly adorned with jewels and scrollwork

trimmed with enamel. The foot carries four eight-
lobed medallions separated by vines clustered
with pearls; each medallion bears a portrait of an
evangelist in colored enamel. The lower part of the
stem is emblazoned with the armorial bearings of
the see of Catalonia, the monastery of Montserrat,
and the city of Barcelona. The octagonal ornament
midway up the stem alternates decorated scalloping
with diamond inserts and cherubim with wings
outlined in diamonds and rubies. The bowl of the
goblet is adorned with three medallions joined
by scrolls set with representations of the Sacred
Heart, the Virgin, and Saint Joseph carrying Jesus.
In the medallions, the Dove of the Holy Spirit
hovers over the emblem of the papal tiara and
keys. An inscription on the foot reads:
"PIO P.IX CATHOLICI… BARCIN. IN L EJUSDEM
EPISCOPATUS ANNIVERSARIO." R.V.

Chalice and Paten

19th century
F.CO J. Lopez, Mexico
Gilt silver, chalcedony, precious stones, pearls, emeralds
Chalice: 19 × 17.5 × 11 cm; paten: 16 × 16 cm
Office of the Liturgical Celebrations of the Supreme Pontiff, Vatican City State Inv. CA97

Conservation courtesy of Dona and Reuben D. Martinez

This chalice takes its shape from what was thought to be the traditional form of the Holy Grail and, like the accompanying paten, is made of gilded silver. The exterior of the bowl is made of chalcedony; the stem is interrupted by a flattened sphere, which is finely engraved; two slender engraved handles curve up and out from the base and are joined to the crown of the chalice. The oval base is quartered by four bands of gold, two of which are studded with twin red stones and round pearls, and the other two with oval emeralds and round pearls. The foot of the base is crowned with a ring of twenty mounted pearls, and the narrow band that runs around the base is exquisitely wrought with tiny rhombuses in open fretwork. Below the base the inscription "Famiglia Uribe" is accompanied by the goldsmith's mark: "Fco J. Lopez orfebre Mexixo D.F." (Francesco J. Lopez, goldsmith, Mexico City). Apart from a dent in the upper surface of the paten, both pieces are in excellent condition. R.V.

Chalice and Paten

16th century
Rock crystal, gilt and enameled silver, pearls
Chalice: 27.5 × 18 × 18 cm; paten: 17.5 × 17.5 cm
Office of the Liturgical Celebrations of the Supreme
Pontiff, Vatican City State
Inv. CA111

Conservation courtesy of The Georgia Chapter of
the Patrons of the Arts in the Vatican Museums

Damaged during the invasion of Rome by the
French republican troops in 1797, this chalice
was later retrieved and returned to Pope Pius VII
by Monsignor Boschi, the bursar of the Reverenda
Fabbrica of Saint Peter's Basilica, and was restored
for the occasion.

The shape of the chalice, with its splayed foot
and large protrusion on the stem, may be dated to
the end of the Mercedarian Order (Order of Our
Lady of Mercy) and the Christian Alliance's mission
to redeem the world from atheist materialism.
The paten bears a scene of the Passion, with
fourteen diamonds marking the Stations of the
Cross and passion flowers and olive branches in
reference to Gethsemane.

Finely detailed with colored enamel inlay,
the circular medallion at the center depicts the
Deposition. Other details include a raised
medallion on the base surrounded by gold pearls
portraying the Lord of the Universe. The piece is
datable to about the mid-sixteenth century and
was restored in Rome between 1815 and 1832
by Paolo Contini. The base is inscribed with the
number "12." R.Z.

Chalice and Paten

1925, Zagreb (Croatia)
Ivo Kerdic, E. Jungmann
Silver gilt, emeralds, various gems
Chalice: 26 × 17 × 17 cm; paten: 0.5 × 18.5 × 18.5 cm
Office of the Liturgical Celebrations of the Supreme
Pontiff, Vatican City State
Inv. CA57

Conservation courtesy of William and Laurie
Brosnahan

The underside of the bowl is embossed with bas-reliefs showing enthroned popes and two other figures beside an enthroned Jesus, who is holding the cross and the Sacred Heart. The bowl also carries three mounted emeralds. Above the heads of the figures is a running inscription. On the stem, a large six-faceted ornament set with three agate medallions is engraved with the keys, the scepter, and the tiara, alternating with chased figures of an eagle, the sacrificial lamb, and the symbol of God. Below the knob the hexagonal stem is adorned with motifs of grapes and wheat sheaves, symbolizing the Eucharist, and around the upper rim of the base runs a circle of small winged cherub heads. The base itself bears six embossed medallions portraying Slavic saints; between these are six ceramic inserts of little shields with coats of arms. The band around the foot is inscribed: "S. P. Pio XI in memoriam primi regis coronati gens Croatica a MCMXXV R.M." (To Pope Pius XI in memory of the coronation of the first king of Croatia in the year 1925). The inside of the base is inscribed by the artist: "Fecit Ivo Kerdic adiuvante E. Jungmann Zagrebiae" (This work was made by E. Jungmann of Zagreb). On the upper side of the paten, in gilded silver, an engraved tondo bears a relief of the Virgin and Child enthroned with an angel at either side. R.V.

Chalice and Paten

Leitão, Portugal
Ca. 1893
Silver gilt, gold
Chalice: 33 × 19 × 19 cm; paten: 18 × 18 cm
Office of the Liturgical Celebrations of the Supreme
Pontiff, Vatican City State
Inv. CA20

Conservation courtesy of Sylvia and John R.
Tillotson

The surfaces of the chalice and paten, cast entirely in solid gold and silver, are lavishly decorated with exquisitely crafted engravings. The goblet carries the inscription "Accipite et bibe ex eo omnes" (Take and drink all of you from this). The bowl is richly decorated with festoons, while the neck emerges in a ring set with four enameled flowers. Each facet of the square stem carries a symbol of the Passion: the column, the spear and sponge, the ladder with the shroud, and the nails. The stem joins the foot with four enameled medallions, two of which are inscribed "19 de fevreiro de 1893; A sua Santidade das senhoras Portuguezas" (To His Holiness from the women of Portugal / February 19, 1893). The chalice and the paten were a donation from the Catholic women of the royal court of Portugal on the occasion of Pope Leo XIII's jubilee. The other two medallions display the coats of arms of the king of Portugal and of Pope Leo XIII, respectively. The base has four feet alternating with semicircular divisions embellished with finely engraved grape vines on the upper surface and edged with winged lions for further support. On one foot is engraved the goldsmith's name and town of provenance: Leitão; Lisboa. In a circle around the underside of the paten the embossed legend reads "Hoc est enim Corpus meum" (This is my body), with a Greek cross at the center.

R.V.

Ciborium

1878
Silver gilt
38 × 16 × 16 cm
Office of the Liturgical Celebrations of the Supreme
Pontiff, Vatican City State
Inv. PIS37

Conservation courtesy of Ruby Rinker and Andrew
Bytnar to honor our children and grandchildren

Among liturgical vessels, the ciborium is normally
accompanied by a chalice. The chalice holds the
eucharistic wine that the faithful believe to be the
blood of Christ, while the ciborium contains the
wafers, the body of Christ, that will be distributed
at communion and conserved in the tabernacle
over the altar.

This ciborium is made of gilded silver and has
a wide bowl. The lid is in the form of a dome, with
a band of embossed leaves along its outer edge,
above which is more chased work in a radiating
pattern of long leaves pointing downward and
alternating with garlands. At the top is a small globe
surmounted by a Greek cross, chased on both sides.
The underside of the bowl reflects the same motif
as the lid: a radiating pattern of leaves and an upper
edge decorated with a long circle of grape vines
and a chased band. The stem is pear-shaped and
entirely embossed with leaves, both above and
below. The upper part of the stem terminates with
three embossed arms with a flower in the center
that supports the cup. On the outside edge of the
circular base is a small embossed band, and above
that another small border with embossed bead
molding. The upper section of the base is decorated
with chased foliage and has three large embossed
arms, each with two flowers and a garland. The
underside is decorated with a large embossed
flower surrounded by a double border, and also
bears a date, 1878, which is presumably the year
of manufacture. There is no reference to the
designer or goldsmith. R.V.

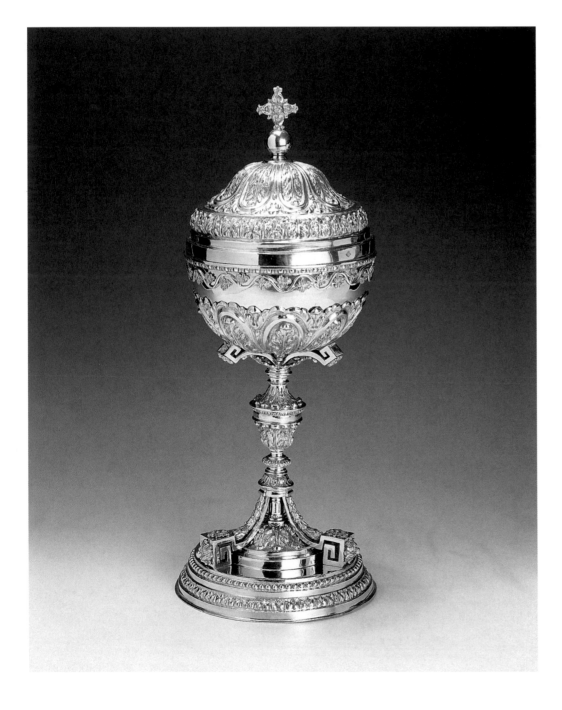

Ciborium

Early 20th century
Silver gilt, enamel, gemstones
34 × 13 × 13 cm
Office of the Liturgical Celebrations of the Supreme
Pontiff, Vatican City State
Inv. PIS41

Conservation courtesy of Mr. and Mrs. Timothy
James Rooney

Because of the use to which ciboria are put
(i.e., holding the Eucharist), they are often made
of precious materials, especially gold, and this was
particularly so in the eighteenth and nineteenth
centuries. The decorations that adorn them often
refer to the significance of the Eucharist: Christ
who becomes the bread and wine that are symbols
of and responses to man's hunger and thirst. The
most frequent symbols, then, as is the case with
this ciborium, are ears of wheat and grape vines;
images which Christ himself used in his teaching
(see Jn 6:34-35; 15:1-2).

This ciborium is made of gold and has a low
bowl. The lid takes the form of a dome and its
outside edge is decorated with six enamel shells.
In the upper part are three enamel symbols, above
which stands a globe crossed by a band that
supports a cross *all'antica* surrounded by stones
of various colors. The underside of the bowl is
decorated with a circular embossed pattern,
enameled in blue and white, with grape vines.
Further down, some magnificent embossing
work represent ears of wheat, flowers, and shells
in blue and white enamel. The triangular stem
is adorned with three flowers and a blue enamel
shell. On the outside edge of the base, four circular
ribbed bands may be seen. The base of the ciborium
is more or less triangular in shape and is divided
by three arms, each with a blue and white enamel
shell, while the three intervening spaces have
chased work representing a scroll and a shell, also
enameled in white and blue. The bowl and the edge
of the base have some slight dents. R.V.

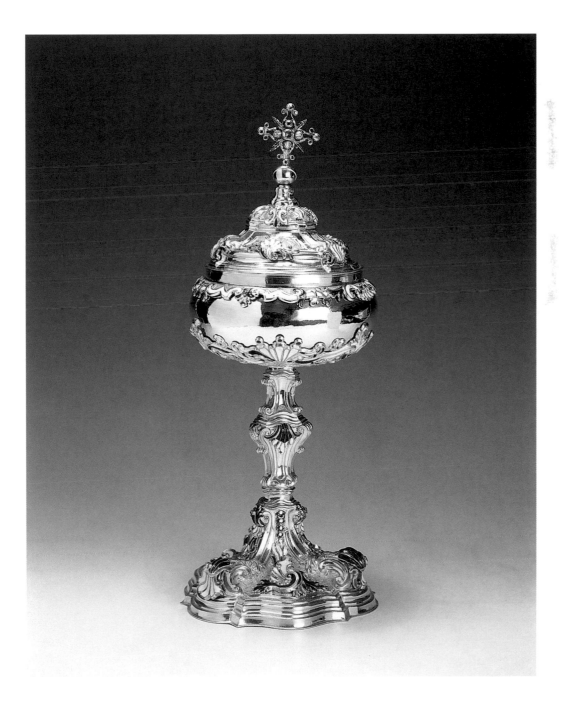

Ciborium

1887 (?)
Silver gilt
41 × 20 × 20 cm
Office of the Liturgical Celebrations of the Supreme
Pontiff, Vatican City State
Inv. PIS43

Practically nothing is known about this ciborium. It can only be assumed that it was donated to Pope Leo XIII for the fiftieth anniversary of his ordination to the priesthood in 1887. The medallions show the principal scenes of the Passion and death of the Lord and conclude with a representation of the Resurrection.

The ciborium is made of gilded silver. The lid is in the form of a dome and has a lower band of embossed foliage. The upper section has more embossed work with various motifs: scrolls, flowers, and vertical fluting. The lid is surmounted by a globe resting on the heads of four cherubs and itself surmounted by a cross *all'antica*. The bowl is wide and deep, and its underside is decorated with three embossed oval medallions that represent the Crucifixion, the Deposition, and the Resurrection. The heads of two cherubs may be seen over each medallion, which are set in a background of various embossed motifs, among them large scrolls, flowers, and, further down, a radiating pattern with raised points. The stem is long and pear-shaped, and divided into six sections with chased flowers and other motifs; its lower end terminates with a pattern of chased foliage. The base is divided into three sections with three medallions representing Jesus with the cross, Jesus in Gethsemane, and Jesus being flogged. The medallions are set in a chased background with floral motifs and ears of wheat divided by three large scrolls, each terminating with a large leaf. R.V.

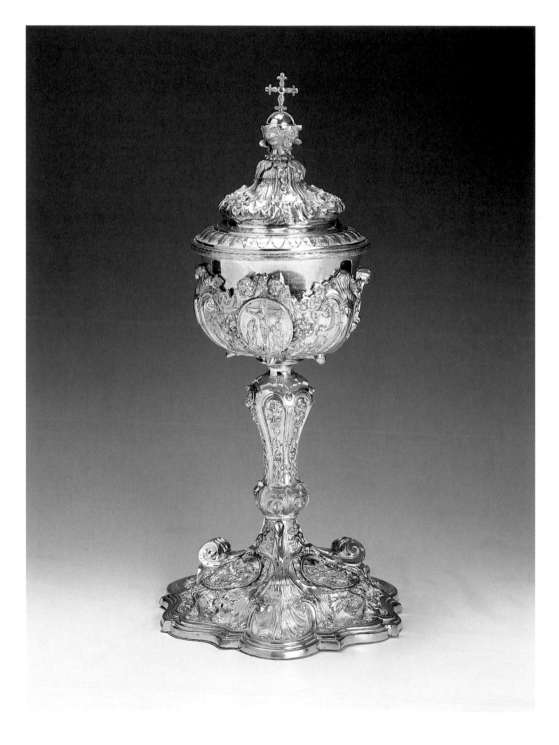

Eucharist Casket of Pope Pius XII

1952
Gilt metal, malachite, turquoises, precious stones
17 × 19 × 12 cm
Office of the Liturgical Celebrations of the Supreme
Pontiff, Vatican City State
Inv. SC20

Conservation courtesy of The Florida Chapter of the
Patrons of the Arts in the Vatican Museums

This casket for the conservation of the Eucharist
is made of gilded metal decorated with inlaid
semi-precious stones of various colors. It was a gift
to Pope Pius XII on the occasion of the Thirty-fifth
International Eucharistic Congress. The base is
rectangular and six orange gemstones serve as feet.
In the center is an embossed image of the Blessed
Virgin and the Infant Jesus on a multicolored
enamel background, surrounded by malachite,
while at either side two panels with multicolored
enamel images of Saint G. M. Claret and Saint
Pasquale appear on a red background. At the outer
edges are two chased flower vases with turquoise
petals, below which are two blue gemstones.
On the back, four saints are represented in multi-
colored enamel on a red background: Saint
Raymond, Saint Michelle, Saint Mary C., and Saint
Joseph Oriel. One side illustrates the eucharistic
symbol and the inscription "XXXV Congress
Eucharistic Internation 1952," surrounded by
olives and olive branches and two embossed
flower vases with light-blue stones. The other side
is chased with an episcopal coat of arms and is
also surrounded by olives and olive branches and
two embossed flower vases with light-blue stones.
Around the upper edge of the casket is the Latin
inscription "O salutaris Hostia quae coeli pandis
ostium bella premunt ostilia da robur fer auxilium"
(O saving victim who opens the door of heaven;
hostile wars are pressing, give strength, bring
help). The hinged lid is decorated with two
large medallions of multicolored enamel — one
showing the papal tiara and the other the coat of
arms of Pope Pius XII — and with two smaller
tondos inlaid with marble. There are also stones
of varying color and size and, at the top, another
tondo with the symbol of Christ in fretwork. The
inside of the lid is decorated with five medallions:
a rose-colored lamb and the symbols of the
Four Evangelists, also in rose. The inside of the
casket is lined with ivory decorated with a
geometric design. R.V.

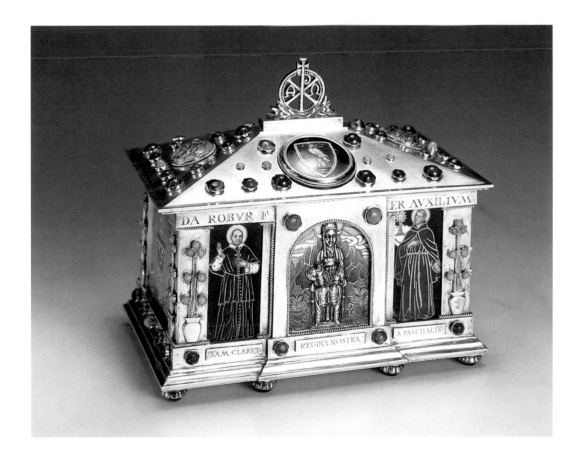

Eucharist Casket of Pope Pius XII

Liturgical Drinking Straw of Pope Pius IX

19th century
Silver gilt
41 × 6 × 6 cm
Office of the Liturgical Celebrations of the Supreme
Pontiff, Vatican City State
Inv. FS2

Conservation courtesy of Rodrigo Saval Bravo in
memory of Dora Woodhouse de Bravo

Usually made of gold, this tubular device known
as a fistula, or drinking straw, was originally
the means by which the consecrated wine was
drawn up from the chalice during Communion.
Subsequently, its use was reserved for masses
officiated by the pope and was used by the sacristan
of the Apostolic Palace attending the pope's
ceremony who, just before the offertory, sipped
a small quantity of wine from the chalice. The ritual
was performed nominally to test the quality of the
wine, though it was also a means of ascertaining
that the wine had not been adulterated or mixed
with poison.

 This fistula, which belonged to Pope Pius IX,
is made of gilded silver and is composed of three
narrow tubes, the central one being slightly
longer. Toward the top end is a small, slightly oval
cup-shaped container engraved inside with two
floral motifs and joined to the tubes via two slender
volutes; from this rises the central tube, which is
fitted with an egg-shaped stopper. R.V.

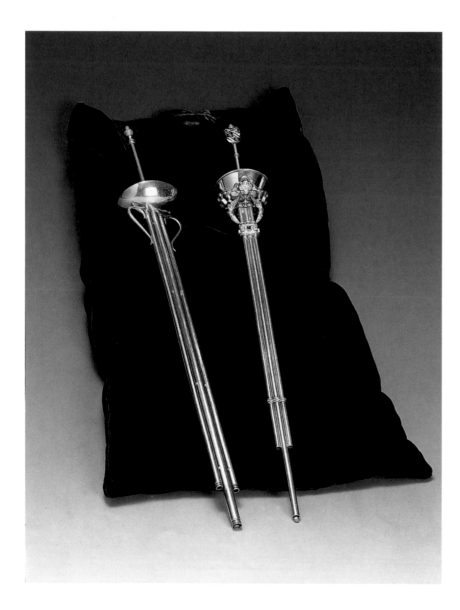

Liturgical Drinking Straw of Pope Pius IX

1871
Silver gilt, emeralds, cut diamonds
38.5 × 5 × 5 cm
Office of the Liturgical Celebrations of the Supreme
Pontiff, Vatican City State
Inv. FS3

Conservation courtesy of Rodrigo Saval Bravo in
memory of Dora Woodhouse de Bravo

This fistula, or liturgical drinking straw, belonging
to Pope Pius IX, is composed of three gilded tubes,
the middle one of which is slightly longer than
the other two, which are attached to a small cup
via a ring-shaped decoration encrusted with semi-
precious stones around the outer border. The gems
include high-quality natural facet-cut emeralds
and small diamonds with various types of faceted
cut. Where the cup is joined to the tubes, two
small angels with outstretched wings hold up a
floral ornament set with semiprecious stones.
Inside the cup, the central tube extends slightly
and continues with a slender stem culminating
in a small enameled ornament of the pontiff's
insignia on a crowned shield topped with the
papal tiara and keys. The rod inside the tube serves
to keep the channel free of obstruction.

 The inscription engraved on the tubes reads
"Pio IX P.M. XVI Kal.Iul. A. MDCCCLXXI.
Cubicularii Palatini Ordinis utriusque Habentes
fiduciam in Sanguine Christi." Before their
suspension at the time of Pope Paul VI, the
Cubiculari Palatini comprised a special body
of chosen functionaries. This particular fistula
was a gift from the Cubiculari Palatini to Pope
Pius IX in 1871.

 The fistula is no longer used during the
liturgical rites celebrated by the pope. R.V.

Missal (Ordo Missae)

Early 19th century
Parchment, leather
74.5 × 110.5 × 4 cm, open
Patriarchal Basilica of Saint Paul's Outside-the-Walls, Rome

Conservation courtesy of The Florida Chapter of the Patrons of the Arts in the Vatican Museums

A missal contains the prayers for celebrating mass. The one on exhibit here — a relatively modern work, known as the Ordo Missae — was created by the artist and priest Don Oderisio Piscicelli Taeggi (1840–1917). Born into a noble Neapolitan family, he studied humanities under the guidance of Bruto Fabbricatore, a pupil of the Neapolitan literary figure Basilio Puoti, and drawing and painting under the three master painters Cardillio, Palizzi, and Morello. Once he had finished his

formal education, he entered the Benedictine monastery at Montecassino on November 13, 1859, where he became a student of theology. During this period Piscicelli spent a great deal of time researching the archives of the monastery, where the abundance of manuscripts inspired him to specialize in the study of the art of illumination and miniature painting.

By 1887 he was able to bring the vast knowledge he had obtained to fruit, and in the space of four years published a major work documenting the impressive heritage conserved in the Montecassino monastery (*Paleografia artistica di Montecassino*, 1878–82), which was followed by another important volume (*Miniature nei codici cassinesi*), published to commemorate the jubilee year of Pope Leo XIII's priestly ordination in 1887. Meanwhile he was preparing an extraordinary illuminated missal of his own, which he sent to the pope in person from Montecassino and is now in the Vatican Apostolic Library.

The missal to which these pages belong are numbered by hand along with the sequential Roman numerals at the foot of each page. The writing is in gold and the calligraphic style is Carolingian. Each page is tinted purple, and the text is framed in a filigree band of gilded green ink; some letters are touched up with green and red, and white filigree. The two frontispieces carry an illumination filling the entire page representing, respectively, the Supper at Emmaus and the Crucifixion, both framed in gold with bust-portraits of monks in black and white. The binding, coeval with the paper and production, consists of brown leather with a gilded cross and frames, and two clasps. P.L.

Antiphonarium Monasticum

Early 19th century
Giuseppe Acernese (1862–1934)
Parchment, leather
Page: 30.5 × 42 cm
Patriarchal Basilica of Saint Paul's Outside-the-Walls, Rome

Conservation courtesy of The Florida Chapter of the Patrons of the Arts in the Vatican Museums

The artist who created this antiphonarium, that is, a bound collection of antiphons for the responsive choral parts of the Divine Office, was a monk by the name of Giuseppe Acernese. When still young he entered the monastery of Saint Paul's Outside-the-Walls and devoted himself to the study of theology, took his vows in 1884, and four years later was ordained.

Acernese was also a superbly skilled miniature artist, completely self-taught. The pages of his antiphonarium are made of parchment produced in the early nineteenth century. The calligraphy harks back to the *littera textualis* technique used for early graduals, books containing the choral portions of the mass. The square musical notations are made on a stave of four red lines. The text is enclosed within a richly ornate frame of gilding, which is different for each folio. The binding is of the same date, and the maroon-colored leather on both sides is embellished with a Greek cross in leather inserts of varying colors. The edge of the folios is gilded, and the inside covers are lined in red silk.

From 1910 until 1929, Acernese was entrusted with overseeing the reconstruction of the basilica of Saint Paul, which had suffered from a disastrous fire in 1823. Among the many restorations and additions he saw successfully through are the choir in the chapel dedicated to Saint Lawrence; the definitive scheme of the court at the front of the building; the removal of the second ciborium that concealed the superb earlier one by Arnolfo di Cambio (1245–1302); the choir stalls in the apse; the ambo; the large stained-glass windows in the entrances to the four chapels; the alabaster windows of the basilica; the central bronze door by Maraini; and the baptismal font. In recognition of his efforts he was made Knight of Honor by the Italian Government and Knight of Saint Maurice and Lazarus, and subsequently *commendatore* of the same order. He also received a medal for his contribution to the arts. P.L.

Missal of Pope Leo XIII

1882
Assembled in Venezuela, printed in Germany
Silver, enamel, velvet, gilded metal, garnets, silk
42 × 30 × 8 cm
Office of the Liturgical Celebrations of the Supreme
Pontiff, Vatican City State
Inv. ME6

Conservation courtesy of Florence D'Urso in
memory of Revered Mother Teresa, Founder of the
Missionaries of Charity, and in honor of Sister M.
Dominga, M.C., Regional Superior, a very special
dear friend

Printed in Regensburg in 1882, this highly ornate
missal, or book of mass prayers, was a gift from a
certain Bishop Ignazio to Pope Leo XIII. The book's
binding is covered in red velvet. On the front is
a framelike design of gilded and silver-plated
metal with quatrefoil medallions at the four
corners containing figures relating to Christopher
Columbus' discovery of America in 1492. The
upper part is decorated with a rhombus containing
the coat of arms of the pope in colored enamel
relief between chased floral patterns against a
textured background. On either side of the binding
are other images and symbols representing the
victory of Christianity over paganism, and some
sailing ships. Toward the bottom a small panel
encloses repoussé festoons with the inscription
"OCEANIA." Filling the central field is a large cross
with a small quatrefoil enamel medallion of the
Four Evangelists at each tip. At the intersection is a
round enamel portrait of the Sacred Heart of Jesus
bordered by what appears to be a crown-of-thorns
motif; the radials terminate in twelve tiny points
mounted with a garnet (one is missing). The cross
is surrounded by a frieze of tiny repoussé triangles.
The back is covered with red velvet and carries
a chased geometric design at each corner and a
small flower at the center. The central part is slightly
concave and in the shape of an elongated octagon,
inside of which is a large red velvet rhombus
inscribed with another repoussé rhombus
bordered by leaves. At the center of the rhombus is
a bishop's emblem against a red ground comprising
a chalice and a little star. The spine is red leather
and divided into six sections with circular repoussé
flower motifs, of which two are lost; written in
one are the words "MISSALE ROMANUM" (Roman
missal); below which another inscription reads
"El arte cristiano" (Christian art). The book is
equipped with two silver-plated clasps decorated
with finely carved openwork quatrefoils and a
small cross at the center. R.V.

Missal Stand

20th century
Metal gilt, enamel, precious stones
23 × 40 × 43 cm
Office of the Liturgical Celebrations of the Supreme
Pontiff, Vatican City State
Inv. LG7

Conservation courtesy of Florence D'Urso
in loving memory of dear friends the Honorable
James and Margaret Brady

In the course of his long pontificate, Pope Leo XIII proclaimed numerous special jubilee years, for which he gained the intense devotion of a great many people across the world who bestowed all sorts of gifts upon him, including numerous works of art of exceptional craftsmanship like the unusual lectern on exhibit here.

This large and elegant missal stand in gilded metal is in the form of a rectangular chest. The surfaces are wrought with detailed open fretwork designs encrusted with enamel inserts and precious colored stones. Each side is bowed outward, with intricate repoussé openwork featuring arabesques and other motifs. The central quatrefoil medallion on the front contains an enamel depicting the Lamb of God with a border of white stones and a red gemstone adorning each lobe. At either side two medallions contain enamel portraits of evangelists bordered by red stones with a green stone at each corner. The bands above and below are mounted with a central enamel portrait of an evangelist, and at either side a large red stone. The sides of the missal stand are likewise divided into three compartments, each one with a mounted jewel at the center. At each of the four corners is a composite lion's foot. The adjustable book rest carries a central trefoil symbol of Christ. The gilding is worn away in many places. R.V.

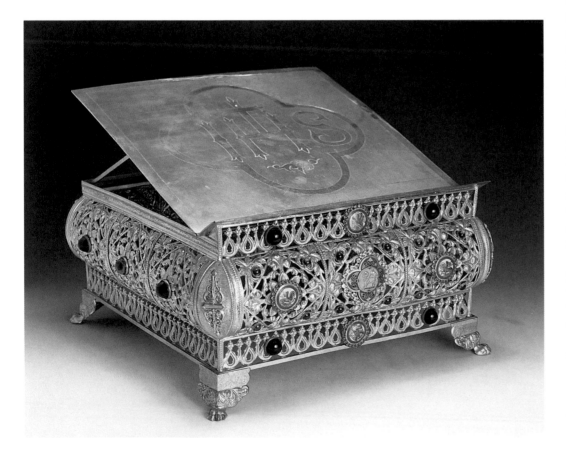

Monstrance with Grain

1750
Genoa, Italy
Silver, partly gilded; glass
105 × 51 × 28 cm
Office of the Liturgical Celebrations of the Supreme
Pontiff, Vatican City State
Inv. OST22

This large disk-shaped monstrance has two panes of glass covering the central compartment, inside of which is the lunette for holding the consecrated Host. The style of the work is clearly eighteenth-century baroque, as can be seen from the modeling of the feet and the stem.

The base rests on four feet supporting a section shaped somewhat like a truncated pyramid. Medallions decorate the sides of the pyramid, finishing off the design of four concave specular surfaces, which are embossed and chased. The frontal medallion has an elaborately framed relief of the Virgin with the Child in her arms. Each corner of the pyramid ends in a volute, on top of which are the Four Evangelists sculpted in the round and carrying their individual symbols. Two cherubs decorate the section between the pyramid below and the stem above, one playfully holding a large cross, and the other seated in an interlocutory pose. These figures are also sculpted in the round.

The stem has the typical shape of a reversed pyramid, with the lower part truncated and decorated in sections with garland motifs, while at the top two small winged angels' heads can be seen on either side of the node. Above the wings around the two angels' heads rises another much smaller reversed pyramid, open at the top, with sheaves of wheat springing from it. The aureole of the monstrance rests on top of the bundle of wheat.

Rays encircle the container for the Host in the middle of the aureole, surrounded by a graceful flight of six angels holding the symbols of the Passion. Starting from the right and from the bottom upward, the angels hold, respectively: the crown of thorns, the pincers, the hammer, the sponge, the spear, the chalice, the pitcher of water, the ladder, and the nails. Some vine leaves mingle with the sheaves of wheat below the monstrance, symbolizing the blood of Christ.

The earliest monstrances date from the Gothic period and used all the symbolism connected with the body of Christ. The shape of these sacred vessels used to preserve the Eucharist began to change after the feast of Corpus Christi was established in 1264. Three centuries later, when public worship of the consecrated Host became popular in the feast of the Forty Hours Devotion, the Host had to be fully visible, and so a circular compartment was created within the monstrance, protected by a little window made of glass or crystal.

According to various papal prescriptions, the container of the Host, known as the "gloria," must be surrounded by rays of light. It may also be decorated with angels, either full-length figures or simply heads with wings, and the angels may surround the gloria or hold up the entire aureole. Even the lunette into which the Host is inserted for presentation can be shaped like an angel's head.

Monstrances are still used for blessings with the Eucharist, during the Forty Hours Devotion, and for Corpus Christi processions and Benediction of the Blessed Sacrament. During a recent cleaning of this monstrance, an engraved inscription came to light, with a date: A. 1790 £5000 / IN DEI HONOREM / R.C.I. R.I. / D.R.I. ET N.B.

The monstrance bears various hallmarks, including a territorial mark and an 800-parts-fine guarantee known as a turret mark, punched by the office of the Genovese Guild of Goldsmiths and Silversmiths; three figures under the mark ("750") indicate the year of manufacture, 1750. The piece also bears the cross of Saint Maurice and Saint Lazarus surmounted by a crown within a circle. This hallmark, applied to objects made in 800-parts-fine silver, was officially applied from 1836 to 1861 by the assayer of the surveyors of the Kingdom of Sardinia, and subsequently, from 1862 to 1873, by the surveyors of the Kingdom of Italy. The third mark, a dolphin curled within a circle, was the territorial mark used by the assayer of the Genoa Surveyors from 1824 to 1875 While the first mark indicates the year of manufacture, the other two, added later, were for export purposes.

<div align="right">L.A. / M.A.D.A.</div>

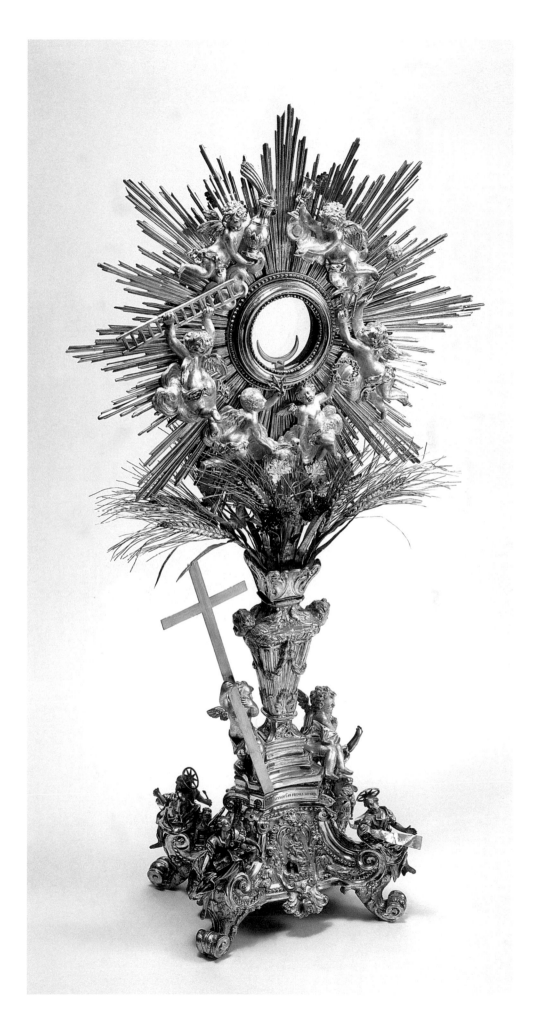

Altar Mass Cards

19th century; ca. 1859
Frédéric Pustet, Paris
Gilt bronze, enamel, glass, paper
CG1a: 43 × 32 × 3 cm; CG1b–c: 20 × 29 × 3 cm
Office of the Liturgical Celebrations of the Supreme
Pontiff, Vatican City State
Inv. CG1a–c

Conservation courtesy of Dr. and Mrs. David Benvenuti

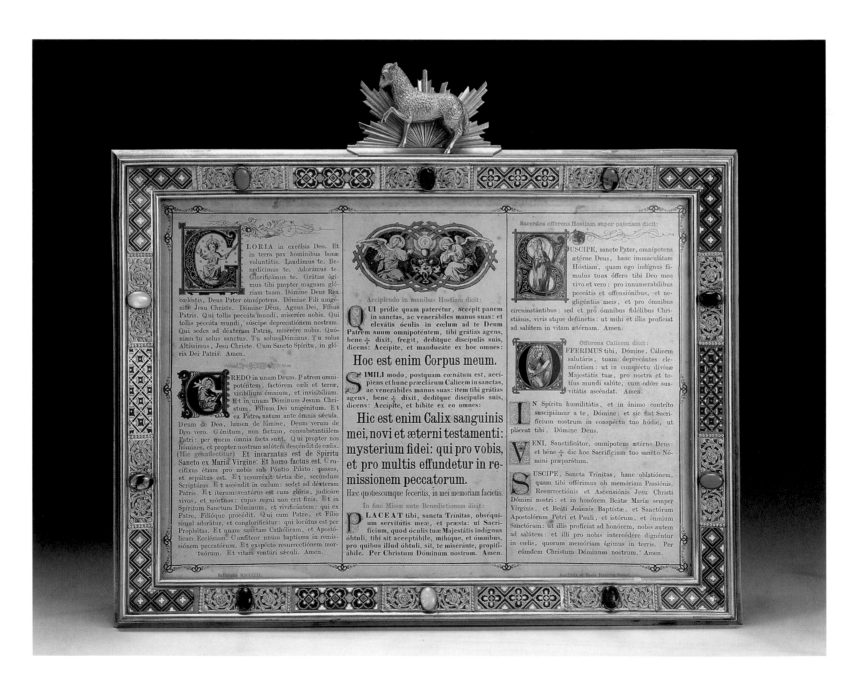

A *cartagloria*, or altar mass card, is an illuminated page of prayers for the mass, often in an ornate frame, and was placed on the altar table to allow the celebrant to read out the prayers directly. Such cards were in regular use before Vatican Council II, but the reforms of the liturgy have eliminated their use.

The origins of the *cartagloria* are uncertain, though some authors have traced it back to the liturgical diptych, which in turn derives from the consular diptych. At any event, only one *cartagloria* was brought into use at any one time, and it was originally placed on the altar below the cross; later, for convenience, a separate card was placed at either side of the altar, one on the left containing the prayers for the Lavabo (washing of the priest's hands), the other on the right with the readings from the Gospel of Saint John. A central card contained the canon of the mass.

The three *cartegloria* exhibited here are enclosed in gilded bronze frames with enamel detailing in geometrical fashion, filigree work, and cabochon-cut glass inserts. Adorning the top of the frame of the larger of the three prayer cards is a victorious lamb in relief; while the other two are surmounted by a representation of the Sacred Heart of Jesus and the pierced heart of the Virgin Mary. Their style is reminiscent of the Parisian workshop of Poussièlgue-Rusand. R.V.

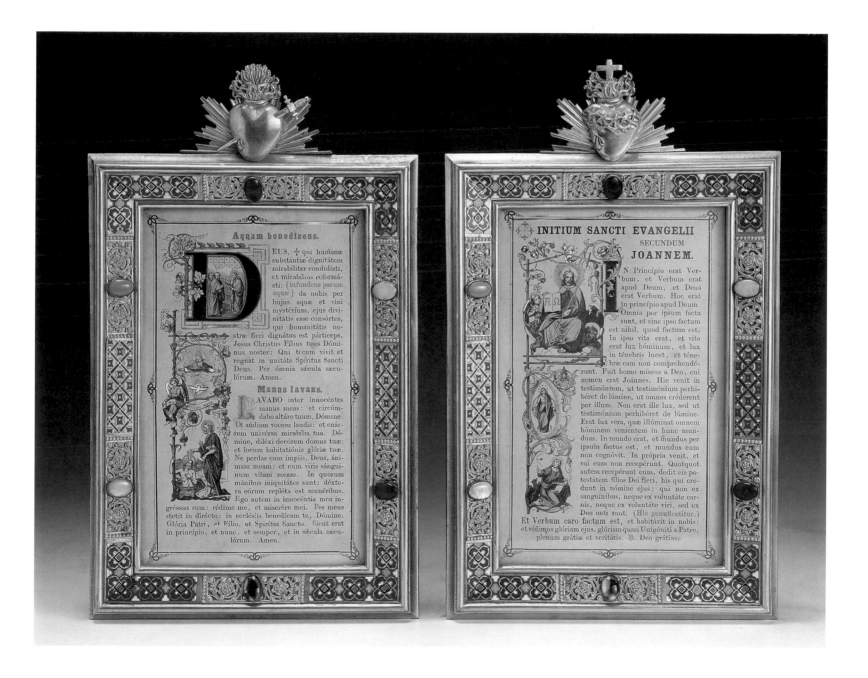

Altar Cross

20th century
Burnished and gilt bronze
210 × 40 × 40 cm
Office of the Liturgical Celebrations of the Supreme
Pontiff, Vatican City State
Inv. CAN46a

Conservation courtesy of The Washington DC/
Baltimore Chapter of the Patrons of the Arts in the
Vatican Museums

As the supreme symbol of Christ's sacrifice, the
cross is always placed in the middle of the altar
and must always be present during the celebration
of mass. By the eleventh century, the cross had
become a standard feature of church furnishings.

Although Pope Saint Pius V had already
prescribed the use of a cross (Latin, *crux*), an
episcopal ceremonial specified that it was to be
a cross "cum imagine sanctissimi Crucifixi"
(with the image of the most Holy crucified One).

The cross that adorns an altar today is almost
exclusively in the form of a Latin cross (that is,
with a shorter horizontal bar intersecting a longer
vertical bar above the midpoint), and is either
made of cast metal or of wood covered with gold
or silver leaf, and is usually decorated with carved
or embossed figures. In Early Christian basilicas,
however, the crucifix was sometimes depicted in
mosaic in the semidome of the apse, or it was
embellished with precious stones, by which the
bejeweled crucifix represented not only the death
of Christ, but also his Resurrection. In the early
Middle Ages, the cross was placed between the
candlesticks on a table behind the altar and was
often of considerable size.

The cross exhibited here, which has matching
candlesticks, is conserved in the treasury of the
Pontifical Sacristy and, when required, is brought
out for use when the pope celebrates mass. Before
the revisions to liturgical practices introduced by
Pope Paul VI, this cross stood on the altar in the
Pauline Chapel, which was often reserved for the
vesting of the pontiff before he entered the Basilica
of Saint Peter to celebrate the liturgy.

The crown of the cross has a gilded terminal in
the form of a shield with leaf motifs, below which
is a gilded scroll, and at the center a gilded aureole
with irregular rays. The figure of Christ is likewise
gilded. R.V.

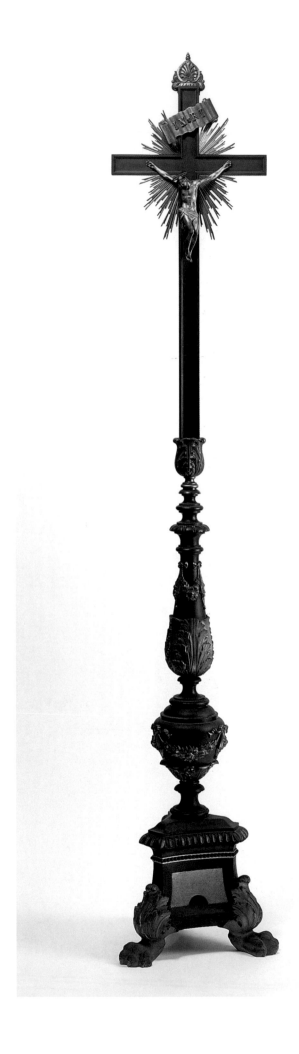

Candlesticks

20th century
Burnished and gilt bronze
128 × 40 × 40 cm
Office of the Liturgical Celebrations of the Supreme
Pontiff, Vatican City State
Inv. CAN46b-g

Conservation courtesy of The Washington DC/
Baltimore Chapter of the Patrons of the Arts in the
Vatican Museums

Often quite ornate, the church candlestick
serves to hold a burning candle during liturgical
celebrations, and at least one is placed on the *mensa*,
or altar table, on either side of the cross. But this
was not always so; in early centuries of Christianity,
the altar table was left empty to receive the gifts of
the congregation. In the West, candles were not
used on the altar until the tenth century. Before
then, candleholders or candelabra were placed at
each end of the altar table, either on the floor or
on special side tables, or even on a balustrade at
the entrance to the sanctuary.

The first to prescribe the placement of two
candles upon the altar table was Pope Innocent III
in 1208. Later, the *Ordo Romanus* of 1254 dictated
the use of seven candles, though their number was
reduced to six in the fifteenth century to allow for
a more symmetrical arrangement.

Each piece in this set of six candleholders has
a triangular base that rests on gilded lion's feet
descending from chased leaf ornaments. The three
faces of the base carry a gilded rectangle with a
half-moon cut out at the bottom. Rising from the
base is an urn-shaped support embellished with
gilded repoussé leaf motifs below and festoons
around the middle. R.V.

Antependium of Pope Innocent X

Ca. 1625
Attributed to Cinthio Sabasio
Silk, gold thread, wood (frame)
98.5 × 185 × 2.5 cm
Office of the Liturgical Celebrations of the Supreme
Pontiff, Vatican City State
Inv. PLT3

Conservation courtesy of Florida Chapter of Patrons
of the Arts in the Vatican Museums

An antependium, or altar frontal, is a decorative
hanging designed specifically for the front of an
altar, lectern, or pulpit. This fine example is made
of cloth, though they can also be made of metal,
marble, or wood. Some authors claim that the altars
of Roman basilicas were completely upholstered
with fabric. The *Liber Pontificalis* relates that Pope
Saint Leo III had the altar of the first Basilica of Saint
Peter draped with precious material woven with
gold embroidery and precious stones. As a regular
part of church furnishings, the antependium
remained in use until the reforms promulgated by
the Second Vatican Council.

This example dates from the pontificate of Pope
Urban VIII. The cloth is divided into two horizontal
sections by a band of gold embroidery with a
fringe. The upper section carries elaborate floral
needlework patterns in gold thread with six bees,
the symbol of the Barberini family, to which
Pope Urban VIII belonged. Against a deep red back-
ground, the lower, much larger section carries
a richly embroidered Greek cross at the center,
complete with radiating sunburst, which is flanked
by the coats of arms of the dedicatee, Pope Innocent
X, born Giovanni Battista Pamphilj in 1574 in
Rome, and elected pope in 1644, succeeding Pope
Urban VIII. After the election, Pope Innocent X's
coat of arms replaced that of his predecessor. R.V.

Bust of Pope Pius VII

Ca. 1820
Antonio Canova (1757–1822)
Marble
62 cm h; base: 88 cm
Vatican Museums, Vatican City State
Inv. 2301

On the right-hand side of the base this bust is
signed "A. CANOVA FECE." The great neoclassical
sculptor completed three portraits of Pope Pius VII.
The busts were sculpted from a single plaster cast
made in 1803, housed in the Gipsoteca (Gallery of
Plaster Casts) in Possagno. The first sculpture was
begun in 1803, a date confirmed by Canova in the
following words written to his friend, Quatremère
de Quincy, a French scholar of fine arts: "During
the last few days I have been molding a bust of the
reigning supreme pontiff, in an attempt to catch
him during one of those moments of serenity and
gentleness, so difficult to observe, that will serve as
a eulogy to his forgiving heart" (Pavanello 1976,
no. 156, 111). The sculpture, finished the next
year, was taken by the pope to Paris as a gift for
Napoleon at his coronation as emperor. It was kept

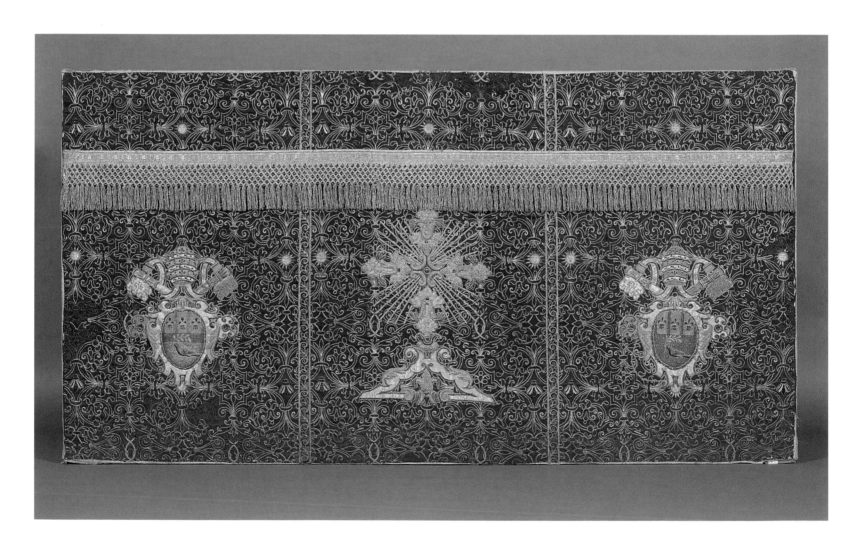

in the Tuileries, and sold after the damage inflicted by the Revolution of 1830. In 1833 it was bought back to the Palace of Versailles, where it remains today.

Canova also signed a second version that was sculpted in 1806 and given to the pontiff the following year. The pope presented it to the Protomoteca Capitolina (Gallery of Busts) on the occasion of its inauguration in 1820. A reproduction was made from this sculpture between 1820 and 1822, which the sculptor gave to Pope Pius VII. Originally this third version was placed at the center of the exedra in the Braccio Nuovo (New Wing of the Vatican Museum), where it glorified the figure of the pontiff dominating the busts of the great Roman emperors.

Pope Pius VII had been planning this new building since 1806. However, construction could not begin until 1817 due to the events caused by the French occupation of Rome. The building of the Braccio Nuovo was started by Roman architect Raphael Stern. After Stern's death, Pasquale Belli took over and completed the hall so that it could be inaugurated in 1822.

The plan was part of a much larger project that involved the renovation and repair of the Vatican Museums ordered by Pope Pius VII. The pope was already responsible for the erection of the new Pinacoteca, and the section which took his name, the Chiaramonti Museum. The Braccio Nuovo was added for the purpose of exhibiting the sculpture that had been transferred to France after the Treaty of Tolentino (1797), but which were returned to the Vatican after Napoleon's fall. However, it was also needed to house the vast number of works purchased for the papal collections.

In fact, Pope Paul VII was alarmed by the rampant phenomenon of buying and selling art works that had made Rome the renowned center for the European antique market. Thus, he had the decrees of August 10 and October 1, 1802, drawn up to prohibit exporting works of art from Rome. This ban included not only paintings and sculpture but any works of antiquity. At this time, the pope also appointed Antonio Canova, "the rival of Phidias and Praxiteles," Inspector General of Antiquities and Fine Arts for Rome and the Pontifical State, a position that included the superintendency of the Vatican and Capitoline Museums. In order to compensate for the inevitable difficult consequences that this ban would have on the various sculptors, restorers, and art dealers (as well as noble families who were forced to sell their artistic treasures because of financial problems stemming from the political ordeals), the pope bought them for the Vatican Museums. Ten thousand scudos a year were appropriated for this purpose, and Canova was appointed president of the commission assigned to consider and propose works of art.

Beyond the universal approval Canova had won, and his undeniable artistic merits, the artist found himself, as a result of these appointments, in the unique position of being a key figure involved in all the historical and cultural events of the Holy See during the long period of time that stretched from 1802 until his death in 1822.

Instead of merely creating a courtly eulogy, Canova deliberately made this bust a psychological study that closely approached the real nature of the individual. This same objective can be detected in the Vatican replica, with its well-defined features. In a certain sense, however, the Vatican version is not as successful because it is less profound. The Capitoline bust reveals exquisite workmanship in rendering the details of the mozzetta as well

as the use of plastic relief that emphasizes the Chiaramonti coat of arms: the three stars, the profiles of the three Moors wearing headbands, the three stylized mountains with a cross on top and the motto PAX.

Although the master signed the Vatican reproduction, it clearly shows the intervention of Canova's assistants, and in particular, Adamo Tadolini. Tadolini is also author of another copy with variations that is kept at the University of Bologna. M.S.C.

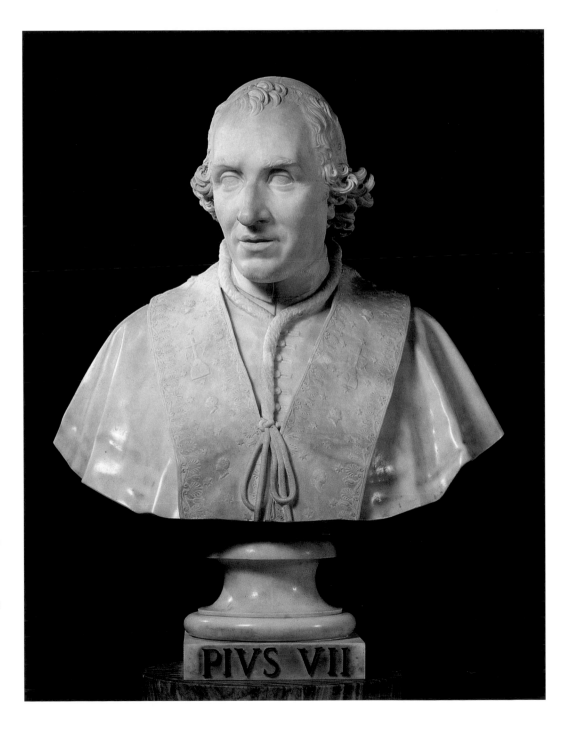

The Teaching Activities of the Popes

The pope's teaching authority originates in the words of Christ to Peter, the first pope, to whom he entrusted the church and made custodian of his Word revealed. Peter carried out this teaching with the other apostles, as does every pope and the bishops who are the successors of the apostles. The word "teaching," in this sense, refers to the pope as interpreter of the Word of God for the community.

The symbol of this activity is the chair. To underline the role of the pope and of every bishop as master and guide of the community, the bishopric was called the seat or chair of the bishop, which in English is now rendered as "see" from the Latin "sedia." In Saint Peter's, sheltered by the apse of the basilica, above the altar, rises the majestic chair designed by Bernini between 1658 and 1666. The bronze monument conserves what is left of a bench that, according to legend, was used by Peter as his episcopal chair.

The pope exercises his teaching authority by means of acts that, according to the nature and form in which they are presented, take on different meanings with differing emphases. Among the most important of these documents are the Apostolic Constitutions handed down directly by the pope. These constitutions are the most important acts of the pontifical ministry. They are general or permanent in character, as, for example, the dogmatic definitions and the most important reforms of the laws of the church. These acts are handed down in the form of bulls, from the Latin for seal, "bulla." Originally the bull was the pontifical seal placed in a metal capsule. Later it indicated the lead seal hanging from a document, and today, by extension, it indicates the document itself, and pertains above all to a papal document.

The encyclical letters are also very important in the life of the church. Their name derives from the Latin "encyclical," and means "circulated." By means of encyclicals the popes deal with doctrinal matters, warn of dangers to which the Christian faith and morality may be exposed, and provide directives regarding particular problems of the day. Above all, they are addressed to the whole of the Christian community, but also to every person of good will, as in Pope John XXIII's well known "Pacem in Terris" (Peace on Earth) of April, 11, 1963, regarding the serious and ever present problem of threats to peace. Almost always written in Latin, encyclicals take their names from the first two words of the opening sentence of the text.

The Cathedra of Saint Peter (copy)

20th century
Inlaid oak
140 × 85 × 65 cm
Reverenda Fabbrica of Saint Peter, Vatican City State

Conservation courtesy of Alice O'Neill Avery

The ancient cathedra, or chair, of Saint Peter is today housed within the monument built by Gian Lorenzo Bernini at the center of the apse of the Vatican Basilica. The venerated relic is enclosed within the lower part of a great bronze throne decorated with bas-reliefs of scenes that affirm Peter's primacy. At the base are four statues of the Doctors of the Church: Saint Ambrose and Saint Augustine for the Latin Church, and Saint Athanasius and Saint John Chrysostom for the Greek. The four majestic figures are not so much carrying as raising up toward heaven the cathedra, which for many centuries was considered the seat of the apostle and which became the symbol of the pope's spiritual authority.

In its present position within Bernini's monument – built during the pontificate of Pope Alexander VII – the cathedra remained inaccessible to the faithful, even on February 22, the feast of the Chair of Saint Peter. According to a tradition recorded between the thirteenth and seventeenth centuries, on that day the cathedra was exposed to the veneration of the faithful, who could touch it with ribbons or strips of cloth (mensure) that, it was believed, would thus acquire healing powers. In 1705, Pope Clement XI decided that the cathedra should once again be the subject of popular devotion and ordered a copy be made according to a design by the architect Carlo Fontana. This copy would be displayed within the same wooden case that, sixty years earlier, had temporarily housed the real one. However, the idea that the faithful might mistake the copy for the original made the pope change his mind, and the copy of 1705 and its wooden case of 1646 were both transferred to the Apostolic Palace. Later the two items were returned to the Fabbrica of Saint Peter and were put on view in the Petrine Museum in 1925.

The external framework of the ancient cathedra dates from the thirteenth century and is made of chestnut, pine, and ash. Fixed to the uprights are four metal rings used to carry the cathedra during the solemn processions in the basilica. This most ancient of seats has the form of a throne without arms, the back surmounted by a pediment within which are three oval spaces for decorations, now lost. Other parts of the chair were once covered with a lamina of precious metal, now also lost, and decorated on both sides with an ivory frieze carved with geometric and vegetal motifs, symbolic images, and scenes of classical inspiration. The sides and back of the throne were decorated with

arches supported by small columns with Attic bases and stylized capitals, of which only a part still remains today.

In all probability, the cathedra was given by Charles the Bald to Pope John VIII, who crowned him in Saint Peter's Basilica in the year 875; indeed, a bust of that emperor with orb and crown appears in the center of the frieze on the horizontal crosspiece of the pediment, between two angels who are offering him a crown. Later, the front of the cathedra was decorated with a panel of eighteen small plaques arranged in three rows of six and representing, at the top, the twelve labors of Hercules and, underneath, six imaginary creatures. The images are finely carved on the ivory plaques that are fixed to two oak boards; the figures of Hercules – and of the imaginary beasts of the six lower plaques – were rendered by means of cavities filled with chased gold leaf. Traces of the frames around each individual scene still remain, giving evidence of the refined technique with which red and green glass paste was inserted into specially prepared hollows. Opinions differ as to the dating of the ivory plaques: Karl Weitzmann suggests that they were made in a workshop in the Rhine valley between the eighth and tenth centuries, while for Margherita Guarducci they were produced in Alexandria, Egypt, between the third and fourth centuries. Guarducci has also hypothesized that the panel with the labors of Hercules was once part of the back of the throne of the emperor Maximian Hercules (286–305), which was later used by Roman pontiffs from the fourth century onward. According to this theory, in the thirteenth century the panel was transferred to the throne of Charles the Bald, which thus became a kind of reliquary for this precious antique.

Over time, the cathedra underwent numerous changes of location, evidence of which is to be found in historical sources and archives. In the old basilica it was kept together with the bronze statue of Saint Peter in Saint Martin's oratory, which stood on the site where later one of the great piers supporting Michelangelo's dome was built: the southwest pier or the pier of Saint Veronica. Later, the cathedra was taken to a chapel at the entrance of the basilica, near the altar of Saints Simon and Jude and, shortly before the jubilee of 1450, was placed in the tabernacle of Saint Adrian built by Pope Nicholas V in the southern arm of the transept. In 1576, it was taken to the so-called Rotonda di Sant'Andrea, or Santa Maria della Febbre, where it was placed near an altar marked with the number 169 in Tiberio Alfarano's plan of the basilica. In 1606, Pope Paul V ordered the cathedra be moved to a reliquary against the side wall of the nearby altar dedicated to Saints Chrysostom, Lambert, and Servatius.

In 1630, Pope Urban VIII decided to bring the ancient and venerated chair back into the basilica and ordered the construction of a small oratory

with an altar dedicated to the Holy Cathedra. In 1636, the cathedra was placed over the altar in the last chapel of the left-hand aisle of the basilica, which it had just been decided should be the baptistery. A drawing by Domenico Castelli (cod. Vat. Barber. lat. 4409, f. 18) shows the cathedra closed within its case standing on a marble pedestal and flanked by two angels against a background of clouds dominated by the radiant figure of a dove, symbol of the Holy Spirit. The wooden case, the work of Giovanni Battista Soria, held the cathedra for ten years but was, in fact, only the model for a bronze case that was completed in 1646 during the pontificate of Pope Innocent X. The cathedra remained in this metal container, now lost, until 1666, when it was definitively transferred to Bernini's grandiose monument against the back wall of the basilica.

The model case, made of gilded wood, which served as a "scabbard" for the cathedra, has doors that open at the front, on the seat, and at the back. Its decorations include vegetal motifs, cherubim, and masks, although they are certainly more modest than those that must have covered the bronze case that was made following indications by Bernini. On the inside, behind the doors that open onto the back of the cathedra, a Latin inscription from 1705 recalls that this wooden container "long guarded the holy cathedra" and also housed "a most faithful copy of the true cathedra that it could more easily be admired by the devoted faithful." P.Z.

Processional Cross of Pope Pius IX

1863
Silver, silver gilt
28.5 × 62 × 28 cm
Office of the Liturgical Celebrations of the Supreme
Pontiff, Vatican City State
Inv. CRP17

Conservation courtesy of The Minnesota Chapter of
the Patrons of the Arts in the Vatican Museums

This processional cross was donated to Pope Pius IX
and used during the opening of Vatican Council I in
1869. A masterpiece of goldwork in the neo-Gothic
manner, the piece was later used only occasionally
in papal liturgical celebrations.

The cross dates to the second half of the
nineteenth century and is made of silver, parts of
which have been gilded. Defined as a "processional
cross," the piece was devised to be borne during
the papal processions. It was carried by a prelate of
the court immediately in front of the *sedia gestatoria*,
with the image of the cross turned toward the
pontiff rather than away from him, as is the custom
in processions, to remind the pope of the example
of the Lord Jesus, by whom he is appointed vicar
on Earth.

Each of the four trilobate arms of the cross is
edged with a fine sculptural border. The base of the
cross, rich in ornamental detail symbolizing death
and Resurrection, consists of a small church in
the Gothic manner featuring the twelve apostles.
The intended message is clear: the promised
redemption through the death and Resurrection
of Christ is realized in the apostles, and its effects
are made manifest and exemplified in the lives of
the saints.

Recently cleaned and repaired with the utmost
care, the piece has been successfully restored to its
original splendor. Despite its fine craftsmanship,
the size and weight of the cross has meant that it
is not frequently used. R.V.

Lead Seal of Sixtus V

1585–90
Lead
Diameter: 4 cm
Congregation for the Evangelization of Peoples,
Vatican City State

Since ancient times, the Roman pontiffs have used
lead bulls or appended seals (*bullae*) to validate
documents. The oldest documents that have come
down to us are from the eighth century. The half-
bust image of Saint Peter holding the keys and the
sacred books appears for the first time during
the pontificates of Nicholas II and Alexander II.
Gregory VII was the first pontiff to have the heads
of Saint Peter and Saint Paul appear on his bulls.
Paschal II introduced the manner of presenting
the papal bulls, which has come down to us.

Description of seal: obverse, the heads of Saint
Peter (right side, with a beard and curly hair and,
above, the letters SPE) and Saint Paul (left side, with
a long beard and bald head, and, above, the letters
SPA). Between the two heads is the cross. The series
of "pearls" or dots surrounding the seal are not
preserved; reverse, the cross and the name of the
pope in the nominative case with the title and
the ordinal number, in four rows, only partially
surrounded by "pearls." First row: Cross between
two "pearls": . + . . Second row: Name of the pope:
SIXTUS. Third row: Title between two "pearls":
.PAPA.. Fourth row: Ordinal number between
two "pearls": .V. L. R.

Lead Seal of Alexander VII

1655–66
Lead
Diameter: 4 cm
Congregation for the Evangelization of Peoples,
Vatican City State

The description of this seal: obverse, the impres-
sion is badly worn, but the heads of Saint Peter
(right side, with beard and curly hair, and, above,
the letters SPE) and Saint Paul (left side, with a long
beard and bald head, and, above, the letters SPA)
can be distinguished. Between the two heads is the
cross. The series of "pearls" or dots surrounding the
seal are only partially preserved; reverse, the name
of the pope in the nominative case with the title
and the ordinal number, in four rows, only partially
surrounded by badly worn "pearls" (top, in the
center to the right). First row: ALE. Second row:
XANDER. Third row: Title between two "pearls":
.PAPA.. Fourth row: Ordinal number between
two "pearls": .VII. L.M.C.R.

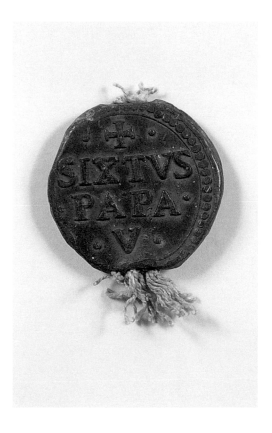

Lead Seal of Sixtus V

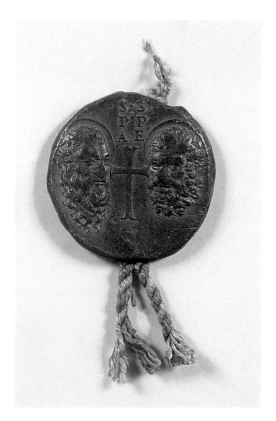

Lead Seal of Alexander VII

Chirograph of Pope Gregory XVI

June 25, 1835
Paper
25.5 × 19.5 cm
Congregation for the Evangelization of Peoples,
Vatican City State
APF, Secret Archives 1, f. 77-78

A chirograph (from the Greek *cheir*, "hand," and
graphein, "to write") is a document written by the
same person who signs it. As regards pontifical
documents, from the sixteenth century on
chirographs were mainly used by popes to
make administrative provisions. Though directly
written and signed by the pope, they are devoid
of the solemnity of the documents issued by the
Chancellery or the Secretariat.

In this document, addressed to Msgr. Angelo
Mai, secretary of the Congregation of Propaganda
Fide, the pope — former prefect of the same
Congregation — gives indications regarding the
dispatch of certain pontifical papers to the Apostolic
Vicariate of England. L.M.C.R.

Chirograph of Pope Saint Pius X

April 24, 1911
Paper
23 × 34.5 cm
Congregation for the Evangelization of Peoples,
Vatican City State
APF, Secret Archives 10, ff. 834-835

With the establishment of the primatial see of Constantinople in 1830, part of the Armenian Catholic community passed under the jurisdiction of the new primate, while the rest remained under the patriarch of Cilicia. From 1866, with the election of Bishop Hassun as patriarch, the two jurisdictions came together under his care. Two movements, however, arose within the Armenian community: the "Latin" (which sought to assimilate itself to the Latin rite) and the "traditionalist." During this period, the Congregation of Propaganda Fide sought to encourage priests and faithful to live in union and harmony.

In 1867, a new controversy had arisen regarding the "right" of the lower clergy and the faithful to present candidates for the patriarchate and the episcopate. This supposed right had been abrogated by Pope Pius IX and by the Congregation of Propaganda Fide. However, faced with the difficulties being undergone by Patriarch Paul Terzian (1910–31), upon whom the "Armenian notables" sought to impose their supposed rights, Pope Saint Pius X, in this handwritten document, communicated to Cardinal Girolamo Giotti, prefect of Propaganda Fide, his plan to send a letter to the patriarch of the Armenians calling an Armenian synod in Rome for the month of October 1911.

In the synod, which was held in Rome, it was emphasized that the election of the patriarch and the bishops remained the prerogative of the synod of bishops with successive confirmation from the Holy See; the Armenian clergy and notables were allowed only to recommend their candidates. Unsatisfied with this result, the notables, with the backing of the Turkish government, deposed Patriarch Paul Terzian. The controversies among Armenian Catholics only ended between 1915 and 1919 when the Turks, under a political pretext, perpetrated the great Armenian massacre. L.M.C.R.

WE PAUL VI,

With the Catholic community of the Island of Upolu, gathered around its Bishop, Pio Taofinu'u, and its clergy,

With our collaborators, Cardinals Eugène Tisserant and Agnelo Rossi, Archbishops Giovanni Benelli, Agostino Casaroli and Sergio Pignedoli, and Bishop Jacques Martin,

Launch an appeal that would be a call to the whole Church scattered to the four corners of the earth, from this privileged land, lost in the immensity of the Pacific Ocean, but long since open to the Gospel message.

Responding to the anguished voices of those eager for light who beg us: "Come across and help us" (cf. Acts 16:9);

Seized with pity for the multitude hungry for the bread of the Word and the Bread of the Eucharist but with no one to give them these;

Filled with admiration before the riches which God has placed in men's hearts and the wonderful promises of harvest for the Gospel:

We repeat the call which, from distant times, God has addressed to generous hearts: "Leave your country, your family and your father's house for the land I will show you" (Genesis 12:1).

To you, bishops of the Holy Catholic Church, who by virtue of the collegiality of the episcopate share the concern for the welfare of the whole Church, (cf. Lumen Gentium, 23), extend your apostolic ardour to the holy cause of spreading the Gospel throughout the world (cf. Encyclical Fidei Donum);

To you, priests, whose faith aspires to communicate itself on wider fields, come and bring the fire of your zeal to those whose simplicity of life has safeguarded their sensitiveness to the values of the spirit;

To you, religious, whose life is totally directed to imitation of the Lord, join the valiant generations of missionaries who for centuries have become, each in his turn, messengers of faith, peace and progress, by proclaiming Christ, their Model, their Teacher, their Liberator, their Saviour (Ad Gentes, 8).

To you, young men and women, whose heart, eager for truth, justice and love, seeks noble causes to defend by disinterested effort, we say: Listen to the call to become heralds of the Good News of Salvation; come with the riches of your faith and your youthful enthusiasm, teach men that there is a God who loves them, who waits for them, and who wishes them to be close to him like children gathered round the head of the family, come to nurse the body, enlighten the intellect, teach how to live better and grow in humanity, and build the Church for the greater glory of God.

You who are rich, give of your possessions which God has placed in your keeping that the apostle may live and that his pastoral undertakings may prosper;

You who are poor, give your struggle and toil for daily bread, that all may share that bread;

You who suffer, you who weep or are persecuted, give your suffering that the body of Christ may grow in justice and hope (cf. Colossians 1:24).

To the whole of Catholic Christendom we say: "Widen the space of your tent, stretch out your hangings freely" (Isaiah 54:2); give the world, as it advances towards unity, the indispensable nourishment of harmony. For, while seeking the truth together brings men closer, only the meeting of hearts cements their unity. In the Spirit of Jesus Christ build up the immense Mystical Body which is the Church in process of being formed. It depends on you that peace and brotherhood should tomorrow scatter the darkness of death. God has need of you that about Christ the Saviour there should be raised and joined in harmony the hymn to the Creator, God who is Father of all (Ephesians 4:6).

Unknown brothers and sisters, listen to our voice. And the grace of the Lord be with you - Amen.

Paulus P.P. VI Viator Xti

[signatures]

Apia, 29 Nov. 1970

Missionary Message of Pope Paul VI

November 22, 1970
Parchment
60 × 47.5 cm
Congregation for the Evangelization of Peoples,
Vatican City State
APF, Parchment Room

From November 26 to December 4, 1970, during
the course of his ninth pastoral trip outside Italy,
Pope Paul VI visited Iran, Pakistan, Samoa, Australia,
Indonesia, Hong Kong, and Ceylon. It was on this
trip, in the homily he gave during a eucharistic
celebration on the Island of Upolu (western
Samoa), that the pope delivered this missionary
message to the local Christian community, led by
Bishop Pio Taofinu'u S.M., and to the entire world.
The original text, on display here, was personally
signed by the pope, as well as by other prelates,
religious, and lay people, on the altar at the close
of the mass. L.M.C.R.

Message of Pope John Paul II for World Mission Day

May 26, 1985
Paper
18 × 45 cm
Congregation for the Evangelization of Peoples,
Vatican City State
APF, New Series, Rub. 70/1, prot. 2699/85

Every year in October, on World Mission Day,
the pope customarily addresses a message to the
Catholic Church reaffirming that all the faithful
are called to announce Christ and expressing
encouragement for the activities of missionaries
(priests, religious, and laity) who, leaving their
homeland, family, and culture, go to proclaim
the love and marvels of God to those who do
not know Christ.

 This document, signed by the pope, especially
encourages the young to announce the Gospel "at
this crucial moment in human history." L.M.C.R.

tendono le mani verso di noi implorando soccorso, possano dire un
giorno, con l'Apostolo: "Adesso ho il necessario ed anche il su-
perfluo; sono ricolmo dei vostri doni... che sono un profumo di
soave odore, un sacrificio accetto e gradito a Dio" (Fil 4,18).

 Che Maria Santissima, Madre di Cristo e Madre della Chiesa ,
vi assista in questo generoso impegno missionario!

 A tutti imparto la mia Benedizione Apostolica, propiziatrice
di abbondanti favori celesti.

Dal Vaticano, il 26 maggio, Solennità di Pentecoste, dell'anno 1985,
settimo del mio Pontificato

Joannes Paulus PP. II

Carissimi Fratelli e Sorelle!

 Ogni anno la Chiesa, nella solennità di Pentecoste, rivive con
gioia ineffabile gli inizi della propria esistenza e dell'opera e-
vangelizzatrice destinata a tutti i popoli della terra. Pertanto,in
questa data tanto significativa mi è gradito rivolgere, come di con
sueto, il mio "Messaggio per la Giornata Missionaria Mondiale", che
sarà celebrata nel prossimo mese di ottobre.

1. La Chiesa nasce sotto il soffio dello Spirito Santo

 nel giorno di Pentecoste

 Gli Apostoli, fedeli al comando di Cristo, sono riuniti nel Ce
nacolo per pregare e riflettere, insieme con Maria. In quegli uomi
ni privilegiati aleggia un sentimento di trepidazione di fronte al
mandato che il Maestro ha loro affidato: "Andate... e ammaestrate
tutte le nazioni, battezzandole nel nome del Padre, del Figlio e del
lo Spirito Santo..." (Mt 28,19). Trepidazione per le recenti minac-
ce dei Giudei, per l'incomprensione di molte affermazioni del Signo
re, e soprattutto per l'esperienza della propria insufficienza e dei
propri limiti nel corrispondere al mandato divino. Quei primi Apo-
stoli, non colti e non audaci, sono stretti intorno a Colei che sen
tono come propria Madre e fonte di speranza e di fiducia.

 Ed ecco, improvvisa, avviene la "trasformazione", al soffio pos
sente dello Spirito Santo. Una trasformazione radicale della mente
e del cuore: gli Apostoli sentono ora come aprirsi la loro intelli-
genza, sono invasi da un incontenibile fervore dinamico; sono domi-
nati da un unico impulso: annunziare, comunicare agli altri quanto

Solemn Letter "Inmortalis Dei Filius"

August 1, 1627
Pope Urban VIII (1623–44)
Document: parchment; seal: silk, lead
33 × 24 cm
Congregation for the Evangelization of Peoples,
Vatican City State
APF, SC Urban College 1, ff. 104–119

On January 6, 1622, Pope Gregory XV founded the Congregation de Propaganda Fide as the supreme central body for the propagation of the faith. The Congregation had two tasks: to seek union with Orthodox and Protestant Churches; and to promote and organize the mission among non-Christians.

The principal characteristic of the new Congregation was that of being the Holy See's ordinary and exclusive instrument in the exercise of its jurisdiction over all missions. In the bull *Inscrutabili divinae providentiae arcano* (1622), by which the pope established the Congregation, there was no stipulation of exceptions or limits to its power regarding people and regions, or other Congregations and their authority.

Of vital importance to the life of the new Congregation was its first secretary, Msgr. Francesco Ingoli, who held that position from 1622 to 1649. Some of the outstanding points of his missionary program were the formation of local clergy and the establishment of national ecclesiastical hierarchies. Msgr. Ingoli lent support to a project of the Spanish prelate, Msgr. Juan Bautista Vives, who, in 1626, founded a missionary college with twelve students in Rome's Palazzo Ferratini (today Palazzo di Propaganda Fide). With the support of the Congregation, Pope Urban VIII—through the document on display here, the bull *Inmortalis Dei Filius*—established that institution as a pontifical college, conceding it the same privileges as Rome's other pontifical colleges and giving it the name of the Urban College.

The number of students depended on the study grants available in the foundations of Msgr. Vives and Cardinal Barberini. In 1644, the General Congregation ordered that only students coming from other countries, and who had no college in Rome, could be accepted. In 1657, Pope Alexander VII allowed Propaganda to admit European students, except Italians.

Pope Urban VIII entrusted the intellectual formation of the seminarians to the Theatines. The magnificent rector and the cardinal prefect of Propaganda Fide were authorized to confer doctorates to students who had completed their studies. These studies included the humanities, rhetoric, philosophy, theology, and, from 1649, Oriental languages. The library of the Urban College became so important that in 1667 the pope himself prohibited the lending of books, on pain of excommunication. Over the centuries, the Urban College of Propaganda Fide has undertaken outstanding formational work in support of missions: of the fifty students who entered the college between June 1633 and January 1634, one was martyred, eight became bishops, and twenty apostolic missionaries. L.M.C.R.

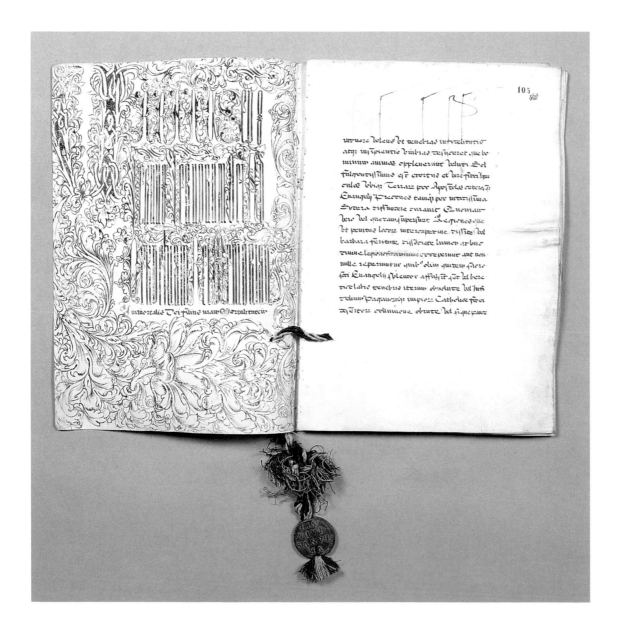

Pope Innocent XI

Ca. 1691
Attributed to Domenico Guidi (1628–1701)
Carrara marble
82 cm (base 20 cm)
Congregation for the Evangelization of Peoples,
Vatican City State

Conservation courtesy of Florence D'Urso in
honor of a fine priest, and very dear special friend,
Reverend Monsignor Gregory A. Mustaciuolo

Benedetto Odescalchi was born into a wealthy
family of Lombard traders. After taking his degree
in law, in quick succession he became cardinal
(1645), legate of Ferrara (1650), and bishop of
Novara (1654). He was elected almost reluctantly
to the papacy in 1676, succeeding Clement X.
He undertook the difficult task of upgrading
the morality of public life, prohibiting usury,
gambling, theatrical performances, and carnival
celebrations, and at the same time trying to
improve the financial situation that had been
upset by the war against the Turks. He promoted
policies of solidarity offering extensive assistance
to the poor, support for childhood education, and
physical and spiritual assistance to the ill. In his
apostolate he fought for the simple preaching of
the Gospel, the teaching of the catechism, and the
observance of the rules by the clergy. He committed
himself to the conversion of Protestants, joyously
welcoming the ascent of the Catholic king James II
to the throne of England, with whom, however,
relations subsequently deteriorated.

This bust seems to make up a set with that of
a bust of Alexander VIII in this exhibition, with
which it shares the same stylistic characteristics.
It represents the pope in a mozzetta and *camauro*,
with a stole decorated with the Odescalchi heraldic
emblems (eagle and griffin). He wears a goatee and
his features correspond to those in a drawing by
Gian Lorenzo Bernini, today in the Gabinetto
Nazionale delle Stampe (EI 1933, p. 331). His face
appears strained and his forehead is furrowed with
lines. The deep folds in the fabric of the mozzetta
are typical of the late works of Domenico Guidi.

The bust may well have been commissioned
in the years straddling the end of the pope's
pontificate (1689) and the beginning of the last
decade of the century, a period which coincided
with the brief pontificate of Pope Alexander VIII.
If this were the case, it would further support the
hypothesis that the two busts were commissioned
at the same time. M.N.

Pedestal

Late 17th century
Circle of Alexander Algardi
Gilded wood
123 cm
Congregation for the Evangelization of Peoples,
Vatican City State

"Stools," or pedestals, such as these that support
the baroque busts of Pope Innocent XI and Pope
Alexander VIII in this exhibition were among the
most common sort of elements furnishing Roman
palaces. They were able to support a good number
of objects (busts, small statues, stone vases or vases
with floral decorations, precious metal urns) and
also function as seats and stools. Usually made in
pairs or sets, they could be placed in the corners of
the rooms or where they could be seen to the best
advantage.

These stools have a sturdy base composed of
leaf motifs with angular spirals, out of which rises
a second structure, a brilliant figurative invention
based on the theme of the four corner caryatids.
The caryatid motif is also seen in a drawing by
Algardi for the Fontana dell'acqua vergine
("Pure Water Fountain"), today in Edinburgh in
the National Gallery of Scotland.

The impression is one of elegant opulence
animated by vibrant creative fantasy and skillful
artistic effects. Works of sculpture rather than
merely decorative objects, these sets of stools
are stylistically a vulgarization of the highest
expressions of the school of Bernini, descending
from the decorations on the Cathedra Petri
(1657–66) in Saint Peter's.

It is not known whether the stools were made
for the busts they support or were coupled with
them at some other time. They may conceivably
have been completed at the same time as the
busts and placed with them in one of the palaces
belonging to the Congregation of Propaganda
Fide, today known as the Congregation for the
Evangelization of Peoples, in all probability the
Borromini building in Piazza di Spagna. M.N.

Christian Doctrine in the Burmese Language

1840
Paper
23.5 × 15 cm
Congregation for the Evangelization of Peoples,
Vatican City State
Archives, ref. SC East Indies, miscell. 6, ff. 1–72

The evangelization of Burma, begun in 1554, can be divided into five periods. In the first, which lasted up to 1721, evangelization was limited to European colonies and located in the chief centers of population. From 1648 onward, Propaganda Fide (Congregation for the Evangelization of Peoples) attempted to set up a true mission, first with the Capuchins and then with the Foreign Missions of Paris. The intent to establish a mission succeeded only in the second period (1721–1830) with the Barnabites. To them is owed the first serious and uninterrupted attempt at evangelization of the Burmese and of the Carian tribes, and the first indigenous linguistic literature.

The third period (1830–39), after the Barnabites abandoned the mission, was that of the Piarists. From 1839 to 1856 (fourth period) the mission is entrusted by the Propaganda Fide Congregation to the Oblates of the Virgin Mary of Turin, who worked with zeal until the English-Burmese war (1851–52). In the last period, from 1856 onward, the mission was entrusted to the Society of Foreign Missions of Paris. The territory of this single mission having been divided into three Apostolic Vicariates in 1866, the Oriental Vicariate was handed over in 1870 to the Seminary for Foreign Missions of Milan.

This volume, a catechism or brief and essential summary of the Christian doctrine, was printed in Burmese in 1840 and shows the care the missionaries took to make Christianity accessible to the natives, providing them with texts in their native language. L.M.C.R.

Illuminated Profession of Catholic Faith
in *Armenian*

1661
David, Bishop of Aleppo
Paper
59 × 31 cm
Congregation for the Evangelization of Peoples,
Vatican City State
APF, SOCG 225, ff. 50–51

The origins of the Armenian colony in Aleppo, a city in
northern Syria not far from Antioch, go back to the
eleventh century. History, however, has not preserved a
complete list of bishops. In 1585, Bishop Azaria, later
elected as patriarch of Sis in Cilicia, made the profession
of faith to Pope Gregory XIII.

Through the history of the Armenian people, relations
between dissidents and Armenian Catholics became ever
more complex and were rendered even more strained
through the power exercised by the religious leaders
of the Armenian dissidents, the patrìks. They also had
jurisdiction over the Catholics who, on numerous
occasions, appealed to the Congregation of Propaganda
Fide to deliver them from the constrictions imposed
by the patrìks. From the mid-seventeenth century, the
Armenian Catholic community of Aleppo underwent
notable development with the efforts of Armenian
missionaries, former pupils of Propaganda Fide, and
missions of Western orders.

This illuminated document in Armenian, of which
we have the Italian translation, is testimony of one of the
many professions of faith made to the Church of Rome
by bishops who had once been adherents to the dissident
side and then chose to abjure in the name of the true
faith. The letter, which bears the date of March 15, 1661,
was written by David, the then-bishop of Aleppo. In it,
"after fifty years of tormented life, miserably led into the
blindness and errors of the Armenians," he confesses and
confirms to Pope Alexander VII that he renounces all
heresies "and opinions contrary to the Holy Roman See."

Having already renounced his adherence to the group
of "rebels against the Roman Church" in the presence of
two missionaries, he now puts himself into the hands of
the pontiff, recognizing the latter's supreme authority and
declaring that he, David, can no longer exercise his own
ministry nor "the office of bishop" because he "received
the Magisterium, priestly ordination and dignity as
bishop from the Armenians, without the approval and
command of the Supreme Pontiff."

With a colorful and rhetorical exclamation he invokes
intercession on his own behalf in heaven from the
"glorious and holy lion," he who in life fought against
heretics while never ceasing to leave the doors of forgive-
ness open to them, to welcome them into Christ's "flock."
Thus, he proclaims his faith in the pope as "leader of the
universal Church. … His alone is the right to dispose
things holy, and to explain the dogmas of the faith to
the entire world." C.G.

Armenian Priest's Ritual

1704
Parchment, paper
33 × 45 cm
Congregation for the Evangelization of Peoples,
Vatican City State
APF, SC Armenia, miscellaneous 10

The Congregation for the Correction of the Books of the Oriental Church was created by Pope Clement XI in 1719 as a permanent body; it was autonomous but linked to Propaganda Fide. The Congregation was created in the wake of many initiatives by Propaganda Fide and the Sant'Uffizio in publishing sacred books for the Oriental Churches, especially the Maronites, Armenians, Syro-Antiochenes, and Greeks. After 1719, these activities came under the jurisdiction of the new Congregation, although Propaganda Fide maintained its interest in the matter.

The Congregation throughout its existence published monumental editions of all the Greek and Coptic liturgical books, Chaldean and Syro-Antiochene missals, and a Malabarese missal and ritual, as well as oversaw the re-publication of Armenian and Maronite books. The chief concern in the revision and correction of the liturgical texts was to remove any affirmation that ran contrary to the faith of the church.

This manuscript volume consists of 379 pages divided into two columns. It is written in Latin and contains prayers and rites to be used by Catholic priests of the Armenian rite. Given that it is full of crossings out and corrections, the book may be considered as an *instrumentum laboris*. In all probability it is a text written with the intention of being corrected prior to the printing of the ritual in Armenian. Between page 1 and 2, the volume contains a color design of a Catholic priest of the Armenian rite wearing his liturgical vestments.

L.M.C.R.

Armenian Pontifical

1704
Parchment, paper
35 × 46 cm
Congregation for the Evangelization of Peoples,
Vatican City State
APF, SC Armenia, miscellaneous 11

A pontifical is a liturgical book containing the description and ritual formulae of liturgical celebrations normally restricted to a bishop (*pontifex*). As an individual liturgical work it did not appear before the seventh century and, especially at the beginning of its history, had various names: *Ordinale*, or *Ordinalis liber*, for ordination, one of the principal celebrations described; *Mitriale*; *Benedictionale*; *Pontificalis ordis liber*; *Pontificalis liber*; *Pontificale Romanum*.

The book on view here is handwritten in Latin and contains prayers and rites to be used by Catholic bishops of the Armenian rite in various liturgical celebrations. Each page is divided into two columns and the work is clearly divided into two parts with individual page numbering: liturgical celebrations presided by the bishop (pp. 1–160); and the ritual for ordaining other bishops (pp. 1–78).

The reason for this division is clear if one considers that episcopal ordination continues the uninterrupted chain that links bishops to the apostles and, consequently, to Christ himself. The consecration of bishops is, then, one of the most solemn and ecclesiastically important acts that a bishop may undertake during his ministry.

Like the Armenian priest's ritual, this book may be considered as an *instrumentum laboris*, because it contains abundant corrections and crossings out; it, too, was probably written with the intention of being corrected prior to being printed in Armenian.

The text is adorned on the first page and at the end of the first half (following page 160) with two color images of a Catholic bishop of the Armenian rite wearing his liturgical vestments.

L.M.C.R.

The Papacy and the Missionary Activity of the Church

Missionary activity is an integral and essential part of the nature of the Church. It is intimately tied to the very words of Christ, who commanded the apostles to "Go out to the whole world; proclaim the gospel to all creation" (Mk 16:16). The apostles put the missionary idea at the center of their activities: once the Church of Jerusalem had been organized, they separated and went to the farthest corners of the known world. The missionary calling is of particular concern to every pope. This activity received particular impetus after the so-called discovery of America, which posed the problem of the evangelization of completely unknown worlds and populations. Immediately after Columbus' voyage, in 1492, Pope Alexander VI wrote to the sovereigns of Spain, Ferdinand and Isabella. In a bull of 1493, *Inter Caetera*, he recognized the right of the sovereigns to the property of the newly discovered lands, but at the same time he ordered them to send young, cultured, just men and witnesses of God to evangelize the indigenous peoples of the new territories. Forty years later, in 1537, Pope Paul III declared that the recognition of human dignity should be given even to the inhabitants of the new territories, who are "men with a soul" like all other men.

Another serious missionary problem to which the popes gave a great deal of attention was that of the Christian message, which often was based on Western culture but seemed to contradict those from other parts of the world. However, encouraged by the popes, particularly those of the last century, in its missionary activities the church is ever more respectful of the diversity of cultures and traditions of all people. The point of departure for evangelization is a dialogue that finds substance in "those numerous common elements," as Pope John Paul II says: "…instead of wondering at the fact that Providence allows such a great variety of religions, we should rather be amazed at the many common elements that can be found in them" (*Crossing the Threshold of Hope*). These nascent ideas are present in the first program document issued by the Congregation for the Propagation of the Faith (Propaganda Fide) by Pope Gregory XV in 1662, with the intention of directing and supporting the missionary activities of the church.

The archives of the Congregation for Evangelization of Peoples have put some very rare and, in part, unedited documents at our disposal for this exhibition. They tell the story, albeit in the widest terms, of the missionary undertakings of the church and the popes during the course of the centuries.

Reliquary of Saint Francis Xavier

20th century
Joalharia Indo Portuguesa Vamong, Maodcoicar
Nova-Goa
Gilt metal, wood, precious stones, velvet
40 × 47 × 30
Office of the Liturgical Celebrations of the Supreme
Pontiff, Vatican City State

This reliquary was crafted by an artisan from India and reproduces the tomb of Saint Francis Xavier, apostle of the East Indies and patron saint of missionaries, who was buried in the former Portuguese colony of Goa on the Malabar Coast.

Saint Francis Xavier died on December 3, 1552. A member of the Jesuit order, he was appointed by the founder of the Jesuits, Saint Ignatius Loyola. Owing to the progressive methods he developed as a missionary, he was proclaimed a saint shortly after his death by Pope Gregory XIII. Later, in 1927, Pope Pius XI proclaimed him patron saint of the church's missionary activity.

The reliquary is made with silvered metal fretwork, inset with gems and colored glass. The color of some of the gems set into the cross and the base suggest a symbolic program — for example, the red and green stones encircling the saint's monogram at the center of the base refer to the virtues of charity and hope that the saint was said to have embodied. The colorless stones around the center of the cross bring diamonds to mind, which is significant in that diamonds were first discovered in India and for many religions have come to symbolize the values of eternity and absolute spiritual purity. The genuine diamond at the center, therefore, portrays the cross not as an instrument of death alone, but of salvation as well. On the sides of the reliquary are small repoussé reliefs that describe episodes from the life of Saint Francis Xavier. R.V.

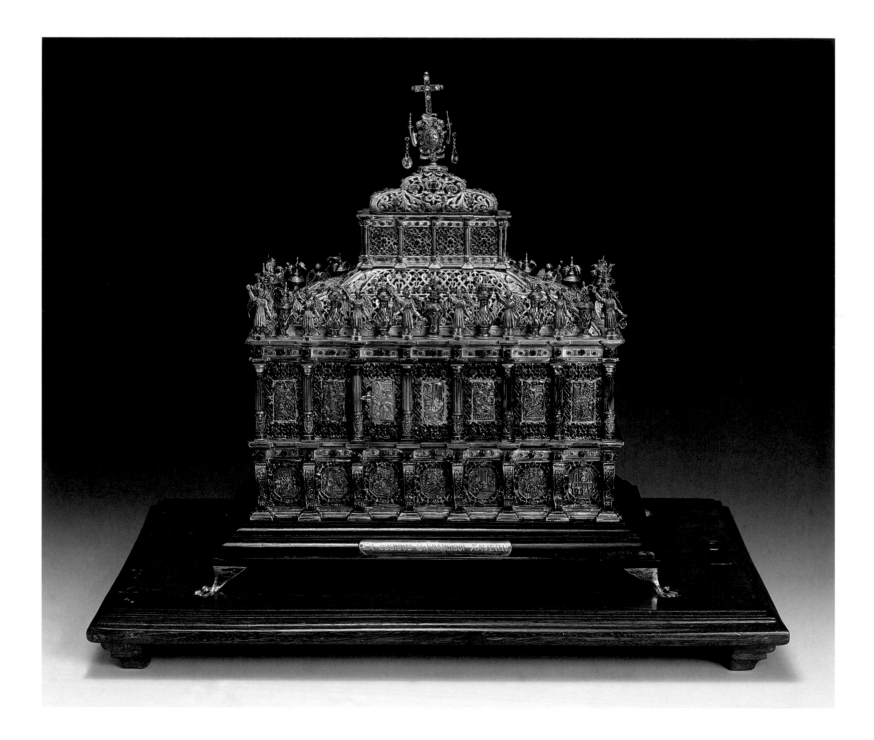

Book in the Tamil Language

First half of the 17th century
Ignacimuthu Mudaliyar
Palm leaves, wood
3 × 40 cm
Congregation for the Evangelization of Peoples,
Vatican City State
APF, Parchment Room

According to tradition, Christianity was brought to India by Saint Thomas the Apostle. A more scientific view is that the religion penetrated the subcontinent in the fourth century with the arrival of Christians seeking refuge from the persecutions of King Sapor II of Persia. They occupied the Malabar coastal area and so gave rise to the Christian Church of Syrian-Chaldean rite, known as the Christians of Saint Thomas.

Catholic missions in modern times began with the arrival of the Portuguese in Calicut in 1498. Some French diocesan priests and Dominican friars founded mission stations in the area occupied by the Portuguese. Cochin was the first center for this evangelization, later giving way to Goa, which became first a diocese and then, in 1557, an archdiocese. With the arrival of Saint Francis Xavier and the Jesuits in 1542, missionary activity, which was originally limited to the Portuguese possessions around Goa, became more organized and extensive.

Saint Francis arrived in Goa on May 5, 1542. In September of the same year he was sent by the governor to the southern regions, which held promise of conversions. Although the Portuguese had already introduced Christianity, their work had been limited to baptizing the native population and prisoners of war who, without sufficient education or preparation, had fallen back into idolatry as soon as the priests left. Saint Francis Xavier's influence on evangelization was tremendous, as this book on his life and writings shows: with the aid of interpreters he first translated the main prayers and most essential articles of faith into the local tongue; passing from village to village he became teacher, doctor, arbiter in disputes, defender against the injustices of pagan chiefs and Portuguese officials, and treated and respected as a saint and faith healer.

This book on the work and spiritual writings of Saint Francis Xavier comes from southern India, the present Tamil-Nadu. According to the introduction, it was written by Ignacimuthu Mudaliyar, the son of Duaraisamy Mudaliyar, guardian of the church of Saint Ignatius at Karukkatkudy. The poor condition meant the book could no longer be used and so, at the suggestion of Arulanandu Udaiyar, the son of Saverimuthu Udaiyar, it was recopied onto palm leaves. L.M.C.R.

Alphabeta Varia Typographiae Sacrae Congregationis de Propaganda Fide

Ca. 1648
Paper
43 × 60 cm
Congregation for the Evangelization of Peoples,
Vatican City State
APF, SC Printing-office 1, f. 122

Some years after the foundation of Propaganda Fide, Emperor Ferdinand II of Austria made a gift to the Holy See of typographical characters in the Croatian Galagolitic script and, at the same time, requested a new edition of the Illyrian Missal. The letters arrived in Rome just as the Congregation of Propaganda Fide was discussing, in the presence of Pope Urban VIII, the suitability of establishing a printing office. Stefano Paolini and Achille Venereo were chosen as heads of the new office and, in 1627, Cardinal Bentivoglio was appointed as its first prefect. Within seven years of its foundation, the printing office possessed more than ten types of characters. However, notwithstanding the continuous progress made over the first twenty years of its activity, the printing office entered a period of deep crisis: a good superintendent was lacking and the books afforded little profit because they were distributed in missions free of charge.

It was in this difficult moment that Msgr. Francesco Ingoli, the first secretary of the Congregation de Propaganda Fide, stood up to defend the importance of his dicastery's printing office in publishing and distributing good books—above all catechisms and liturgical and prayer books—translated in the various languages of the mission territories.

Even during Ingoli's time, the printing office of Propaganda Fide had become one of the foremost foreign-language publishers in Europe. This document is proof of that, being a print test from around 1648 showing the twenty-one types of Oriental characters used by the Congregation's printing office. L.M.C.R.

"Terra Australis Quinta Pars Orbis"

1676
Vittorio Ricci, O. P. (1621–76), Manila
Paper, Indian ink
31.2 × 41 cm
Congregation for the Evangelization of Peoples,
Vatican City State
Archives, ref. SOCG 493, f. 242

Father Vittorio Ricci, O. P., was born in Fiesole in 1621 and died in 1676. He entered the Dominican Order in 1635. After taking his vows, he studied and taught at the convent of Santa Maria sopra Minerva in Rome before asking to be sent to China. He arrived in the Philippines in 1648, and in 1655 was assigned to the missions in China. After enduring many hardships while carrying out his ministry, he returned to the Philippines in 1666 where he was elected prior of the Convent of Saint Dominic in Manila. During his term as prior he wrote to the sacred Congregation of Propaganda Fide on June 4, 1676, informing them of

… a rare mission (…) I am trying to discover and enter the Southern land, that they call unknown, which is the fifth part of the world, a land that contains innumerable countries and nations, of which I am sending a rough sketch, and, since there is no part of the world belonging to the Catholic faith from which one could carry out the mission with more ease, or less difficulty, than here, as can be seen from the map, I therefore long to go to these places in order to give them news of God (it is such a deplorable thing that in such a vast expanded part of the world they have not yet heard the most holy name of God). Here in Manila there are certain native men from the first beaches of that land taken as slaves by the Dutch, who have discovered the land, and they are of a dusty color, and some negroes, men of valor and strength, and they say that one can walk in the interior of that land for more than two years without ever seeing the sea, and that there are white and red nations, like us, and it can be believed, because the land in that part of the South stretches as far as the Antarctic pole which corresponds to our Arctic pole.

With this document, the first known geographical map of Australia, and going on information received from the natives and the Dutch, Ricci tried to demonstrate that the Philippines was the best place for a missionary expedition to depart from for Australia. The map, with Australia in the center (*Terra Australis olim incognita — nunc ex parte cognita:* "Southern Land, once unknown — now in part known"), America on the right (*Pars Peru — Brasil:* "Part of Peru — Brasil"), the southern part of Africa at the lower center (*Africae pars*), and the Philippine Islands, Java, Borneo, etc., at the lower left, bears the following inscriptions: upper center: *TERRA AUSTRALIS Quinta pars Orbis* ("SOUTHERN LAND The fifth part of the Globe"); upper left: *Sacrae Congregationi* ("To the Sacred Congregation"); upper right: *de propaganda Fide* ("for the propagation of the Faith"); lower left: *Tabula haec cum in minimo puncto facta sit desunt penes innumerabiles Insulae, cum* ("This map being drawn on a very small scale, many islands are lacking, since"); center right: *finis noster sit tantum ostendere ubi sit Terra Australis et quanta* ("our aim is only to show where the Southern Land is and how big it is"); lower left: *Ex istis Insulis haud difficilis est aditus ad Terram Australem* ("It is not hard to reach the Southern Land from these Islands"); lower center: Manila 1676 ("Manila 1676"); lower right: *Humillimus Subditus Fr.Victs. Riccius Ord. Praedicat.* ("Your very humble servant F. Vittorio Ricci, O. P."). L.M.C. R.

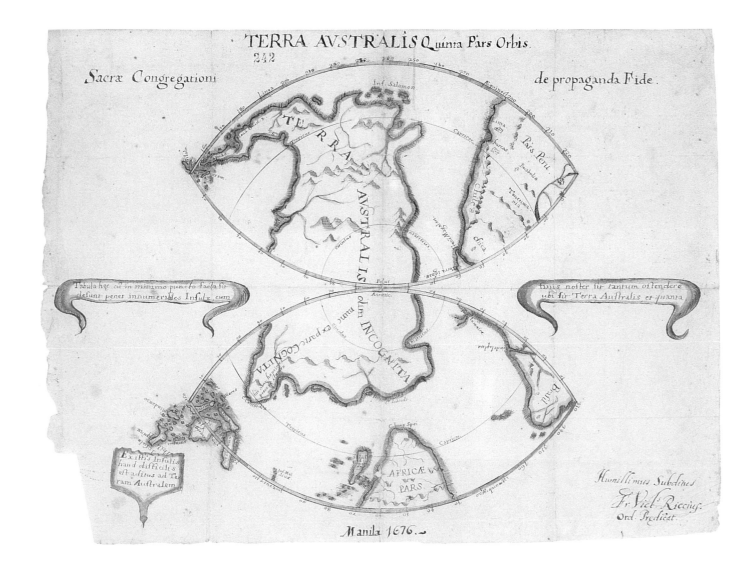

Letter in the Chaldean Language from Joseph, Patriarch of the Chaldeans

1717
Paper
34 × 45 cm
Congregation for the Evangelization of Peoples,
Vatican City State
APF, SOCG 612, ff. 82-87

Throughout the whole of the eighteenth century, Propaganda Fide gave active assistance to the Assyrian-Chaldean Church. In 1696 — following the resignation of Patriarch Joseph I of Diarbekir, who later moved to Rome — Patriarch Joseph II was elected. In 1708, he was forced to take refugee on Mount Lebanon and in 1712, two days prior to his death, he consecrated Patriarch Joseph III as his successor. During his long patriarchate (1712–57), Joseph III was imprisoned four times, exiled twice, and for thirteen years forced to live outside his territory.

For his part, from the year 1735 Patriarch Mar Elia XII of Babylon made it clear that he wished to unite with the Catholic Church. The numbers of Catholic faithful in his patriarchate grew steadily. His successor, Mar John VIII Hormisd, was elected in 1779 with the support of Catholics and Dominicans. Under him, full communion was restored between the universal church and the patriarchate of Babylon, which since the fifth century had gone its own way, expanding into China and Mongolia while putting ever greater distance between itself and the Catholic Church.

The document here, written in the Chaldean language and addressed to Pope Clement XI, illustrates some of the difficulties involved in continuing the work of evangelization and coexisting with the Eastern Churches: "we live among rapacious wolves … who day and night think of nothing but ways to shed our blood." It also includes references to economic problems: "this year they have caused us to lose a great deal of money in defense of the Holy Faith." L.M.C.R.

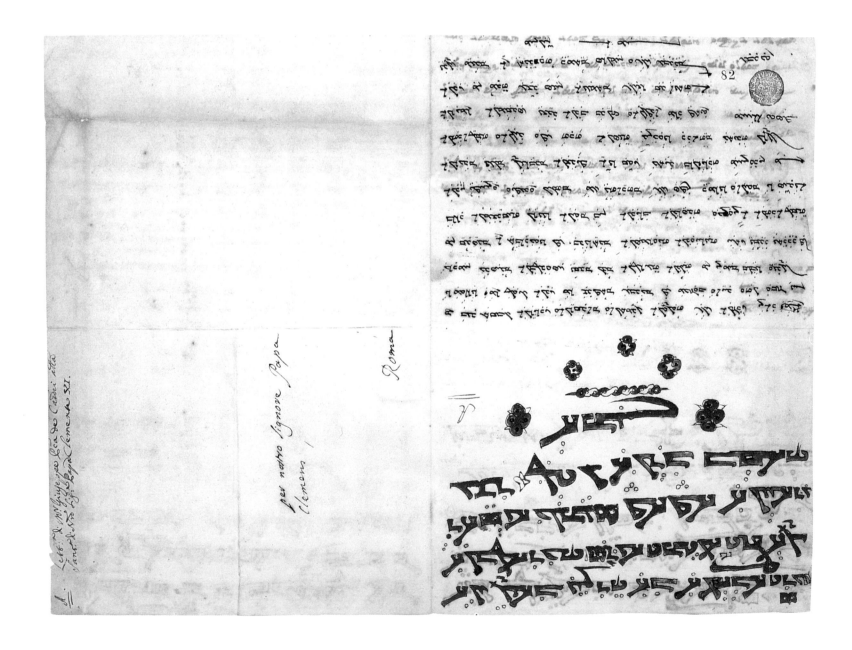

Letter in Arabic to Pope Urban VIII

1637
Matthias, Coptic-Orthodox Patriarch of Alexandria
Paper, pure gold
120 × 28 cm
Congregation for the Evangelization of Peoples,
Vatican City State
APF, SOCG 180, f. 352

Christianity entered Egypt in the age of the apostles.
According to tradition, it was Saint Mark himself
who brought the Gospel to the banks of the Nile,
where, sometime between AD 62 and 68, he was
martyred. No evidence of persecutions exists prior
to the third century, but at the beginning of the
fourth Egypt became a theater of violent conflicts.

This was the land where Arianism, the fourth-
century heresy that, in effect, denied the Dogma
of the Trinity, had its roots. Saint Athanasius, bishop
of Alexandria, was its most staunch opponent. In
later years, Nestorianism, the heresy that denied
that Christ had two natures (human and divine),
attributing to him only the human, was combated
by Saint Cyril of Alexandria, who helped prevent
its spread into Egypt. However, with the advent of
Monophysitism, which attributed only a divine
nature to Christ, a schism was created in Egypt that
continues to this day. At the Council of Chalcedon
in 451, Monophysitism was condemned as a
heresy and the Coptic Church came into being.

Egypt thus had four original Christian commu-
nities: Copts, or Monophysites; Greek Orthodox;
Coptic Catholics, who accepted the decisions of
the Council of Chalcedon; and Melchite Catholics,
Byzantine rite faithful of the patriarchates of
Antioch, Jerusalem, and Alexandria. This letter from
Patriarch Matthias of Alexandria to Pope Urban VIII
was written in 1637 and is a reply to an earlier
letter from the pontiff requesting news regarding
the spiritual life of Patriarch John. After offering
effusive greetings to the pope and making a lengthy
acclamation of Christianity, Matthias makes an
absolute profession of Christian Catholic faith,
although he also maintains that only God can know
the torment in the heart of a man. He concludes by
asking the Holy Father to join him in prayer. V.M.

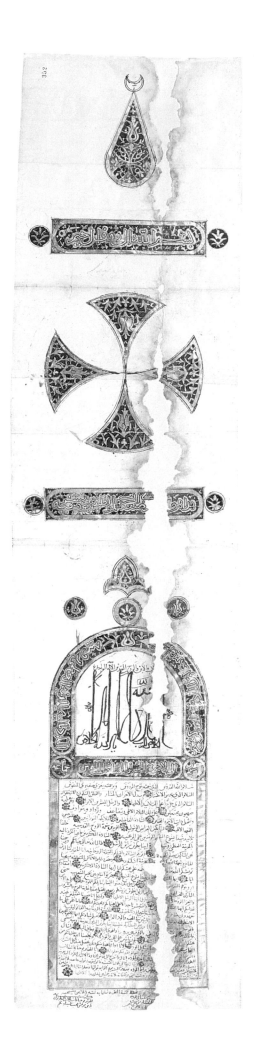

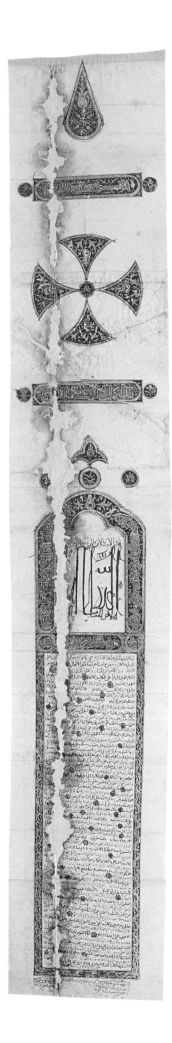

265

Letter in Arabic to Pope Urban VIII

1637
Matthias, Coptic-Orthodox Patriarch of Alexandria
Paper, gold
155 × 27 cm
Congregation for the Evangelization of Peoples,
Vatican City State
APF, SOCG 180, f. 345

In this letter Patriarch Matthias of Alexandria
praises the pontiff and the Holy Roman Church,
thanking Pope Urban VIII for having written him a
letter, delivered to the patriarch by Friar Arcangelo
da Pistoia.

Matthias writes at length about Alexandria
and the situation of the church, about pastoral
activities, and the joy of community life. It does
not appear that his letter had any particular aim,
save that of informing Pope Urban VIII about the
pastoral situation in Alexandria. V.M.

266

Geographical Map of Jerusalem up to Aleppo

1778
Arsenio Diab
Paper
51.5 × 69 cm
Congregation for the Evangelization of Peoples,
Vatican City State Archives, ref. SC Maronites
10, f. 323

The map is accompanied by a report, dated March
1778, which deals with "1st, Mt. Lebanon and its
inhabitants; 2nd, the city of Syria from Jerusalem
to Aleppo; 3rd, an exact list with a concise note of
the dioceses of the Maronite bishops." The author
of the report is a monk, Arsenio Diab, "agent" of
the bishops. It is addressed to the prefect of the
Congregation of Propaganda Fide, Cardinal Castelli.

This is the description the monk gives, among
others, of the city of Aleppo:

> The last city of Syria, and the most beautiful, and the
> busiest of the cities of Syria, and of all the cities of the East,
> three and a half days away from Antioch and four and a
> half days from the sea, and much desired both for its good
> air and for its beauty, and it is famous for the trade of
> merchants coming there from all parts of the world. Lastly
> it is a city in which the Catholic religion flourishes greatly,
> much more than in all the cities of the East. The total dis-
> tance from Jerusalem to Aleppo is nineteen or twenty days.

Ever since its foundation the Congregation of
Propaganda Fide has paid special attention to
the Holy Land. The Franciscans had custody of the
sacred places, receiving and assisting pilgrims who
came there and seeing to the spiritual care of all
the Latin faithful who for various reasons lived in
Palestine, Syria, Egypt, and Cyprus. Propaganda
Fide helped and encouraged the Order to organize
the activities of the custody. These common efforts
resulted in the statutes of the Holy Land drawn up
by the minister general of the Order, Father Raffaele
da Lugagnano, and approved by Pope Benedict XIV
on January 7, 1746, with the letter "In supremo."

The superior of the custody of the Holy Land
was known as the custodian, also called the
guardian of Mount Zion. It was stipulated that there
had to be a hundred and sixty friars (a hundred
priests and sixty lay brothers) living in the custody.
Before the seventeenth century, the Catholic clergy
was made up only of friars minor. From 1600,
Jesuits and Capuchins also began to arrive.
Propaganda Fide established that everybody had to
recognize the ordinary jurisdiction of the guardian
of the Holy Land.

At the beginning of the eighteenth century
the strong centralization brought about by the
patriarch was threatened. Through the students
of the Maronite College of Rome, and the Latin
missionaries in the country, the reforms of the
Council of Trent took a greater hold in Lebanon,

influencing the question of residence of the bishops in their dioceses. A deep crisis concerning discipline arose among the bishops and in 1709 developed into the "revolt" of the bishops against their Patriarch Aouad.

This is what Father Pietro di Moretta said in a letter addressed to the Cardinal Prefect of Propaganda Fide, written on February 18, 1778, and presumably sent with the map and the attached report. Father Pietro wrote from Bkirki and referred "things related to the Maronites and the nuns who had come out of the monastery."

In these countries all is confusion as far as ecclesiastical discipline is concerned. The chiefs are wretched and the people are worse. After having received the Pallium, the patriarchs think they have the authority to destroy any and all law, and the bishops do the same when they can. The Maronites have become the scum of the entire East. […] As far as I am concerned, if it were possible to gradually
remove *these Patriarchs or at least, when giving them the Pallium in the future, restrict their powers with some means able to keep them to their duty. […] The Maronite Patriarch recently ordained as a bishop an ignorant boy who was not yet and perhaps is still not yet twenty years old, and after a few days the bishop Gabriele of Baalbak ordained as a priest a man guilty of bigamy. It is true that unfortunately the Latin missionaries still have the upper hand, despite their bad example, and they are indirectly encouraging and applauding such disorderly behavior. In Aleppo our religious orders with the Latin and tertiary missionaries are pitiful, not yet having yielded to depriving them of that external cord, which causes so much trouble, and the Maronites cry out: why does our Patriarch have to obey Rome when the missionaries do not? […] If the Latin missionaries could agree with each other and there were somebody to handle them, one could hope for a very good outcome, or at least much evil would be avoided. But unfortunately they benefit from the fact that Rome is so far away, and from the air of freedom of these regions.* V.C.

Appeal to Pope Clement XI

1716
Emperor K'ang-Hsi of China
Rice paper
44 × 98.5 cm
Congregation for the Evangelization of Peoples,
Vatican City State
APF, SC East Indies and China 13, ff. 419–420

The question of Chinese rites marked the history of the Church in China during the seventeenth and eighteenth centuries. These rites included the ritual ceremonies that people celebrated in temples in honor of Confucius and their ancestors, as well as the usages and rites they practiced in veneration of their forebears at funerals, on tombs, or in the home, in front of a commemorative ancestral tablet. The question gave rise to many years of bitter conflict within the church, both among the missionaries and in Rome.

Some people considered the rites to be purely secular ceremonies, expressions of courtesy and gratitude toward Confucius and the forefathers, and did not attribute any religious significance to them. This was the opinion of the Jesuit Matteo Ricci, the pioneer of Catholic missions in China, who arrived in the country at the end of the sixteenth century. At his death in 1610, two thousand people had been converted to Christianity, four hundred of them in Peking. His missionary activity, characterized by the greatest respect for Chinese spiritual and intellectual values—"an apostolate of the pen and of conversion," as it was defined—was associated by some people with support for religious syncretism to the detriment of dogma. For example, contemporary Dominicans and Franciscans judged Chinese rites as equivalent to superstition and prohibited Christians from participation.

To end the conflict, the Holy Office published two decrees. The first, of September 12, 1645, banned the rites, a decision that all missionaries were obliged to respect. The second, of March 13, 1656, permitted the rites, yet without abrogating the decree of eleven years earlier. In 1669, the Holy Office made it clear that both decrees had to be observed "according to circumstances," but by then four years had already passed since the total ban on Christianity in China, and nearly all the missionaries had been transported to Canton, where they were held as "prisoners" in the Jesuit residence. It was necessary to wait until 1692 when Emperor K'ang-Hsi conceded the freedom to preach the Gospel in his kingdom.

On November 30, 1700, the Jesuits presented a memorandum to the emperor in which ceremonies in honor of Confucius and the ancestors were declared political and civil acts of courtesy. K'ang-Hsi approved the memorandum and had it sent to Rome; the following year it was also published in China. The year 1705 saw the arrival in Peking of the apostolic delegate De Tournon, who opposed the memorandum. In fact, some months previously, on November 20, 1704, Pope Clement XI had issued a decree prohibiting Christians from participating in "Chinese rites" either in public or in private. De Tournon published that decree in 1707.

In 1706, in response to pontifical pressure, K'ang-Hsi issued his own decree obliging missionaries to the "Piao," that is, to request permission from the emperor before preaching the Gospel in China, permission granted only to missionaries who promised to observe the Chinese rites. The majority of Jesuits and other missionaries who accepted the "Piao" appealed to Pope Clement XI against the 1704 decree. K'ang-Hsi himself sent the Jesuits Provana and Arxo to Rome to act as his legates and obtain the revocation of the decree.

The pope rejected the protests and on March 17, 1715, published the constitution *Ex illa die*, wherein he solemnly confirmed the decisions of previous decrees and imposed an "oath of observance" on all missionaries. The constitution was published in China in 1716. The missionaries made the prescribed oath, though many Christians refused to submit and continued to practice the rites.

The question of rites was only definitively resolved in 1742 with the publication of the constitution *Ex quo singulari* by Pope Benedict XIV, who confirmed the prohibitions laid down in *Ex illa die* and prescribed a new formula for the missionaries' oath.

The document on view dates to the period of disagreement between Emperor K'ang-Hsi and Pope Clement XI. It is written in three languages—Tartar-Manchurian on the left, Chinese in the center, and Latin on the right—and signed by Matteo Ripa and Teodoro Pedrini, missionaries of Propaganda Fide, and by fourteen Jesuits including Kilian Stumpf, José Suares, Gioacchino Bouvet, and Giovanni Francesco Foucquet. It is a circular letter addressed to "all those who have come from Europe" that they "may carry it with them." The authors recall the Jesuit mission in 1706 of Frs. Antonio Barros and Antonio Beauvolier, and that in 1708 of Frs. José Provana and Raimondo de Arxo, sent to Rome by Emperor K'ang-Hsi to oppose Pope Clement XI's decree banning Chinese rites. "Since then, for many years no response has been forthcoming, making it impossible to discern truth from falsehood and, indeed, receiving many confusing rumors," says the document. "If the men we sent were to return and if matters were entirely clear, then we could demonstrate the faith." The reference here is precise: K'ang-Hsi had banned from China all missionaries who had not accepted the "Piao," among them the apostolic vicar Maigrot. V.C.

Letter to Pope Pius IX

1847
The Faithful of Peking
Red silk
17 × 37 cm
Congregation for the Evangelization of Peoples, Vatican City State
APF, SC China and Adjoining Kingdoms 12, f. 474

In the history of the church in China, this document falls in the so-called period of religious tolerance (1844–1912), years marked by the reorganization and subsequent development of the missions. On the one hand, this was facilitated by greater religious freedom, beginning with the treaties with England in 1841 and fully accomplished by 1912, and, on the other, was favored by the French protectorate, by which France, following the treaties of 1844, safeguarded Catholic missions in the same way it safeguarded its own interests and citizens.

The important feature of this document is that it is written on red silk, a material used only for correspondence with the emperor. A letter addressed to the pope and written on red silk indicates that the pontiff was being accorded the same authority as the emperor. The translation of the document is as follows:

A letter from the Church of the South of Peking to the Holy Father,

Father Zhao, sent by the king of Portugal, arrived in China to work in the missions. In May 1847 he unexpectedly went to Macao. In June, Bishop Meng of Mongolia expelled him because of an act of disobedience towards the bishop of Propaganda Fide. Father Zhao has dedicated his entire life to the mission as a good shepherd. He has worked hard for the mission, but Bishop Meng, as soon as he arrived, began to gather up precious things. He revealed the secret of the confessional and gave rise to great scandals concerning communion. There was great confusion among the faithful and for this reason they have written a letter to the Holy Father asking that the Church of the South of Peking may belong to Portugal and that Fr. Zhao be consecrated bishop of Peking.
July 1847. V.C.

Nineteenth-Century Account of the Korean Christians

1811
White silk
17.5 × 38 cm
Congregation for the Evangelization of Peoples,
Vatican City State
Archives, ref. SC China and Adjacent Countries 3, ff.
837–838

Christianity was introduced into Korea through books coming into the country with the annual embassies to the court of Peking, of which Korea was a vassal. Some scholars began to study these books in 1777 and one of them, Pietro Ri seung-houn-i, was baptized in Peking in 1784. The mission, a unique case in the history of the church, was therefore begun by an enthusiastic group of laymen, even if already during the Japanese occupation (1592–99) some children were probably baptized on their deathbed by Japanese Christian soldiers. When the first priest, the Chinese Giacomo Tsiu, arrived in Korea he found a Christian population of four thousand faithful that had become ten thousand by the time of his death in 1801.

This letter, written in Chinese, reports the sorrowful situation of a persecuted Christian community without shepherds (and which would continue to be an orphan community until 1834) that tries to keep the faith it has received and that shows its great desire to have fathers in the faith. The carrier of the message had sewn this document into the leg of his trousers so as to be able to take it out of the country. He was caught, however, and murdered. Only after eighty years did the letter reach the hands of the missionary priest in his land.

L.M.C.R.

Letter to Pope Clement X

1671
King Michael Korybut of Poland
Parchment
28 × 48.5 cm
Congregation for the Evangelization of Peoples,
Vatican City State
APF, SOCG 430, f. 374

The region of "universal Poland" was part of the
Polish-Lithuanian State as it came to be formed
through the definitive political union of the
Kingdom of Poland and the Grand Principality of
Lithuania, agreed in Lublin in 1569. The ruler of
the united state bore the title King of Poland and
Grand Prince of Lithuania; nonetheless, in the
terminology adopted by the Roman curia, this
state was often simply referred to as Poland.

The Polish-Lithuanian State, though politically
united, was pluralist in national and religious
matters. Apart from Catholics of the Latin rite, there
were Christians of the Byzantine-Slav and Armenian
rites, Protestants of various denominations, Jews,
and Muslims.

In this letter, written in Latin and sent to Pope
Clement X through the apostolic nuncio, King
Michael Korybut of Poland "expresses the desire
to have, in that kingdom, a Capuchin mission."
He adds that "as concerns the founding of
Convents, it would be most appropriate to engage
the activities of Friar Giacinto di Tyminski, a Pole
who adopted the monkish habit in Paris and who,
with the permission of his superiors, has come
here to visit his relatives, being of noble Polish
family and a good religious … and of youthful
age, who may render a fine service to his Religion
with the talents he has."

From certain comments attached to the king's
letter we know that the cold climate was the main
reason for which the introduction of the "Capuchin
Religion" had been delayed up to that moment,
despite repeated requests: the low temperatures
rendered it impossible to walk barefoot. Thus, it
seemed appropriate to dispense with the rule over
this particular and allow the friars the possibility
"of wearing shoes."

Regarding the foundation of a mission, this
seemed more practicable "as the missionaries are
not obliged to arise during the night for Matins,
nor to leave their house more frequently than the
needs of their ministry require." As for Fr. Giacinto,
should any considerable difficulties arise due to his
youth, he could be assigned an older superior for
the necessary period.

The Polish king's letter is brief but cordial and
full of sentiment; a magnificent testimony of the
good relationship between the Church of Rome
and Catholic Poland. C.G.

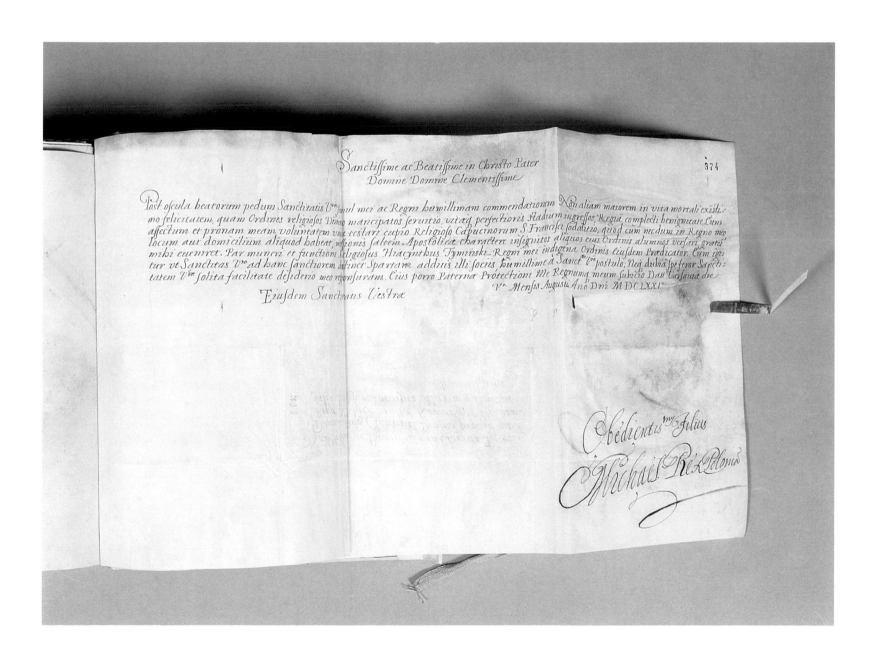

Illuminated Letter in Armenian to Pope Alexander VII

1661
James, Catholicos of Ejmiacin
Paper, pure gold
53 × 35 cm
Congregation for the Evangelization of Peoples,
Vatican City State
APF, SOCG 222, f. 89

Once Armenia became Christian in 313–314, through the efforts of Saint Gregory the Enlightener, consecrated bishop and appointed catholicos by Saint Leontius, exarch of Caesarea, the Armenian Church remained linked, through Caesarea, to the see of Peter. Following a misunderstanding that caused them to believe that the Council of Chalcedon in 451 had approved the Nestorian doctrine, the Armenian hierarchy broke off relations with Rome between 552 and 553. Communion was restored once the confusion was resolved, and full union of faith between the two churches was reestablished in 1198. The conquest of the Kingdom of Cilicia by the Mamlukes of Egypt caused another break in relations between the two churches, which were only restored with the union of the Council of Florence in 1439.

Although there was always a Catholic presence among the Armenians – many patriarchs of Sis and of Ejmiacin enjoyed cordial relations with the popes through the Congregation of Propaganda Fide, as is shown by some of the documents in this exhibition – the majority of Armenians remained dissident.

As there was no clear distinction between "nation" and "religion," the patrìks, the religious leaders of the Armenian dissidents, managed to obtain, from the sultan of the Ottoman Empire, jurisdiction over Armenian Catholics, obliging them to be baptized and receive the sacraments from dissident Armenian priests. In order to release them from the jurisdiction of the patrìks, Armenian Catholics asked Propaganda Fide to give them their own spiritual leader. It was only in 1830, after long negotiations, that the Congregation persuaded the Turkish empire to allow the creation of the Primatial See of Constantinople. Thus, a part of the Armenian Catholic community found itself under the jurisdiction of the primate, who also enjoyed civil authority, while the other remained under the patriarchate of Cilicia, which had been instituted in 1742.

In this document, dated September 28, 1661 (year 1110 of the Armenian calendar), and addressed to Pope Alexander VII, James, catholicos of Ejmiacin, tells the pontiff of the difficulties faced by the Armenian Church in living a Christian life in the Turkish Empire:

> … we live under the yoke of foreigners. And although we hope — even being among enemies of the cross of the Savior — that the name of Christ must not needs be vilified but rather raised and glorified, and that there will be occasion to celebrate, we together with you, as members in Him; yet nonetheless, finding ourselves for our sins presently under the dominion of cruel, violent and terrible beasts, we live in much affliction and our hearts are oppressed by unbearable woe.

The strong and clear language expresses the anguish in which Armenian Christians lived under Turkish domination. Yet, it is also manifest that simply having the chance to communicate the difficulties and suffering of the Armenians to the pope, father and pastor of the universal church, was itself a source of solace.

> Finding ourselves, thus, amidst such anguish, and receiving no true comfort to our afflictions from any other quarter, we come to express them to Your Holiness that, with our hearts strengthened, we may thus receive some alleviation as you share the sorrow of our afflictions, having compassion for our people as bones of your bones and limbs of your limbs. Do not deny us your paternal mercy, because non sumus advenae, but the price of the Blood of Christ and sheep of His Flock, and we continue to give glory among these foreign people.

L.M.C.R.

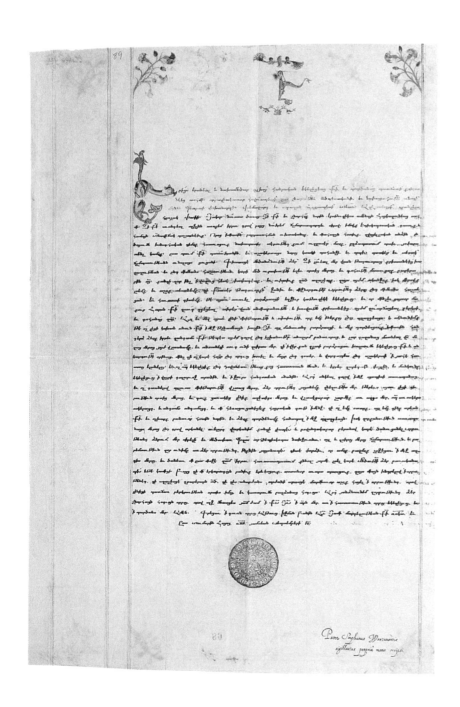

Illuminated Letter in Armenian Expressing the Complaints of a Group of Bishops and Pilgrims at Being Attacked by "Latin Pirates"

1687
Paper, pure gold
59 × 38 cm
Congregation for the Evangelization of Peoples,
Vatican City State
APF, SCOG 500, f. 210–211

This illuminated document in Armenian falls into a particular historical context, that of a Mediterranean infested by "Italian" corsairs. The letter, dated 1687, recounts the dramatic situation in which a number of bishops, together with other priests and pilgrims, found themselves on two different occasions.

Elia, the Armenian bishop of Bethlehem, was sent by Msgr. John, bishop of Saint James of Jerusalem, to present, on behalf of priests, religious, and all the Armenian people, this description of the intolerable treatment suffered at the hands of the corsairs.

It was customary for both eastern and western Armenians to make a yearly pilgrimage by ship to visit the Holy Sepulcher. In the course of the voyage they could be attacked by pirates, stripped, wounded, and sometimes even killed. This letter describes two firsthand experiences of suffering undergone by the bishops who sign the document and their faithful.

Two ships returning from Palestine were taken by pirates from Livorno. The vessels were carrying more than three hundred pilgrims, including seven bishops, twenty-one priests (of whom two died), and "four secular clergy and six women." After having suffered iniquities that the authors of the letter "abhor to mention as unworthy of the name Christian," they were robbed and left naked.

The other case is similar. A vessel was carrying the bishop of Saint James on his return from Rome. After having "enjoyed the privilege of being admitted by His Holiness to the number of the twelve whose feet His Holiness washes on Holy Thursday," and having secured a passport written for him by Cardinal Cybo, he embarked with two hundred other Christians of his rite. They were attacked by vessels bearing the flags of Malta, Poland, and Venice. The women were stripped and mistreated; the bishop's passport was disdainfully thrown to the dogs by the pirates, who also tore up the passport of the French ambassador who was traveling with him; the gold and silver medals donated to the bishop by the pope were taken, as were two rings and the sacred ornaments; the goods of all the other pilgrims were ransacked. The travelers were then held for thirty-three days with bread and water before being abandoned, naked and adrift at sea, for fully five months. They arrived in Jerusalem in time for Easter.

As it says in the summary, which illustrates what is written in the letter, "they have thus resolved to send Msgr. Elia, in the name of all of them, … to describe their suffering and beseech that measures be taken to ensure that in future they are not forced to undergo similar oppression." They request the pope to publish a bull or papal brief condemning those who practice these cruel and wicked deeds against the Armenian people. C.G.

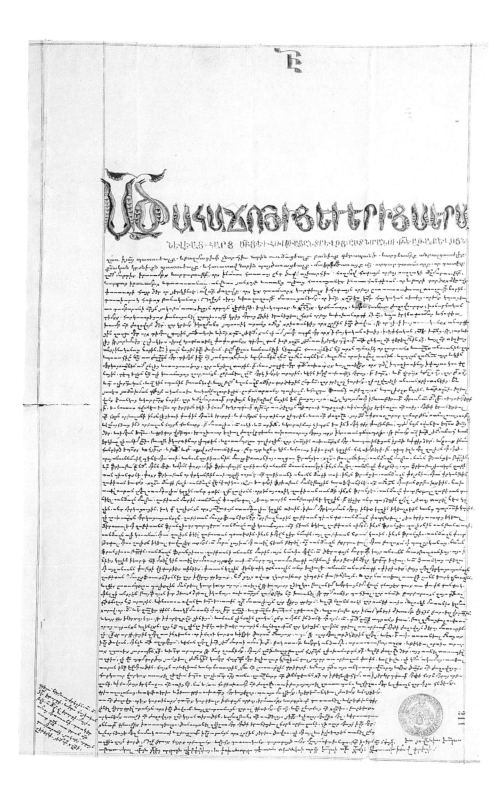

Letter in Greek Requesting the Pope's Help Against the Turks

1672
Paper
31 × 42 cm
Congregation for the Evangelization of Peoples,
Vatican City State
APF, SOCG 441, ff. 406–407/414–415

At the time Propaganda Fide was founded, in 1622, the prospect facing the institution in the Middle East was truly desolate: few episcopal sees, few missionaries, few Catholics. In Candia (modern-day Crete), as in other parts of the Middle East, a Latin hierarchy was established with various bishoprics, but little progress was made in recruiting faithful from among the locals. Once Venetian domination (ca. 1210–1669) came to an end Catholics left the island, as they had already begun to do during the long war with Turks. Thus was the turbulent situation in 1672 when this letter

was written (originally in Greek) and signed by two bishops, fourteen abbots, and six priests of the island of Candia.

Following the traditional metaphor of Christ-Sun whose rays illuminate the darkness of the night, symbol of the impiety of the followers of Islam, the authors of this document invoke the assistance of the pope to defend them against the "repugnant and barbarous people," servants of the "lunatic Muhammad." They complain of the ferocity of the Turks, especially toward the children "violently abducted … and forced to repudiate the faith of their fathers." Using the incisive image of Jesus, the Good Shepherd, they launch a heartfelt appeal to the pope: "Defend and protect your flock, … assailed by the vicious wolf of the foul Ishmael. Come to our aid as a watchful shepherd and drive the rapacious wolf from our holy and mystical (land). Remember the mercy of Christ, the Supreme Pontiff, who did not abandon the sheep who did not stray to go in search of those who did."

The tone of the letter is so compelling and dramatic because of the overwhelming isolation and fear in which the Christians of all "unhappy Candia" were forced to live. "We supplicate Your Holiness not to delay in delivering us from slavery to the barbarous infidels." It is interesting to note that the pope is requested to unite with the kings of the west against the Muslims.

At the end of the document there is an additional note in which the signatories certify that the king of Libya "has arisen against the impious Ishmael, he has seized the body of their Muhammad and now gathers people from all parts against him; thus, now is the propitious moment." The request addressed to the pope was, then, supported by the political situation, which the priests felt appropriate for an effective intervention by the Church of Rome.

In reality, it was only in 1874 that the episcopal see of Candia, with residence at Canea, was reestablished. C.G.

Letter to Michael Plunket

1681
Saint Oliver Plunkett (1629–81)
Paper
30 × 42.5 cm
Congregation for the Evangelization of Peoples,
Vatican City State
APF, SC Ireland 1, ff. 455-456

Saint Oliver Plunket was born in Loughcrew,
Ireland, and moved in 1645 to Rome, where he
studied at the Irish College and La Sapienza
University. He was ordained a priest in 1654
and, unable to return to Ireland because of the
Cromwellian persecutions, became a professor at
the Urban College of Propaganda Fide, consultant
to the Congregation of the Index, and procurator
of Irish bishops. Elected as archbishop of Armagh
and primate of Ireland, he was able to return to
his see only in 1670. Forced to exercise his ministry
in hiding because of anti-Catholic persecutions,
he was betrayed and arrested in Dublin in 1679.
He was taken to London, condemned to death for
"high treason," and hanged, drawn, and quartered
on July 11, 1681.

This letter, excerpts of which are given below,
was written by Saint Oliver Plunket in English
interspersed with some Latin and Italian. The
document, which gives us a glimpse of the saint's
resolve and spirit with which he faced death, was
written during his imprisonment in the Tower of
London a few days before his martyrdom. It is
addressed to a relative, Michael Plunket, a student
at the Urban College:

> Sentence of death [...] against me [...] il che non mi
> spaventò niente ne mi levò un quarto di sonno. I am
> innocent of all reasons [...] I dye most willingly, ed essendo
> il primo degli Ibernesi, con la gratia di Dio darò buon
> esempio alli altri di non temere la morte, but how am I a
> poore creature [...] I have considered [...] Christ [...]
> meritò a me d'esser privo de paura. I was refused sufficient
> time to bring me wittnesses and records from Ireland.

He continues the letter with an expression of
gratitude for everything Catholics had sought to
do for him:

> The English Catholics were here most charitable to me,
> they spared neither money nor gold to release me, and in
> my tryall, did for me all that even my brother would doe.

It is encouraging, finally, to discover how readily
he faces his imminent martyrdom, even knowing
the details of what will happen to him:

> I expect dayly to be brought to the place of execution where
> my bowels are to be cut out, and burned before my face,
> and [...] my head to be cut off [...] Death I embrace
> willingly. Cupio dissolvi. I did expect yesterday to be
> brought to execution, but finding I am not to be brought
> to it untill friday or saturday, I thought to write to you
> these few lines.

> L.M.C.R.

Letter of Cardinal John Henry Newman to Cardinal Giovanni Simeoni, Prefect of Propaganda Fide

1881
Cardinal John Henry Newman (1801–90)
Paper
26.5 × 20.5 cm
Congregation for the Evangelization of Peoples,
Vatican City State
APF, SC Anglia 22, f.321

John Henry Newman was born to a Protestant family in London, England, on February 21, 1801, and died in Edgbaston on August 11, 1890. The decisive point of his youth was his "first" conversion at the age of sixteen. From 1817, he was a student at Oxford, becoming a bachelor in 1820 and a fellow of Oriel College two years later.

He was ordained an Anglican deacon in 1824 and appointed as a tutor at Oriel College in 1826. In 1828, he became curate of the church of Saint Mary. His friendship with R. H. Froude was a decisive factor in his life and the two undertook a journey to the Mediterranean and Italy. Newman went on alone as far as Sicily but there he fell gravely ill with a fever. He returned home in July 1833 and heard J. Keble's sermon on "national

apostasy," the first expression of the nascent Oxford Movement.

Newman sought to reconstruct an Anglican theological tradition by going back to the Fathers of the Church and the English theologians of the seventeenth century. The doctrine of the "three branches" of the universal church is largely his. Of these three branches — Roman Catholic, Greek, and Anglican — the last is presented as being a "middle way" between Protestantism and Catholicism. Against Protestantism he affirmed the principle and authority of tradition, and against Catholicism he condemned and rejected abuses and innovations. During this period, following historical studies on early Christianity, above all on the Arians of the fourth century, he began to put this "middle way" in doubt. Finally, in the 90th Tract for the Times, he openly declared his sympathy with Catholicism, in favor of which he sought to interpret the thirty-nine articles of the Anglican confession. Condemned by Oxford University's Hebdomadal Board and denounced by forty-two bishops, Newman resigned his parish. He retired with a number of friends to Littlemore, where he revised the "Essay of Development of Christian Doctrine" and matured his conversion to the Catholic Church, into which he was received on October 9, 1845. In 1846 he was sent to Rome to study with Msgr. Wiseman and completed his Catholic training at Propaganda Fide's Urban College, where he received priestly ordination from the prefect of the dicastery, Cardinal Fransoni, on May 26, 1847.

With encouragement from Pope Pius IX, he founded the religious congregation of the Oratory of Saint Philip Neri in England, and in 1854 was appointed as the first rector of the Catholic University of Dublin, a position he held until 1858. His life as a Catholic was also embittered by failures and misunderstandings but Newman remained faithful to the church, undertaking his work, the defense of truth, with writings that gained for Catholicism the sympathy of Anglicans, and for himself the admiration of his adversaries. The shadows faded from his life in 1879 when Pope Leo XIII made him a cardinal, thus recognizing his genius and doctrine.

The document on display is a letter dated May 23, 1881. Cardinal Newman writes: "This morning I received Your Most Reverend Eminence's gracious letter and, with it, the Apostolic Constitution in which the Holy Father's condescendence honored me. For both of these, I pray Your Eminence accept my most deeply felt thanks and, humbly kissing Your hand, I have the honor to be Your Eminence's most humble and devoted servant. John Cardinal Newman." The Apostolic Constitution mentioned by Newman is "Romanos Pontifices," written by Pope Leo XIII, to regulate the relations between the ecclesiastical hierarchy and religious, especially those involved in pastoral care. Thereafter, the constitution became a norm for canon law on

Report On Recent Civil Wars in the Congo — Portrait of Kimpa Vite

1710
Friar Bernardo Da Gallo O.F.M. Cap.
Paper
27 × 37 cm
Congregation for the Evangelization of Peoples,
Vatican City State
APF, SOCG 576, ff. 290-315

Propaganda Fide's greatest field of missionary endeavor in Africa during the eighteenth century was the prefecture run by Italian Capuchins in the Congo, Matamba, and Angola. This territory belonged to the diocese of the Portuguese padroado and, from 1626, the ordinary had his residence in Luanda. Portugal paid the Propaganda Fide missionaries' travel expenses from Lisbon to Luanda. The biggest obstacle to the complete evangelization of the Congo and the adjacent kingdoms was the lack of missionaries. Other impediments included the anarchy to which the civil wars had reduced the country and the so-called Antonine sect, a national political-religious movement founded by Kimpa Vite, a twenty-year-old Congolese woman whose aim was to reestablish the past glory of the kingdom and to africanize the Christian religion. The movement dissolved when Kimpa Vite was condemned to death at the stake.

To make up for the lack of missionaries, the Capuchins fell back on the collaboration of catechists who, at the same time, acted as interpreters. A further impediment to missionary work was the slave trade in which westerners, not excluding a number of the missionaries themselves, were implicated. As a remedy, Propaganda Fide insisted, to no avail, on the necessity of creating a seminary for local clergy at Luanda.

The document on view here, a long "Report on the recent Civil Wars in the Kingdom of the Congo, on the battle of King Don Peter IV and of his victory against the rebels, and on the schism in the faith caused by a woman who feigned to be Saint Anthony, happily resolved by her death," was written by Friar Bernardo Da Gallo during his stay in Rome after having spent eleven years as a missionary in the Congo. The occasion to write the report arose with a visit Da Gallo made to Cardinal Sacripanti, then prefect of Propaganda Fide, and a later audience conceded to the missionary, through the good offices of Cardinal Sacripanti, by Pope Clement XI. During the audience, the pope asked Friar Bernardo to write a full account of "everything concerning the said missions: in other words, the good that is done for the spiritual consolation of the Holy See and the needs that exist." He wrote a long report dated December 12, 1710, and entitled "Account of work in the Mission of Angola" and, five days later, on December 17, the report on display here.

The first information the missionary received concerning Kimpa Vite came from an African lay helper,

who served the missions; he told me that there had appeared a person called Saint Anthony, … and they say she is a woman, not the old woman but a young one, who works miracles; and where she passed as she climbed the mount, curved and fallen trees were straightened. Now she is in the palace of the king where she confirms everything the old woman said against you; affirming that you are deceitful and do not wish there to be saints in the Congo.

The informant goes on: "She is preaching against you, against the Pope, and many other things against our Holy Catholic Faith."

While the king found himself in difficulty, not knowing whether or not to believe the woman, she continued to take advantage of his indecision and her impunity to further her own aims, casting "spells, idols they brought her together with crosses, … seizing the opportunity to claim to be a saint, to make sermons, prophecies and threats."

Finally, the king decided to let her be interrogated by Friar Bernardo, who came away with a negative impression, describing the woman in the following terms:

Considering that she walked upon the toes of her feet, not touching the ground with the soles; that she moved her hips and her whole body like a snake; that she held her neck stiff as if possessed; that her eyes protruded and that, finally, her speech was frenetic and delirious to the point that I little understood what she said, and her every act was awkward and unseemly, I did not believe that these were mere simulations but, indeed, that the Devil dwelt within her.

The woman and her followers created division within the church as well as political problems in the kingdom and it was for these reasons that Kimpa Vite was condemned to death. As the document says:

The people were, then, brought together on that Sunday July 1, 1706 and the condemned were brought into the square among the people. The judge appeared and himself publicly declared the sentence against them, that they be thrown alive into the flames, stressing once more the atrocity of the crimes against the Crown and the Faith for which such dreadful severity was being shown. In the meantime, Fr. Luca and I stood waiting that, once the judge's speech was finished, we could assist the souls of those wretches who were about to die. Yet this was not possible for us. … Once the speech was finished and the judge had retired, the ministers and the mob assailed them like so many bull hounds and, dragging them over the ground, I know not how the dust, the pain, the weight of people and the deafening cries did not kill them before reaching the scaffold. Yet, once arrived, and more dead than alive, they were tied fast and thrown upon two heaps of wood not far the one from the other. The fire was lit and soon after, in the space of a Hail Mary, they gave up their

souls, one with the name of Jesus, the other with that of the Virgin Mary — or so I was told — and soon were reduced to ashes. The wretched false Saint Anthony who used to die only to arise again, that time died and arose no more.

Of particular importance in the document on display, apart from the text itself, is the portrait of the woman concerned, Kimpa Vite, the only one that exists in the world. L.M.C.R.

423

Missal Stand

Late 15th – early 16th century, Cuba
Wood, fish spine, tortoiseshell
31 × 37 × 8 cm
Vatican Museums, Vatican City State
Inv. 8879

This shell-shaped lectern is carved from a single block of wood. The fanlike form is inlaid with a radiating pattern of thin strips of fish spine and tortoiseshell, fixed in place by numerous pins. These pins, also of wood and fish spine, are arranged so as to contrast with the color of the strips. The base upon which the missal rests is perforated by a wide hole, perhaps originally used to fix a pedestal. This base is cylindrical and has three sections; however, only the central part is inlaid while the two side sections — their extremities decorated with engraved spiral patterns — have striped black and white designs in vegetable pigments that simulate the inlay.

The inventory entry for this object, which was donated by the Augustinian Fathers of the Assumption to the Pontifical Missionary Ethnological Museum in January 1936, reads as follows:

> *Caribbean indigenous work from Cuba. It once belonged to Fra Bartolomeo de las Heras who was chaplain to Christopher Columbus on his first voyages of discovery in the Americas. Later, Fra Bartolomeo — according to las Heras family tradition — remained many years in Cuba in order to evangelize the Caribbean tribes. This lectern passed from generation to generation on the female side of the family and was given to the donor by his mother, Doña Ana Moulin y Sabon de Morel, born in Santiago in Cuba. She had been given it in her turn by Don Federico de Mora, advocate general of the supreme court of the Republic of Cuba, who had himself received it from a relative who was a descendent of the las Heras line that had remained in Cuba.*

The sources on Columbus affirm that the first religious (around a dozen) to land in the New World only arrived in the course of Columbus' second voyage (1493–94), under the leadership of Fr. Bernardo Boyl, a Benedictine of Catalan origin and apostolic vicar of Hispaniola (Dominican Republic — Haiti). Thus, it may be assumed that Fra Bartolomeo de las Heras, to whom this lectern belonged, saw the Antilles for the first time on that occasion.

According to documentation kept in the Vatican archives, this lectern is to be considered as "Caribbean indigenous work from Cuba." However, it has no indigenous stylistic traits or iconography; nor can it be attributed to the Carib or Caniba, the inhabitants of the Lesser Antilles who were in perpetual conflict with the inhabitants of the Greater Antilles, the so-called Taino. All these groups were aborigines of the Arawakan linguistic group, originally from the Orinoco-Amazon basin.

On the basis of archaeological documents, it can be affirmed that the center of Taino cultural influence was in Hispaniola and that they reached their greatest population density on that island, only fleeing to eastern Cuba after the Spanish Conquest. Furthermore, it would appear that it was in Cuba, before the other islands of the Antilles, that a form of hybridization between indigenous and European cultures arose, with the further addition, after the arrival of the first slave contingents, of African culture. Parallel to this, and going back to pre-Columbian times, were phenomena of transculturation that gave rise to forms of religious syncretism that are still alive in Cuba today.

It may thus be supposed that this lectern was carved by an indigenous craftsman working on a European commission and using both local materials, such as the wood and the tortoiseshell, and imported ones, such as fish spine. Although it may be classified as an example of colonial sacred art of the Renaissance period, the object does not present any outstanding religious characteristics, apart from its function and its shell-like form, the shell being symbolically associated in Christian iconography with Resurrection and eternal life. The shell also had an important symbolic meaning for the Indians of the Antilles, linked as it was to the cults of water and fertility. D.Z.

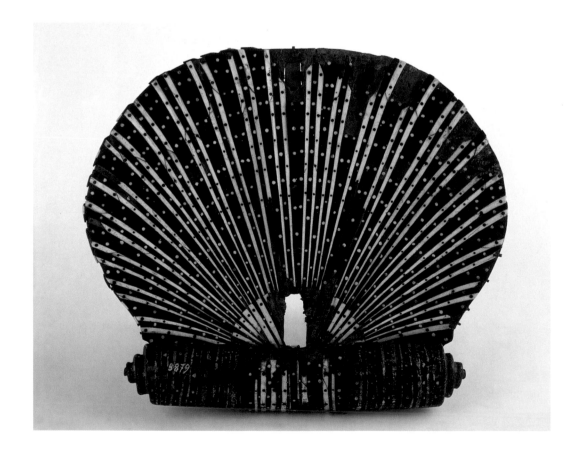

Saint Joseph

End of the 17th century
Pilar, Paraguay
Painted wood
56 × 22 × 16.5 cm
Vatican Museums, Vatican City State
Inv. A7040/m

The unmistakable iconography, like the flowering rod, symbol of virginity, and the Child in the arms, indicate that this is Saint Joseph, spouse of Mary and the putative father of Jesus. Two elements, which are materially absent but of which traces remain, serve to underline the sanctity of the person represented. On Saint Joseph's head, in fact, is a hole that clearly indicates the joining of a halo. On the top part of the globe held in the left hand of the Child, another fracture refers to a small cross, which indicates, as is typical of analogous iconography, that this is Jesus and that the globe is the world redeemed by the death of Christ on the Cross.

The sculpture comes from Paraguay, more specifically from the area of the Jesuit missions, and dates from the end of the seventeenth century. A similar statue is to be found in the Museum of the Assumption, House of Independence, in Asunción. The statue there is almost an exact replica with a silver halo and a cross over the globe. This statue was donated by President Alfredo Stroessner of Paraguay to Pope John Paul II on October 12, 1979, on the occasion of the papal visit to that country. Today it is preserved in the Museum of Missionary Ethnology of the Vatican. R.Z.

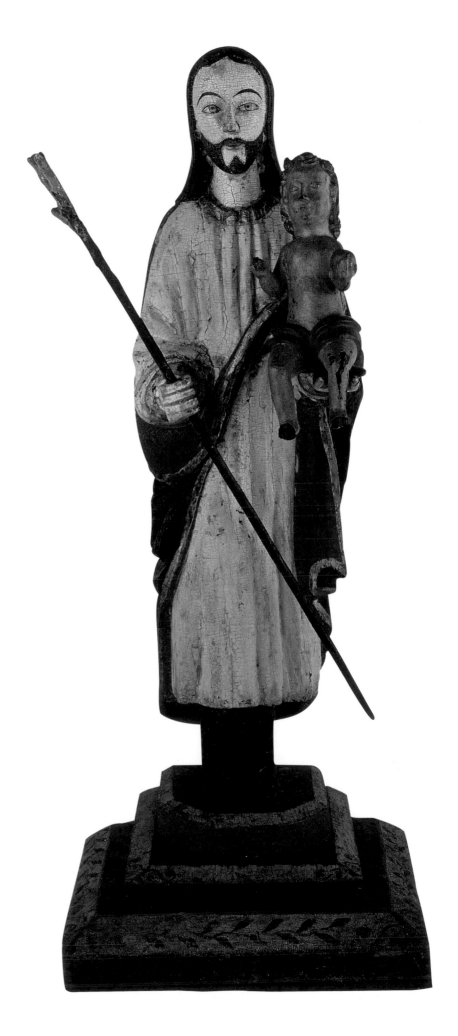

Processional Cross

End of the 20th century
Wood
247 × 32 × 32 cm
Office of the Liturgical Celebrations of the Supreme
Pontiff, Vatican City State

This ebony processional cross, a gift to Pope John Paul II, has a richly carved surface. The lower shaft is modeled in the form of a serpent winding round the shank, and the central section is wrought with elaborate intaglio carvings that rise up the staff. Starting from the bottom, these carvings represent a group of serpent heads with the papal keys; four rings enclosing an anteater, a chameleon, and a scorpion; four African figures bearing shields; three globes engraved with figures and faces; four more African figures in various poses; and rings enclosing an eagle. The crossbar of the crucifix curves slightly downward, and the figure of Christ has African features. Below the cross is a narrow handgrip carved with leaves and fruit.

During his many trips to foreign lands, the pope frequently receives gifts that express the culture and traditions of those he is visiting. This processional cross was undoubtedly fashioned by a local craftsman and was used in the mass celebrated by the pope on his trip through Africa. Regrettably, there is no record in the Pontifical Sacristy to help identify either the country of origin of the piece, or the particularly journey during which the pontiff received the gift. Nevertheless, the cross attests to an important fact underlined by the Second Vatican Council, namely, that Christianity is a universal religion and as such is valid for all humanity. Consequently, it is appropriate that the forms of ritual take account of local cultures and traditions, a process of cross-acculturation to which this piece bears eloquent witness. R.Z.

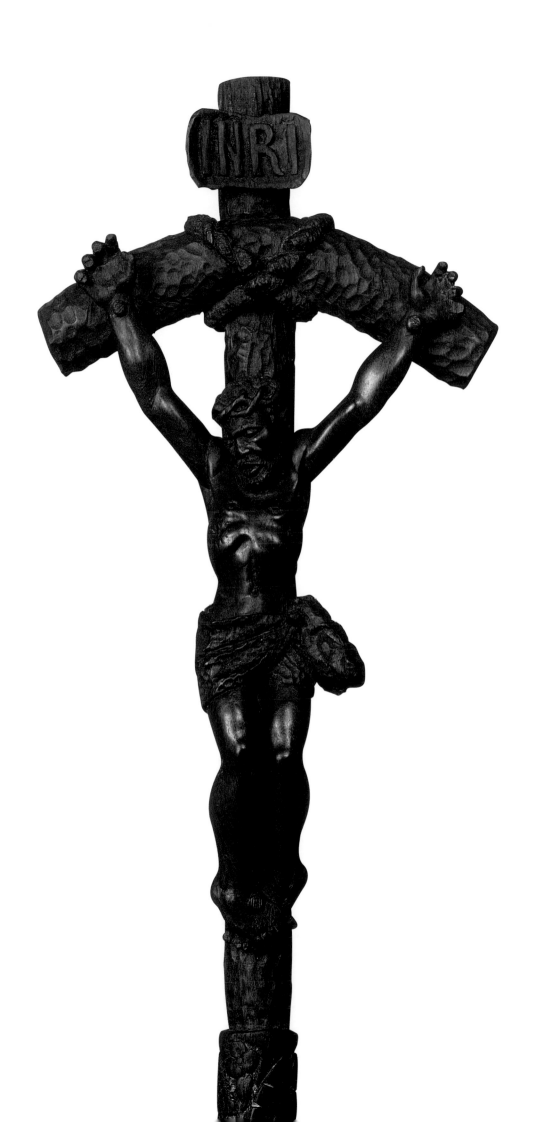

427

Drawing of the Church of Saint Francis di Pera in Constantinople

Ca. 1639
Paper
29 × 41 cm
Congregation for the Evangelization of Peoples,
Vatican City State
APF, SOCG 163, f. 259

Constantinople, the Byzantium of old, was founded in 658 BC by a colony of Megara. It was almost completely destroyed by Septimius Severus in AD 196 but soon after rebuilt. It took the name of Constantinople in 324 when Constantine chose it as the capital of the Roman Empire with the title of the "New Rome." Its present name, Istanbul, derives from a Greek phrase meaning "toward the city."

A point of transit between Europe and Asia, the city's greatest splendor fell in the period between the death of Justinian (565) and the death of Basil II (1025). From that moment an irreversible decadence set in: in 1204, Constantinople was sacked by the troops of the fourth crusade and in 1453, under the dynasty of the Palaeologi, it fell to the sword of the Ottoman Muhammad II.

Nonetheless, it was thanks to the Ottoman Turks that during the sixteenth century Constantinople regained its ancient splendor, although only for a brief period, until 1566. There then followed a period of political and military decadence that lingered on to 1922. The proclamation of the republic in 1923 divested Constantinople of its status as capital city, which was transferred to Ankara.

The Christian origins of Byzantium are obscure; given the city's geographical location it may be supposed that Christianity penetrated in the period between the first and second centuries. Later, the city was no stranger to the controversies arising from Arianism and other heresies.

From 381 to 451, Constantinople was a patriarchate, thus taking its place alongside the four that already existed: Rome, Alexandria, and Antioch (which had been established as such during the reign of Diocletian), and Jerusalem. However, in June–July 1054, a great dispute arose between the Patriarchate of Rome and that of Constantinople (the Eastern Schism), and the latter continued to exist in complete autonomy.

This drawing dates to the period in which the Ottoman Empire began to disintegrate. Although the church of Saint Francis di Pera probably pre-dates 1639, it was in that period that Propaganda Fide financed its reconstruction. For this reason drawings and plans of the restoration of the church and of the adjoining convent were sent to the Congregation. V.M.

Drawing of Twenty-Two Survivors from the Wreck of a Vessel bound for Angola

1674
Fra Giovanni Antonio di Monte Cuccolo, O.F.M.
Cap.
Paper
22 × 31 cm
APF, SOCG 457, ff. 342r-344v (report) and f. 375
(drawing)

Under the guidance of Propaganda Fide, the most
important apostolic activity in the Congo was
begun by Capuchins in 1645 under the prefecture
of Bonaventura d'Alessano with the assistance of
the former general, Tiburio de Redin, who had
become a Capuchin lay brother with the name
Francesco de Pamplona. Until 1700, more than
180 Capuchins, most of them Italian, worked in
the Congo, Angola, and Matamba, performing
several hundred thousand baptisms.

This drawing, which shows how twenty-two
survivors from a shipwreck managed to save
themselves, forms part of the report submitted by
Fr. Giovanni Antonio di Monte Cuccolo, O.F.M. Cap.

On July 16, 1674, a convoy of three vessels left
the port of Lisbon, bound for Angola. The first ship,
Capitana, was carrying 170 people, among them the
bishop of Angola, Msgr. Antonio dello Spirito Santo
O.C.D., and Pietro Cesare di Maneses, who had been
appointed governor of Angola. The second vessel,
Almirante, carried a hundred persons, among them
eight Jesuit fathers destined for the company's
college in Luanda. Finally, the third and smallest
craft carried forty-five people, including six
Third Order Franciscans, also destined for the
convent in Luanda.

On the night between November 18 and 19,
tragedy struck and the two largest ships sank in
the storm, with only the witness and twenty-one
others surviving. They undertook a perilous,
thirteen-day voyage in a longboat before reaching
Benghella, a Portuguese possession, on November
30, feast of Saint Andrew the Apostle. After having
received assistance they were joined by the third
vessel, which had been delayed by the storm, and
managed to reach Luanda shortly thereafter.

As the author indicates in his account, of the
more than 150 people embarked on the *Capitana*,
only sixteen or eighteen survived, the rest falling
prey to the sea or the natives. L.M.C.R.

Martyrdom of Lorenzo Ruiz and His Companions

1981
Raffaele del Casal
Oil on canvas
152 × 78 cm
Congregation for the Evangelization of Peoples,
Vatican City State

Conservation courtesy of Ellen and John Grimes

This portrait represents the martyrdom of the first Philippine saint, Lorenzo Ruiz, who left from Manila for Japan in June 1637 and was murdered with his companions in September of that year in Nagasaki, under the government of the shogun Tokugawa Iemitsu. At that time, there was a persecutory regime acting against Christianity, which was considered a threat to the nation. When Ruiz's ship reached the island of Okinawa, it was sighted by the Japanese, who took Ruiz prisoner along with the entire crew. He was then taken to

Nagasaka and subjected to torture so that he would renounce the Christian faith. This scene shows Ruiz, clad in western clothes, in the center, undergoing torture, along with his traveling companions, the Dominican fathers.

Ruiz, born in Binondo, near Manila, of a Chinese father and a Filipino mother, a scribe by profession, married and the father of three children, fled from Manila because of problems with the law (he was involved in criminal activities) and joined a missionary expedition. Captured by the Japanese, he suffered torture and at first abjured Christianity. Encouraged by his companions, he subsequently repented and was condemned to be beheaded. He professed his faith in Christ until the very end. Together with the central figure of Ruiz, whose rosary is held by the Spanish Dominican Miguel de Aozaraza (later beheaded), the scene represents the elderly Dominican F. Antonio Gonzalez (in the lower-left corner), who later died in prison, held by F. Guglielmo Courtet (also beheaded). To the right, another martyr, the Japanese Dominican Vincenzo della Croce Shiotsuka, undergoes torture by which water was forced down the throat through a funnel before being expelled by sudden compression of the stomach. Further down can be seen a tub, an instrument of torture with which suffocation was induced.

Besides Ruiz another lay person undergoing martyrdom for Christ was the Japanese Labaro, born in Kyoto, who can be seen here holding a small crucifix beside Aozaraza. Repenting of his retraction of the Christian faith, he then continued to declare his faith until he was beheaded. On the top left another martyr is undergoing torture of the pit (*isurushi*), which consisted in a drowning in nauseating liquids.

To the right of Ruiz, holding a fan in his hand, the local representative of the emperor of the Land of the Rising Sun observes the scene, assisted by a servant who is holding a sign bearing the inscription in Japanese "They met with their death by spreading Christianity." Ruiz and his companion martyrs were beatified in Manila by Pope John Paul II in 1981, the year of the painting, in the first beatification ceremony celebrated outside of Rome. Subsequently, these and other Japanese martyrs were canonized on October 18, 1987. The painting was executed by Raffaele del Casal, a Spanish artist whose work entered the collections of the Congregation on the occasion of one of these two events. It was executed *en pendant* with another painting of the same size, also housed in the Congregation of Propaganda Fide, depicting a scene of female martyrdom. L.M.F.

Letter in Chinese Concerning the Martyrdom of Saint John Gabriel Perboyre

1840
Rice paper
25.5 × 37 cm
Congregation for the Evangelization of Peoples, Vatican City State
APF, SC China and adjoining kingdoms 9, f. 770

The first half of the nineteenth century was a period of oppression for Chinese Catholics; the numbers of foreign missionaries grew ever scarcer because of upheavals in Europe and persecutions in China. These persecutions, beginning in 1811, not only eliminated the missionaries from the provinces and the capital, but also led to numerous martyrdoms.

The document exhibited here is the testimony of the martyrdom of Fr. Jean-Gabriel Perboyre, born at Puech in Montgesty, France, on January 6, 1802, and died in Wuciang, China, on September 11, 1840. The letter is written in Chinese with a Latin translation and narrates the deeds of the courageous martyr through the testimony of various witnesses, among them Fr. Francesco Saverio Maresca, apostolic missionary in the province of Hou-quang, who wrote the letter to the apostolic vicar of the province of Lian-sy and Iche-Kiang, Alexander Rameaus.

Perboyre obtained permission to leave for China on March 21, 1835, and was sent first to the mission of Honan and then to that of Hupé. Persecution broke out and on September 16, 1839, he was captured at Tcha-Yuen-Keu and imprisoned at Wuciang. There he was interrogated by mandarins and the viceroy, who condemned him to death. He spent eight months in prison and on September 11, 1840, confirmation of the execution order arrived from the emperor, and he was strangled.

Fr. Maresca's letter recounts Perboyre's vicissitudes from the moment of his capture. As for the manner of his death—especially as regards the aspect of the saint's body—even better than his pen is the description of the witnesses who were "ad locum supplicii." Perboyre's eyes were peacefully closed, like those of one alive who does not speak, his face rosy like that of a living person. They say he was taken to the scaffold along with others and that the mandarin ordered that his death be different, slower and more painful. Before dying, the saint fell to his knees and prayed. After his death, the soldiers took his clothes and the body was placed in the coffin. Perboyre was buried in the Red Mountain cemetery of Wuciang. He was beatified on November 10, 1889. C.G.

The Papacy and Religious Dialogue

The most evident characteristic of Pope John Paul II is his passionate search for dialogue with everyone, not at a distance, but in a direct relationship, in their own places of origin. His journeys demonstrate the pope's desire to communicate with the church throughout the world, but also with the other Christian and non-Christian religions, with all persons of good will whatsoever the faith that they profess.

Pope John Paul II bases the dialogue on the need to ask forgiveness for the sins that the church has committed in the past. Thus, during the holy year, on March 12, 2000, the pope celebrated a Day of Forgiveness in Saint Peter's Basilica. "As Peter's successor I ask that in this year of mercy, the Church, strengthened by the blessing that it receives from The Lord, should kneel before God and implore forgiveness for the sins of its children in the past and present. They have all sinned, 'for there is no man who does not sin' (cf. 1 Kgs 8:46)...Before God and men who have been offended by their behavior, Christians must assume the burden of their transgressions. They shall do it asking nothing in exchange, strong in the belief that 'the love of God has been poured into our hearts'" (Rom 5:5).

This section contains some very interesting documents and testimony on this theme. There are also some gifts to the pope from heads of state as well as from humble people. They testify to mutual caring and the desire for dialogue with everyone without exception.

Document Granting Freedom of Belief
by Bezarar, Great Lama of Tibet

1741
Bezarar VII, Great Lama of Tibet
Rice paper
111 × 73 cm
Congregation for the Evangelization of Peoples,
Vatican City State
APF, SOCG 711, f. 163–164

This document, signed by Bezarar, Great Lama of Tibet, comes from the same historical period as the following entry and its contents are similar. The synchronism between civil and religious power, expressed here in welcoming the missionaries, was later also evident in rejecting and expelling them when their missionary zeal came to be considered a danger and they were banished.

Particular attention should be given to the red-ink seal of the Great Lama. An Italian translation dating from the same period as the document was sent to Rome by the Capuchin missionaries:

> Tidings from Us, Bezarar, Supreme Lama in the Great Kingdom of Tartary by authority of the King of Gold [in other words the emperor of China, so-called because his documents were written in golden characters according to the contemporary translator]
>
> We do universally order all Men who are under the sun and in particular the Ministers of Our Residence; the Ministers of Lhasa; the Chiefs of Men; the Chiefs of a hundred men; the Chiefs of ten men; the Chiefs of the Tartars; all, great and small; the Ministers known as Nemor, Gnalep, Cirtagn; all the Governors of the Fortresses and Provinces; all the Governors of many castles; subordinate Governors; Nobles; the Privileged, and the Powerful and less-Powerful that all these European Fathers of Religion called Capuchins, or Lami Gochar in this Kingdom of Tibet, not being mixed with others who come in their own interests, nor having come to trade but to obey their King and the Ministers of this Supreme Pontiff or Lama—who bringing love and doing good to all men, has sent them to this Kingdom—wherever they may go, be helped and assisted in that which they wish. And may no-one do anything hostile, troublesome, unworthy or harmful, but in all the Kingdom may they peacefully work to the end for which they have been sent.
>
> Written and dated at the Great Palace of Putala on the twenty-sixth day of the first month of the Autumn of the Trumtho Star. Year of the iron bird [October 7, 1741].
>
> L.M.C.R.

Document Granting Freedom of Belief by King Mi Vagn of Tibet

1741
King Mi Vagn of Tibet
Rice paper
51.5 × 50.5 cm
Congregation for the Evangelization of Peoples,
Vatican City State
APF, SOCG 711, f. 165

Although the Jesuits had already passed through Tibet in the seventeenth century, it was only in 1703 that the mission there truly began, a mission entrusted by Propaganda Fide to Capuchin friars from the Italian Marches. The first missionaries arrived in Lhasa on June 12, 1707; however, due to the enormous distances and a lack of means, the missionaries were forced to abandon Tibet in 1711 so as not to die of starvation.

After organizing adequate logistical links between India and Tibet, the Capuchins returned to their mission in 1716 only to find the Jesuit Fathers Ippolito Desideri and Emmanuel Freyre already installed in Lhasa. Various difficulties arose between the two groups. In 1732, Propaganda Fide confirmed that the mission there was the exclusive prerogative of the Capuchins, but a lack of means and of personnel forced a second abandonment of the mission in the same year.

The missionaries returned a third time, but were definitively expelled from Tibet in 1745 because their missionary zeal provoked persecution from the lamas.

This document, signed by King Mi Vagn of Tibet, is dated just four years before the expulsion of the missionaries. Particular attention should be given to the distinction the Tibetan monarch makes between the entirely commercial intentions of other foreigners and the pure and merely spiritual ends of the missionaries. The document gives evidence of great openness and understanding toward Christian missionaries, the king ordering his subjects not to hamper or impede their mission. The royal seal in red ink is particularly noteworthy. The document reads as follows:

I, Mi Vagn, King of Thibet, do universally order all Men who are under the sun and in particular the Ministers of the Residence of the Great Lama; the Ministers of Lhasa; the Chiefs of Men; the Chiefs of a hundred men; the Chiefs of ten men; the Chiefs of the Tartars; all, great and small; the Ministers known as Nemor, Gnalep, Cirtagn; all the Governors of the Fortresses and Provinces; all the Governors of many castles; subordinate Governors; Nobles of all Thibet; the Privileged, and the Powerful and less-Powerful that all these European Fathers of Religion, known as Capuchins or Lami Gochar (not being mixed with others who come in their own interests, nor having come to trade but only to do good to all, to teach how to act as true saints, to lead everyone along the true path to Paradise, to teach

subjects to remain loyal and make heartfelt obeisance to their King, Viceroy and Ministers, and to preach and propagate the Law of the true God, in other words the Evangelical law).

May none of you afore-mentioned seek to impede the implementation of this Privilege. The Supreme Pontiff, in other words the Great and Supreme Lama of all these Fathers—as a most loving Father bringing compassion and love to all men to liberate them from the paths of Hell and bring them to enjoy the eternal and immense glory and joy of Paradise and the saints, with not a thought for the vast expense—does send to all possible Kingdoms Preachers of the true Law and to that end (and for no other motive) he has sent them into Our Kingdom. Thus, we grant and concede forever Our Seal to all these European Fathers, or Lami Gochar, and to all those who will come after them in the future, that they may preach and propagate the Law of the true God freely, openly and publicly; not only in Lhasa but in all the Kingdom of Thibet, in any and all places and to any and all people, be they religious or secular.

To all of you mentioned above, the Powerful and less-Powerful and especially Chinese, Tartars and Hor, and others be they religious or secular, we command that no-one challenge or impede them. And those whose hearts are illuminated by the light of the true God to the point

that—unhindered and of their own free will—they embrace the true Law, all you above-mentioned do not dare to prevent them from doing so. And having embraced it, may no-one impede or prevent them from freely, openly and publicly observing that true Law.

We further make it known to all of you mentioned above that we will look upon all those who have embraced this true Law and continue to observe it as our most faithful subjects, even more than before. And all those Preachers of the true Law or Apostolic Missionaries, we will safeguard and defend, we keep and will continue to keep them under Our special protection. And do nothing, be it so slight as touching a hair of their heads, that may be a cause of disturbance to them; yet let them go about their ways in peace.

All you above-mentioned, note this letter well.

Written at Cadenchagnsar, Residence of the Victor of all the world, the year of the iron bird, thirtieth day of the seventh month [September 9, 1741]. L.M.C.R.

Mahomed Pulalu, Sultan of Joló, in 1847

After 1847
Oil on canvas
85.5 × 67 cm
Congregation for the Evangelization of Peoples,
Vatican City State

Conservation courtesy of Lisa D'Urso

In 1847 the seafarer Carlos Cuarteron, wearing the Scapular of the Third Order of the Barefooted Trinitarians, undertook an expedition to Indonesia on the sailing ship Lynx, which was flying the English flag. The scope of the expedition was the "redemption of the Christian slaves, … the eradication of piracy, which was such a threat in that vast archipelago, and the exploration of all those innumerable islands so as to be able to set up Missions there." Cuarteron's voyage, which met with the opposition of the Spanish authorities then dominating the Philippines, took in islands of the archipelagoes of Talaour: Sulu, Bally, and Salibaboo. Here the courageous priest was obliged to set fire to his ship so as not to fall prisoner. After eighteen months of pilgrimage, he disembarked from the Dutch brigantine Mercurius in Java.

After reaching Singapore and obtaining a Spanish pass for Manila, Cuarteron wanted to travel to China. In the end, however, he was obliged to leave Hong Kong for Europe. In England he contacted Sir Edward Belcher, an explorer of the East Indies from 1843 to 1846, of whom he had heard mention in Sulu in 1847. Sir Edward was able to give Cuarteron more information, especially about those islands he had not reached. When he returned to Rome Cuarteron decided to publish all the knowledge of those distant countries he had gathered either directly or indirectly (customs, political relations with European countries), to "supply all possible information in order to be able to establish Missions in those remote barbarian regions." His intent was essentially to favor the work of evangelization so that "Propaganda Fide may have all possible information so as to be able to send the Apostolic Workers there safely, and not forgo the fruit of the work already begun."

To this end he decided to donate fourteen paintings that described either the places he had explored or illustrious natives, "the only fruit of that unfortunate expedition… for the exaltation and prosperity of the Holy Church in the different places they represent." In September 1852 the paintings were publicly presented and donated to the Congregation with a dedication to Cardinal Giacomo Filippo Fransoni, prefect. These works were then to form the theme of the volume *Spiegazione e traduzione dei XIV quadri relativi alle isole di Salibaboo, Talaor, Sanguey, Nanuse, Mindanao, Celebes, Borneo, Bahalatolis, Tambisan, Sulu, Toolyan, e Labuan* ("Explanation and Translation of the XIV Paintings Relative to the Islands of Salibaboo, Talaor, Sanguey, Nanuse, Mindanao, Celebes, Borneo, Bahalatolis, Tambisan, Sulu, Toolyan, e Labuan") published by the Congregation's Press in 1855 (copies can be found today in the Vatican Apostolic Library and the University of Leiden). This volume contains a description of the series of fourteen paintings located and identified in the picture gallery of the Propaganda Fide on the occasion of this exhibition. The paintings include *Portrait of Mahomed Pulalu* and *Portrait of Kombea Raja of Salibaboo* (next entry).

Cuarterton met Mahomed Pulalu, sultan of Sulu, in 1847. He described the sultan's green velvet attire embroidered in gold as a "combination of Chinese and Oriental," with a waistband "of golden braid clasped in the center with a large gold clip studded with gems." The sultan was a short, thin man with weak features whose health had perhaps been undermined by opium. Cuarterton reports that he reigned over Sulu, an archipelago to the south of the Philippines made up of numerous series of islands, including Sulu, Basilan, and Tawi-Tawi.

In the *Explanation* Cuarterton described in detail the customs of the inhabitants of Sulu: from the habit of not exchanging Christian prisoners and of martyring them when they did not consent to conversion, to that of committing suicide with their entire family rather than submit to capture by the enemy, as the Spanish observed during their battles. He illustrated the laws that governed the political life of the sultanate, stressing the constant threat posed by pirates, who were hunted down by the Spanish.

Cuarterton voiced his hopes that in agreement with the Spanish government a mission under the direct control of Propaganda Fide be set up on the island of Toolyan, to the north of Sulu.

He hoped that his friendship with the sultan would allow him to establish diplomatic relations with the sultans of Kuran and Bolungan, who were his friends, as well as with other chiefs of the coast of Borneo. This was, he said, "so as to see whether, in the name of this Congregation, I can plant the banner of the Cross in some of those remote barbarian regions."

The portrait is not of particularly good pictorial quality, but is rich in details of local custom and thus an extremely interesting source of information with an ethnographic flavor. It may be the work of a European (Spanish?) painter commissioned by Cuarterton himself for the express purpose of documentation, as in his *Explanation*. M.N.

Kombea, Raja of Salibaboo, in 1848

1868
Oil on canvas
86 × 68 cm
Congregation for the Evangelization of Peoples,
Vatican City State

Conservation courtesy of Lisa D'Urso

A meeting between the sailor Cuarteron and the raja Kombea took place on September 10, 1847, at the mouth of the harbor of the Talaor islands where, dressed as an English seafarer, the raja welcomed Cuarteron. In his *Explanation* Cuarteron specified that fifty-three rajas governed these islands. Kombea, the chief of Salibaboo, one of the main ports, was usually the first to come into contact with the Europeans. The portrait represents him formally attired for one of the local feasts (birth, death of a raja, declaration of war, peace treaty: the only feasts possible since the natives had no calendar), which according to Cuarterton were very much like those of Java.

In describing Kombea, Cuarterton depicted an avid man always ready to cheat the Europeans who set foot on the island of Salibaboo. He gave a colorful account of the subtle negotiations for the concession of a piece of land for a farm, carried out not only with Kombea but also with the other raja Meneka. He was, moreover, amazed at the great consideration in which the inhabitants of these islands held the bronze cannons, which they put on display on feast days. The military capacity noted by Cuarterton (a great number of guns, and a great amount of gunpowder) was seen by him as inciting the natives to become war mongers. He also denounced slavery, which still obtained on the island of Talaor (for example, children who had lost their parents were taken as slaves and the property they had inherited was confiscated).

The custom of polygamy reported by Cuarterton does not, however, seem to concern Kombea, who is described in the company of one wife, Noor Loreto. Cuarterton found himself having to step in and smooth out the problem when Kombea beat his wife. His mediation brought about the reconciliation of the couple. The description of Kombea ends with the warning that when dealing with the rajas of the islands one should, as far as possible, avoid getting involved with Kombea, preference being given instead to Taluna, chief of Liron.

Seated on a richly carved and gilded throne, Kombea is depicted in three-quarter profile with a colored turban on his head. He is clad in a rich satin robe resembling a dressing gown, tied at the waist by a sash. Beneath the robe he is wearing a red jacket adorned with a row of gold buttons. His crafty expression seems to correspond to the psychological characteristics attributed to him by Cuarterton: "very active and accommodating,

he is at once extremely ambitious and envious; and he would like to be the favorite of the ships, and sell them the things they need according to his own whims and at the highest possible price."

Like the portrait of Mahomed Pulalu (previous entry), this painting could be the work of a European (Spanish?) artist among Cuarterton's traveling companions, or one paid by him in the Indonesian archipelago. The work came into the hands of Propaganda Fide in September 1852 when Cuarteron donated fourteen paintings to Cardinal Giacomo Filippo Fransoni, prefect of the Congregation. These paintings, which provided documentary evidence of his expedition, are illustrated by his volume *Spiegazione e traduzione dei XIV quadri relativi alle isole di Salibaboo, Talaor, Sanguey, Nanuse, Mindanao, Celebes, Borneo, Bahalatolis, Tambisan, Sulu, Toolyan, e Labuan* ("Explanation and Translation of the XIV Paintings Relative to the Islands of Salibaboo, Talaor, Sanguey, Nanuse, Mindanao, Celebes, Borneo, Bahalatolis, Tambisan, Sulu, Toolyan, e Labuan"). The volume was published in Rome in 1855. M.N.

Illustration of a Funeral in Vietnam

1840
Fr. Giuseppe Maria de Morrone, Franciscan and
apostolic missionary
Rice paper
34 × 99 cm
Congregation for the Evangelization of Peoples,
Vatican City State
APF, SOCP 75, f. 383

Following the death of Gia-Long, his son Minh-
Mang (1820–41) instituted fresh hostility against
the church, which culminated in two general
decrees of persecution in 1833 and 1836. His
successor did not seek to implement the decrees
and the Congregation of Propaganda Fide took
advantage of the new situation to erect, up to 1850,
six new ecclesiastical circumscriptions to intensify

evangelization in Cochin China, Tongking, and
Cambodia. During the reign of Tu-Doc (1847–82),
hostilities and persecutions increased and 115
priests were killed, 2,000 female religious
dispersed, and 100,000 Christians gave their
lives for the faith. Even during these persecutions,
missionaries continued to operate, evangelizing
and forming the local clergy. Suplicians,
Redemptorists, Franciscans, Brothers of Christian
Schools, and many female congregations arrived
to assist the Spanish Dominicans and missionaries
from the Paris Foreign Missions Society.

This document, attached to a petition sent to the
Congregation of Propaganda Fide, seeks to illustrate
some of the dogmatic ambiguities into which a
number of Christians fell in accepting certain rites
practiced by pagans in Vietnam. In so doing, it
provides valuable historical information on the
culture and anthropology of that country, and

makes us familiar with the musical instruments
and other cultural elements used in Vietnamese
funeral rites in the first half of the nineteenth
century. The drawing is entitled "Brief idea of the
manner and order in which, with sacro-pagan
rites, funerals are celebrated in Cochin China and
the bodies are taken to be buried in the Christian
cemetery." This is, then, an important document
not just for the history of the church, but also for
the history of Vietnamese culture. Apart from
giving a summary description of the participants
and their role in the proceedings, the document
describes, from the viewpoint of a western
missionary, the significance of certain objects
used during the funeral rite. The captions that
accompany the illustration are given below;
each letter appears next to one of the elements
or individuals, and describes their function
and meaning.

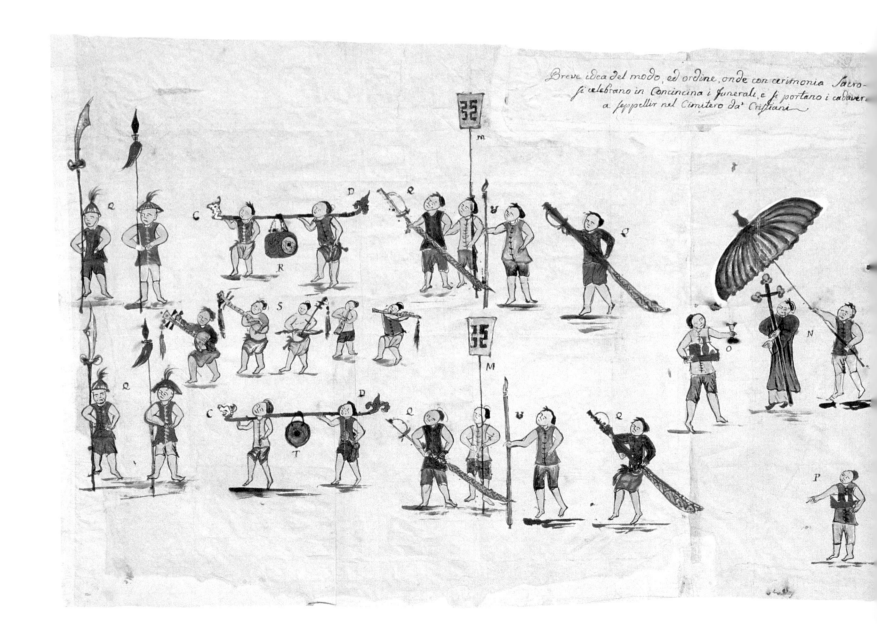

A. Exterior casket, in which columns, pedestals, and turrets are decorated with gilded bas-relief representations of birds, reptiles, gods — superstitions all — and in which the funerary coffin is enclosed.

B. Coffin enclosing the body, upon which money is sometimes placed, the price agreed with the bearers of the same, that they may carry it with great delicacy in the fear that, as belief holds, any perturbation will disturb the peace of the departed.

C. Heads of dragons, believed to be powerful spiritual divinities.

D. Tails of the same that support the casket and coffin, or have percussion instruments suspended below.

E. Lantern carrier.

F. Umbrella, the size of which depends on the social standing of the dead.

G. Person bearing wine and betel to dispense to those who request it along the way.

H. Image of the crucified Christ, situated between the dragon heads.

I. Vessel containing incense for the dead.

K. Person carrying two chairs, which are to be placed upon the casket when the bearers tire and ask for rest and wine.

L. Person beating two wooden sticks in time with the drum and other copper instruments.

M. Flag bearers, as if in the order of a military march.

N. Another umbrella, borne in honor of and under the upright cross. Similar to the one covering the coffin, it places the honor given to the dead on the same level as that given to Christ.

O. Person carrying a bottle and glasses to offer wine to those who request it along the way.

P. Person offering betel.

Q. Persons bearing, as soldiers, arms in colored wood, which, it is believed, have the power to chase away the Devil.

R. Large drum, similar to those used by military bands, painted with superstitious images.

S. Musical string and wind instruments, normally played by Gentiles.

T. Another copper instrument, beaten in time with the drum.

U. Persons with lighted wax torches. L.M.C.R.

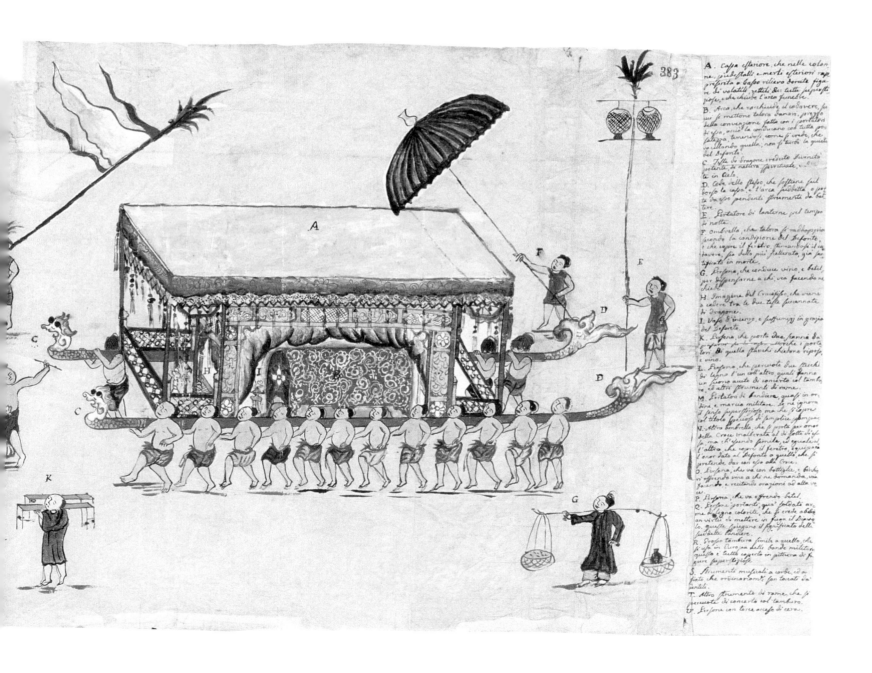

Thanka

1978
Fourteenth Dalai Lama, Tibet
Multicolor silk, pearls, coral
165 × 111 cm
Vatican Museums, Vatican City State
Inv. AS9368

Conservation courtesy of Anne and Robert Scott
in memory of Alexander and Elizabeth J. McGivney

The central image of this Tibetan Buddhist thanka is mounted in damask silk, interwoven with tassels of multicolored cloth. The upper and lower edges are furnished with two wooden dowels, from which the cloth can be hung or rolled up. A yellow and orange silk drape protects the image and hides it from view until the image is to be contemplated by the faithful.

The external layer of cloth has a brilliant yellow background, upon which a dragon stands out, part of the traditional iconography of the Far East. Its jaws are open to follow a flaming pearl, and its snakelike body lies in spirals among multicolored clouds, which augur good fortune. The fabric surround of the icon is composed of multicolored silk tassels, arranged to form clouds, trimmed in white.

The sacred image is seated upon a throne in padmasana, the lotus position. In front of the throne is a small altar with bowls, chalices, and votive lamps for the offering. The right hand of the figure is raised in the gesture of Bhumisparsha Mudra, called to witness to the world the coming of the illumination of Buddha. In the left hand, the palm facing upward, the figure holds a bowl of rice, upon which rests a three-dimensional mandala in the form of a stupa.

The Buddha figure, probably to be identified as Amithaba, the Buddha of infinite light who resides in the Western Paradise of the Pure Earth, is wearing a tunic of damask silk and a short cloak trimmed with pearls and coral and studded with semi-precious stones. The head of the figure is crowned with a diadem. A double halo of peonies surrounds the head and shoulders of the figure. Above, to the right and left, are two Apsara figures seated upon clouds: one is blowing into a shell, while the other pours ambrosia from a kundika, from which peacock feathers emerge.

Thankas are large cloths displaying religious subjects and are a typical expression of Tibetan Buddhism. They are generally hung in monasteries and over domestic altars, or unfurled in the open air during special ceremonies. They may be painted, embroidered, or made of woven cloth. As they are objects of worship, they are manufactured according to strict norms laid down in iconographic manuals. These manuals contain detailed descriptions of the divinity, who must be represented in accordance with sacred scripture, and it is important to strictly adhere to their instructions so as not to risk compromising the sacredness of the icon.

The construction of a thanka, itself an act of devotion, involves four distinct stages: the preparation of the base; the sketch of the outlines; the completion of the design and the addition of color; and, finally, the assembly and the consecration, which gives the object religious value. The cloth most commonly used is cotton muslin treated with a mixture of gum and chalk. The colors used are above all mineral pigments: cinnabar, lacquer, azurite, and malachite, emulsified with animal gum. The fabric surrounds are made of precious damask silks, generally of Chinese manufacture.

Consecration represents the final demiurgic act, with the ceremony of the "opening of the eyes."

Despite the iconographic and iconological restrictions within which they must work, the artists, whose skills are passed from generation to generation through long apprenticeships, use infinite chromatic variations and give great attention to detail to create masterpieces that can also be appreciated from an aesthetic point of view.

This particular example is all the more valuable because it was a gift to Pope John Paul II from the present Dalai Lama, who made an act of devotion in creating this thanka and, in donating it to the pope, an important gesture of homage charged with spiritual significance. M.C.R.

Astasahasrikaprajnaparmita Sutra on the Perfection of Knowledge in 8000 Verses

17th–18th century
Paper, wood, cloth
8.5 × 31 × 12 cm
Congregation for the Evangelization of Peoples,
Vatican City State
APF, Parchment Room

At the end of this volume, mention is made of a minister *Tshe dbañ nor bu*, a monk (btsun) *Byams pa* (Maitreya), and a place called *Mdo khams* (in eastern Tibet, today in the Chinese province of Sichuan). This edition, on a wooden block, probably comes from one of the two famous book-producing monasteries in Derge: that of dGon-chen (founded during the reign of King bsTan-pa-tshe-ring of Derge, 1678–1738) or dPal-spungs (founded in 1727 by the famous grammarian Si-tu bsTan-pa'i-nin-byed).

The book was donated in Mongolia in 1997 to His Holiness' apostolic pro-nuncio in Korea, Archbishop Giovanni Bulaitis, who later presented it to the Congregation for the Evangelization of Peoples to be kept in the historical archive.

L.M.C.R.

Christianized Tablet Honoring Deceased Forebears

1718
Rice paper
43.5 × 30 cm
Congregation for the Evangelization of Peoples,
Vatican City State
APF, SOCP India and China 30, f. 490

With a decree dated November 20, 1704, Pope Clement XI prohibited Christians from taking part in offerings and sacrifices to Confucius and to their dead ancestors, either in public or in private. According to the document, "Chinese rites" were indistinguishable from superstitions and, although occasional presence at such ceremonies was not condemned, there was a categorical imposition to remove from the home any kind of tablet of ancestors indicating the throne, the seat of the spirit, the name of the soul, etc. The only tolerance expressly allowed by the papal decree was that of a tablet marked simply with the name of the late ancestor and with a declaration by Christians toward the departed and an expression of piety by children toward their parents. This was so as to convince pagans that such tablets had a quite different significance with respect to their own. An example of such a "corrected tablet" is this rice paper document from 1718, which translates as follows:

(right)

"The heavens, the earth and the ten thousand beings are created by a one true God. He created the heavens as a cover, the earth as a support. Everything on earth and in the heavens, God gives to man for his use and enjoyment. Man lives in the world and must be prudent. He seeks to worship God, to do good and to avoid evil."

(center)

"Adore the true God of heaven, of the earth and of the ten thousand beings.
Respect your forefathers and your parents.

Father	[vertically]	Mother
date of birth	Remembrance of ancestors	date of birth
date of death	in the generation	date of death"

(left)

"The grace of having parents is the greatest that a man can receive, save that of God. After their death, reward and punishment come immediately; they go to paradise or to hell and return home no more. Their children and grandchildren, with filial piety create tablets and images, not to defend themselves from evil spirits, but to recall the grace of their parents."

This "Christianized tablet" dates to the period following the imposition of the "Piao" on missionaries by the emperor K'ang-Hsi (1706) and the publication of the constitution *Ex illa die* of Pope Clement XI (1715, published in China the following year). All the missionaries took the prescribed oath, though many Christians continued to practice the rites. In 1717, K'ang-Hsi signed a sentence of the court of rites of Peking that exiled all missionaries, prohibited Christianity, and, in effect, obliged all Christians to commit apostasy. This sentence, which was never put into effect, would constitute the pretext for future persecutions. V.C.

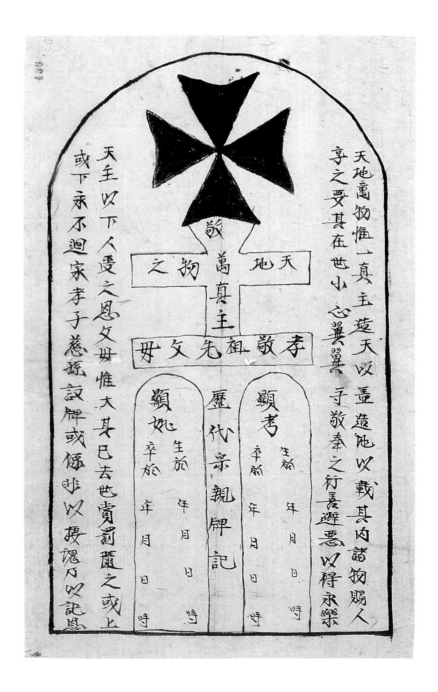

Cast of a Young Indian Girl of the Sauk-Foxes Tribe

Second half of the 19th century
Ferdinand Pettrich (1789–1872)
Painted gesso
24 × 43.6 cm
Vatican Museums, Vatican City State
Inv. AM7869

Conservation courtesy of the Florida Chapter of the Patrons of Arts in the Vatican Museums

This cast is the rough plaster model for a life-size statue. The sculptural technique has an immediate graphic impact and a visual intensity accentuated by its red coloring, which was obtained from red earth containing a high percentage of iron oxide and fixed to the plaster using animal gum, thus giving the statue a uniform hue and a polished and smooth appearance. The Native American girl, depicted from a life model, is attaching a fox tail to her moccasins and is sitting on an animal-skin seat. She is wearing the clothing, ornaments, and insignia of the ethnic group to which she belongs. Part of her hair is plaited and a section hangs down her back, while her forehead is girt with a band decorated with a two small bells and a plume of feathers. She wears a necklace of small bells, to which five bird feathers are attached, and around her right arm is a bracelet. A loincloth is tied around her waist by a braided belt, and she also wears fringed leggings with twelve small bells and a pair of moccasins.

The Sauk, to whom the young Indian depicted here belonged, are part of the Algonquian linguistic group. They once lived in the northeast of the American continent, where their economy was primarily based on hunting and farming. From 1733 they entered into a close alliance with the Foxes, to whom they were related. Following tragic encounters with French colonialists and with the U.S. Government, they were expelled from their territory. At present, some of their descendants are in Kansas, while the rest, together with the Foxes, live on a reservation in Oklahoma.

The cast described here is part of a collection of thirty-three pieces (four bas-reliefs, four life-size statues, sixteen busts, and nine rough casts) that represent events, people, and portraits from Native American history.

The artist, Ferdinand Pettrich, was born in Dresden but moved to Rome while still young and became an apprentice to the Danish sculptor Bertel Thorvaldsen, who encouraged him to seek inspiration across the ocean. He followed this suggestion and, in 1835, reached Washington, where he lived until 1843, witnessing the events that led to the destruction of the Native Americans. He came into contact with various indigenous ethnic groups, especially the Sauk-Foxes, the Sioux, the Creek, and the Winnebago, some of whom modeled for him. These casts, bas-reliefs, and statues were only completed later, between 1845 and 1856, when Pettrich moved to Brazil. There he lived for fourteen years and completed his entire work. In 1857 he returned to Europe. In London, his Indian Collection was displayed at the Pall Mall gallery and enjoyed great success. A year later he went to Rome where he was able to realize his desire to give "his Indians" to Pope Pius IX.

The Pettrich Collection was conserved and exhibited at the museum of Saint John Lateran, where the pope himself visited it, expressing his appreciation and offering a gift in his turn in the form of a substantial life pension for Pettrich. The sculpture remained in that museum until 1925, when they were moved to the pavilions of the Missionary Exhibition. Later, through the intercession of Pope Pius XI, the "Indian Gallery" was transferred to the Pontifical Missionary Ethnological Museum, where it remains to this day. D.Z.

Inuk Man

20th century
Canada
Soapstone
41.5 × 16.5 × 16.7 cm
Vatican Museums, Vatican City State
Inv. AM6547

This statue, in brilliant green soapstone, depicts an Inuk man sitting with his arms resting in his lap. He is wearing traditional costume (*kuletak*), boots (*kamik*), and mittens. His oval-shaped face has high cheekbones, a protruding forehead, almond eyes carved with the pupil in relief, a prominent nose with nostrils, and a smiling mouth. At the bottom of the back is the carving of a large anthropomorphic face with the same characteristics. The sculptural technique is noteworthy for the lines and volume that confer great fluidity to the whole; soft curves and shallow incisions are prevalent. Careful polishing gives the statue its shiny appearance. A metal plate at the base bears the inscription "Canadian Armed Forces, 23 nov. 1975. Forces Armées Canadiennes."

Archival documents confirm that the statue was a gift to Pope Paul VI from Canada and entered the collection of the Pontifical Missionary Ethnological Museum on October 17, 1977.

Inuk means "men" or "people" and is the term the Inuit use to define themselves. The Inuit came from northern Siberia and settled in Alaska, northern Canada, and Greenland about 3000 BC. Their economy was principally based on hunting (bears and caribou) and fishing (marine mammals). Over time, their lifestyle changed more slowly than that of other indigenous groups in the northeast of America due to a lower level of European cultural infiltration, which only became an important influence at the start of the nineteenth century. On April 1, 1999, the State of Nunavut came into being, a new territory within the Canadian Confederation, self-governed by the Inuit.

Inuit artistic work is characterized by tools, amulets, and other objects made of walrus ivory, bone, and horn. Apart from their function, the objects have outstanding artistic qualities and their decorative motifs reflect the Inuit vision of the world, founded on a profound respect for nature and the forces that govern it. In the past Inuit cosmological beliefs centered on a supernatural world of spirits and invisible forces. Their carved work was marked by a prevalence of miniatures in ivory and bone, rendered with great accuracy and precision and often embellished with engravings showing hunting scenes, geometric designs, and components of the ecosystem. However, in about 1950, a process of transformation in indigenous artistic production was accomplished, based on the introduction of steatite (soapstone) carvings.

Steatite is a hard stone with particularly intense colors and was once used only to make lamps for burning seal oil. Thus, miniatures gave way to large statues carved in the round, and the eminently practical and ritual use of the objects yielded to new, purely artistic, connotations. The ancient myths, which have been handed down by oral tradition, are now restated and translated in stone sculptures that may be defined as mythical-narrative and illustrative. The originality of the statues also lies in a synthesis between the old and new. For example, the Inuk man here who has two faces, one of which is hidden. This, perhaps, is the expression of a soul that is not immediately visible, and of a profound spirituality that resists over time, just like the stone in which it is sculpted. D.Z.

Popes of the Modern Era

Over the last two centuries, fifteen pontiffs have governed the Roman Church. Pope Pius VII was elected at the dawn of the 1800s, while Pope John Paul II closed the twentieth century with the celebration of the jubilee of the year 2000 and introduced the church into the third millennium. Of these, Pope Pius IX had the longest reign in history (1846–78), not counting that of Saint Peter, while Pope John Paul I lived for just one month after his election (September 1978).

Over the nineteenth and twentieth centuries, the modern world has lived through some of the greatest and most dramatic events of history: from the Industrial Revolution and the move from a rural to an industrialized society, and subsequently to the modern media-dominated world; think also of the birth of ideologies that have marked the destinies of so many people and of entire continents. Two World Wars during the first half of the twentieth century and a series of social and political tumults have redrawn the map of the world and changed the ways people live: a world that has become a "global village" due to new communications technology.

The popes and the church have not been passive spectators to these revolutionary changes. The church called a council in the middle years of each of the two centuries: Vatican Councils I and II, the stated aim of which was – with great attention and sensitivity – to reflect upon the emerging problems, evaluate them, and find answers. The history of the papal ministry in the 1800s and 1900s gives evidence of this concern. The Magisterium of the popes has underlined the need for a new and more mature relationship between the church and the world. The popes, each with their different personalities, have sought to create a more responsible relationship between the church and the world. We may mention, for example, the famous encyclicals *Rerum Novarum* on the world of work and *Pacem in Terris* on the vital question of peace. The document that more than any other expresses this path of dialogue and concern is *Gaudium et Spes* (Joy and Hope) published during the second section of Vatican Council II: "The joys and hopes, the sadness and anguish of the men and women of today, especially of the poor and of all those who suffer, are also the joys and hopes, the sadness and anguish of the disciples of Christ, and there is nothing truly human that does not find an echo in their hearts." Although it is clear that the church was politically and culturally isolated in the 1800s and during the first half of the twentieth century, the end of that century was quite different and the present pope could declare before world public opinion at the United Nations headquarters on October 6 1995: "I stand before you as a witness of the dignity of man." This profound change has been particularly noteworthy in the pontificate of Pope John Paul II, but it was patiently constructed by all the popes who have preceded him over the last two centuries.

Portrait of Pope Pius VI

1775
Pompeo Batoni (1708–87)
Oil on canvas
137.7 × 98 cm
Vatican Museums, Vatican City State
Inv. 40455

Giovanni Angelo Braschi's brilliant career in the church led to a prestigious appointment as treasurer of the apostolic chamber. Later he was made a cardinal, and on February 5, 1775, he was elected pope. Fond of pageantry and favorably disposed toward patronage, Pope Pius VI worked tirelessly, lavishing resources and energy in an effort to leave his mark.

As pope, he promoted archaeological research and excavations in the Papal States, which led to the acquisition of much sculpture for the Vatican. When added to the statues already collected by popes at the beginning of the sixteenth century, these works so enriched the papal collections that Pope Pius VI deemed it necessary to have the majestic Pius-Clementine Museum (Museo Pio-Clementino) built. His predecessor, Pope Clement XIV, had started a project to create a venue worthy of these treasures, and he continued it. Pope Pius VI is also linked to the foundation of the Vatican's first Picture Gallery (Pinacoteca) in 1790. Moreover, he commissioned Carlo Marchionni to design an impressive new sacristy for Saint Peter's.

Pope Pius VI was widely celebrated for these undertakings as is demonstrated by the literature praising him that circulated widely at the time. With the rise of Napoleon, however, his fortunes reversed. The last years of his reign were ravaged by the French occupation of the Papal States. The harsh provisions of the Treaty of Tolentino that Pope Pius VI was forced to sign in 1797 provided for transferring the masterpieces in the pontifical collections to Paris. He was arrested and sent to exile in France. He died in Valence at the end of August of 1799, before reaching Paris, and his remains were not returned to Rome until 1802. He had wished to be portrayed while kneeling in front of Saint Peter's *confessio*. Therefore, in 1822, the pope's nephew, Duke Braschi, commissioned Antonio Canova to sculpt a commemorative statue of his uncle kneeling in prayer. This statue was first placed in the *confessio*, and is now in the Vatican Grottoes.

In the Vatican Pinacoteca's portrait, Pope Pius VI is dressed in his pontifical robes. He is depicted sitting on a throne with the Braschi family's coat of arms on the volute of the backrest. This was the first time a pope was portrayed wearing a rochet, mozzetta, and stole, with only a simple white zucchetto (skull cap) on his head instead of the traditional *camauro* (red velvet and satin cap). The papal *camauro* is on a pile of books on the table next to an inkstand and a splendid pendulum clock made of porcelain.

The painting appears to have been left unfinished with the exception of the pendulum clock, which is rendered in great detail. The Museum of Rome has an almost identical version of this painting that is closer to completion. In it, the pope is holding a piece of paper in his left hand with the following words written: *Alla Santità di*

N.ro Sig.re papa Pio VI / Per Batoni Pinxit 1775 ("To His Holiness of Our Lord Pope Pius VI / Painted by Batoni 1775"). This inscription leaves no doubt as to the authorship or date of the painting. Documents confirm that the artist was commissioned to paint the portrait on April 1, 1775, shortly after Braschi was elected pope. On July 5 of the following year, Batoni received 500 scudos as payment for the completed picture.

The portrait is kept in the storeroom of the Apostolic Floreria. Thus, it is probable that it has been a part of the Vatican Collections from the time it was painted. The following note, written by Canova when he went to the Quirinal Palace on April 7, 1780, probably refers to this painting: "we saw the portrait of the Pope painted by Pompeo Batoni, but the Drapery pleased me endlessly" (Canova [1779–80], 1959, 116).

This painting was exhibited for the first time in the Vatican Pinacoteca in 1932 as the work of the German artist Anton Raphael Mengs. Mengs was active after 1750 in Rome, where he painted many remarkable portraits. This attribution changed when Incisa della Rocchetta decided that the painting should be ascribed to Pompeo Batoni because of its pictorial style. He considered it to be a study from life for the above-mentioned official portrait of the pope preserved in the Museum of Rome in the Braschi Palace (Incisa della Rocchetta 1957, 4). Various reproductions or variations were later made from this model, signed by the artist or completed by his workshop. Among them it is worthwhile to mention one in Turin's Sabauda Gallery, as well as one that belonged to the king of Poland, Stanislaw August Poniatowski, now in the National Museum of Warsaw (Narodowe).

Portrait painting occupied an important position in Batoni's portfolio, although he was an accomplished artist of all genres (historical, religious, and mythological). He was particularly good at interpreting the wishes and satisfying the tastes of the European nobility that passed through Italy on the Grand Tour. Batoni asserted himself as a major celebrity in the versatile sphere of eighteenth-century Roman art. Instead of tiresomely repeating Carlo Maratta's style or adhering superficially to rococo, the artist from Lucca developed an original idiom founded on his personal elaboration of meaningful studies of models from the past. He incorporated elements from the styles of ancient times, Renaissance classicism, and seventeenth-century painting. His portraits succeeded in combining spontaneity and psychological understanding with the refined cultural references and intellectual needs emerging during the Enlightenment. G.C.

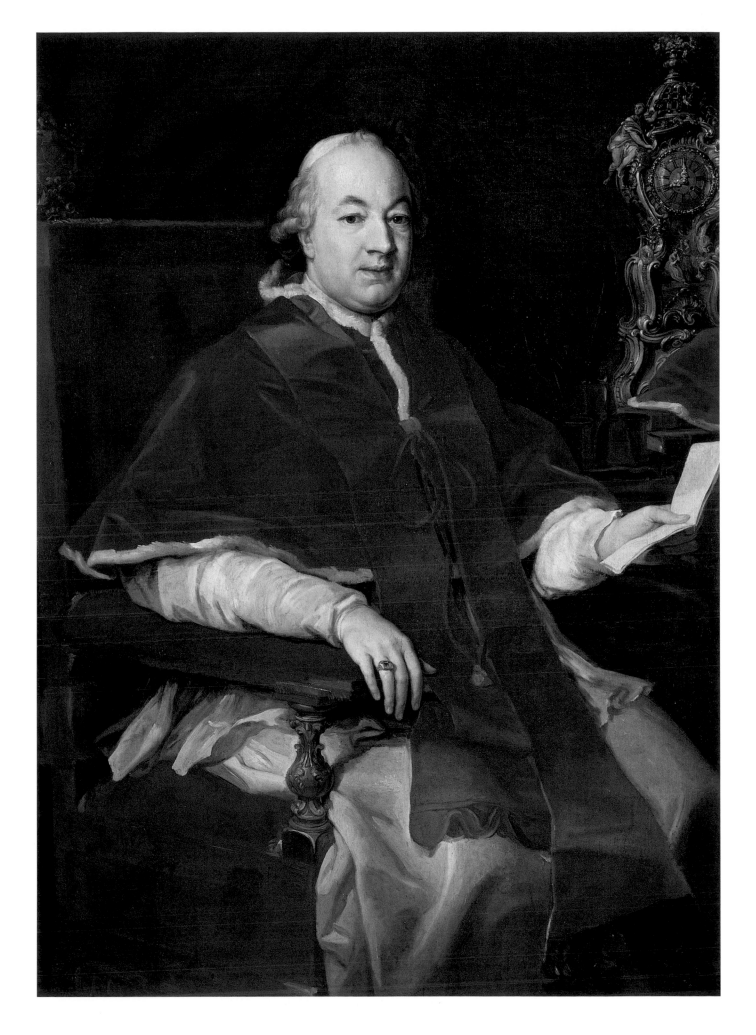

Portrait of Pope Pius VII

1814
Vicenzo Camuccini (1771–1844)
Oil on canvas
60 × 49 cm
Basilica of Saint Paul's Outside-the-Walls, Rome

Portrait of Pope Pius VII

Pope Pius VII had special connections with the Benedictine abbey at Saint Paul's Outside-the-Walls. He himself became a Benedictine monk in 1758 at Santa Maria del Monte in the Italian coastal town of Cesena, and then completed his studies in philosophy at the abbey of Santa Giustina in Padua. Subsequently he was sent to Rome to study theology at the school of Saint Anselm, then housed at Saint Paul's Outside-the-Walls, where he remained for another three years until 1766. Once ordained he returned to Rome, this time as a resident lecturer in theology at Saint Paul's from 1772 to 1781. In the abbey one can still see his modest monk's cell, number 111. He was elected pope in 1800 by the conclave held in the Benedictine monastery of San Giorgio Maggiore in Venice. After the well-known incidents in which Napoleon's armies had devastated the Papal States, he returned to Rome triumphant in 1814 and remained there until his death in 1823, retaining his long-standing devotion for the abbey at Saint Paul's where he had spent his early days as a monk.

Vincenzo Camuccini was born in Rome in 1771 and began his artistic training as a painter at the renowned Accademia di San Luca, where he cultivated a neoclassical aesthetic while furthering his understanding of painting through the study of antiquity and the art of the sixteenth century discussed in the writings of J. Winckelmann.

In 1798 he left Rome for Florence, but in 1802 was back with a post as teacher at the Accademia di San Luca. The following year Pope Pius VII appointed him director of the mosaic studio at the Basilica of Saint Peter. Throughout his career, Camuccini showed his fondness for religious subjects, but he also completed many portraits of prominent figures of his day. Large-scale works of his middle period include a *Portrait of Marie-Louise of Bourbon* and *Scenes from the Life of Marcus Atilius Regulus*. In 1812 he was appointed to the team of specialists to restore the imposing Quirinal Palace in Rome.

When Pope Pius VII was released by the French in 1814, and the city of Rome restored to the papacy, he had Camuccini paint his portrait and simultaneously appointed him director of conservation of paintings in the capital. The artist also received commissions from the king of Naples and executed numerous works on religious subjects. Subsequently, in 1829, the newly elected Pope Pius VIII likewise commissioned his portrait from Camuccini and assigned him the job of reorganizing the Vatican Picture Gallery. P.L.

Cross of Pope Pius VII

1809–12
Cross: wood; container: wood, glass, silver leaf
33.5 × 17.5 × 5.5 cm
Office of the Liturgical Celebrations of the Supreme
Pontiff, Vatican City State
Inv. CRT8

Conservation courtesy of Florence D'Urso,
in honor of His Eminence, Eduard Cardinal
Gagnon, S.S. an outstanding Prince of the Church,
and dearly loved friend of the D'Urso Family

The only information available about this unusual
crucifix is the entry made in the inventory of the
Papal Sacristy, where the piece is normally kept.
The entry offers a verbal account from Pope Pius
VII, who related that while he was being held
prisoner by Napoleon in France the crucifix offered
him constant consolation and companionship in
prayer in a period of immense turbulence for the
papacy. On May 17, 1809, Napoleon Bonaparte
annexed all of the Papal States to the French Empire.
In reaction, the pontiff promptly excommunicated
the perpetrators of this outrage against the Holy
See. Napoleon counteracted by putting the
pope under immediate arrest and in July 1809
had him taken to Savona, where he remained
in confinement until he was transferred to
Fontainebleau in 1812. In such dire circumstances
Napoleon was able to bully the pontiff into
signing a humiliating concordat on January 26,
1813—which, however, the pope duly retracted
two months later.

The single event that overturned the situation,
besides the vacillating fortunes of Napoleon and
his campaigns, was the sudden swing of Joachim
Murat toward Italian nationalism. Napoleon had
little option but to allow the pope to return to
Rome, where he was received to immense public
acclaim and reestablished his court in the Quirinal
Palace. L.O.

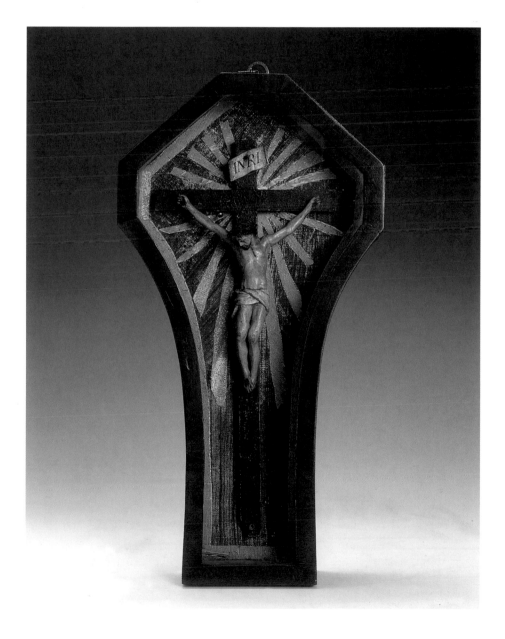

Papal Tiara of Pope Pius VII

1804
Henry Auguste and Nitot, Paris
Gift from Napoleon Bonaparte
Cask: wood, velvet, silk; crown: gold, precious
stones; top: emerald, gold
44 × 26 × 26 cm
Office of the Liturgical Celebrations of the Supreme
Pontiff, Vatican City State
Inv. TR1

Conservation courtesy of Angela and
James McNamara Jr.

This tiara was a gift to Pope Pius VII from Napoleon
at the beginning of 1805 to redress the damage
caused by the Treaty of Tolentino (February 19,
1797), a pact the pope had been forced to sign
when the Papal States were overrun by the French
troops. The tiara disappeared during the subsequent
unrest of 1831, and then, according to a contem-
porary chronicler, Gaetano Moroni, it was restored
by Annibale Rota.

Mounted to a backing of beige velvet, the three
crowns are studded with cabochon-cut tinted glass
joined together with pseudo-filigree scrolls. Fixed
to each of the crowns is a small plaque bearing
an inscription. The bottom one reads "JUSTITIA
ET PAX OCULATUS SUNT. SPAL. 84/11"; the
middle one, "HINC SUNT DUAE OLIVA E DUA
CANDELABRA IN COSPECTU DOMINI APOC
11/4…"; and the top:, "SPIRITUS SANCTUS
POSUIT REGERE ECCLESIAM DEI. ACT. APO. 20/18."
The piece is crowned with a jeweled cross that rises
out of a milled emerald of impressive size known as
the "Emerald of Gregory XIII." This remarkable
stone was set into the tiara of Pope Julius II at the
request of Gregory XIII in about 1580, with an
inscription on the molding: "GREGORIUS XIII
PONT. OP. MAX." Pope Pius VI likewise had the
jewel remounted on one of his tiaras. Subsequent to
the Treaty of Tolentino the stone was placed in the
Musée d'Histoire Naturelle in Paris. After the
seizure of the tiara, Napoleon ordered the famous
emerald to be reused. Originally, the tiara was
adorned with 2,990 fine pearls, and 3,345 stones
including 2,450 cut-diamonds, 335 natural dia-
monds, and 1,228 fine pearls, 108 rubies, and fifty-
four emeralds. The central crown was embellished
with over fifty emeralds surrounded by cut dia-
monds. The other two crowns were adorned with
50 rubies also set in brilliants.

Three engraved bas-reliefs adorn the crowns.
The lower crown shows the restoration of public
worship in France with the words *Auspice Primo Cos.*
Bonaparte / Sacer Cultus Solcnniter Restit. / Parissis in Basi.
BcataeVirginis / Die Paschali 1802. (Sacred Worship was
solemnly restored to the Basilica of the Blessed
Virgin In Paris on Easter, Day, 1802 under the aus-
pices of Bonaparte, The First Consul.). On the mid-
dle crown was represented the signing of the
Concordat between France and the Holy See with
the inscription *Pie VII Summi Pontif. / Cum Bonaparte Reip.*
Gallic. Cos. / De Rebus Ecclesiac Composiendis Partic. / Parissus
14 Julli 1801 (The Supreme PontiV Pius VII with
Bonaparte, the Consul of French Republic reorgan-
ize the aVairs of the Church.). On the highest
crown is pictured the imperial coronation at Notre
Dame in Paris with the accompanying inscription:
Napoleo Gallorum Imperator / Sacro Inunctus Oleo / A Pio
Summi Pontif. / Die 2 Dicember 1804. (Napoleon is
anointed Emperor of the French with Holy Oil by
the Supreme PontiV, Pius VII on December 2, 1804).

The tiara was stripped of these bas-reliefs and
of its original precious gems most likely at the time
of its restoration sometime after 1831. It has a
heavy wooden trunk, and the circumference of the
base is so narrow that it was never able to be worn.
R.V.

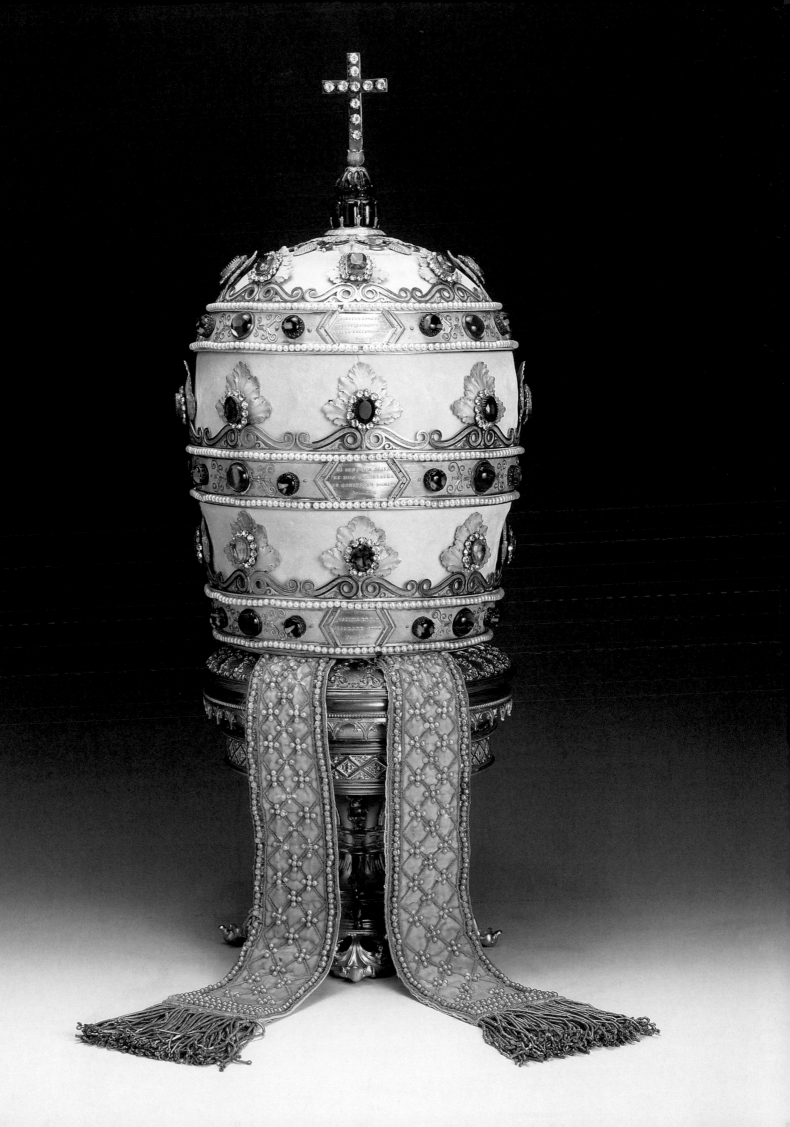

Pastoral Staff with Scepter of Pope Pius IX

1877
Thomas-Joseph Armand-Calliat, Lyon, France
Silver gilt, enamel, shell, amethysts, gemstones,
pearls, turquoises
153 × 10 × 10 cm
Office of the Liturgical Celebrations of the Supreme
Pontiff, Vatican City State
Inv. PAS23

Conservation courtesy of Reverend Monsignor
Michael A. Souckar, J.C.L. in honor of the silver
jubilee of ordination to the priesthood of the
Reverend Kenneth D. Whittaker, J.C.L.

This pastoral staff was given to the pontiff by the
French diocese of Besançon in 1877.

The reference to Mary Immaculate is an allusion
to Pope Pius IX's proclamation on December 8,
1854, of the Immaculate Conception of Mary,
Mother of Jesus, to be a dogma of the faith.

The staff is divided into six sections surmounted
by a statue of the Immaculate Conception. More
than one hundred figures in bas-relief represent key
moments in the history of the diocese of Besançon.
In the first section, the saintly founders sent by
Saint Peter appear in sequence: Saint Linus with
keys and a chalice, and Bishop Ferréol with his
deacon, Ferjeux, carrying their severed heads, each
surrounded by a halo. The second section shows
Saint Colette kneeling and Saint Vincent Ferrer
under his standard marked with the monogram of
Mary, presenting a letter to Archbishop Thiébaud de
Roucemont in which they announce the end of the
great schism of 1417. In the third section, Claude
de la Baume, surrounded by men at arms, gathers
the inhabitants of Besançon under the flag of Mary
Immaculate to face the Protestant troops who
threatened the city in June 1575. In the fourth
section, Saint Peter Fourrier distributes votive
cards with the inscription "MARIA SINE LABE
CONCEPTA" (Mary conceived without stain) to
victims of the plague, while in the fifth section,
Archbishop Claude d'Achey, kneeling at the feet
of the Virgin, consecrates his diocese to Mary
Immaculate. Finally, in the sixth section, a
procession winds upward in a spiral bearing a
band with the words of the creed; the procession
is led by Archbishop Antoine-Julien Paulinier,
who presents the scepter to Pope Pius IX. The six
medallions on the orb show the four symbols of
the evangelists and the two guardian angels of the
province and the city. This object reflects the spirit
of ultramontane Catholics who, in donating a
scepter to the last pope-king, give evidence of an
attachment that bordered on glorification. R.V.

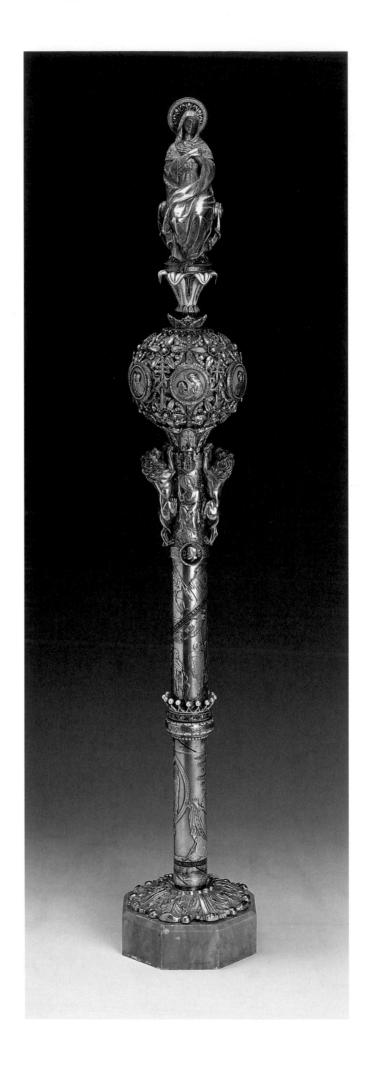

Coffer and Urn of Pope Leo XIII

1888
Gilded wood
70 × 67 × 40 cm
Office of the Liturgical Celebrations of the Supreme
Pontiff, Vatican City State

Conservation courtesy of Florence D'Urso, in
honor of two treasures of the Church, Bishop
Patrick V. Ahern, and Bishop Patrick J. Sheridan,
who for many years so faithfully served the
Archdiocese of New York with distinction and
dedication

Traditionally, gifts to the pontiff were presented in
special boxes or coffers. The inscription on this one,
decorated in the Renaissance style with lion's feet,
reads "LEO XIII" on one side, and "ANNO 1888"
on the other.

In antiquity, large urns not unlike the one
shown below, were generally used to hold the ashes
of ancestors after cremation. In Catholic liturgy,
however, "urn" refers to the article of church
furnishing used to contain the Host on the altar
during Holy Week, after the *In Coena Domini* Mass
and until communion on Good Friday. R.Z.

Ring of Pope Pius IX

19th century
Gold, diamonds, glass
3 × 2.6 × 3.2 cm
Office of the Liturgical Celebrations of the Supreme
Pontiff, Vatican City State

The episcopal ring is worn by every bishop as a token of his office and his commitment as pastor of the church. The composition of the ring has changed through the centuries, but in most cases it is of solid gold. Of the two possible types, the signet ring is not mounted with a jewel but with an official seal, carved in reverse, bearing the coat of arms of the bearer. Those mounted with a jewel follow a color code, by which the bishop's is set with a purple quartz stone and that of a cardinal is set either with a ruby or sapphire.

In his role as the bishop of Rome, the pope wears an episcopal ring, the stone of which has evolved over time. At first the mount enclosed a colored stone, then a diamond, then again a precious stone of a given color. Today episcopal rings are usually without a stone, but carry a liturgical symbol or image of the Redeemer, the Virgin Mary, apostles or saints, or a simple cross.

One of the episcopal rings worn by the pope is known as the "fisherman's ring" in reference to Saint Peter's charge as the "fisher of men."

The ring on exhibit here is made of low-carat gold and carries the image of Pope Pius IX studded with tiny cut diamonds, surrounded by a corona of twenty-four tiny brilliants. The inscription on the lower rim of the ring reads: "Lumen Ecclesia," Light of the Church. R.V.

Clasp of Pope Pius IX

1871
Cellini
Silver, silver gilt, rubies, emeralds, turquoise,
enamel
15 × 15 × 6.5 cm
Office of the Liturgical Celebrations of the Supreme
Pontiff, Vatican City State
Inv. RA16

Conservation courtesy of Kathleen Dolio Thornson in memory of Father Richard Bourgeois, O.S.B.

According to the Book of Exodus, Jewish high priests wore a square metal "clasp" (actually a kind of pendant) around their necks during the more solemn religious and also during some civil ceremonies (Ex 28:15-28). This type of clasp was generally used on the cope worn by popes or bishops. In the past, it hooked the cope worn by the pope when he sat on the *sedia gestatoria* (papal gestatorial throne). Jewels enhance the beauty of the clasp, making it suitable for the pope. Originally, the precious stones decorating the clasps used by Jewish high priests for important occasions symbolized the twelve tribes of Israel. In Catholic tradition, the stones became associated with various saints or with the Virgin Mary.

This clasp belonged to Pope Pius IX, to whom it was presented, on the silver jubilee of his consecration as pope, by the Prima Primaria Congregation. It is carved in a special design based around a central image with some asymmetrical decorative elements on the outer border. A blue globe covered with stars is in the center of the clasp, while the upper part is encompassed by God the Father, who looks benevolently toward the globe, and the lower part is supported by a group of three full-length cherubs. On either side, two graceful angels hold scrolls that read *Sine labe originali* (without Original Sin) and *Non deficiat Fides* (that Faith be not lacking). Decorative half-shell elements form the four corners, with angel heads between them.

The liturgical symbolism of the clasp can be understood in terms of its function: it holds in place the papal cope, a symbol of the abundance of God's mercy toward humanity. Thus the clasp represents the "seal" of God's grace on humanity's conversion, and by extension this meaning of conversion can also be applied to the entire cope.

The imagery used on this clasp symbolizes God's closeness to the world at his feet, while the stars suggest an empyrean, limitless universe or eternity. L.O.

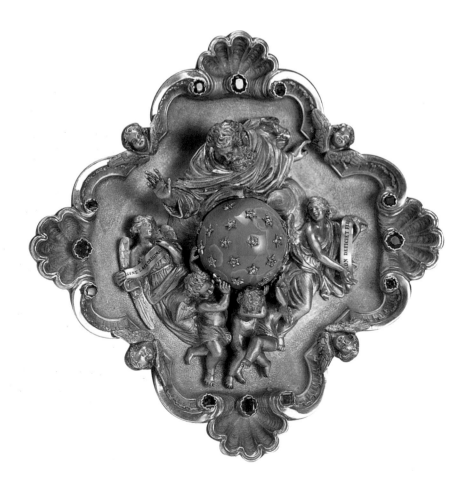

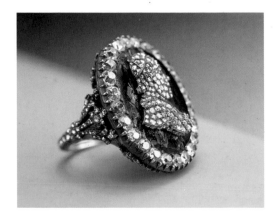

Prie-dieu of Pope Leo XIII

1887
Francesco Grandi (1831–91), A. Guidi and
apprentices Esposito, Miccio, Giordano
Ebony, wood, ivory
140 × 77 × 99 cm
Office of the Liturgical Celebrations of the Supreme
Pontiff, Vatican City State
Inv. VR108

Conservation courtesy of Mr. and Mrs. Timothy
James Rooney

This exquisite prie-dieu, or kneeling bench, was
made by master craftsmen in Sorrento, including a
designer, an engraver, and a veneerer. A refinisher
touched up the inlay with India ink to add promi-
nence and a polisher coated the object with shellac.

This piece is made of ebony and inlaid with
woods and ivory. A wooden statue with two putti
holding Pope Leo XIII's coat of arms was placed on
top with a figure of Christ crucified. The back of the
crucifix contains an inlay partially made of mother-
of-pearl; the figure of Christ is sculpted in ivory.
On the top, two scenes, finely inlaid with colored
woods, depict Jesus in the olive grove and the Three
Marys near Golgotha. Other ivory inlays depict
the lamb on the Book, the head of Saint John the
Baptist, and five thorn crowns with multicolored
crosses. Two ivory medallions, in relief, portray
Saint Thomas Aquinas and Pope Leo XIII and are
engraved around the top edge, together with other
decorations. The inscriptions *Scuola di Sorrento* and
Anno 1887 are found on the sides.

Wood sculptures of praying angels are inlaid
on each corner. Between them, eight pillars once
supported eight ivory medallions representing
heads of saints and bishops. Of these, four are
extant, two have been replaced with wooden
knobs, and two are missing.

The side facing the worshiper contains a large
inlay of honey-colored wood that reproduces
the papal coat of arms over a garland of leaves and
berries. On the occasion of the pope's fiftieth
year of priesthood, the archdiocese of Sorrento
commissioned this work; the bishop of Sorrento's
emblem is engraved at the bottom.

In several places, dated inscriptions commemo-
rate Pope Leo XIII's principal encyclicals. C.P.

Cross of Pope Leo XIII

19th century
Gold, diamonds, emeralds, pearls, sapphires
50 × 18.5 × 10.5 cm
Office of the Liturgical Celebrations of the Supreme
Pontiff, Vatican City State
Inv. CRT 1

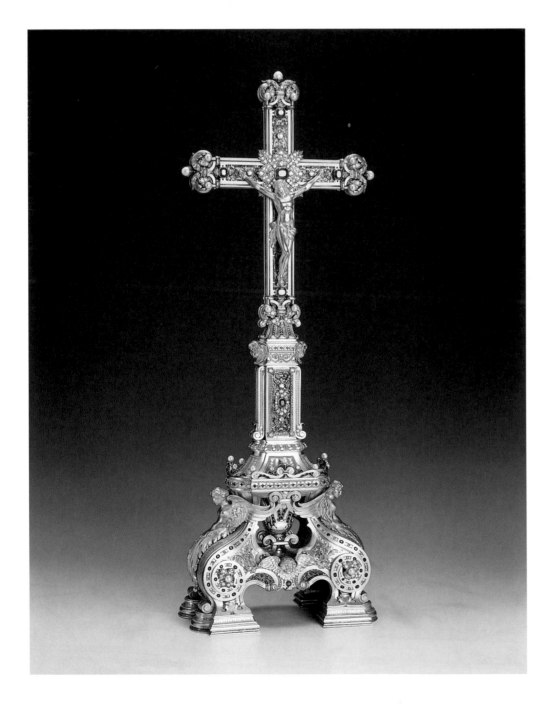

To commemorate the jubilee year of the priestly ordination of Pope Leo XIII in 1887, Emperor Franz Josef of Austria commissioned the court goldsmith to craft a cross to present to the pontiff as a worthy gift. The result was this superb table cross, the outstanding workmanship of which makes it one of the finest examples of goldwork ever produced under the Austro-Hungarian Empire.

The piece consists of a corpus mounted to a cross made entirely of gold, with an elaborate base in three distinct sections; the feet rest on small tiered bases and form volutes that develop upward into three figures of angels.

Resting on the shoulders of the angels is a pyramid supporting the pedestal of the cross, which has arms with openwork and lobate terminals. No expense was spared in the manufacture of the piece, which besides the various enamel details has a profusion of diamonds, sapphires, and high-quality natural pearls.

The cross occupied a prominent place on the desk of the pontiff in the library of the official papal apartment, and was later transferred to the Papal Sacristy, where it has since remained.

The inscription on a small plaque on the back reads "Leoni XIII / Pont. Max. / Jubilaeum Sacerdotale / 31 dec. 1887 / Celebranti. / Filius devotissimus / Fanciscus Josephus I. / Austriae Imp. Rex Bohemias etc. etc. / Hungariae Rex a post."

L.O.

Processional Cross of the First Vatican Council

1867
Armand Calliant, Lyon (France)
Silver gilt, enamel, carnelian, amethyst, turquoise, semiprecious stones
260 × 45 × 18 cm
Office of the Liturgical Celebrations of the Supreme Pontiff, Vatican City State
Inv. CRP6

Conservation courtesy of David, Leonard and Richard Negri, in loving memory of their mother, Lorraine Santaniello Martin Negri

This cross was a gift to the pope from the marquis of Bute of Cardiff, Wales, for the opening of the First Vatican Council in December 1869. It is mounted on a staff of gilded bronze composed of three pieces. The crucifix, the arms of which terminate in budding floral motifs detailed in red and green enamel, carries a figure of Christ in solid silver. Openwork scrolls between the arms of the cross form a large aureole studded with garnets. Adorning the foot of the crucifix are two kneeling angels holding up chalices to collect the blood of Christ. The cross here does not represent the withered tree of suffering but rather the tree of life, nourished by the blood of the Savior, who is represented as both redeemer and king. This sentiment is expressed by the dominant green of the enameled details and the burgeoning terminals of the three arms of the cross.

R.V.

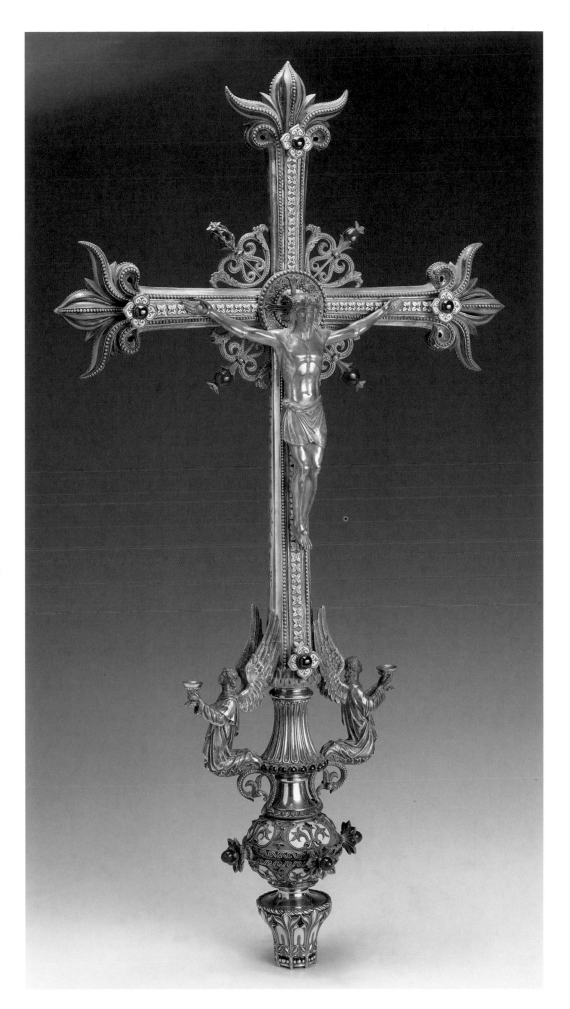

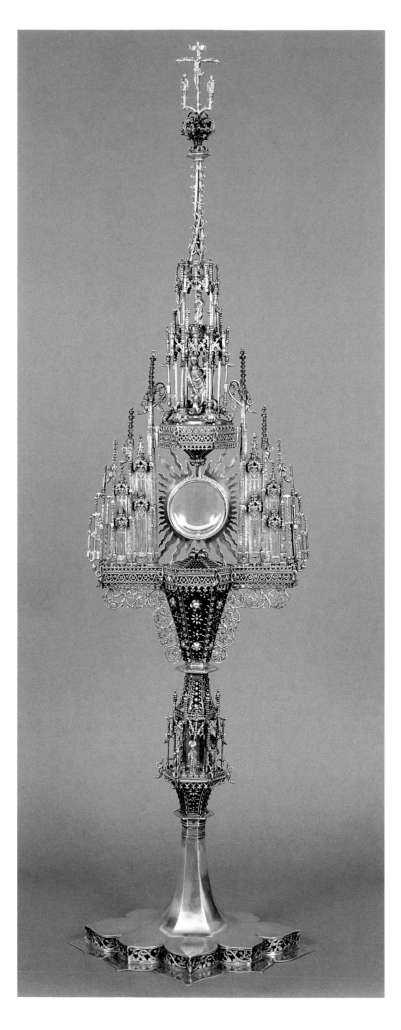

Monstrance of Pope Leo XIII

1887
István Fülöp Wink, Budapest
Facsimile of the 15th-century monstrance of the church
of Velká (Czechoslovakia), restored in the 18th century
Silver, enamel
112 × 32 × 25 cm
Office of the Liturgical Celebrations of the Supreme Pontiff,
Vatican City State
Inv. OST6

Conservation courtesy of Texas Patrons, in memory of our late
Chairperson Emeritus, Mrs. Lucille (Lupe) Murchison

The history of this monstrance can be reconstructed from the
three inscriptions on the base. The piece was donated in 1887
to Pope Leo XIII for his jubilee year by the bishop of Szepes,
György Császka, and was crafted by the goldsmith István
Fülöp Wink as an exact replica of the one conserved in the
town of Velká. The upper section dates from the fifteenth
century, whereas the base is a reconstruction in the Gothic
manner dating from the end of the eighteenth century.

On the occasion of his jubilee, the pontiff received
many precious gifts from rulers, dignitaries, and Catholic
institutions from all over the world, who each sent something
of special artistic merit from their region. This Czech replica
of the Velká monstrance was such a gift and aptly represents
the local tradition of working with gold and silver. For
centuries the region of Szepes, now in the modern state of
Slovakia, was part of the Kingdom of Hungary, and here since
the fifteenth century silver- and goldsmiths had flourished,
earning wide esteem for their craftsmanship throughout
Hungary and later the Austro-Hungarian Empire.

Richly decorated in the Gothic style with minute, pain-
staking detail, complete with flying buttresses and tracery
in imitation of the great Gothic cathedrals, the Császka
monstrance shows its specifically Hungarian origins in the
choice of imagery for the saints adorning it. The first
enclosure above the receptacle for the Host contains a tiny
statue of the Virgin representing the *Patrona Hungariae* (Patroness
of Hungary), bearing the scepter, crown, and the Infant Jesus
on her left arm. This composition, which has belonged to the
devotional imagery of Christian Hungary since the time of
King Saint Stephen in the eleventh century, assumed this
characteristic format in the seventeenth century in the region
of Transylvania, and quickly became the distinguishing
symbol of Hungarian Christianity. The ornamental protrusion
on the shaft is decorated with various Hungarian saints
flanked by others of universal importance. Those featured
include the apostle Andrew, Saint Anthony Abbot, Saint
John the Evangelist, Saint Stephen of Hungary, Saint Ladislas
(László) of Hungary, and one saint in particular portrayed as
a young king holding a large sword in both hands, standing
over a prostrate male figure. This unusual composition may be
a special representation of Saint Stephen, specific to Hungary,
where he was revered as the savior of the nation and defender
of the Christian faith. M.A.D.A.

Ciborium of Pope Leo XIII

1887
Eugenio Bellosio, Milan, Italy
Gold, rubies, sapphires, emerald
18 × 7 × 7 cm
Office of the Liturgical Celebrations of the Supreme
Pontiff, Vatican City State
Inv. PIS54

The word pyx (i.e., ciborium) derives from the Greek *pyxis* and means box. In the liturgy of the Catholic Church, the ciborium is a metal "box," or container, used to hold the Eucharist for the adoration of the faithful and the communion of the sick. The ciborium and the Eucharist it contains are kept in the tabernacle located over or near the altar.

In ancient times, following the Edict of Milan (313), the ciborium took the form of a dove which hung by a chain over the altar. Later, it evolved to such forms as a tower or a small temple until, with the Renaissance, it took the universally adopted semicircular shape with a bowl and lid supported by a stem and a base.

This ciborium was donated to Pope Leo XIII in 1887 by Francesco Mondellini, a parish priest of the diocese of Milan, Italy. Nothing is known of the artist who made it save his name: Eugenio Bellosio.

An image of the pope is recognizable in one of the four medallions with embossed heads in the base of the ciborium. The underside of the bowl is decorated with embossing and fretwork. The four medallions show the coat of arms of Pope Leo XIII, the Resurrection of Christ, the papal tiara, and the Last Supper. This ciborium was used in the pope's private chapel until the time of Pope Pius XII. R.V.

Portrait of Pope Benedict XV

1914–22
A. Zoffoli
Oil on canvas
102 × 76 cm
Inscriptions: A. Zoffoli Roma
Congregation for the Evangelization of Peoples,
Vatican City State

Conservation courtesy of John J. Brogan

Giacomo Della Chiesa studied in Genoa and took his degree in law, after which he studied theology at the Gregorian University in Rome. He was private secretary to Mariano Rampolla del Tindaro, a great diplomat, and was able to study at his school when the latter was elected cardinal and became secretary of state. Called by Pius X to the episcopal see in Bologna, he was elected cardinal in 1914. While the First World War was raging, between August 31 and September 3, 1914, the cardinals elected him successor to Pius X. As a homage to his predecessor, he took the name of Benedict XV.

The attitude of the new pontiff toward what he considered a "most disastrous war" is outlined in the encyclical "Ad Beatissim," which condemns the nationalistic egoism and racial hatred and the class struggle, and denounces the dechristianization of society. The encyclical had a vast following in the Italian Catholic movement, which fervently sustained neutrality. The repeated appeals for peace launched by Benedict XV remained unheeded. Meanwhile, the intensive diplomatic activity of the Holy See was aimed at possible negotiations between the governments of Rome and Vienna and, at the same time, the organization of aid to the wounded, prisoners of war, and the civil population. As Leo XIII and Pius X had done before him, Benedict XV dreamed of the return of the Eastern Churches that had broken away. When the Russian revolution broke out, he tried to free the Slavic Orthodox Church from the influence of the government. On May 1, 1917, with a Motu Proprio, he constituted the Congregation for the Eastern Church, in the same year erecting a pontifical institute for higher Oriental studies. He was also active in the missionary movement.

This portrait was executed in Rome by A. Zoffoli, an artist who was not particularly well known. The soft pictorial style is enlivened by flashes of light falling upon details of the vestments (the mozzetta, the stole, the gilded cord) and the furnishings (the arms of the papal throne). Pope Benedict XV is portrayed conferring a blessing, his expression absorbed and sadly aware of the terrible trials of the war undergone in his pontificate. The portrait may have been executed for the Propaganda Fide (Congregation for the Evangelization of Peoples), perhaps to celebrate its fusion with the Pontifical Organization for Evangelization (1919), and since then has been located in its present setting. M.N.

Vatican dignitaries gather for the conclave that would elect Pope Benedict XV, 1914,
L'Osservatore Romano

Footrest and Foot-warmer of Pope Benedict XV

20th century
Wood; lining: velvet, embroidery, ermine
14 × 50 × 40 cm
Apostolic Floreria, Vatican City State

Conservation courtesy of Elizabeth M. Bowden and
Col. Charles W. Bowden, Jr.

For centuries, pontifical ritual held that the "kiss
of the slipper" was a reverential act required
when in the presence of the pontiff. The believer
was to kneel at the pope's feet and render homage
to him. This custom was still in effect at the time
of Pope Benedict XV and this was his footrest for
use in that ceremony.

This particular footrest has details that provide
a glimpse into the pontiff's everyday life. The pope
is head of the church but he is also a man, and
thus not immune to difficulties and discomforts.
Pope Benedict XV was an individual of great moral
and religious authority, and above all, of great
humanity. He was tireless in his effort to condemn
the First World War and offer assistance to
prisoners, the wounded, and refugees. But he
also had a weak constitution and was subject to
illnesses. Many of his portraits show him dressed
in mozzetta and *camauro*, the pope's red velvet cape
and cap, lined in fur, because he suffered from
the cold. This footrest has a hidden ermine-lined
compartment into which he could slip his feet
for warmth. This was done in the execution of
nonpublic duties, while working at his desk in
the Apostolic Palace, which is as majestic and
picturesque as it is cold and difficult to heat in
the winter. G.P.

Snuffbox of Pope Benedict XV

19th century
Gold, diamonds
4 × 9 × 6 cm
Office of the Liturgical Celebrations of the Supreme
Pontiff, Vatican City State
Inv. SC2

At some point during his reign, the emperor of
Brazil, Don Pedro II (r. 1831–89), donated this
exquisitely decorated snuffbox to the then
archbishop of Bahia as a token of his esteem and
gratitude for services the latter had rendered to
the House of Braganza. At a later date the snuffbox
passed into the hands of the archbishop of Cuyabà
who, in the course of an *ad limina* visit to the Vatican,
made a gift of it to Pope Benedict XV, who had it
deposited in the Pontifical Sacristy.

A small box with a removable lid, the snuffbox
evinces the baroque styling typical of articles
manufactured for personal use in the later nine-
teenth century and is entirely embellished with the
engraved patterns used in baroque *objets d'art*.

The box is solid gold and studded with
diamonds of varying size and cut; the four larger
diamonds set into a tiny rosette at each corner are
from a Brazilian mine and are brilliant cut in the
antique fashion. Adorning the center of the lid
and employing smaller cut diamonds set into
white metal to offset the container is the emblem
of the emperor—the letters "P II" surmounted
by a crown—all in white metal for contrast and
studded with tiny natural diamonds.

There is no evidence that the object was ever
actually used by any of the popes, though some
are known to have taken snuff or to have smoked
tobacco. L.O.

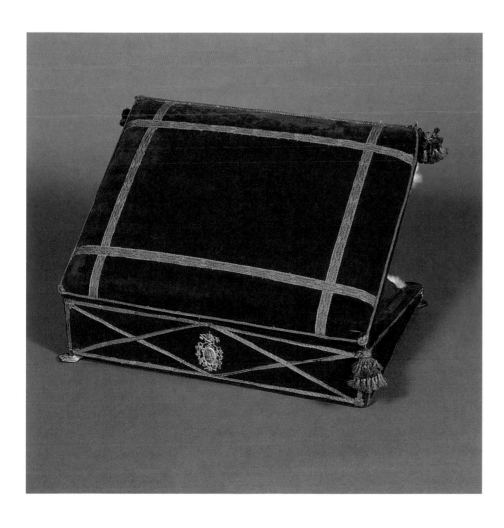

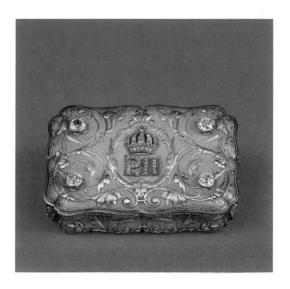

Bust of Pope Saint Pius X

Early 20th century
Terracotta
84 × 65 × 44 cm
Office of the Liturgical Celebrations of the Supreme Pontiff, Vatican City State

Conservation courtesy of Elizabeth M. Bowden and Col. Charles W. Bowden, Jr.

This bust may have been modeled from a cast of an earlier marble of Pope Pius X. In the entrance to the Museo Pio Cristiano is a bust which to all effects appears to be the original from which this was copied. However, the bust has little artistic or documentary value as it is too idealized a portrait of the pontiff and too youthful to be considered realistic.

This notwithstanding, the bust offers documentary evidence of the particular article of dress in which the pontiff is portrayed, namely, a special mantle known as the moretta, worn by bishops and other dignitaries of the clergy. The title and rank of the wearer is distinguished by the cloth's color. The pontiff's mantle was normally red and fringed with ermine, whereas during the octave of Easter, the mantle he wore was white. Pope Paul VI gave up wearing the white mantle at the end of his pontificate, and the present pope has never worn it. R.V.

Ring of Pope Saint Pius X

First half of the 20th century
Silver gilt, precious stones
3 × 2.5 × 2.5 cm
Office of the Liturgical Celebrations of the Supreme Pontiff, Vatican City State
Inv. AN6

Conservation courtesy of Siobhan Nicole McNamara

The ring is made of gilded silver. The band is adorned with two four-leaf clovers, each with a tiny flower in its midst, embracing the oval setting mounted with a superb red stone. Fixed to the band by a short piece of red cord is a small elaborate tag bearing the inscription: "anello d'argento dorato, applicato al dito del Beato Pio X li 29–5–51" (ring in gilded silver, applied to the finger of the Blessed Pius X on May 5, 1951).

The word "applied" is appropriate in this case, as the ring was made to be slipped over the finger of the dead pope when his body was being prepared to be exhibited to the public in the Basilica of Saint Peter, on the occasion of his beatification on June 3, 1951. Pope Pius X was subsequently made a saint in 1954, and on that occasion the ring was replaced with a copy. The one on exhibit here is the original.

R.V.

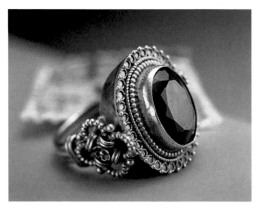

Portrait of Pope Saint Pius X

First two decades of the 20th century
Oil on canvas
60.5 × 49 cm
Congregation for the Evangelization of Peoples,
Vatican City State

Conservation courtesy of John J. Brogan

Giuseppe Melchiorre Sarto, of very humble origins, studied to become a priest and was ordained in 1857. Bishop of Mantua from 1884 onward, he was called to the patriarchy in Venice in 1893 and elected cardinal. Having distinguished himself there for his simple lifestyle and exemplary zeal, he was elected pope in 1903. From his first encyclical ("Instaurare omnia in Christo") his pontificate took on a predominantly religious significance; in politics he more than once suspended the prohibition inaugurated by Pius IX with his "Non expedit," which prevented Italian Catholics from participating in political elections. In dealing with the split between France and the Holy See, which culminated in the seizing of the ecclesiastical goods, he proved to prefer a poor clergy to one that favored a persecutory and atheist state (in this he received the approval of the French clergy). With an attitude of reconciliation he embarked on an intense activity of diplomatic relations with the Italian state, which was to lead to the signing of the Lateran Treaty on February 11, 1929.

The portrait, an anonymous oil on canvas of good pictorial quality and vibrant luminosity — inspired by more widely known photographs of the pope, as the slightly fuzzy image from which the author of the painting drew would lead one to believe — is difficult to date. It represents Pope Saint Pius X with an intent expression in a fur-trimmed mozzetta. The stole falling from his shoulders over his chest is held in place by a large triangular clip and decorated with historiated plaquettes that bear the emblem of the patriarchy of Venice surmounted by the papal tiara and the keys of Saint Peter. The date of the painting and when it entered the collections of the Sacred Congregation of Propaganda Fide, where it is still housed, is unknown. M.N.

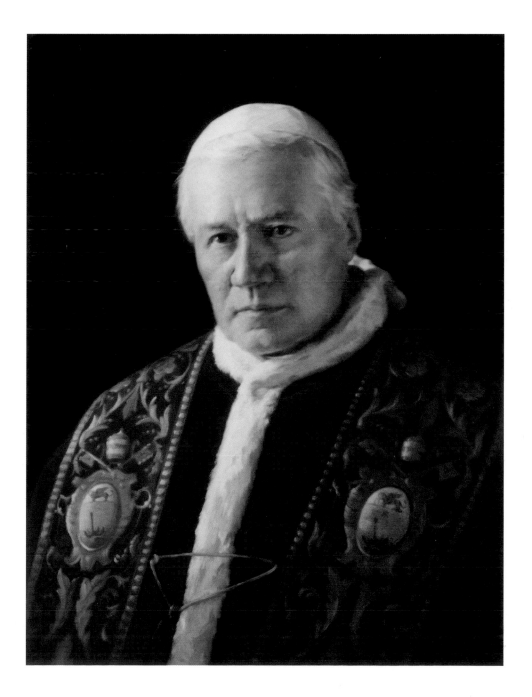

Portrait of Pope Pius XI

1925
Unknown artist of the Franciscan Missionary Order
of Mary
Oil on canvas
104 cm
Inscriptions: F.M.M., Rome 1925
Congregation for the Evangelization of Peoples,
Vatican City State

Conservation courtesy of John J. Brogan

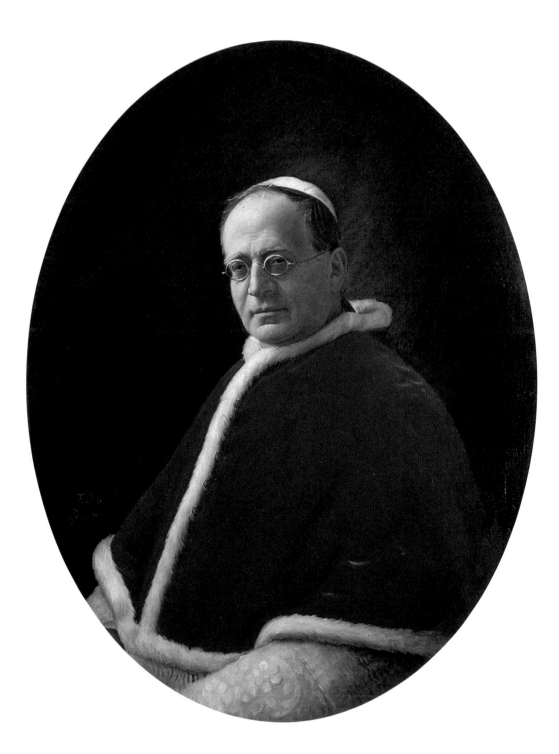

Achille Ratti studied at the Theological Seminary
of Milan and was ordained priest on December 20,
1879. He then furthered his studies in Rome,
where in 1882 he took diplomas in theology,
canon law, and philosophy. On his return to Milan
in 1882, he refined his scholarly talent at the
Ambrosian Library, where he succeeded Msgr.
Antonio Ceriani as director. Called to the Vatican
Library in 1912, he became prefect there in 1914.
In 1921, he was appointed archbishop of Milan
and cardinal, and on February 6, 1922, was
crowned Pius XI. His pontificate aimed at the
moral reconstruction of a humanity that was
sorely tried by the horrors of the First World War.

Striving for the fulfillment of a universal
apostolate and paying close attention to missionary
policy, with the "Rerum Ecclesiae" (1926)
Pope Pius XI appealed to all believers to assume
responsibility for the conversion of the world, a
responsibility which was even more impelling
for those who had a mission and an apostolate to
fulfill. This zeal for evangelization earned him the
name of Pope of the Missions. He instituted the
clergy and the indigenous episcopate (China and
Japan) and the founding or the reorganization of
missionary institutes such as the Russicum and
the Ethiopian Institutes, and the Congregation for
the Evangelization of Peoples (Propaganda Fide).
The institutions for the spiritual and intellectual
edification of the clergy (seminaries, universities)
were dear to the pope and he reorganized them.
He also gave a good deal of impetus to culture
(Institute of Sacred Archaeology, Ethnographic
Museum, Biblical Institute, Academy of Science)
and, foreseeing the extraordinary innovative
importance of a new mass medium, the radio,
in 1931 he inaugurated the Vatican radio station.

The portrait, an oil on canvas in an oval frame,
bearing the signature "F.M.M." and dated 1925,
is of considerable pictorial quality, enhanced by
the play of light. It represents the pope in three-
quarter view with a dignified expression; in this
it replicates an iconography of Pius XI known
from photographs. The painting was executed in
1925 for the Congregation for the Evangelization
of Peoples, where it is still housed today, by an
unknown artist belonging to the Franciscan
Missionary Order of Mary, hence the inscription
F.M.M. M.N.

Statue of the Virgin Mary

1929
Silver
58 × 15 × 15 cm
Office of the Liturgical Celebrations of the Supreme
Pontiff, Vatican City State
Inv. VR8

Conservation courtesy of James Augur

Although Pope Pius XI was particularly fond of this
statue of the Virgin Mary, and kept it on his desk in
his private study in the Papal Apartments, nothing
is known about the artist who created it.

The statue is made of solid silver and was a gift
from the princesses of the House of Savoy, at that
time the royal family of the Kingdom of Italy.

The vigorous stirrings of the folds of the Virgin's
gown are in striking contrast with the serene
expression on her face, as is she were enthralled
by a sublime vision. The gown has a matte finish,
whereas the shawl is polished. At her feet lie two
attributes of the Immaculate Conception: a serpent
and a half-moon.

On the front of the plinth beneath the statue
is a small panel containing a gilded wreath around
the legend "D XX FEB"; the front of the square
base is emblazoned with the pontiff's coat of
arms and inscribed "Pius XI Pont. Max. Philippus
a Lutharingia et Brabantia Hassiae Prin. et Land.
Mafalda a Sabaudia Hassiae Prin. et Land.
MCMXXX"; the back carries the emblem of the
princes of Hesse and Savoy. R.Z.

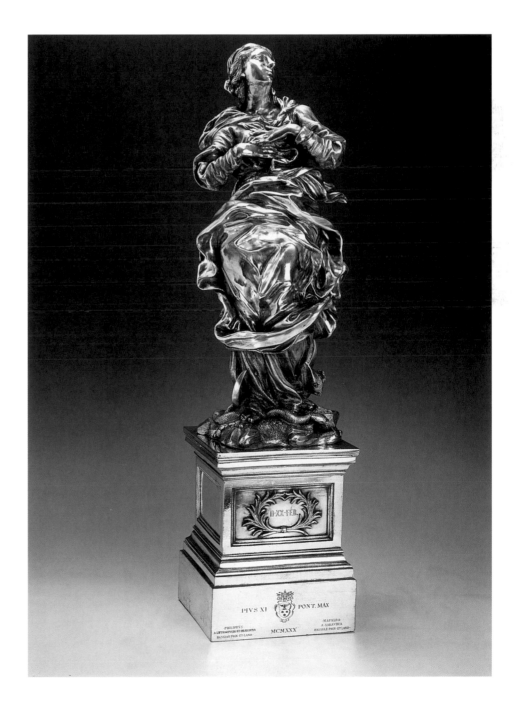

Cameos

20th century
Shell
8 × 7 × 2 cm
Office of the Liturgical Celebrations of the Supreme
Pontiff, Vatican City State
Inv. VR 11 a-b

Shell cameos are obtained by carving out layers
from the interior of mother-of-pearl to extract
figures in relief. The raised design and background
consist of layers of contrasting colors that exploit
the characteristic feature of the material.
The carving is executed with fine chisels, then
the cameos are polished with pumice and oils
and rinsed in lukewarm water.

The most common subjects derive from Greek
and Roman mythology or classical works, and such
images as flowers and female figures are rendered
in a purely classical style. These cameos, large and
of exquisite workmanship, have been executed in a
typical classic style. They portray Christ and Mary.

The artists and place of origin have not been
ascertained, although it is known that the cameos
were a gift from King Victor Emmanuel III of Italy
to Pope Pius XI. C.P.

Pectoral Cross with Chain of Pope Pius XI

Gold, pearls
9 × 7 × 2 cm
Office of the Liturgical Celebrations of the Supreme
Pontiff, Vatican City State
Inv. CR13

After much tribulation, on February 11, 1929,
the Italian king Victor Emmanuel III and Pope
Pius XI signed the Lateran Treaty, putting an end
to the so-called Roman Question, by which the
papacy officially recognized the State of Italy and
in exchange was granted sovereignty over the
territory of the Vatican.

To mark this solemn occasion, the king gave
the pontiff this pectoral cross made of solid gold
and encrusted with natural, perfect pearls all of
the same tone of white. The arms are studded with
rows of smaller pearls and end in slightly trilobate
terminals carved with a delicate open fretwork,
at the center of which is mounted a large pearl
in a raised border with a veil of enamel. The top
terminal is fitted with a hook for the chain, and
between the intersections of the arms a series of
radial elements is also finely studded with pearls.

The cross is kept in a small brown wooden
box with delicate floral designs inlaid on the lid.

Although the cross was frequently used by Pope
Pius XI and his immediate successor, Pius XII, it was
less often used by later popes and has never been
worn by the present pope. L.O.

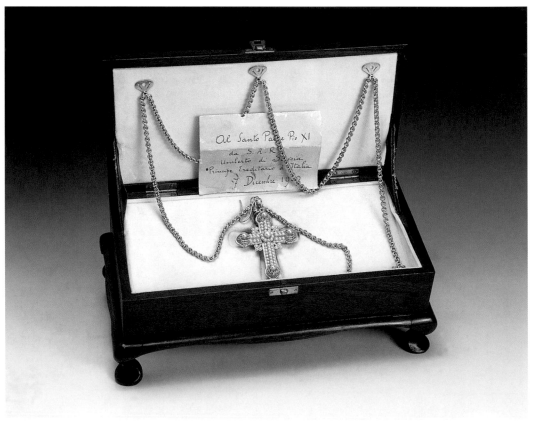

Pope Pius XII

1962
Francesco Messina (1900–1995)
Bronze
61 × 55 × 21 cm
Vatican Museums, Vatican City State
Inv. 54942
Donated by the artist

Francesco Messina, one of the great masters of modern Italian sculpture, began his artistic training in Genoa in the workshop of a marble sculptor and perfected his personal expression through a close study of the works of other sculptors in museums all over Europe. His eventual mastery of the medium enabled him to take on a variety of different types of commission. Ten of his works completed around 1959 are conserved in the Southern Methodist University in Dallas, Texas.

This is a model for the monument to Pope Pacelli in Saint Peter's Basilica. It required an enormous effort from the artist, as he himself was to describe years later in a memoir (1974). In fact, he prepared eighteen models for the piece. In the model exhibited, a study for the final statute, Pope Pius XII is depicted with his arms open wide as immortalized in the famous photograph taken on July 19, 1943, in the San Lorenzo district of Rome after the bombardment of the city.

The artist, however, chose to depict the pope wearing his papal vestments and miter in the finished statue, which can be seen in Saint Peter's Basilica. R.V.

Pectoral Cross of Pope Pius XII

First half of 20th century
Gold, amethysts
13 × 8 × 1.5 cm
Office of the Liturgical Celebrations of the Supreme
Pontiff, Vatican City State

This type of cross hangs on a chain or piece of
cord and is worn by prelates and by the pope. It is
always outside whatever vestment he is wearing,
so that the cross is visible at all times. Normally
these crosses were made of gold, often encrusted
with gems. Those worn by prelates or by the pontiff
have a small compartment at the intersection of the
arms that contains a relic of a saint or a small piece
of the True Cross.

The pectoral cross, which is often exquisitely
crafted, has dual symbolic value: as a cross it
symbolizes the sacrifice of Jesus Christ; the jewels
and gold are symbols of the Resurrection.

Today more and more prelates have turned
to wearing less precious crosses, usually made
of more humble materials as a sign of respect for
the poor of the world.

This magnificent jeweled cross with seven
large oblong amethysts in a gold setting was used
by Pope Pius XII. It had previously belonged to
Cardinal Sbarretti, who had been made cardinal
by the Consistory of December 4, 1916. He
became subdeacon of the College of Cardinals
and secretary of the Congregation of the Holy
Office (now known as the Congregation for the
Doctrine of Faith). One month after Pope Pius XII's
election, however, Cardinal Sbarretti died and his
family donated the cross to the new pontiff.

No further information on the cross is
conserved in the Pontifical Sacristy records, and
it bears no hallmarks or inscriptions to indicate
when or in which workshop it was crafted. R.Z.

Stole of Pope Pius XII

First half of 20th century
Silk, velvet, gold thread
109 × 35 cm
Office of the Liturgical Celebrations of the Supreme
Pontiff, Vatican City State
Inv. ST24

This stole belonged to Pope Pius XII. It is made of
deep red velvet and finely embroidered in silk and
gold thread, with a Greek cross in the lower section
and a shield midway carrying the papal coat of
arms, all enclosed amid a variety of floral designs
and ears of wheat. A cord of silk and gold thread
with matching tassels holds the stole in place, and
the bottom edge terminates in golden fringe. R.Z.

Portrait of Pope John XXIII

1962
Giacomo Manzù (1908–91)
Bronze
105 × 79 × 75 cm
Vatican Museums, Vatican City State
Inv. 23321

Giacomo Manzoni, called Manzù, began his artistic training very early, working as an assistant in the workshops of a woodcarver, a gilder, and a stucco artist. The experience instilled him with a certain eclecticism, and while he devoted himself to drawing, engraving, and painting, his preference remained for sculpture, which he imbued with uniform plasticity. The pinnacle of his achievement is undoubtedly the Door of Death for Saint Peter's Basilica, one of the most impressive and complex works undertaken by a contemporary sculptor.

This bust of Pope John XXIII was commissioned from the artist the day after Cardinal Angelo Roncalli was elected pope. It was completed, however, only after a long and sef-reflective process which included the creation of seven models, three of which were destroyed and others melted down and then completely rejected.

This model, the last of the three which remain (the others are preserved in Saint Mark's Basilica in Venice and in the office of Monsignor Capovilla, who was secretary to the pope at the time), seems to be the best representation of the complex personality of Pope John Paul XXIII: Father of the Church, wise, conscious of working within a universal dimension, a simple man, friendly and profoundly human. R.V.

Ring of Pope John XXIII

20th century
Gold, diamonds, emeralds
3 × 3 × 2 cm
Office of the Liturgical Celebrations of the Supreme Pontiff, Vatican City State
Inv. AN5

This superbly precious ring is composed of a large emerald surrounded by twelve cut diamonds. The band is inscribed on either side of the mount with a cross and the bishop's miter. Other than the fact that this particular ring was most certainly worn by Pope John XXIII, little else is known of its origins or manufacture. R.V.

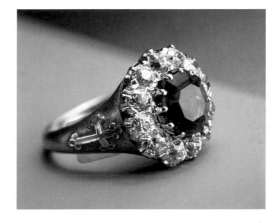

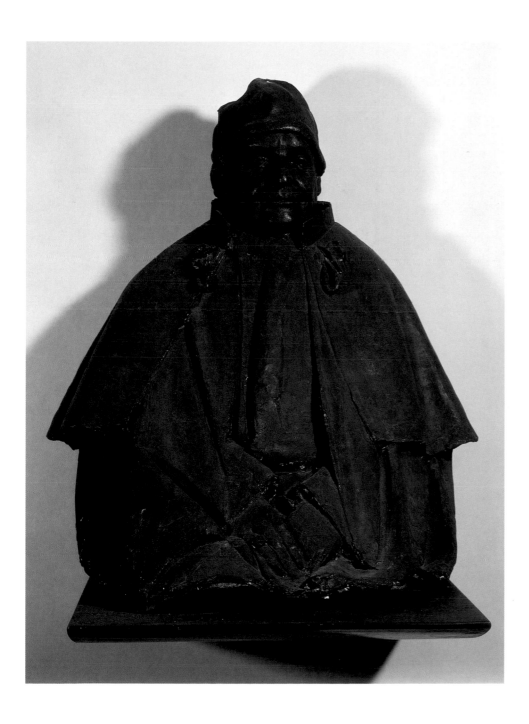

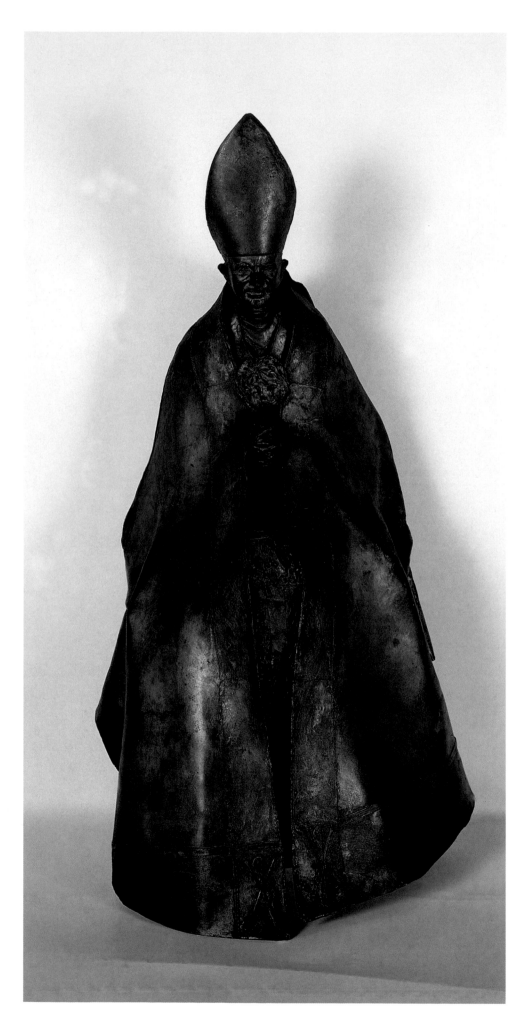

Pope Paul VI

1965
Lello Scorzelli (1921–97)
Bronze
120 × 60 × 67 cm
Vatican Museums, Vatican City State
Inv. 23535

Lello Scorzelli, the creator of this bronze sculpture of Pope Paul VI, was born in Naples in 1921. He began as a self-taught artist. After the Second World War, he developed a passionate interest in the Renaissance after reading the Life of Benvenuto Cellini. He was able to deepen his knowledge of that period during a study trip to Florence.

In the 1960s, Scorzelli began to be interested in sacred sculpture, which came to represent the greater part of his artistic production. His meeting with Pope Paul VI, whom he had met in Milan in 1959 when the future pontiff was archbishop of that city, also strengthened his interest in sacred and religious subjects. For Pope Paul VI he also made a pastoral cross, later inherited by his successors Pope John Paul I and the current pontiff, Pope John Paul II.

This work is housed in the galleries of the Collection of Modern Religious Art. This collection was created from gifts, both from collectors and from the artists themselves, and represents— in the words of Pope Paul VI, pronounced on June 23, 1978, at the opening of the Collection— a direct testimony of the "prodigious capacity of expressing, beyond what is authentically human, the religious, the divine, the Christian."

Here Scorzelli has represented the pope with his solemn attire enveloping his frail but determined silhouette. R.Z.

Pope Paul VI wearing the papal tiara, L'*Osservatore Romano*

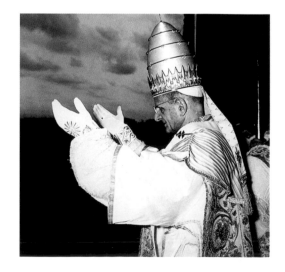

Miter of Pope Paul VI

1963
Designed and manufactured by the Beato Angelico
School of Milan
Satin, silk, gold braid
32 × 33.5 cm
Office of the Liturgical Celebrations of the Supreme
Pontiff, Vatican City State
Inv. MI5

This miter was used by Pope Paul VI who, after having donated the papal tiara (see photo on facing page) to support the struggle against hunger in the world, no longer used that traditional form of pontifical headdress.

Indeed, all the portraits of Pope Paul VI show him wearing this miter, which is very simple and much adapted to his style. He chose this model from the designs prepared for him by the Beato Angelico School of Milan. After having been continuously used by the pope for fifteen years, the miter was donated to the Pontifical Sacristy to be kept in memory of the pontiff.

This miter is of a traditional though slightly shortened form. The style recalls the tastes typical of the period immediately following Vatican Council II. It is made of satin with embroidery in silk thread and some very simple decorations. Each side is adorned with a cross that merges with the headband and divides each of the two faces into four parts. The four lower quarters, two on each side, are embroidered with the symbols of the evangelists. The *infulae*, which are of the same material as the rest, are long and simple. The bottom of the left infula is embroidered with the papal tiara and keys, while the right one bears the coat of arms of Pope Paul VI and the inscription "In nomine Domini" (In the name of the Lord).

R. V.

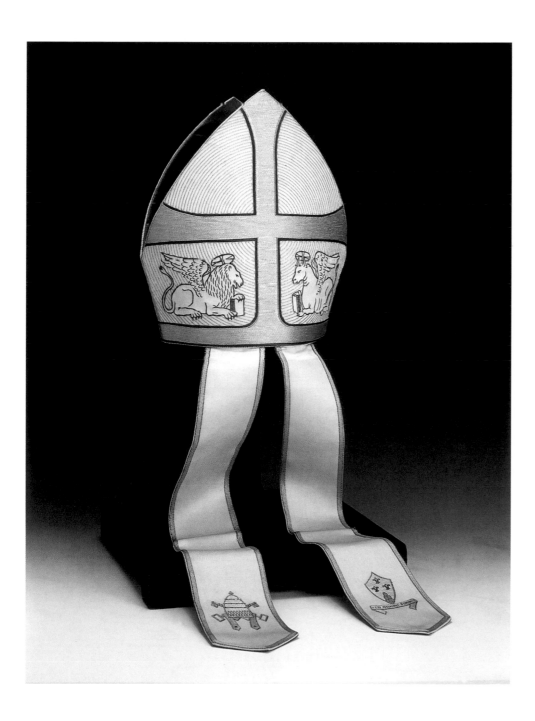

Pope Paul VI with his miter and papal staff on the balcony of Saint Peter's Basilica, *L'Osservatore Romano*

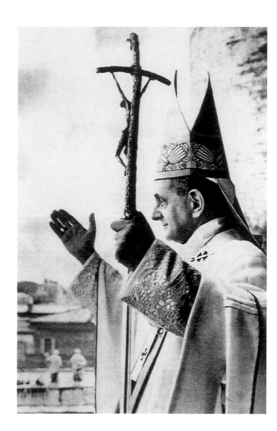

Chalice and Paten

First half of the 20th century
Crystal, gold (chalice), metal (paten)
Chalice: 14.5 × 6.5 × 6.5 cm; paten: 16 × 16 cm

Office of the Liturgical Celebrations of the Supreme
Pontiff, Vatican City State
Inv. CA81

At first sight, neither this chalice nor the paten
appear to have anything to qualify them for inclu-
sion in the Treasury of the Papal Sacristy: the goblet
is of plain glass, albeit embellished with gold trim
on the foot; the paten, moreover, is of ordinary
metal. Despite their humble appearance, however,
both are charged with great significance: they were
used by priests imprisoned during the Second
World War. Overcoming all obstacles to celebrate
mass in the prisoner-of-war camp in spite of the

intolerance of the guards, they used this simple
glass vessel for celebrating the Eucharist, together
with a paten improvised from the bottom of a
metal canister. At the end of the war, the liberated
priests bequeathed their chalice and paten to
Pope Paul VI, who celebrated mass with the goblet
and had its foot embellished with gold and an
inscription engraved on the base: "Sacro hoc vitreo
calice auro pretiosiore a sacerdotibus Friderico
Dombek eiusque sociis confecto dum in ergastulo
detenibantur quo plures annos usi sunt ad
Eucharisticum sacrificium secreto celebrandum
Paulus VI Pont. Max. divina Hostia litavit die III M.
Iulii A. MCMLXIX." (On this day of July 3, 1969,
Pope Paul VI did receive as a gift from the priest
Federico Dombek and his companions, this
glass chalice which for many years served in the
celebration of the Eucharist during their captivity,
and had it thereafter embellished with gold.) R.V.

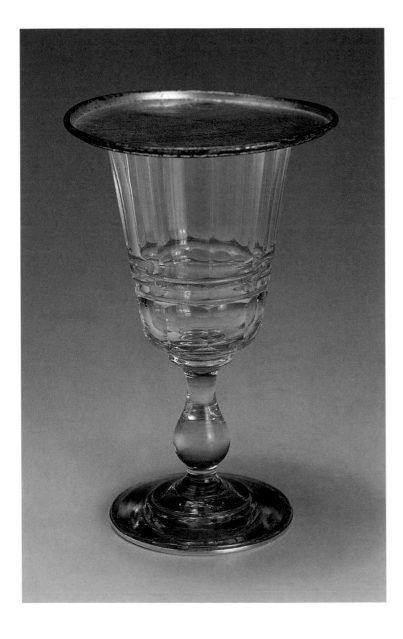

Pectoral Cross

Ca. 1963
Turkish-Byzantine silversmith
Gilt silver with chain
8.1 × 4.7 cm
Vatican Museums, Vatican City State
Inv. 70170

The gilt-silver pectoral cross is decorated with
an image of Christ, surrounded by a dedicatory
inscription. It is to be worn on a chain of different
types of links, including, on the back, nine crosses
with arms of equal lengths. The cross was a gift
of the patriarch of Constantinople, Athenagoras.
It was given to Pope Paul VI on December 28, 1963,
during the course of the private audience granted
to the patriarch's delegation.

The gift was presented during one of the most
meaningful moments of the ecumenical movement
of reconciliation among Christian churches.
Vatican Council II (1962–65) gave a strong thrust
to reestablishing cordial relations between different
confessions and expressions of the one faith in
Jesus Christ. After initial contact with Pope John
XXIII, the patriarch of Constantinople, spiritual
leader of Eastern Orthodox Christians, became the
privileged interlocutor of Pope Paul VI. Together
they attempted to clear up the misunderstandings
and dissension that followed the Eastern Orthodox
Schism of 1054.

The visit of Athenagoras' delegation was the
occasion of this extremely simple, yet meaningful
gift. The episcopal cross implies the recognition
of equal dignity in apostolic succession. It occurred
at a very delicate moment during the dialogue
between the churches, immediately after the
second session of the council, in December 1963.
This session had debated at length the draft of the

The Patriarch of Constantinople, Athenagoras,
presenting the pectoral cross to Pope Paul VI,
December 28, 1963, *L'Osservatore Romano*

De Oecumenismo, preliminary to one of the most important documents of the council, the Unitatis Redintegratio ("Reestablishment of unity…") decree, which was promulgated during the council's third session on November 21, 1964.

On December 28, 1963, the following news report appeared in the *Osservatore Romano*:

> *The Holy Father received the Most Eminent Athenagoras, Metropolitan Bishop of Thyatira, [...] the Official Delegate of His Holiness the Patriarch Athenagoras and the Holy Synod of the Eastern Orthodox Church of Constantinople. [...] At the end of the interview, the Holy Father gave the Metropolitan Bishop a gift of a precious, artistic pectoral cross.*

The actual meeting between Pope Paul VI and Patriarch Athenagoras took place just a few days later, on January 5, 1964, in Jerusalem during the pope's visit to the Holy Land. Two more meetings followed three years later: on July 25, 1967, in Istanbul, and, shortly after, between October 26 and 28 of the same year, in Rome. These memorable encounters, the first between the highest representatives of the two churches after the Council of Florence of 1439, resulted in a strong inducement for further theological dialogue in an effort to overcome the differences separating members of a single community of Christians. The progress obtained has been continued by Pope John Paul II, and is even closer to achieving its goal. U.U.

327

Pectoral Cross of Pope Paul VI

1977
Manlio Del Vecchio
Gold, emeralds, pearls
17 × 11 × 1.5 cm
Office of the Liturgical Celebrations of the Supreme Pontiff, Vatican City State
Inv. CR2

This superb pectoral cross was a gift to Pope Paul VI from the Handmaidens of the Sacred Heart of Jesus on January 23, 1977. Made of solid gold, the cross was crafted by the silversmith Manlio Del Vecchio and carries four large emeralds set into the face, each complemented by large natural pearls. At the bottom is a small reliquary carrying the remains of Saint Raffaella of the Sacred Heart, foundress of the Order, whose members donated the cross to the pope when she was canonized. The cross is kept in a custom-made case in white leather bearing the emblem of Pope Paul VI. L.O.

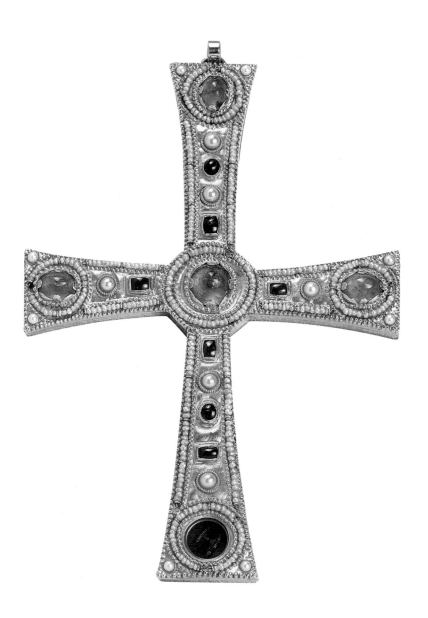

Medallion of Pope John XXIII

After 1963 – Before December 1968
Metal, fabric, enclosed in a cylinder of methacrylate
Diameter 6 cm; h: 2.5 cm
Vatican Museums, Vatican City State
Inv. 70172

We open the window, and instinctively our gaze, our thoughts, our heart goes towards the sky, unable to be indifferent to the allure of wonder and expectation for the launching to the moon of Apollo 8 with aboard three men prepared for the celestial exploration of the silent, silvery satellite of our Earth. With the entire world anxiously following this daring, well-planned enterprise, we also extend our praise to the inestimable scientific and organizational effort that made this bold, unbelievable adventure possible. We send our best wishes to the courageous astronauts flying into space at breakneck speed, and hope for the success of this risky interplanetary journey. We pray to the Lord on their behalf and on behalf of the world, dumbfounded by the conquests of science and human endeavors, that this new event may enhance man's opinion of himself, as a citizen of this marvelous universe where the greatness, the power, and the wisdom of God are continuously revealed.

These were the words that Pope Paul VI addressed to the crowd gathered in Saint Peter's Square for the Angelus of December 22, 1968. Just a few hours earlier, the mission of Apollo 8 had begun: for the first time a spacecraft would transport its three astronauts – Frank Borman, James A. Lovell, and William A. Anders – in orbit around the moon.

Shortly after the successful completion of the Apollo 8 mission, on February 15, 1969, Colonel Frank Borman, commander of the crew, was received by the pope in the Vatican. At that time, Borman presented the pontiff with a large photograph of the moon as seen from Apollo and a medallion with a relic of Pope John XXIII that he had carried with him into space. The medallion, together with a small piece of fabric from John XXIII's robe, was placed in the collection of Gifts to the Popes in the Vatican Apostolic Library, which has recently been transferred to the Vatican Museums. U.U.

Samples of Lunar Rocks
and Flag of the Vatican City State

1969, Apollo 11 space mission
20 × 23 × 27.5 (container)
Vatican Museums, Vatican City State
Inv. 70166

These fragments of lunar rock and this small Vatican flag are associated with the historical space mission of Apollo XI, when man first set foot on the moon. They were a gift of the president of the United States, Richard Nixon, to citizens of the Vatican City State. This flag, along with the flags of all the countries in the United Nations, accompanied the astronauts on their expedition. The rock fragments were among those specimens collected from the ground by astronauts Neil Armstrong and Edwin Aldrin in the area of the Sea of Tranquility during the first exploration of the lunar surface.

Armstrong and Aldrin landed on the moon at 4:17 pm EDT on July 20, 1969 in the lunar module "Eagle." Pope Paul VI watched the landing from the Schmidt room in the Vatican Museum's Astronomical Observatory in Castel Gandolfo.

The pope was accompanied by Father O'Connel, who provided him with scientific information regarding the space mission. After looking at the satellite through the observatory's telescope, Pope Paul VI addressed the astronauts:

Here, from His Observatory at Castel Gandolfo, near Rome, Pope Paul the Sixth is speaking to you astronauts. Honor, greetings and blessings to you, conquerors of the Moon, pale lamp of our nights and our dreams! Bring to her, with your living presence, the voice of the spirit, a hymn to God our Creator and our Father. We are close to you, with our good wishes and our prayers. Together with the whole Catholic Church, Pope Paul the Sixth salutes you. C.L.

Two American astronauts present lunar rock to Pope Paul VI on behalf of President Nixon, 1969, *L'Osservatore Romano*

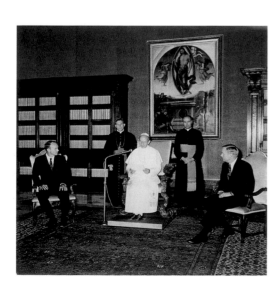

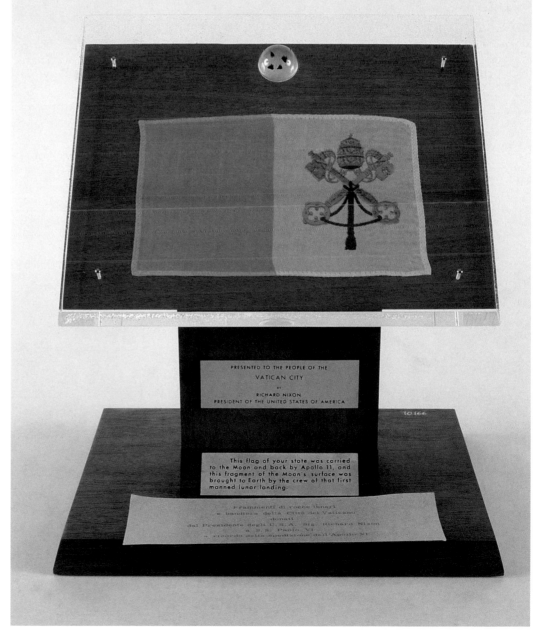

Into the Third Millennium

The most important symbol of the jubilee is the door that is opened and closed by the pope at the beginning and the end of a holy year, a tradition begun with Pope Martin V in 1423. The words of Pope John Paul II in the document *Incarnationis Mysterium* (The Mystery and the Incarnation) describe the importance of the holy door, and in particular the opening of the it during the jubilee of 2000. It "evokes the passage that every Christian is required to make from sin to grace. Jesus said 'I am the gate...' (Jn 10:7), to indicate that no one can have access to the Father unless it is through Him. This designation by Jesus of His role signifies that he alone is the Savior. There is only one entrance that is thrown open for life in communion with God. This access is Jesus."

The symbol of the door recalls the responsibility of every believer to cross the threshold. Thus, passing through the door means confessing that Jesus Christ is the Lord, and reinvigorating the faith in him to live the new life that he has bestowed. It is a decision that presupposes freedom of choice and also the courage to leave certain things behind. It is with this spirit that the pope first entered the holy door on the night between 24 and 25 December, 1999. By crossing the threshold, he demonstrated the words of the Gospel to the church and the world: it is the fount of life and the hope for the third millennium.

Miter of Pope John Paul I

1978
Cloth of silver, gold braid, coral
32.5 × 36 cm
Office of the Liturgical Celebrations of the Supreme
Pontiff, Vatican City State
inv. MI8

This miter was given as a gift by the diocese of Milan to Pope Paul VI shortly after his election in 1963, though the pontiff never actually used it, preferring to wear a different miter. On the death of the pope in 1978, his successor John Paul I, who lived for little more than a month, wore it on the day of the solemn inauguration of his pontificate. The present pope took it as his own and personalized it by substituting John Paul I's coat of arms with his own.

Of a traditional and rather low form, in the preconciliar style, this miter is made of cloth of silver, decorated with a double line of gilt braiding at the edge. In the center is a vertical band with a grape vine embroidered in gold. Above and below are two bunches of grapes in rose-colored coral. The same design is repeated on the other face of the miter. The *infulae* are made of the same material, with a double-gilt border. At the center of each *infula* is a grape vine embroidered in gold with a bunch of grapes in rose-colored coral, and at the bottom is the coat of arms of Pope John Paul II.

R.V.

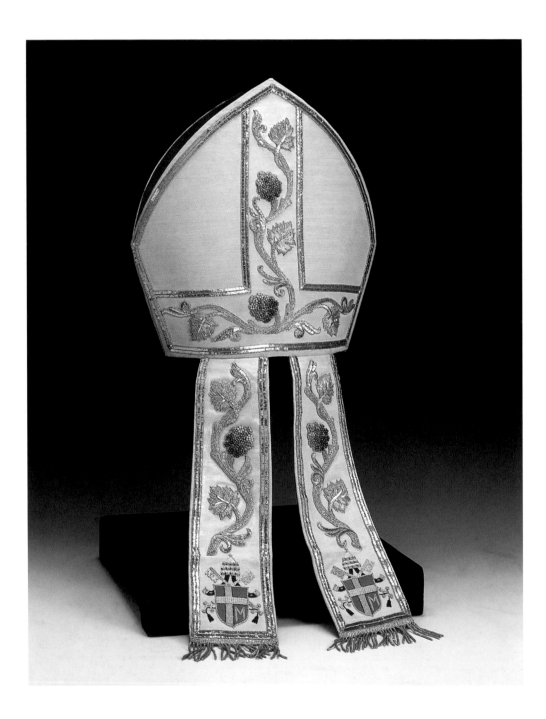

Pope John Paul I with his miter and papal staff seated on the *sedia gestatoria*, *L'Osservatore Romano*

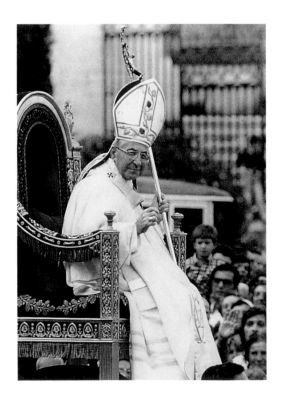

Bust of Pope John Paul II

20th century
Enrico Manfrini (born 1917)
Bronze
40 × 29 × 36 cm
Private Collection, Vatican City State

Enrico Manfredi lives in Milan and works from his studio in the historical palace of Villa Clerici. His artistic studies began at the Brera Academy, where he became a pupil of Francesco Messina, and then worked as his assistant from 1946; later, in 1973, he was given the chair in sculpture at the Academy, a position he held until 1983. Much of Manfredi's artistic expression is devoted to portraiture and works of a religious nature. In Milan Manfredi had met Cardinal Montini, and when the latter became Pope Paul VI, Manfredi entered the select group of artists working for the Vatican, where he began exploring the art of metal working, including medals. In this medium he has produced numerous sculptures in the round and medallions, which are notable for their quiet, incisive simplicity in commemorating each of the pope's journeys and special events. He has continued to produce commemorative medallions for the present pope.

In this life-size portrait bust of Pope John Paul II, the artist has accurately captured the character and indomitable strength of the pontiff. The face is that of a man full of youthful vigor and determination, and there is the trace of a smile in his eyes, which are rendered with extraordinary realism and express the pope's resolve and the total commitment to his mission as the head of the Catholic Church.

This striking bronze confirms once more the artist's unique capacity to convey the character and inner strength of his subject. R.Z.

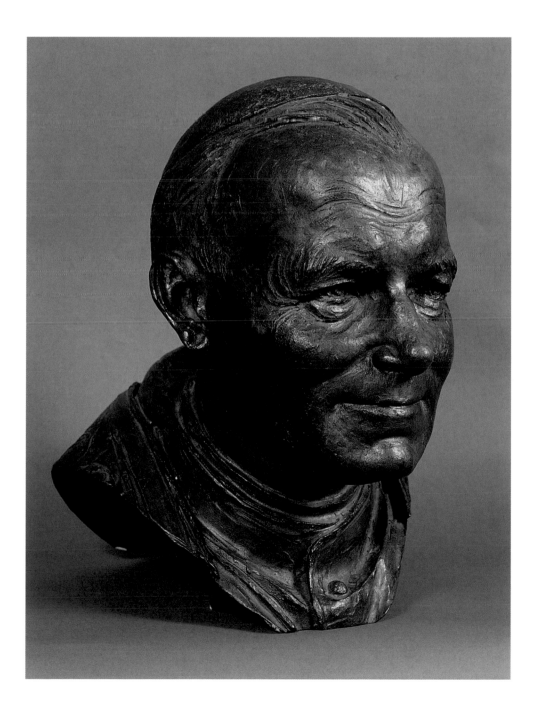

Clasp of Pope John Paul II

1979
Lello Scorzelli (1921–97)
Silver, silver gilt
14 × 14 × 4 cm
Office of the Liturgical Celebrations of the Supreme
Pontiff, Vatican City State
Inv. RA13

Conservation courtesy of The Washington
DC/Baltimore Chapter of the Patrons of the Arts
in the Vatican Museums

Lello Scorzelli was one of the Vatican artists to have
the closest contacts with Pope Paul VI, as well as
with his successor, Pope John Paul II, to whom he
donated this clasp. He presented Pope Paul VI with
the beautiful bronze statue that is also part of this
exhibition.

This clasp presents an embossed and hollowed
surface. In the center is the bust of Saint Stanislaus
wearing pontifical raiment and surrounded by
four scenes illustrating his apostolic life: the saint
making penance, giving his cloak to a beggar, being
murdered before the king, and his body devoured
by two eagles. The back of the clasp bears the
engraved coat of arms of Pope John Paul II and his
motto "TOTUS TUUS" (All yours). Saint Stanislaus,
the patron saint of Poland and bishop of Cracow,
is the distant predecessor of the current pope,
John Paul II. R.V.

Cope and Stole of Pope Pius VII

19th and 20th centuries
Silk, silver and gold thread
310 × 150 cm
Office of the Liturgical Celebrations of the Supreme
Pontiff, Vatican City State
Inv. PV58

This cope is of white silk decorated with vertical
stripes of silver thread and gold embroidery. It was
made for Pope Pius VII, who led the church from
1800 to 1823 during the difficult Napoleonic
period.

Originally this cope was much larger and
would have been classified as a pallium, or mantle.
This type of pallium was used, until the time
of Pope John XXIII, during the most solemn
ceremonies when pontiffs were carried on a
gestatorial chair.

The pallium was altered and made into a
cope during the early years of Pope John Paul II's
pontificate. His coat of arms was substituted for
the original one, and he used the cope on several
occasions. This cope has not been used in recent
years, however, due to its weight. For this reason,
the master of liturgical ceremonies is contemplat-
ing restoring Pope Pius VII's coat of arms, which
are kept in the papal sacristy.

An abundance of flowers, spirals, leaves, and
shells are embroidered on the cope, especially on
the front orphrey. The coat of arms with the papal
symbols were sewn on the bottom.

The fastening is rectangular with the same
embroidery used on the cope. It is closed with
three metal hooks and eyes. A gold braid ending
in two tassels joins the two sides together.

The shield on the back is also richly
embroidered with a floral design. The edge of
the shield is trimmed with gold fringe and
decorated with knots and flowers.

The stole is embroidered in the same style
as the cope and is decorated with three crosses and
the coat of arms of Pope Pius VII in multicolored
silk and gold. The stole's simple fringe is composed
of spirals and small flowers. C.P.

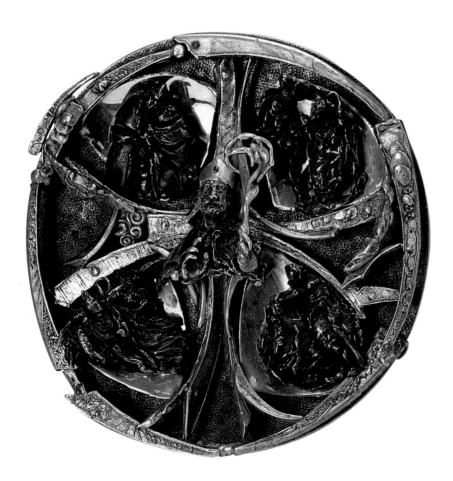

Detail of the orphrey of the cope with embroidered coat of arms of Pope Pius VII

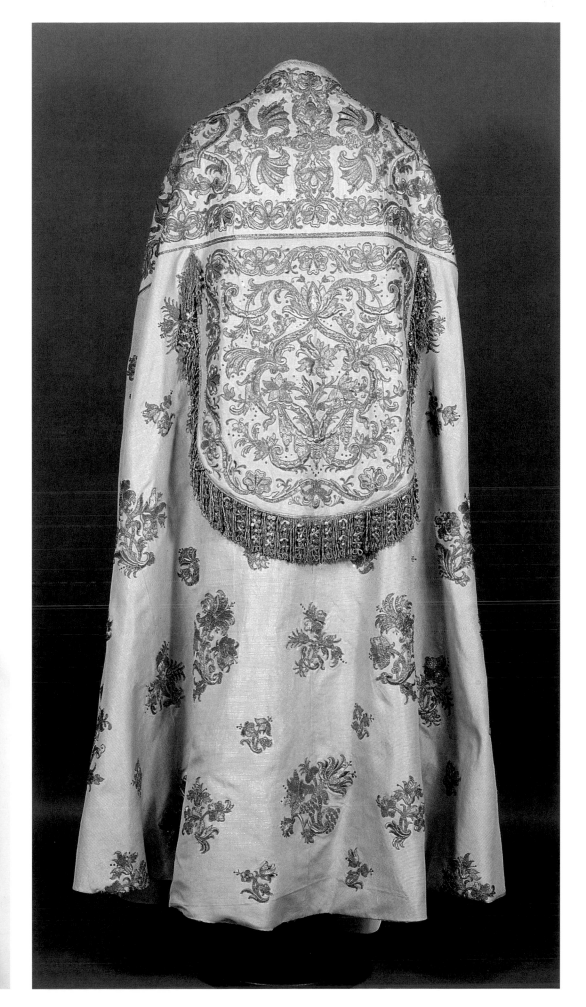

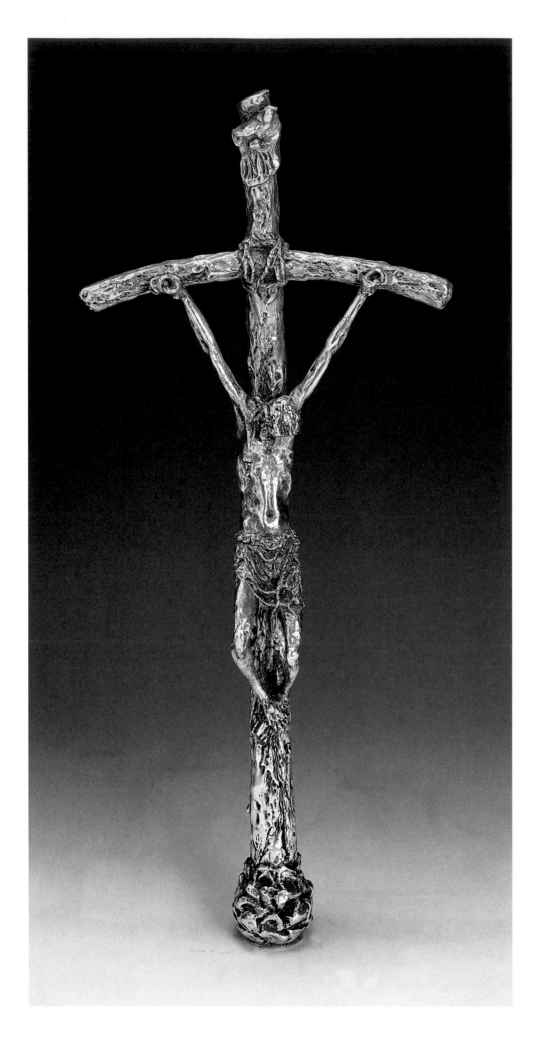

Pastoral Staff of Pope Paul VI and Pope John Paul II

20th century
Lello Scorzelli (1921–97)
Manlio del Vecchio
Silver
188 × 18 × 8 cm
Office of the Liturgical Celebrations of the Supreme
Pontiff, Vatican City State
Inv. CRP15

Conservation courtesy of Stella and Michael Banich

The sculptor Lello Scorzelli began his career as an artist largely without any formal training. In 1938 he began to present his works at exhibitions, and in 1942 made his first appearance at the Venice Biennale. From the outset his work was marked by an intense personal expressiveness, which he communicated through portraits that delved into the subject's personality. In 1964, Pope Paul VI commissioned Scorzelli to paint his portrait and reserved a room for him in the Vatican so that he could proceed undisturbed and produce other works for the Holy See. Among the fundamental works created in those years are the *Last Supper* and the *Via Crucis* in the pope's private chapel. Other works include the Door of Prayer in Saint Peter's Basilica.

This pastoral staff is composed of four parts, which when assembled reach a total length of 186 centimeters. The piece was designed by Lello Scorzelli and forged by the silversmith Manlio del Vecchio. The shaft is smooth and carries the insignia of Pope John Paul II on the upper section. The cross with the corpus is made from a single piece, with two crossbars curving slightly downward and joined with a carved chain-link device. The vertical bar terminates in an embossed carving with the letters INRI. At the bottom the bar rests on a convex circular element decorated with a repoussé stone.

The cross was created for Pope Paul VI, who used it during the last years of his life. It was inherited by the present pontiff, who continues to use it in papal ceremonies. This is the first time the cross has left the Vatican for an exhibition, and given that it is the personal property of the pontiff, it rarely leaves his person. In the last few years, the cross has been replaced by a perfect replica in a lighter alloy to make it easier to carry. During the many long and complex celebrations officiated by the pontiff, one can observe how he also uses the cross as a means of physical support. R.V.

Thurible, Incense Boat, and Spoon of Pope Pius II

1995
Silver
Thurible: 38 × 18 × 18 cm;
incense boat: 20 × 30 × 10.5 cm;
spoon: 2.5 × 27 × 1.5 cm
Office of the Liturgical Celebrations of the Supreme
Pontiff, Vatican City State
Inv. TU5/NA5

Conservation courtesy of Stella and Michael Banich

The thurible, or censer, serves to waft coils of scented smoke around the church to honor the Lord present in the Eucharist and the persons who represent him, especially the ministers of the Word. It is attached to three chains and works like a brazier. Grains of incense are placed on hot coals, and on touching these coals the incense releases perfumed smoke.

The incense is normally kept in a small boat-shaped vessel, hence the term incense boat, and is placed on the coals by means of the spoon. The censer and the incense that releases its fragrance are thus a symbol of the Church's prayer that rises up toward God, expressing honor and glory to him.

The thurible and incense boat are made of silver and were donated to Pope John Paul II by the Augustinian Friars on the occasion of the beatification of Anselmo Polanco and Felipe Ripoll on October 1, 1995. The censer is tall and its lid tapers up to form a column. The base is circular and richly embossed with an external band of leaves and spearheads and, in the center, a radiating pattern on a background of raised furrows. The bowl is wide and entirely embossed with scrolls and leaves. The fastenings for the three small chains have the form of winged figures each with a ring. The lid is fully decorated with embossing and fretwork, with shells and large leaves at the bottom, oval forms and leaves in the middle, and rhomboid shapes and scrolls at the top. At the very top, the lid is round, fluted and bell-shaped, and is decorated with three dragons, each bearing a ring through which the chains pass. The uppermost tip is embossed and also has a ring. Along the lower outer band is inscribed "Beatificación Anselmo Polanco y Felipe Ripoll, 1-10-1995."

The incense boat is large and has two sections covered by separate hinged lids. The base is circular; it has an embossed external band of leaves and spearheads and, in the center, scrolls and flower. The main part of the incense boat is chased with scrolls, leaves, and bombé forms. The lids are also embossed with such decoration. The underside of one bears the same inscription as the thurible. The spoon is long and tipped with a smooth bombé oval surrounded by small scrolls and shells. R.V.

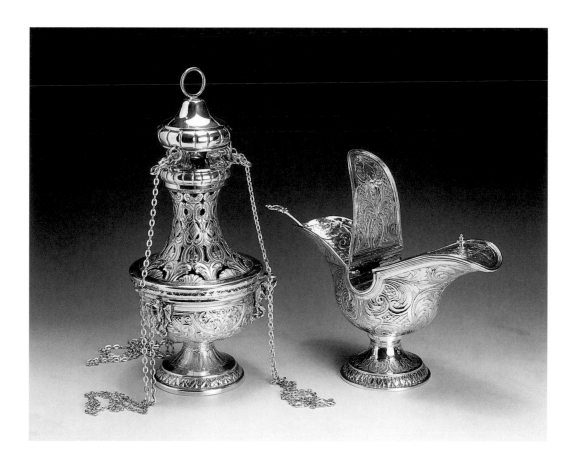

336

Cast of the Hand of Pope John Paul II

October 2002
Cecco Bonanotte (born 1942)
Bronze
100 × 100 × 10 cm
Office of the Liturgical Celebrations of the Supreme
Pontiff, Vatican City State

The pope has given this exhibition his special and personal attention. First, it was his wish that those visiting the exhibition be welcomed by a personal blessing signed by him. This in itself is singular and unusual, but he also consented that a cast of his hand be taken and put on view as a further sign of welcome, almost as a handshake to each visitor. The extending of the hand is today an international symbol of reciprocity, friendship, and goodwill.

When the idea was proposed to him, the Holy Father accepted immediately and with great enthusiasm. Cecco Bonanotte, an internationally renowned sculptor who designed the doors for the new entrance to the Vatican Museums, was entrusted with the work necessary to make the cast.

The work has clear artistic merit, but its true meaning is to be sought above all in its symbolic significance. The pope, as he arrives in the various countries of the world, kneels, places his hands upon the ground, and leans down to kiss the earth; this image is an integral part of our memory of his journeys. In those hands is no desire for possession or conquest, but a wish for respect and dialogue with the citizens of the land he visits. Touching and kissing the earth is meant to signify openness, attention, and a willingness to share with all those who live upon it. If the church in history has sometimes erred, this gesture is also an explicit request for forgiveness.

The cast of the pope's hand is intended to highlight these meanings, which are the themes often reflected in this exhibition. R.Z.

Hammer and Trowel for the Holy Year

1975
Amerigo Tot (born 1929)
Gilt bronze
Hammer: 29 × 19 × 6.5 cm;
trowel: 39 × 11.5 × 7 cm

Conservation courtesy of Thomas W. McNamara & James J. McNamara III

The set was created for Pope Paul VI on the occasion of the holy year of 1975 by the Roman artist of Hungarian origin Amerigo Tot. The handles were designed to fit the pope's hands and are decorated with his emblem. The artist signed the work (TOT) and added the inscription "PAULUS VI PONT MAX ANNUS SANCTUS MCMLXXV." On the hammer, four small cast medallions depict the evangelists.

Three large bronze nails protrude from the head. On the upper part of the trowel, a medallion depicts an allegorical scene of two shepherds seated on the ground holding up a crook between them, while in front of them the Child Jesus picks up a cross. Close by lies a pilgrim's water flask. The scene alludes to redemption through the Cross and the act of pilgrimage during the holy year. The trowel and hammer were the traditional instruments for the ceremonial opening of the holy door in both ordinary and special jubilee years. In the 2000 jubilee, Pope John Paul II replaced the ritual of the instruments with a simple gesture of hands pushing open the doors. The door of the holy year symbolizes Jesus, as declared in the passage from Saint John's Gospel (10:7), in which Jesus states "I am the gate," meaning the way to the kingdom of heaven. R.V.

Trowel of Pope Pius IX

Second half of the 19th century
Gilded silver
6.5 × 9 × 32.6 cm
Office of the Liturgical Celebrations of the Supreme Pontiff,
Vatican City State
Inv. CZ5

A trowel was once used in the rites for the closing the holy door. There
is evidence for its use as far back as Christmas 1525, during the holy
year proclaimed by Pope Clement VII. The last pope to adopt such an
instrument was Pope Pius XII for the closure of the holy door in 1950.
The trowel is similar in all respects to that normally used by builders,
but is richly decorated and often bears the coat of arms of the pope.
Generally, the trowel commissioned by the popes for jubilee years was
part of a set that also included the hammer used to open the holy door.

 This fairly large trowel was donated to Pope Pius IX, who never
actually used it as he was prevented from celebrating the holy year of
1875. It is made of gilded silver and is richly ornamented. The handle
is lavishly decorated and ends in a Greek cross atop a globe supported
by three putti with crossed hands. The middle section has hexagonal
geometric designs of differing sizes, and a small fluted cylindrical
shaft joins this to the brace that is fully embossed with large leaves.
The upper surface of the scoop is decorated with the coat of arms of
Pope Pius IX, surrounded by a design of clover leaves that borders the
edge. The underside is smooth and on the back of the trowel is the
number 2. R.V.

Hammer for the Opening Ceremony
of the Holy Door

1999
Goudji (born 1941)
Silver, wood, ivory
32 × 16 × 4.5 cm
Office of the Liturgical Celebrations of the Supreme Pontiff,
Vatican City State
Inv. VR125

This elegant ceremonial hammer fashioned by the artist Goudji was
given to the Pontifical Sacristy in March of 2000. The head of the piece
is in the form of an eagle, and the end for striking terminates in
a cylindrical ivory cap. The inscription reads "2000 Magnum anno
MM Jubilaeum." The handle is made of ebony and the bottom end is
capped with silver.

 The artist gave the hammer to Pope John Paul II in the early months
of 1999 in the hope that it would be employed in the official opening
ceremonies for the holy year 2000. Instead of symbolically striking
the holy door with a hammer before opening it, the pontiff chose to
push it open with his bare hands; consequently, the hammer was never
used, though it remains a symbol of the ceremony heralding the start
of the jubilee year of 2000. In addition to this hammer, the Pontifical
Sacristy has various works that testify to the consummate skill of this
goldsmith of Georgian origin. R.V.

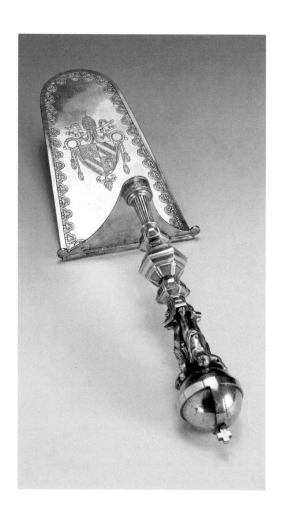

Hammer for the Opening Ceremony of the Holy Door

1999
Ernesto Lamagna (born 1945)
Gilt silver, malachite
37.5 × 18 cm
Office of the Liturgical Celebrations of the Supreme Pontiff, Vatican City State

Conservation courtesy of Jo Campbell in honor of The Campbell Family

The sculptor Ernesto Lamagna was born in Naples in 1945. Among his best-known works are those in the basilica of S. Maria degli Angeli e dei Martiri in Rome (*Angel of Light*), and in the churches of S. Maria delle Vittoria and S. Vito dei Normanni, and not least the magnificent bronze doors of the basilica of Nostra Signora di Bonaria in Sardinia.

This ceremonial hammer is made of gilded silver and is adorned with an olive sprig complete with olive fruits in malachite. The inscription on the handle reads "Max. Joannes Paulus II; Annus Sanctus MM" and is followed by the artist's mark; the head carries the insignia of Pope John Paul II. Although the hammer was donated to the pope by the artist for the opening ceremony, it was not actually used.

The use of a hammer for the opening ceremony is documented as early as the 1500s. Pope Alexander VI is reported to have used one to strike the wall alongside the door, though initially a mason's hammer was used, and the action was not merely symbolic. Soon, however, with each new design the ceremonial hammer assumed a more sophisticated and artistic form. By 1525 it had become an elaborate instrument made of gold, whereas the one used in 1575 was made of finely crafted gilded silver with an ebony handle. R.V.

Commemorative Brick for the Holy Door

1899
Terracotta
3.5 × 28.5 × 13.5 cm
Office of the Liturgical Celebrations of the Supreme
Pontiff, Vatican City State
Inv. VR13

This commemorative brick bears the papal tiara
and keys and the inscription "R.F.S.P.A. Iubilaei
MCMI" on the front.

 At the end of each jubilee year, the holy door is
officially sealed with bricks especially made for the
occasion. The ritual sealing of the door dates back
to the jubilee of 1500, which was performed by
Pope Alexander VI, and a chronicler of 1423
records that the scramble for sacred buildling
rubble was so great that no sooner was the job of
sealing the holy door finished than "pieces were
spirited away by the public and worshipped as if
they were holy relics."

Conversely, the ritual closing of the holy door
formulated by Bucardo for the feast of the Epiphany
of 1501 envisioned a ceremony by which two
cardinals each inserted a small brick into the fresh
masonry, one made of gold and one of silver.

 By custom, the turn of a century is celebrated
with a jubilee, and after a lapse of seventy-five
years, the holy door was reopened for the first
time since the reign of Pope Leo XII. Later, in 1850,
Pope Pius IX was not able to celebrate the opening,
as he had been exiled from Rome. The reopening
ceremony was performed on December 24, 1899,
by Pope Leo XIII. The solemn event marked the
first holy year since the demise of the temporal
power of the papacy. For the first time, the event
was organized with the backing of the Italian
government. The ceremonial opening of the
holy door, therefore, took place in a climate of
widespread reconciliation, and the solemnity
of the occasion was accompanied by the joyous
participation of the entire city, which was flooded
with pilgrims from all over the world. R.V.

Commemorative Brick for the Holy Door

1975
Gilded terracotta
3.5 × 28. × 13.5 cm
Office of the Liturgical Celebrations of the Supreme
Pontiff, Vatican City State
Inv. VR74

This gilded commemorative brick was made for
the reopening of the holy door in 1975. The front
is marked with the insignia of Pope Paul VI and
the inscription "Paulus PP. VI Portam Sanctam
Patr. Vaticanae Basilicae clausit Anno Jiubilaei
MCMLXXV." The back carries the manufacturer's
hallmark "Saunini Impuneta."

 On the occasion of the holy year, it is customary
to manufacture a greater number of bricks than are
actually necessary for walling up the door, and the
remaining bricks are kept for their documentary
value. The gilding that this brick has received attests
to its special purpose as a record of the event.

Commemorative Brick for the Holy Door

The holy year 1975 was celebrated a decade after the conclusion of the Second Vatican Council. The clergy were concerned that such a celebration might appear somewhat anachronistic in light of the discussions put forward by the council, and that a revival of the ceremonies would seem out of spirit with the new mandate. Aware of the problem, Pope Paul VI decided, nonetheless, to continue with the tradition, and saw the advent of the holy year as a persuasive occasion for spiritual renewal. As an expression of his position, he published the *Gaudete in Domino*, a rousing document that aimed to bestow a spirit of joyousness on the entire cycle of jubilee celebrations for the holy year, and he championed three essential goals: joy, spiritual renewal, and reconciliation.

As it happened, the 1975 jubilee was a resounding success, not only for the vast numbers of faithful who took part, but because the very goals the pope hoped for were achieved. R.V.

1975
Terracotta
3.5 × 28.5 × 13.5 cm
Office of the Liturgical Celebrations of the Supreme Pontiff, Vatican City State
Inv. VR75

The front of the brick carries an image of the tiara and papal keys accompanied by an inscription above and below that reads "A. Jubilaei—R F S P—MCMLXXV." The inscription on the back reads "1902 Gratis Quovis titulo."

From 1500 to the jubilee year of 1975, the holy door of each of Rome's four basilicas was walled up until it was unsealed for the next jubilee year, as was the case with the special jubilee of 1983 and the holy year 2000. Reopening, therefore, involved first demolishing and removing the masonry to enable access to the door. During this ceremony, the pope would symbolically remove a part of the masonry, and the rest of the demolition was carried out by builders. This is precisely what took place during the opening ceremony of 1975, held according to tradition on Christmas Eve of the preceding year, and people may still remember the sudden cry of alarm when rubble from the demolition fell very close to the then pontiff, Paul VI, during the opening ceremony. R.V.

Holy Door Coffer

1983
Gismondi
Bronze
34 × 32 × 26 cm
Office of the Liturgical Celebrations of the Supreme
Pontiff, Vatican City State
Inv. VR119

Conservation courtesy of Anne and Robert Scott
in memory of Robert F. and Marcella M. Scott

Pope John Paul II proclaimed the extraordinary
holy year of the Redemption for 1983. At the end
of the year, on April 29, 1984, the holy door of
Saint Peter's Basilica was closed and walled up,
and a bronze coffer by the sculptor Gismondi was
placed inside the wall. Similar celebrations took

place in Rome's other three major basilicas: Saint
John Lateran, Saint Mary Major, and Saint Paul's
Outside-the-Walls. In earlier holy years, different
coffers made by different craftsman were used, yet
for the holy year of 1983 the coffers were all the
same and the work of the same hand. In keeping
with tradition, the coffer contained the medallions
coined during the pontificate of the pope, in this
case of Pope John Paul II, and the official document
of the closure of the holy door. The bronze
coffers of the holy year of 1983, recovered before
the opening of the holy door of Saint Peter's on
Christmas night 1999, are now conserved in the
Pontifical Sacristy of the Sistine Chapel. The bronze
coffer on view here is one of the four.

The inside of the coffer is lined with red
damask decorated with floral motifs and pontifical
emblems. The coffer rests on four spherical
supports and its corners are adorned with chased

designs of olive branches. The front panel of the
coffer has an embossed image of Christ with his
arms slightly opened; behind him are the rays
of a sunburst and he is surrounded by the symbols
of the Four Evangelists. The back panel bears a
crowned figure of Mary with the Infant Jesus
and the embossed inscription "Mater Ecclesiae"
(Mother of the Church). On the side panels are
the embossed images of two saints: Saint Casmir
with a scepter and a cross, and Saint Charles with
folded hands. The lid has an embossed portrait of
Pope John Paul II with his coat of arms and the
inscription "Totus Tuus" (All yours). Further
down, another inscription reads: "Anno Iubilari
Redemptionis MCMLXXXIII-IV" (In the Jubilee
Year of the Redemption 1983–1984). The lid is
closed by two levers that have the form of doves
resting on spheres. R.V.

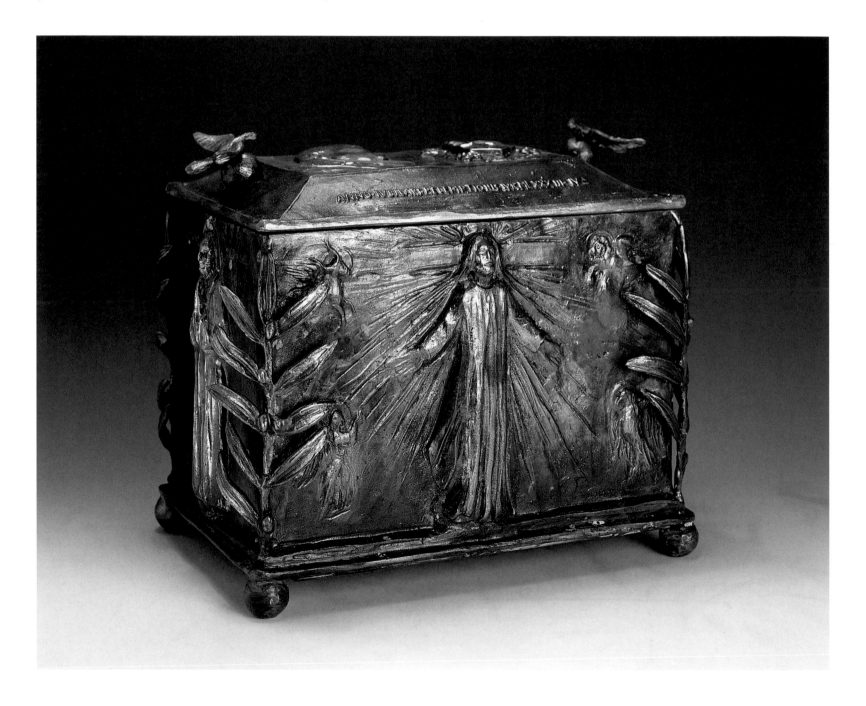

Three Medallions

1983
Marcello Tommasi, Florence
Gold, silver, bronze
4.5 × 4.5 cm
Office of the Liturgical Celebrations of the Supreme
Pontiff, Vatican City State
Inv. VR119

Ever since the jubilee of 1500, in the time of Pope
Alexander VI, it became customary to place coins
relevant to the holy year directly into the mortar
of the wall that closed the holy door. The tradition
of placing the coins in a metal box began with the
jubilee of 1575 during the pontificate of Pope
Gregory XIII.

 Here are three of the medallions that were
contained in the coffer of the 1983 jubilee. They
are the work of the Florentine artist Marcello
Tommasi and were all coined for the sixth year of
the pontificate of John Paul II. In all, seventeen
medallions were placed in the coffer: one of gold,
six of silver, nine of bronze, and one representing
Saint Peter's Basilica. In addition, there was also
a commemorative medallion of the Sovereign
Military Order of Malta. R.V.

348

Document of the Closure of the Holy Door

1984
Parchment
35 × 45 cm
Office of the Liturgical Celebrations of the Supreme
Pontiff, Vatican City State
Inv. VR119

This parchment was in the coffer that was walled
up in the holy door of Saint Peter's Basilica on
April 29, 1984, at the end of the extraordinary
holy year of Redemption of 1983. It is signed by
Cardinal Aurelio Sabattani, archpriest of Saint
Peter's Basilica; Bishop Giacomo Martin, prefect
of the Pontifical Household; and by twelve other
witnesses to the closure. R.V.

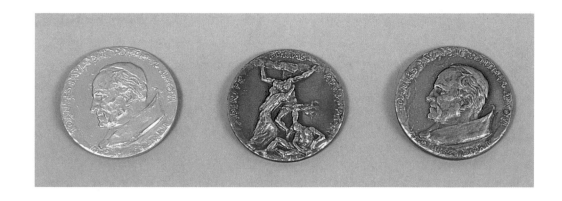

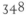

Cope of Pope John Paul II

1999
Jacquard fabric made on electronic loom
Composition: 52% acetate, 28% polyester, 20% silk
Fabric design: Gianluca Scattolin and Stefano
Zanella, Treviso (Italy)
Weaving: Unione Industriali Pratese, Prato, Italy
Manufacturer: Sartoria X Regio (Decima Regio),
Treviso, Italy
345 × 166 cm
Office of the Liturgical Celebrations of the Supreme
Pontiff, Vatican City State
Inv. PV/S16

This cope is made of brocade with a pattern of small arches overlapped by an angular design in equal, continuous, infinite modules. The motif is also called "clathrated," derived from the Latin clatratus meaning "closed with a lattice." Its historical roots go back to Greco-Roman and later Christian decoration. A series of golden doors are reproduced on the blue background, which are overlapped by two red rays indicating that the doors to the Kingdom of Heaven are opened by Christ's blood. The three colors are found in traditional iconography portraying Christ the Pantocrator. They represent sovereignty, divinity, and humanity, and are also the colors of the Mother of God. The repetition of the design creates a magnificent, dazzling impression. Another characteristic of the fabric is that it is very lightweight to render its use less burdensome for the pope.

The stole is made out of the same fabric, and decorated with 180 semiprecious stones: 60 lapis lazuli, 60 rock crystals, and 60 red carnelians forming three crosses.

This cope was designed and made expressly for use by Pope John Paul II during the opening of the holy door of the Vatican Basilica on Christmas night, 1999, the inauguration of the great jubilee of the year 2000. In addition to the cope, the deacons' dalmatics and the chasubles and miters for concelebrating cardinals were specially made with a reproduction of the same pattern inserted in a rectangular band. S.Z.

Miter of Pope John Paul II

Manufactured by Sartoria X Regio (Decimo Regio),
Treviso, Italy
November 1999
acetate, polyester, silk
25 x 36.5 (without *infulae*) × 75 cm (with *infulae*)

Office of the Liturgical Celebrations of the Supreme
Pontiff, Vatican City State
Inv. MI 99

This miter belongs to a set of liturgical vestments specially commissioned for the opening of the holy door of Saint Peter's Basilica on December 25, 1999, the solemn beginning of the great jubilee of 2000. This set also includes a matching cope, chasuble and two dalmatics to be worn by the cardinals assisting the pontiff. The colors gold, red, and blue departed from the traditional liturgical colors of white, red, green, and purple, which aroused a number of positive and negative reactions. In response the pope wore a miter of a different color and a different chasuble. Thus, this miter was never actually worn by John Paul II, yet it forms an integral part of the pontifical vestments for the great jubilee of the year 2000, and is thus a part of the history of the first holy year celebrated in the the new millennium. R.Z.

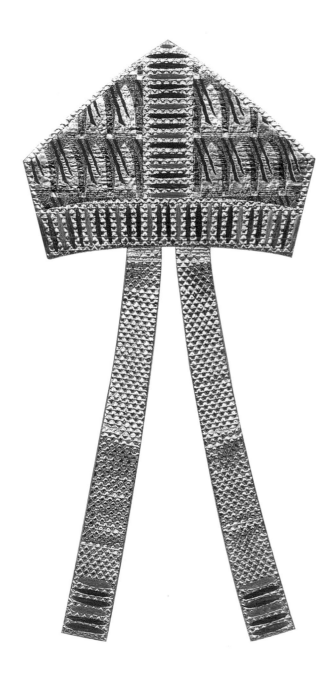

"Celestial Jerusalem" Clasp, or Rational

1999, Paris
Goudji (born 1941)
Silver gilt, stones, precious stones, ivory
12 × 12 × 2.5 cm
Office of the Liturgical Celebrations of the Supreme
Pontiff, Vatican City State
Inv. RA17

Known as a rational, this gilded silver plaque serves as a clasp for the pontiff's cope, a long ecclesiastical vestment worn over an alb or surplice.

The creator of this rational is a French artist, who takes the name "Goudji." The artist was born in 1941 in Georgia in the former Soviet Union, studied at the art academy of Tbilissi until 1962, and in 1964 settled in Moscow, where he became a member of the official Union of Artists. In 1974 he moved to live and work in Montmartre in Paris. Most of Goudji's artistic output is in the form of finely crafted metalwork, and his highly personal techniques and unique works have earned him recognition as one of the world's finest goldsmiths.

The rational on exhibit here is round and has a square insert formed by stones of varying colors, several of which are precious. In the square is an ivory lamb carrying a cross. The back of the piece is fitted with a clasp and bears the inscription "In nocte nativitatis Domini anno MCMXCIX Ioannes Paulus Episcopus Servus Servorum Dei Patriarchalis Basilicae Vaticanae aperit portam sanctam incipiente anno Jubilaei MM."

This rational was worn during the opening ceremony of the holy door on December 24, 1999, by Pope John Paul II, and it carries the pontiff's emblem at the top. The symbols are straightforward but effective. According to Early Christian tradition, the standing lamb represents the Risen Christ and refers to the Book of Revelation, which speaks of the lamb seated on the throne. Similarly, the stones around the lamb also allude to a passage in Revelation (4:3): "There was a rainbow encircling the throne, and this looked like an emerald." Both texts are linked to the notion of the new Jerusalem, the holy city: "Then the One sitting on the throne spoke. 'Look, I am making the whole of creation new'" (Rv 21:5). In confirmation of this, the artist Goudji entitled the work *The New Jerusalem*. R.Z.

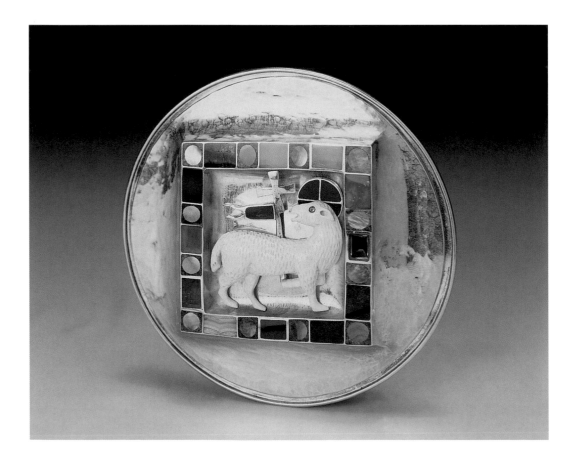

Portrait of Pope John Paul II

1966
Dina Bellotti (born 1912)
Pencil and chalk on canvas
87 × 67 × 3.5 cm
Private Collection

Dina Bellotti lives and works in a studio very close
to Saint Peter's Basilica. She is known for her skill
in blending a palette of strong, warm colors.
With a few strokes of the brush she conveys a
keen impression of a landscape or still life, but
her special talent lies in portraiture, through which
she manages to communicate the physical and
psychological characteristics of her subject by
means of elementary features.

 This portrait of Pope John Paul II is an excellent
example of the painter's unique treatment of her
subject. The intense, penetrating gaze embodies
the greatness of this pope, communicating his
self-assurance and powerful personality.

 In a far corner of the room during many papal
audiences it is not uncommon to see a small
woman with a sketchpad intent on capturing the
pope's expressions and gestures. That woman is
Bellotti, and she is rightfully considered the official
portrait artist of the pontiff. Her works hang in
many offices throughout the Vatican, and one of
her portraits of Pope John Paul II is conserved in
one of the largest seminaries in America, at Los
Angeles, California. Her work is also frequently
reproduced in publications.

 Pope Paul VI had the highest esteem for the
artist's work, and among the Collection of Modern
Religious Art in the Vatican Museums, which he
founded and inaugurated, Bellotti's artistry is
represented by a vast canvas of *The Miraculous Draft
of Fishes*, portraying that miracle as recounted in
the Gospels. R.V.

Waiting in Hope

Cecco Bonanotte (born 1942)
Bronze
75 × 68 × 40
Private Collection

This sculpture, created by Cecco Bonanotte, gives meaning to this exhibition as a whole and epitomizes its significance.

Waiting in Hope comprises two wings that suggest a partially opened door. Beyond the threshold is a field of wheat; a flock of birds fly overhead, while a human figure emerges from among the grain. On the front of the doors, in relief, are indications of suffering and death: barbed wire, hanged men, crucifixions. On the back, each side is divided into twelve spaces framing twenty-four heads, the features of which are generic.

The style is typical of Bonanotte. The incisive power of his art lies entirely in delicate allusions between the ancient and modern, where the classical tradition of perfection dissolves into a vision of open lines, suggestive of infinity. The characteristics of the artist are confirmed in this, his most recent work, a high point in his aesthetic-artistic journey.

The symbolic understanding of this sculpture must not, then, be overly rigid. The fundamental element behind the work is in the contrast between death and life, suffering and liberation. The sculpture is linked to man's suffering, but also to the tension of the entire human race in its continuous search for forms of reality that may give meaning to existence itself.

The twenty-four faces on the back of the doors are also significant. In Indo-European cultures, the number twelve and its multiples have a precise symbolic value: twelve recalls totality. Thus, those twenty-four faces—precisely because they cannot be identified with any one individual—represent all humanity; humanity marked by death but yearning to open itself to hope. Those open doors are a symbol of life; the wheat, the figure, and the birds are an expression of the search for a life free from death, suffering, and pain. The title of the work "Attesa e Speranza" ("Waiting in Hope") highlights these meanings.

In human psychology, waiting is never completely free from contradiction and fear; hope is the overcoming of limits, the full realization of freedom. This understanding of the work justifies, as we said at the start, its position toward the end of the exhibit. It also justifies the express intention of the artist in dedicating the sculpture to John Paul II, the pope who opened the holy door of the jubilee 2000, but also the pope who is himself open to a continuous dialogue with the world and with all men and women of good will.

In those open doors is the pope's invitation to "cross the threshold of hope, do not hesitate before it, allow yourselves to be guided"; there is the cry of his entire pontificate, "open wide the doors!" These words are a continuation of the message that the first pope, Peter, addressed to the original Christian community: "we wait for what God has promised: new heavens and a new earth, where righteousness will be at home" (2 Pet 3: 13).

It is difficult not to be struck by the beauty of Bonanotte's sculpture, but impossible not to recognize therein an effective artistic translation of the Magisterium of John Paul II. R.Z.

Glossary

Abbey A complex of monastic buildings that includes the church, the convent, and the cloister. The abbey is presided over by the abbot who, as suggested by the origin of the Hebrew word *abba*, is the "father" of the monastic community.

Allocutio A formal address by the pope when speaking to a particular audience, such as bishops, diplomats, or pilgrims.

Altar (Lat., *ara*) A table or structure where sacrifice is offered. In Christian worship the altar is generally found at the center of the sanctuary where the sacrificial act of the mass is celebrated. The altar is the symbol of Christ, the cornerstone upon which the Church is founded, and as such is venerated with a kiss and incense. In ancient basilicas there was only one altar, but over the centuries a proliferation of private masses and side chapels led to numerous altars in monasteries and churches.

Altar frontal A cloth, usually of precious fabric or weaving, that covers the entire front of the altar from the lowest part of the *mensa*, or tabletop, to the floor.

Ambulatory The passageway around the perimeter of centrally planned churches; in Romanesque and Gothic churches it is behind the high altar and around the apse.

Antependium A hanging suspended over and in front of the altar.

Apostolic Constitution A formal papal document used by the pope to promulgate law.

Apostolic See This term refers not only to the Roman pontiff, but also the secretary of state, the council for public affairs of the church, and other institutions of the Roman curia.

Apostolic succession Through the laying on of hands during the rite of episcopal ordination, the College of Bishops continues from Saint Peter to the present.

Apse A semicircular or semipolygonal section at the rear of a church in which the nave and sometimes also the aisles terminate.

Archbishop Generally refers to a bishop who has immediate jurisdiction over an archdiocese. He also exercises certain authority and privilege over one or more dioceses that, together with his own, compose an ecclesiastical province. In that case, the archbishop is called a metropolitan and wears the pallium that he receives from the pope.

Archdiocese An ecclesiastical territory usually presided over by an archbishop. It can be immediately subject to the Holy See. An archdiocese is usually located in a major city and has historical precedence.

Archpriest A priest chosen to assist the bishop or to substitute for him at a specific function. A cardinal-archpriest represents the pope in particular responsibilities, such as in a Roman basilica.

Atrium In its earliest meaning, the atrium referred to the vestibule or entry of a Roman or Greek house. Today it refers to the first or principal entry, internal or external, of a building, usually decorated or flanked by columns. The atrium in Saint Peter's, for example, is the broad, open area between the façade—the main front or face of the building—and the actual entrance.

Baldachin (also baldachino, *baldacchino*, baldaquin) Technically, a canopy of fabric over an altar or throne. A canopy resting directly on four columns made of wood, stone, marble, or metal is more properly termed a ciborium. Liturgically, the baldachin symbolizes the tent that covers, protects, and embellishes, and is a direct reference to John's Gospel, which refers to the Word made flesh and his "tent" dwelling among us (Jn 1:14).

Baptistery A Christian building on a central plan devised for celebrating the rite of baptism, originally built alongside the Early Christian and Romanesque basilicas; later, the baptismal font was included within the church itself.

Bas-relief (also *bassorelievo, bassorilievo*) A carving, embossing, or casting moderately protruded from the background plane.

Basilica Originally a term for a ceremonial or judicial hall. Emperor Constantine used the basilica prototype in the fourth century for church buildings. A basilica always had a forecourt, with trees and a fountain, and a colonnade, or loggia, enclosing it. The great hall was attached to the loggia. There are two types: the major basilicas in Rome, including Saint Peter's in the Vatican, Saint Paul's Outside-the-Walls, Saint John Lateran, Saint Mary Major, Saint Lawrence Outside-the-Walls, and Saint Sebastian, as well as the Basilica of the Holy Cross in Jerusalem; and the minor basilicas, which are other important churches found in Rome and throughout the world.

Bells The use of bells in the church can be traced to the eighth century. Bells have often been call the *vox Dei*, or voice of God, because they call the faithful to worship.

Bema A transverse space in a church a few steps above the floor of the nave and aisles and separating them from the apse, usually reserved for clergy in Early Christian churches. The bema was found in synagogues from which the Torah was read. In Byzantine churches it is the raised area behind the Iconostasis that contains the altar.

Biretta A square cap with three ridges or peaks. The biretta is often distinguished by color – red for a cardinal, violet for a bishop, and black for a cleric.

Bishop (Gr., *episkopos*) A priest who enjoys the "fullness of the sacrament of holy orders" by his consecration to the episcopate. The bishop's function is to teach, lead, and sanctify. Diocesan bishops are the overseers of their territory in liturgical, theological, canonical, and administrative matters. Through ordination bishops become a member of the College of Bishops, the head of which is the bishop of Rome, the pope.

Bull From the Latin *bulla*, meaning seal. Bulls, or bullas, refer to the lead or wax seal that was formerly affixed to important church documents. By extension, this has come to mean the papal or apostolic document. A Bullarium is a collection of papal bulls.

Burse A receptacle, often ornately decorated, for the corporal and paten when they are not in use prior to the mass. In the sixteenth century it took the form of a square with one open side or pocket.

Camauro The fur-trimmed bonnet reserved for the popes. It can be seen in portraits of the pontiffs from the eleventh century until the papacy of Pope Saint John XXIII. The original camauro was made of suede or soft leather, lined and trimmed in fur. Its purpose was to keep out the cold. By the twelfth century, suede gave way to red velvet, and eventually the fur remained only as trim. After nearly a century Pope Saint John XXIII resurrected the camauro and wore it on solemn occasions. Even though it is not worn today, the camauro remains part of the papal vesture.

Camerlengo of the Holy Roman Church A member of the sacred College of Cardinals, chosen by the pope, who is temporarily responsible for governing the church following his death. This period is known as the *Sede Vacante*. The *camerlengo* is the one who officially announces the death of a pope.

Canon An ecclesiastical title of honor that refers to a diocesan priest attached to a cathedral and to a member of a particular religious order. A cathedral canon is a member of the college of priests whose duties are to celebrate solemn liturgical functions in a cathedral or college church or basilica. A canon regular is a member of a particular religious order such as the Canons of Saint Norbert, who is also obligated to perform particular liturgical functions and follow a monastic rule.

Canon law The law of the church. The Code of Canon Law was published in 1917 by Pope Benedict XV and has been revised since the Second Vatican Council for both the Latin and Oriental rites.

Canon of the Mass The central prayer of the Eucharist Liturgy now more commonly known as the Eucharistic Prayer. "Canon" comes from the Greek meaning "measuring rod" or "rule" and thus conveys an established norm. Prior to the Second Vatican Council (1962-65), "Canon of the Mass" was the phrase used for the single Eucharistic Prayer that prevailed in the Western church from the Middle Ages until the council's liturgical reforms. Its roots are from the fourth century and it is now known as Eucharistic Prayer I.

Canons A body of diocesan priests responsible for the spiritual and temporal concerns of a local cathedral. Canons continue in major basilicas throughout Rome and gather daily for the celebration of the Liturgy of the Hours.

Cardinal Following that of pope, the title of cardinal is the highest dignity in the Roman Catholic Church and was recognized as early as the pontificate of Sylvester I in the fourth century. Rooted in the Latin word *cardo*, meaning "hinge," cardinals are created by a decree of the Roman pontiff and are chosen to serve as his principal collaborators and assistants. Cardinal is an honorific title and not one of the three ordained orders (deacon, priest, and bishops). Only bishops are named as cardinals.

Catacombs From the Greek *kata*, meaning "under," and the Latin word *cumba*, which means "cavity." It referred to a consecrated underground cemetery complex.

Catafalque From the Latin word *catafalicum*, which means scaffolding or a wooden siege tower. An elaborate structure on which the body of a deceased person lies in state.

Cathedra From the Latin *cathedra*, meaning "chair," this refers to both the seat of the bishop who governs the diocese, and thus symbolizes his teaching authority, and to the church in which the bishop celebrates the principal liturgical ceremonies in his diocese.

Cathedral A church that serves as the seat of the local bishop, wherein his teaching authority exists.

Chapter An assembly of men or women from a religious institute. The word originated with the monastic practice of assembling daily to listen to a reading of a chapter from the monastic Rule.

Chirograph A formal message in the pope's own handwriting.

Choir In architectural terms, that part of a church between the sanctuary and the nave reserved for singers and clergy.

Ciborium A canopy of stone, wood, or marble supported on four columns over an altar, or the chalicelike vessel or bowl that contains the Host used in the liturgical celebration of mass.

College of Cardinals The cardinals of the Holy Roman Church collectively constitute the college of electors and chief assistants of the pope. The pope appoints bishops (with occasional exceptions) to the college, most of whom are the heads of their own dioceses and archdioceses. The college of cardinals meets with the pope at ordinary and extraordinary consistories to provide consultation. According to current practice, after the pope's death all cardinals under the age of eighty gather to elect a new pope. In the eleventh century the practice began of appointing cardinals from ministries outside of Rome. In 1059 Pope Nicholas II designated the cardinals as the representative body of the Roman Church in the election of a pope. The practice continues today.

Conclave The meeting of all cardinals who are eligible to vote for a new pope. The word is derived from the Latin *con* (with) and *clavis* (key), and refers to the fact that the meeting of cardinal electors takes place behind locked doors.

Confessional A small enclosure in which a priest hears an individual's private confession of sin. Usually situated in a chapel or against the wall of an aisle.

Consistory Assembly of the college of cardinals.

Cope A ceremonial version of an outdoor cloak commonly worn in the Roman Empire. It is a semicircular cloth worn over the shoulders and held together with a clasp. The cope and clasp (morse) are often decorated and generally worn by officiating prelates or clerics at noneucharistic celebrations such as baptisms, weddings, or the Liturgy of the Hours.

Crypt A chamber usually below the main floor of a church housing the relics of the titular saint, or the tombs of bishops and other illustrious persons.

Dogma A definitive, or infallible, teaching of the church. The promulgation of a dogma is the prerogative of an ecumenical council, including the pope, or of the pope acting as earthly head of the Church, apart from a council.

Dogma of the Immaculate Conception Dogma officially promulgated by Pope Pius IX in 1854 that states the Blessed Virgin Mary was free from original sin from the first instant of her existence. This teaching is commemorated on December 8, the liturgical feast day.

Episcopal College The body of bishops, headed by the pope, who are successors of the apostles in teaching and pastoral jurisdiction in the church. Membership is through sacred ordination to the episcopate. The college exercises supreme authority in the church when it acts in an ecumenical council or by collegial action by the bishops in union with the pope.

Ex cathedra The term used when the pope speaks infallibly as head of the church on matters of faith and morals.

***Fabbrica* of Saint Peter (la Fabbrica di San Pietro)** The Vatican commission that oversees the maintenance of the Basilica of Saint Peter.

Faldstool A backless chair, sometimes highly decorated, used by a bishop during such liturgical ceremonies as ordinations, when he sat apart from the *cathedra*.

First Vatican Council The ecumenical council that met from December 1869 to October 1870 in Saint Peter's Basilica. It was called by Pope Saint Pius IX and it approved two dogmatic constitutions: *Dei Filius*, regarding the relationship of faith and reason, and *Pastor Aeternus*, on the papacy's juridical primacy and on the infallibility of the pope.

Fisherman's ring The papal ring having a setting cut to serve as an official seal. It is no longer worn by the pope but is in the custody of the prefect of the Papal Household. Its image shows the apostle Peter standing in a boat casting a net.

Fresco A wall painting executed in a technique by which the pigments are applied to the surface of the fresh plaster (*intonaco*) while it is still moist.

Galero The grand, red tasseled hat that was placed upon the head of a new cardinal. In other colors and with fewer number of tassels the *galero* is still used in the coats of arms of prelates and clerics. Tradition often finds the *galero* suspended from the ceiling of a deceased cardinal's cathedral.

Holy door A walled-up door, actually a double door, found in each of the four major Roman basilicas to be visited by pilgrims during a holy year. The cemented or walled-up portion is on the inside of the church, and it is this part that is dismantled to allow the outer door to be opened, generally on Christmas Eve, for a holy year.

Holy See A see refers to the place from which a bishop governs his diocese, namely, the specific geographical territory over which he has the pastoral care of Catholics. The Holy See, sometimes called the Apostolic See, is the see of Peter, the bishop of Rome, who is the pope. Holy See, referring to the primacy of the pope, denotes the moral and spiritual authority exercised by the pontiff through the central government of the church, the curia.

Holy year A period decreed by the pope for the universal church, during which the faithful may acquire plenary indulgences by fulfilling certain conditions established by the church. A holy year begins on the Christmas Eve preceding the start of the year.

Iconostasis A screen in the presbytery of many Eastern rite churches on which icons are placed. This screen separates the sanctuary from the space occupied by the laity.

Indulgence The Catechism of the Catholic Church (N. 1471) defines indulgence as "a remission before God of the temporal punishment due to sins whose guilt has already been forgiven, which the faithful Christian who is duly disposed gains under certain prescribed conditions through the action of the Church which, as the minister of redemption, dispenses and applies with authority the treasury of the satisfactions of Christ and the saints."

Investiture Controversy This late eleventh and early twelfth-century debate focused on the question of the separation of church and state. In the early Middle Ages lay lords often chose candidates for the episcopacy. In 1075, Pope Gregory VII forbade lay investiture and excommunicated the emperor Henry IV, who subsequently drove the pope from Rome and placed his own candidate on the papal throne. At the Diet of Worms in 1122 the emperor Henry V gave up the right to appoint bishops, but retained the right to receive the homage of bishops in exchange for land holdings.

Jubilee A biblical term, from the Hebrew word *jobhel*, or ram's horn. A jubilee is the celebration of an anniversary, a period of rejoicing. They are preeminent religious occasions and periods of great grace: times for the forgiveness of sins and punishment due to sin, for reconciliation between man and God and man and man.

Lateran Basilica Saint John Lateran is Rome's cathedral, founded at the behest of Emperor Constantine between 312 and 314 on the Celian Hill.

Lex orandi, lex credendi "The law of worship is the law of the church," an axiom of the fifth-century Prosper of Aquitaine. The understanding of this phrase is that authentic worship always points to true doctrine.

Liturgical Calendar The list of commemorations observed throughout the Christian year consisting of two parts: the temporal and the sanctoral. The temporal, indicating the passage of time, is a series of christological festivals based upon the two great feasts of Christmas and Easter. The sanctoral is concerned with the celebration of the feasts of individual saints. The temporal cycle depends upon the day of the week upon which Christmas falls and the date of Easter. Saints feasts are fixed in the calendar year. The liturgical year begins with the season of Advent, which looks toward the coming of the Lord at Christmas. Epiphany, the Baptism of the Lord, and the Wedding Feast of Cana conclude the time known as the manifestation of the Lord upon which the original feast of Christmas is based. Lent is a time of penance and reconciliation, which originated as a period of preparation for those who were to be baptized at the Easter Vigil. Holy Week begins on Palm Sunday and continues with Holy Thursday, Good Friday, and Holy Saturday. Easter Sunday commemorates the Resurrection of Christ, and fifty days later the Feast of Pentecost is celebrated to mark the descent of the Holy Spirit upon the apostles.

Liturgical colors The association of certain colors and the celebration of the liturgy has developed over the centuries. For the first millennium colors of vestments and hangings were without significance, save for a preference of white robes used by the newly baptized. Although liturgical vesture remained the same in form as civilian dress, the clergy maintained special white vesture, sometimes with stripes, for use in the liturgy. During the twelfth century various colors began to be used to differentiate liturgical feasts and seasons. The Missal of Pius V (1570) defined specific rubrics regarding the use of color in the liturgy. Current usage follows the tradition of white for Easter, Christmas, feasts of Christ (other than the Passion), of Mary, of angels and saints (not martyrs), All Saints, Saint John the Baptist, Saint John the Evangelist, Chair of Peter, and Conversion of Saint Paul; red for the Passion and Palm Sundays, Good Friday, Pentecost, feasts of the Passion of Christ and of martyrs; violet for Advent and Lent and possibly for funeral masses in place of white or black; rose for Gaudete Sunday (Advent III) and Laetare Sunday (Lent IV); green at other times.

Loggia An open-sided, arcaded structure with columns, occupying either the ground story (portico) or an upper story (gallery) of a building.

Master of ceremonies (It., *cerimoniere*) The one who prepares and directs liturgical celebrations, especially when presided over by the pope or a bishop.

Mozzetta A short, usually elbow-length cape that encircles a prelate. It has an upright collar and fastens with twelve silk-covered buttons that traditionally represent the twelve apostles. Usually of a light wool (merlino) and silk, it is worn by all bishops when vested in choir; only the pope wears one of velvet. The mozzetta is currently reserved for the episcopal dignity and certain other clerics and is also worn by chaplains of the Equestrian Order of the Holy Sepulcher and the Order of Malta.

Nave The central section of a church flanked by rows of pillars or columns, often separating two aisles. In Early Christian basilicas the nave usually had twelve columns, symbolizing the twelve apostles and founders of the Church. The nave is generally reserved for the congregation and is broader than the aisles; in the basilica hall-type of church the nave and aisles are of the same height.

Parish church Toward the seventh century, the diocese began to build parish churches in the countryside, tantamount to extra-urban cathedrals, with their own territory, and complete with baptistery, like those in the city, and a priest responsible for the congregation in the name of the bishop.

Pilgrim A pilgrim is one who undertakes a pilgrimage, that is, a journey to a sacred place, as an act of religious devotion. It may be to venerate a holy place, a relic, or other object of devotion; to do penance; to offer thanksgiving for a favor received or to ask for such a favor; or any combination of these. A pilgrimage is symbolic of our earthly existence, that is, our journey to the heavenly kingdom.

Pope The bishop of Rome or Roman pontiff. When, upon the death of a pope, the College of Cardinals enters into conclave to elect his successor, they do not elect the pope but, rather, the bishop of Rome, who, by virtue of that office is pope. Canon 331 of the Code of Canon Law states: "The bishop of the Church of Rome, in whom resides the office given in a special way by the Lord to Peter, first of the Apostles and to be transmitted to his successors, is head of the college of bishops, the Vicar of Christ and Pastor of the Universal Church on earth; therefore, in virtue of his office he enjoys supreme, full, immediate and universal ordinary power in the Church, which he can always freely exercise."

Presbytery The section of a church, reserved for the clergy, between the chancel, or choir, and the high altar. Key features of the presbytery include the altar, the seat for the officiating priest, and the place from which the Word of God is proclaimed.

Quadriportico An open court surrounded by porticoes placed in front of a temple.

Relics (cult of). The veneration of the mortal remains of the saints, or the clothing or objects that once belonged to them. The scope and justification of such veneration is to proclaim the wonders of Christ and provide the faithful with an example to emulate.

Tabernacle. A case or box on a church altar containing the consecrated Host and wine of the Eucharist. Through the centuries, these receptacles have assumed various forms, including towers, caskets, doves, or niches carved out of walls; they usually have a closing hatch or door. The fifteenth century saw the introduction of tabernacles built in the form of little temples, and in the following century they found their place on the altar.

Transept The transverse part of a church intersecting the nave at right angles and giving the plan its cross shape.

Select Bibliography

Andaloro, M. "Il mosaico con la testa di Pietro: dalle Grotte Vaticane all'arco trionfale della basilica di San Paolo fuori le mura." In *Fragmenta Picta. Affreschi e mosaici del Medioevo romano*. Rome, 1989.

Angels from the Vatican. Exhibition catalogue. Alexandria, Va., 1998.

Aquinas, Thomas. *Summa Theologia*. 5 vols. Westminster, Md., 1981.

Barbier de Montault, X. *La Bibliothèque Vaticane et ses annexes*. Rome, 1867.

Barraclough, G. *The Mediaeval Papacy*. London and New York, 1968.

Bellori, G.P. *Le vite de' Pittori, Scultori et Architetti moderni*. Rome, 1672. Reprint ed., Rome, 1931.

Berthod, B. *Dictionnaire des arts liturgiques*. Paris 1996.

Cambridge Mediaeval History. 8 vols. Cambridge, England, 1967–69.

Cancellieri, F. *Notizie sopra l'origine e l'uso dell'anello pescatorio e degli altri anelli ecclesiastici*. Rome, 1823.

Catechism of the Catholic Church. Chicago, 1994.

Chadwick, H. *Heresy and Orthodoxy in the Early Church*. Aldershot and Brookfield, Vt., ca. 1991.

Chadwick, H. "Saint Peter and Saint Paul in Rome," Journal of Theological Studies, n.s. 8 (1957), 31-52.

Dalla terra alle Genti. Ed. A. Donati. Milan, 1996.

D'Archiardi, P. *I quadri primitive della Pinacoteca Vaticana provenienti dalla biblioteca Vaticana e dal Museo Cristiano*. Rome, 1929.

Davies, R. *The Book of the Pontiffs (Liber Pontificalis)*. English trans. 3 vols. Liverpool, 1989–95.

De Bruyne, L. *L'antica serie di ritratti papali della basilica di S. Paolo fuori le mura*. Rome, 1934.

De Rossi, G.B. *Catalogo del museo sacro vaticano (Biblioteca Apostolica Vaticana, ms. Arch. Bibl. 66A)*. Vatican City, [1894].

Di Stefano Manzella, I. *Le iscrizioni dei Cristiani in Vaticano*. Vatican City State, 1997.

Enciclopedia dell'Arte Antica Classicae e Orientale. Rome, 1958–.

Enciclopedia Cattolica. Vatican City, 1948–54.

Encyclopaedia of the Early Church. 2 vols. Cambridge, 1992.

Eusebius, *Ecclesiastical History*. Loeb ed. 2 vols. Cambridge, Mass., 1973.

Falconi, C. *The Popes in the Twentieth Century*. English trans. London, 1967.

Fallani, G., V. Mariani, and G. Mascherpa. *Collezione Vaticana d'Arte Religiosa Moderna*. Ed. M. Ferrazza and P. Pignatti. Milan, 1974.

La Fe y el arte. Exhibition catalogue. Montevideo, 1998.

Ferrua, A., E. Josi, and E. Kirschbaum. *Esplorazioni sotto la Confessione di San Pietro in Vaticano*. Vatican City, 1951.

Frend, W.H.C. *Martyrdom and Persecution in the Early Church*. Oxford, 1965.

Guarducci, M. *The Tomb of Saint Peter*. English trans. London, 1960.

Hebblethwaite, P. *John XXIII*. London, 1984.

The Holy See. Vatican Collections. Exhibition catalogue. World Expo 88. Brisbane, 1988.

Inscriptions Christianae urbis Romae septimo saeculo antiquaries. Ed. A. Silvagni. Rome, 1935.

Kitzinger, E. *Römische Malerei vom Beginn des 7. Bis zur Mitte des 8. Jahrhunderts*. Munich, 1934.

Ladner, G.B. *God, Cosmos, and Humankind—The World of Early Christian Symbolism*. Berkeley, Los Angeles, London, 1995.

Ladner, G.B. *I ritratti dei papi nell'antichità e nel medioevo, I, Dalle origini fino alla fine della lotta per le investitur*. Monumenti di Antichità Cristiana. Vatican City, 1941.

Lanzani, V. "'Gloriosa Confessio.'" Lo splendore del sepolcro di Pietro da Costantino al Rinascimento." In *La Confessione della basilica di San Pietro in Vaticano*. Cinisello Balsamo, 1999.

Lefron, J. *Pie VII*. Paris, 1958.

MacDonald, A.J. *Hildebrand, a life of Gregory VI*. London, 1932.

Mancinelli, Fabrizio. "Capella Sistina." In Angelo Tartuferi, ed. *Michelangelo-Pittore, scultore e architetto*. Bagno a Ripoli, 1993.

Mann, H.K. *The Lives of the Popes in the Early Middle Ages*. 18 vols. London, 1925–32.

McKitterick, R. *Carolingian Culture: Emulation and Innovation*. Cambridge, England, 1994.

Morrison, K.F. *Tradition and Authority in the Western Church, 300–1140*. Princeton, 1969.

New Catholic Encyclopedia. 15 vols. and 2 suppls. New York, 1967–79.

Le Origini degli Anni Giubilari. Ed. Marco Zappella. Casale Monferrato, 1998.

Pastor, L. *The History of the Popes from the Close of the Middle Ages*. English trans. 40 vols. London, 1891–1953.

Pietrangeli, C. *The Vatican Museums*. Translated by Peter Spring. Rome, 1993.

Pietri, C. *Roma Christian*. 2 vols. Rome, 1976.

Pietro e Paolo. La storia, il culto, la memoria nei primi secoli. Ed. A. Donati. Milan, 2000.

Southern, R.W. *Western Society and the Church in the Middle Ages*. London, 1970.

Two Thousand Years of Vatican Treasures. Exhibition catalogue. Vatican City State, 1994.

Vatican Collections: The Papacy and Art. Exhibition catalogue. New York, 1982.

Volbach, W.F. *La croce. Lo sviluppo nell'oreficeria sacra (Guida del Museo Sacro, II)*. Vatican City, 1938.

Wallace, L. P. *Leo XIII and the Rise of Socialism*. Chapel Hill, 1966.

Walsh, J.E. *The Bones of Saint Peter*. London, 1983.

Wittkower, R. *Art and Architecture in Italy 1600–1750. III. Late Baroque*. New York, 1999.

Index

Note: This index is intended as a guide both for the reader of the catalogue and the visitor to the Exhibition. There is thus a good deal of double reference to the text of the catalogue, including illustrations and to the exhibits. In order to assist users who may wish to pursue a particular thread in the catalogue or exhibition, there is also a good deal of double entry between headings. For example, portraits of the popes are listed under both "portraits of the popes" and under individual popes. Roman figures indicate discussion or textual reference, italic figures refer to illustrations (with the relevant figure number when appropriate) and references to exhibits are grouped at the end of each entry by exhibit number.

515